NEW ART CITY

NEW
ART
CITY

JED PERL

ALFRED A. KNOPF NEW YORK 2005

THIS IS A BORZOI BOOK PUBLISHED BY ALFRED A. KNOPF

Owing to limitations of space, all acknowledgments for permission
to reprint previously published material may be found at the end of the volume.

Knopf, Borzoi Books, and the colophon are registered trademarks of Random House, Inc.

Library of Congress Cataloging-in-Publication Data
Perl, Jed.
New art city / Jed Perl.
p. cm.
Includes bibliographical references and index.
ISBN 1-4000-4131-7 (hc)
1. Art, American—New York (State)—New York—20th century. 2. New York
(N.Y.)—Intellectual life—20th century. I. Title.

N6535.N5P46 2005
700'.9747'109045—dc22 2004048846

Manufactured in the United States of America
First Edition

Gray-suited Dawn O day
of many voices, ma-
 trix of moments, speak
 to and bring this thing I seek

 —PAUL GOODMAN, "TO DAWN"

it is not the plunder,
but "accessibility to experience."

 —MARIANNE MOORE, "NEW YORK"

CONTENTS

THE EMPIRICAL IMAGINATION

NEW ART CITY

THE PAINTER AND THE CITY

I

"Mitcha, why aren't you home painting?" This was what Hans Hofmann said to Joan Mitchell when he saw her out walking her dog early one morning in the paint-happy 1950s. Hofmann was in his seventies and Mitchell was turning thirty. She had studied with him briefly, in the school he had run in Manhattan since 1933. And like so many other artists of her day, she had felt the casually messianic impact of this man who was thickly built, with a large, powerful head and an orator's way of using his arms and hands to underscore a dramatic point. In the 1950s Hofmann and his wife, Miz, were living in a fifth-floor walk-up on Fourteenth Street, not far from his school, which was on Eighth Street, and Mitchell worked in several studios in the neighborhood. Hofmann and Mitchell would run into each other in Washington Square Park, that patch of green dominated by the famous triumphal arch, and all around them was Greenwich Village, with its extraordinary cache of nineteenth-century domestic architecture and its occasional modern storefronts and its faded fascination. The Washington Square of Henry James's story, with its Old New York gentility, had vanished long ago. For half a century the neighborhood had been home to bohemians who placed their hopes in socialism or in art-for-art's-sake, and by now the artists and writers sometimes seemed to be outnumbered by the tourists in search of a glimpse of the *vie de bohème*. All of this was an amazingly comfortable backdrop for Hofmann and Mitchell and their friends, who walked along those familiar Village streets, immersed in their own glorious reimaginings of art and life and New York City, secure in the knowledge that they would make everything new.[1]

Hofmann, a painter and teacher who laid out the principles of modern art in a sometimes nearly impenetrable German accent, could have been Mitchell's grandfather. He could have been a father to Willem de Kooning and Jackson Pollock, artists who had already racked up achievements that left

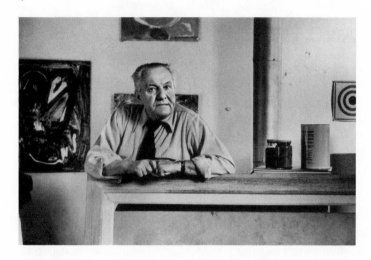

Mitchell and her young friends awestruck. And yet there was an agelessness about Hofmann. Rudi Blesh, a writer who was as interested in ragtime and jazz as he was in the new American painting, observed that Hofmann "paints spontaneously with fury that is a real fury even if it is cheerful rather than grim." For painters and sculptors of Mitchell's generation, who listened to Hofmann in his school or on a street corner or at a gallery opening, it was almost incredible to imagine how far he had traveled. And now Hofmann's rich and varied life—which had begun in Bavaria in 1880 and had included long periods in two of the great European cities—was coming to a climax in New York in the mid-century years, when the melting-pot city was reaching the boiling point. New York itself was incredible, "really like a Byzantine city," according to de Kooning, who was thinking of a city of contrasts and contradictions, a city where people from all over the world came together.

The thought was seconded by Robert Motherwell, a young painter who had begun to exhibit in the 1940s and who explained to the poet Frank O'Hara that "New York City is a Constantinople, a great Bazaar."[2]

The Byzantine city was a trading city, a place of exchanges, of cross-fertilizations.

*Students from the Hofmann
School in Washington Square
Park, 1948–49. Seated in the
foreground are Jane Freilicher
(left) and Nell Blaine (right).*

Pat Passlof, another young painter, who had studied at Black Mountain, the experimental college in North Carolina, was back in New York in the fall of 1948 and found that the artists she knew created a Byzantine city within the Byzantine city. She said that her artist friends were as varied as "the characters from a Russian novel. . . . There were Italians; there were Greeks; there were Egyptians and Dutch and Spaniards and Armenians and Russians and even two Icelanders." And they were all "so extreme in their personal and national traits and philosophies, so shrewd in dialogue, so immersed in art, that conversation, even a chance encounter on the street, was complex"—and there were those street encounters again, encounters that we will be hearing about all through the mid-century years.[3] Many of the artists Passlof was talking about had studied with Hofmann, and most of those artists would have agreed that what Hofmann, a tough-minded visionary, brought to New York were the secrets of modern art, of an art that exulted in essences and that sometimes seemed to have changed everything about art and that was now as old as Hofmann himself. He had been born a year before Pablo Picasso and two years before Georges Braque, both of whom he'd known in Paris at the beginning of the century. Hofmann grew up in Munich, where his father was a minor government official. In the decade leading up to World War I, he had lived the artist's life in Paris, where he had been close to Robert Delaunay, one of the pioneers of abstract painting, and had drawn beside Matisse at a legendary school, La Grande-Chaumière. World War I forced Hofmann back to Munich. It was there, in 1915, that he had opened his first school and taught until the beginning of the 1930s, when, in response to the worsening political situation, he began to accept teaching offers in the United States, some of them from Americans who had earlier traveled to Germany to study with him.

In each of the world cities where Hofmann lived—in Paris, in Munich, and, finally, in New York City—he was passionately involved with drawing and painting. When he was alone in the studio, however, he had not always found it easy to let loose with paint. In Germany he had painted hesitantly if at all; he had become something of a custodian of Parisian discoveries, subsuming his own creative urges in his urge to bring the meaning of modern art to a younger generation. Only after he had settled in New York was Hofmann really able to jump back into painting. He had a one-man show with Paul Cassirer in Berlin in 1910, and no other solo exhibition until 1931, in San Francisco; in the late 1940s he began to show his paintings regularly in New York. His American years, all the way from the early 1930s to his death in 1966, were an expansive time in New York, and Hofmann contributed more than his fair

share to the heat and brilliance of the city. He was a man with a romantic sense of the individual's at-an-angle relationship with society and a dialectician's belief that to flourish in the world you had to embrace a broad, grand struggle. And Hofmann found in the new city of art a place where his gifts were at last fully in play. "If I had not been rescued by America," he announced in 1944, "I would have lost my chance as a painter."[4] As the New York years passed, Hofmann's painting—which in the 1930s and 1940s included some boldly, exuberantly calligraphic canvases of that primal scene, the artist's studio—became ever more daringly intuitive, until his knockabout abstract clashes of hot and cold colors and soft-edged and hard-edged forms were capable of telegraphing any emotion or impression, from black-midnight terror to summer's-day ecstasy.

The paintings that Hofmann produced in the 1950s and 1960s are a dazzle of color. While this is unabashedly painted color, with all the lurid force and crazy artificiality of the stuff that comes out of a tube, Hofmann somehow manages to use his electrically unnatural hues to create a whole variety of naturalistic effects. He excels at shimmers and halos and sparks and radiant glows, and he's terrific at suggesting a mysteriously effulgent darkness. He's also a master of textures, which in his work range from watercolored to impastoed, from cake-frosting smoothness to stucco-like roughness. Often in his painting, colors and textures are pushed to dissonant extremes, so that the artist's power is presented in perpetual, turbulent play. He knows how to achieve a beyond-analysis impact, as if we are seeing a brilliant sunset right after a fast-moving storm. *Pompeii* (1959) is a red painting, insistently vertical. The full cry of the red is opposed by rectangular forms, in magenta, cool lemon yellow, deep golden yellow, and bright light green. Other areas of the canvas have softer, darker edges. There's one large form in a blackish but frothy green, and there are a few small bits of blue. The painting is jazzy, swank, opulent. While you may miss some element of honest equivocation, there is no question that the painting's stentorian presence is unforgettable. *Pompeii*, which lives up to the volcanic history of the ancient Roman city, is one of many compositions in which the hyperbolic effects are paired with unabashedly metaphoric titles, such as *Orchestral Dominance in Yellow*, *Golden Blaze*, *Moonshine Sonata*, *Summer Night's Bliss*, *Pre-Dawn*, *Lava*, *Towering Clouds*, and *Indian Summer*. These works announce a new kind of free-flowing pictorial experience. The rapid-fire play of color and shape and texture incites wild metaphoric imaginings, until you hardly know where the ecstatically melodramatic experiences end and the beguilingly sensuous ones begin.

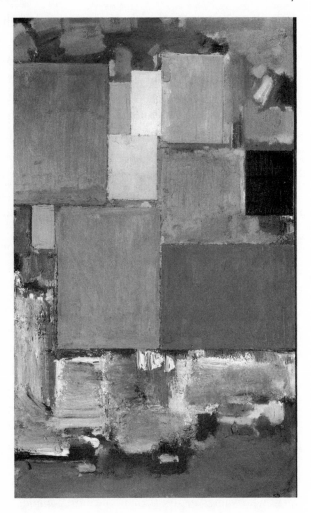

Hans Hofmann,
Pompeii, 1959.
Oil on canvas,
84 × 50 in.

II

While mid-century New York did not produce a single quintessential artistic figure, Hofmann held a unique, almost talismanic position in that very complicated world, and it is good to linger with him for a while now, as we approach the Manhattan of the 1940s and 1950s, with all its crazy variety, with all its artists and dealers and museum people and collectors and critics and gallerygoers and museumgoers. The lectures that Hofmann gave in Manhattan in the late 1930s attracted an extraordinary roster of young New Yorkers, including Arshile Gorky and Clement Greenberg, and although in the early years Hofmann's school was not especially well attended, with perhaps a dozen or so students at a time, his underground fame was spreading very fast.

Nell Blaine, who began painting in Virginia when she was a child, had heard about Hofmann from a teacher, Worden Day, who had studied with Vaclav Vytlacil, who had studied with Hofmann in Germany. America was beginning to develop an underground network of young artists who were crazy to grasp the principles of modern art. Blaine was twenty when she arrived in Manhattan in 1942 to attend the Hofmann School; she would later recall, "I came . . . to New York to study with Hans Hofmann as a pilgrim comes to Mecca."[5] And as time went on, his influence only grew. Writing in 1948, the year after *A Streetcar Named Desire* opened on Broadway, Tennessee Williams, who was a frequent visitor to Provincetown, where Hofmann ran his school in the summer, described Hofmann as a "bold and clear-headed man who paints as if he understood Euclid, Galileo and Einstein, and as if his vision included the constellation of Hercules toward which our sun drifts."[6] Look closely at Hofmann's forcefully, exultantly improvisational canvases, Williams seemed to be saying, and you will find that this man who had left the Old World and embraced the New World reveals not only the secrets of modern art but also the secrets of modern life.

There was nothing static about the grandeur of art, at least not as Hofmann presented it. There was always a sweep, a lift to Hofmann's pronouncements. He spoke of the "movement and countermovement" in a work of art as creating a "spiritual life." He spoke of "a life of the spirit without which no art is possible—the life of a creative mind in its sensitive relation to the outer world."[7] And Hofmann took these mystical German pronouncements and gave them a concreteness, a New York practicality. He offered his students a new version of what amounted to the eternal verities of art. He insisted that an artist who wanted to give form to the most complex and ecstatic dimensions of human experience had to begin by attending to the humdrum specifics of his craft. When the critic Harold Rosenberg, who had himself attended Hofmann's lectures in the 1930s, sought to explain the secret of Hofmann's essential place in New York, he said that as far back as the 1930s, that "decade of ideologies—New Deal, Marxist, Fascist—it was plain that the Hofmann teachings, too, offered a KEY." The key, for Rosenberg, was Hofmann's insistence that "art was the supreme activity."[8] Fair enough. And how did Hofmann give such a supremacy to art? At this point we have to listen to Hofmann very closely, we have to try to imagine ourselves back in his school, with the model, the chockablock easels, and all the unfinished charcoal drawings. Standing there, Hofmann would hold up before his students a sheet of plain-as-plain-can-be paper and announce in that crazily accented English of

Hans Hofmann, Drawing, *1945. Ink on paper, 41 × 30½ in.*

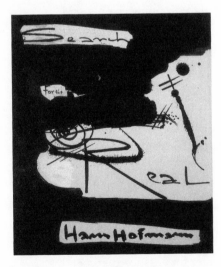

Hans Hofmann, study for the title page of the essay collection Search for the Real, *1948. Ink on paper, 17 × 14 in.*

his that "within its confines is the complete creative message." Now, this could sound like a very small thing, but it was in fact a very large thing. What Hofmann was saying was that when you drew a line on a piece of paper, you were creating a world. "Pictorial life," Hofmann asserted, "is not imitated life; it is, on the contrary, a created reality based on the inherent life within every medium of expression. We have only to awaken it."[9] And here, in this talk of life and reality and awakening, we see Hofmann's fascination.

The life that an artist awakened within the dimensions of the sheet of paper was all mixed up with the awakening of mid-century New York. And Hofmann's genius had everything to do with pushing artists to go into the studio and find, there, the world outside. He insisted that only by concentrating on the small, practical things in the studio—by attending to the nitty-gritty, to the step-by-step construction of a painting or a sculpture—would artists ultimately discover the big truths, the grand ideas. Hofmann refused to accept any mechanistic relationship between art and life, and yet wasn't it becoming increasingly clear that the hard labor of several generations of artists was having its magical effect, and that mid-century Manhattan was coming alive with a tidal wave of new forms? These included Hofmann's brazen flourishes of color; Mark Rothko's shimmering, hovering, soft-edged, forever floating rectangles; Jackson Pollock's quicksilver skeins of paint unfurling panoramic arabesques; and the crushed, jagged, turning-back-on-itself calligraphy of Willem de Kooning's gnomic alphabets. And there was much more: Joseph Cornell's beguiling boxes, with their propi-

tious juxtapositions; Burgoyne Diller's levitating rectangles; Joan Mitchell's delicate weaves of muffled, sooty color; Nell Blaine's explosive renderings of quotidian scenes; Fairfield Porter's cool interiors, all pale grays and pinks and browns; and Ellsworth Kelly's extraordinary simplifications, suggesting sails or semaphores. And all of that was still only the beginning.

III

The broadest outlines of this postwar story are very familiar, some might say all too familiar. As early as 1960, the art historian Robert Goldwater—who was married to the sculptor Louise Bourgeois and knew the Abstract Expressionists from the days when they were anything but famous—observed that the New York School had already "lived a history, germinated a mythology and produced a hagiology; it has descended to a second, and now a third artistic generation."[10] Goldwater had been following the arts since the 1930s (his pioneering study, *Primitivism in Modern Painting*, appeared in 1938), and he may have been a little stunned at how rapidly events had unfolded in the years after the war.

Earlier generations of New York artists, such as Alfred Stieglitz and his circle, had also achieved a mythic aura, but somehow it didn't seem as if as many people had fallen under their spell. While the avant-garde art of Jazz Age Manhattan had had a kind of popular fascination, that could seem a localized phenomenon to the generation of Pollock and de Kooning, who found that American avant-garde art was becoming an internationally recognized shorthand expression for the postwar boom—for its fast-forward, experimental spirit. In 1949, when the *Magazine of Art*, of which Goldwater was editor, sponsored a symposium on "The State of American Art," Douglas MacAgy, who had turned the California School of Fine Arts in San Francisco into a West Coast outpost for the New York ferment, argued that the new American art embodied an "esthetic variability" that mirrored "the frank acknowledgment of heterogeneity, which marks the present century."[11] MacAgy was celebrating American art, with its panoply of new forms, as a reflection of a broader, international experience. And in a fifteen-year period that began roughly with de Kooning's first one-man show at the Charles Egan Gallery in 1948 and ended when Pop Art was the darling of the news media, New York became, by near universal agreement, the world center for artistic experimentation. New York was a magnificent symbol of the new American prosperity, and even though the artists often regarded themselves as being out of step

with a consumer society, their extravagant images could be seen as symptomatic of an era that—in spite of the Korean War, the Cold War, and the threat of the Bomb—felt to many like a time of expanding possibilities.

What was clear to just about all the artists was that the ball was in New York's court. The grand old themes now belonged to Manhattan. These themes included the artist's relationship with society; the struggle to define and redefine quality; and the place of meaning in art, and especially, now, in abstract art. While there has been a temptation to present this as a story of victory against all odds, I am not convinced that such a triumphalist approach ultimately tells us very much about how artists ticked then—or how their achievements have actually affected the best artists who are working today. The mid-century years interest me for their own sake, but also as a kind of exemplary case of how a range of artists, nourished by a richly braided-together sense of what an artist can do, shot off in different directions and made of the very dissonance that is inherent in tradition their own divergent traditions. MacAgy, writing in the *Magazine of Art*, believed that "the diversity and contrast of belief, curiosity and behavior in society at large occur as well within the individual." And he believed that "a demonstration of diversity in a collective sense is, by extension, an affirmation of the individual's privilege to form his own patterns of action."[12] In New York—and in San Francisco and other places—there was beginning to develop a range of more or less formal and sometimes utterly informal institutions dedicated to the heterogeneity of American art, and to a community that affirmed that "esthetic variability." These included a group of galleries, both commercial ones and artist-run ones; curators who were anxious to devote more exhibitions and museum programming to the work that younger artists were doing; freewheeling discussions at places such as the Artists' Club; and schools, including MacAgy's School of Fine Arts in San Francisco, Black Mountain College in North Carolina, and, of course, the Hofmann School, which achieved an importance equal to any art academy that had existed since artists began to gather together to draw from the model in the first academies of the sixteenth century.

Hofmann was becoming much more visible in those mid-century years. By 1947 he had begun to have annual one-man shows at the Kootz Gallery, and these events gave the artists who had known him primarily as a teacher an increasingly rich and nuanced sense of his work as a painter. In 1949 Samuel Kootz arranged for Hofmann to show at the Maeght Gallery in Paris, an establishment that was achieving a high profile through its exhibitions of such old

and new modern masters as Braque and, soon, Alberto Giacometti. In 1956 Hofmann designed a group of murals, executed in mosaic, for the elevator bank in the lobby of a building at 711 Third Avenue; with its madcap assortment of all-over-the-rainbow hues and piled-high rectilinear forms intercut by zigzags and curves, this elaborate composition suggested an orchestral fanfare for Manhattan's mid-century prosperity. The next year, 1957, when Hofmann was given a retrospective at the Whitney, which toured the country, there was a profile, "A Master Painter," in *Life* magazine. *Life* and other large-circulation magazines had been paying a certain amount of attention to the New York avant-garde since the late 1940s, and if people across the country who subscribed to these magazines were laughing at the stories about the doings of the downtown New York artists, something in those reports on free-spirited Manhattanites was also getting under readers' skin. At least that was how it seemed to the editors back in New York, who would not have produced these art features if they did not believe they held people's interest. Apparently the editors were not wrong. By 1958, Hofmann had closed his school, but the attention that *Life* and *Vogue* and other magazines had given to the New York avant-garde in the previous decade had certainly helped to bring young artists to New York, some of whom had at one time or another found themselves studying with Hofmann.

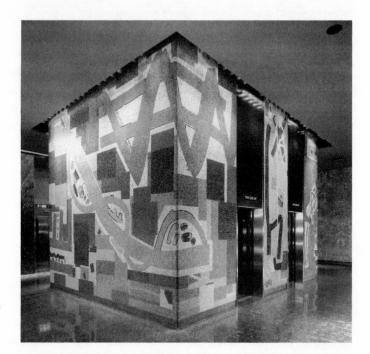

Hans Hofmann,
711 Third Avenue
mural, 1956.
Mosaic.

Within a matter of decades, many of the painters and sculptors who were only beginning to be known in 1950 had become figures in an American pantheon, a pantheon full of elders who, we are led to believe, never had a dull moment. By now the colorful old stories about downtown New York have been studied by several generations of artists, museumgoers, critics, curators, and historians, many of whom are inclined to regard the 1950s as a grittily glamorous Golden Age, and who probably regret never having had the opportunity to know that world firsthand. Some of the artists of the 1950s have been hoisted up on pedestals and studied under microscopes. Indeed, all the attention that has been lavished on the ins and outs of the period—on the secondary characters, on the sexual escapades, on the disputes and adventures—can have an almost creepily sentimental feel. Hofmann never received the kind of klieg-light attention that was focused on de Kooning or, especially, on Pollock, and maybe we should be glad of that. Even as New York's bohemian youth were inspired by Hofmann's feverish determination to keep stretching as a painter, they were falling in love with his rootedness, with his steadiness. Many people who were lucky enough to be invited to his house in Provincetown were fascinated by his wife, Miz, a 1910 bohemian mellowed into old age. Hofmann had come to America before Miz, and it was said that he had been reluctant to have her follow him, and yet their differences were not what people noticed in the later years. "I was very, how do you say, *populaire*, when I was young," she told a visitor in the early 1950s, and the visitor continued, "So she still is, and will always be." In her diary, Judith Malina, who in those years was starting the Living Theatre with her husband, Julian Beck, wrote about talking to Miz at one of Hofmann's openings at the Kootz Gallery. "The important things," Miz said, "are, after all, the paintings. They are the only things that count and all this politics—what does it matter?" And Malina added: "When she says politics, she means money."[13]

There are many photographs of the Hofmann house in Provincetown, and it was a striking artist's habitat, a kind of essence of the bohemian style of countless houses up and down the Eastern seaboard, of all the inexpensive old places that the artists bought in the pleasantly aging villages and towns. The walls were painted white and the floors were in various startling bright hues. This brilliant arrangement set off the pieces of old furniture that Miz had brought from Europe and the primitive paintings of Paris by Louis Vivin that she collected. Here, as in Hofmann's teaching, there was a sense of both the importance of modern art's revolutionary ideas (those flat white walls and sharply colored floors) and of preserving older values (that nineteenth-

Fred McDarrah,
Hofmann house
in Provincetown,
circa 1960.

century Biedermeier furniture). The stark white walls juxtaposed with shots of strong color echoed the look of Piet Mondrian's studios and numerous other de Stijl and Constructivist interiors, but within this modern environment there were elaborately ornamented forms, which complicated and romanticized the space. Those interiors, with their vehement colors and traditional furnishings, were not unlike Hofmann's paintings, in which a dramatically contemporary attitude was mixed with a sense of shape and structure that was rather traditional, even a little old-fashioned.

IV

In Hofmann's writings and conversations, the names of the titanic figures of European art rang out time and again. He spoke of "Michelangelo's monumentality" and of "Rembrandt's universality." And he explained that "Beethoven creates Eternity in the physical limitation of his symphonies. Any limitation can be subdivided infinitely." This idea about Beethoven echoed the eighteenth-century poet Friedrich Schiller's vision of a "replete infinity" in his *On the Aesthetic Education of Man,* one of the cornerstones of romantic

thought, which was not surprising, since so much in Hofmann's thought and in the drama of his paintings was rooted in romantic thinking and feeling.[14] If the generation that flocked to Hofmann's lectures and classes tended to be less infatuated than he was with such high-flown romantic rhetoric, those booming ambitions were nonetheless destined to become the backdrop for the younger artists' thinking, and the streetwise spirit of the 1950s did have its romantic foundations. When Hofmann spoke of Rembrandt and Beethoven, those heroic, world-transforming figures, he spoke of a yearning for freedom and intensity of expression, of an individualism that transcends humdrum events and aims for the experiences that are most intense, most essential. In a series of analytical exercises drawn directly on photographs of Old Master paintings—they were studies for a projected treatise—Hofmann sought the timeless abstract structures that were implicit in the representational forms of the work of Giotto and El Greco and Rembrandt.

If Hofmann, as Rosenberg had argued, offered an artist's individualist riposte to the communitarian longings of the radical 1930s, then the fascination of the most formidable artistic figures—of Rembrandt and El Greco and Picasso, and perhaps of de Kooning as well—was that they were reshaping the history of images, which was also the history of ideas. As the workers' paradise that many had hoped to see in Soviet Russia turned out to be a human catastrophe, many intellectuals who had been immersed in the thought of Marx and Engels, such as Sidney Hook, who was in the *Partisan Review* crowd, began to take another look at the promise of what Hook called, in the title of a 1943 book, *The Hero in History.* There he discussed what he referred to as the "heroic determinism" of great literary and artistic figures, and thanked Meyer Schapiro, the art historian who was a friend of de Kooning's and of so many other downtown artists, for suggesting the glittering list of heroic artists whom Hook mentioned in his book. "The New Yorkers," the critic Thomas Hess explained, "worshipped the heroes of art history."[15] By the 1950s, the radical politics of the 1930s seemed to many artists to be a dream, at once exhilarating and night-

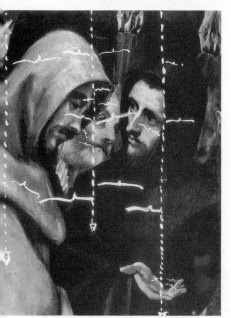

This analytical drawing by Hans Hofmann, done over a photographic detail of El Greco's Burial of Count Orgaz *(1586), is one of a series prepared for a projected treatise on art.*

marish, from which they had awoken, but Marx's famous words in *The Eigh-
teenth Brumaire of Louis Bonaparte* could sound more relevant than ever be-
fore, only now as an artistic credo. "Men make their own history, but they do
not make it just as they please; they do not make it under circumstances chosen
by themselves, but under circumstances directly encountered, given, and
transmitted from the past." Hofmann could have almost been echoing those
words when, shortly before he died, he said that "you belong to a certain time.
You are yourself the result of this time. You are also the creator of this time."[16]

The consciousness of their place in history could be an encouragement, an
inspiration, a goad, but also an oppressive awareness, a force that robbed
artists of their sense of freedom. Hofmann warned that "an artist is valued for
his personal interpretive insight and not for his conformity to traditional pat-
terns. So it is always an indication of uncertain knowledge if, when judging a
work of art, one compares the work of one artist with that of another." And
yet there Hofmann was, invoking Rembrandt and El Greco, not, perhaps, as a
comparison, but as a goad, an inspiration. Asked late in life, after a visit to
Venice, which artists he particularly liked, Hofmann spoke of the works by
Titian and Rubens that he knew from Munich and Vienna, and observed, "As
an artist, you love everything of quality that came before you. In Venice the
Tintorettos are fantastic, and I also admire the Italian primitives. Then there's
Grünewald—he stands alone, but Rembrandt is even greater."[17] The quicken-
ing comparison of Grünewald and Rembrandt suggests Hofmann's taste for
dialectical oneupmanship, a recognition that he brought to his teaching when
he gave students a contrarian shove, a shove that got them moving forward in
unexpected ways.

In a novel by Anton Myrer, *Evil Under the Sun*, set in Provincetown in the
summer of 1947 in the circles around the Hofmann School, the Hofmann fig-
ure is named Carl Roessli, and we have one of the fullest, most convincing
portraits of the artist as a teacher who was constantly pressing his students to
be critical, to look at every situation from several angles. Roessli went from
easel to easel, and his conversation, though all derived from an idea that
"Nothing must be arbitrary; everything follows a logic," was constantly read-
justed in response to the student, to the situation. When some of the more
sophisticated painters were amused by the rather primitive naturalistic efforts
of Mrs. Munner, Roessli announced, "It is a great error to despise representa-
tional painting; if academic art obeys the laws of the canvas it is just as valid.
What of the old masters—Rembrandt, El Greco, Goya, the Italians?" But
when another talented student argued that "abstract painting's turned into a

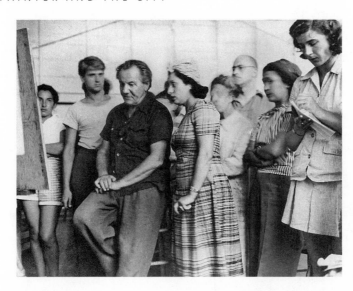

Hofmann with students at the school in Provincetown, circa 1941. Robert De Niro is to the left of Hofmann.

lousy lullaby in rhythm. . . . Two-dimensional building blocks, that's what it is," Roessli mounted a defense of pure abstraction. "Ja, it can become that," he said. And then, "with a tiny smile, his eyes twinkling," he continued. "There are many kinds of meaning; and everyone has to find his own way to the expression of it. But you must not think that the inclusion of symbolic or literary meaning in a painting *necessarily* increases its greatness; in fact, the opposite is more often true."[18]

While Hofmann's students spent most of their time in his school working from still lifes and models, this engagement with the traditional genres was in many respects only a jumping-off point, and the artists who emerged from the school went in a variety of directions that reflected Hofmann's essentially liberal impartiality in stylistic matters. Both as a painter and as a teacher, he was determined to move beyond rigid choices about abstraction versus representation or painterly expressionism versus hard-edged geometry. Hofmann's pluralism had no whiff of eclecticism, for it was powered by a belief that all of the branches of the tree of art shared a single, ineradicable root system, and this belief was in turn powered by a fascination with origins and genealogies that had always been a cornerstone of the modern movement. Hofmann's talk was full of births and beginnings; when he was not encouraging artists to focus on the first line that they put down on a sheet of paper, he was attempting to explain where Cubism came from. But then the whole question of where modern art came from and where it was going preoccupied artists, as it did the critics and curators who were taking an interest in their work. Most

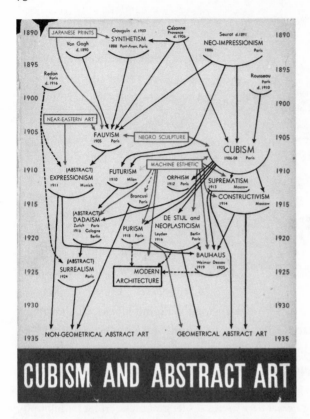

CUBISM AND ABSTRACT ART

Cover of the catalog for Alfred H. Barr's "Cubism and Abstract Art" exhibition, at the Museum of Modern Art in 1936.

New York artists knew the diagram that Alfred Barr had created for the dust jacket of the catalog of the seminal 1936 exhibition "Cubism and Abstract Art," a complex genealogical plan in red and black, with piled arrangements of movements and artists connected by arrows and broken and unbroken lines. And in a series of cartoons published in art magazines, Ad Reinhardt was creating his own genealogies, in one of which the New York art world became an enormous tree, with branches representing the artistic tendencies that went off in various directions and leaves representing the individual artists who appeared and, eventually, disappeared.[19] Each artist aimed to solidify a vision that might in turn give birth to other visions, and to look at postwar New York is to see far more branchings and blossomings than many people are now aware of. Among the considerable but sometimes too little recognized artists who were influenced by Hofmann and whom we will be encountering in the new city of art are Richard Stankiewicz, whose sculptures of welded junk metal combine a rollicking, comic eccentricity with a sense of bold, architectonic structure, and Louisa Matthiasdottir, whose rapidly brushed portraits and still lifes, at once opulently colored and angularly composed, suggest a

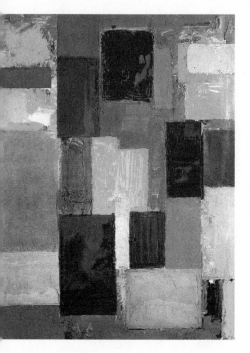

Hans Hofmann,
Abstract Euphony, 1958.
Oil on canvas, 50 × 40 in.

route back from Constructivism to naturalistic classicism.

Hofmann believed that there were many different artistic approaches that could turn out to be equally absorbing. And this, when you come right down to it, was the great idea that energized New York in the postwar years, even though it was an idea that was all too often in danger of being eclipsed by the theatricality of the trend-spotters, who were, successively, preoccupied with painterliness and then with hard-edged effects and then with Pop subject matter and then with something else. Even Clement Greenberg, one of Hofmann's staunchest admirers, could not help feeling that Hofmann's "variety of manners and even of styles" was problematic. Unlike most of the Abstract Expressionists, who tended to explore a single iconographic look—Rothko's soft-edged rectangles; Franz Kline's enlarged calligraphic strokes; Clyfford Still's dark, ragged shapes; Barnett Newman's hard-edged "zips" of color—Hofmann was constantly reaching for different, even contradictory effects. "Such a diversity of manners," Greenberg wrote, "makes

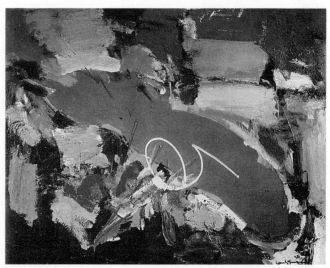

Hans Hofmann, The Pond, 1958.
Oil on canvas, 40 × 50 in.

one suspect an undue absorption in problems and challenges for their own sake."[20] And yet if an artist had the toughness that was needed to go off in a number of different directions, what was the sin in embracing a range of possibilities? An important little magazine, edited by Robert Motherwell, Harold Rosenberg, and others—which published only one issue, dated Winter 1947/8—was called *Possibilities*.

V

Amid the proliferating possibilities of the postwar years, there is certainly some pattern to be found, and this pattern has everything to do with changing attitudes toward history and toward tradition, which is history in its timeless aspect. In the first half of the 1940s, the most interesting American artists were struggling to find a place for themselves within the wider development of art, and that struggle often gave their work a dark-toned romantic fervor. In grappling with the awe-inspiring achievements of the past, artists were drawn into confrontations that were by their very nature dialectical, and out of these confrontations came the conviction that New York was at long last becoming a world city of art. What made Hofmann such a rousing presence in the midcentury years was that he knew that it was only by embracing the dialectical spirit—by embracing the belief that contradictions generate revelations—that New York's artists would be able to take their place in history. But Hofmann also understood something else that was extremely important, namely that in order to sustain a high level of achievement, artists had to continually reaffirm the empirical nature of creation. It was by maintaining a healthy skepticism about what could turn out to be the vaporous promises and misty epiphanies of the dialectic that artists remained free to focus on what was most immediate, on what mattered to *them*. This need for immediacy involved not empiricism in the philosophical sense of the tiniest elements of perception, but empiricism in the more general sense of a recognition of the fundamentals of artistic tradition, whether those were the paints on your palette or the landscape before your eyes, or some idea about the structural essentials or the beauty of materials. Hofmann taught his students that the finest dialectician was also always an empiricist, and that the empiricist who did not grasp the dialectical movements of history and tradition would never go very far. No wonder Miz called Hofmann a creature of contradictions—*Widerspruchsgeist* in German.[21]

The struggle for independence, which every modern artist has embraced,

took on a particular vehemence among the painters and sculptors of New York, and that vehemence was in part an echo of an older kind of American toughness. Most of the downtown artists would have agreed with Hamlin Garland, the turn-of-the-century American author who had announced in his manifesto, *Crumbling Idols*, that "art, I must insist, is an individual thing,—the question of one man facing certain facts and telling his individual relations to them."[22] The big question, of course, was what made for individuality in art. The often anarchic energy of the city could be seen as justifying a do-whatever-the-hell-you-want-to-do attitude that began by energizing art but could also collapse into a debilitating nihilism. By the middle of the 1950s, New York was already beginning to feel the impact of what was to become an ever widening revival of the Dadaist hijinks that had begun in World War I Europe and had been more or less exhausted by the 1920s, at least so many believed. Marcel Duchamp, the King of Dada, had lived in Manhattan off and on for decades. For a long time he had believed that art ought to be dissolved into life, and now he was discovering that there were younger artists, among them Jasper Johns and Robert Rauschenberg, who agreed.

Duchamp found the smell of turpentine unbearable, and wondered how anybody could ever want to paint. In place of works of art, he offered gnomic observations about the nature of art and found objects around which his admirers could spin whatever theories they liked. Another view of the art-and-life equation was offered by Ad Reinhardt, a painter who was turning out to be the gadfly's gadfly among the downtown artists, and believed that art was always a thing unto itself, that art always signified only itself, that art was related to nothing but itself. Reinhardt described art in such exalted terms that it was in danger of vanishing entirely. Reinhardt and Duchamp, in their very different ways, represented a pessimistic view of the possibilities of art in the New World, and their pessimism had a paradoxically glittery allure, and would become a dominant force in the New York City of the 1960s. Already in 1958, Nell Blaine was worrying in a journal entry about the rise of "the idea of novelty above all" as well as "the love of cruelty and art brut of the Post-Atom 2nd string Dadaists." All this, she wrote, "has stuck in the craw of many serious artists who may go their own way quietly." At least until the end of the 1950s, however, Duchamp's and Reinhardt's dark, contrarian views were held in check by a gloriously optimistic sense, the sense that Hofmann epitomized, that art was organically, dialectically related to the hurly-burly of life—and that art could transcend life. "Those with a capacity for life, *joie de vivre*," Blaine observed, "will go on in the face of annihilation."[23]

While this story has its chronological logic, unfolding events do not so much overturn yesterday's preoccupations as they force artists to see old themes from new vantage points. In his memoir, *The Intellectual Follies,* the philosopher and playwright Lionel Abel recalled that when he visited the Cedar Tavern, the legendary artists' watering hole, there was a sense of "ideas in the air," and he believed that you could not really understand what was happening in New York until you had allowed yourself to feel the pull of those ideas.[24] What were some of them? Well, they were hard to define. But surely they included the sublime, the dialectic, the romantic, the heroic, the abstract, the empirical, the quotidian, the nihilistic. Many of these were ideas that, as Hofmann suggested through his stirring allusions to El Greco, Rembrandt, Goethe, and Beethoven, came out of a tradition. But what New Yorkers chose to do with all those ideas was their own business. Hofmann saw artists as knockabout Olympian figures, juggling dissonant forces, embodying principles of joy and sorrow in the very unfurlings of their voluptuous brushstrokes. And if New York was ready to accept this kind of easygoing philosophical grandiosity, it was because this was a city in which not only modern art but also modern ideas had become virtually the air that people breathed.

In D. H. Lawrence's *The Plumed Serpent,* a novel about Anglo encounters with Indian culture in Mexico and the American Southwest, which was originally published in 1926 and reprinted as a Vintage paperback in the 1950s, one character asks, "What else is there in the world, besides human will, human appetite? because ideas and ideals are only instruments of human will and appetite."[25] Readers still felt the tug of this great vision that went back to Nietzsche and Schopenhauer. In an essay in *View,* one of the key avant-garde magazines of the 1940s, the young critic Parker Tyler, who wrote an important early piece on Pollock, quoted the legendary dancer Vaslav Nijinsky as saying, "I am a philosopher who does not reason—a philosopher who feels."[26] A New York artist endeavored to be just that: a philosopher who feels. It was true that each New York artist was determined to go off in his or her own direction, which often involved dissenting from somebody else's big idea, and yet the very vehemence with which they rejected any number of grand philosophical and artistic schemes suggested how powerfully they had felt the pull of those ideas. In 1948, in "The Sublime Is Now," Barnett Newman was railing against the "confusion" that he saw in Kant's and Hegel's theories of beauty. And Clyfford Still, in a letter written in 1959, complained about the "self-appointed spokesmen and self-styled intellectuals with the lust of immaturity for leadership" who had stuffed the ideas

of Hegel, Kierkegaard, Plato, Marx, Spengler, and Freud down American throats.[27]

When Newman and Still and many other American artists rejected the teachings of the grand European thinkers as well as the polemics of the Surrealists and the Constructivists, the intensity of their "No's!" felt like a liberating act, not a rejection of philosophical or artistic faith but an announcement that they were determined, at long last, to be their own philosophers, to have their own faith. The avant-garde filmmaker Maya Deren, who was an influential figure in those years and who was also, as anybody who watched her movie *Meshes of the Afternoon* could see, a dark-haired beauty, published a book called *An Anagram of Ideas on Art, Form and Film*. There she declared that "the history of art is the history of man and of his universe and of the moral relationship between them." If Deren was not borrowing directly from Hofmann's ideas, she certainly suggested how pervasive his sense of the dynamic relationship between art and life had become when she said, "Whatever the instrument, the artist sought to re-create the abstract, invisible forces and relationships of the cosmos, in the intimate, immediate forms of his art, where the problems might be experienced and perhaps be resolved in miniature."[28] Artists were philosophers of life, expressing the vastness of experience through the stamp of a personal style.

In art, style is a person's or a period's particular version of the eternal verities, and if a style has greatness, it is truth itself. The artists who came of age in New York in the 1950s were absolutely familiar with the story of modern art as a succession of textbook-appropriate styles—as a succession of "isms" that followed in an orderly genealogy from Impressionism to Cubism and Surrealism. And what was so marvelous about Hofmann was that he made that history, with all its branchings and flowerings, seem unruly, exotic, a matter of fresh, urgent connections. Artists could see that a whole range of nineteenth- and early-twentieth-century ideas was helping to give point and force to their passionate labors in the studio, which involved their responses to the new work of Pollock, de Kooning, Rothko, and other New Yorkers, as well as to Picasso's still mutating art, to Matisse's final, triumphant paper cutouts, and to the late Impressionism of Pierre Bonnard, whose retrospective at the Modern in 1948 the poet John Ashbery had seen while he was still a student at Harvard. If the artists of the 1950s and 1960s were fated, as some believed, to be a generation "after"—after Matisse and Picasso, not to mention, now, after Pollock and de Kooning—they nevertheless did not want to see all those extraordinarily variegated achievements turned into an official history. Of

course they had their idols, but they were inclined to accept each artist as what de Kooning called a one-man movement. New York School painting, Hess wrote in 1961, "is an untitled Style because it has no single, common style. Rather there has been a series of brilliant, connected, individual visions that have revolutionized art and exploded styles."[29] Artists, for better and for worse, were feeling themselves into their places as figures in history, some-times as heroic actors, sometimes as bit players at the mercy of overwhelm-ingly antagonistic forces. Each brushstroke could be part of some immense, unwinding story, what the art historian Henri Focillon, in the title of a book that was published in New York in 1948, called *The Life of Forms in Art*.

VI

"The history of culture," Johan Huizinga wrote in *The Autumn of the Middle Ages*, "has just as much to do with dreams of beauty and the illusions of a noble life as with population figures and statistics."[30] Dreams and illusions, Huizinga believed, shape life, and certainly the life of images. I agree, and I think that too little attention has been paid to the dreams and illusions of the artists of the 1950s. Of course there was a world of difference between the chivalric aspirations of Huizinga's late-medieval artists and poets and the tough-minded aestheticism of postwar New York, but the shifting, now-you-see-it-now-you-don't relationship between the world as people experience it day by day and the world as they remake it in their dreams is always an essen-tial aspect of the artistic adventure.

The concept that is most often associated with Hans Hofmann is the con-cept of push-and-pull. This was a formal idea, an idea about the creation of space on a two-dimensional surface through the manipulation of tensions between form and form or color and color. But there was more to push-and-pull, because these formal operations could become a way of grappling with man's energizing, unquenchable desires. For Hofmann, push-and-pull was a dream of what life could be, a dream simultaneously rooted in the dynamic relationship between one form and another, and in the dynamic relationship between a person and an environment. And who could doubt that this idea was tailor-made to describe the art of New York City? Wasn't New York a city of pushing and pulling, of constant pressure and counterpressure? And would not Hofmann have wanted his students to understand that connection, at least subliminally? While such dynamics may be an aspect of any booming city, the look of New York, with its sky-high, sharply angled buildings and its

no-nonsense grid of streets, gave urban pressures a new kind of visual defini-
tion. As long ago as 1913, the painter John Marin had spoken of New York as
made of "powers [that] are at work pushing, pulling, sideways, downwards,
upwards." "I see great forces at work," Marin wrote, "great movements; the
large buildings and the small buildings; the warring of the great and the small;
influences of one mass on another greater or smaller mass. Feelings are
aroused which give me the desire to express the reaction of these 'pull
forces.' "[31] This extraordinary statement, with its insistence on warring, push-
ing, and pulling forces, transformed the principles of Cubist composition into
a life principle, and in so doing prefigured the dialectical drama that was at the
core of Hans Hofmann's teachings. Students who attended the Hofmann
School on Eighth Street, where a sign in elegantly up-to-the-minute lower-
case sans-serif type was mounted to the right of the side entrance, were leav-
ing the street, with all its pushing and pulling, to enter a studio where they
could embrace the push-and-pull of art.[32] And the closer you look at the artis-
tic thinking of the 1940s and 1950s, the more overlapping dialectical dynamics
you will see—whether the dialectic involved the relationship between the
artist and tradition, or between the artist and the world beyond the studio, or
the push-and-pull of forms in a particular painting or sculpture.

Hofmann's whole life was push-and-pull. He was the old man from the
Old World who in certain respects seemed younger than his students. He
pushed those students to recognize fundamental principles, even as they
pulled him into an artistic milieu that reveled in increasingly high-stakes artis-
tic experimentation. During the first couple of years that he spent in the
United States, Hofmann was pretty much just drawing. Then, when he began to paint again in 1934, his work was by and large representa-tional—landscapes and still lifes in which flashing lines and bright swaths of color were dramatically balanced. This work would not have been seen that much by his students, for Hofmann did not begin to exhibit in New York until he had his first one-man show in 1944 at Peggy Guggenheim's Art of This Century, the gallery with a striking, curvilinear interior by the architect Frederick Kiesler where Pollock scored many of his early triumphs. There were retrospectives—at Bennington in 1955,

Hans Hofmann, Landscape, *1930.*
Ink on paper, 8½ × 11 in.

and finally at the Museum of Modern Art in 1963. In the 1950s and 1960s, this man who was in his eighth and ninth decades was as visible as any artist in New York. For Greenberg, already in 1955, Hofmann was "the most remarkable phenomenon in the abstract expressionist 'school' . . . and one of its few members who can already be referred to as a 'master.' "[33] Hofmann became, in those last decades of his life, a master of heroic generalizations. And he found himself, perhaps more than ever before, in sync with New York artists and critics who were fascinated by the possibility of combining grandeur of scale with simplified effects.

Hofmann was better equipped than almost anybody else alive to give broadly conceived structures a force, a depth. He had never much cared for particulars. In his landscapes and still lifes, he had always been inclined to rush past the specifics—the trees, figures, tables, vases, and apples—because there was some bigger point to be made. In a cycle of interiors from the late 1930s, the bold generalizations took on a geometric dazzle. Cupboards, easels, canvases, and window frames created a jostling architecture, and the color, all acidic purples and greens and oranges and blues, shot these scenes of everyday life straight up into the empyrean. If it was the fascination and sometimes, too, the weakness of Hofmann's work that he seemed not quite engaged by the particulars, this strangely ebullient disinterestedness could turn out to be a strength when he began to navigate a whole range of Surrealist fantasies and biomorphic labyrinths in the 1940s. He embraced the new realities of abstract art with a knockabout ease. Hofmann had no use for the arcana of alchemy and magic that fascinated such slickly accomplished fantasists as Pavel Tchelitchew and Eugene Berman, painters who were known as Neo-Romantics and exhibited at some of the same galleries that were friendly to the new American painting. Hofmann may have been referring to Tchelitchew and Berman and their supporters when in the mid-1940s he spoke bitterly of "the glamour boys and the snobs" who he believed dominated art in New York.[34] And in an appreciation written for a 1948 show at the Kootz Gallery, Tennessee Williams took a gentle swipe at those glamour boys when he observed, "It is a relief to turn from the reasonably competent and even gifted painters who paint as if their inspiration were drawn from Esmeralda's Dreambook."[35] While most of the Neo-Romantics and many of the Surrealists were laboriously transcribing their dreams—and giving the details of people and places a torpid, academic look—Hofmann found his dream book on the surface of the canvas, in the virtually alchemical clashes of colors and shapes and textures. He didn't give a damn about the iconographic niceties, for he knew

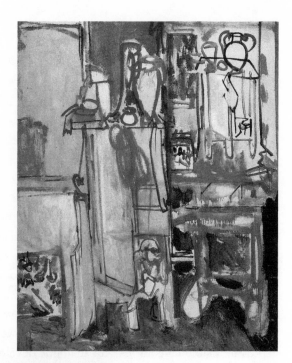

Hans Hofmann, Vases on Yellow Cupboard, *1936. Oil on canvas, 51½ × 38 in.*

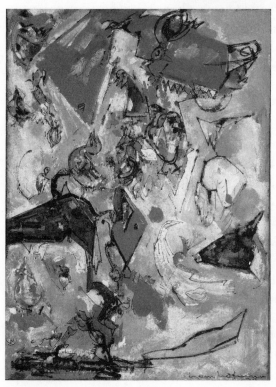

Hans Hofmann, Circus, *1945. Oil on panel, 55 × 40 in.*

that he could extract all the secrets of being and becoming from the substance of his pigments.

When Hofmann evoked a myth, what mattered weren't the narrative specifics but the powerful, almost antediluvian emotions that the story suggested. He liked exuberant, extravagant images, and printed, beside one of his paintings in the catalog of his 1965—eighty-fifth anniversary—show at Kootz, these lines from Rilke's *Sonnets to Orpheus:* ". . . and out of the caves, the night / threw a handful of pale, tumbling pigeons into the Light." For Hofmann, that image must have summoned up the quick flash of brushstroke against brushstroke, of hard against soft, of dark against light. What Williams saw in Hofmann's work was an "understanding of fundamental concepts of space and matter and of dynamic forces, identified but not explained by science, from which matter springs. He is a painter of physical laws with a spiritual intuition." The painter Fritz Bultman, who had studied with Hofmann, suggested another combination of physical laws and spiritual intuitions. He observed that Hofmann's paintings expressed what Baudelaire called "the duality of human nature" by "maintaining two totally different painting expressions simultaneously. . . . A dialogue develops between those paintings that pursue the idea of a pure and rational plasticism and those spontaneous inventions that arise from an unconscious response to the means of art."[36] Bultman was referring to the astonishing fact that in the very same months and years, Hofmann was finishing canvases composed of hard-edged rectangular forms and canvases on which the colors were deliriously mixed in a froth of agitated brushwork. Sometimes he would contrast the two approaches within a single canvas. Hofmann was a one-man dialectical vision of art. The miracle of his work was that the more he celebrated pure dynamic forces, the more specific his effects became. He found particularity in generality— empirical experience within the sweeping drama of the dialectic.

In the paintings of the 1950s and 1960s, Hofmann had a repertory of forms and manners: the dripped and flung paint; the scumbled, almost foamed-up paint; the boldly impastoed rectangles; the calligraphic lines; the rapidly executed strokes; the thinly stained areas. He had color to match: bold primaries; moody, atmospheric, purplish and greenish darks; crazy, stinging golds. And he summoned up and dismissed these effects with an ease that suggested the way that magically quotidian effects—sunrises or rainstorms—appear and disappear in the natural world. Bultman, in fact, recalled a sunset ride with Hofmann on Cape Cod, and how the artist, who had started out as a painter working from nature, observed that "he would like to paint in the landscape

again with what he knows now about painting."[37] Everything implied every-
thing else, and just as in certain paintings a hard-edged form precipitated a
soft-edged form, so the going away from the landscape eventually precipi-
tated a return. Hofmann captured all the sunny and dark days, the light and
the shade, rain, snow, foliage, water, clouds, and wind. The paintings were,
gloriously, the demonstration of the idea of everything being there, dormant,
imminent, in the canvas. He caught the sense of a man's movement through
the world—a man's mood in relation to the mood of the day and to other peo-
ple's moods. The paintings were all relationship. "Hofmann explains," wrote
a visitor to the house, Frederick Wight, who was organizing an exhibition,
"gesticulating, his hand going over the canvas as though repeating the original
attack."[38] He used musical terminology: "Thirds, fourths, fifths, how do you
say? We make an octave, what is the word?—blue here, you look for another
blue . . . yellow starts here, one here, the eyes are permanently guided in a
rhythm, each color has its own rhythm." Such musical metaphors could also
be found in the letters of van Gogh, and went back to ideas in Goethe. To
Tennessee Williams, who was himself one of the great American romantics,
Hofmann, like van Gogh, had "the authority of pure vision."[39]

Romanticism, which nineteenth-century artists and writers had embraced
as they stood alone, contemplating nature's dynamics, became with Hofmann
a drama that shattered the natural order, a drama in which everybody could
take part but nobody could ever quite place himself or herself. At heart, the
drama of Hofmann's art was in its refutation of specifics, in his refusal to allow
anybody to alight anywhere, at least not for very long. Mondrian's rectangles
of color might be pure, unrelated to nature, but they had an abstract classical
perfection, so that you could linger over the red or blue shape in the upper or
lower corner, which had a value that was eternal if not fixed. With Hofmann,
each angle, each splatter, each color was a spark tossed off by life's wild
unpredictability. His art was disquietingly restless. More than any other artist
who worked in New York, it was this old man from Munich who would not let
gallerygoers settle down. There was probably no other artist who caught so
much of New York City's light, with its clarity and penetration, its brilliance
that was like a wake-up call, like an alarm clock going off. Hofmann's work,
with its clashes of heartlessly brilliant colors and thick, jutting brushstrokes,
was so changeable yet so consistently forceful that an exhibition of his paint-
ings could have struck a visitor as being nearly as varied as the work of all the
rest of the New York School put together. Hofmann spent the first fifty years
of his life in Europe and then reinvented himself as a one-man School of New

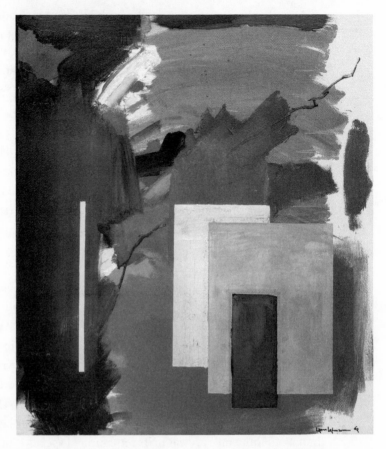

Hans Hofmann,
Autumn Chill and Sun,
1962. Oil on canvas,
60 × 51 in.

York. His essential subject was his own impossibly ambitious spirit, his desire
to embrace so much that even his most ardent admirers sometimes found
themselves losing track of him when they attempted to see him whole. What
astonished his students—and all the younger artists who felt his impact—was
not that he had shown them the way but that when he arrived along with them
at the victory celebrations, he was the one with energy left to burn.

CLIMATE OF NEW YORK

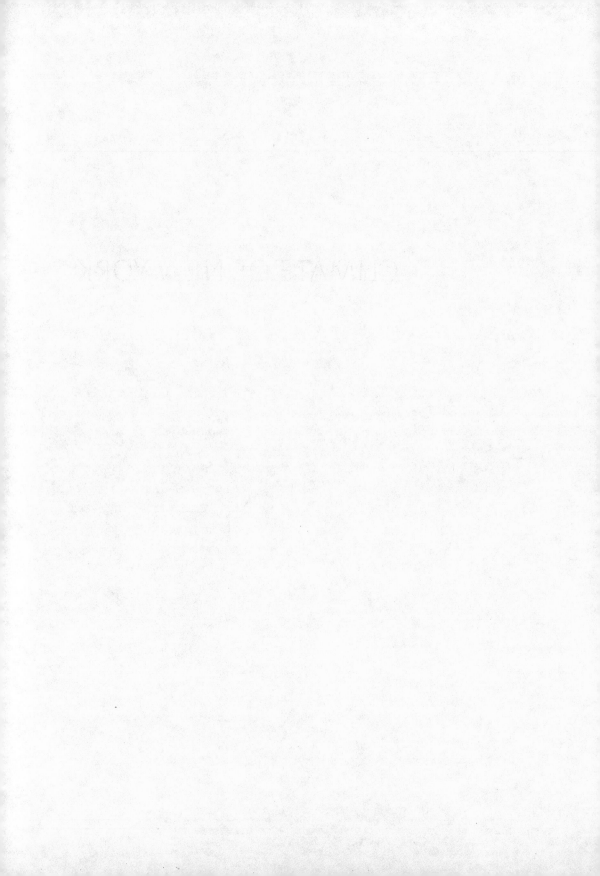

1. MANHATTAN GEOGRAPHY

I

At least since the rising merchant class of Northern Italy found its ambitions mirrored in the lucid empiricism of the painting and sculpture of the early Renaissance, many of the turning points in the visual arts have occurred not in royal courts or through religious commissions but in urban centers running at full throttle. And this has never been truer than it was in New York in the change-everything years between the late 1940s and the early 1960s. The city where so many artists started out was harsh and dazzling and very much unfinished—a city that at one moment was as headstrong and mercurial as an adolescent and a moment later exuded all the seamless confidence that we associate with the prime of life.

To discover art and ideas and New York all at once in the couple of decades after World War II was to be enveloped by experiences that could be as confusing as they were mesmerizing, and no doubt the confusion was part of the fascination. "Swimming in the reflected surfaces of some great goldfish bowl" was how the literary critic Alfred Kazin recalled a lunch in midtown, in the roof garden of the Museum of Modern Art's chic building. "New York," he said, "was gold skin, kaleidoscopic glass." And on Second Avenue, the poet and dance critic Edwin Denby, a friend of de Kooning's since the 1930s, watched "herds of vehicles go charging one way all day long disappearing into the sky at the end like on a prairie." The year was 1952. In the winter sky the tops of the buildings looked "miraculously intense, a feeling like looking at Egyptian sculpture. Down in the streets the color, the painted colors are like medieval color, like the green dress of the Van Eyck double portrait in the National Gallery, intently local and intently lurid." Denby, who had just returned to New York after four years in Europe, "hadn't expected so intense a pleasure, looking at New York again." The city was a medium that magnified private experience. "New York light," Thomas Hess observed, "is a fluid

in which the cosmopolitan styles of postwar art developed; it is exemplified in New York School painting and experienced in the raw in the New York lofts."[1] Whether artists were working in the relative quiet of downtown studios or visiting galleries and museums in Manhattan's booming midtown, New York was not just bricks and concrete and glass and steel, it was also a mysterious concentration of experiences and attitudes and aspirations that were drawn together by the city's sumptuous, penetrating light.

Artists and writers who choose to live in a city are always living in two cities at once. Even as they are walking the streets of this particular place, they are also moving through a city of the imagination. And they may be so exhilarated by the overlap of these two cities, by the sense that the imagination is fortified by the facts, that they are hard put to disentangle the two. "Bohemia is always bigger than the sum of its garrets," the critic and poet R. P. Blackmur observed. Blackmur believed that bohemia was "the practical social

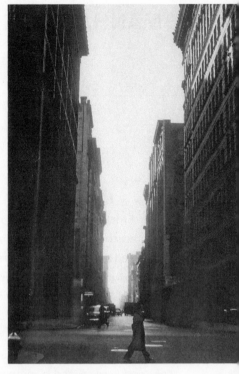

Rudy Burckhardt, Chelsea Evening, *1940.*

experiment which makes the objective correlative to Art for Art's sake"—which is another way of saying that the physical reality is related to an imaginative reality.[2] And because the physical city is the springboard for the city of the imagination—which can be, indeed, the city of art-for-art's-sake—we need to do some disentangling before we begin to grapple with the city of the imagination. We need to have a sense of the actual geography of bohemian Manhattan: its streets, its neighborhoods, its landmarks. We need to know where artists were living—all over town, of course, but with concentrations below Fourteenth Street, often in cold-water flats and lofts, and some even farther downtown, below Houston Street. And we need to know the points of an artist's compass, which included, within just a few blocks, the Hofmann School on Eighth Street, the Artists' Club, the cooperative galleries on Tenth Street, and bars such as the Cedar Tavern and the San Remo. For only when we have the setting in place can we begin to see how the city became a center for "the elaboration of individuality itself," an idea that the German sociologist Georg Simmel developed in an essay called "The Metropolis and Mental

Life," which appeared in an English translation in 1950. The city, Simmel said, is the place where men attempt to define a "qualitative uniqueness and irreplaceability," and only when we have begun to grasp that sense of uniqueness, which comes out of the combustible confrontation between the real city and the imaginary city, can we begin to understand the part that New York City played in artists' lives.[3]

II

Already in the 1940s, the painter Barnett Newman had written a lyrical description of downtown New York, the workaday city, packed with rush-hour commuters. Newman—who had a loft on Wall Street in the 1950s—wanted to bring out the harmony-in-dissonance that was the city's strength. "The tip of the island of Manhattan," he wrote, "forms a compact heterogeneous cosmopolis where one can still have the charming feeling of living in two centuries, . . . where one can still savor the distinctive American flavor." A heterogeneous cosmopolis, that was mid-century New York. Boom times were bringing in whole new industries, and yet in the 1940s the city's old industrial base was still, for the time being, intact. The city moved to many rhythms, and far downtown an artist could sometimes feel the presence of a number of different pasts: colonial New York, the New York of the Gilded Age. "Hemmed in by two rivers on its sides," Newman wrote in this essay that was not published until decades later, "where a short walk can take you from one to the other, and by two old-fashioned commons on the north and south, Bowling Green and City Hall Park, one feels a sense of the whole city and its past. The huge wall that lined the narrow lanes of a colonial village, the skyscrapers and the two-story Revolutionary houses, the marketplace and the central office directing the Transcontinental Corporation, . . . the old

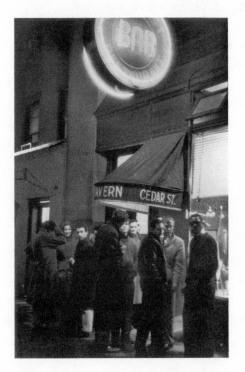

John Cohen, The Cedar Tavern, *1959.*

landing piers and the gigantic bridges, the tiny shops and the huge department stores, the old bookshop and the immense newspaper plant—all are jammed close together as can [happen] only in New York; and all, the small and the large contrast, can be seen at once, together."[4]

Quite a few artists, including some who would later become New York stars, lived at one time or another in this neighborhood that Barnett Newman described. In 1953 Rauschenberg—who would soon become the most outrageously eclectic of the many artists who worked with collage, juxtaposing found objects to create what John Ashbery called "grubby urban palimpsests"—was renting a top-floor loft with twenty-foot ceilings on Fulton Street for next to nothing (there was no heat or water); then Rauschenberg lived on Pearl Street with Jasper Johns.[5] Later in the decade, Ellsworth Kelly, back from Paris, was living on Coenties Slip, as were Agnes Martin and Fred Mitchell, two other artists who, like Kelly, were doing delicate abstract paintings. There were streets down by the water that still had rich troves of early-nineteenth-century commercial buildings, sober and dry and elegant, in a style that the architecture critic Ada Louise Huxtable called "commercial classic."[6] These buildings created a flat, rather severe streetscape, a repeating pattern of windows and doors with minimal decoration, the beauty being in the rhythm of a few rectangular shapes, a rhythm that could not go unnoticed by artists such as Kelly and Martin, who were attuned to an antiromantic, antiexpressionist aesthetic. These façades embodied something of the factuality of New York, its directness, a directness that could, paradoxically, come to be part of the city's romance. A few years later Kelly clipped from a newspaper a photograph of a sailing ship passing beneath the Gothic arches of the Brooklyn Bridge, that masterpiece of nineteenth-century engineering, and he obviously saw in the tensile forms of the old-fashioned ship and the powerfully built bridge two designs that were related, in some familial way, to the taut configurations in his own abstract paintings.[7]

This city was a grand collage, visually as well as in every other way, with concentrations of very high buildings and stretches of low ones, of blocks where high and low were juxtaposed, of streets that seemed to extend to infinity. The look of Manhattan was complex and variegated, a richly figured fabric, a crazy quilt of activity, a geometry overgrown with designs that had no easily identifiable pattern. In 1947, Mary McCarthy, who was writing for *Partisan Review,* with offices on Astor Place, near where the artists congregated, wondered how she might explain the vitality of New York to a visiting French intellectual. She knew that what she needed to show this visitor was New

York's cosmopolitan variety: "Sukiyaki joints, chop suey joints, Italian table d'hôte places, French provincial restaurants with the menu written on a slate, Irish chophouses, and Jewish delicatessens." McCarthy's New York was full of "movies, plays, current books . . . *Open City, Les Enfants du Paradis,* Oscar Wilde, a reprint of Henry James."[8] To fall in love with New York was to fall in love with all of this, which recalls an assertion by Hegel, whose thinking had had such an impact on New York intellectuals since the 1930s, that "since love is a unification of life, it presupposes division, development of life, a developed many-sidedness of life. The more variegated the manifold in which life is alive, the more the places in which it can be reunified; the more places in which it can sense itself, the deeper does love become."[9] Hegel's words might double as a description of an artist or writer falling in love with the variety of New York City.

In 1946 Cyril Connolly came over from London to work on a special American issue of his magazine *Horizon,* and he counted his dinners with the *Partisan Review* group, some of whom had close ties with the artists, among the highlights of his trip. In the introduction that he wrote for "Art on the American Horizon" in 1947, he gave a rapid-fire tour of the city—and made it clear that he had fallen head over heels in love with the place. His pen portrait whizzed readers by "the felicitous contemporary assertion of the Museum of Modern Art, the snow, the sea-breezes, the late suppers with the Partisans, the reelings-home down the black steam-spitting canyons, the Christmas trees lit up beside the liquorice ribbons of cars on Park Avenue, the Gotham Book Mart, the shabby cosiness of the Village." Albert Camus was also visiting New York in 1946, and he was astonished by the sky. "New York," he said, "is nothing without its sky. Naked and immense, stretched to the four corners of the horizon, it gives the city its glorious mornings and the grandeur of its evenings, when a flaming sunset sweeps down Eighth Avenue over the immense crowds driving past the shop windows." Camus did not feel that he could make sense of New York; he was left with "only these powerful and fleeting emotions, a nostalgia that grows impatient, and moments of anguish." Perhaps that was enough for Connolly, who observed in *Horizon* that he had found in New York "an unforgettable picture of what a city ought to be: that is, continuously insolent and alive, a place where one can buy a book or meet a friend at any hour of the day or night, where every language is spoken and xenophobia almost unknown, where every purse and appetite is catered for, where every street and every quarter and the people who inhabit them are fulfilling their function, not slipping back into apathy, indifference, decay. If

Paris is the setting for romance, New York is the perfect city in which to get over one, to get over anything."[10]

Introducing postwar New York—and America—to readers back home, Connolly aimed high. "Something important is about to happen," he announced grandly and a little vaguely, "as if the wonderful *jeunesse* of America were suddenly to retain their idealism and vitality and courage and imagination into adult life." The year after Connolly's comment, in 1948, de Kooning, a man past forty, had his first, dazzlingly confident one-man show, uptown at the Charles Egan Gallery, which the critic Kenneth Sawyer would some years later describe as "a casual, rather shabby place, where, on winter afternoons, painters were likely to congregate for talk."[11] De Kooning exhibited ten paintings, mostly in black-and-white, in which the shattered, fractured, abstracted figural forms suggested an archaeological dig into the prehistory of modern art, a dig from which de Kooning emerged with a trove of exquisitely constructed shards. Clement Greenberg, who wrote his famous essay "The Present Prospects of American Painting and Sculpture" for Connolly's special American issue of *Horizon,* reviewed de Kooning's show in *The Nation* and spoke of the "plentitude of his draftsman's gift," of an artist "com[ing] before us in his maturity, in possession of himself, with his means under control." Writing for Connolly's English readers, Greenberg announced, "It is still downtown, below 34th Street, that the fate of American art is being decided— by young people, few of them over forty, who live in cold-water flats and exist from hand to mouth." De Kooning, although over forty, was still young. Talk about setting the stage—this was *La Bohème* all over again. "A collection of *peintres maudits,*" Greenberg wrote, "are already replacing the *poètes maudits* in Greenwich Village." You can feel Greenberg savoring the moment.[12]

Tenth Street, where many of the artists would be showing in the 1950s, was a village within the metropolis, and artists and writers who were lucky enough to at least temporarily solve the problem of how to pay the rent could go for days and weeks without setting foot outside their own sometimes over-stimulating neighborhood. When Thomas Hess described the Ninth Street show of 1951, a huge salon-style exhibition in a freshly whitewashed space that brought together work by a great many downtown artists, he said that the event had "an air of haphazard gaiety, confusion, punctuated by moments of achievement."[13] In the 1950s, a slew of artist-run galleries flourished on Tenth Street and thereabouts: Tanager, Hansa, James, Brata, Camino, March, Area, Phoenix. They had been preceded by the Jane Street Gallery, which had been in the West Village in the 1940s.[14] Artists began their careers with one-

ALCOPLEY • BOUCHE • BROOKS • BUSA • BRENSON •
CAVALLON • CARONE • GREENBERG • DE KOONING • DE
NIRO • DZUBAS • DONATI • J. ERNST • E. DE KOONING • FERREN
• FERBER • FINE • FRANKENTHALER • GOODNOUGH • GRIPPE
• GUSTON • HARTIGAN • HOFMANN • JACKSON • KAPPELL •
KERKAM • KLINE • KOTIN • KRASSNER • LESLIE • LIPPOLD •
LIPTON • MARGO • MCNEIL • MARCA-RELLI • J. MITCHELL
• MOTHERWELL • NIVOLA • PORTER • POLLOCK • POUSSETTE
DART • PRICE • RESNICK • RICHENBERG • REINHARDT • ROSATI
• RYAN • SANDERS • SCHNABEL • SEKULA • SHANKER •
SMITH • STAMOS • STEFANELLI • STEPHAN • STEUBING •
STUART • TOMLIN • TWORKOV • VICENTE • KNOOP •

COURTESY THE FOLLOWING GALLERIES: BORGENICHT, EAGAN,
TIBOR DE NAGY, THE NEW, PARSONS, PERIDOT, WILLARD, HUGO

MAY 21ST TO JUNE 10TH, 1951
PREVIEW MONDAY, MAY 21ST, NINE P. M.
60 EAST 9TH ST., NEW YORK 3, N.Y.

9TH ST.

EXHIBITION OF PAINTINGS AND SCULPTURE

*Poster for the Ninth Street show, 1951.
Designed by Franz Kline.*

John Cohen, Tanager Gallery
Opening, 1959.

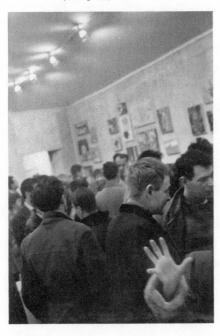

person shows in these catch-as-catch-can spaces, while more established figures such as Kline, Reinhardt, Motherwell, and de Kooning contributed work to the group shows and generally appeared whenever something was happening. The Hofmann School, the Cedar Tavern and the San Remo, the Artists' Club— all of these places offered opportunities for friendships and love affairs to begin or flourish or end, for careers to get going or jump forward or derail. From the bohemian vantage point, Tenth Street and the surrounding blocks were Our Town, complete with success stories and hard-luck stories and love stories galore. The actress and director Judith Malina's diary is full of the excitable camaraderie of those days. She wrote of the opening of the Ninth Street show as "a great splash. Some wonderful painters have rented a large loft, painted it white, and hung hundreds of canvases in the bare rooms. We seek relief from the intense night heat outside, under the sign painted by Franz Kline, lit from the window of a studio across the street. I talk for a long time with John Cage about painting and music. . . . After the exhibit there's a party at the Three Arts Club. . . . Clement Greenberg jitterbugs violently to Louis Armstrong's 'I Ain't Rough.' Sidney Janis jitterbugs conservatively and does a very suave tango."[15]

In her diary, Malina wrote about a production of Picasso's play *Desire Trapped by the Tail,* in which John Ashbery and Frank O'Hara play the two Bow Wows, who "do not know themselves how wise they are. They believe that they are in disguise. But it is part mask and part innocence." Another day, coming out of a rehearsal of a play by Paul Good-

man, Malina saw Harry Jackson, a painter friend, near his car, which was loaded with canvases. Gathered on the street were Jackson, his "dazzling dancer, Joan," and Philip Smith, an actor in whom Malina took a romantic as well as a professional interest but who was then sleeping with Goodman. "Everyone looks at the paintings in the sunlight," Malina explained. "They stir the street. People stop and comment. His melancholy portrait of Philip upsets me."[16] Goodman himself, in his novel *The Empire City*, described the corner of Greenwich Avenue and Seventh Avenue, as seen by a musician named Bufano. "Never in the history of mankind," Bufano announced to the young dancer Rosalind, "in any age in any place, have there been so many works of art, of the imagination, speaking feeling, communicating feeling, as you may here endure. The quality is various, but consider only the quantity of it." Around Bufano and Rosalind the city was in constant motion. "People came out of a cinema theater where they had just seen two long dramas. They were going to hear other plays and stories over the radio. On a stand there were thirty-four brightly covered storybooks. From different windows came the sounds of music, both from machines and live fingers and throats. The eye could not avoid seeing drawings and paintings, small, large, enormous, relating various ideas to feelings by means of forms, colors and images. There was a mobile sculpture, a barber pole, the red, white and blue spiraling endlessly upward from nowhere to nowhere." Bufano exclaimed at the mingling of "idiotic ideas, meticulous training and technique, timid expression, bizarre combinations, witty invention, banality, outcries of the heart, lies." Taking it all in, he asked, "Are these arts bad?" And he answered, "They are indispensable. Without the excitement of these arts everybody would lie down and stifle. Yes!"[17]

Perhaps no author created a darker portrait of New York's bewildering variety than William Gaddis in his 1955 novel *The Recognitions*, in which the protagonist was a young man whose masterly forgeries of Netherlandish paintings earned him an underground renown. Gaddis's Manhattan was a sinister place. The air was full of "fly-ash, cinders and sand, tar, soot, and sulfuric acid," but nobody seemed to notice "the billions of particles swirling round" them. In the small neighborhood restaurants and bars where artists and writers gathered, the atmosphere was so creepy that "a *poet* entering"— the italics meant to indicate a *true* poet—"might recall Petrarch finding the papal court at Avignon a 'sewer of every vice.' " In the evening the rooms of the Viareggio, a small Italian bar that had once been a place "of nepotistic honesty," were "taken over by the educated classes, an ill-dressed, underfed, over-

drunken group of squatters with minds so highly developed that they were excused from good manners, tastes so refined in one direction that they were excused for having none in any other, emotions so cultivated that the only aberration was normality." In the Viareggio, "smoke and the human voice made one texture. . . . There were poets here who painted; painters who criticized music; composers who reviewed novels; unpublished novelists who wrote poetry." It was a world full of phonies—the perfect backdrop for Gaddis's troubled forger of Old Master paintings. A young man explained to the woman he was bringing up four flights of stairs to a party, " 'They all talk about painting. Now remember, no matter what anyone says, you just comment on the solids in Uccello. You can say you don't like them, or say they're divine. Can you remember that? The *solids* in Oo*chel*lo, can you say that?' They arrived at a room full of people who spent their lives in rooms."[18]

Against the intimate—occasionally all too intimate—character of these downtown encounters, the vastness of New York City could become a fascinating, sometimes alien spectacle, romantic in its sweep and full of picturesque incidents. What affected everybody in New York all the time was a dynamic interaction between the solitary individual and the overwhelming size of the city. This was an off-kilter dynamic, an experience of the one against the many, a dynamic that pushed artists into a hyperbolic, me-against-the-world situation. To walk through the city and let your imagination soar was to feel like the great horn player in the jazz group who took off on a wild solo as the drummer and pianist and bassist stood back, supporting the soloist's gonzo bebop foray. Artists are always as much actors as they are acted upon, and the work that they do is never merely a reaction to a place. But in New York there was no way that a painter or a poet was not going to be challenged by the unbalanced relationship between the parts and the whole—and by the bewildering variety of the parts, by all the dissonances and contradictions.

Allen Ginsberg was a very young poet in the early 1950s, and the descriptions that he jotted down in his journal of some of the older people who caught his attention on the subway have a richly surreal cast that relates to Gaddis's New York. Ginsberg noticed "a woman of indeterminate age—forty or so" on the Lexington Avenue subway, and "a man in his fifties—again the indeterminacy of age," on the Seventh Avenue line at 135th Street. These two people struck Ginsberg as in some way artistic personalities, but then it was easy to believe that any wanderer in the city might have been an artist; at least it was easy if you agreed with Newman's argument, presented in the artists' maga-

zine *The Tiger's Eye*, that "man's first expression, like his first dream, was an aesthetic one."[19] To Ginsberg, the woman on the Lexington Avenue line looked "aged by madness or suffering"; with her seedy yet careful clothes and long face and "aura of sensitivity and aristocracy," she might have been "an even thinner and more dangerously ill Virginia Woolf." As for the man on the Seventh Avenue line, he "looked like a rich recluse in worn-out hermit gentility," and made Ginsberg think of an aged Béla Bartók "riding to York Avenue, starving to death."[20] These ghost-spirits sat by themselves in the subways of the booming 1950s, and the subway was of course itself a sort of theater, where you could sit and see and be seen. Here, in Ginsberg's journals, we find the physical city and the imaginary city merging.

III

Bartók had in fact died in New York in 1945, an exile from wartime Hungary. Mondrian, Marc Chagall, and André Masson had also been in exile in the United States during the war, and if they had not had all that much contact with younger artists, their presence had nonetheless been felt, even as Hofmann and other immigrants, especially Josef Albers and the printmaker Stanley William Hayter, became influential teachers who enabled their students to navigate the ins and outs of modern art. From the 1930s until he moved to Yale University in 1949, Albers had taught at Black Mountain, the experimental college near Asheville, North Carolina, instilling in students fundamental principles of invention and construction that he had first articulated as a teacher at the Bauhaus. Black Mountain became a legend in New York. Many New York artists, among them de Kooning and Kline, taught there in the summers, and many Black Mountain students moved to New York to take up the artist's life. Hayter, although he was not much older than many of the American artists who were just making names for themselves, had already run a printmaking studio in Paris before the war, and when he transferred it to New York, it became a place where Louise Bourgeois, Jackson Pollock, and many others experimented with intaglio techniques. When A. Hyatt Mayor, the curator of prints at the Metropolitan, spoke of Hayter's impact on younger artists, he might have been speaking about Hofmann and Albers as well. Artists, Mayor announced, "have clustered around [Hayter] like athletes who discover a natural leader for their games." The teacher functioned "like a magnetic field that knits haphazard particles into lines of force. This invigorating interplay of endeavor and opinion among young and old, aspirants and

Stanley William Hayter,
Cinq Personnages, 1946.
Engraving, soft ground
etching, and three-color
offset, 15 × 24 in.

masters, is doubly precious here in the United States, where artists often lose strength in solitude. Individualism makes itself more rugged, not less, by learning where to merge itself in a common effort."[21]

By the end of the 1940s, the older New Yorkers who had felt the impact of the Europeans were rubbing shoulders with younger artists, many of whom had also felt the impact of Hofmann and Albers—and, if they traveled to France after the war, of Hayter and Fernand Léger, who had returned to Paris and who were both teaching there. Indeed, to look at New York City in the early 1950s is to see several generations of artists getting to know one another and to see an art world growing out of all their multiplying encounters. The careening conversations that took place in studios, in galleries, in bars, at parties, on street corners, at the Hofmann School, and at the Artists' Club revved up the atmosphere and propelled the life of art forward. Many of the artists who became famous in New York City in the 1950s were middle-aged or nearly middle-aged: In 1950 Willem de Kooning was forty-six, Franz Kline was forty, Jackson Pollock was thirty-eight. This is significant. It is easy to forget that while the late 1940s and early 1950s were the time when careers really began to take off, for the artists whose work defined the Abstract Expressionist style, 1950 was also rather late in the day. The artists who had started out in New York in the 1930s had lived through periods of stark poverty and mind-boggling uncertainty. Day-to-day existence had not been pleasant. The painter Carl Holty, in a journal that he kept in the 1960s, recalled how he had "hated the doleful half-empty cafeterias" where artists congregated late at night in the 1930s, cafeterias around which a romance had begun to grow a generation later. Holty remembered buns that were "nothing

but an aerated baby blanket" and the hostile glances of the man-
agement, who disliked the artists who "did not consume enough
and . . . tarried too long over what they did not buy."[22] But all of
this was relatively remote to the ebullient spirits of the postwar generation,
which included Mitchell and Blaine and Kelly and Rauschenberg and Wolf
Kahn and Larry Rivers and countless others, and they could hardly imagine
how really tough things had been.

The 1940s had been about the dark mysteries of modern art, and the
painterly brush had been a tool of research, part of the Cubist or Surrealist
method of discovering hidden truths. De Kooning and Pollock, through much
of the 1940s, painted as if they wanted to take everything apart, and that gave
the work its febrile, anxious power. By the end of the 1940s, they may have felt
that they had gotten to the bottom of matters, and then everything that had
been intractable and hidden was gradually—and then all of a sudden—
revealed, released. The years around 1950 saw a lightening-up in the work of
Hofmann and de Kooning and Pollock, who were shedding their lowering,
overwrought temperaments, moving toward an unfurling, let-loose, almost
rococo ease, and this shift was enthusiastically received by the young, who
had been galvanized by the atmosphere of the war years and the rising opti-
mism of the postwar period. By the 1950s, everybody was brought together by
the fever of questions and answers, of arguments and counterarguments, of
myths and anti-myths, of heroes and hero-worshippers and antiheroes, too.
Fueling all the work that was being done and all the talk that was going on was

a confrontational exuberance, an attraction-of-opposites kind of drama that would have been impossible without the mid-century mix of painters who were already demi-mythic figures and younger aspirants who were avid, aggressive, and sometimes more than a little shy. In *Evil Under the Sun*, Anton Myrer's novel set in the ambience of the Hofmann School, the Hofmann character reflects that his students "knew nothing of the long times of defeat, the dead spells, the savage bite of poverty in middle age; they were still carried on the rush of their young blood, the limitless, bursting possibilities. What a joy it was to see. What a joy!"[23] The young responded to Hofmann with an openness that was at times ecstatic.

After graduating from Harvard in 1949, John Ashbery moved to New York, where he almost immediately became part of this extraordinarily upbeat scene as he got to know painters such as Jane Freilicher and Rivers and Blaine; Frank O'Hara was already a friend from his Harvard years. These newcomers, at once dazzled and dazzling, were rapidly developing their own kind of approach-avoidance relationship with their elders. The new

Jane Freilicher,
Early New York Evening,
1953–54. Oil on canvas,
51½ × 31¾ in.

paintings by Pollock and de Kooning and Rothko and Hofmann and a host of other artists provoked days and nights full of talk, and younger artists responded to all the talk by going into their studios and seeing what they could do. And then works by the younger artists and the older artists were presented together in casual, salon-style exhibitions such as the Ninth Street show and the Stable Annuals, and everybody piled into the galleries on opening nights to see how everybody stacked up against everybody else. "I hadn't realized it," Ashbery recalled in an essay about Freilicher, "but my arrival in New York coincided with the cresting of the 'heroic' period of Abstract Expressionism, as it was later to be known, and somehow we all seemed to benefit from this strong moment even if we paid little attention to it and seemed to be going our separate ways. We were in awe of de Kooning, Pollock, Rothko and Motherwell and not too sure of exactly what they were doing. But there were other things to attend to: concerts of John Cage's music, Merce Cunningham's dances, the Living Theatre, but also talking and going to movies and getting ripped and hanging out and then discussing it all over the phone."[24]

The early moderns, literary as well as artistic, were all still newish classics. Around 1950 Mitchell's husband, Barney Rosset, who built Grove Press, was attending a course on Proust given by Wallace Fowlie at the New School; and younger artists and writers were very much aware that Pound was working on some of his greatest Cantos and that Cocteau, who had astonished Dia-ghilev, was breaking new ground as a movie director. The impact that older artists were having on younger artists was set in particularly high relief by the very climate of New York, by the extent to which the city provoked clashes of taste and values and experience, and gave those clashes a surging, dialectical power.

The old-timers, many of whom had waited for decades to have their work seen and discussed, were blinking in the first glare of renown—they loved the attention. Who wouldn't want to end up at the Venice Biennale, as de Kooning and Pollock did? As for the idolizing sons and daughters who had just arrived, they were aching to bust that little town wide open. The bars were just one of the places where the veterans met the younger generation, and in those jam-packed, drunken rooms, a painter could go from being well-known to being notorious in the twinkling of an eye. And yet, as Paul Goodman wrote in *The Empire City,* the novel that he published at the end of the 1950s, New York still had "many of the charms of a small town, and without the disadvantage of sti-fling small-town gossip, for one could always take one's custom to another tavern."[25] This was the city of the older artists, who remembered the 1930s and were now glad to see the small town getting bigger.

IV

The Bauhaus dream of a new kind of steel-and-glass beauty was actually becoming a reality, as building upon building went up in midtown, mere blocks from the Museum of Modern Art, where Philip Johnson and Henry-Russell Hitchcock had in 1932 mounted the show of new architecture that gave the International Style its name. New York had had its overwhelming scale for decades, but now there was a whole new generation of big buildings, which were stripped down, unornamented. Artists might pass their days and weeks downtown, but they were absolutely aware of these architectural inno-vations, and some of the places that were most important to them were at the center of the postwar building boom—the Museum of Modern Art on West Fifty-third Street, just off Fifth Avenue, and the Whitney, which moved from the Village to West Fifty-fourth Street in 1954, and the galleries on Fifty-

seventh Street and farther uptown, where everybody hoped to show. A guide to the city, published in 1958, stated that in all Chicago there was not as much office space as had been built in Manhattan in the previous ten years. Park Avenue was "getting a new look again. The tall exclusive apartment houses between Grand Central Terminal and 59th Street are coming down one by one and being replaced by towering office structures of brick, steel, glass, bronze, and copper." The Seagram Building was going up, and, according to the guide, Lever House had already "been widely acclaimed as the imaginative pace-setter of contemporary office architecture."[26] The sculptor Isamu Noguchi was commissioned to design an elaborate sculpture garden for the street-level plaza at Lever House, a project that the powers at Lever ultimately rejected.

The sleek regularity of the International Style, which turned Bauhaus ideals into American practicalities, was something about which artists were often more than a little suspicious. They had no great love for what they regarded as the strictness of some of the structural and compositional ideas that had been taught at the Bauhaus. They could not reconcile a theory of color or drawing with their passionate commitment to the freedom of the imagination. What had in Europe been the wild dreams of the Constructivists now struck many artists as mere good design, and that was all mixed up with

Model of Lever House, designed by Gordon Bunshaft of Skidmore, Owings & Merrill and completed in 1952.

corporate ambitions. In 1953, when the Modern mounted a show called "Built in U.S.A." that celebrated postwar architecture, Saul Steinberg published a humorous rejoinder in *Art News,* razzing the ambitions of modern architecture. Although Steinberg was an artist who always marched to his own drummer, his elaborately fanciful comic devices were seen by as close a student of the downtown scene as Harold Rosenberg as being "no less the projection of an estranged self than Rothko's floating plateaus of tint." Steinberg called the Modern show "an optimistic survey of a few handsome works selected from an enormous field of nonsense." He mocked the slick look of the new architecture, "the new role of the architect as interior decorator or lay-analyst to affluent families." He spoke of "easel architecture," of "city planning made to impress airplane passengers."[27]

One of Steinberg's drawings was an illustration of architectural "photogenics." A couple of photographers and their lighting technician and fierce editors are all bearing down on a small model of a modernist house, behind which an assistant holds up a panel on which are inscribed some puffy clouds that form a backdrop for the spiffy home complete with a tree coming through the roof and free-form pool. Here, Steinberg seemed to be saying, was an architecture you couldn't even live in; it was strictly for publicity purposes. Steinberg's amused disdain for the slick, status-climber pretensions of modern architecture and design was an attitude that he shared with many of the downtown artists. Good design was becoming a cover for production values, and the artists were especially sensitive about this because they knew that modern

Saul Steinberg,
drawing in Art News,
February 1953.

painting—*their* painting—was becoming another good-taste product. Ad Reinhardt, in a cartoon that he published in *Art News*, complained about the "middlebrow" taste and sell-or-else mentality of galleries associated with the downtown artists. He referred to the "Wholesale & Retail" of Sidney Janis, who showed de Kooning and Pollock but struck Reinhardt as being "Janis Butcher Baker & Candystickmaker." There was an aura of anti-Semitism to some of these jokes; a number of dealers were turned into little old Jewish merchants, especially Kootz, who was said by Reinhardt to offer "Bar Mitzvah at Kootz." This was a gallery where, according to Reinhardt, you could find "occasional emerging Talent regular fading Talent sign painting for singing gags & xmas poetry"—which was a reference, as we shall see, to the comic-poetic broadsides that Kootz produced as announcements for his holiday shows. As for Betty Parsons, with whom Reinhardt himself was exhibiting, she was said to operate a "gift Shoppe" selling "antiques jewelry workes of arte for the upper lowbrow."[28]

Thomas Hess, the editor of *Art News*, suggested that in the 1950s artists had the feeling that avant-gardism was degenerating into mere novelty, for "publicly to admit being avant-garde is felt to be as bad as trying to sell yourself in

a new wrapper."[29] As one artist made it big, others began to conform to his idea of individualism, and individualism became a cliché. But even if Tenth Street was worrying about having a Madison Avenue side, painters and sculptors could not simply reject the new design mafia that was all mixed up with the new gallery mafia. The artists were beginning to sell, and they were well aware that among the architects and designers and ad people and their friends in the business world were potential buyers, though that could make an artist, again, all the more wary of

Ad Reinhardt,
detail of cartoon in
Art News, April 1954.

these people, for they had a power over him or her. Long Island, at first a haven for the artists, was rapidly becoming a meeting ground for the doctors and ad executives who came to be where the artists were. In *But Not for Love*, a novel that May Natalie Tabak, who was married to Harold Rosenberg, published in the 1960s, "each of the 'early settlers' had become the nucleus of a circle of his own, consisting of artists, architects, editors, psychoanalysts, lawyers, big magazine gentry, forward-looking advertising people."[30] Any one of them might buy a painting. The kind of architecture that most artists probably preferred was an industrial loft or an old house that could be shaped to one's needs—a found object to be transformed, Americana in a new key, like Hofmann's house in Provincetown. But the old modern idea, the idea that the painter or sculptor might join with the architect in the invention of a new kind of environment, this still had its power. Collaborations of artists and architects were discussed, and even supported, by Samuel Kootz, who organized a number of shows highlighting the potential for such projects several years before Hofmann received his mosaic mural commission for 711 Third Avenue, where there was also a stainless steel wall sculpture by José de Rivera.

V

The importance of art dealers in New York City cannot be overestimated. They were merchants, but they were also idealists, for they believed that contemporary painting and sculpture was an aspect of the American experience that a growing public was ready to embrace. At the Betty Parsons Gallery— where Ellsworth Kelly, Jack Youngerman, and Agnes Martin all showed— there were twelve exhibitions a season, between September and May. The paintings flew on and off the walls, with a speed and efficiency that had to do with the sense that things were happening very fast, that the expansive democratic spirit of the New York School, which was a natural outgrowth of the expansive democratic spirit of the city as a whole, demanded many shows, many opportunities.

The great art dealers were oxygenators of the new. Their idiosyncratic elitist attitudes were grounded in the belief that other people could see what they had seen. In the 1920s and 1930s, dealers such as J. B. Neumann and Curt Valentin and Pierre Matisse arrived from Europe and exhibited avant-garde paintings and sculptures by French and German artists and then, to some extent, by Americans as well. In the 1930s and 1940s, Julien Levy and Peggy Guggenheim opened galleries where younger Americans were featured along

with already legendary Europeans. During his lifetime, all Gorky's one-man shows were at Levy, and Guggenheim gave Pollock a stipend that enabled him to move to Long Island and give his full attention to his painting. Early on, both Samuel Kootz and Sidney Janis published books that dealt with the new American art. Janis's 1944 *Abstract and Surrealist Art in America,* which was accompanied by a show organized by the San Francisco Museum of Art, included work by Pollock, Gorky, and Rothko; and Janis's wife, Harriet Janis, was a significant writer about the new art, and coauthor, with Rudi Blesh, of one of the first monographs on de Kooning. In his *Abstract and Surrealist Art,* Janis actually devoted a couple of pages to the spread of modern ideas through museums, schools, and arts clubs, and mentioned, among others, the Arts Club of Chicago, the Carnegie Institute in Pittsburgh, the Oakland Art Gallery, the Albright Art Gallery in Buffalo, Cincinnati's Modern Art Society, the Philadelphia Art Alliance, the Institute of Modern Art in Boston, the Harvard Society of Contemporary Artists, Black Mountain College, the Institute of Design in Chicago, and Mills College in Oakland, "where Feininger, Léger, Ozenfant, and Archipenko were guest instructors for consecutive years."[31]

Dealers such as Janis—and Kootz and Parsons—respected the public enough to believe that gallerygoers would, ultimately, take the leaps they themselves had taken. Along with the curators at the Museum of Modern Art, they were helping to spread the word. And their message was reinforced by an outpouring of serious publications about modern art. George Wittenborn, a book dealer who was born in Hamburg and had worked at the Buchholz Gallery in Berlin, opened his first shop in New York in 1937. He catered to the interests of artists, and became involved in publishing. He formed a partnership with Heinz Schultz, and they invited Robert Motherwell to edit the Documents of Modern Art series, which included translations of writings by Jean Arp and Mondrian and others; in the early 1950s, Wittenborn, Schultz also published magazines and yearbooks, including *Modern Artists in America,* edited by Ad Reinhardt and Motherwell, and *trans/formation,* edited by Mondrian's friend Harry Holtzman. Wittenborn was one of the great merchants in modern ideas. If you look inside the back cover of a book about art published in the 1950s or 1960s, there is a good chance that you will find the elegant blue-and-white label of Wittenborn Art Books. He was the bookseller to a nation's avant-garde.

In 1951, a visitor to the Parsons Gallery, where Pollock and Rothko were showing before they moved to Janis, saw in Parsons's office a map of the country covered with red pins from California to Maine, each of which

marked the presence of work by one of the gallery's artists in a museum exhi-
bition.[32] The dealers were passionate promoters, especially Kootz, who some-
times gave his announcements a boisterous edge, turning them into amusing
avant-gardist variations on nineteenth-century broadsides. For a December
1952 holiday show, Kootz produced an elegant elongated sheet, printed in
gray on cream paper, with ornaments by one of his artists, William Baziotes,
and a holiday-season poem that amusingly hawked the available art. The
gallery, Kootz explained, had "Paintings American, paintings from France, /
Paintings dynamic by HOFMANN, HANS." And there was "a GOTTLIEB
with symbols mysterious, / It surely will get
a reception delirious."[33] These promotional
jeux d'esprit had a serious point: They were
meant to get the paying public involved in
the ever widening promise of modern art. In
1949 Kootz had presented "The Intrasubjec-
tives," a group show that included Hofmann
and other Abstract Expressionist eminences;
the statement on the announcement, by
Harold Rosenberg, argued that the painter
was now inspired "by something he hasn't
seen yet"—and wanted the viewer to see,
too.[34] On the announcement for a summer
show in 1951, Kootz offered a "Suggestion to
Collectors," urging them "to experiment
with the hanging of pictures," moving them
around their homes. Kootz's "Talent 1950"

Robert Motherwell, cover of Modern
Artists in America, *No. 1, 1951.*
Published by Wittenborn, Schultz, Inc.

Cover of trans/formation *1:3, 1952.*
Published by Wittenborn, Schultz, Inc.

show, chosen by Meyer Schapiro and Clement Greenberg, was regarded by many as a signal event. The twenty-three artists included Franz Kline, Esteban Vicente, Al Leslie, Harry Jackson, Elaine de Kooning, Sue Mitchell, Manny Farber, and Hyde Solomon. When "Talent 1950" opened, the poet and painter Weldon Kees, who was friends with Hofmann and was writing about art for *The Nation*, described "a very *young* show, with all such a show's uncertainties and gropings, but with enormous spirit and optimism and love of paint." There might not be anything revolutionary about the work on display, Kees observed, but it was exciting to see that a major gallery such as Kootz was giving this kind of attention to "outcast and unrecognized painters who are ordinarily brushed off by Fifty-seventh Street."[35]

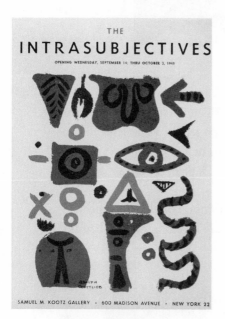

THE
INTRASUBJECTIVES
OPENING WEDNESDAY, SEPTEMBER 14, THRU OCTOBER 3, 1949

SAMUEL M. KOOTZ GALLERY · 600 MADISON AVENUE · NEW YORK 22

Cover of 1949 Kootz Gallery announcement for "The Intrasubjectives," with drawings by Adolph Gottlieb.

"Talent 1950" came in the midst of an explosion of new galleries that were dedicated to representing the work of younger American artists. There was, as we have already seen, the string of galleries, often artist-run, along Tenth Street, which included Tanager, March, Brata, Phoenix, Area, and Hansa. In the late 1940s, Lou Pollack had opened his Peridot Gallery on West Twelfth Street, where he showed Philip Guston and James Brooks, as well as Alfred Russell, whose dramatic turn from abstract to representational painting we will look at later. After Pollack's death in 1970, Hess recalled the almost mysterious atmosphere of the Peridot Gallery, which had "a special light; . . . it's hard to figure out exactly where it emanated from; certainly [Pollack] always chose beautifully proportioned rooms and fixed them up with a spare elegance that had something of the well-fitted, ship-shape, nautical look to it. The paintings he showed—that is, the art he preferred—also radiated a marine quality. I recall the first shows of Vicente, Brooks, Crampton and Guston as light dancing over waves, a shimmering quality; perhaps 'glint' would be the word."[36] Many of the galleries had their own, distinct ambiences, and how you responded to each ambience depended on who you were. As a reporter for *Vogue* explained, some people found the Parsons Gallery rather forbidding, with paintings "hung deliber-

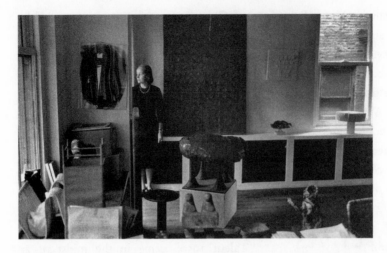

Betty Parsons in the
office of her first gallery,
15 East Fifty-seventh
Street, circa 1953.

ately like ritual objects in a temple" and Parsons herself acting as a "protecting priestess."[37] But for those who eventually got to know Parsons and the work she was showing, the gallery felt very different. When Parsons celebrated her tenth anniversary in December 1955, Greenberg wrote, "In a sense like that in which a painter is referred to as a painter's painter or a poet as a poet's poet, Mrs. Parsons' is an artist's—and critic's—gallery: a place where art goes on and is not just shown and sold."[38]

Galleries seemed to beget other galleries. Elinor Poindexter, who had been involved in the Charles Egan Gallery, where de Kooning had had his first one-man show, opened her own gallery, where Nell Blaine, Richard Diebenkorn, and Robert De Niro would exhibit. The Tibor de Nagy Gallery, directed by John Bernard Myers, opened in what Judith Malina described as "a friendly, fashionably remodeled old apartment."[39] Tibor de Nagy was where Fairfield Porter would exhibit his paintings for many, many years; Helen Frankenthaler, Larry Rivers, and Blaine were among the artists who showed there early on. Myers, who had been involved in the Surrealist magazine *View* in the 1940s—and

Exhibition of antique lace at the
Tibor de Nagy Gallery, 1951.

who published early editions of the poetry of John Ashbery and Kenneth Koch as well as a magazine called *Semi-Colon*—had wide-ranging tastes; he titled his autobiography *Tracking the Marvelous*. Among the marvelous things he presented in the early 1950s was an exhibition of antique lace. The idea had come to him after reading Henri Focillon's *Life of Forms in Art,* a book published by Wittenborn, Schultz, which Myers had bought in Wittenborn's Fifty-seventh Street store, and which led Myers to wonder about the evolution of artistic forms from anonymous folk expression to aristocratic avowal. The show was cleverly installed by the painter Alfred Leslie—a follower of de Kooning's at that time—who draped the lace over thin dowels and hung pieces from the ceiling. And Myers recalled that Jackson Pollock, whose paintings had their own kind of laciness, "came twice and took great pleasure in the notion of *art anonyme;* the rhythms of swirl and crosshatch, even the highly conventionalized images of French eighteenth-century lace, with its peacocks, pheasants, roses, waterfalls, grottoes, pagodas, ruins and costumed personages, delighted him."[40]

The galleries mounted a complex campaign that mixed education and amusement. Eleanor Ward, whose Stable Gallery was the site of some of the most exciting group shows of the mid-1950s, had grown up in a cultivated family in New York, and remembered that in her youth art openings had been very proper events, "you know—striped trousers and gloves—and I used to think then what fun it would be just to have a gallery where people could walk in off the street and be informal and free and relaxed."[41] The new galleries catered to an audience that had come to know modern art at the Museum of Modern Art and the more established galleries, and included people who read the sophisticated criticism by Greenberg and others that was appearing in *Partisan Review* and *The Nation* and kept up with the latest publications by going to Wittenborn's bookstore. This new generation of collectors included Lois Orswell, a woman of means who, after years of looking, had made her first purchase in 1944, a Paul Klee, from Curt Valentin, who ran the Buchholz Gallery. She was soon collecting the younger Americans, especially David Smith, at first from Marian Willard, who represented him in the years when he sold almost nothing; Orswell and Smith ultimately became good friends. Later, she recalled her immersion in the galleries along Fifty-seventh Street. "I haunted 57th street thoroughly when I first started going to galleries and there was probably not a door or a wobbly elevator or a dirty staircase that I did not explore, and I met a sort of fascinating connoisseur/dealer one never meets now." She recalled first seeing Kline and de Kooning in Egan's "tiny

room on the top floor of a building on 57th Street. . . . The two shows that really moved me were the Gorky black and whites at [Julien] Levy and Egan's first Kline show. His first large black and white, called I think WANAMAKER'S, I nearly wept over. Stupidly I did nothing about it but several years later I was able to acquire it from Janis."[42]

VI

All this bursting artistic life, both uptown and downtown, could be seen as mirroring a more general upsurge in national prosperity. If a paintbrush, picked up on a lark by a kid in college after the war, was becoming the open sesame to a new kind of life, the whole country was at the very same time moving away from the jobs in agriculture and small- and medium-sized industry that had been the economic backbone of the United States. Artistic New York seemed to be echoing a pervasive national change, for at least in Manhattan there was a symbiotic relationship between the expansion of art and the shrinkage of other parts of the urban economy. In the two decades between 1949 and 1968, the number of employees in the apparel and textile industries in New York declined from 354,000 to 229,000—by about a third. And artists in search of cheap space found themselves moving into the old industrial and working-class neighborhoods. Between 1958 and 1968, the number of manufacturing jobs in Manhattan went from 538,000 to 456,000; by 1976 it was under 300,000—a drop of more than 40 percent in twenty years.[43] For people who arrived as the manufacturing city was already past its prime but not yet really ailing, the old New York could itself begin to look like an aesthetic object, an emblem of the dynamic impulse that was now most alive in the work of the painters who lived in the old neighborhoods. Though the enormous number of working people whose manufacturing jobs were vanishing was by no means replaced by the influx of artists, the artists did ultimately take over the manufacturing world, and it became their backdrop. And an artist could catch afterimages and echoes of the working man's struggles, of those struggles that had been the very lifeblood of New York, in the worn wooden floors and creaking elevators and stained façades of all the buildings full of lofts and cold-water flats where the painters and sculptors were now making their homes.

Artists, like many other Americans, had reason to believe that with the end of the war the worst was behind for the country. Prosperity beckoned. Certainly there was a feeling that modern culture, stymied for a decade and more,

was now on the move. And yet there was also a sense of living in the lingering shadow of World War II. The war had blotted out the struggles of the 1930s without resolving them and now new dangers were multiplying—the Korean War, the Cold War, and the threat of nuclear annihilation, for the first H-bomb tests, in 1954, had been far more powerful than scientists had predicted and had sent waves of anxiety all through the country. In 1952, when *Partisan Review* published a symposium on "Our Country and Our Culture," some younger writers seemed both perplexed by the country's direction and disinclined to attempt any sort of rousing critique. Norman Mailer observed that "the enemy is vague, the work seems done, the audience more sophisticated than the writer. Society has been rationalized, and the expert encroaches on the artist. Belief in the efficacy of attacking his society has been lost, but nothing has replaced the need for attack."[44] There was little question but that the Cold War was pushing the country into an increasingly conservative, conformist mold, and in response, writers—and artists, too—looked inward. While in the 1930s many painters and sculptors had embraced or at least felt the tug of socialist ideas and ideals, even back then artists had, as Barnett Newman would point out, felt alienated from the political scientists and social planners who "cannot understand how anybody is able to make anything, particularly a work of art, spontaneously or directly—*a primo*."[45] When Meyer Schapiro wrote in 1957 that "the artist must cultivate his own garden as the only secure field in the violence and uncertainties of our time," he was not offering a prescription so much as he was describing a viewpoint that was prevalent among the artists he knew. True, Newman had a special sympathy with anarchist ideas (he wrote an introduction to an edition of Pyotr Kropotkin's *Memoirs of a Revolutionist* in 1968), but he probably also spoke for a more general artistic attitude when he defended the artist's ability to create quite simply because "he has it in him to do so" against the social or political thinker's desire to rationalize all experience.[46]

After the war the majority of the artists were liberal anticommunists, and they were obviously troubled by the unfolding drama of the McCarthy hearings. If they had voted in 1952, it was for Adlai Stevenson, and they would have reacted to his defeat the way a professor quoted in Eric F. Goldman's *The Crucial Decade* did: "It's not just that a great man has been defeated. It's that a whole era is ended, is totally repudiated, a whole era of brains and literacy and exciting thinking." While artists, intent as they were on cultivating their own gardens, were unlikely to be much engaged in the hairsplitting debates about people's former and current political affiliations that gripped so many intellec-

tuals, they nonetheless had to share the general relief in the country in June 1954, in the midst of Eisenhower's first term, when Joseph McCarthy was finally undone at the Army-McCarthy Hearings by the lawyer from Boston, Joseph Welch, with his bottom-line question: "Have you no sense of decency?"

And yet it is striking how little we hear about current events in the writings and conversations about the visual arts that have come down to us from those years. Artists seem to have had very little to say about the political situation in a country where, as Goldman wrote in *The Crucial Decade*, "for the first time in twenty years, the term 'conservative' was being used . . . widely and without embarrassment."[47] The closest that anybody in the art world came to describing the artists' attitude was Thomas Hess, in his study "U.S. Painting: Some Recent Directions," published in the *Art News Annual* in 1956. He observed that "G.I.ism" was "the perfect expression of American culture in 1955." This was "a working philosophy, not restricted to veterans, whose slogan is the admonition 'Never volunteer.' It embraces a belief in short aims, day-to-day cures for changing symptoms; larger problems are ignored."[48] If artists were willing to take this rather passive attitude toward the wider world, it may have been because at a time when the economy was moving forward and they were almost inevitably benefiting from the upswing, these proud bohemians didn't know quite what to do with their own sense of alienation. When Hess observed that among his artist friends "no attempt that seems bound to fail . . . is made," he spoke for a generation that yearned for absolutes and avoided the disappointments that were inherent in equivocal situations. If artists felt alienated from an increasingly conservative United States, they would simply ignore their go-with-the-flow neighbors. They would give their all to the work in the studio.

VII

I think it's important to understand that the climate of New York tended to heighten experiences—tended to put the screws on, so to speak—and that went for artistic experiences as well as all others. In 1948, just as a new generation of artists was streaming into New York, Greenberg argued that the life of the avant-garde in New York was a sort of hyperbolic version of the avant-garde life of Paris. He said that New York artists were living a life "as old as the Latin Quarter; but I do not think it was ever lived out with so little *panache*, so few compensations, and so much reality. The alienation of

Bohemia was only an anticipation in nineteenth-century Paris; it is in New York that it has been completely fulfilled."[49] Joan Miró was living in America in 1947, around the time that Greenberg had made his comment about bohemia, and in response to a question about his daily schedule of painting, Miró observed, "Well, here in New York I cannot lead the life I want to. There are too many appointments, too many people to see, and with so much going on I become too tired to paint."[50] Obviously the immensely well-known artist who made this remark was living in a rather different universe from the still barely known New Yorkers whom Greenberg had in mind. But it's significant that both Miró's and Greenberg's observations emphasize, if in contradictory ways, this even-more-so aspect of New York. And if we consider that Miró was an artist who had flourished amid the Surrealist bohemia of Paris, which was never known for its placidity, his reaction to New York suggests something rather extraordinary about the frenetic pace in the years just after the war. That pace would only pick up as time went on.

Of course there is no simple way to explain how the quality of an artist's life affects the character of the work—this is going to be different in each case—but there is no doubt that a bold, vehement approach became second nature for some of the new New York painters, although where that approach led depended entirely on who was wielding the brush. Everybody agrees that Abstract Expressionism was the culmination of a decades-old push into improvisation and risk; but then, almost everything that went on in art in New York could be said to have an even-more-so element. The painterly realism of Porter and Blaine and others emphasized a tendency toward the wayward, the impulsive, the casual, the ad hoc that had already flourished in Fauvism and in the paintings of Bonnard and Édouard Vuillard. In New York, the old French intimism was, if not more intimate than it had ever been before, certainly *as* intimate as it had ever been before. In the 1960s, when a sharp-focus realism came to the fore in New York, it could seem more explicit than anything that the Europeans had ever done. Meanwhile, Ellsworth Kelly and Burgoyne Diller and, later, Donald Judd were giving Constructivist ideas a hyperbolic simplicity. Of course no two artists ever experience the same time or place in quite the same way. Ultimately, each painter or sculptor is alone with the work in the studio. Paul Goodman, reflecting on the life of Arshile Gorky, who had died in 1948, just as fame was coming to the New York School, spoke of the "autonomous but not isolated world of the artists" and of the "paradox of being trapped and therefore representative" but also "escaping and becoming one's self."[51]

Fairfield Porter,
Laurence Typing, 1952.
Oil on canvas, 40 × 30⅛ in.

 A great modern city like New York became a theater in which all the tensions between the individual and the group were played out. You feel these tensions in a statement that Hofmann made in 1950, when some artists gathered for a discussion of the new American art. "Everyone should be as different as possible," he said. "There is nothing that is common to all of us except our creative urge." But a moment later he admitted that it was not that simple. "Every one of us has the urge to be creative in relation to our time—the time to which we belong may work out to be our thing in common."[52] The time

that Hofmann and other participants in that discussion, such as de Kooning, Newman, and Reinhardt, had in common was the New York of the 1950s. And the question of how an artist responded to such an urban environment was raised by Katharine Kuh, the curator of modern painting and sculpture at the Art Institute of Chicago, when she organized an exhibition called "American Artists Paint the City" for the Venice Biennale in 1956.

Cover of Art News, *May 1961, with*
Burgoyne Diller's First Theme, *1942–43.*

The show ranged from O'Keeffe and Marin to de Kooning, Pollock, and Kline, whose abstract works Kuh said "envelop one with the same insistence as the city itself."⁵³ For many artists—even ones such as de Kooning and Kline, who had given certain of their paintings urban titles, including *New York, Ninth Street,* and *Gotham News*—Kuh's show suggested popularization, a way of turning abstractions into illustrations. When he was asked about the Biennale show, Pollock exclaimed, "What a ridiculous idea, expressing the city—never did it in my life!"⁵⁴ But it was difficult to deny the impact of urban experience on artistic expression.

In an essay called "Gotham News, 1945–60," the painter Louis Finkelstein, who wrote astutely about the art of his contemporaries, drew readers' attention to a canvas called *The Painter's City,* which Guston had done in 1956–57. Here the urgent, agitated movements of Guston's brushstrokes suggested, at least in certain areas, a rough-hewn mosaic. You can argue that too much can be made of a title, considering that *The Painter's City* looked quite a bit like other Gustons from those years that did not have urban titles. And yet to Finkelstein, *The Painter's City* invited an interpretation that had a good deal to do with urban experience and that Finkelstein characterized as "polyreferential." "It is not," he explained, "a view of a city from outside, [it is not] the

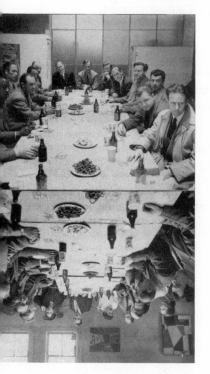

shapes of the city from the inside, buildings, people hurrying in the street, the feeling of being in the city, the idea of a city, a dream or a romance of the city, the tatteredness, the dirtiness, the elegance, the charm—but all of these. In fact, from conversations with Guston, I am quite sure that whatever I see he will call it something else, and yet I will be right too." The impact of the city was complicated, multifaceted. And the artist had to respond in kind. Hess recalled that both Arp and Giacometti, in visiting New York, had told him that "what impressed them most was how fast they got lost in it, because there are no European-type landmarks." While there was a danger in making too much of what amounted to the ordinary experience of a foreign visitor, Hess felt that Arp and Giacometti were responding to

Artists' session at Studio 35, 1950, including
Willem de Kooning, Hans Hofmann, Robert Motherwell,
Ad Reinhardt, Barnett Newman, and others.

*Philip Guston,
The Painter's
City, 1956–57.
Oil on canvas,
65 × 77 in.*

New York's democratic spirit, to the sense that "its thousands of buildings, of every shape, size, and color, suggest that each is something else." And Hess quoted Dostoyevsky's "A Raw Youth": "It's all so vulgar and prosaic that it borders on the fantastic."[55]

Certainly, the special character of an artist's work—its unique mix of qualities, of romanticism and pragmatism and idealism and other isms too new to have names—is always the product of a dynamic interaction between the artist and the city, and a great city does not only have its own architecture, weather, seasons, neighborhoods, industries, fads, and fashions, but also its own conventions and its own view of the past. New York pushed artists in certain directions; the city's pressure-cooker atmosphere had a way of making you feel that all traditions were in extremis. But artists also pushed back—and went their own ways, which could involve rethinking anything from the greatest hits of Renaissance art to the nitty-gritty of studio practice.

2. THE DIALECTICAL IMAGINATION

I

If what initially attracted artists to New York was the rush-hour-in-the-arts drama of a city that was taking its place in history, what eventually held them about the place that they called home was its heterogeneity. America's Byzantium was not only physically heterogeneous, it was also psychologically heterogeneous, a city where painters and sculptors and just about everybody else experienced their individuality dialectically, in terms of tensions and oppositions, in terms of a constant accretion of variegated, often dissonant impressions. And the many dialectical visions that were discussed by New York's artists—whether Freud's ego and id, or Nietzsche's Apollonian and Dionysian modes, or Hofmann's push-and-pull, or Mondrian's verticals and horizontals, or what Harold Rosenberg referred to as a conflict between redcoat academicism and coonskin improvisation—suggested a panoply of analytical patterns that lay beneath the house-of-mirrors complexities of the urban imagination.[1]

Nietzsche, a philosopher in whom artists recognized an impassioned admirer of their difficult vocation, had announced in 1888 in *Twilight of the Idols* that "one chooses dialectic only when one has no other means." The dialectic, Nietzsche argued, "is not very persuasive" and "arouses mistrust," for "nothing is easier to erase than a dialectical effect."[2] Surely New York artists and intellectuals embraced Nietzsche's skepticism. The philosopher Sidney Hook, in a long attack on the dialectic published in his 1940 book *Reason, Social Myths and Democracy,* hoped that the term would "sink into the desuetude of archaisms." And yet such skepticism, however necessary it might be, was itself a response to a time of dialectical ferment. Rejecting the dialectic often turned out to be a way of embracing the dialectic, because so many important artistic assertions were responses, reactions, alternative views—what might be called, to borrow a phrase from the critic Kenneth

Burke, a counter-statement, a principle "matched by an opposite principle flourishing and triumphant today."[3] The very idea of a counter-statement had a venerable lineage, for Nietzsche, in "The Will to Power as Art," had offered, in response to the decadence of religion, morality, and philosophy, "The *countermovement: art.*"[4] A constant movement of statement and counter-statement gave the New York art world a boisterous, crazy freedom, so that many artists were able to establish their own intense yet easygoing relationships with tradition and find their own unique ways of handling the tools of their trade. A tremendous variety of counter-expressions flourished in the very midst of the gestural abstraction that dominated downtown New York through so much of the 1950s. These counter-expressions ranged from the painterly realism of Fairfield Porter and Robert De Niro and Nell Blaine and Earl Kerkam to the geometric abstraction of Burgoyne Diller and Ilya Bolotowsky and Myron Stout—and the work of these artists ought to be counted among the signal achievements of the School of New York.

All the triumphs of the new city of art—the sense of the individual as reinventing tradition, the new forms of romantic experience, the embrace of empiricism—were dialectically related to what had come before. And the dialectical spirit had been woven into the urban consciousness for centuries, at least since Socrates urged the young men of Athens to learn through a succession of questions and answers. Wolfgang Paalen, a painter who edited a magazine called *Dyn* that was closely read by New York artists in the 1940s, observed that "the *dialectic* of Plato might be understood as deriving from some profound though troubled memory of the relativity of all contradictory terms"—so that the dialectic became a way of grappling with man's most basic apprehensions. Paalen had less use for the Hegelian dialectic; he complained that it was a "primitive complementary concept."[5] And yet many artists were aware of how deeply Hegel had pondered the miracle by which new styles emerged from old styles in the great capitals of art. "True originality," Hegel observed, "does not consist in merely conforming to the paramount conditions of style, but in a kind of inspired state personal to the artist," who takes a subject or motif and reimagines it not in relation to the art of his own time but in relation to a universal sense of the Ideal.[6] As for dialectical materialism, the process that orthodox Marxists described, by which the members of the proletariat, recognizing the misery of their lives, would inevitably push for change, this had also been framed as an essentially urban phenomenon, as a product of the industrialized city.

Although painters and sculptors might not actually have read Plato or

Hegel or Marx, they had philosophical inclinations and had osmosed many dialectical ideas, perhaps through articles in *Partisan Review* and other little magazines, perhaps through the conversations that were taking place all over Manhattan. Most artists would probably have assumed that Hegel had invented the concept of a thesis and an antithesis yielding a synthesis, although down-towners such as Clement Greenberg, who had studied philosophy seriously, would have understood that this was a later equation, now widely and erro-neously ascribed to Hegel. But something more than a history lesson was involved in the artists' interest in philosophy. The painter Pat Passlof, who met de Kooning when she was studying at Black Mountain College in 1948, has observed that Kierkegaard—who had his own kind of dialectical vision, one that had nothing to do with Hegel—"suited the sense of fervor that per-meated the downtown atmosphere then."[7] Kierkegaard's most famous book, *Either/Or,* defined a conflict between romantic and idealist values as they were reflected in the writings of two fictional characters. We know that Elaine de Kooning was reading passages from Kierkegaard to Bill in the late 1940s, and to confront the nearly unfathomable choices that Kierkegaard provoked was to go to the very core of urban experience.

Dialectical processes were reflected in the look and feel of the streets of Manhattan, in the contrasting ethnicities, in the clash of cultural expressions that fascinated Mary McCarthy, and in the very layout of the city, which had a pulse that seemed to come from the constant rhythm of the right-angled streets and the way the buildings shot up, straight into the sky. As for

how all the city's physical and psychological and philosophical dialectics might be knit to-gether, Mondrian, the Dutch artist who ended his days in New York, had suggested in *Broad-way Boogie Woogie,* the last painting that he finished, in 1943, that the opposing pressures of the city would give birth to an entirely new kind of artistic expression. Mondrian had long ago argued that the verticals and horizontals of his composition were a way of approaching the very essence of art, of creating a compositional counterpoint that artists recognized as distill-

Piet Mondrian, Broadway Boogie Woogie, *1942–43.*
Oil on canvas, 50 × 50 in.

ing the give-and-take of human experience into certain essential, primal moves. In the paintings that he had done in Paris in the 1920s, in which all of art and experience were reduced to a few verticals and horizontals and a few rectangles of color, he had discovered an astonishing realm of restrained lyric feeling. Yet since the 1920s, and especially after his arrival in New York in 1940, the dialecticism that was implicit in his counterposed lines and colors had begun to leap beyond thesis and antithesis to an entirely unexpected place. In *Broadway Boogie Woogie* the rectangular units became smaller and smaller, and their proliferation began to create not just the implied diagonals that we know from his earlier works, but curvilinear streams of mosaicked areas, a sense of waves of movement that do not refute the essential rectilinearity of his vision so much as they bubble up out of it, creating a synthesis that is all coursing, barrier-breaking animation. In *Broadway Boogie Woogie* we have an allegory of New York's dialectical spirit—a sense of thesis and antithesis pushing beyond themselves, into a reeling, dancelike synthesis. In New York, Mondrian, who had two decades earlier reached a sublime purity, leaped to another place, where what he called pure plastic relations were re-naturalized amid the pressures of the city.

II

All great cities are by their very nature dialectical extravaganzas, places of startling extremes, extremes that overlap, collide, even explode. And by the 1940s, New York, as much as any city in history, had come to be known as *the* place of dazzling contradictions, as *the* place where life was lived at a fever pitch, and a big part of that story had been telegraphed through the bluntly confrontational black-and-white images of the city that were instantly recognizable around the world. New York had its own kind of look, jam-packed as it was with electric lights and neon signs, and photographers and filmmakers loved to let those nocturnal contrasts burn into their film, creating intensely graphic, almost expressionist effects. The new, unornamented skyscraper architecture, with its skeletal frames and expanses of glass, seemed designed for black-and-white photography, whether the building was lit up at night to define a simplified grid, or silhouetted at midday against Manhattan's high, brilliant light. The city generated black-and-white images that, almost immediately, became black-and-white clichés: the crazy patterning of fire escapes, which were themselves set in a dialectical tension with old, brick-and-mortar buildings; the aerial traceries of laundry lines crisscrossing the backyards of

Alex Steinweiss, Boogie Woogie *cover for Columbia Records, circa 1940.*

the Lower East Side; the piles of tabloid papers composing a spontaneous black-and-white collage on every newsstand. New York was a city where people ordered black-and-white ice-cream sodas and dressed up in black-and-white evening clothes for a night on the town. And it was also, to turn to far more serious matters, a city of different races, a city where black and white people lived in different neighborhoods, although they also sometimes danced and drank and listened to music together in what, since the nineteenth century, had been called black-and-tan dives; the Black-and-Tan was a music hall on Bleecker Street in the 1880s.[8]

The image of a city as a collage of syncopated lights and darks had originated in Paris, not New York, but like so much that came to seem native to New York, the black-and-white city was an Old World vision that in Manhattan achieved a hyperbolized, New World form. Most photography was in black-and-white until sometime around mid-century, and the look and feel of London and Paris generated their own powerfully graphic representations, but if black-and-white images of European cities often suggested a gentle chiaroscuro, a symphony of grays, the streets and vistas of New York provoked a tougher, more dialectically charged drama. New York had grown up with the black-and-white of photography; the city's story has always been entwined with the development of photography and photojournalism and film. One of the first newspaper images taken directly from a photograph, a primitive halftone of New York's shantytown, appeared in the *Daily Graphic* in 1880. Edison was filming the life of the city in the early years of the new century, including fairy-tale views of brilliantly lit amusement parks. And Weegee's photoflash images of life high and low filled the pages of the *Daily*

Rudy Burckhardt,
Haircut 20¢, *1939.*

News in the 1930s and appeared in 1945 in his book *Naked City.* All of this had an impact in Hollywood, where New York was regarded as one of the perfect settings for the enveloping romantic ambience of film noir.

In the 1930s, Rudy Burckhardt, a close friend of de Kooning's, brought the eye of a dialectical comedian to the city's self-absorbed pedestrians and to the overload of signs that competed for the walker-in-the-city's attention. There's an ironist's sense of fun poking through the black-and-white play of Burckhardt's photographs, as when the stripes of a barbershop pole get in the way of the window display, so that what you can buy for twenty cents is an AIRCUT—above which there's an advertisement for the latest movie at the RKO 23rd St., *Second Fiddle.* In the mid-1940s, the photographer Aaron Siskind insisted on a close-up relationship with the urban scene in New York and Chicago, a relationship that yielded black-and-white distillations, among the earlier ones being *New York,* done around 1947, a study of a single iron-work curl with a weatherworn surface, a fragment of city experience turned into a Constructivist sculpture. Within a few years, Siskind was photographing the graffiti on urban surfaces, giving these glimpses an abstract elegance that very consciously evoked the compositional strategies of Kline and de Kooning. Then, emerging after the war, there was a new generation of photographers, including William Klein, Ted Croner, Robert Frank, and John Cohen, who created a New York hipster's expressionism by mixing the gritty

William Klein, Wings of the Hawk,
42nd Street, New York, *1954.*

stylizations of film noir with a Dadaist playfulness that was more elaborately
self-conscious than Burckhardt's and a feeling for the randomness of abstract
structures that made Siskind look like a classicist. Around 1960, Cohen took a
series of photographs of the artists' haunts—among them the Cedar Tavern,
the Club, and the Tanager Gallery—and created a definitive photographic
impression of a hell-bent, headstrong time. Cohen's provocative arrange-
ments of high-contrast lights and darks had as many undercurrents as a
Rorschach test. He discovered in these images of maximum animation—
whether a quickly smiling face or a dramatically outstretched hand—a snap-
shot rhetoric with an underlying emblematic power. "Grain, blur, contrast,
accidents, cockeyed framing, no problem" was William Klein's description of
how he photographed the images collected in his book, *New York,* which was
published in 1956.[9] But however informal an artist might want the process to
appear, black-and-white photography was by its very nature analytical, a
process by which the chaotic colors and shapes and movements of the world
were reduced through the operations of the camera, the film, and the dark-
room. New York, when seen as the black-and-white city of photography, was
itself a kind of X-ray of a city—the city not as reality but as an object of mod-
ern research.

The black-and-white look of New York, which was telegraphed across
the country and the world in movies, in magazines, in ad campaigns, had a

particularly urgent hold on the artistic imagination, for this striking visual dialectic, like so many other aspects of the city, seemed to be the immediate expression of deeper historical processes. What other dialectical scheme was at once as grand and as simple as black-and-white? In the late 1940s, when de Kooning and Pollock and other New York artists began doing paintings in black-and-white, they were surely responding to what they saw before their eyes in Manhattan and to the way Manhattan was represented in photography and film, but they were also responding to the fascination that black-and-white had held for artists for the past hundred years—for Manet, Matisse, Picasso, Kasimir Malevich, and Mondrian. Did artists see New York in a certain way because they were attracted to certain kinds of art? Or did the experience of New York leave them especially open to particular forms of artistic expression? We can never say for sure, and the truth is that the process is probably always working in both directions.

In the early nineteenth century, Goethe had already suggested that a black-and-white painting, through its extreme reduction of reality, suggested "a violent abstraction." By 1913, when Malevich had exhibited a work that, as he explained, was "nothing more than a black square on a white field," the idea of black-and-white as a distillation of "pure feeling" was becoming an artistic reality.[10] And what all New York artists recognized as the key twentieth-century effort to transform human conflict into a visual crisis in black-and-white, Picasso's *Guernica*, completed in 1937, was itself at the very heart of the black-and-white city, on extended loan from the artist to the Museum of Modern Art since the beginning of World War II. In *Guernica*, Picasso was using the dialectical confrontation between black and white—plus an admixture of their comrade in arms, gray—to define a political confrontation between freedom and fascism; indeed, the absence of color may in part have been inspired by the black-and-white of news photography. *Guernica* was also about an art historical dialectic, for Picasso was responding to the vast, densely plotted panoramic allegories of nineteenth-century painters even as he was presenting an intricate weave of personal symbols and near-abstract forms. By 1951, this idea that the glorious traditions of figure composition could be distilled into black-and-white had been seconded by Matisse, in the tile murals for the chapel at Vence, to which Alfred H. Barr, Jr., the guiding spirit of the Museum of Modern Art, devoted a special gallery at the time of his epochal Matisse exhibition that same year.

Clement Greenberg, reviewing de Kooning's first one-man show in 1948, a show that was full of black-and-white canvases, suggested that a number of

Willem de Kooning,
Painting, 1948. Enamel and
oil on canvas, 42⅝ × 56⅛ in.

contemporary New York artists were reaching for black-and-white as a way of concentrating their energies. They hoped, Greenberg wrote, to "solve, or at least clarify" problems. Black-and-white seemed to suggest "a more advanced phase of sensibility at the moment"—because it was, Greenberg implied, so forcefully refined. If we consider the wildly heterogeneous mix of elements in de Kooning's abstractions of the late 1940s, which included afterimages of body parts and urban architecture and who knows what else, the black-and-white might have been a way of giving some coherence to the chockablock allusions. Matisse, on the occasion of an exhibition titled "Black Is a Color," at the Maeght Gallery in Paris in 1946, had observed, "Like all evolution, that of black in painting has been made in jumps and starts," and the New York artists were now making one of those jumps. Harriet Janis and Rudi Blesh, writing about de Kooning's black-and-white paintings, referred to them as the "positive-negative series," a term that clearly evoked a photographic idea, but also gave an emotional or philosophical spin to the formal properties of black-and-white. Black was no, white was yes; or perhaps it was the other way around. The poet Robert Creeley, writing of Franz Kline's black-and-white paintings, observed that "we are living in a place where everything has the

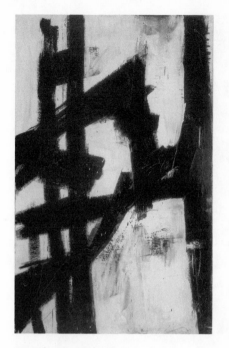

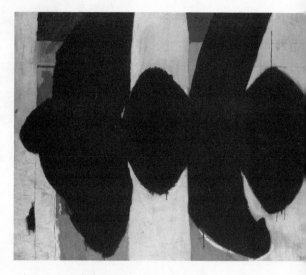

Franz Kline, New York, N.Y., *1953.*
Oil on canvas, 79 × 51 in.

Robert Motherwell, Elegy to the Spanish
Republic XXXIV, *1953–54. Oil on canvas, 80 × 100 in.*

quality of a photographic negative." And he went on, almost helplessly, to announce, "It has to be black on white, because there he is, New York." The New York artists were, as the critic Ben Heller wrote in the catalog of a show called "Black and White," at the Jewish Museum in 1963, "creating expanding horizons out of constricting situations."[11] The roll call of artists in that show was large, ranging from de Kooning, Hofmann, Newman, Pollock, and Kline to Ellsworth Kelly, Jim Dine, Robert Rauschenberg, and Jasper Johns.

A slightly different title, "Black or White," was given to an exhibition organized at the Kootz Gallery a decade earlier, in 1950. The artists included Baziotes, de Kooning, Hofmann, Motherwell, and some Europeans, among them Jean Dubuffet, Miró, Mondrian, and Picasso. The use in the title of the Kootz Gallery exhibition of *or* rather than *and* was significant; it gave the theme an edgy animation. Robert Motherwell, who would over a long career do a great many black-and-white compositions, provided a statement for the brochure, which he began by suggesting that the relationship between black and white was "simple," but he immediately contradicted himself, writing, "Not even *it,* no more than any other relation in art, is *so* simple." "Are we to mark this day with a white or a black stone?" Motherwell quoted from

Don Quixote. He mused on the origins of colors, the blacks, for example, which are made from bones or horns; he cited Hermann Melville's fascination with white, to which a chapter of *Moby-Dick* is devoted; he quoted Arp, referring to black as "the fearful void." And in the end, the either/or seemed to have turned into an idea of thesis and antithesis and synthesis, for Motherwell observed that "if the *amounts* of black or white are right, they will have condensed into quality, into feeling."[12] One of the artists who was developing a particularly striking condensation of black-and-white around that time was Richard Pousette-Dart, and if his paintings were not included in the Kootz show, it was perhaps because in his work white had almost entirely banished black. Pousette-Dart's delicately worked surfaces were animated by a muffled calligraphy, mostly a matter of dark pencil lines that picked out half-obscured glyphs and skeletal architectural fantasies. It was as if the fearful void of black had been absorbed into the expansive spirit of white, until a delicate balance had been achieved, a balance in which black, barely present, was the confounding, shadowy Other. Pousette-Dart's most beautiful canvases have a wintry delight—the whiteness turns all the world's complexities into whispered essences.

Richard Pousette-Dart, Chavade, 1951. Oil and pencil on canvas, 53³/₈ × 96¹/₂ in.

The title of the Kootz Gallery exhibition was quite obviously designed to echo Kierkegaard's most famous title: *Either/Or.* And that title had come, by the 1950s, to telegraph a whole range of

dialectical choices and processes, many of which had nothing to do with Kierkegaard. The composer Morton Feldman, who knew all the downtown artists and wrote a number of essays about those years, titled one essay "Nei-ther/Nor," which suggests a sort of ambivalent dialectic. Feldman observed that his friend Philip Guston "was the quintessence of what Kierkegaard would define as an artist. Someone who was always in one mood and then another." Feldman also recalled John Cage giving two lectures at the Club, "Something" and "Nothing." " 'Something,' " Feldman wrote, "is about me, 'Nothing' is about him. I told him I wanted it the other way around." In his "Lecture on Something," Cage explained that "this is a talk about something and naturally also a talk about nothing. About how something and nothing are not opposed to each other but need each other to keep on going."[13]

III

The painters and sculptors who lived in the Byzantium that was New York City had an instinctive affinity with any twentieth-century artists who were interested in doing more than one thing at once. Klee and Miró, two artists who were immensely influential in 1940s Manhattan, both liked to dream up compositions in which two ideas operated simultaneously, so that a color idea, which was a sort of thesis, would be counterposed to a linear idea, which was a sort of antithesis, and thereby generate the totality that was the work of art. Some of Klee's titles, such as *Barbarian-Classical-Festive*, from a 1926 water-color, suggested a thematic or literary dialectic, which in this instance con-sisted of the barbaric and the classical perhaps merging to create a festive feeling.[14] Dialectical pressures also accounted for some of the fascination that Balzac's story "The Unknown Masterpiece" exerted on de Kooning and his friend Meyer Schapiro and many others in New York, for Frenhofer, the leg-endary old artist at the core of this tale, was attempting to create a painting that would at last unite the age-old conflict between color and line, a synthesis that was stillborn in the incoherence of Frenhofer's never-to-be-finished chef d'oeuvre.[15] And Picasso, whose illustrations for Balzac's story were well-known to New Yorkers through various exhibitions at the Museum of Modern Art, was himself presented as an artist of an essentially dialectical turn of mind when Alfred Barr chose, for both the dust jacket and the color frontispiece of his 1946 book *Picasso: Fifty Years of His Art*, a painting completed fourteen years earlier, *Girl Before a Mirror*. This canvas might be described as a case study in the dialectic, for here we have the young woman times two: the thesis

Pablo Picasso, Girl Before a Mirror, *1932. Oil on canvas, 63¾ × 51¼ in.*

of the woman herself, the antithesis of the woman as she appears in the mirror, and the synthesis of the two of them into the rhythmic whole that is the painting that we see before our eyes.

Back in 1936, in the catalog of the Museum of Modern Art's "Cubism and Abstract Art" exhibition, Barr had included a section called "Dialectic of Abstract Art," which was more Platonic than Hegelian in spirit, for Barr quoted the discussion of "the beauty of shapes" in the *Philebus,* a dialogue that he reported was often referred to by "defenders of abstract art during the past twenty-five years." While Barr distanced himself from the staunch supporters of pure abstract art, he understood that when they drew a distinction between a "resemblance to nature" that is "at best superfluous" and the "composition or organization of color, line, light and shade," they were echoing Plato's distinction between the shadows in the cave and the ultimate reality of things. At a roundtable on modern art held in San Francisco in 1949, Kenneth Burke pushed this idea a couple of steps further, arguing that, for Plato, "abstraction, as a transcending of the sensory, is a way of dying and yet living." But for Barr, Plato's dialectic also had a simpler function, since the very process of abstraction had the power to provoke questions from museumgoers; such paintings could be valuable as question-producing machines. Meanwhile, Hofmann, who by the late 1930s had been teaching and lecturing in New York for half a decade, was fascinated if not by dialectics, certainly by dualisms— by a going *from,* but also a going *to.* Fritz Bultman wrote that "Hofmann invoked duality, ambivalence and dialogue," and quoted Hofmann as saying, "The mystery of plastic creation is based upon the dualism of the two-dimensional and the three-dimensional"—the reality of the canvas and the reality of nature.[16] And in 1937, a year after "Cubism and Abstract Art" was mounted at the Modern, John Graham, an artist and theorist who had grown up in Russia and knew Hofmann and became a sort of mentor for de Kooning, David Smith, and others in New York, published a book called *System and Dialectics of Art.* Here the dialectic referred not to a Hegelian process and certainly not to a Marxist process but rather to the question-and-answer format, and Graham's repeated questions—"What is art?" "What is the Language of

Form?"—might simply have echoed the late-night discussions in the cafeterias of downtown New York, where artists who couldn't afford much more than a cup of coffee sat and talked and talked. Graham, who prided himself on being a White Russian with military experience, was probably offering his *System and Dialectics* as a riposte to the Marxists, although the title may also have been his way of passing among them, if there was anybody who actually cared.[17]

SYSTEM
and
DIALECTICS
of ART

JOHN D. GRAHAM

Cover of John Graham's System and Dialectics of Art, *1937.*

In the 1930s, even as avant-garde artists and art historians were discussing the importance of non-Marxist and even non-Hegelian dialectics for the visual arts, a number of downtown intellectuals were taking an increasingly critical attitude toward orthodox Marxist ideas. There was a turning away from the belief that dialectical materialism was a scientifically verifiable methodology, at least on the part of socialist thinkers such as Max Eastman and Sidney Hook, who would later write *The Hero in History*, and this rejection of hard-line Marxist theory became a part of the dialectical ferment of New York City. In 1942, when Wolfgang Paalen included a symposium called "Inquiry on Dialectic Materialism" in *Dyn*, many New York intellectuals, including Greenberg and Schapiro, responded in one way or another to a series of questions about the scientific claims of dialectical materialism. Most of them found those claims insupportable, much as Hook had in his book *Reason, Social Myths and Democracy*. The responses were more positive, however, to a question about the continuing validity of Hegel's belief that beauty was generated by "development through contradictions" and by "conflict of content and form."[18]

Greenberg observed that "Hegel's 'laws' are valuable literary devices for the exposition of the results of theoretical thought, and like all literary devices can effect the processes themselves of thought, especially when these take the forms of historical analysis." Surely this line of thinking provided the backdrop for a parenthetical remark that Greenberg included in the final version of his essay "New York in the Thirties," where he observed that "some day it will have to be told how 'anti-Stalinism,' which started out more or less as 'Trotskyism,' turned into art for art's sake, and thereby cleared the way, heroically, for what was to come."[19] This capsule history suggested a dialectic in miniature. And yet Greenberg might just as well have pointed out that art-for-

art's-sake had been there in the background of Marxism all the while, as a secret carried within the hard-edged activism of Marxist thought. To the extent that Hegel begat Marx, Hegel's vast writings on the nature and history of art could seem a lost branch of the dialectical adventure, one that had sought to give a historical dimension to the aesthetic idealism of Kant, whom Daniel-Henry Kahnweiler, the first dealer of the Cubists, had quoted in his book *The Rise of Cubism*, which was published in Wittenborn, Schultz's Documents of Modern Art series in 1949. Even earlier, in 1934, five years before Greenberg published his seminal essay "Avant-Garde and Kitsch," and decades before Greenberg turned to the investigations of Kantian aesthetics that would preoccupy him in the last years of his life, it was an unconventional Marxist, Max Eastman, who in his book *Art and the Life of Action* observed, " 'Art for art's sake' as a Bohemian battlecry on the lips of Gautier was quite a scandal in the world, but the same idea formulated as an act of understanding by the God-preserving philosopher, Immanuel Kant—'purposiveness without a purpose'—seemed right enough and proper to the age."[20]

For Hegel the history of art moved through classic and romantic phases, toward "the Idea of beauty itself." And if this could sound off-puttingly exalted to the artists of the 1940s and 1950s, they nevertheless hungered for the sublime and took it for granted that you arrived at the sublime through a process of trying this and trying that—through a dialectical process. Hegel understood that the very structure of a work of art was a reflection of the artist's struggle to master the world. And for painters and sculptors who had no use whatsoever for Marx's dialectic, there could still be a good deal that was of interest in Hegel's description of the romantic artist, who handed over external existence to contingency and "the adventurous action of imagination, whose caprice is just as able to reflect the facts given as they are, as it can change the shapes of the external world into a medley of its own invention." The artist is operating "in the emotional realm, and this is manifested in the medium of that realm itself rather than in the external and *its* form of reality." This emotional realm is one where it is possible "to secure or to recover again the condition of reconciliation . . . in every accident, in all the chance circumstance that fall into independent shape." We may be at a loss to say exactly what art Hegel had in mind when he wrote these words, but in 1950 such passages could certainly be read as a description of Pollock's dripped paint, with all that his process implied about an openness to the artistic implications of accident and chance. Indeed, when Hegel spoke of the character of romantic painting, he foreshadowed Greenberg by praising painting as "visibility in its

pure nature . . . defined in the continuity of color."[21] And when Greenberg, in "The Crisis of the Easel Picture," published in *Partisan Review* in 1948, wrote of the "dissolution of the picture into sheer texture, sheer sensation," he offered an almost Hegelian explanation of that dissolution, arguing that it "seems to answer something deep seated in contemporary sensibility. It corresponds perhaps to the feeling that all hierarchical distinctions have been exhausted."[22]

In the Hegelian scheme, culture was a materialization of historical pressures, and for a New Yorker the beauty of this idea was that it suggested that a grand design fueled the very physicality of the art that was being produced in Manhattan. Among the important exhibitions that Barr listed in the catalog of his "Cubism and Abstract Art" show in 1936 was "These Antithese Synthese," mounted at the Kunstmuseum in Lucerne the year before. The show in Lucerne included many of the artists whom the New Yorkers revered: Picasso, Mondrian, Miró, Léger, Klee, and Wassily Kandinsky, among others. And what was the dialectical process that was at work in this gathering of contemporary art? Well, it was a formal process. The thesis, so Paul Hilber explained in his catalog introduction, was some combination of Purism, Constructivism, and abstraction. The antithesis consisted of Dadaism and Surrealism. And as for the synthesis, it was a merger of all of these stylistic impulses into a new kind of artistic expression, which was of course exactly what some New York artists believed they were accomplishing at the end of the 1940s, when Pollock and Rothko wedded the Surrealist iconography of that decade to a streamlined sensibility and came up with paintings of an increasingly knit-together, everything-is-one-thing, homogeneous character.[23] Already, back in the 1930s, Julien Levy had included in his book *Surrealism* an essay by Gaston Bachelard in which Bachelard expressed the hope there might be a break-through to "the final dialectics of experimental ideas." And some such experimental dialectic was the driving force behind the art of Pollock and Rothko, who garnered so much attention in the early 1950s as they pushed beyond the autonomous yet interlocking realms of color and line to a place where all the old theses and antitheses would no longer exist.[24]

In some sense this move beyond the dialectic had been prefigured in Wolfgang Paalen's essay "The Dialectical Gospel," published back in 1942 in *Dyn*. There was a new kind of free-flowing power to the work by Paalen, Motherwell, Pollock, Hayter, and Baziotes that was gathered together in *Dyn;* and this power was related to Paalen's conviction that the dialectic, with its strident oppositions, was an artificial way of thinking. Through his reading of

Freud, Paalen had discovered the writings of a late-nineteenth-century linguist named Karl Abel, who argued that in ancient languages, and sometimes even in modern languages, opposite meanings could in fact be ascribed to the same word. Thus in ancient Egyptian, according to Abel, there were compound words such as old-young, far-near, bind-separate, outside-inside. From this piece of linguistic history, Paalen concluded that "in very ancient language as in the origin of all thought, there is no opposition of *contraries*, but (through the absence of an abstract concept of exclusive signification) a *complementary* concept." Paalen quoted some remarks that Freud had made apropos of Abel's work and the character of dreams. "The way in which the dream expresses the categories of opposition and contradiction is particularly striking," Freud explained. "It does not express them, it seems to ignore the 'not.' It excels in uniting contraries and in representing them in a single object."[25] There was a sense in which Pollock and Rothko, in the work that they were doing by the end of the 1940s, were also ignoring the "not," were mingling contradictory modes and manners and meanings. Certainly it was this muffling of distinctions that gave their compositions an aura of dazzling, peremptory maturity. By 1948 the imagery in Pollock's work had, at least for the time being, dissolved into an all-enveloping atmosphere, and Rothko, with each round of paintings, was winnowing his soft-edged shapes until the two or three that were left seemed composed of the same singular substance, what the critic Sam Hunter called a "chemical brilliance."[26] Rothko's hovering rectangles presented a dialectic so attenuated as to suggest beatification. You might be seeing the sunset of the dialectic, the beginning of the end of all opposition and contradiction.

As for the paintings that de Kooning and Hofmann were finishing during the same years, they offered radically different approaches to the paradox of the dialectic;

Mark Rothko, No. 5 (Untitled), 1949.
Oil on canvas, 85 × 63 in.

they suggested that although the dialectical landscape might be a shattered landscape, there was still something fascinating about the view that unfolded before an artist's eyes. De Kooning and Hofmann were still pushing one thing against another, still juxtaposing forms. In a statement made in 1955, Hofmann sounded like the most orthodox of dialecticians, insisting that "in a relation, two physical carriers always produce a non-physical higher Third as the aesthetic affirmation of the relation." And de Kooning, in his own infinitely more evasive way, also believed that an artist had to keep the pressures and counter-pressures of theses and antitheses alive, had to acknowledge that, insofar as art was related to life, conflict would continue and that art's greatest triumphs would occur while a final synthesis was still somewhere in the future. To the extent that the New Yorkers were embracing Hegel, it was the philosopher whom Maurice Merleau-Ponty had described in his essay "Hegel's Existentialism," first published in *Les Temps modernes* in 1946. According to Merleau-Ponty, Hegel viewed "man not as being from the start a consciousness in full possession of its own clear thoughts but as a life which is its own responsibility and which tries to understand itself."[27]

IV

The dialectic of the 1950s was utterly different from the dialectic of the 1930s. Whereas it had once been communal, it was now personal. Whereas it had once been political, it was now aesthetic. Hess summarized this sea change by saying that "the self-directed community became self-oriented. Art replaced Revolution as its eschatology." Which was another way of saying that the dialectic of history had been replaced by the dialectic of sensibility.[28] Edwin Denby recalled in the 1950s that although the Marxist talk of the 1930s could be horribly "one track . . . what was interesting was the peremptoriness and the paranoia of Marxism as a ferment or method of rhetoric."[29] There was an anarchic element hidden deep in the dialectical process—Engels himself observed that the "dialectical method . . . dissolves all dogmatism"—and in this sense the dialectic was indeed the method of the mid-century artists, who were sometimes glad to follow the dissolution of dogmatism into the madhatter's-tea-party nonsense of the discussions at the Club. Hess described de Kooning as playing with a thesis (artistic tradition); and then an antithesis (the rejection of artistic tradition); and then arriving at a sort of anti-synthesis, because he "refuse[d] any conclusion that would close the argument."[30]

In 1951 Hess wrote that the painters' conversations "in cafeterias, bars,

lofts and museum lobbies" had "a cheerful optimism as far as the future is concerned, a self-reliant re-examination of the past, and an assertive enjoyment of the present." Hess, who was a bon vivant and a man about town and who doubled as a power broker and a connoisseur of art-world dustups and rivalries, was unabashed in his celebration of the heterogeneity of those mid-century years. Although his criticism has been overlooked in recent decades, a study of Hess's writing, all or nearly all of which is out of print, reveals one of the wisest and truest voices of the third quarter of the century. If he saw the artists of the 1950s as "accepting everything, fighting everything, in continual controversies, receiving and sending stimuli like a dynamo," this was a disputatious dialectical spirit that had taken on a filigreed kind of self-absorption.[31] "In Paris," Hess observed, "the bourgeoisie had a set, tormenting role, which cued even as it attacked the artist. In New York, and throughout America, painter and poet find no such advantageous foil." And yet the more that you look at the postwar years, the more you can see that there was some advantage for New Yorkers in not having such an obvious foil and that the muffling of the sense of opposition could be a kind of strength. "Is there an avant-garde?" Hess asked in 1956. His answer was that contemporary painters were no longer interested in this oppositional spirit. They "are unhappy with the phrase [avant-garde] and deprecate its connotations of bohemia, revolution, shock-for-shock's-sake; they infer an action that is beside the point, old-fashioned, absurd." What mattered, Hess continued, was an "expression [that] has something to do with self; the individual contribution has value in its uniqueness."[32] Hess may have been too close to fast-moving developments to see that the old sense of revelation through opposition was now only sunk deeper into the artistic imagination.

Wolf Kahn, Portrait of Thomas Hess, 1955. Oil on canvas, 42 × 35 in.

"Today," Hess said, "almost all painters are content to communicate with their own small but expanding universe."[33] The swaggering self-assurance that artists brought to their work signaled both the rejection of any kind of world-historical drama and a new phase in that drama. In a notebook entry that dates from around 1960, Fritz Bultman complained about the tyranny of art history, "with its debris of

disappointed Marxism, that orders the sequence of isms." And yet Bultman also observed that "painting deals with paradox . . . paradox that is the time of Both—or rather all at once—compounded of denials and affirmations, of opposites."[34] This certainly sounded like dialectical thinking. The intellectual and artistic thought of the postwar years suggested a scrambled dialectic, at once wry, ironic, self-dramatizing, playfully rhetorical, attracted to the weirdly enigmatic and the abruptly mystical.[35] The young critic Anatole Broyard criticized this almost nihilistic spirit in a famous essay, "A Portrait of the Hipster," published in 1948 in *Partisan Review*. Broyard's prey were the ultra-cool musicians, the creators of cutting-edge jazz, but what Broyard described as the hipster's dialectical critique—which he believed had destroyed the integrity of the older American jazz—was not all that different from a taste for the slashing critical gesture that you sometimes found among the New York artists, who were in any event often immersed in jazz. "Using his *shrewd* Socratic method," Broyard explained, the hipster "discovered the world to the naïve, who still tilted with the windmills of one-level meaning. That which you heard in bebop was always *something else, not* the thing you expected; it was always negatively derived, abstraction *from,* not *to.*"[36]

In the 1950s and early 1960s, the dialectic survived as a contrarian impulse, and while Broyard was not wrong to warn of certain dangers, the artists who knew how to march off in their own gloriously independent directions gained strength by internalizing an oppositional spirit, by making of the dialectical gesture a psychological credo. Certainly this was true of de Kooning. After painting figures in the 1940s, he focused on abstractions in his first one-man show and then embarked on a series of studies of the female figure. Later he moved back into abstraction, at least for a time. If nobody could rival de Kooning's high-profile shifts between abstraction and representation, there were nevertheless many artists who believed that their truest artistic inclinations involved presenting a counter-statement, a riposte to the art-world status quo. When Fairfield Porter, who had taken a great interest in Marxism in his younger years, complained in a letter to *Partisan Review* that Clement Greenberg "seems to think that the artist today must give up the figure" because "the figure has been done and nothing new remains," Porter's response was to insist that he would go his own way and stick with his landscapes and still lifes and portraits and interiors.[37] And surely only an artist who had absorbed the dialectical spirit of New York could grasp the unity beneath the variety of this new city of art where abstraction and representation and painterly forms and hard-edged forms were all turning out to be branches of a single tree.

V

Wallace Stevens, who gave a famous lecture titled "Relations Between Poetry and Painting" at the Museum of Modern Art in 1951, offered a richly paradoxical view of dialectical experience in "Connoisseur of Chaos," a poem published in *Parts of a World* in 1942. The theme of the poem had an immediate appeal to the postwar generation, for as the poet Robert Creeley, who was friends with Guston and de Kooning and many of the other artists, has explained, "Coming of age in the forties, in the chaos of the Second World War, one felt the kinds of coherence that might have been fact of other time and place were no longer possible."[38] Creeley, in writing about the experiences of artists and writers in the 1950s, actually cited a poem by William Carlos Williams in which the theme, the word choice, and the construction were quite similar to that of Stevens's "Connoisseur of Chaos." This poem was "Descent," in which Williams explained,

> From disorder (a chaos)
> order grows
> —grows fruitful.
> The chaos feeds it.[39]

Creeley may have been more immediately attracted to the work of Williams than to the work of Stevens, and yet there was no question that Stevens was a poet who interested artists, in no small measure because he had always responded so deeply to the visual arts. He had seen the Armory Show in 1913; he had been a frequent visitor to the home of Walter Arensberg, one of the early, great American collectors of Cubist paintings; and it seems fairly certain that one of Stevens's most famous poems, "The Man with the Blue Guitar," completed in 1937, had been precipitated at least in part by his having seen Picasso's *Old Guitarist* in 1934, at the first Picasso retrospective to be held in the United States, at the Wadsworth Atheneum in Hartford, where Stevens lived. Some of Stevens's notebook entries had been published in *View* in the early 1940s, and they surely revealed a taste for oppositions. "X: The romantic cannot be seen through; it is for the moment willingly not seen through." "XVI: The real is only the base. But it is the base."[40] Stevens's Museum of Modern Art lecture, in which he spoke about poetry and painting "as sources of our present conception of reality," was much discussed by New York

artists.[41] Many, many painters felt the impact of Stevens's poetry. The painter Jack Tworkov always spoke of how important it had been to hear Stevens at Black Mountain College; and Fairfield Porter was devoted to Stevens's writings and, years later, included his copy of *Opus Posthumous* among the elements in a still-life painting.

Stevens's "Connoisseur of Chaos" began with what might be called a triple synthesis.

> A. A violent order is disorder; and
> B. A great disorder is an order. These
> Two things are one. (Pages of illustrations.)

Stevens was more than a bit ironic about this idea that everything could merge into everything else; it was an idea with the rigid appeal of something in a textbook, something that "we cannot go back to," since, as Stevens explained, "The squirming facts exceed the squamous mind." Stevens could not accept the idea that the conflict between order and disorder could be so neatly resolved; he was not living in a time when people could believe in some classical idea into which everything could be merged. "Now," Stevens announced,

> . . . A
> And B are not like statuary, posed
> For a vista in the Louvre. They are things chalked
> On the sidewalk so that the pensive man may see.[42]

For readers who are familiar with the memories that Edwin Denby and Rudy Burckhardt have published about their friendship with de Kooning in the New York of the 1930s, this sentence about the "things chalked/On the sidewalk" has a startling, déjà vu kind of ring. For Denby would indeed later write about how he remembered "walking at night in Chelsea with Bill during the depression, and his pointing out to me on the pavement the dispersed compositions—spots and cracks and bits of wrappers and reflections of neon-light—neon-signs were few then—and I remember the scale in the compositions was too big for me to see it."[43] I am not suggesting that there was in fact any connection between Stevens's sidewalk and the ones that de Kooning and Denby and Burckhardt knew so well, and yet there was a shared sense of the quotidian as defying any pattern that a person might imagine. History, composition, and the interlocking forces of order and disorder were not something

clear, like "a vista in the Louvre," but something to be gathered casually, on the sly, through the provisional arrangements that artists and writers encountered in the world around them. That "vista in the Louvre" was the art of the Old World; the sidewalk was where the art of the New World began. De Kooning and his friends could see that a great city was an open-ended demonstration of the paradoxical nature of the modern dialectic. And the power of a capital of art had to do with the extent to which artists who were working in a particular time and place found themselves refracting, scrambling, recomposing the elements of the past. Dialecticalism became, willy-nilly, a form of improvisation.

In 1959, when Harold Rosenberg published his first essay collection, *The Tradition of the New,* de Kooning designed the dust jacket, which presented the clearest imaginable illustration of the process by which the art of the present involved a scrambling of all the elements that made up the art of the past. This striking cover, with white calligraphic lettering on a black ground and Rosenberg's name in a red sans-serif typeface, was a primer of the new—New York—view of the past. In the top half of the dust jacket, de Kooning wrote the title of the book in his inimitable calligraphic hand, with jagged, loopy letters. In the bottom half of the cover, with Rosenberg's name acting as a dividing line, many of the letters of the title reappeared, only now liberated from their old roles. Thinking of the paintings in which de Kooning incorporated letters, Hess wrote, "The letter, freed from any duties, is a shape that is perfectly familiar and perfectly new."[44] But of course here the letters were not exactly free. De Kooning still began, at the upper left, with a *T,* but after that came an *a.* Just a little way below this was a *d;* the jumps and elisions had a jazz-riff quality. *OF* drifted off to the right; the *N* of *New,* which in the upper half was backward (not yet new?), was now right-way and autonomous, center stage down below, with de Kooning's signature next to it. A *W* did a little

Willem de Kooning, dust jacket for Harold
Rosenberg's The Tradition of the New, *1959.*

vanishing act off the bottom edge. The dust jacket was thesis and antithesis. With the synthesis to come. Or perhaps the point was that the antithesis was also the synthesis, and that all the dialecticians had in fact turned into connoisseurs of chaos. In any event, I believe that what happened in New York between the end of the 1940s and the early years of the 1960s was not unlike the process that de Kooning presented on this dust jacket. The old languages—all the themes and obsessions and passions that had dominated European art in the late nineteenth and early twentieth centuries—were reshaped in New York. Old ways of feeling met new ways of feeling, and they turned out to be both more like and more unlike than anybody had imagined.

3. THE PHILOSOPHER KING

I

By the 1950s, New York's avant-garde had its own history, going back many decades, and no figure with whom you could rub shoulders in Manhattan had lived that history as fully as Willem de Kooning. De Kooning had arrived in the United States at the age of twenty-two in 1926, a stowaway without a visa, and in its own way his conquest of Manhattan had been as dramatic as Peter Minuit's twenty-four-dollar real estate deal of 1626. Robert Creeley, in a memoir written in the 1970s, called him "Bill the King"—which is, of course, what *Koning* means. He was, to many of the younger generation of the 1950s, a spellbinding kind of being. Downtown he ruled, with the power of his brushstrokes softened by his smiling, genial presence, heated up by his movie-star looks and drinking sprees, and then complicated by a conversational style that was at once quixotic and Socratic.

One day in the 1950s, Creeley was given the responsibility of taking care of

the drunken de Kooning. He has written about how, while he was watching over the sleeping giant and tried to move de Kooning's leg, which was hanging off the bed, onto the bed, he happened to look "up at his face—to find that he'd been watching me all the time, with a lovely, wry smile." Those smiles of de Kooning's bewitched an entire generation, or at least a good part of a generation. "To see Bill on the

Rudy Burckhardt, photograph of Willem de Kooning, 1950.

street," Rauschenberg recalled, "was to witness a vision whose aura eclipsed even his own shadow." De Kooning's remarks, by turns oracular and elliptical, are peppered through the recollections of the 1950s. And his thick accent only added an extra layer of beguiling ambiguity. "What you do when you paint," Burckhardt recalled him saying, "you take a brush full of paint, get paint on the picture, and you have fate." "That," Burckhardt explains, "is 'faith,' as pronounced with a Dutch accent."[1]

There were many people who believed that whatever words came out of de Kooning's mouth had a magical power; they patched together an aesthetic from his off-the-cuff observations. "I was in the Cedar Tavern last night," Kenneth Koch wrote in a letter to Frank O'Hara. The legendary Cedar, at University Place and Eighth Street; a plain-as-plain-can-be place, just a bar and some tables and booths, no decoration to speak of, murky and crowded, with people spilling out onto the street in the evenings. "And," Koch's letter goes on, "Bill de Kooning was there, so I asked him if he'd seen your poem about his picture." Koch was referring to O'Hara's "Radio," which contains the lines

> Well, I have my beautiful de Kooning
> to aspire to. I think it has an orange
> bed in it.

Koch continued, "He said, 'Yeah . . . but how can I be sure it's about my picture, is it just about a picture?' I quoted him, 'I have my beautiful de Kooning / to aspire to. I think it has an orange / bed in it.' " We may wonder how, if de Kooning had in fact read the poem, he had missed the mention of his own name; but, anyway, de Kooning was not one to disappoint younger poets and painters who were hanging on his every word, and even if he hadn't read the poem, he was glad to discuss it. Koch continued to explain that according to de Kooning the bed was " 'a couch. But then it really is my picture, that's wonderful.' Then he told me how he had always been interested in mattresses because they were pulled together at certain points and puffed out at others, 'like the earth.' "[2] So here, from the horse's mouth, was another small insight into de Kooning's art.

There was a throwaway charm to many of de Kooning's observations, but also a kind of staying power, a force. Some of his stories were still being repeated in New York a half century after he first told them. There is, for example, de Kooning's description of watching a drunken man crossing a

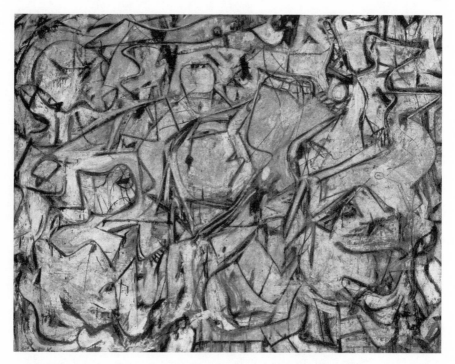

Willem de Kooning, Attic, *1949. Oil, enamel, and newspaper transfer on canvas, 61⅞ × 81 in.*

street, weaving this way and that way; the point of the anecdote, of course, is that that haywire path is de Kooning's line, de Kooning's space.[3] In a number of prepared statements that he made around mid-century—"A Desperate View" and "The Renaissance and Order," presented at artists' meetings downtown in 1949 and 1950, and "What Abstract Art Means to Me," written for the Museum of Modern Art in 1951—the throwaway charm of his anecdotes was tossed high into the air, juggled, spun around. In these brief lectures, huge ideas about history, style, and creativity were alluded to; a line of thinking was suggested; and then the idea was as casually turned on its head or swept aside. Reading these lectures is very much like looking at the black-and-white abstractions with which de Kooning established his reputation at the end of the 1940s. In canvases such as *Attic* and *Mailbox,* the turning-in-on-themselves strokes of paint generate a heightened mood, anxious yet somehow comic, and possibilities appear that only seem to point to impossibilities. The curving or angling lines, often drawn in black paint and sometimes ending in bits of dripped paint that are like exclamation points, take uncertain paths, as if the strokes are musing on their own destinies. And in the more complicated paintings, these lines pile up, subvert one

another, like crisscrossing thoughts filling a person's mind. One is left with a sense of hard-won paradoxes and enigmatic vistas.

De Kooning's statements are exceedingly difficult to understand. As in his paintings, we glimpse surfaces, depths, levels, layers, but each perspective is cut off or at least obstructed by another one. De Kooning himself observed, "It is impossible for me ever to come to the point." His published remarks have such an unprepared sound that you may be tempted to accept the pithy bits and assume that there is no overarching trajectory, no clear direction. They are maddening statements to try to disentangle, because at one moment he seems to be raising a question in all seriousness, and the next moment he seems to want seriousness itself to be slippery and suspect. The statements have a parodistic element. De Kooning is grand, but he is also making fun of grandeur, the way he does in the paintings of women that he was working on in the early 1950s and would show in 1953. He floats a thought and then improvises. "In art," he says, "one idea is as good as another." That is an idea, and he immediately proceeds to see where he can take it. "If one takes the idea of trembling, for instance, all of a sudden most of art starts to tremble." He runs through Michelangelo, El Greco, the Impressionists; and then the Egyptians, it turns out, "are trembling invisibly and so do Vermeer and Giacometti," while Raphael is "languid" and Cézanne is "trembling but very precisely."[4]

De Kooning is riffing on the history of art. There is a stream-of-consciousness pull to his remarks. The statements are surely more confusing now than they were when they were originally presented, because we no longer have so immediate a sense of the themes that de Kooning is playing with. In the 1950s, de Kooning's casually oracular pronouncements were revered because his listeners could see that he was juggling all the ideas that were in the air—and if a couple of them smashed to smithereens, all the better. I imagine that de Kooning's audience, hearing the word *trembling*, would have immediately thought of Kierkegaard's *Fear and Trembling*. When he spoke of Michelangelo and El Greco and trembling, his listeners probably recognized that he was referring to an expressionist tradition in Western art, which art historians had been emphasizing since the beginning of the century. They would have recalled the trembling trees in the paintings of van Gogh and Soutine, and the trembling brushstrokes in the very late Cézannes. (A study by Max Dvorak, "El Greco and Mannerism," in which he discussed El Greco and his relationship with Michelangelo, was published in January 1953 in the *Magazine of Art*, where the editor, Robert Goldwater, also published Louis Finkelstein's article on de Kooning.) Something else that could have come to mind

was a watercolor by Paul Klee, *The Twittering Machine,* which had been acquired by the Museum of Modern Art in 1939. Klee's twittering mechanical birds might have been regarded as a joke on the theme of trembling. In a sense, de Kooning was telling his audience, "We know all this history—know it well enough that we can kid around with it," and that was exciting, liberating. While de Kooning held true to an old Netherlandish idea that art ought to be democratic, anti-idealistic, and progressive, he found an American anarchism buried inside the Dutch empiricism and developed ideas—and paintings— that in their unsettling combination of violence and elegance have come to be regarded by many people as a veritable definition of what is American in American art.

II

The artists of New York, a city that had started life as New Amsterdam, looked to de Kooning as a founding father. He was not, however, the only Dutch painter who had stood tall in Manhattan and been regarded by his con- temporaries as a herald of everything that was advanced in art. In 1950 only six years had passed since Piet Mondrian had died in New York, after spend- ing the last four years of his life in the city, first with a studio at 353 East Fifty- sixth Street and then at 15 East Fifty-ninth Street. Mondrian gave the city its greatest self-portrait in paint, *Broadway Boogie Woogie,* which was exhibited in a memorial show at the Museum of Modern Art. The years Mondrian lived in New York were in many respects the happiest of his life. He had an impor- tant one-man show at the Valentine Gallery in 1942; there was interest in his work at the Museum of Modern Art; and younger artists, especially Harry Holtzman, who had sponsored Mondrian in America, were eager to hear what he had to say and help him publish his writings in the United States.

In 1940, when Mondrian arrived in New York, de Kooning was still an unknown artist. A decade later, de Kooning was among the first small group of American avant-garde artists who were having what promised to be a large international success. And pretty soon, de Kooning would be offering New York, in *Gotham News* and a number of other canvases, a portrait of the city that artists might set next to *Broadway Boogie Woogie.* You could say that between 1940 and 1950, many New Yorkers made their decision as to which of these artists who hailed from old Amsterdam or thereabouts was going to set the pace in New Amsterdam. An artist could not help but wonder who was the true heir of Rembrandt and van Gogh. Was it Mondrian or de Kooning? Of

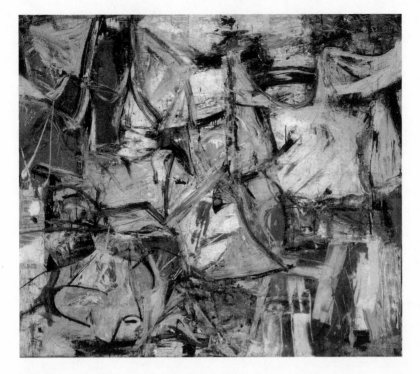

Willem de Kooning,
Gotham News,
1955. Oil, enamel,
charcoal, and
newspaper transfer
on canvas,
69 × 79 in.

course you did not necessarily have to choose. But for some artists it proved impossible to entertain both possibilities, at least simultaneously. There can be no question that by 1955 it was not unusual to hear New York painters expressing some sort of sympathy with de Kooning, who had criticized Mondrian and Theo van Doesburg, one of the artists who banded together with Mondrian in the movement called de Stijl, for "try[ing] to force a style."⁵ *Broadway Boogie Woogie,* with its intricate mosaic of red, yellow, and blue rectangles creating a whirling, pulsating universe, is one of the towering achievements of twentieth-century art, but for many artists it was the rough-hewn surface of an infinitely less important painting, *Gotham News,* that defined the mid-century moment.

In *Gotham News,* which was painted in 1955, just over a decade after *Broadway Boogie Woogie,* the impress of newspaper, which de Kooning had used to keep layers of paint wet over a period of days, becomes part of the finished work, part of the swerving, jerking rhythm of the composition. In this nearly six-foot-high canvas, the bloody reds and dirty yellows and unnatural greens seem to be ripped right out of the urban streetscape; they are the saturated, off-putting hues of the color photography that was just beginning to appear everywhere in those years. The painting, for all its exuberantly handmade

messiness, alludes to a mass-produced world—through the impress of newsprint, with its regular typography; through the astringency of the colors, which have the shrillness of the aniline dyes in late-period Japanese prints. You feel that de Kooning is in the thick of things. He has created the dance but he is also the dancer. Mondrian is all choreographer, watching the boogie-woogie from a place at the side or above. The apparent detachment of this elder statesman of modern art disturbed some New Yorkers. And to understand what it was that so many New York artists were eager to embrace in de Kooning, one must also understand what made them back away from Mondrian.

Well before Mondrian came to New York, when he lived in Paris, he had found that his nonobjective idealism was in danger of being eclipsed by the lushly metaphoric visions of Picasso, Matisse, and the Surrealists. And New York artists were generally inclined to go along with Paris's preference for the juicier, more libidinous and impulsive side of modern art. Mondrian's Neoplastic vision had a philosophical assurance that fascinated American painters, and also, perhaps, made many of them uneasy. His idea that the dialectical pressure of visual elements was pushing art toward a particular kind of synthesis—toward a single, essential, abstract idea—could strike New Yorkers as something stern and grand, not unlike the Marxist vision of a proletarian utopia. In Mondrian's philosophy of art, specific feelings—the tears in the eyes of the Virgin Mary, for example—gave way to the feeling of the composition, to an emotion that was subsumed in the very architecture of the composition. And what Mondrian believed was a distillation of emo-

tion struck some New York artists as a flight from emotion. True, New York was home to a number of very impressive Neoplastic painters. Among the extraordinary artists who developed their own variations on Mondrian's strict verticals and horizontals and primary colors were Burgoyne Diller and Ilya Bolotowsky, who had started out in the 1930s and would be receiving increasing attention in the 1960s. These artists tended to shy away from the grandly social implications of Mondrian's ideas. You might say

Piet Mondrian, Composition (No. IV) Blue-White, *1935.*
Oil on canvas, 39 × 31⅝ in.

that Mondrian's most ardent American admirers were liberal idealists; this was surely true of Diller, who'd seen his first Mondrian in the mid-1930s, around the time he was studying with Hofmann, and who was probably as sophisticated a Mondrianist as there was in the world in 1940.

If Mondrian was almost universally admired by the artists of New York as a man who had managed to turn the look of painting inside out, to many of them he felt like a hero who was already slipping into history. He had, in the principles of his Neoplastic style, defined an extreme, and certain artists were beginning to believe that Mondrian's radical statements had a built-in obsolescence. Speaking at Mount Holyoke College in 1944, Robert Motherwell observed, "History has its own ironies. It is now Mondrian, who dealt with the 'eternal,' who dates the most." On the occasion of the memorial exhibition for Mondrian at the Museum of Modern Art in 1945, Greenberg, writing in *The Nation,* did assert that "Mondrian was one of the greatest painters of our time," but even this comment somehow lacked warmth. The paintings, Greenberg wrote, "are an attempt to create conditions of existence and stabilize life itself." And the carefully chosen word "attempt" suggested what had not been achieved. "Acquaintance with Mondrian's theories," Greenberg continued, "may expand one's idea but will hardly deepen one's experience of his work. They are real feats of speculative imagination but seem to have been more a rationalization of his practice than a spur to it. Theories were perhaps felt necessary to justify such revolutionary innovations. But Mondrian committed the unforgivable error of asserting that one mode of art, that of pure, abstract relations, would be absolutely superior to all others in the future."[6]

As the postwar period moved into high gear in the early 1950s, the Constructivist tradition of which Mondrian was so essential a part, with its long list of don'ts—don't abstract from reality, don't use modeled form, don't show off your virtuosity—struck many New Yorkers as constricting, academic. The American abstractionists wanted to match Paris at its own wildly hedonistic game. Mondrian's insistence that all form could be subsumed in his right angles and primary colors riled New Yorkers; the argument could seem too tightly circumscribed, too programmatic. Even artists who admired Mondrian's ideas were astonished by the purity of his optimism. Myron Stout, who had studied with Hofmann in the 1940s and who by 1950 was painting spare, abstract compositions based on latticework or grid patterns, commented on Mondrian's essay "Home-Street-City" in his journal. "Mondrian's 'universal' concept is an amazing thing. He is obsessed by oneness, and his ability to con-

Myron Stout, Untitled, 1950.
Oil on canvas board, 18 × 14 in.

ceive in terms of oneness, wholeness and no disparity of parts should be a model to all who have trouble rising above the immediate and particular." The immediate and particular were of course what de Kooning was all about, and Stout understood Mondrian's work well enough to see that the immediate and particular had a place there, too. "In spite of the rarefaction of the realm which he thus inhabited," Stout wrote of Mondrian, "he never lost the feeling of his anchor in the process by which he came to his universal concept—the tangible and sensational world was still the raw material for the universality which he would create for himself." Yet there were many artists who were unwilling to credit Mondrian with being "anchor[ed] in the process," with caring about "the tangible and sensational world." When Fairfield Porter remarked in 1960 that "Mondrian seems to deny sensibility, but really what he lacked was quickness of intuition, a quality close to trust," his announcement sounded rather close to Greenberg's, and that was quite surprising, considering that there was very little on which these two men agreed.[7] Porter, as he made clear a few sentences earlier in his essay, preferred another Dutchman's way—de Kooning's.

For the time being in the 1950s, Mondrian's art of the 1930s was, like the politics of the 1930s, something that many people felt they had outgrown. Artists had an idea about doing their own thing; they didn't want to feel boxed in by Mondrian's rectangles, no matter how beautifully arranged they might be. His idealism did not jibe with a new sense of the world. In the essay "Home-Street-City" that Stout had written about, Mondrian presented a dream of the city that was in almost all respects the opposite of the place where de Kooning and Denby and Burckhardt had felt so at home, beginning in the 1930s. In Mondrian's utopian city, interior and exterior were going to be united in a visionary synthesis of art and architecture; Mondrian's city was a city of the imagination, a dream-perfect community. De Kooning's nitty-gritty New York was all knock-you-in-your-teeth actualities, all surprising particulars: the dramatically contrasted sizes of adjacent buildings, the abandoned lots and demolition sites, the oil stains and graffiti on the pavements, the reflections of neon signs on wet streets.

III

But if in the 1950s Mondrian was history—and an increasingly dim, art-museum history at that—the life that de Kooning had been living back in the 1930s and 1940s was no easier to understand. What it had been like to be a painter who received little attention in New York before World War II was hard to comprehend in the 1950s, and de Kooning was not sorry, at least so far as his very earliest years in New York were concerned, to leave things somewhat vague. In one of the first accounts of his life, written by Rudi Blesh and Harriet Janis in 1960, the authors explained that "virtually nothing is known of de Kooning's work during the nine years he spent in America prior to 1935. He himself recalls only a time of struggle to earn a living at peripheral pursuits such as house painting and executing decorative murals."[8]

So far as anybody knew or cared in the 1950s, the working lives of the Abstract Expressionists had begun in the mid-1930s, when many of them were involved with the Works Progress Administration, or on a separate mural project that was directed in New York by none other than Diller. While the weekly paychecks—$23.50—were small, it was miraculous to be paid to do what you wanted to do, even if the WPA did play a sort of supervisory role that artists could find uncomfortable.[9] As for the various mural projects, they gave artists, among them de Kooning, Gorky, and Bolotowsky, the opportunity to work on what were among the first abstract murals done in the United States. The WPA also, perhaps, gave artists a sense that they were no longer working in such complete isolation, and although it was surely easy to romanticize the cama-

Willem de Kooning, study for mural in the Hall of Pharmacy, New York World's Fair, 1939.

raderie that the various projects inspired, it was probably the case that the sense of community that impressed younger artists in the 1950s had its origins two decades earlier. Still, when Denby eventually set down his memories of those years in two essays, one published in the late 1950s, the other in the early 1960s, his tone was laconic and restrained. Writing in 1957, for the catalog of a show at the Poindexter Gallery called "The '30s: Painting in New York," which was an attempt to teach the new avant-garde a thing or two about the old avant-garde, Denby gave a picture of a marginal life, animated by talk, mostly it seems about a few European artists, especially Picasso, which went on in the cold-water flats, over late-night cups of coffee at Stewart's cafeteria, and during the long walks through the city. Denby's voice only rose when he compared life in the 1930s with the current scene. He could not quite get over the shift from those years when nobody even had a hope of exhibiting to the Manhattan of the late 1950s, with miles of galleries that were "as luxurious to wander through as a slave market."[10]

Denby related—in his famous pared-down style, with each image presented in a stark, chiseled form—how he and Burckhardt, the photographer he shared a loft with, met de Kooning "on the fire escape, because a black kitten lost in the rain cried at my fire door, and after the rain it turned out to be his kitten." De Kooning struck Denby as "a young man cheerfully in earnest," and in the 1950s he remembered "walking at night in Chelsea with Bill," and looking so closely at those sidewalks that, as we have already observed, in some respects resemble the sidewalk in Stevens's "Connoisseur of Chaos." Denby also wrote poetry about those sidewalks, at one point describing

> The sidewalk cracks, gumspots, the water, the bits of refuse,
> They reach out and bloom under arclight, neonlight— . . .
>
> These pictures, sat on by the cats that watch the slums,
> Are a bouquet luck has dropped here suitable to mortals.

"At the time," Denby continued, "Rudy Burckhardt was taking photographs of New York that keep open the moment its transient buildings spread their unknown and unequalled harmonies of scale. . . . We all talked a great deal about the scale in New York, and about the difference of instinctive scale in signs, painted color, clothes, gestures, everyday expressions between Europe and America. We were happy to be in a city the beauty of which was unknown, uncozy, and not small scale."[11]

In a memoir published in 1989, Burckhardt recalled those same years and evoked a less confident de Kooning—and that has to have been a surprise to those who had first met him in the 1950s, when he was everybody's golden boy. Burckhardt remembered Bill living alone, and how "he complained how when a girl stayed over he'd have to take her home on the subway at two or three in the morning, there'd be ashtrays full of cigarette butts with lipstick on them in the studio, and the next day's work would be ruined. 'Maybe things would be simpler if I turned queer,' he said to

Willem de Kooning and Arshile Gorky in Gorky's studio, circa 1935.

Edwin"—who was. But of course Burckhardt also remembered all the talk between de Kooning and Edwin Denby, talk of "painting, art-for-art's sake, Picasso (who was the guy to beat), the Spanish Civil War, Marxism."[12] In his own memoir, Denby wrote of de Kooning's great friendship with Gorky: "I knew they talked together about painting more than anyone else. But when other people were at Bill's, Gorky said so little that he was often forgotten." Once, at a party, talk turned to the situation of the American painter—"the bitterness and unfairness of his poverty and disregard. People had a great deal to say on the subject, and they said it, but the talk ended in a gloomy silence. In the pause, Gorky's deep voice came from under a table. 'Nineteen miserable years have I lived in America.' Everybody burst out laughing. There was no whine left."[13]

Denby's recollections of 1930s New York brought home to the artists of the 1950s and 1960s how much had changed, yet the astringency of these recollections, with their shades of brown and gray, offered only a partial picture. There was a kind of dry cunning to Denby's memories. He gave the artistic life of the 1930s an emptied-out quality, and this made the emergence of Gorky and de Kooning and a few other artists all the more amazing. They arrived out of nowhere, with a deus-ex-machina kind of drama. Denby gave a sense of the endless conversations and of de Kooning's attentiveness, yet he gave no sense of the surprisingly wide opportunities that New York afforded to see important works of art, new and old, or of the complex historical sense

that de Kooning and Gorky and David Smith were already developing in those faraway years. America had a good many art collectors, some fairly ambitious, and a number of adventuresome galleries, and the Depression had not entirely altered the situation. There was much to see. The Museum of Modern Art, which had been founded in 1929, kept up a hectic exhibition schedule. Indeed, a study by de Kooning for a WPA mural project was among the works on exhibit there in "New Horizons in American Art," in 1936. And already in 1927, two years before the Modern had opened its doors, the collector Albert Gallatin had inaugurated his Gallery of Living Art at New York University, which by 1930 contained important works by Picasso, Braque, Klee, and others.

In the 1930s, New York offered opportunities to see an impressively heterogeneous range of works of art. The Marie Harriman Gallery had a major show of work by Le Douanier Rousseau in 1931. The Knoedler Gallery had an exhibition of paintings from the collection of the great dealer Ambroise Vollard in 1933. This included choice works by artists that Vollard had championed, such as Degas and Cézanne; the formidable Cézanne *Bathers,* which Albert Barnes had already bought for his foundation in Merion, Pennsylvania, was here. The Knoedler exhibit also gave gallerygoers an opportunity to examine the edition of Balzac's "The Unknown Masterpiece" that Vollard had published, with illustrations by Picasso, a book that was going to mean much to New York artists a decade later. The impact of Bonnard on the Abstract Expressionists is often related to his retrospective at the Museum of Modern Art in 1948, but fourteen years earlier, in 1934, Wildenstein Galleries had already held a show of forty-four paintings. De Kooning was a long way from the "Impressionist" color that he would experiment with in the mid-1950s. He and his friends might not have yet known what to make of the extraordinary painting of a woman in a bathroom completed in 1933 and at the time called *The Toilet,* with its gloriously high-keyed meltdown of colors, its dark little dog, and its tiny clock set at five. But the thought that there were still things that might be done with this coloristic heritage had been planted in their minds. In 1936 there was "Modern French Tapestries," including recent works by Picasso, Matisse, Braque, and Léger, at the Bignou Gallery. And the exhibitions were by no means all of nineteenth- and twentieth-century art. In 1937, a huge exhibition of German art came to the Brooklyn Museum, which included drawings by Dürer, Grünewald, and Albrecht Altdorfer, and paintings by Hans Baldung, Lucas Cranach, Martin Schongauer, and Konrad Witz.

IV

One of de Kooning's friends then, and a catalytic force in his life as well as in the lives of Gorky and Smith and Stuart Davis and other artists, was the painter, collector, and writer John Graham—a man who was striking in appearance, with broad, high Tartar cheekbones and penetrating, elongated, oval eyes. Graham, who was born in Warsaw in 1886, was a singular figure in the American avant-garde—a veritable tornado of ideas about art, past and present. To understand John Graham is to understand a good deal about the way that mid-century New Yorkers regarded the history of art, and it hardly mattered that by 1950 Graham was an increasingly shadowy figure who had by his own testimony turned his back on the very idea of modern art.

Graham's sense of the history of art was grandiose but also chaotic. He aimed to grasp the shape of the art of the future by means of a feverish engagement not only with the art of the present but also with all the highways and byways of the art of the past. Graham knew Paris as well as he knew New York, and was at one time or another passionately interested in everything from African sculpture to Renaissance bronzes. He responded quickly to innovative, barely resolved new art, which it has to be said is rather unusual in a man who also had a connoisseur's eye for classical perfection. He was a painter, he was a writer, he bought and sold works of art, he advised collectors, he organized exhibitions. When, in 1957, Greenberg wrote an essay about New York in the 1930s for *Art News*, he listed Graham— along with Gorky, de Kooning, and Hofmann—as one of the figures who "dominated" this underground scene. "Graham I did not even know by sight," Greenberg explained, "and only met in the middle forties after he had renounced (so he said) modernism, but I was aware of him as an important presence, both as a painter and connoisseur."[14] At times, Graham did preach purity. He may have been

John Graham, 1930s.

John Graham, Aurea Mediocritas, *1952.*
Oil on canvas, 24¼ × 20 in.

the first person to use the term *minimalism,*
way back in the 1930s, when he was doing
some dramatically reduced abstract paint-
ings. But his mind worked in labyrinthine
ways, and his taste could be as eclectic as
it was aristocratic and ascetic. The idealized
portraits of women that are his finest works
—they date from the 1940s and 1950s—
gave Renaissance elegance a neurotic mod-
ern pulse. When de Kooning was getting to
know Graham, the older man was preparing
his strange manifesto, *System and Dialectics
of Art,* a mad alchemist's anti-theory of art
history, published in 1937.

Graham was a mythomaniac of the first
order, and he was determined to keep the
people who knew him in the United States
after he arrived at the beginning of the 1920s
in a state of uncertainty about his past. He had grown up in Kiev. His father
was a lawyer. The family was apparently Polish nobility on his father's
side and German nobility on his mother's. Graham was a commissioned
officer in the Russian army in 1915, and after 1917 seems to have been in-
volved in anti-Bolshevik action. By 1922, when he was in New York and
had signed up at the Art Students League, he had left behind the name he
was born with, Ivan Gratianovitch Dombrowski, as well as two wives and
three children; in the United States he married two more times and had
another child. By the late 1920s, his landscapes and figures, in a pared-down,
semiabstract style, were being purchased by the Cone sisters in Baltimore,
who were among Matisse's greatest collectors, and by Duncan Phillips,
who gave Graham a one-man show at the Phillips Collection in Washington,
D.C., in 1929, the year when a monograph on his work, written by the well-
known French art critic Waldemar George, was published in Paris. He was
represented in the Whitney Museum's "First Biennial Exhibition of Contem-
porary American Painting" in 1932, with an abstraction in which curved and
angled forms are caught in a sort of shadow play as they compete for our
attention.

How Graham made all the contacts that he did appears to be a mystery
even to close students of his career, yet there can be no doubt that he was

astonishingly well connected in the late 1920s and
1930s, both in New York and in Paris. Dorothy
Dehner, the sculptor who was married to Smith in
the 1930s, recalled that Graham "had an amazing
capacity for fitting himself into what must have
been an environment totally alien to the life he had
led in Russia."[15] And he was pretty much immune to
the financial disasters of the time, as he was acting as
an agent for Frank Crowninshield, publisher of
Vanity Fair, building for him a collection of African
art. De Kooning had apparently introduced himself
to Graham at an opening the artist had in 1929. And
after that, in the 1930s, Graham became a magnet
for young American artists, among them Gorky,
Smith, Davis, and Pollock. He gave them the kind
of firsthand reports from Paris that they hungered
for, reports that gained force from his claims that
he was actually having conversations with Picasso
and Matisse. Graham appeared to know everything
there was to know about Parisian art and its history.

John Graham, Painting, *1932.
From the catalog of the Whitney's "First
Biennial Exhibition of Contemporary
American Painting," 1932.*

He was an expert on primitive art, but he was also attuned to the Neoclassical
preoccupations of postwar Paris (George, who wrote the monograph on Gra-
ham, was editor of *Formes,* an important if sometimes somewhat stodgy mag-
azine that supported classical values in 1930s Paris). When Smith and Dehner
went to Paris, Graham met them at the station, ran them around the city, and
introduced them to artists and galleries; the experience, Dehner recalled years
later, was overwhelming. "He recited bits of history and art history," she
wrote; "he pointed out monuments, cathedrals, museums, bridges, bookstalls,
the Opera, and everything else; that same day he took us to four exhibitions of
African art and introduced us to the dealers." The man was a wonder. "He
delighted," Dehner recalled, "in bringing people together who he thought
might enjoy one another."[16] And he promoted their careers. The "Exhibition
of French and American Painters" that Graham organized at the McMillen
Gallery in New York in 1942 was an unprecedented event in which the
unknown Pollock and de Kooning were exhibited side by side with Picasso
and Braque.

It was during the years when John Graham was seeing de Kooning and
Smith that he was in the thick of writing and publishing *System and Dialectics*

of Art, which was like some mad, caffeinated all-night bull session about the meaning of art—exactly the kind of session that Graham must have had with de Kooning and Smith and maybe Denby.[17] Here Graham stated that "America as the most modern country in the world would logically require the most modern art." This felt like a rallying cry to some of his New York friends. "So far," Graham went on, America "does not realize that need. The art practiced now in America is of the French Impressionist tendencies of fifty years ago." But Graham was opening the door, suggesting the possibilities. *System and Dialectics of Art* was organized in the form of 129 questions and answers, beginning with "What is art?" and offering capsule definitions of every style and period, and ending with a vast "Table of Comparative History of Art." The book took the form of a grandiose catechism on the history and philosophy of art. Graham asked the big questions: "What is the Language of Form?" And he gave big answers. It is "a definite language of great eloquence which is open to those who have eyes and to those who can read." Not surprisingly, for a man who wanted to believe that he came from nowhere, the book was short on specifics and quoted hardly any other thinkers on art. There was, however, a list of sources consulted at the end, which included, in alphabetical order, everybody from Clive Bell and André Breton to Freud, Roger Fry, Ingres, Kant, Jung, and Vasari. When Graham said that "the spirit of the epoch is inescapable in its creations," he was speaking the language of Hegel, although as an anti-Marxist he might have preferred not to be associated with a figure who loomed so large in the prehistory of Marxism. He said, "*Culture as a process* is the evolution of *form* and nothing else."[18]

Graham was very much attuned to the individuality of the creator—to the magic of genius. He spoke of imagination as "the ability to create images irrespective of reality, using nature as a point of departure only." The struggle for the artist was to penetrate beyond appearances, to find a way to grasp what he called "the language of pure form," and in this sense Graham's thinking recalled that of Hofmann, whom he knew in the 1930s. "Form speaks clearly," he wrote, "more clearly and in a more exalted way than the subject matter. It is more direct." But there was a problem. "Few possess the gift of reading the language of pure form, due to lost affinity to nature through miseducation. Pure form speaks of subject matter by means of transposition or transmutation." Graham gave an example of "form language," using "a beautiful old chair. The first element of its beauty will consist in its being handmade, therefore individualized clearly and bearing the certain imprint of the personality of the maker. Sufferings, deceptions, apprehensions and hopes of the diligent

maker by hand are automatically transferred to what he makes."[19] Although Graham's writing reflected the single-mindedness of a classicist, he liked to find purity in impure forms and out-of-the-way places. When Graham called his readers' attention to the grandeur of the applied arts—to the grandeur of a beautiful but modest chair—he did so with none of the Machine Age optimism of the teachers at the Bauhaus. Graham liked the blood, sweat, and tears dimension of humble handmade objects; he liked the way that the basic forms of that chair, when realized by a skilled although anonymous craftsman, could "automatically" convey the emotions of the maker. The beautiful old chair turned out to be a form filled with messy feelings. And that curious fact underscores the wonderfully devious emotionalism that's packed inside John Graham's holier-than-thou formalism.

As to the painters who were actually able to achieve these elusive goals, Graham felt that there were very few. Although in later years Graham would reject Picasso as an artist whose distortions were hopelessly arbitrary, Picasso was the man whose spirit hovered over *System and Dialectics of Art;* five of his paintings were included among the scant fifteen reproductions in the book. What may, however, have interested Graham's young friends more than his ideas about Picasso were his ideas about the history that led up to the work of the essential Cubist. So they might have turned to Graham's list of great painting up to the beginning of the twentieth century, a list that contained only eight names: Uccello, Giovanni di Paolo, Leonardo, Breughel, Le Nain, Ingres, Seurat, and van Gogh. Graham's taste in early modern painters and Old Masters was not exactly uncharacterisic for an avant-garde artist of his time and place. In the wake of Seurat, there was a widespread fascination with the emphasis on purity of contour that one found in Uccello, Poussin, and Ingres. And Leonardo's interest in the ineffable effects of water and wind, his fascination with the apparently freestanding value of studies and sketches, and his constitutional inability to finish paintings had made him seem an avatar of modernity. Many—indeed all—of the names that Graham mentioned were ones that de Kooning could have heard about from a number of sources.

There is, however, something different about the name Le Nain, which Graham used to stand for three brothers, Louis (the best known) and Mathieu and Antoine. There's something more complex—and maybe cultish—about their status as modern icons. And their significance is well worth delving into, because the work of these artists meant an enormous amount to de Kooning in the late 1930s and early 1940s—more, perhaps, than that of almost any other

artists. In the paintings of men that de Kooning worked on obsessively in those years—portraits of Denby and Burckhardt and sometimes self-portraits—the poses, the gestures, the color, the mood all derived from the work of the Le Nains. Just as Denby and Burckhardt were among the people de Kooning was closest to, so the paintings of the Le Nains were among the pre-twentieth-century works that he was closest to.[20] Even years later, when his work had moved in different directions, de Kooning still spoke of his interest in the work of the Le Nains. Janis and Blesh, writing about de Kooning's portraits in their pioneering 1960 monograph, comment that he has "named Le Nain as a stylistic source at this time." And when the critic Selden Rodman visited de Kooning's studio in the 1950s, there was a reproduction of an Uccello battle piece on the wall—Uccello, remember, was one of Graham's favorites—and de Kooning "pulled out a small panel from a pile of miscellaneous objects in the corner and we looked at it. It was a fairly conventional picture of three figures—'in the Le Nain manner,' he said—painted in the late thirties or early forties."[21]

V

The first question that has to be answered is: Who were the Le Nains? It is a question that art historians are still asking, for the epochal exhibition devoted to their work at the Grand Palais in Paris in 1978 provoked as many questions as it answered.[22] The three brothers were all active in Paris in the 1630s and 1640s; they were founding members of the French Academy of Painting and Sculpture in 1648, although two of them, Louis and Antoine, died later that year. Among their grandest works are the studies of groups of peasants, often gathered around a table. The finest of these have traditionally been assigned to Louis, although most scholars now question the attributions, and some historians suspect that the brothers actually collaborated on certain canvases. The color in these paintings, all silvery grays and reddish browns, is rich yet austere, and the figures, whether they are seated or standing, have a sculptural power. Contours are very clear; volumes are lucidly rendered; everything is definite. In an unpublished passage in Graham's papers, he wrote that the Le Nain brothers were "probably the greatest artists of the XVII century. In understanding the function of the big form, color and tone they were the true precursors of the modern painting. Their form is big but subtle and never bombastic or brutal, their color is used as a spatial statement."[23] As for who exactly was depicted in these paintings, it is not entirely clear. Many scholars

*Le Nain brothers,
The Peasant Meal,
1642. Oil on canvas,
38¼×48 in. This
painting was in
the Knoedler
exhibition in 1936.*

have argued that the homes represented are in fact those of prosperous
landowners; the theme of many of the paintings may be gatherings of wealthy
landowners giving charity to the poor.

In an odd way, the paucity of information about both the Le Nain brothers
and the people they were painting adds to the fascination of these composi-
tions, at least for modern artists. Although they were founding members of
the Academy, we can approach the work of the Le Nains without fixed
assumptions, almost as we might approach a beautiful weather vane created
by an anonymous nineteenth-century New Englander. For an artist, being
ignorant of the circumstances in which an earlier work of art was created can
be liberating, can make it possible to see forms clearly—in one's own way.
The fascination of the Le Nains, working in France in the seventeenth cen-
tury, a time of strict stylistic hierarchies, was that they seemed to elude fixed
definitions and generate their own, instinctive sense of form—a sense that was
not, perhaps, unlike what Graham discerned in an old chair. In any event, the
Le Nains could not be fitted easily into the old stylistic categories, into the
division of seventeenth-century art into classical and baroque or some such
thing. This, at least, was what struck the Frenchman Paul Fierens in 1933,
when he published a book on the brothers in Paris, and placed them at the
beginning of a French naturalist tradition, a development that would lead
through Chardin in the eighteenth century to the nineteenth-century achieve-

ments of Corot and Courbet.[24] But if many writers saw the Le Nains as part of a realist tradition, by the 1930s there were also a number of artists who were inclined to push the analysis further, and view the startlingly fresh realism of the Le Nains as leading the way to abstract art.

Perhaps the most interesting passage written in France in the 1930s about the Le Nains was in an article by the young abstract painter Jean Hélion. Hélion was a friend of Mondrian's and Kandinsky's—and, living in New York a decade later, at a time when his work was moving away from abstraction, he would have an enormous impact on younger American painters, among them Leland Bell and Nell Blaine. In 1934 the Le Nains were the focus of two major exhibitions in Paris, a retrospective at the Petit Palais and a survey at the Orangerie, "Les Peintres de la Réalité en France au XVII Siècle." In response to these exhibitions, Hélion published an article in *Cahiers d'Art*— the essential journal of the avant-garde, which was closely followed by the younger American artists—in which he argued that the central issue in art was the painter's response not to the reality of the world so much as to the reality of the painting itself, and he found in the powerhouse naturalism of the Le Nains a case in point. The reality of art, Hélion argued, "is grounded in the painter's relationship with his canvas, not in his relationship with nature or with his subject." The goal was a canvas that was "organic, total, homogenous, independent."[25] Hélion's argument was that the weight, the resolution, the clarity of the Le Nains' compositions constituted a reality unto itself, a reality that by bringing perception into agreement with the inherent qualities of the canvas—its flatness, its unreality—offered a foretaste of the new reality of abstract art. In 1934 Hélion's argument could be read as one of progressive

Jean Hélion, Abstraction-Verte,
1937. Oil on canvas, 35 × 46 in.

distillations, for in his *Cahiers d'Art* essay he moved through Cézanne and Cubism to Mondrian. But the importance that he gave to the Le Nains, these gritty naturalists, also suggested a complication of Hélion's own idealism. Reading Hélion's essay today, we are keenly aware that within a decade he would, like the Le Nain brothers before him, be painting seated figures in rumpled clothing. His insistence, even in 1934, on arguing for the abstractness of an art as emphatically naturalistic as that of the Le Nains suggested that the reality of the canvas was shaped by laws—and by kinds of logic and illogic— that were as messy as life itself. You might say that Hélion was suggesting an anti-idealistic vision of the idealism of the canvas, and to the extent that he found that vision in the work of the Le Nains, who were also so much admired by de Kooning, Hélion's thoughts may help us to understand the anti-idealism of the New York School, where there was so strong a sense that the reality of the canvas ought to be as fraught with and as full of conflict as life itself.

Tradition, for artists, is the part of the past that is alive in the present, and the aliveness of tradition at a particular time can depend on something as serendipitous as the proximity of certain paintings in certain exhibitions. The enormous excitement occasioned by the shows at the Petit Palais and the Orangerie in Paris in 1934 reached New York in November 1936, when "George de La Tour and the Brothers Le Nain" opened at Knoedler on East Fifty-seventh Street. At the time, Graham was living in Brooklyn Heights, where David Smith also lived, and one can imagine Graham going to look at the Le Nains with him and de Kooning and other friends, such as Gorky and Davis. Graham knew the organizer of the Knoedler show, the Parisian dealer Louis Carré; and Frank Crowninshield's name appeared on a list of Americans who were lending their support. And as if the confrontation with the Le Nains might not have been enough for one winter, it also happened that a few weeks before the Le Nain show opened, Jacques Seligmann and Co.—where Graham had connections; he had organized a show of African art for the gallery that same year—mounted a major exhibition of works of Picasso's Blue and Rose periods.[26] Although there were already Le Nains in the Louvre in the nineteenth century, I do not know if Picasso had the Le Nains' work in mind when he did his Blue and Rose period figures, with their clear contours, weighted volumes, and grave presence. But in the dream universe of tradition, precise connections are not necessarily what matters. If the gravity of the early Picassos at Seligmann—with a graphic lucidity that emphasized the reality of the canvas—suggested the Le Nains, it was a suggestion that Graham may have been able to flesh out. He could well have known that Picasso

had painted, in 1917–18, a free interpretation of the Le Nains' *Return from the Christening,* which happened to be in the Knoedler show; Picasso's version would have especially interested Graham, an admirer of Seurat, as it was done in a pointillist style. Graham might also have known that another painting at Knoedler—*The Feast of the Wine,* then ascribed to Mathieu but no longer given to the Le Nains—was at that very time passing into Picasso's collection, if it did not indeed already belong to him; it is now in the Musée Picasso in Paris.

If Graham did in fact go to the Knoedler show with de Kooning and Smith and Gorky, there are passages in *System and Dialectics of Art* that suggest what he might have said to them about these seventeenth-century paintings of people living in straitened circumstances—and about the Le Nains and Picasso. "In time of crisis," he wrote, "it appears obvious that peasants know something, perhaps crude but certainly vital, while intellectuals know absolutely nothing and are therefore panic-stricken." Graham's remark might be a comment on Depression-era intellectuals. The severity of the interiors in the Le Nain paintings could look familiar to artists living in bohemian poverty in 1930s New York. And the artists did have a particular kind of peasant knowledge—which was their artistic instinct, which was a kind of formal knowledge. Even the scenes by the Le Nains of elegant guardsmen playing cards or dice were often set in virtually unornamented interiors. The austerity of the rooms painted by the Le Nains and by Picasso—the relatively simple clothes, tables, and crockery; the restrained color—emphasized what Graham called materialism, which was a little like Hélion's reality. *"Materialism bases its discoveries on exhaustive and coordinated study of matter in space.* Materialism is *not a belief* in material explanation of the world (above all not a mystic belief)." In the Le Nains, Graham would have seen the "truly great, austere, structural art" that he associated with Uccello. And the association of the Le Nains with austerity related to another observation in Graham's book, namely that Cubism was "gothic: lofty austerity, constructive distortions, analysis of form." Which in turn might have been derived from an observation made by the art dealer and critic Wilhelm Uhde, namely that Picasso was "the great representative of Gothic and vertical art."[27] And yet the paintings by the Le Nains also represented living, breathing people. It was as if the essence of tradition was found in some mysterious convergence between great principles— the gothic, the vertical, constructive distortion, analysis of form—and the most concise and specific rendering of a man's nose or the highlight on a glass of wine.

VI

In the portraits of his friends Edwin Denby and Rudy Burckhardt that de Kooning was painting in the 1930s and early 1940s, we can see all these criss-crossing issues being presented, examined, scrambled, juxtaposed, composed, decomposed, and recomposed. What was closest to de Kooning—the faces of his next-door neighbors and sometimes his own face as well—became the site on which a battle for tradition was waged. Even as de Kooning was struggling to represent the people he knew best, he was also grappling with ideas about the concreteness and abstractness of painting and portraiture—and with a kind of abstractness that predated abstract art. It was here that the sense of tradition as being discovered in the hurly-burly of immediate experience became a key New York idea. By attempting to find abstraction in the very anti-abstractness of the Le Nains, de Kooning was registering his discomfort with Mondrian's idealistic vision of abstract art as a place apart.

Willem de Kooning,
Portrait of Rudy Burckhardt,
circa 1939. Oil on canvas,
48 × 36 in. Formerly collection
of Rudy Burckhardt.

Le Nain brothers,
The Dice Players,
circa 1630s/40s.
Oil on canvas,
36⅝ × 47⅞ in. This
painting was
in the Knoedler
exhibition in 1936.

In his work of the 1930s and early 1940s, de Kooning explored the nitty-gritty of life, which in turn generated all kinds of abstract speculations. In one of de Kooning's many unfinished portraits, Burckhardt's pose was almost identical to that of the figure at the right of the Le Nains' *Dice Players*, from the Rijksmuseum. But was Rudy Burckhardt the issue? And were the Le Nains? To draw on the Le Nains was to evoke a primal idea of art, with its form that "is big but subtle and never bombastic or brutal." In regard to his friends, de Kooning was yearning for a directness and simplicity that went back to the Le Nains and even earlier. But the Le Nains were also a route to abstraction—to the idea of the canvas as a reality that existed apart from reality. Certainly, the issue was not simply painting a portrait—as if anything could be simple. A dream of pure form, albeit an impure variety of pure form, was also involved. Of portraiture, Graham had said: "Portrait, with likeness as an aim, cannot be a work of art, because when the artist takes a canvas of his choice already pre-determining to a certain extent the solution and makes a first gesture on the canvas, what happens? There are other gestures—moves on the canvas that have to be taken *in logic* to the size-shape of the canvas and the initial gesture."[28]

The unfinishedness of so many of de Kooning's portraits of this period would be, according to Graham, almost a necessity. The friend's physiognomy was a reality against which all the competing realities of the canvas had

Willem de Kooning, Two Standing Men, *circa 1938. Oil and charcoal on canvas, 61 × 45 in. Formerly collection of Thomas Hess.*

Le Nain brothers, The Forge, *circa 1640. Oil on canvas, 27⅓ × 22⅔ in. This painting was in the Knoedler exhibition in 1936.*

Willem de Kooning,
Seated Man, *circa 1938.*
Oil painting, described as
"now destroyed" in Thomas
Hess's 1959 monograph.

Willem de Kooning,
Untitled, *circa 1937.*
Oil on board, 13½ × 19 in.
Formerly collection of
Rudy Burckhardt and
Edwin Denby.

Le Nain brothers, Return
from the Christening *(also*
known as The Happy Family*),*
circa 1642. Oil on canvas,
24 × 30¾ in. This painting, of
which Picasso did a pointillist
version in 1917–18, was in the
Knoedler exhibition in 1936.

to be measured. The paintings kept asking: What is the real reality? Thinking of Hélion going from the Le Nains to Mondrian, you might see the de Koonings as a different kind of attempt to resolve that evolution—a kind of anti-evolution, whereby abstraction and representation were in a dialectical process, an eternal conflict. Interestingly enough, though, Denby said that when he first saw de Kooning's paintings—which were probably not portraits, but abstractions painted under the influence of Miró—"the resemblances to Picasso and Miró were misleading," and it might have helped to approach these paintings "from Mondrian." Now this was in 1936, right around the time of the Knoedler show. The de Koonings, Denby explained, lacked the "seduction and climax" of Picasso; they were more like Mondrian in that you had to get into them "all at once."[29] There was indeed a peremptory power to Mondrian's imagery that always interested the New Yorkers; and certainly de Kooning wanted his work to have that kind of bolt-from-the-blue power. Which all went to show that the line that Hélion had seen running from the Le Nains to Mondrian was not completely irrelevant to de Kooning. The portrait tradition, in any event, would not resolve itself within realism. A beautifully finished portrait was as much a perfect synthesis as Mondrian's rectangles—and de Kooning rejected both. "The form of the model," Graham said, "is not perfect in the sense of composition." It must be transposed "to suit the . . . rectangular, measurable, flat space of the canvas."[30]

Painting his close friends, de Kooning recorded in their unresolvable physiognomies a crisis in the abstraction of form, a crisis that had already in some people's minds found its resolution in abstract art, but that he personalized, psychologized, with a tumble of allusions. There was a back-and-forth, stream-of-consciousness, Q-and-A quality in these portraits. Their moody, ambivalent atmosphere—their appealing pathos—may have also carried traces of de Kooning's conversations with Denby, who quoted in his essay on Nijinsky, published in 1946, de Kooning's remark that "Nijinsky does just the opposite of what the body would naturally do."[31] This, interestingly, tied back to Graham's comments on portraiture. We know that de Kooning spent time with Denby looking at the photographs of Nijinsky, and that may suggest other connections. The diamond-patterned surface in the middle of a small double portrait is worth considering. There was, apparently, originally a third figure, and one might speculate that in obliterating a figure but including a group of diamond shapes de Kooning was recalling the costume that Nijinsky wore in *Le Carnaval*, a ballet in which he played Harlequin.[32] Denby had danced professionally when he was a young man, and when de Kooning

painted his lithe figure (or Burckhardt's—the two men looked quite a bit alike), the artist may have felt not only that he was recalling the Le Nains' somber young men but also Picasso's itinerant circus performers, which he could have looked at with Graham. Harlequin, who had figured among the Nijinsky photographs, was also a subject that was of interest to Graham—he, too, had painted Harlequin. Graham had said that "Harlequin is no one else but Hercules, the mighty symbol of manhood, the god (strange to say) of pessimism and welt-schmerz, the god who after completion of his twelve heroic deeds fell under the spell of the beguiling nymphe Omphala, and was destined to spin her loom while she toyed away with his mighty club."[33] For Graham, "Hercules' club in the Comoedia del Arte degenerated into the milder slapstick of Harlequin. Comoedia del Arte is a mysteria, tragico-burlesque." This brought Graham to the painters. "The actors of the poor traveling circus in patched and faded tights with pale, emaciated bodies frequently inspired great artists, such as Watteau, Daumier, Seurat, Toulouse-Lautrec, Rouault, Picasso. All European civilization was deeply concerned with the development of the Comoedia del Arte."[34]

In de Kooning's portraits of Denby and Burckhardt, the circus troupe came to a stop in New York, and began to change, destabilize, turn into something—but into what? Through the days and weeks and months in his studio, as de Kooning rubbed out an arm, a leg, a head, and then painted it back in only to rub it out again, he was both invoking and revoking the importance of the Le Nains and everything that had come after them. We see decomposition, recomposition—and Hercules, who had become Harlequin, becoming a diamond pattern on a tabletop. That might seem to be a move toward an absolute. Yet what de Kooning ended up with was not Mondrian's pure rectangle but a fragment of the world. Harlequin had tossed his costume over the Le Nains' wooden table while Edwin Denby watched. De Kooning was suggesting that abstraction was not so far from representation, and that tradition, if not directionless, was certainly provisional, perpetually in disarray, a grand conundrum. That, more or less, was how a great many artists in New York would come to feel.

VII

De Kooning never disavowed the Le Nains, but by the time he had his first one-man show, at the Charles Egan Gallery in 1948, he was painting labyrinthine abstractions, often in black-and-white, with fractured, over-

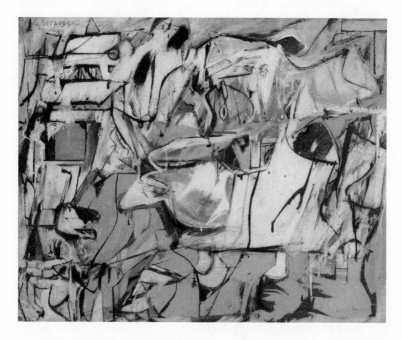

Willem de Kooning,
Asheville, 1948. Oil and
enamel on cardboard,
25 9/16 × 31 7/8 in.

lapped, jumbled calligraphic forms, and there was no reason for a gallerygoer to even suspect that these seventeeth-century masters had been on his mind a decade earlier. But Thomas Hess remembered, and in his pioneering 1951 book, *Abstract Painting: Background and American Phase,* he wrote beautifully about de Kooning's early portraits. "Fascinated by the strange lyricism of Louis Le Nain, he translated the seventeenth-century sensibility . . . into a detached romanticism that sometimes recalls Picasso's Pink Period. Le Nain's falling greys that freeze in silver to define a farmer's smock, his solitary musicians and forgotten still-lifes, all found burnt rose and cerulean translations in de Kooning's pictures—many of which were never finished. . . . Hardly any emotion is allowed utterance in these images filled with cool, tough blankness. When the fury of sensation returned, it would tumble the reticent actors into a surging mechanism of fragmentation and re-creation. Still, nothing an artist creates is ever lost, and de Kooning's fragile-boned men and women, with their staring eyes and gently folding hands, inform the splashing impastos and streaking shapes that inhabit his present abstractions."[35]

You might say that by 1950 de Kooning had spent two decades coming to terms with the nature of abstraction, and that he had done so through his confrontations with the figure, with Picasso, with the Le Nains—and with other artists, especially Ingres, who also fascinated Graham. While de Kooning had

grappled with the purity of form, he had ultimately decided not to purify his forms. The work that he did in the late 1940s defined a confrontational spirit, and his brushstrokes were the essential expression of that spirit. The electricity of these brushstrokes—the strange sense of incompleteness, of energies and counter-energies—was an abstraction of perpetually competing forces, of an unresolvable dialectic. These brushstrokes were very beautiful, more beautiful, studied one by one, than almost any whole painting that de Kooning ever did. De Kooning's strokes were sometimes as thin as lines done in pen and ink, sometimes as broad as a housepainter's brush. The strokes angled and curved. They constructed a headlike or bonelike shape; there was a glimpse of an arm or a face that might have recalled shapes in a painting done in the years when de Kooning was looking at Denby and Burckhardt and thinking of the Le Nains. But after that shot of naturalistic allusion, de Kooning's strokes snapped back into their elusive dance. The temperament of these paintings recalled something that the painter Charmion von Wiegand, who was a friend of Mondrian's, wrote about John Graham's work on the occasion of a show of his drawings at the Pinacotheca Gallery in 1946: "The more he abstracted, the more personal and disturbingly nostalgic the object became."[36]

De Kooning's brushstrokes were the secret of his art. They were what gave his paintings their aura of emotional disclosure. And this artist's equivocations about how much he was willing to tell were something that, in typical New York fashion, he laid bare on every inch of every canvas. He promised to tell, but what he told was another matter entirely. De Kooning once observed that "content is a glimpse"—an observation that became the title of a little essay distilled from his conversation. And this idea of the glimpse placed de Kooning firmly in a modern romantic tradition that included the Symbolist traits that the English author Arthur Symons saw in Degas, who offered "unreal glimpses of the dancers on stage," and the fascination with ancient Greek poetic fragments that shaped Ezra Pound's poetic language, which Hugh Kenner has characterized as "an aesthetic of glimpses."[37] De Kooning's flair for perpetually partial disclosure—for that romantic glimpse—was what turned his paintings into such terrific theater. He transcribed his most private equivocations into ambiguous brushstrokes and hung them right up there on the gallery wall. The best de Koonings were soliloquies; gallerygoers felt as if they were eavesdropping on his musings. For de Kooning, abstraction was, of course, a question of form, but what he had come to believe in the late 1930s and early 1940s was that painting was not so much about the purity of form as it was about the pathos of form.

Some years later, in 1961, Fairfield Porter wrote about the Le Nains in a way that suggested what they had meant to de Kooning. "As Descartes proved existence by his own existence, validated in introspection, so these bourgeois artists proved art by their own practice, validated less by comparison to Italian precedent than within the paintings themselves."[38] What Porter was suggesting was that the idea of operating within painting itself, which Hélion had seen as foreshadowing the purism of Mondrian, could also provoke psychological or philosophical introspection—a welter of impressions as unresolvable as the darting thoughts in one's mind. When de Kooning, in a brief text called "A Desperate View," said that "the only certainty today is that one must be self-conscious," he may have spoken ruefully, but he was presenting his credo. As the painter Louis Finkelstein wrote in 1950, de Kooning had rejected "all discipline save that of the experience itself." To paint abstractly was not to purify tradition but to brood over it, at least that was the case in the late 1940s. De Kooning saw the artist as living in a dangerous, stormy dialectic with the forces of history. "Insofar as we understand the universe—if it can be understood—our doings must have some desire for order in them," he said in "The Renaissance and Order," yet "all that we can hope for is to put some order into ourselves."[39]

By 1950, de Kooning had come to see himself as a grand figure in the dialectical movement of art, but for him this dialectic was labyrinthine and unstable, at once melancholy, ambivalent, funny, confused. In "What Abstract Art Means to Me," the lecture he presented at the Museum of Modern Art, de Kooning rejected, in a very personal way, any hope of resolution or clarity. "Art never seems to make me peaceful or pure. I always seem to be wrapped in the melodrama of vulgarity." You certainly feel that melodrama of vulgarity in the paintings of women that preoccupied him in the early 1950s. De Kooning's confessional mode, as we gather from his lecture at the Modern, was unabashedly romantic, even if he was canny enough to give that romantic spirit a self-deprecating edge. If you remove the ironic element, however, you realize that although Graham might not have figured all that much in what was written about de Kooning in the 1950s, de Kooning was in fact conceiving of himself in the terms in which Graham had described Picasso in 1937 in *System and Dialectics of Art*. "There are artists more modern than Picasso," Graham had written. "His is a purely romantic basis. Picasso signifies the end of the old hand-made world. His art is a gorgeous funeral to the departing order, the romantic individualism, the weltschmerz, the melancholy of isolation." In de Kooning's late 1940s abstractions, there was that melancholy, that welt-

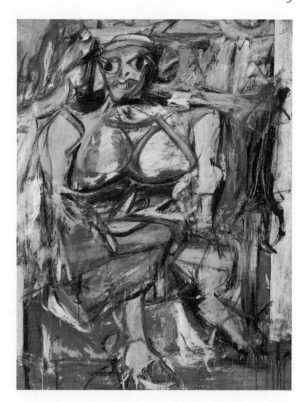

Willem de Kooning,
Woman I, 1950–52.
Oil on canvas, 75⅞ × 58 in.

schmerz. De Kooning said, "Spiritually I am wherever my spirit allows me to be, and that is not necessarily in the future." "Vulgarly speaking"—this is Graham again—"time marches on and the machine-age and consequently the collective age is asserting itself from the two opposite ends of the globe. Picasso is the last vestige of hand-made art. It is the swan song to the glories of the past and the apprehension of the future for there is nothing more terrifying than the unknown."[40]

Remove the darkly sober 1930s accents from this description, and you have a figure very much like the de Kooning of the 1950s. That sense of being a great creator at the end of a tradition would not have bothered de Kooning, who believed that "innovators come at the end of a period. Cézanne gave the finishing touches to Impressionism before he came face to face with his 'little sensation.' " Everything that de Kooning painted from the late 1940s to the early 1950s, from the nocturnal, somnambulistic black-and-white abstractions, with their hide-and-seek of bone forms and figure fragments, to the raucous *Women* exhibited in 1953, could be said to pick up on some element of Picasso's handmade art, and turn that element around—playfully, anxiously,

sometimes angrily. With de Kooning, the gorgeous funeral of which Graham had spoken continued, and no artist of the 1950s was more conscious of the extent to which the handmade had itself become the final, definitive emblem of romantic individualism. If *Woman I,* which de Kooning labored on for several years and considered abandoning, was a howl, it was not directed against women so much as it was a howl of giddy frustration at the possibilities that eluded this artist who said that "Rubens is still better than most *new* painters."[41]

VIII

Art life in the 1950s could sometimes feel like one big drunken party, and de Kooning, while he was not interested in staying sober, was determined to give the young artists a serious lesson or two. Though never an intellectual in any ordinary sense of the word, he took an active role in all the discussions about the new art, an art that could never be comprehended by any of the labels, such as Abstract Expressionism, Action Painting, and "American-Type" Painting, that the critics found convenient. The idea of labels, of definitions, was anathema to de Kooning, but that did not prevent him from offering his own anti-definitions at a symposium on the topic "What Abstract Art Means to Me," organized at the Museum of Modern Art one evening in February 1951. Six artists contributed to this event, which took place as the Modern was becoming more and more involved with the contemporary art scene. The participants included, along with de Kooning, Stuart Davis, Alexander Calder, George L. K. Morris, Fritz Glarner, and Robert Motherwell. While a number of them had something interesting to say, de Kooning's remarks are, at least in retrospect, the most striking. He turned the symposium into a one-man show, coming through with what was probably the single most suggestive statement made by any American artist in the 1950s. This was the School of New York's ad hoc declaration of independence—from Europe, from the first half of the century, from anything that might be defined as the old modern art. De Kooning was saying: "Be yourself." He was describing a new era in the life of form.

De Kooning's talk was daringly roundabout, like one of those late-night walks through the city. Perhaps because Alfred Barr had insisted that all the remarks be written out in advance, de Kooning had worked especially hard on this text. The occasion was Andrew Carnduff Ritchie's big survey, "Abstract Painting and Sculpture in America," which was currently up at the museum, and de Kooning may have had little patience for this neatly mapped explo-

ration of recent developments. Who could miss this painter's knack for presenting and then inverting and obliterating a theme? Or the way that the zigzagging arguments echoed the controlled chaos of his paintings? For younger artists, who were weary of what they regarded as the enigmas of Surrealism and the absolutes of Mondrian, de Kooning's abrupt but sweeping statements must have sounded startlingly, thrillingly fresh. And compared to de Kooning, the five other artists involved that night were throwbacks, old news. In his friendly, sweetly casual way, de Kooning was in attack mode from letter *A*. He did not like the topic that he'd been asked to address, because the very word *abstract* came "from the light-tower of the philosophers." "As soon as it—I mean the 'abstract'—comes into painting," he explained, "it ceases to be what it is as it is written. It changes into a feeling which could be explained by some other words, probably." De Kooning was saying that nothing that was in a painting was abstract, and that that was all to the good. He believed that an obsession with abstract ideas robbed painting of its specifics and ended up freeing "art from itself."[42]

De Kooning was giving a sardonic farewell to the official history of modern art. The idea that there is some grand logic to history was one that de Kooning seemed to regard with humor—as arbitrary. In "A Desperate View," he had already imagined that everything could be organized around the idea of "trembling"—a whole history of shivering and shaking. And in "The Renaissance and Order" he presented another comic view, speaking of "a train track in the history of art that goes way back to Mesopotamia. It skips the whole Orient, the Mayas and American Indians. Duchamp is on it. Cézanne is on it. Picasso and the Cubists are on it. Giacometti, Mondrian and so many, many more—whole civilizations. Like I say, it goes way in and back to Mesopotamia for maybe 5,000 years, so there is no sense in calling out names."[43] To this tidal force of history—to its inevitability—de Kooning opposed the individuality of the artist's will. And I think he believed that artistic individuality was itself a principle that could be traced back, deep into the history of art. In "The Renaissance and Order" he made an argument about perspective that in some respects paralleled the ideas of Erwin Panofsky and others who believed that Renaissance perspective was not so much a pure response to nature as it was an effort to construct—to will—a logic. For de Kooning this was not so much a scientific operation as it was a psychological operation. He might have adapted some of his ideas from Meyer Schapiro, who was a friend and who had had a good deal to say about perspective in his essay "On a Painting of Van Gogh," published in the artists' magazine *View* in

1946. Schapiro had written about the collapse of the objectivity of Renaissance perspective in van Gogh's work, especially the last pictures. But the effect of Schapiro's argument was to make it seem that all ideas about perspective were in some sense subjective; even the objectivity of Renaissance perspective reflected not an ultimate truth but a kind of human yearning. Schapiro argued that in certain of van Gogh's late landscapes we are confronted by a diagonal push of perspective that "is rarely unobstructed or fulfilled; there are most often countergoals, diversions," and that all of these perspectival suggestions are "charged with feeling"—with the artist's tangled relationship with the world.[44] When de Kooning speculated that the artist was "in a way, the idea, the center, and the vanishing point himself—and all at the same time," he was speaking in the same spirit.[45]

De Kooning's discussion of contemporary art in "What Abstract Art Means to Me" offered the clearest argument that he ever made for the supremacy of artistic subjectivity. He rejected the idea that an artist could create forms that had an impersonal power. Every form—even the lucid perspective of the Renaissance—reflected a sort of mental weather. All form, for de Kooning, was psychological, personal. "Painting—any kind of painting, any style of painting—to be painting at all, in fact—is a way of living today, a style of living so to speak. That is where the form of it lies." The brushstroke that made the form was the subject, for it was the autobiography of the will, of self-consciousness, of the artist in the midst of his painting. Speaking of the romantics in his Museum of Modern Art lecture, de Kooning praised them for eluding the philosophers. Hegel might have written about romanticism, but the romantics would have the last word. De Kooning was opposed to any historical vision that pressed the individual into the service of some higher idea—and this placed him in the tradition of the romantic, who lived so intensely within his self-consciousness that the great sweep of history was obliterated. De Kooning rejected a whole range of anti-individualistic visions that he believed had appeared at the beginning of the twentieth century, when "a few people thought they could take the bull by the horns and invent an esthetic beforehand." This was the origin of all the modern isms—Cubism, Futurism, Neoplasticism, Constructivism. De Kooning knew full well that the whole idea of history as a pattern, a system—of its organization around "trembling" or some other idea, of its being a train ride, a dialectic—was typical of the early twentieth century. What he liked about the romantics of the nineteenth century was that they had not allowed themselves to be hemmed in by ideas—they knew how to cut through the bull, even their own bull. "When

they got those strange, deep ideas," he said of the romantics, "they got rid of them by painting a particular smile on one of the faces in the picture they were working on."[46] That might have been the meaning behind de Kooning's enigmatic smiles—the ones that he shot at young friends such as Robert Creeley, as well as the ones that he put on some of the figures in his paintings, such as the scabrous, unsettling *Woman and Bicycle.*

And as for the formalist thought that was perhaps best known in New York through the writing of Clive Bell and Roger Fry, de Kooning rejected completely the idea of "significant form." He played with it, he mocked it. "This pure form of comfort became the comfort of 'pure form.' The 'nothing' part in a painting until then—the part that was not painted but that was there because of the things in the picture which were painted—had a lot of descriptive labels attached to it like 'beauty,' 'lyric,' 'form,' 'profound,' 'space,' 'expression,' 'classic,' 'feeling,' 'epic,' 'romantic,' 'pure,' 'balance,' etc. Anyhow that 'nothing' which was always recognized as a particular something—and as something particular—they generalized, with their book-keeping minds, into circles and squares."[47] De Kooning was for preserving the particular emotional uniqueness—the something, you might say—of this or that nothing. Which was of course also an idea that was in some way derived from Graham, who had spoken about how the "sufferings, deceptions, apprehensions and hopes of the diligent maker by hand are automatically transferred to what he makes"—which was an idea about the glorious impurity of the purest form. De Kooning's statements were, in their wackily existentialist way, a plea for a postwar pragmatism. What he had learned from Graham in the 1930s was not so much that the Le Nains were as modern as Picasso but that each work was an individual act, an attempt to give form a shape that matched the artist's emotion.

De Kooning's talk at the Museum of Modern Art ended with a sensational, anarchic conceit about an oddball whom the artist had known over in Hoboken in the 1920s—the years about which even his early biographers seemed to have no information. This man, the painter explained, "found a place . . . where bread was sold a few days old—all kinds of bread: French bread, German bread, Italian bread, Dutch bread, Greek bread, American bread and particularly Russian black bread. He bought big stacks of it for very little money, and let it get good and hard and then he crumpled it and spread it on the floor in his flat and walked on it as on a soft carpet. . . . I could never figure him out, but now when I think of him, all that I can remember is that he had a very abstract look on his face." Was this meant as a fairy tale about the European

past, which had to be crushed, turned into a soft carpet? Was it a joke about the authoritarian muddle of abstract art? (De Kooning observed that his friend had at one point "become some kind of a Jugend Bund leader and took boys and girls to Bear Mountain on Sundays"—and then later was a Communist.) Or was de Kooning's Hoboken story just a conundrum with which to end a talk? For listeners who knew "The Renaissance and Order," this peculiar story might recall the story with which de Kooning had ended that piece, a story that came from Jack Tworkov. Tworkov's story was about a village idiot named Plank who "measured everything"—"roads, toads, and his own feet; fences, his nose and windows, trees, saws and caterpillars. Everything was there already to be measured by him." Jack said he "always walked around with a very satisfied expression on his face. He had no nostalgia, neither a memory nor a sense of time. All that he noticed about himself was that his length changed!"[48]

In both cases, de Kooning was alluding to some obsession with the past. In "The Renaissance and Order," the village idiot suggested a parody of the old idea of the Renaissance painter, that rationalist who turned out, like Graham's beloved Uccello, to be a madman, with perspective itself as his obsession. In "What Abstract Art Means to Me," the bread from different countries that was crushed together might suggest the gathering of world art into the kind of systematized vision that one found in Hegel—and that John Graham had attempted. The story recalled, in fact, Dehner's description of some of Graham's earlier work, the work he referred to as "minimalism." "I saw only three of the paintings which reflected that concept," Dehner explained. "The backgrounds in all cases were dark brown, achieved, John said, by mixing all colors together."[49] Surely the mythical old man in Hoboken had some of Graham in him, with his obsessive collecting, and also some of de Kooning, who had absorbed all of Graham's ideas, and crushed them, made them submit to his will. Who could be sure? Yet de Kooning knew what dramatic impact might be achieved by invoking an idiosyncratic failure, the old friend in Hoboken, in front of an audience that saw de Kooning as standing on the threshold of a decade of rip-roaring success. The carpet made of all those crushed loaves of European bread was the history of art, all the dreams of what form might be, now mastered by New York, as you might master a demolition site, so that building could begin anew. By introducing these somewhat theatricalized recollections of old-time eccentrics into his reports on the state of abstract art, de Kooning was giving the new decade a bit of the wacky-bleak fascination of a play by Samuel Beckett.

4. "I CONDEMN AND AFFIRM, SAY NO AND SAY YES"

I

Something in the spirit of Manhattan made many artists leap at the opportunity to say "No!"—to one another, to the American present, to the European past. "Personally," de Kooning said, "I do not need a movement." And that personal feeling had a way of suggesting a new kind of movement. The artists of the postwar years could sound like the hero of Ralph Ellison's *Invisible Man,* who at the end of his adventures announced, "I condemn and affirm, say no and say yes, say yes and say no."[1]

A short story called "Reunion in Spain," written in the early 1960s by B. H. Friedman, who would later publish a biography of Pollock, presented a sort of parable of that New York "No!"—which was followed by a New York "Yes!" The story was narrated by a critic, Enid Sloan, who was recollecting her affair with the Abstract Expressionist painter Max Kraus. Friedman had something to say about the competition between artists and critics, which was between immediate experience and systematized experience, and how that competition revved everything up. "There was always a tension between Max Kraus and me," Enid Sloan recalled. "Always, ever since the mid-fifties, when he was beginning to show his paintings and I was beginning to publish frequently in the art magazines." Kraus wrote to Sloan, saying, "Thanks for your seemingly sympathetic words. But my work's not about 'whiplash line' or 'frontal attack.' And it's not about 'shallow space' or 'holding the picture plane,' either." And then Kraus gave the affirmative, which was couched in the most concrete terms. "It's about paint—paint's color, thickness, juiciness." Critic and painter met, and then "more words from him led to more articles by me." Eventually, they became lovers. But before that a gift arrived from Max, a painting. It was "a strong composition, mostly in black, with scraps of paper collaged beneath the heavy paint. As usual I admired Max's energy and his control of what he'd called paint's 'juiciness,' now playing

against freely torn edges of paper. It took a few minutes of close looking to realize that the scraps were torn from my reviews of his work." Enid thought of returning the painting, but didn't, "because I really liked it, liked it as art if not as message."[2]

There are several points to be made about this story. Certainly, Friedman was satirizing the kind of criticism that he thought made too much of formal values. But I think he was also saying that creativity involved saying "No!" And that the people to whom you said "No!" might turn out to like you—or even love you—for speaking your mind. This "No!" was fueled by the thinking of the existentialists, and also by the interest in Zen, which Hess said offered concepts such as "*no-thought, no-form, no-abode*." This "No!," however, took on a particular vehemence in Manhattan. The painter Jack Tworkov wrote, "There is no theory of color which has much practical momentum in painting." "If we see structure in the past," George McNeil was quoted as saying at the Artists' Club, "we should be anti-structural." And in an essay called "Sensation and Modern Painting," McNeil said that almost all the important painting done since the early nineteenth century "has been marked by non-beauty." The sculptor George Sugarman said, "I am not a constructivist." Philip Pavia spoke of "non-history," de Kooning of "no-environment." Greenberg wrote of " 'antidrawing' drawing," and Rosenberg spoke of American artists as being "willing to take a chance on unStyle or anti-Style." McNeil said that Pollock's overall paintings achieved "a total, non-shape form." William Seitz, in his pioneering study of the Abstract Expressionists, reported discussions about "non-commitment" and "not join-ing." Allan Kaprow spoke of creating theatrical works that "have no structured beginning, mid-dle, or end" and "no separation of audience and play." And as for Ad Reinhardt, that painter of ultra-pared-down abstractions composed whole essays full of negatives. For the exhibition "Con-temporary American Art" at the University of Illinois in 1952, he wrote "Abstract Art Refuses," turning the entire history of modern art into a stream of "No's!" "For Manet and Cézanne—no myths or messages, no actions or imitations, no orgies, no pains, no dreams, no stories, no disor-ders." And as for the present, he explained that

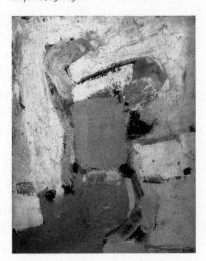

George McNeil, Estuary, 1957. Oil on paper on panel, 29 × 23 in.

"many artists like myself refuse to be involved in some ideas. In painting, for me no fooling-the-eye, no window-hole-in-the-wall, no illusions, no representations, no associations, no distortions, no paint-caricaturings, no cream pictures or drippings, no delirium trimmings, no sadism or slashings, no therapy"—and so on through a long paragraph.[3]

The New York "No!," which was epitomized in de Kooning's rejection of all the isms of modern art, could lead to nihilism and an end-of-art ethic. That would be part of the story of the early 1960s, when Duchamp, who had for decades been living quietly in Manhattan, suddenly found himself widely regarded as a seminal figure. In 1963 Mercedes Matter, an early student of Hofmann's, wrote an essay for *Art News* about what she saw as the deplorable state of art-school education, and she worried that students were being overwhelmed by "waves of cynicism, jaded feeling and no-belief."[4] But at least at the beginning of the 1950s, this "No!" was, interestingly enough, not only a constructive but also a moderating force. Camus had written—in "Art and Revolt," which appeared in *Partisan Review*—that "just as all thought means something, even the thought of no-meaning, so there is no art of no-sense."[5] That observation, although difficult to parse, suggested the optimistic side of the New York "No!" For the very "No!" that emboldened the Abstract Expressionists to reject traditional ideas of structure or finish necessitated their developing new ideas of structure or finish. And the "No!" could be carried a step further. There were some artists who wanted to say "No!" to the new kind of no-sense, and to reaffirm a more classical sense of structure or a more direct relationship to nature, but reaffirm it with a "No!" that still felt individualistic, felt not like a capitulation to tradition but like a reimagining of tradition.

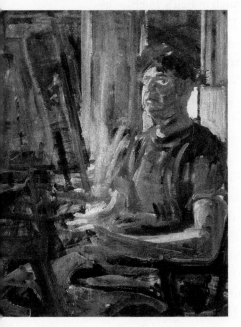

Leland Bell, Self-Portrait at Easel, *1954.*
Oil on canvas mounted on board, 24 × 19 in.

Certainly, there was a roiling, churning, street-smart dialectician's energy to the painter Leland Bell's embrace of the past. When Bell said "No!" to certain aspects of the downtown scene, he was affirming a whole range of other possibilities. In the 1950s Bell was beginning to exhibit self-portraits done in a dashing expressionist style, paintings in which the whirling brushstrokes summon up the artist's oddly dramatic head, with

prominent eyes and a crown of curly hair. At the same time, Bell was develop-
ing his own brand of traditionalism, which was so arrestingly independent
that it could feel antitraditional; he was an important figure, and we will meet
up with him a number of times in the course of our story. John Ashbery, writ-
ing about a visit to Bell's studio some years later, caught Bell's restless anima-
tion. Ashbery described Bell's "acrimony" for "such artists as Kline, Rothko,
Newman and de Kooning. He grudgingly grants points to the last, but is much
more severe about Pollock ('one Pollock in a hundred *really* succeeds—
there's this phenomenal dryness to them'), and is even more negative, not to
say irascible, about the others. Yet this is not the sour-grapes irascibility of
an artist who has refused to conform to contemporary taste and has thus
renounced the more gratifying forms of New York art-world success. Listen-
ing to him fume one day about the wishy-washiness of an Eakins he had seen
in Washington hanging near a Bonnard, I realized that his hard line is the
reflection of a coherent and completely honest aesthetic attitude." The
"No's!" vibrated through Ashbery's account. Although for Bell "the art that
matters . . . is French, . . . he does not mention Picasso very much, and
though he is quick to defend himself against the charge of neglecting both
Matisse and Braque, it is the painters most of us tend to think of, when we
think of them, as secondary ones whom he considers the masters of the twen-
tieth century." Bell's entire pantheon had a dissident ring. He admired André
Derain—"the mere utterance of whose name puts a catch in Bell's voice"—as
well as "Rouault, Dufy, La Fresnaye, Marquet, van Dongen ('he painted the
people of their day in their clothes and it worked')—in short, the painters of
what we usually think of as the Silver Age of modern art." Bell's ideas were
like a drumroll of "No's!"—a counter-statement to the Abstract Expressionist
statement. And the very vehemence of his passions gave his un–New York
taste a New York kind of urgency. "Bell's commitment to the past," Ashbery
observed, "is almost violent."[6]

All the "No's!" that we are hearing among the artists can be related to
some observations that Dwight Macdonald made in his famous plea for a
more humane radicalism, "The Root Is Man," first published in his magazine
politics in 1946. Macdonald listed, among the essential qualities of the radical
thinker, a belief in "The Positivism of Negativism" and "The Realism of
Unrealism." The old-fashioned progressive, Macdonald explained, "a good
Deweyan or Marxian, does not believe in values apart from action." Macdon-
ald, however, saw radicalism as involving the ability to act "by not acting." He
even extolled the value of "self-ishness," which had to be "restored to

respectability in our scheme of political values."[7] Certainly de Kooning also believed that artists, in their own way, needed to be "selfish." They needed to liberate themselves by refusing to accept any style, even an avant-garde style, that had been thrust upon them. They needed to be willing to reject any vision—even a supposedly progressive vision. You can feel the positivism of negativism in Bell's ringing support of an alternative tradition in twentieth-century French painting. Each artist needed to take part in the movement of style in his or her own way—to act selfishly, to explore his or her own will. "No!"—with all its aggressive, combative spirit—was a sign of strength, of a willingness to be yourself, to embrace paint and canvas and old ideas and new ideas, sure in the knowledge that what you didn't care for you could simply set aside. There was a certain serenity in being able to say "No!" You could say it and then get on with your own work, sure in the knowledge that you were at last bending the history of art to your own will—which was a way of saying "Yes!"

II

We are offered a fascinating glimpse of the whirlingly combative "No!"-and-"Yes!" conversations that went on at the Cedar Tavern in a witty mock-Socratic dialogue written by the poet Frank O'Hara and the painter Larry Rivers. They celebrated the juggling acts that artists and poets were doing with ideas, juggling acts in which it was difficult to say where big thoughts ended and vapid absurdities began. They opened their skit with the young poet Kenneth Koch, who had just returned from Europe. Standing at the Cedar Tavern, Koch was effusing about the glories of Europe to nobody in particular. "Foreign cities," Koch proclaimed, "the Catholic temples of God, the triptychs of Masaccio, the napkins of Matisse, the skies wherever they are I forget, the fields where Michelangelo laid plans for David." Pretty soon, all the artists in the place, including de Kooning and Milton Resnick, were in on the discussion. De Kooning, thinking of Koch's trip and the whole question of Europe versus America, said, "Yah, travel is okay, Poland, the marshes, it's terrific." De Kooning was in his oracular-absurdist vein; no one could tell if he was revealing the key to his art or just stumbling through some non sequiturs. "It's like the signs I used to paint in Holland when I was a kit. Maybe inside the steeples it's dark, I don't know. But there's something about America that's further away. Take the hotdog for instance, it's simple and it's dumb and you eat it standing up. Cafes, talk, bah!" This was an American's—and a former

European's—way of saying "No!" to the Old World. Eventually Resnick decided to get serious and gave a "Yes!"-and-"No!" view of tradition, but the result was closer to a comic jeremiad. "Tradition," he said, "it's like a brick wall, you build it up, it gets higher and heavier every century but yuh keep going because yuh think there's plenty of room, and then it falls over on yuh. Why, in a hundred years nobody'll be able to do anything. And America, yuh know what America is? It's pushing that wall down."[8] Tradition, it turned out, was like a Manhattan demolition site.

To be in New York in the 1950s was to be in on all the jokes—and the jokes could have an Olympian incandescence. Writing about Hofmann, Rosenberg observed that "if art was a 'reflection of the spirit,' the 'spirit' in this case was full of grand jocundity and intellectual expansiveness, endlessly vital, erotic, disciplined, self-indulgent, simple, boyishly tricky, a Dionysius determined to set himself down completely in his system of ideas."[9] The shouted "No's!" and the sarcastic equivocations and street-smart exclamations were grounded in the bedrock of belief—in beliefs that were so fundamental that artists felt free to toss those beliefs high in the air, play with them, even parody them. The critic and playwright Lionel Abel recalled in his memoir, *The Intellectual Follies,* that there was "a certain Dionysiac feeling of renewal" among the painters in the postwar years—a feeling "which even today resists our explanations." Abel, who was trained as a philosopher and knew Sartre and took part in all the debates that swirled around the *Partisan Review* crowd, felt that the playful atmosphere had an underlying force, a force so strong yet elusive that in describing it he could do no more than say that whenever he walked into the Cedar Tavern or the Club he had the feeling that "ideas were in the air."[10] What exactly those ideas were, Abel himself was hard put to say, but we can be sure that their

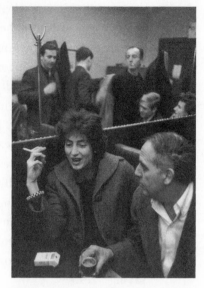

John Cohen, The Cedar Tavern, 1959. Mercedes Matter and Philip Guston seated in the foreground, Frank O'Hara standing, at right.

Larry Rivers and Nell Blaine (right) at a party, circa 1950.

roots went very far back, to a vision of the singularity of artistic experience that Kant had described in the eighteenth century, a vision that had been affecting artists, philosophers, and art historians for a very long time.

One of the ideas that was certainly in the air at the Cedar Tavern was "significant form," an idea that had originated a generation earlier and to which de Kooning had said "No!" when he complained about the "comfort of 'pure form,'" although he was probably thinking as much of John Graham, who used the term *pure form*, as of the Englishmen who spoke of *significant form*.[11] Clive Bell had first presented this striking phrase in his immensely influential book, *Art*, published in London in 1914. In his preface, Bell recalled the many conversations "about contemporary art and its relation to all other art" that he had had with his friend, the critic and painter Roger Fry. The world of Bloomsbury aesthetes like Bell and Fry, with their Oxbridge educations and frequent trips to France, was in many respects alien to the rough-and-tumble ambience of Tenth Street. And yet significant form had a back-to-basics appeal for many New Yorkers, for it provided such a succinct definition of complex phenomena—it was a way of saying "No!" to all the arcana of iconography, to all the smothering intricacies of art history. The beauty of significant form was that it located the logic of artistic tradition in some grand but essentially simple formal principle. Bell believed that "there must be some one quality without which a work of art cannot exist. . . . What is this quality? What quality is shared by all objects that provoke our aesthetic emotions?" And in order to answer this ringing question, Bell asked how it was that art created in so many different times and places could touch us in similar ways. "What quality is common to Sta. Sophia and the windows at Chartres, Mexican sculpture, a Persian bowl, Chinese carpets, Giotto's frescoes at Padua, and the masterpieces of Poussin, Piero della Francesca, and Cézanne? Only one answer seems possible—significant form. In each, lines and colours combined in a particular way, certain forms and relations of forms, stir our aesthetic emotions. These relations and combinations of lines and colours, these aesthetically moving forms, I call 'Significant Form'; and 'Significant Form' is the one quality common to all works of visual art."[12]

That traditional values were essentially formal values was not, of course, a discovery that Clive Bell and Roger Fry had made on their own. Kant, whom Greenberg would call the first modernist, had pointed to such ideas, and they were foreshadowed in the writings of Delacroix and Baudelaire, as well as in the sculptor Adolf Hildebrand's *The Problem of Form in the Fine Arts*, published in Germany in 1893, all works that in one way or another had an impact

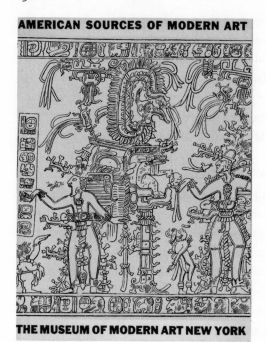

AMERICAN SOURCES OF MODERN ART

THE MUSEUM OF MODERN ART NEW YORK

Cover of American Sources of Modern Art, *published by the Museum of Modern Art in 1933.*

on Bell and Fry.[13] In the years when these Englishmen were developing their ideas, artists such as Kandinsky and Mondrian were beginning to put similar thoughts down in print, and in America the artists in the Stieglitz circle, and later Hofmann and Graham, had been thinking in related ways. In New York all these formalist ideas were embraced with a special kind of fervor, because New Yorkers, aware as they were of the distance, whether geographical or historical or cultural, that separated them from the old stomping grounds of art in Rome and Venice and Paris, were eager to believe that there was, as Bell said, "one quality common to all works of visual art." There was something democratic about formal values—they were a mystery, but they were a mystery that you needed no particular cultural key to unlock. Formal values were a universal language: An artist could grasp the workings of line and color and form in Rembrandt or Piero even when he or she knew almost nothing about the world out of which a masterpiece by Rembrandt or Piero (or for that matter Matisse) had emerged. Years later, when Clement Greenberg—whose name would become almost synonymous with a particular kind of formal values—returned from a visit to India, he was pleased to announce that "it doesn't take so long to get with it and match your eye against the indigenous eye. And you'll find that the judgments of your own taste aren't that discrepant from theirs."[14] Greenberg might not know the name of the god or

the episode in the *Ramayana* represented in an Indian sculpture, but he could grasp the significant form as easily as anybody else, and this put him on an equal footing with his cultivated Asian colleagues when he looked at Asian art.

Even America, it was clear, had its place in this great history. It meant something that in the opening pages of *Art*, Bell had included Mexican sculpture among the works that were full of significant form. All the way back in 1933, there had been a show called "American Sources of Modern Art" at the Museum of Modern Art, organized by Holger Cahill, a curator who also mounted some of the earliest exhibitions of American folk art at the Newark Museum and the Metropolitan Museum of Art. Cahill had observed of American folk art that this often anonymous work "goes straight to the fundamentals of art—rhythm, design, balance, proportion, which the folk artist feels instinctively"—exactly the characteristics of significant form.[15] The Surrealists were fascinated by American Indian art. Max Ernst amassed a huge collection of kachina dolls after coming to the United States in the 1940s, and Wolfgang Paalen had devoted special sections of *Dyn* not only to the dialectic but also to what he called "Amerindian Art." Many of the Abstract Expressionists took an interest in American Indian art; it has often been said that Pollock's technique of painting with his canvas on the floor was inspired by the sand paintings of the American Southwest, and Newman organized shows of pre-Columbian stone sculpture and Northwest Coast Indian painting for

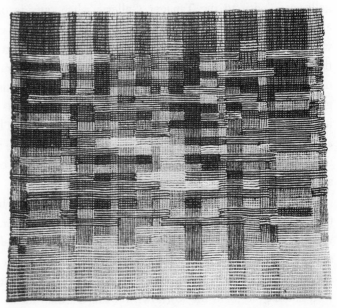

Anni Albers, Untitled, 1948.
Linen and cotton, 16½ × 19½ in.

Betty Parsons, and wrote that the Indian mounds in the Ohio Valley "are per-
haps the greatest art monuments in the world, for somehow the Egyptian
pyramid by comparison is nothing but an ornament."[16]

Artists of a Constructivist bent were also fascinated by this material.
Beginning in 1935, Josef and Anni Albers made something like a dozen trips to
Mexico, and were overwhelmed by the ancient art there and, later, in South
America, art which they had already known about in Germany, where Central
and South American material had been collected and written about since the
beginning of the century. In 1937 Josef Albers mounted an exhibition of
Mayan art at Black Mountain College. In ancient Peruvian textiles Anni
Albers discovered "the magic of things not yet found useful," a kind of signif-
icant form that emboldened her to create what she called her "pictorial weav-
ings"—compositions in thread that are among the greatest textiles of the
twentieth century.[17]

III

The concept of significant form could not come near to answering all the
questions that artists had about the nature of art, and the artists were con-
stantly saying no and saying yes to a whole range of ideas about art and art
history, and in some cases they were actually saying these things to art histori-
ans. The critic Dore Ashton recalled, in a memoir about the Tenth Street
galleries, a visit to the Tanager Gallery, when outside of the gallery she
encountered de Kooning in conversation with a bum who called himself and
who Ashton suspected really was a *Kunsthistoriker*—an art historian.[18] Now
this is an anecdote that bears some consideration, for any number of reasons,
not the least of which is that the Germanic grandeur of art history, with its ori-
gins in Hegel, was so familiar to de Kooning and his friends that among them
it became the occasion for jokes and amusing nicknames. The artists may not
all have been close students of art history (although some surely were), but
they were bumming around with the *Kunsthistoriker,* who could be regarded
as part of the ordinary flotsam and jetsam of New York.

Newman complained that artists were "surrounded by the art critic-
theoriticians and the art historians—the *Kunstwissenschaftler.*"[19] And even if it
was fun to say "No!" to the *Kunsthistoriker*—and mock their grandiose Ger-
manic titles—many artists valued their connection with a generation of
American art historians, especially Meyer Schapiro and Robert Goldwater,
who could give them the lowdown on the German ideas. In a long article

Meyer Schapiro, Self-Portrait, 1960.
Conté crayon on paper, 7 × 5 in.

called "Style" that Schapiro published in 1953, he spoke of the tradition that had grown out of Hegel's writings on art, a tradition that suggested how art's essential spirit was reconceived in different times and places. When Schapiro said that it was necessary, when speaking about art, to use "the vague language of qualities," he was surely aware that this was exactly the kind of language you might hear in the studios and the artists' bars.[20] In the late 1940s and early 1950s, Schapiro gave lectures on modern art at the New School for Social Research and New York University that were attended by many artists. In 1955, when Hess interviewed some twenty-five artists, including Porter, Frankenthaler, and Mitchell for an article titled "Recent American Painting," Schapiro's name came up repeatedly. "They attended his lectures. They came to his door and introduced themselves." Schapiro, Hess recalled, was a regular visitor to the Hansa Gallery on East Twelfth Street, one of the first artists' co-ops.[21] Schapiro was said to have convinced de Kooning to keep working on *Woman I,* which the artist had pretty much abandoned. Schapiro spoke at the Club; together with Greenberg he organized "Talent 1950," an exhibition of younger artists at the Kootz Gallery; and he helped curate "Artists of the New York School: The Second Generation," at the Jewish Museum in 1957.

While the great art historian Erwin Panofsky was anything but a supporter of Abstract Expressionism, some of the artists and their friends were aware of his ideas and concerns, and they shared with Panofsky an essentially Hegelian feeling for the dynamic relationship between art's timeless and timely dimensions.[22] In the late 1940s, Panofsky's essay "Style and Medium in the Motion Pictures" had appeared in the short-lived magazine *Critique: A Review of Contemporary Art,* in an issue that also included an Ad Reinhardt cartoon and an essay by the painter Romare Bearden. In 1945, John Bernard Myers, who worked at the Surrealist magazine *View* and would a decade later be running the Tibor de Nagy Gallery, wrote in his diary about his excitement at reading Panofsky, whose work had been suggested to him by Schapiro in a New School class.[23] One might note as well that Panofsky's essay "Meaning in the Visual Arts" appeared in 1951 in the *Magazine of Art,* a publication that kept a close watch on downtown developments; Goldwater was the editor from 1947 to 1953. There can be no doubt that when historians approached works of art, they asked rather different questions than the artists, but there were also some

important issues, about the nature and evolution of form and its relationship with society, that everybody was raising, and artists and art historians were not framing those issues in entirely different ways. When de Kooning, in his Museum of Modern Art talk, mocked the "comfort of 'pure form,' " he was encouraging his listeners to think about the meanings of forms, and those meanings were not entirely different from what Panofsky was after when he described changing perspective systems or changing conceptions of human proportion. That a form had a resonance and might even reflect a worldview was a not uncommon assumption.

In those years there was nothing unusual about alluding, almost casually, to broad conceptions of the history of style. In 1946, when Greenberg wrote about some new works by Robert Motherwell and David Smith in *The Nation*, he said they showed artists turning toward "the baroque, which Wölfflin (who died in Zurich the other day) has defined as the 'open' style par excellence— open to variety and violence of emotion as well as to large and complicated formal rhythms." In one of the small notebooks that Philip Pavia kept during his years running the Club, notebooks that are mainly accounts of who paid what in dues, there is this little bit of information: "Wilhelm Borringer: Psychology of Form." Pavia wasn't much of a speller; Borringer is of course Worringer, and *Psychology of Form* is the subtitle of his book *Abstraction and Empathy*, a book that the young critic Joseph Frank described as presenting a "continual alternation between naturalistic and nonnaturalistic styles."[24] And among the lecturers at the Club was the philosopher Heinrich Bluecher, who was married to Hannah Arendt and who believed that "our best spirit has erected an enormous edifice, the cosmopolitan style, which encompasses all forms, past and present, of man's artistic experience. Art has emerged once more as an essential of life." Bluecher's lectures at the Club, which were devoted to the idea of style and probably included discussions of Hegel and Nietzsche and Wölfflin and Worringer, so excited Alfred Kazin that he got Bluecher a job teaching art history at the New School. The great thinkers were familiar figures—almost family. During a panel discussion in 1960, when Ad Reinhardt wanted to counteract the "assumption that if you like art and you like life, you mix them up," he referred, perhaps almost in frustration, to a couple of men who had spun world-historical visions of art. "Focillon and Malraux have made this point so many times: a painter is in love with painting, not scenery."[25] Focillon and Malraux, with their panoramic view of the history of art, brought a Frenchman's voluptuous aestheticism to the wide-angle vision of the German philosophers of art.

IV

In Meyer Schapiro's and Robert Goldwater's writings, you find some interesting references to European thought, especially to Alois Riegl, an important and at the time still somewhat obscure German historian who was born in 1858 and died in 1905. I would wager that Riegl's great idea of the *Kunstwollen* was one of the ideas that Abel felt was hovering in the air at the Cedar Tavern and the Club. If Bell's "significant form" was formalism's pragmatic, what-you-see-is-what-you-get side, Riegl's *Kunstwollen* was formalism's yeasty, unstable, fascinatingly amorphous doppelgänger.

The *Kunstwollen* is the artistic will or will-to-form, and in German and English it has an immediate, peremptory ring, a sense of artists (and cultures) *willing* shapes into being—and this surely struck a chord in the ebullient atmosphere of postwar Manhattan. The art historian Christopher Wood defines *Kunstwollen* as the "ineradicable impulse to design and figuration."[26] Riegl, in his famous studies titled *The Late Roman Art Industry* and *The Dutch Portrait Group*, tried to focus on the internal, freestanding logic of groups of forms ranging from Roman belt buckles to the portraits by Hals and Rembrandt. He rejected the idea that art was always moving toward some single, ideal kind of quality; what interested him was how a culture found a form that matched its spirit. Riegl could be—and was—attacked for what some said was his indifference to the historical particular, his downgrading of evolutionary forces, and his disregard for the autonomy of the individual. But his ideas could also be fruitfully combined with an interest in historical evolution.[27] He believed that the drive to formal expression is a universal drive, one that is reimagined in every time and place. But he rebelled against the historical determination of style, against the gradual climb to a perfect classical vision. Goldwater, in *Primitivism in Modern Painting*, published in 1938, pointed to Riegl as a guide to appreciating the freestanding value of different kinds of art. Riegl, Goldwater wrote, "is, in effect, forcing attention to the forms of art, whether naturalistic or abstract, as they appear as finished products. He is opposing an evolutionary point of view which seeks the explanation of each thing in a forerunner of that thing rather than in itself. His intention is simply to induce consideration of the abstract styles as styles"—which made him, Goldwater suggested, "the prophet of an expressionism whose beginning he just lived to see" at his death in 1905.[28] And of course that expressionism was in turn one of the forerunners of Abstract Expressionism.

The more I think about Lionel Abel's description of the ideas that were in the air at the Cedar Tavern and the Artists' Club, the more I believe that he was talking about the *Kunstwollen*. "There was something *living* in [the Cedar Tavern] which gave reality to the ideas expressed there," Abel explained. "Something had made the painters who came to the art club and the Cedar Bar at that time similarly enthusiastic about the employment in painting of nonfigurative forms. What caused their excitement for these forms to that degree at exactly that time I cannot say. . . . But it was the conjunction of the excitement with these forms that made for the life of the bar."[29] The *Kunstwollen* could be regarded as a more specific, sharply focused variation on a more general idea, the idea of the weltanschauung. As Paalen put it in *Dyn*—in an article called "The New Image" that had been translated from the French by Motherwell— "Each conception of the world, each Weltanschauung of a given culture has a corresponding 'cosmogony' of pictorial representation."[30] Riegl's *Kunstwollen* might be in some ways less tightly lashed to a general cultural experience than the phenomenon that Paalen was describing, but they clearly overlapped, and for New York artists, whether they knew Riegl's terminology or his name hardly mattered. His ideas had been absorbed through the root system of the New York School. By melding a Nietzschean will-to-power with the very power of form, Riegl offered a solution to the old mystery of how form and content might be merged. Riegl led people to admire art that was untouched by the naturalistic ideals of the Renaissance—and this could, specifically for New Yorkers, include the sand paintings, rock carvings, rugs, and totem poles of the North American Indians, which Pollock, Newman, Rothko, and Adolph Gottlieb had been interested in since the 1940s. Riegl was fascinated by the decorative arts; and I imagine that when John Bernard Myers, as a fledgling avant-garde art dealer, mounted the exhibition of antique lace of which we have already heard, he felt that he was spotlighting the formal values of minor arts, as Riegl had in many of his writings. Pollock, it is worth remembering, visited the show twice. Riegl also had a taste for painterly painting—for Rembrandt, for Hals—which tied right in to postwar New York. He liked, in fact, anything that was not exactly high classical, which was a Manhattan sort of attitude.

Riegl's art history—and the work of historians who responded to him in one way or another, including Wölfflin, Worringer, and Focillon—had its prehistory in the same nineteenth-century romantic mingling of idealism and anti-idealism that lay behind the work of Hofmann, de Kooning, and Pollock. Certainly, by the 1950s, a great many influences were all mixed together.

William Seitz, a young art historian writing a Ph.D. thesis about the Abstract Expressionists for Princeton, quoted Focillon on Celtic art, on its "undulating continuity where the relationship of parts ceases to be evident, where both beginning and end are carefully hidden," and pointed out that "Pollock and Focillon are contemporaries. Can it be possible that the modern critic's remarks apply to the modern painter, whose work he never saw, even more aptly than to the manuscripts that actually inspired his imagination?"[31] And interestingly, although Schapiro was a precise writer, in introducing in his 1953 essay "Style" the account of the ideas of Wölfflin and Riegl and many others, he gave a definition of *style* that the guys at the Cedar Tavern would understand. He said, "Style is, above all, a system of forms with a quality and a meaningful expression through which the personality of the artist and the broad outlook of a group are visible."[32] True, painting might be stifled by a system—Hess would head his first monograph on de Kooning with Nietzsche's observation, in *The Twilight of the Idols,* that "the will to a system is a lack of integrity"—yet the expressive grandeur of form, the *Kunstwollen,* was at the core of Abstract Expressionism.[33] New Yorkers responded instinctively to the idea that artistic style was a way of realizing oneself in a time and place—and for them the time was 1950 and the place was Manhattan. The artists were caught up in a new, optimistic view of their place in history; they would not be pawns in anybody's dialectic. Riegl emphasized the sense of forms as being willed into being in the moment of their creation, and that appealed to New York's the-time-is-now spirit. "Modernity," Schapiro explained, "saw a new awareness of the . . . timeliness of one's present historical moment or century . . . marking the distinctiveness of a new historical epoch and attributing especially to the initiative of bold, innovating minds the motions of an historical process."[34] The "new" in the New York School was connected to such sweeping ideas.

V

Artists and art historians are often represented as inherently mismatched, like oil and water. When Panofsky, early in the 1960s, received a copy of *Art News* that contained a review of his book *Renaissance and Renascences in Western Art,* he noticed elsewhere in the magazine what turned out to be a typographical error in the spelling of the title of Newman's painting *Vir Heroicus Sublimis,* and wrote a letter to the magazine. *Art News* had printed *Sublimus*—an antiquated form. Newman's vast red vision, punctuated by five of the vertical

Barnett Newman, Vir
Heroicus Sublimis, 1950–51.
Oil on canvas, 95⅜ × 213¼ in.

lines that he called "zips," was one of the canvases
illustrating a pioneering article by the young histo-
rian Robert Rosenblum, "The Abstract Sublime," in
which he argued that Newman "explores a realm of sublimity so perilous that
it defies comparison with even the most adventurous Romantic explorations
into the sublime."[35] Responding not to Rosenblum's essay but to the mis-
spelling of the painting's title, Panofsky wrote, "I find myself confronted with
three different interpretations of the curious form *sublimus:* does Mr. Newman
imply that he, as Aelfric says of God, is above grammar; or is it a misprint, or
is it plain illiteracy?" Newman, with the help of Schapiro, entered into an epis-
tolary argument about Latin grammar.[36] Barnett Newman correcting Erwin
Panofsky's Latin is something to contemplate: an example of crazy American
gutsiness that recalls Edmund Wilson's taking on Vladimir Nabokov's Rus-
sian a few years later.

While Panofsky and Newman lived in very different worlds and clearly
had little or no patience for each other's ideas, they nevertheless shared some
basic concerns. Both believed that visual forms reflect deep personal and com-
munal necessities; so did all the artists and art historians they knew. This idea
had been revolutionary a half century earlier; now it was becoming part of the
climate of New York. And that climate was affecting both artists and art histo-
rians. In 1945, the year that John Bernard Myers heard about Panofsky from
Schapiro at the New School, *The Art Bulletin* published, in a single issue,
Schapiro's essay on the hidden symbolism in Robert Campin's early-fifteenth-
century triptych of the Annunciation and Millard Meiss's study of light in
early Netherlandish painting. Meanwhile, during 1947–48, Panofsky gave his
lectures on early Netherlandish painting at Harvard; they were published in

Willem de Kooning,
Judgment Day, 1946.
Oil on paper, 22⅛ × 28½ in.

book form in 1953. Three years after that, the Metropolitan bought the Robert Campin altarpiece. It is true that Robert Campin, Jan van Eyck, and Rogier van der Weyden were not names that came up much in artists' discussions in the decade after the war. When an Old Master was mentioned at the Club, it was more likely to be Rembrandt or Piero. We know, nevertheless, that what interested Schapiro interested many New York artists, and I believe that the combination of bluntness and mysteriousness that Schapiro and Panofsky saw in early Netherlandish painting was relevant to Abstract Expressionism, too. The contorted figural forms in de Kooning's *Judgment Day* (1946), which de Kooning told Hess represented the four angels of the Gates of Paradise, were said to have been inspired by elements in Bruegel's prints of the vices, which de Kooning had seen in a *Metropolitan Museum of Art Bulletin*.[37] And the sculptor Seymour Lipton, whose abstractions, with their chambers-within-chambers configurations, were much admired in the 1950s, said that "in the

Pieter van der Heyden
after Pieter Bruegel the Elder,
Desidia (Sloth), 1558. Engraving,
8⅞ × 11½ in.

late thirties I made wooden pieces based on social problems, the formal mood stemming from such things as Gothic bestiaries, Hieronymus Bosch, German Expressionism and primitive sculpture."[38]

When Harriet Janis and Rudi Blesh, in their 1960 book on de Kooning, wanted to suggest the broad metaphoric implications of de Kooning's fractured figural imagery, they turned to Panofsky's *Studies in Iconology* and quoted his observation that when we look at a work of art we can see how "the total habits of the time bear subtle witness to themselves."[39] Thoughtful people were intrigued by that subtle witness—which often involved a kind of hidden symbolism. In the postwar years, Schapiro, Panofsky, and Meiss were all convinced that the miraculously frank naturalism of early Netherlandish painting carried a greater freight of meaning than many had imagined. Hess observed that "we often become lost in wonderment among [Pollock's dancing gestures], as we are among the invisible brushmarks of Jan van Eyck or the feathered glazes of Giorgione." Like the brushstrokes in a de Kooning, the still-life objects in the Campin Annunciation were regarded as lasting records of immediate experience; and in both cases there was something going on beneath the surface—a mysterious meaning lodged in the very obviousness of the form. A mousetrap in a carpenter's shop might suggest the way God baits the Devil; light flooding through a stained-glass window symbolized the otherworldly intactness of Mary's womb. Certainly the idea of hidden symbols was on Ralph Ellison's mind when in 1962 he published "On Bird, Bird-Watching and Jazz," and mused on the reasons why Charlie Parker was called Bird. Ellison reminded his readers, perhaps somewhat sardonically, that the "symbolic goldfinch" that "frequently appeared in European devotional paintings . . . during the thirteenth and fourteenth centuries . . . became a representative of the soul, the Passion and the Sacrifice."[40]

The idea that objects and experiences had hidden meanings made perfect sense in a city where Freud and Jung were reaching the zenith of their influence. In 1939 Pollock began seeing a Jungian analyst, Dr. Joseph Henderson. Initially, Pollock was having a difficult time verbalizing his thoughts. After a while, though, he began to present Dr. Henderson with drawings, and as he discussed these images, he found that it was much easier to talk about what he was feeling. Looking at the drawings, we see a sort of Surrealist bestiary that obviously had as much to do with Pollock's close study of contemporary work by André Masson and José Clemente Orozco and David Siqueiros as with the artist's unconscious. Yet from Dr. Henderson's perspective, the emblematic character of these drawings, with their centralized devices and

Jackson Pollock, Untitled, 1939–40.
Pencil on paper, 13 × 10¼ in.

half-animal, half-human figures and angular designs, illustrated "the experience he had been through. They seemed to demonstrate phases of his sickness . . . showing a gradual psychological reintegration." By analyzing these images—by understanding, for example, that "the huge snake . . . denotes the unconscious . . . upon which the human figure is completely and dependently attached"—Henderson could help Pollock come to terms with his demons.[41] The Jungian analyst was approaching Pollock's drawings in a way that was not entirely unlike the way that Panofsky or Schapiro approached the search for hidden symbols, and for some this might in turn be related to the esoteric philosophy of a figure such as P. D. Ouspensky, who believed in the existence of "a knowledge which surpasses all ordinary human knowledge" and who was widely read at the time. Lois Orswell, an important collector of contemporary art and a good friend of Smith's, was fascinated by some of Ouspensky's ideas.[42]

Postwar American painting was often spoken about as being both frankly expressive and complexly symbolic—and this was exactly how the art historians were describing Netherlandish art. There were far-off echoes and secret affinities that linked the New York artists to a wider sense of history and ideas. Surface and substructure, outside and inside were discussed at the Cedar Tavern and the Club, just as they were discussed among art historians. The *Kunstwollen* was both conscious and unconscious, and its workings were related to a time and place, which in New York was the daily onslaught of urban life, which also had lingering, enigmatic implications.

VI

It's not surprising that the New York artists, addicted as they were to the hardest-to-define ideas, should have created a freewheeling, decade-long seminar-cum-party whose full significance nobody has ever really been able to explain. The Club was the place where the artists gathered to "condemn and affirm, say no and say yes, say yes and say no." Irving Sandler, who ran programming at the Club in the late 1950s, began a 1965 *Artforum* piece by explaining that he wanted to counter the "myth-making," the "distortion of

past events," by attempting "to reconstruct what actually happened."[43] Yet this has not proven very easy to do, since at the end of a long evening at the Club, different people often had wildly contradictory recollections of what had actually been said, to say nothing of what what had been said might actually mean.

Goldwater, in a 1960 essay about the New York School, characterized the conversation at the Club as possessing a "migratory, amorphous, but always positive spirit." And how could it have been otherwise, when there were so many feelings in the air? There were lectures by historians and philosophers, conversations among the Abstract Expressionists, panel discussions with artists and poets on topics ranging from "The Purist Idea" to "The Image in Poetry and Painting" and "The Problem of the Engaged Artist."[44] There was always socializing after the panels, and from time to time there were parties— a "Come as a Painting" costume party; a party for Sandy and Louisa Calder on the eve of their departure for France; a wedding party for the painter Joop Sanders and his bride, Isca. The atmosphere at the Club was fairly chaotic; people were analyzing one another's ideas in so many different ways that, as Pavia recalled, "the arguments went in a see-saw pattern; encountering of personalities, feuding of personalities; play down ideas, play up ideas; wronging down the cause and righting up the effect," and

John Cohen, The Artists' Club, 1959. Thomas Hess is at center.

so on and on. In November 1956, the fall after Pollock's death, when the Club held an evening in his memory, there was a good deal of discussion about de Kooning's already famous remark that Pollock had broken the ice. As the writer B. H. Friedman recalled, Greenberg asked, "Broke the ice for whom?" and made the argument that de Kooning and Pollock were not part of the same tradition. De Kooning responded that he had simply "used a typically American phrase about a typically American guy." Friedman described Newman announcing dramatically, "Jackson lives!," to which de Kooning replied, "What do you mean? I saw him buried in Springs." As Friedman summed up the evening, "Two opposing feelings were expressed strongly:

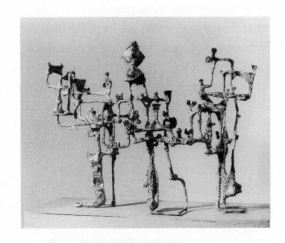

Ibram Lassaw,
Procession, 1955–56.
Bronze and silver, 32 in. high.

first, that this should be a proper memorial, and second, that there should be neither sloppy sentimentalizing nor premature myth-making." The talk went round and round, and was occasionally brilliantly skewered. Another evening, there was a discussion as to whether it was vain to sign one's paintings. Fairfield Porter was there, and he stopped the discussion by saying, "If you are vain it is vain to sign your pictures and vain not to sign them. If you are not vain it is not vain to sign them and not vain not to sign them."[45]

Great art centers have probably always been fueled by painters and sculptors who were self-conscious in the extreme, and for a time in the 1950s there was no more self-conscious city than New York, and in that city there was no

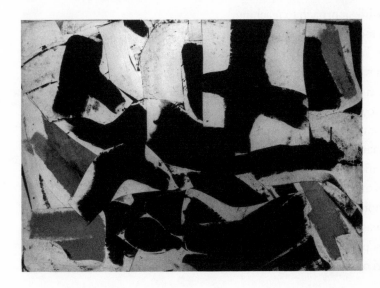

Conrad Marca-Relli,
Junction, 1958.
Collage of painted canvas,
56 × 77½ in.

place where artists were more likely to stand up and say what they believed, or what they thought they believed, than at the Club. Apparently a group that had been meeting at the sculptor Ibram Lassaw's home at the end of the 1940s had all agreed that the artists needed a place where they would be able to go when they needed a break, something like the clubs so common in Italian neighborhoods. Years later, when artists liked to reminisce about the Club, the painter Lewin Alcopley wrote that Kline had heard of a loft on Eighth Street that was going to be vacated by a commercial artist who was going back to New Zealand. The problem of raising the five hundred dollars in key money that was needed for the loft held things up a bit, but finally Pavia advanced almost all of it. The Club first met in this loft on Eighth Street and later was at various addresses in the neighborhood. Some accounts say that there were twelve charter members, namely de Kooning, Lassaw, Cavallon, Pavia, Kline, Alcopley, Resnick, Sanders, Landes Lewitin, Conrad Marca-Relli, James Rosati, and Jan Roelants. Other accounts of the initial membership include twenty names, among them Jack Tworkov. Although there was some initial talk that the membership should exclude women, homosexuals, and artists who had had significant affiliations with the Communist Party, none of this lasted long. Since Lewitin was invariably opposed to taking on new members, the original rule that new members had to receive a unanimous vote of the charter membership was revised to allow for new members to be admitted despite one negative vote. The first women admitted were Elaine de Kooning and Mercedes Matter, the latter of whom would found the New York Studio School a decade later, an immensely important institution modeled on Hofmann's drawing-from-life approach to teaching.

At first, each Club member had a key and came when he pleased. Wednesday was members' night; Friday, anybody could come. To Goldwater, the goings-on at the Club were all "a little like a floating crap game . . . the proceedings always had a curious air of unreality. One had a terrible time following what was going on. The assumption was that everyone knew what everyone else meant, but it was never put to the test; no one ever pointed to an object and said, see, that's what I'm talking about (and like or don't like)."[46] Keeping out the specifics—not discussing A's work or B's work, at least directly—was a policy at the Club. It was a means of preventing the meetings from turning into ad hominem critiques, and an important by-product of that understandable rule was some of the mad-hatter's-tea-party airiness of the talk, the way the crazy play of ideas created an exuberantly abstract buzz. In April 1952, Jack Tworkov wrote in his journal that "the enthusiastic clash of

ideas that takes place in the Club has one unexpected and, in my belief, salutory effect—it destroys, or at least reduces, the aggressiveness of all attitudes." This could seem a happy chaos—a ramshackle dialectic. "I enjoy the talk," Tworkov wrote, "the enthusiasm, the laughter, the dancing after the discussion. There is a strong sense of identification. I say to myself these are the people I love, that I love to be with. Here I understand everybody, however inarticulate they are."[47]

The driving force in the early years of the Club was Philip Pavia—the man who had made a note of Worringer's *Abstraction and Empathy* in one of the little books that he used to record phone numbers, ideas for future lectures, and membership dues. Pavia was the son of an Italian immigrant stonecutter who, as Hess recalled, "made some of the perfectly hewn stone arcs that ring the curb of many old New York streets. Some are as long as eight feet. This was one of Louis Pavia's specialities." Philip was born in Bridgeport, Connecticut, in 1912. He'd been on the WPA, and had known Gorky and Pollock since the 1930s, when they all walked the streets of the city late into the night, perhaps stepping over the curbs that Pavia's father had cut. It was men such as Pavia, who remembered New York before the war, who took the initial steps in finding the space and setting up a structure for the Club. Pavia was better fixed financially than many downtowners. He felt able to help people out with loans, and he put up more than his share of the operating expenses. Later in the 1950s, Pavia edited and published an elegant artists' magazine, *It Is,* which

Philip Pavia, sculpture installed at the Kootz Gallery, 1961.

intermingled high-quality reproductions and pages of notes and observations by the artists. Hess said that "among the artists of his time and place, Philip Pavia is the best soft-ball player. . . . He likes progressive jazz, basset-hounds, beer, and most of all sharp, controversial talk among painters and sculptors."[48]

At the Club, as general master of ceremonies with the obviously ironic title Dean of Faculty, Pavia kept the conversation going for the first years, until he relinquished his position in 1955 in order to devote more energy to his own work. His first one-man show, at Kootz in 1961, consisted of darkly patinaed bronzes. These enigmatic, totemic configurations came out of Abstract Expressionism; it was as if the encounter of several brushstrokes in de Kooning's *Attic* or *Mailbox* had given birth, a decade later, to a three-dimensional form. There was something arresting and even a little alarming about Pavia's looming sculptural presences, with their knifelike edges and muffled figural associations. Working with modeled forms—which he cast in one of sculpture's most traditional materials—Pavia was getting involved with a revival of bronze casting that seemed to go against the School of New York's ultra-casual sensibility.[49] Much of a decade would pass before de Kooning himself modeled some figures and exhibited them in bronze editions. Nobody would have predicted *that* in the 1950s, when it was apparently Pavia's position as a sculptor in a milieu dominated by painters that enabled him to stay a bit above the fray. At the Club, he was probably less of a participant than an impresario creating an environment where everybody could get in their two cents, if not exactly say their fill.

VII

Although de Kooning and Kline and many others of their generation were key figures at the Club, as a social force this meeting place was ultimately more important for the younger artists than for the older ones, who by the early 1950s were already beginning to establish careers far beyond Eighth Street. For certain senior members, the Club was becoming less a place to discover things than to confirm what you already knew. It was their downtown power base. Lionel Abel recalled being invited to speak at the Club by Hess, and how Motherwell urged him not to go. "You know what the Club is, don't you? . . . I'll tell you what it is. . . . It's Bill de Kooning's political machine."[50] Even de Kooning's friends had their reservations. Fairfield Porter, writing to the critic Lawrence Campbell in 1960, complained of "a desire to 'administer' the art world (which the academicians have, though now less effectively) and

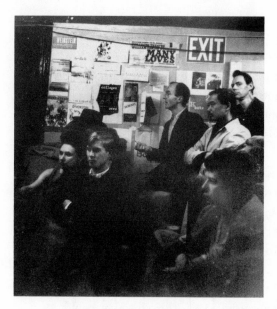

Fred McDarrah, Club Panel Discussion, 1959. Frank O'Hara is at center.

the Club has, and Pavia." Porter, in fact, in a letter to his son Laurence in 1956, said that de Kooning was the only one of the old-timers at the Club who was worth listening to. He complained "of the complacent and conceited painters at the Club, who still repeat the ideas which are not painterly ideas (always excepting Bill) that no longer (if they ever did) nourish me." For Porter, who by this time was close to a new generation of writers and artists, including O'Hara, Ashbery, Rivers, Jane Freilicher, and James Schuyler, it was "younger people I know, especially in literature, [who] keep me alert."[51] In 1956 Irving Sandler, who was just beginning to write about artists such as Mitchell and Alex Katz, was organizing the Friday-night programs. At the Club, it was probably the younger participants—no doubt including many painters whom Porter found "inarticulate, perhaps even stupid"—who sustained the conversation over the long haul.

No single idea was promoted at the Club, but there was a fascination with how ideas bumped up against one another or slipped into one another or appeared or disappeared. In 1954, when James Schuyler was visiting the American Academy in Rome, he complained in a letter to Freilicher about the dull conversation. "What a bunch," he exclaimed. "They make an off-night at the artists' club sound like 'Socrate.' "[52] What presumably gave the goings-on at the Club their unique dynamic was the fact that a number of different generations—and backgrounds and attitudes—were involved. The Club could be a crazy laboratory, where these two generations, as different as they were, discovered that they were equally suspicious of ideologies, artistic or otherwise, either because they had already seen too much of that kind of thing, or because they were too young to have experienced any of it and could not imagine why anybody would care. The historians and philosophers who were invited to speak in the first years of the Club—including Arendt, Bluecher, the student of mythology Joseph Campbell, and also younger philosophers

such as William Barrett and Abel—might almost have been invited to inform the artists about ideas that the painters and sculptors could go right ahead and reject. Goldwater, in an editorial that he published in the *Magazine of Art* in 1952, observed the strange ambivalence that the artists evinced toward "their invited guests, whose ideas they had come to hear," but to whom they acted in a way that was "at once proud and humble, eager and resentful, explosive and secretive, generous towards art but possessive of the results of their own work."[53] The confusing talkathons at the Club might obscure the mixed motives that lay behind this or that particular statement, but that could be therapeutic. Painters and sculptors were feeling their way through things. The older artist who appeared indifferent to Surrealism could have once upon a time been a great admirer of André Breton, while the younger poet who embraced the brusque pronouncements of his elders was probably looking for a way out of the formalism of the New Critics that he had studied in college.

The very presence of a thinker like Arendt, who was absorbed in the question of man's relationship to society but not from a Marxist perspective, could be a dialectical—or at least an oppositional—presence at the Club, where the prevailing attitude was that you wanted to be left alone in your studio. The Club was an absurdist clearinghouse for ideas, and the artists were glad to speak their minds as intellectual currents whizzed by. Arendt had been a student of Heidegger's, and would later introduce American readers to the writings of Walter Benjamin, who had been interested in the work of Riegl. During the 1951–52 season at the Club, there was a lecture on Heidegger, whose ideas were of interest to Schapiro, who later wrote several responses to the German philosopher's discussions of van Gogh's shoes. Schapiro believed that Heidegger was wrong to believe that these were the shoes of a peasant, and to argue that they revealed "a truth about the world as it is lived by the peasant." For Heidegger, these shoes became the vehicle for a rather grand, general idea about the work of art—about "the happening of truth." But Schapiro pointed out that the shoes Heidegger was talking about were in fact van Gogh's own. According to Schapiro, these battered leather objects were a more personal and inward-turning avowal by the artist, "endowed with his feelings and revery about himself." Heidegger's ideas surely attracted Schapiro on account of their very scale; the essay in which the philosopher discusses van Gogh, "The Origin of the Work of Art," was, according to Schapiro, a study of "the nature of art as a disclosure of truth."[54] But once Schapiro had acknowledged Heidegger's ambitions, he immediately proceeded to whittle away at them. In a sense, Schapiro's van Gogh was closer to

Fri., March 14, 9:30 PM (sharp)
Speaker: JOHN CAGE
 "CONTEMPORARY MUSIC"
Introduced by Frederick Kiesler

Last Friday Night's Panel was:
Moderator: JOHNNY MYERS
FREILICHER, HARTIGAN, LESLIE
MITCHELL, O'HARA, RIVERS.

Guests must be accompanied by
members or present written invi-
tation. Please limit guests per
Club regulations.
 39 East Eighth St.

*Postcard announcing
a lecture by John Cage
at the Artists' Club,
March 1952.*

an Abstract Expressionist, more purely involved with himself than with the situation of another—of the peasant, for example. And there was something in Schapiro's healthy skepticism that was characteristic of the spirit of the 1950s. Like the artists at the Club, Schapiro "entertained" Heidegger, but only in order to reject him. Indeed, there are many essays by Schapiro that, in their carefully reasoned way, register a resounding New York "No!"—just think of his eviscerations of Freud's work on Leonardo.

Certainly everybody who got together at the Club enjoyed the prospect of walking away from a big idea, whether that idea was Surrealism or Existentialism or significant form or Riegl's *Kunstwollen*. If there was one strong impression that comes through from the Club, it was a general one—a sense of the muscular, oppositional heat of debate and dialectic. There was a belief that to enter into that contradictory spirit was to enter into a large history, and, by opposing and juxtaposing the parts of that history, to find painting's essence—which would be its future. Panels—or possible panel ideas—such as "Weakness of Bauhaus" and "The Sickness of the Cult of the Hero" highlighted the Club's taste for puncturing an orthodoxy or an illusion. In the Ph.D. thesis that William Seitz was writing about the Abstract Expressionists at the beginning of the 1950s, we are given an unusually convincing description of the thinking and feeling at the Club. He titled one of his chapters "The Problem of Opposites," and quoted Motherwell as saying, "Drama moves us: conflict is an inherent pattern in reality." Seitz invoked classicism and romanticism, Nietzsche's *Birth of Tragedy*, the Apollonian and the Dionysian. And

he observed that "among artists the question of opposites is usually tied up with the words romantic and classic. In a discussion at the Artists' Club, de Kooning opposes the 'potatoes of van Gogh' to the 'pebbles of Arp': 'The Potato seems like a Romantic [organic] object; . . . you can watch it growing if you don't eat it. It is going to change—grow, rot, disappear. A pebble is like a Classical thing—it changes little if any. . . . If it was big you could keep the dead down with it. . . . The Classical ideal is not around much anymore.' " "A few weeks later" at the Club, Seitz recalled, the critic James Johnson Sweeney offered "another metaphor, quoting Wordsworth's image of the stone as 'Euclid's element,' and the shell as poetic truth: 'something of more worth.' "[55]

One of the talks at the Club that has come down to us was given by Frank O'Hara in 1952. His subject was design in poetry, which he started right off by saying must be distinguished from form—here were those opposites again. "I would say that design, as it relates to and exists in Poetry, is the exterior aspect as opposed to the interior structure which we call form. Form may be completely mysterious to the reader, though nonetheless real in its existence and causality; design must be apparent, it *is* that which is apparent to the eye and ear." O'Hara set up a dialectic, and then he reached into history to discuss different kinds of poetry design. There were the "long, involved, rather grandiose lines of Whitman, each almost a paragraph, [which] must be read and heard in a noble Homeric tone; the short line for love lyrics and meditations (say Byron's 'So we'll go no more aroving') must be read slowly." O'Hara emphasized "the visual and typographical appearance of design," yet he said that design "also works beneath the surface of the poem and still does not slip into the category of form."[56] But then where did design end and form begin? And where was significant form in all this? Form seemed to be deep meaning—a truth with its own logic, the large shape, the direction, the *Kunstwollen*—the trajectory of a love lyric, say. Design was more conscious. But no clear distinction could be made, and here we begin to understand the confusions that were reported by artists and writers who frequented the Club.

VIII

I would describe the chaotic discourse at the Club as melting-pot dialectics. There was a clash of styles, theories, sensibilities, each with its long history; and now, in the melting-pot city, they were mingled in strange, ever more mysterious ways. A brusque kind of dialectical thinking, familiar from the

radical politics of the 1930s, was inherent in an art scene that got a kick out of surveying the Old World from a New World perspective. De Kooning, in his lecture at the Museum of Modern Art in 1951, said, "Some painters liked to paint things already chosen by others, and after being abstract about them, were called Classicists. Others wanted to select the things themselves and, after being abstract about them, were called Romanticists. Of course, they got mixed up with one another a lot too."[57] And of course the mix-up was what interested the New Yorkers. The melting-pot idea also had a history, a genealogy that went back to Paris, and dated at least to the nineteenth century. The English writer George Moore had written of his friend Manet that "the artist must arrive at a new estimate of things; all must go into the melting-pot in the hope that out of the pot may emerge a new consummation of himself."[58] A new consummation of himself, a new *Kunstwollen:* This was what the New Yorkers were after.

The thrill—the grandeur—of art was in the mix-up, the melting pot, and what an artist could pull out of that. And as critics looked back from this everything-becoming-something-else moment, the past could look like one great melting pot, too. Greenberg, writing in 1947, might maintain a fairly straightforward view of the classic-romantic split that had animated art for much of the nineteenth century, arguing that "while Delacroix indicated the color and brushwork of the future, it was the 'cold' Ingres who prescribed the mood of its composition and draftsmanship." But by the 1950s, the classic and romantic lines were getting all jumbled together. Hess argued that "Ingres' inspired Neoclassicism and formal invention . . . led so inexorably . . . to the Postimpressionist 'wild-beast' streaks of pigment." Hess was saying that Ingres was a kind of stealth romantic, drawing from his curving lines a heedlessness that would seep into the intensified color of the Post-Impressionists. And Porter observed in 1955 that "Willem de Kooning's work is full of paradox. . . . He seems to have gotten from Ingres an appreciation of color, and it is as if Delacroix's influence led him to demonstrate Ingres' dictum that 'what is well drawn is well enough painted.'" How confused history had become in New York, the melting-pot city, now that Delacroix, Mr. Color, could inspire one's draftsmanship, and Ingres, Mr. Line, could guide one's color. In *Counter-Statement,* Kenneth Burke had played with the " 'classic-romantic' dichotomy," suggesting that a classicist's sense of reason could discipline a romantic's sense of dynamic life, so much so that at certain times "classicism might . . . be called the flowering of a romantic excess."[59] In the work of certain New York painters, line and color were forever playing an attraction-of-

opposites drama, and classicism could indeed emerge from romantic excess. In Robert De Niro's canvases, the extravagant, loose-edged areas of color were just barely contained by the careening black lines—as the critic Martica Sawin has put it, he reconciled "the rhythm of the line and the melody of the color."[60] And in Leland Bell's mature work, the hard-edged areas of deep blue and strident orange and Pompeian red had the imperious power of purist abstraction, a power that was set in a tense confrontation with the athletic naturalism of bounding black outlines.

Classic and romantic were switching places, so much so that at certain points they seemed to become one and the same. The two books that Schapiro published in the early 1950s, one on van Gogh and one on Cézanne, might have been said to represent a pairing of romantic and classic, a reaffirmation of the age-old conflict between the painterly and the linear, except that van Gogh, through the dark outlines that he used to surround his objects, could be said to be more linear than Cézanne, and that Cézanne was, for all his classical longings, as Schapiro would point out, even late in life a man of furious though submerged expressionist emotions. In *Arts* magazine in June 1959, the painter and critic Sidney Tillim observed that the distance that had once seemed to exist between the painterly (which was romantic) and the Constructivist (which was classic) now hardly existed at all. "If today the 'geometric' is classic," he wrote in this piece, which had the resounding title "What Happened to Geometry?," "it differs from the romantic only in technique, for at the root both share a common goal—art (classicism or romanticism) as its own subject, art as attitude."[61] Style was not structure but attitude, maybe not form but design—to go back to O'Hara. And a polarity such as classicism versus romanticism was now something to be treated playfully, arranged in different ways, but then that was because it had all been going on for so long already. What was it that Marx had said about history being tragedy the first time around and farce the next?

Robert Motherwell, speaking at a symposium in Provincetown in the summer of 1949, criticized an attempt that had been made by the legendary Parisian art dealer Daniel-Henry Kahnweiler to define romanticism in relation to classicism. Motherwell's canvases, painterly yet angular, with figural references that are a kind of ultrasophisticated version of the abbreviated mystery of glyphs found in prehistoric caves, were already pretty well known in the late 1940s. It is "silly," Motherwell said in Provincetown that summer, pointing to a passage in what he characterized as Kahnweiler's "beautiful book on Juan Gris," to make a distinction "between 'classical' artists who place 'the

unity of the work above the expression of their emotion' and 'romantic' artists who 'sacrifice form in their need to express themselves.' " And why was it silly to draw a distinction between romanticism and classicism? Motherwell's line of argument, which was of a piece with the melting-pot dialectics that were being heard from de Kooning and others around the same time, was that all successful art was always both romantic and classical, that it had "qualities [that] depend on the qualities of the self who made it" (and are therefore romantic) and also, if successful, the capacity to arouse "in us that unity of feeling that we call 'classical.' " The idea here was that the individual artist had the ability to unify and transcend opposites, but this was an idea that was in itself deeply romantic. And when Motherwell focused on the artists "who unify their expressions by their subjective force" and went on to argue that "a shriek" could have "a prolonged, complicated, clear internal structure," it would be difficult to feel that for him the core of art was not closer to what we think of as romantic than to what we think of as classical—at which point it hardly mattered what he said about the particular words.[62]

In their zigzaggingly argumentative way, the New Yorkers were taking their stand on what modern art was about. It was clear that everybody enjoyed tossing around the old meanings, almost as if European art were a charming but maddening family genealogy, with secrets and confusions that each artist was going to have to spin together in his or her own way. Ultimately, the melting pot was to be found inside the studio. In 1952, the painter Alfred Russell, a man of romantic literary tastes who rubbed shoulders with everybody at the Cedar Tavern and the Club, wrote about his experience in the studio. He had been painting abstractions, delicate compositions with bundles of lines and tiny swatches of color that amounted to another color-versus-line dialectic, but his interest was gravitating to figures echoing the ambiguous dramas of late Hellenistic reliefs. "The space discovered in the studio," Russell observed, "is a pathetic space filled with sounds and movements, the Homeric clanking of the hoplites, fragments of amber tossing in the Euxine Sea, the muffled cries of Villon and Ronsard, Goya's protest, etc. To indicate them we use calligraphy, invented constellations for future navigation outward to the edge of the canvas, outward to the edge of all space."[63] The studio was a kind of cauldron. And each artist was his or her own alchemist-cum-dialectician, using calligraphy and "invented constellations" to will experiences—those "sounds and movements," those echoes of Villon and Goya—into form and space.

SOME VERSIONS OF ROMANTICISM

5. HEROES

I

"Romanticism is not dead," Eugene Jolas announced in 1941 in *Vertical: A Yearbook for Romantic-Mystic Ascensions,* which was published by New York's Gotham Book Mart. The yearbook had a striking frontispiece and cover design by Calder, with a snakelike, ascending spiral, and a trio of drawings of romantic heroes—Jean Paul, Kleist, and Dionysus—by the great Surrealist painter André Masson, who was living in the United States at the time, an exile from war-torn Europe. Jolas, a close friend of James Joyce's and the founder of the magazine *Transition,* who was himself living in the States, argued that the romantic revolutions of the eighteenth century, which had been "paralyzed by the advent of the positivist-mechanistic age," were now at last resurgent. "We are again in the midst of a romantic revolution in the arts—and in life—which is sweeping across continents with the force of a tidal wave. It is part of the apocalyptic sensation which we all experience in the present social convulsions accompanying the war, and it is also the expression of vast creative forces that are preparing the way for a spiritual resurrection."[1]

To be an artist in New York in the mid-century years was to be on a romantic quest. Painters and sculptors hungered for a form of self-expression that was abstract yet concrete, more-than-material yet grounded in the materials of art. And the fact that the romanticism of the New York School was full of contradictions and sometimes even involved a rejection of the very idea of romanti-

Alexander Calder, Frontispiece for Vertical: A Yearbook for Romantic-Mystic Ascensions, *1941.*

A YEARBOOK FOR ROMANTIC-MYSTIC ASCENSIONS. Edited by Eugene Jolas. Published by The Gotham Bookmart Press · New York

cism only made that quest all the more romantic. You might call this the "no-romantic romantic" attitude. Artists were primed to act intuitively, perhaps almost instinctively. They wanted to express feelings that denied everyday experience entirely or that alluded to the everyday only in order to leap beyond the everyday. And if their work took on an utterly unexpected form, so much the better. Barnett Newman was certainly being hyperbolic when he announced in 1948 that some artists were "reasserting man's natural desire for the exalted, for a concern with our relationship to the absolute emotions," and yet most painters would have agreed that if you were incapable of expressing broad emotions, you were also going to be unable to get into the specifics. "It is [the] inward or ideal world which constitutes the content of the romantic sphere," Hegel had written; "romantic art must be regarded as art transcending itself, albeit . . . in the form of art itself."[2] What Hegel was suggesting was that the artist's immersion in motifs and materials and methods—all the physical characteristics of the work—became the vehicle for an expression so exalted that it defied the physicality of the work that had precipitated it. And if that was a paradox, it was the paradox at the heart of the School of New York.

In 1947, in the first and only issue of *Possibilities*, Rothko published a statement in which he distanced himself from the look and style of earlier generations of romantics. "The romantics," he observed, "were prompted to seek exotic subjects and to travel to far off places. They failed to realise that, though the transcendental must involve the strange and unfamiliar, not everything strange or unfamiliar is transcendental." These observations had a personal meaning, for Rothko was on the cusp of his own romantic breakthrough, leaving behind the blossoming, spinning sea-anemone forms of his Surrealist period for the shimmering eloquence of his blurred and delicately yet brilliantly colored rectangles. Rothko's notes offered a critique of the old romanticism. When he spoke of "the unfriendliness of society to [the artist's] activity" or the possibility that "this very hostility can act as a lever for true liberation," he was squarely in a romantic tradition. The difference was that he wanted to reject the old subjects. Rothko, too, would "travel to far off places," only for him "the strange and unfamiliar" was a series of forms invented on a canvas, forms that he was increasingly intent on distinguishing from the self-consciously fantastical landscapes of the Surrealists, which often suggested the theatrical extravaganzas of an earlier age. Rothko, however, had his own idea about the relationship between painting and theater, an idea of the canvas as a stage that had its prehistory in the theater-obsessed imagination of the nineteenth-century romantics. "I think of my pictures

Mark Rothko, The Source, 1945–56.
Oil on canvas, 39⅝ × 27¹⁵⁄₁₆ in.

as dramas," Rothko explained; "the shapes in the pictures are the performers." They are "a group of actors who are able to move dramatically without embarrassment and execute gestures without shame."[3]

This description in *Possibilities* could have been—almost—a description of some of Delacroix's Shakespearean works, except that Rothko offered an abstracted version of that romantic drama. Three years before Rothko wrote in *Possibilities*, Greenberg had reviewed a Delacroix exhibition at the Wildenstein Galleries, and had approvingly quoted Baudelaire's observation that it was never "by tricks of technique that Delacroix obtains [his] great result, but by the ensemble, by the deep and complete accord of color, subject, and drawing, and by the dramatic gestures of his figures." Going further, Greenberg seemed to be stripping Delacroix of what Rothko might have referred to as the "exotic subjects"—he could have been turning Delacroix into an artist of the postwar years. "The slanting arabesque of *Desdemona at Her Father's Feet*," Greenberg wrote, "tells nothing as to why Desdemona is at her father's feet; instead, it generalizes her attitude beyond anything even so unspecific as supplication. It gives a hint of the quality of *all* emotion." Delacroix is all "antitheses." His work "is all confrontation, contradiction, opposition, and exchange"—the work of a romantic dialectician.[4] Forms enacted a drama—which was what the artists of Greenberg's own time were after. Rothko and his contemporaries were reclaiming romanticism, not as a

Eugène Delacroix, Desdemona at Her
Father's Feet, 1839. Oil on canvas, 15¾ × 12⅜ in.
Exhibited in the 1944 Wildenstein exhibition
that Clement Greenberg reviewed.

Robert De Niro, Crucifixion
After Mantegna, *1962.*
Oil on canvas, 65 × 78 in.

fixed position, but as a paradox, a cultivation of opposites, a view of conflict-as-beauty where, as Blake had said, "contrarities" might meet. For Newman the point was to get beyond the things that were in front of you, to seize the sublime. De Kooning, less apocalyptically inclined, was happy to grapple with the bits and pieces of objects discovered on meandering strolls through the night city, just so long as they might offer a "glimpse" of something beyond. And when Greenberg wrote that "pictorial art is driven to express as directly as possible only what goes on inside the self," he surely understood that he was expressing a romantic belief.[5]

If you follow nearly all the ideas that counted in New York in the 1940s and 1950s—ideas about painterliness, expressionism, surrealism, primitivism, existentialism, nihilism, the baroque, the Gothic, the pastoral—you will find that they ultimately wind back to romanticism. The entire enterprise of Hofmann's legendary school, where so many of the artists who came of age in the 1940s and 1950s gathered to "Search for the Real," as Hofmann put it, had its origins far back in European history, in the sense of young romantics, all outside the academic system and in revolt against the rules of classicism, freely coming together to learn from a revered master. Hofmann had described himself as having "a lyrical as well as a dra-

Robert De Niro, Two Figures,
1970–71. Oil on canvas, 60 × 72 in.

matic disposition"—which was practically a description of the romantic imagination.[6] And the Hofmann School, in turn, gave birth to new forms of older feelings, an example being the paintings of Robert De Niro, in which an odalisque and a Crucifixion and the legendary courtesan Lola Montez and the ultra-elegant Greta Garbo were somehow all aspects of the same informal romantic myth, summoned up with thick yet looping lines and patches of deep-toned, burning color. De Niro, whom a friend described as exemplifying "Baudelaire's dandyism on a low budget with a Hollywood flair," sometimes signed his letters Bob Verlaine de Niro. Of a painting from the 1940s called *Venice at Night*—a title, borrowed from Cocteau, that was scrawled across the canvas—De Niro remarked that it was "a kind of romantic antithesis to Hofmann's formal cubist training," a training that Hofmann had himself presented with an anti-formalist bravado.[7]

For the young poet Robert Duncan—who was friends with, and even seems to have slept with, De Niro—the very idea of the essential place of form in artistic experience was a romantic phenomenon. He opened his "From a Notebook," in *The Black Mountain Review*, by announcing, "This series of notes serves to explore a style and temperament in which the Romantic spirit is revived." And a little later he argued that "the persistent idea in these notes that form is Form, a spirit in itself, we owe to the Romantics." Among the values that Duncan prized in the arts were "rigor and even clarity," but also "muddle and floaty vagaries. It is the intensity of the conception that moves me." And to describe that intensity, he spoke—crazily, lyrically—of "a fervent marshmallow dandy lion fluff."[8] The wild variability of the romantic sensibility was something that B. H. Friedman had observed when

he wrote about "The New Baroque" and said that the neo-Baroque romanticism of works in the Museum of Modern Art's "Fifteen Americans"—which included paintings by Baziotes, Rothko, and Still—seemed to break out of the frames, because "the compositions themselves are so fluid, so free, so tentative, so self-indulgent, so purely technical that they won't be contained." This kind of variability and unpredictability was also drawing artists to the work

Chaim Soutine, Alley of Trees, 1936. Oil on canvas, 30 × 27¼ in.

of Chaim Soutine, who was the subject of a Museum of Modern Art retrospective in 1950, a show that the painter Jack Tworkov wrote about in *Art News*. Tworkov said that "it is precisely [Soutine's] impenetrability to logical analysis as far as his method is concerned, that quality of the surface which appears as if it had happened rather than as 'made,' which unexpectedly reminds us of the most original section of the new painting in this country." And a little later Tworkov observed that "his picture moves towards the edge of the canvas in centrifugal waves filling it to the brim; his completely impulsive use of pigment as a material, generally thick, slow-flowing, viscous, with a sensual attitude toward it, as if it were the primordial material, with deep and vibratory color; the absence of any effacing of the tracks bearing the imprint of the energy passing over the surface. The combined effect is of a full, packed, dense picture of enormous seriousness and grandeur."[9]

"My way of composition," Paul Goodman announced in the first issue of *Semi-Colon*, the four-page journal that John Bernard Myers began publishing at the Tibor de Nagy Gallery in 1954, "is like a beast or fish over which is cast a net. The animal then with unexpected force—but not equal to *my* force, but I should never have hunted him if I thought he had so much as this—he strains to writhe away ever in a new direction." The artist and the animal engage in a great struggle, the net tightens, and finally "in a paroxysm he rears up, into a posture unknown and also against his nature; he tears a few meshes of the net." And then the animal died, and Goodman offered to the reader the grimacing dead body—or perhaps "only the net, with its unequal strains and a few cords torn."[10]

II

The yearning for spirit, for muddle, for clarity, for fluidity, for technique, for impulsiveness, for seriousness—and the yearning that all of this might be mingled—was a romantic yearning. And if the word *romantic* was not being bandied about at the Cedar Tavern and the Club and in the cold-water flats and lofts where the artists were living, if there was a continuing ambivalence about romantic ideas, or at least about labeling certain feelings as romantic— this was because so many young American painters and sculptors had been watching in horror as the so-called educated public rushed to embrace the gauzy Neo-Romantic kitsch of Pavel Tchelitchew's dreamworlds.

For many years, one of the most popular paintings at the Museum of Modern Art would be Tchelitchew's *Hide and Seek*, a vast, magic realist phantas-

Pavel Tchelitchew,
Hide and Seek, *1940–42.*
Oil on canvas, 78½ × 84¾ in.

magoria, in which a tree was reimagined as a nebulous labyrinth of weirdly translucent children's heads out of some creepy-chic Halloween party. And for painters of de Kooning's generation, there could be no question that Tchelitchew, whom Denby referred to as "the uptown master" with his "flickering light," was one thing and Picasso and Miró were quite another. Yet the Neo-Romantics had a fascination in the 1930s and 1940s, so much so that Thomas Hess would later argue in his book on de Kooning's drawings that for a time in the 1930s de Kooning had evolved for certain projects "a cooler style, drained of the tension of his other drawings, and purposefully related to what at the time seemed the most promising, at least the most often praised, post-Picasso tendency: the Neo-Romanticism . . . which, in the hands of Tchelitchew, would reach its purest expression in the impure medium of stage design."[11]

The Neo-Romantics—especially Tchelitchew, Christian Bérard, Eugene Berman, and Leonid Berman—were art-world powerhouses, with ties to uptown fashion, café society, the ballet, but also to the experimental magazines and galleries where artists such as Gorky and Pollock and de Kooning were getting their first chances. And Surrealism, too, had its soft-core, Neo-Romantic side, which was epitomized by Dalí's slickly engineered fantasies, with their melting watches and dramatic desert vistas given a glossy, photographic finish. Things could get pretty mixed up; to some, the new abstraction might look like little more than a subset of Neo-Romanticism. From our perspective, it may not be very hard to tell the difference, but the truth was that Surrealism and Neo-Romanticism had common roots and that the artists

involved had common enthusiasms, for dreams and
myths and unfettered fantasies. Artists such as Pol-
lock and Motherwell who were lucky enough to
exhibit at Art of This Century found their work in
close proximity to Frederick Kiesler's curvilinear
dreamworld décor, which had an aggressively fan-
tasyland look that cannot have pleased these down-
town artists, who believed that a painting should
stand on its own.[12]

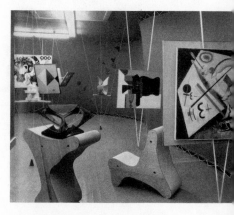

The disagreements between the no-romantic
romantics and the Neo-Romantics were so violent
that they could still haunt New Yorkers decades
later, long after Neo-Romanticism had been eclipsed

*Berenice Abbott, interior of Art of This
Century gallery, 1942.*

and Tchelitchew, who had once reigned at the Museum of Modern Art, had
become a marginal figure. In Saul Bellow's "What Kind of a Day Did You
Have?," a story about a famous art critic closely modeled on Bellow's good
friend Harold Rosenberg, the critic has been harassed during an interminable
delay at the Buffalo airport by Wrangel, a wealthy culture vulture. Wulpy, the
Rosenberg figure, was convinced that Wrangel was up to no good. And what
was his evidence? As Wulpy explained to his lover, Katrina, Wrangel had given
himself away when "he mentioned Parker Tyler and Tchelitchew. Tche-
litchew, you see, attacked me. He said *he* had a vision of the world, whereas the
abstract painting that I advocated was like a crazy lady expecting a visit from
the doctor and smearing herself with excrement to make herself attractive—
like a love potion. Wrangel was trying to stick me with this insult."[13] The con-
versation with Tchelitchew that Wulpy described must have taken place thirty
years earlier, and the fact that it still rankled suggests exactly what a threat the
Neo-Romantics had once posed.

The Neo-Romantics and the Surrealists and the younger New York artists
spent years locked in social as well as professional interactions. At the opening
of the Soutine show at the Museum of Modern Art—a signal day for no-
romantic romantics—Edith Sitwell, a great admirer of Tchelitchew's, was in
attendance, described by Malina in her diary as "in another fabulous cape, this
one of yellow and gold, accompanied by Sacheverell [her brother] of the
mighty mane. She peers boldly at everything, including Lincoln Kirstein, hor-
ribly handsome tonight."[14] Tennessee Williams, who spent the summer of
1944 in Provincetown and knew Hofmann, who was running his school there,
wrote in a letter that June that "the whole lunatic fringe of Manhattan is

already here, Valesca, Joe Hazan, Robert Duncan, Lee Krasner and Pollock, the Bultmans and myself. Such a collection could not be found outside of Bellevue or the old English Bedlam." And a few weeks later, who should appear but "Charles Henri"—the editor of *View*, the Surrealism–Neo-Romanticism fusion magazine—"his mother, and Tchelitchew . . . , all looking remarkably well. They took me to lunch. The poor little mother was the first example I have seen of a thoroughly intimidated southern matron. Tchelitchew had her completely in awe of him, she even paid for the lunches."[15] So there, in the summer of 1944, they all are in Provincetown, the Neo-Romantics and the new no-romantic American romantics. It was no wonder that the conflicts between the Neo-Romantics and the no-romantic romantics could have a fraternal violence—these people sometimes felt too close for comfort. Duncan, who was close to artists in the orbit of Hofmann, called the kind of art featured in *View* a "charade of producing things." Duncan complained that "the romantic painters, Berman and Tchelitchew, and the romantic revolutionists, Breton and Calas, were taken up and taken in by the culture collectors."[16]

III

During the 1940s many artists had been awakening from the restless dreams and druggy intoxications of romanticism. They had had enough of the deracinated romantic look of Max Ernst's Surrealist dreamscapes, of the elaborate cultivation of the irrational and the unconscious that inspired the British critic Cyril Connolly to call Surrealism "romanticism's last stand."[17] But what the New Yorkers were awakening to was only another, perhaps infinitely more lucid side of the romantic equation. This complex phenomenon was reflected in an artists' magazine of the late 1940s, *The Tiger's Eye*, with its title borrowed from Blake, who was of great interest to many American artists and writers and was also, along with the eccentric nineteenth-century landscape painter Samuel Palmer, the essential figure for a group of artists in England, including Graham Sutherland and John Piper, who were also known as Neo-Romantics. The nine issues of *The Tiger's Eye* that appeared between 1947 and 1949 and included work by Rothko, Newman, Pollock, and Still, among others, were edited by Ruth and John Stephan, a writer

John Stephan, cover of The Tiger's Eye 5, 1948.

and a painter respectively, with funding from Ruth's family fortune (she was the Walgreens drugstore heir). The Stephans had spent the early months of 1946 in Peru, and they included ancient South American textiles and ceramics among the illustrations in *The Tiger's Eye*, which suggested a link between their magazine and the tastes of Wolfgang Paalen and Josef and Anni Albers. A statement of purpose by the editors, who sometimes received editorial assistance from Newman, another admirer of indigenous American art, suggested a Blakean journey "through the Dusk of Fantasy and the Morning of Reality." In some of its themes the magazine echoed the Neo-Romantic sensibility, and that was not just because the Stephans agreed that contemporary artists needed to understand the fire in Blake's tyger's eye. One issue, dedicated to "A Selection on Night. A Darkness of the Mind or of Nature" and including Blake's image of "Behemoth and Leviathan," from his *Book of Job*, might have brought to mind a show called "Night Scenes," mounted in 1940 at the Wadsworth Atheneum, which under Chick Austin's direction had become a center of Neo-Romantic activity. *The Tiger's Eye* served up a rich, dark stew,

yet the mix of elements—which included Giacometti's new, elongated figures and Still's rough-edged, Gothic abstractions—conveyed a restless, forward-moving energy, a no-romantic romantic attitude.[18] *The Tiger's Eye* featured unclassifiable independent artists, among them Loren MacIver, whose work has a daringly distinctive melancholy—a poetic fragrance all its own. *Violet Hour*, from 1943, was a vision of the city at dusk. MacIver imagined Manhattan as a series of hieroglyphic images—pedestrians, seagulls, fire escapes, chimneys, street—and then she veiled the everyday scenery in layers of shadowy eloquence.

In 1949, Robert Goldwater, the editor of the *Magazine of Art*, who published in those pages pioneering studies of de Kooning and Motherwell, presented a long article by the historian

Loren MacIver, Violet Hour, 1943.
Oil on canvas, 90 × 58 in.

Jacques Barzun, "Romanticism: Definition of a Period," which could not but have been meant to give fuel to the gathering no-romantic romantic movement. When people talk about romanticism, there is always a question as to whether what they are thinking about is a timeless ideal or a period idea, and Barzun, the author of a classic study of Berlioz, did some of both. He argued that romanticism's "aim is to bring into a tense equilibrium many radical diversities, and it consequently produces work that shows rough texture, discontinuities, distortions—antitheses in structure as well as in meaning. From the classical point of view, these are flaws; but they are consented to by the romanticist—indeed sought after—for the sake of drama. They are not oversights on the artist's part, but planned concessions to the medium and the aim it subserves."[19] For many American artists, that tense equilibrium was best defined in the poetry of William Blake, who, well before the advent of *The Tiger's Eye*, had been singled out by André Breton as one of the precursors of Surrealism; examples of his work had been included in the landmark 1936 show at the Museum of Modern Art, "Fantastic Art, Dada, and Surrealism." At Black Mountain College, Alfred Kazin had taught a Blake seminar. In 1946, in an introduction to *The Portable Blake*, he wrote that Blake "asserts the creative freedom of the imagination within his work and makes a new world of thought out of it." The fecundity of Blake's illuminated books, in which, as Kazin said, you felt that "the symbolic synthesis to be created by his imagination was an image of man pressing, with the full power of his aroused creativity, against the walls of natural appearances," was a harbinger of the struggles with reality that were so central to New York painting in the 1940s and 1950s.[20]

If Blake's transcendently personal brand of romanticism was on American minds, he shared mental space with some equally independent American artists and writers. There was Albert Pinkham Ryder, who was recognized immediately as an influence on Pollock, and whom Lloyd Goodrich, in the catalog of the 1947 Whitney retrospective, had praised for his "masterly sense of the harmony of the whole picture [in which] all elements played their parts in a total design."[21] And there was Melville, about whom Kazin had also taught a course at Black Mountain. Melville's genius for giving an idiosyncratic vision heroic proportions excited many artists. In Provincetown in 1944, Pollock and Lee Krasner may have been among a group that listened to Tennessee Williams's friend Joe Hazan read passages from *Moby-Dick* by lamplight. The painter William Baziotes loved to quote a line of Ishmael's about "a damp drizzly November in my soul." And another painter, Paul

Albert Pinkham Ryder,
Under a Cloud, *1880s*.
Oil on canvas, *20 × 24 in.*

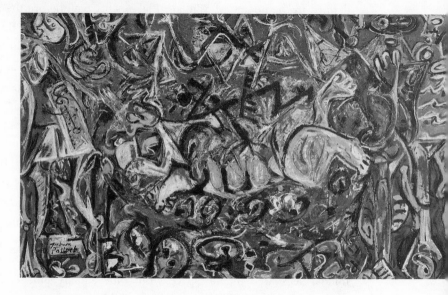

Jackson Pollock,
Pasiphaë, *circa 1943*.
Oil on canvas,
56⅛ × 96 in.

Jenkins, said of Pollock that meeting him "was an assault on the moral senses because in a frontal attack he would question your very being. I think of him somewhat like Melville's Billy Budd." Pollock's 1943 *Pasiphaë* had originally been titled *Moby-Dick*. And Rosenberg, in 1952, in what was perhaps his most famous essay, "The American Action Painters," wrote that "the American vanguard painter took to the white expanse of the canvas as Melville's Ishmael took to the sea."[22] American artists saw these two troubled, solitary figures, Melville and Blake, as forging new cosmologies out of the wreckage of Western belief.

IV

When romanticism was rejected in the postwar years, it was generally in the name of a subjectivity and a reliance on individual instinct that brings us straight back to the romantic spirit. The very look of this downtown bohemian world—its streets, its homes, its styles of dress—was anti-picturesque, and in that sense anti-romantic. Just think of the mundane interior of the Cedar Tavern, or the down-and-out banality of the stretch of Tenth Street where many galleries were located, or the simple, workingman's style of dress that so many artists favored. All of this suggested an attempt to burn off the rotted romantic trappings of the old Greenwich Village and recapture some essential spirit of revolt—which was, when you came right down to it, a romantic impulse. At the very moment that the avant-garde was saying good-bye to the old romantic nonsense, the goodbye had a way of turning into a sneaky sort of no-romantic romantic hello.

Everywhere a younger artist looked, there were fascinating, exemplary figures, some of whom had come of age in a period saturated in romantic longings, a period that was passing or had already passed. Elaine de Kooning, who was an able reviewer as well as a painter, contributed an article to *Art News* in which she turned the spotlight on a painter who was twelve years older than her husband and a close friend of his close friend Kline. This was Earl Kerkam, who Elaine observed "looks . . . like a character out of Damon Runyon's Broadway sagas." Kerkam was one of those extraordinary artists about whom we no longer know much and wish we knew more. Only when you look at what are too often described as the minor characters can you begin to understand the richness of the postwar scene. Hess, in a tribute to Kerkam, remembered him as "an old man who can nurse a beer for hours at the Cedar Bar, listening to the conversations of his newly famous artist friends." After Kerkam's death in 1965— a death that David Smith noted in a letter to his friend Lois Orswell, who collected both Kerkam's and Smith's work—the

Photograph of Earl Kerkam, circa 1955.

painter Louis Finkelstein wrote an article about
him, and related a fascinating anecdote that tells
us exactly just how much Kerkam counted at the
Cedar Tavern. When Pollock was already a leg-
end in New York, he received a postcard from
Kerkam, who had seen some of his work in
Paris. "Overjoyed, he waved it under the noses
of the boys at the Cedar Bar, shouting, 'Earl says
it's not bad!' "[23] At the time of the Pollock post-
card, Kerkam was in his sixties, and those years
at the Cedar Tavern and the Club and the open-
ings uptown at the galleries of Betty Parsons and
Charles Egan, where Kerkam's paintings were
seen, were a heyday for him. In the 1920s
Kerkam had had another life. He had a wife and
a son and a very successful career as a commer-
cial artist, doing posters for Warner Bros. But
Kerkam yearned to give himself entirely to
painting. He went with his family to Paris, and

Earl Kerkam, Nude, circa 1960. Oil on board.

after a time his wife and son returned to Philadelphia, and he went on to estab-
lish himself in New York, where he maintained a warm if distant connection
with his son, E. Bruce Kirk, who became a stalwart supporter of his father's
work after Kerkam's death.

There's really not any mystery to Kerkam's obscurity, since he did por-
traits and self-portraits and still lifes in a subdued style, a style with a muffled
power that did not immediately say "New York." But in the case of Kerkam—
and he's not the only one—when we do get to know the paintings, they turn
out to be more interesting, more substantial than the work of some of the few
dozen players who have come to be regarded as the Olympians of the New
York School. Kerkam's still lifes and nudes and self-portraits, some of them in
a faceted semiabstract style, were nothing like what the Abstract Expression-
ists were doing, and yet there was an emotional affinity between the big-name
artists and Kerkam, with his commanding, darkly vivid spirit. His paintings
were shaded with melancholy—the melancholy of late winter afternoons
in New York, when the gathering evening could make a person feel lost in
the shadows, heavy yet without substance, anonymous. These canvases came
out of the same twilit New York as Ryder's seascapes. Kerkam's paintings
reflected the gravity of New York, and there was a flickery delicacy to them,

too. While his brushwork was open and sometimes a little bit rough, he also used his strokes to melt things together; you feel the heat of creation, but it is a heat that has cooled. In Kerkam's work, Hess saw a portrait of "the serious artist in brutalizing New York [who] has to remind himself every waking minute who he is and what he does."[24] Kerkam had his own kind of romantic will.

Kerkam told Elaine de Kooning that he went to Paris in the early 1930s "to find out what people meant when they talked about modern art. I used to go to Picasso shows. Didn't understand them at all, so I thought Picasso was a faker. Then I met a painter in Paris, student of Hofmann, name of Jensen, who pointed out the way that Picasso constructed—so you could say that indirectly I got my first insight into modern drawing from Hofmann."[25] Kerkam drew at La Grande-Chaumière, the legendary school where Hofmann, years before he came to teach in New York, had worked from the model along with Matisse. Kerkam moved to New York in the 1930s and in 1935 went on the Federal Art Project, like so many of the artists who would be famous two decades later. In 1941 he had a two-person exhibition at the Artists Gallery with John Graham. There are dark, solid nudes from the 1930s, and they are in many respects like what he was doing in the 1950s and 1960s. The struggle that absorbed Kerkam through the years had to do with rejecting the sentimentality of those old subjects, with painting a figure or a bouquet of flowers so honestly, so straightforwardly, that the directness obliterated nostalgia. Kerkam's painterly magic deepened, and younger artists seemed to understand that he was on their wavelength, and they responded. In Kerkam's work, an old modern yearning for the solidity of form was recapitulated, now with an almost existentialist fervor.

Everybody who knew Kerkam was struck by the frugality with which he lived. The critic Martica Sawin recalls that "the studio was shared with a schlock painter who slept in the day while Kerkam worked and they switched places at night; while I looked at Kerkam's paintings his studio mate was asleep on the only bed." Louis Finkelstein described Kerkam's studio as "so sparsely furnished that it did not look furnished at all. In one room there was a broken-down cot with a slab of foam rubber. In the kitchen he had a bucket for washing his clothes (which he sometimes let burn on the stove while he was painting)." The clothes themselves tended to come from thrift shops. In the 1960s, when he apparently suffered a stroke in his studio, it was hours until he was found, by which time he had developed pneumonia. He was taken to the hospital without identification. When the hospital personnel found out

that he was a painter, he was asked, "Who is the greatest living painter?" Kerkam's voice came back: "Picasso." Kerkam was dead a few days later. And yet despite his spartan existence, he had shown at some of the finest galleries of the day—at Charles Egan, home to so many of the Abstract Expressionists, and then at World House, where a landmark Giorgio Morandi retrospective was among the most important shows of representational painting mounted in the late 1950s. Kerkam's funeral, at the Episcopal Church of the Ascension, was attended by more than four hundred people on, as Gerald Nordland wrote in the catalog for the memorial show, "a rainy Saturday morning, the light so dim that even Kerkam wouldn't have been able to paint."[26]

If Kerkam's romanticism had a fascination in the 1950s and 1960s, this was to some degree because it felt related to the weighty experiences of the 1930s, to the dark emotions of those times. Hess described Kerkam walking "around like a ghost from a Kenneth Fearing social-realist poem of the 1930s. And the fantastic thing about that ghost, color of tobacco juice and cherry-phosphate, was that it sheltered a pure dream of delectable painting." That reference to Fearing, a leftist poet of the 1930s, is underscored by the existence of a composition by Kerkam—of two men, apparently in the midst of a conversation—among the reproductions in the program for "In Defense of Culture," the 1941 American Writers Congress and Congress of American Artists. It would be unwise to draw too many conclusions about Kerkam's political views from his participation in an event linked with the Communist Party. The painting of Kerkam's that was reproduced in the program did not, in and of itself, have any political import, and yet Kerkam's rather austere image of two men took on a polemical import, for it had been set opposite a capsule history of the United American Artists, of the organization's "brilliant, militant struggle to win economic security and cultural freedom for the artists and art workers."[27] The painting, with its dark modeling, does seem related to some of the canvases that de Kooning did of Denby and Burckhardt around the same time. And there was certainly about Kerkam's rather heavy yet sketchy brushwork a weary vehemence that brings to mind Denby's recollection of "the peremptoriness and the paranoia of Marxism as a ferment or method of rhetoric."[28] That atmosphere, which interested Denby as a way of thinking that could be freed of political implications and used as a tool for artistic research, lingered on in Kerkam's later paintings of isolated female nudes or the artist's own face or a vase of flowers—lingered on as an afterimage of that ferment, an afterimage that registered as a romantic intensity.

Kerkam's central achievement was the self-portraits and female nudes that

Earl Kerkam, Composition with Forms of
the Head, *1960. Oil on board, 26 × 19 in.*

he did in the 1950s and the small still lifes from the 1960s. He told one writer, "I can't talk French, but I can paint French."[29] And the paintings resisted literary or symbolic readings in a way that suggested the factuality of French painting since Chardin. Yet there was no School of Paris ease to Kerkam's work. Although the self-portraits of the early 1960s, with the little lines running over them making a geometrical cage, evoked Jacques Villon, they were sometimes superior to all but the best Villons in their hardness and sobriety, their feeling that this particular array of lines had been arrived at through a terrific struggle. The faces in these Kerkams, which were so often self-portraits, were on the point of vanishing, or at least of collapsing into dozens of shattered, purplish-grayish shapes, shapes with the angled edges of bits of cut glass. In his later years Kerkam could be a masterful colorist. Jewel-like, plangent, surprising, somewhat unreal blues and reds and oranges flashed out of the gloom. Many of the paintings were done from life, but there was also a search for broad, general effects. When he painted a young woman, Kerkam apparently had no compunction about using different models for the same figure, so that in the end it was not a portrait of a particular person. The faces of the female nudes recalled the anonymity of some of Picasso's early work—the Rose period especially, with its sweet sadness—and that suggested a spiritual affinity with what Hess called the "detached romanticism" of some of the early de Koonings.[30] As for the self-portraits, Kerkam didn't really care about getting a likeness. He was reaching for an intent ordinariness. It was Everyman's self-portrait.

What was most important to Kerkam was the weight of the pigment. While he believed in the inviolable flatness of a painted surface, he also yearned for the illumination of volumes and gave his deep colors an atmospheric richness. It's a rare artist who can reach for a romantic mood without slipping into the wishy-washiness of romanticism, but that's what Kerkam did. His paintings were grounded in the romantic spirit of his time, a time that was so in love with the possibilities of paint that the fear of failure could be overpowering and leave an artist feeling that since the work could never

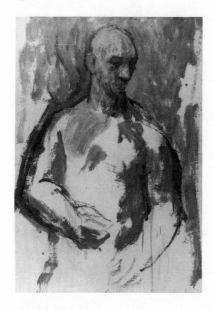

Earl Kerkam, Self-Portrait,
circa 1960. Oil on board.

really be finished, it might just as well be broken off. There were places in Kerkam's paintings where an arm or a hand was just roughly indicated with a couple of sweeps of the brush, as if the strain of accomplishing so much had become too much and the artist had to back off. Yet the nakedness of the process was never self-aggrandizing, as was so often the case in the work of a number of Kerkam's 1950s friends, among them Kline. Kline's swaggering black-and-white abstractions can have a perfunctory look—they suggest a too easily existentialized romanticism. Even the less interesting among Kerkam's paintings can engage a viewer, because they are the sum of many difficult decisions, decisions that have been made painted inch by painted inch.

Earl Kerkam was an ambitious man who was also comfortable with a certain anonymity. This is a more common emotional mix than one might imagine. To make a mark in the big city while scarcely being known suggests a desire to give the imagination free rein, to allow one's imagination to be the part of oneself that is known in the world. That in turn suggests the underlying wistfulness of big-city life—the near-anonymity of those who play a part but only occasionally emerge from the wings. The magic of Kerkam's paintings had to do with the struggle to be absolutely concrete while recognizing that appearances are not enough. After Jean Cocteau made a brief visit to New York in 1949, he observed that this was "a standing city, because if it sat down it would relax and reflect, and if it lay down, it would sleep and dream."[31] In

his finest paintings, Kerkam fought against relaxation, but the dreams kept coming in. A lot of the paintings were vehement in the middle and then just faded away at the sides. This was the poetry of the hoped-for, the just-beyond. To his friends, Earl Kerkam was the tough guy with the golden heart. The work that Kerkam has left us is at once delicate and brusque, and the effect can be exceptionally moving. If de Kooning was the public poet of the city—all bare, tough, explosive movement—Kerkam reflected a quieter kind of yearning. De Kooning's art had a gonzo, exhibitionistic romanticism—skeletal, exposed, bones and muscles without the skin. But Kerkam's paintings were also romantic acts. And younger artists, as they saw what a de Kooning or a Kerkam was doing, could begin to find out something about themselves and what they were going to be capable of doing. To think of Earl Kerkam, working day after day on these paintings in which it is hard to tell where the facts end and the dreams begin, is to grasp the fantastic complexity beneath the thrilling simplicity of the rush-hour city.

V

The new no-romantic attitude began in the imagination, but it also began in the concrete facts of the streets and the studio, in the sense that artists had of being related to their surroundings, in the way the artist chose to shape the environment. This was the kind of experience that the critic Wylie Sypher was describing, in his 1960 book *Rococo to Cubism,* when he wrote that "the romantic in his quest of personal evidence uses his own kind of realism . . . ; and since his feelings cannot be fixed, he is always forced to make new appraisals as his responses change. He has nothing to trust beyond this unstable experience."[32] Back in the 1930s, when de Kooning had taken those long night walks with Denby and Burckhardt, they were connoisseurs of modern instability. These men were romantics—imaginers, you might say— gathering empirical evidence, evidence that would still be relevant years later, when de Kooning explained to younger artists how his meandering compositions operated, by pointing to the zigzagging path that a drunken man made when he crossed the street. Empirical experience was feeding the imagination, guiding its peregrinations, an idea that Denby was thinking of in 1947 when he wrote of the nineteenth-century poet and dance critic Théophile Gautier, who had been at the premiere of *Hernani* and had written about Delacroix, that "Gautier assumes that one strolls through the world of art as familiarly as one strolls through Paris, looking about in good weather or bad, meeting conge-

nial friends or remarkable strangers, and one's ene-
mies, too."[33] And Anatole Broyard said that part of
Nietzsche's appeal for New Yorkers was that he was
a philosopher "who said that the best thoughts come
while walking."[34]

Rudy Burckhardt,
No Encroachment, NY, 1938.

Among the documents of the new no-romantic
romanticism that survive from the 1930s and 1940s,
little has as much quiet power as the photographs
that Burckhardt was taking during those years,
photographs in which he broke the city down into
a mosaic of fascinating, off-kilter fragments—a
new, cooler version of the picturesque. Burckhardt,
like Denby and de Kooning, was a flaneur, but he
was not after charm, at least not charm of any known
variety. Burckhardt loved Manhattan's terrific de-
tails. He photographed the textures of brick and
stone walls, the bulky commercial buildings, the crazily variegated roof-
scapes, the cacophonous signage. He was also fascinated by what he saw when
he looked down, and often photographed the feet that were pounding the
scarred pavement or cooling at the corner, waiting for the light to change. The
photographs suggest a serene, Zen-like watchfulness, as if they had been taken
by a cat who was sitting very still. Burckhardt registered the city's constant
jittery pressure, the pressure that came from every direction and kept a per-
son hyperalert, but he approached the romantic drama of the city with his
own kind of slowed-down attentiveness. There was a Blakean, world-in-
a-grain-of-sand concentration to Burckhardt's feeling for urban details.
Here was a new category: the ordinary sublime. This was an ordinary-
extraordinary mood, and in that sense not unlike the atmosphere of some of
the canvases that de Kooning was painting in the late 1940s, canvases that rep-
resent what he called the "no-environment." The no-environment was, as
Hess put it, the place where the artist "lives (where we all live); it is the place
of his studio and its environs, where he paints, and stops to look out of the
window, sits down, takes a walk." It was in the no-environment that the no-
romantic found his romantic visions.[35]

Artists and writers were still playing out a drama of the *vie de bohème,* of
slashing Delacroixesque brushstrokes, Baudelairean sensations, and theatrical
excitement that had inspired attic dwellers long before it inspired loft pio-
neers. At the same time, artists of de Kooning's and Denby's and Burckhardt's

generation were intensely aware of how corrupted those old romantic atti-
tudes had become. They wanted to continue the great tradition of the artist as
a voyager through the city, with all its revelations and illusions, yet the
painters and poets wanted to have a sneakier, less predictable relationship with
the city than they saw in earlier bohemian generations, and they announced
that change through the very way they dressed. They might have Gautier's
curiosity, but unlike bohemians of forty years earlier, they would not try to
look like Gautier. The men tended to be clean-shaven and to wear pragmatic
work clothes or generic sport jackets and chinos; they were saying that they
wanted to be a bit anonymous, that they wanted to declare their distance from
New York's old, self-conscious bohemia of berets, brown velvet suits, and
goatees, which had of course been a long-deteriorated replica of the grand
Parisian original. Still, their relationship to the quaint Greenwich Village of
what one writer had called "garrets and pretenders," of tearooms and coffee-
houses that had already sunk into tourist gentility in the 1930s and 1940s, was
more complicated than one might imagine.[36] The new generations didn't
reject the old drama of the artist's life so much as they reinvented it.

The ramshackle-proletarian kind of dress that Kerkam favored, perhaps
because he could afford no other, was something that everybody at the Cedar
Tavern could relate to. There was a new-style bohemian logic to his down-
and-out garb. Rosenberg, in an essay published in 1954 called "Tenth Street: A
Geography of Modern Art," focused on the street where a lot of the artists'
studios and galleries were centered in the 1950s, and delineated what he saw as
the difference between the old and new bohemias. The old Greenwich Village
had been "imitation Paris—and in a manner which showed that what it adored
in Paris was a smaller town than New York and an older one." There were lit-
tle trees and crooked streets and even "a GENUINE COPY [of] the Arc de
Triomphe on Washington Square." Rosenberg acknowledged that American
art had grown up in those streets, but it "was habitation as art-setting and a
distraction for the artist who wished to begin with himself." That last thought
brings you right to the heart of the matter. Artists of de Kooning's generation
had been in revolt against the old coziness of Greenwich Village, and they
loved the fact that Tenth Street was anti-picturesque, and thus a perfect setting
for the new anti-romantic romantic painting. "Everything on Tenth Street,"
Rosenberg wrote, "is one of a kind: a liquor store with a large 'wino' clientele;
up a flight of iron steps, a foreign-language-club restaurant; up another flight,
a hotel-workers' employment agency; in a basement, a poolroom; in another,
something stored; in the middle of the block, a metal-stamping factory with

a 'modernistic' peagreen cement and glass-brick front; on the Fourth Avenue corner, to be sure, an excavation." Looking at Tenth Street, Rosenberg felt that he could see in its "found" atmosphere a space analogous to that of the new American painting, much as Denby recalled Gautier, a hundred years earlier, reading a painting as if it were a saunter through Paris. The attraction of Tenth Street was that it was a location that was "hospitable to anything, except what might denote a norm." He said that "the modernism of Tenth Street has passed beyond the dogma of 'aesthetic space,' as its ethnic openness has transcended the bellicose verbal internationalism of the thirties. Its studios and its canvases have room for the given and for the haphazard, as against the clean-up of the advanced Look or the radical Idea."[37] We were, once again, in the no-romantic's no-environment.

John Cohen, Tanager Gallery, 10th Street, *1959.*

Rosenberg distanced Tenth Street from the old Greenwich Village, but as he did so his emphasis on the artists' environment recapitulated an old romantic belief that a painter or sculptor created not on the basis of a received formal order but on the basis of an idiosyncratically individual response to a particular time and place. The value of Tenth Street was that it provided "room for the given and for the haphazard," that it was an undesigned environment—unfinished, unresolved, and unresolvable. In 1953, for an *Art News* article on de Kooning's first *Woman* painting, Burckhardt took a marvelous series of photographs of the artist's sun-filled studio; they provided a vivid portrait of the artist's relationship to the forever-under-construction city and its exuberantly unpredictable streetscape. Here was the artist's paint table and his windows looking out on Fourth Avenue on a warm June day.[38] It was a great image of the artist's city, and the juxtaposition of indoors and outdoors became an essay in the way that the city affected the artist. In the foreground there was the old paint table, the top crowded with cans and bottles and brushes—a purposeful studio mess. And in the background—but a background that was brought close by the photographer's framing of the scene—there was Fourth Avenue, with a blurred moving car, a casually dressed couple crossing the street, the far

Rudy Burckhardt,
De Kooning's Paint Table,
1953.

sidewalk, and a woman just walking along. In Burckhardt's photograph the jumbled paint cans and angled paintbrushes and a car and several people were united in a jumpy little dance. Paint table and streetscape were two sides of the same equation. What was outside was inside and vice versa. And inside and outside produced the synthesis that was the painting.

In those years, a visitor to de Kooning's studio noticed that there was always, "lying on his table, next to one of the huge wooden chairs he sat in to think over his paintings-in-progress . . . the *Police Gazette* or some cheap sensational magazine, featuring gangsters, murderers, or lurid girly magazines with toothpaste ads, showing a gash of wolfish white teeth."[39] The papers, arriving every morning, every afternoon, printed with ink that left a gray film on your fingers and palms, helped people keep up with the city's frenetic, exhausting pace. And de Kooning found a way to sink that tabloid imagery into the very substance of his paint. He was in the habit of pressing sheets of newspaper into his unfinished paintings in order to keep the paint wet in preparation for the next day's bout of work. And when the impression of the type came off in the glistening oil, he was glad to leave the counter-print of type there, as an afterimage of the city, a half-erased recollection of yesterday's news. What better reminder could there be of the inextricable connection between the studio and the city? *Gotham News* he called a big painting with newspaper impressions. There were also paintings titled *Police Gazette*, *Street Corner Incident*, *Saturday Night*, and *Easter Monday*—each a drama, with time or place indicated. In these canvases the lines and colors got into

scuffles and confrontations that were abstract echoes of the exciting-yet-all-too-familiar stories that kept the reporters busy at a big newspaper's city desk.

VI

Absolutes were beside the point, at least so far as many of the artists who gathered at the Club were concerned. The key question was what Wylie Sypher had referred to as the question of "personal evidence," of what an artist gathered about nature, which included the nature of the city and the nature of the artist's materials, as he or she went about creating a work of art. The poet Robert Duncan, in his "Notes on the Psychology of Art," published in 1948, said that in art "it is what is undergone . . . in the rendering itself, in the selection and relating, in the depth and intensity of the worker's involvement, that distinguishes a work of art from other kinds of portrayal or recounting."[40] And if there was ever an archetypal demonstration of this idea, and of the danger that it entailed, it was to be found in the story "The Unknown Masterpiece," which Balzac wrote during the 1830s. We have already encountered this story, and now we have to take a closer look at it, for even if artists had not read "The Unknown Masterpiece," they were aware of it through the series of illustrations by Picasso that formed an accompaniment to a limited edition published by Vollard in 1931. Balzac's story, set in seventeenth-century Paris, was about the visits of a young painter—the young Poussin, in fact—to two older artists, Porbus and Frenhofer, and how, when Frenhofer finally permitted Poussin and Porbus to view his mysterious final work, a portrait of a beautiful woman that he had worked on for ten years, it turned out to be nothing but "colors daubed one on top of the other and contained by a mass of strange lines forming a wall of paint."[41] Balzac had come of age among the French romantics, and "The Unknown Masterpiece" was in some sense a salute to the artistic spirits of his youth.

This fable about an artist who carried his personal search for poetic truth into a realm where none of his contemporaries could follow—into what some might call abstraction—had been admired by Cézanne and Picasso, and in the 1940s and 1950s, many New York painters and sculptors would have known at least one of Picasso's illustrations, in which the artist, looking intently at his middle-aged model busy with her knitting, was drawing on his canvas a labyrinth of curves. Graham had already, in *System and Dialectics of Art* in 1937, cited Picasso's work on the Balzac volume as an "example of perfect illustration."[42] When writers such as Hess and B. H. Friedman, who were in

Pablo Picasso, The Painter with a Model Knitting, *1927. Etching, 7⅝ × 11⅜ in. Illustration for Vollard's edition of Balzac's "The Unknown Masterpiece," 1931.*

the thick of things at the Club and the Cedar Tavern, referred to Balzac's story or to Picasso's drawings, they were responding to these works as a bare-bones allegory of the artist's plunge into abstraction. But they may also have been conscious of the deeper themes of Balzac's story, for what he in fact suggested, through his careful transcription of Frenhofer's heated discussions of technique, was the degree to which the nature of a work of art grew out of the most concrete experiences of handling and manipulating materials—which was an argument that writers as various as Duncan and Greenberg were making in the late 1940s. Balzac's "The Unknown Masterpiece" is one of the most extraordinarily textured accounts of the shoptalk of artists that has ever been put in print. "You've achieved neither the severe charm of the Germans' dry outlines nor the deceptive illusions of the southerners' chiaroscuro," Frenhofer said of a painting by Porbus, a distinguished artist but not on Frenhofer's subtle level. Frenhofer went on to observe that Porbus had unfortunately "resisted and throttled the splendid excesses of the Venetian's palette."[43] Balzac takes us into the intense technical discussions about the properties of paint, the struggles to achieve clarity, unity, completeness. The give-and-take among the young Poussin, the elderly Frenhofer, whom he had met on the stairs when he went to visit Porbus, and Porbus is beautifully handled. Porbus, who we are told was for many years painter to Marie de' Médicis, was the experienced worldly figure who brought together the youthful Poussin, with everything before him, and Frenhofer, an old man, the only student of Mabuse, a kind of artist's artist whose work immediately reminded Poussin of Giorgione, that most enigmatic of masters.

I think that "The Unknown Masterpiece" had a talismanic power by the late 1940s. The story was a clear-eyed parable of the messy dangers of artistic passion. Fielding Dawson, who had studied at Black Mountain College, where Kazin had taught his courses on Blake and Melville, has written a remarkable memoir that includes beautiful snapshots of postwar New York. His description of being taken by Kline to meet de Kooning, if not consciously modeled on the opening of Balzac's story, falls into a kind of pattern of which Balzac's story is the original. In "The Unknown Masterpiece," Poussin "slowly mounted the spiral staircase, stopping on each step like a new courtier uncertain of the king's reception." He was in that state of "youthful . . . passion brimming with boldness and fear." Poussin was, in fact, too shy to get himself into Porbus's studio, but, luckily, on the stairs he encountered Frenhofer, an older artist he'd never met before, who knocked on Porbus's door. Dawson, visiting New York, was taken in hand by Kline. They "entered the doorway of a slummy-looking building, went up a couple of flights of dark and shaky stairs. . . . Franz looked at me warmly smiling. He winked and my blood raced. I was about to crack apart." The door of Porbus's studio was opened by the artist, and Poussin was "under the spell that must beguile any born painter at the sight of his first real studio. . . . A skylight illuminated the master's studio; falling directly on the canvas fastened to the easel and as yet marked by only three or four strokes of white paint." And back in New York, "The door opened, and behind the almost silhouetted figure I saw a long beautifully clean loft, warmly filled with sunlight."[44]

We know from Harold Rosenberg that "The Unknown Masterpiece" occupied de Kooning's thoughts in the early 1950s when he was working on the *Woman* series. Hess believed that de Kooning's obsession with continually wiping out his paintings was influenced by the example of Frenhofer, who "did not want to finish his pictures because they always could be improved."[45] And surely Balzac's story was on Meyer Schapiro's mind in 1952, when he visited de Kooning's studio and advised the artist that his first *Woman* was indeed close to completion, although de Kooning felt like abandoning the canvas— a most "Unknown Masterpiece" emotion. In the same year, Schapiro was publishing his book on Cézanne, in which he observed that in Balzac's story, which Cézanne had so admired, "the goal of the mad Frenhofer" was to discover "a standpoint in which important values of . . . the art of the colorist and the art of the pure draftsman . . . could co-exist within one work."[46] Which suggested that Frenhofer was a kind of dialectician. How could Schapiro have felt that de Kooning's abstracted *Woman*, dissolving into an ambiguous envi-

ronment, was not approaching Frenhofer's? De Kooning, like Cézanne and Frenhofer, wanted to find a way beyond what Schapiro referred to as the old idea "that Classic and Romantic were incompatible kinds of art." At least that was how Fairfield Porter saw de Kooning's work—when he remarked that de Kooning took his color from Ingres and his line from Delacroix, and scrambled the old distinctions between line and color and classic and romantic in a way that would seem to lead to Frenhofer's inadvertent abstraction.

At the heart of Balzac's story was the struggle to resolve all the old clashes between color and design—between romantic and classic, Venice and Florence—and forge a new kind of art. When Poussin and Porbus finally saw Frenhofer's canvas, they did manage to discern a beautifully painted foot, but aside from that it was all a "chaos of colors, shapes, and vague shadings, a kind of incoherent mist." The point in the story, written a generation before the advent of Impressionism, was not, of course, that Frenhofer had had a premonition of abstract art. The truth was that for Balzac, Frenhofer, far from being the inventor of Impressionism or Cubism or Abstract Expressionism— although of course these thoughts would have occurred to, respectively, Cézanne, Picasso, and Schapiro—was mad. Yet his madness fueled a push toward the furthest point where art could go, which Porbus confirmed with his observation that "right here ends our art on earth." Frenhofer, having shown his labor of ten years to his friends, saw their reactions and was left exclaiming that it was all "nothing, nothing!" And he mused, "I'm an imbecile then, a madman." Later that night, Frenhofer died after burning his canvases.[47]

A great many New York artists would have agreed with Frenhofer when he observed, "It's not the mission of art to copy nature, but to express it! Remember, artists aren't mere imitators, they're poets!"[48] Just think of Pollock's famous remark, when challenged by Hans Hofmann as to why he didn't paint from nature: "I *am* nature." Indeed, if the circling forms in Picasso's *Painter with a Model Knitting*, shown frequently at the Museum of Modern Art, would have brought to mind anything, it might well have been the Pollocks of those years, the circling, jutting, boomeranging arabesques of *Gothic* (1944), *There Were Seven in Eight* (circa 1945), *Croaking Movement* (1946), or *Galaxy* (1947). Frenhofer, Balzac's wealthy, aged, and reclusive artist, would not have brought Jackson Pollock, the man, to mind. Still, Pollock's abstractions often included, here and there, a face or a body fragment sticking out of the welter, like the foot in Frenhofer's last painting. And the sense of painting being in extremis that hovered around Pollock's

career made him, in spite of the fact that he was the New York artist of his generation who became most famous most quickly, in many ways the unknown master. Clement Greenberg complained in 1955 in " 'American-Type' Painting" that "though Pollock is a famous name now, his art has not been fundamentally accepted where one would expect it to be."[49] Pollock's paintings remained, so far as Greenberg was concerned, the unknown, or at least the insufficiently understood, masterpieces.

VII

Pollock was at the core of the romanticism of the 1940s and 1950s. In a preface to his first one-man show, at Art of This Century in 1943, James Johnson Sweeney invoked the arch-romantic Victor Hugo's injunction, "Ballast yourself with reality and throw yourself into the sea. The sea is inspiration." He quoted George Sand's words in a letter to Flaubert that "talent, will, genius are natural phenomena like the lake, the volcano, the mountain, the wind, the star, the cloud." And he went on to say that "Pol-

Jackson Pollock, Gothic, 1944. Oil and enamel on canvas, 84⅝ × 56 in.

lock's talent is volcanic. It has fire. It is unpredictable. It is undisciplined."[50] The explosive drama of this language was already, in the 1940s, not to everybody's taste, yet the very recoil from this way of thinking about Pollock was a part of the story of the no-romantic romantics, for it marked a fundamental shift from a sense of giddily dramatic rhetoric to a new way of describing art's powers—to what might be called the matter-of-fact romanticism suggested by Greenberg's writings. Between Sweeney's prose and Greenberg's there was a gap as wide as the one that Rosenberg had described between the old Greenwich Village, with its pseudo-Parisian picturesqueness, and the new no-environment of Tenth Street. And yet there was a connection, too.

When Pollock died at the wheel of his car in August 1956, he was forty-four years old and had been showing in New York since he was in his early thirties. This artist, born in Cody, Wyoming, the youngest of five sons of Stella May McClure and LeRoy Pollock, had had a hardscrabble youth and early manhood, but since 1943, when he had been taken up by Peggy Guggen-

heim and given a one-man show at Art of This Century, he had become the first of his generation to exhibit regularly and begin to make a significant living. Two years later he and Lee Krasner moved to Springs, Long Island, buying a farmhouse, five acres of land, and a large barn for five thousand dollars, with financial help from Guggenheim. His most productive years were the second half of the 1940s; by 1952 or 1953 alcohol and depression had reduced his output to next to nothing. In the 1950s, Pollock was still visiting New York regularly—to see a psychiatrist, to visit the galleries and the bars. Pollock had been very handsome when he was young, and even toward the end, when he was swollen and sick, B. H. Friedman recalled that "the power, energy, and intensity of his face and body were magnetic, even charismatic." That is a lingering power that you sometimes encounter in people who were especially attractive in their younger days and somehow still seem that way, long after they have in fact lost their looks and their gifts. Pollock, an unhappy, difficult drunk, had a way of rallying people to his cause and keeping them there. In his youth there had been his older brothers, Charles and Sande, who were themselves artists in New York; later, Lee Krasner, Peggy Guggenheim, Clement Greenberg, and a number of others kept him going. But even in the 1940s, he struck Motherwell as "a deeply depressed man . . . and like most depressed men, rather reticent . . . and beneath his depression you could often sense his potential rage."[51]

For the younger artists who were arriving in New York fresh from college or the army, Pollock was a man whom you might encounter at the Cedar Tavern, but it was not likely that you would have gotten to know him in the sense

Herbert Matter,
Jackson Pollock,
circa 1950.

that you got to know de Kooning or Kline. At the Cedar he could sometimes be charming, but he was also, increasingly, morose, hunkered-down, even downright hostile, certainly not the genial hero that de Kooning or Kline or Hofmann could be. True, Denby, in a poem written after the death of Franz Kline, whom he described as an "adorable hero," recalled: "At first sight, not Pollock, Kline scared / Me, in the Cedar." But Denby soon realized that there was "No one Franz didn't like," and that was not true of Pollock.[52] Pollock would not—could not—be part of a group, and this isolation gave him an added kind of fascination, as if he were the genuine American article that the others were contemplating as an aesthetic object. Despite the stripped down, generic American look of the Cedar, there was probably an aura of the European tavern or café that lingered in this place where de Kooning, with his thick accent, presided, and many of the artists and visitors, if not themselves immigrants, were the children of immigrants. Pollock stood apart from that. As time went on, people found it harder and harder to connect with him at all. In the last years his circle was thinning. The final summer of his life, Krasner was in Europe, preparing herself for a divorce, when in August, on the way to a party at the house of the artist Alfonso Ossorio, Jackson Pollock drove his car into a tree, killing himself and Edith Metzger, a friend of his girlfriend, Ruth Kligman.

The less an artist has to say, the more room there is for others to say their piece. When Paul Jenkins described Pollock as reminding him of Billy Budd, that romantic icon, he was describing a kind of goodness that might be too frustrated to express itself through anything but violence, but he was also describing a person who, through his very reticence, comes to be what others believe him to be. Certainly, Pollock was a paradox. He might be the most instinctive of American artists, and yet you could argue that no artist of his generation had been brought before the public with anything like the careful and dedicated support that had accompanied Pollock since he first became involved with Peggy Guggenheim's Art of This Century. This, of course, said nothing about the quality of the work, yet the support system around Pollock, while it provoked what many saw as an unprecedented series of journalistic attacks on the excesses of abstract art, also isolated him and had the effect of making his art feel like a pure, solitary phenomenon, a mysterious achievement ripe for interpretation, whether in terms of the Surrealist's beloved ancient myths or some idea of America's essentially rough-and-tumble spirit. In the 1940s and 1950s, Pollock's work was accompanied by an ever-growing literature in which the old-fashioned romantic hero became a new-fashioned

hero, but romantic in spite of the fact that those doing the writing might think otherwise. Did Pollock see it this way? We do not really know.

A couple of months before Pollock died, the critic Sam Hunter published a long essay about Pollock, "The Maze and the Minotaur," in *New World Writing,* a paperback format literary magazine. The most interesting observations in Hunter's essay were about Pollock's romantic Americanness. Pollock's life reminded Hunter of "D. H. Lawrence's picture of the American free spirit in *Studies in Classic American Literature.* Lawrence was acute enough to see in American writing of the golden age (Melville, Poe, Hawthorne, Whitman) a refreshing, new human consciousness. At the same time, he suggested that the American writer, lacking so many of the assurances of a cultivated existence and sui generis a romantic, showed a tendency to shrink from the harsh forms of native reality and seek relief in the expression of extreme states of mind." Hunter was also reminded, by the "ambiguous content of Pollock's painting," of some remarks by Poe in his *Marginalia,* namely that "there is a class of fancies, of exquisite delicacy, which are *not* thoughts, and to which, *as yet,* I have found it absolutely impossible to adapt language."[53] When Hunter wrote another essay for the catalog of the retrospective mounted at the Modern after Pollock's death, he observed that at first Pollock had offered viewers his mythological images—the moon woman, the she-wolf, and other phantasms. But not too much later, he "eliminated from his work those medusa images and fearful presences which had been released with such facility in his first two exhibitions. His surrealist symbolism was part of the romantic commitment to the self, but once he had discharged his own rancors, fear and more disturbing fancies, he was free to break the limits of the self"—another romantic idea, but without romantic trappings.[54]

Jackson Pollock, The Flame, *circa 1936. Oil on canvas, 20½ × 30 in.*

Pollock had studied with Thomas Hart Benton, whose work had been included in the exhibition "Romantic Painting in America," at the Modern in 1943, and Pollock's early works included turbulent landscapes, with all the elements soldered together into a thickly painted knot of careening form. The best of those canvases, from the mid-1930s, were some small studies of flames, in which his fascination with the art of the Mexican muralists Siqueiros and Orozco, which all too often inspired a coarsely abstracted musculature, was compressed into images of febrile intensity. Working with black, deep brown, red, dirty white, and a little yellow, he created a densely armored, compressed image that had an insistent yet quiet resonance, like some of the best of Ryder's landscapes. Later, in the 1940s, Pollock pulled into his work, with a kind of sloppy, rapid-fire ferocity, the whole wild Surrealist encyclopedia, with its animal-people, idols, split-apart figures, automatic scrawls, and scrambled mythology. There was a voraciousness to his accessions of Miró, Masson, Picasso; it was not the imagery that was new, but the hell-bent, almost trashy informality with which he *embraced* Surrealism in the *Moon-Woman Cuts the Circle* (circa 1943), *Male and Female* (circa 1942), *Guardians of the Secret* (1943), *The She-Wolf* (1943), and *Pasiphaë* (circa 1943)—all pictures whose rather grand titles were generally said to have been dreamed up by friends rather than by the artist himself.

Pollock was a wildly unruly talent, but then, for a few years in the mid- to late 1940s, he was able to distill that unruliness and achieve some dense, poignant effects. In 1944, having rejected the Surrealist-mythological trappings, he painted *Gothic*, an inscription of curving black and white lines over deep blues and greens, a tight surface of upward-hurling, boomerang lines. I wonder if it is significant that in 1943, in the catalog of the "Romantic Painting in America" show at the Modern, there had been a section titled "The 'Gothick,' " where some works by Charles Burchfield were discussed in terms of "a macabre Romanticism which relates to the 'Gothick' tradition brought to this country by Washington Allston."[55] Pollock's *Gothic* was actually not all that far from the feeling of a turbulent dream landscape of Burchfield's, *Church Bells Ringing—Rainy Winter Night;* Pollock's arcing forms also evoked ecclesiastical architecture, the world of the cathedrals that writers such as Worringer associated with the beginnings of Expressionism. And even without knowing Pollock's title, you might feel that Barzun was speaking of *Gothic*—or *Cathedral*, done three years later—when he wrote that the aim of the Gothic style "is to bring into a tense equilibrium man's radical diversities, and it consequently produces work that shows rough texture, discontinuities, dis-

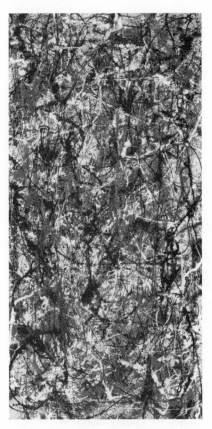

Jackson Pollock, Cathedral, 1947. Oil on canvas, 71½ × 35 7/16 in.

tortions—antitheses in structure as well as in meaning."[56]

At his absolute best, in the very restrained *Cathedral* from 1947, Pollock was an artist with a fine-tuned, rather small lyric gift. This painting brings to mind not the jutting drama of a great Gothic nave but the enveloping delicacy of a late Gothic chapel. Here Pollock has a beguilingly informal way of setting little swipes of yellow and orange within a dense, silver matrix. He gives chamber drama an epic quality; the small-scale incidents echo and reverberate, they add up to a sense of expansiveness that refutes the actual size of this roughly six-foot-high painting. *Cathedral* has a shimmering, twinkling power—a quiet resplendence. There's some sinew to its lacy fascination. In *Cathedral* I see a mind musing over its own operations. While the mood is a little melancholy, there is also a cheerful undercurrent to the melancholy, a pleasure in making all these distinctions that are so fine that they are just barely there. I like the speculative mood of *Cathedral* and some of the other works from 1946 and 1947; the drip technique has not yet become an end in itself. By the end of the 1940s, however, a lot of Pollock's effects feel overly regularized. The technique of dripping or flinging the paint, which Pollock originally borrowed from the Surrealists and at first used to suggest loopy unfolding journeys, soon became repetitive, a maze of lines that lock up the canvas all too efficiently in big works of 1950 such as *Lavender Mist, One: Number 31, 1950,* and *Autumn Rhythm.* And after composing those vast skeins of paint, Pollock turned for a time to black-and-white compositions, with faces and figures again emerging. And then, by 1953, he was in his studio less and less.

No other artist of those years attracted as much discussion, confusion, and dispute as Pollock. From the late 1940s, he was the lightning rod for all the dissatisfaction about abstract painting that appeared in the press, both in the United States and in Europe. In 1951, after Pollock's work had been included in the 1950 Venice Biennale, Hess observed that "he is accused of being too

fashionable and too obscure, the head of a coterie and minor eccentric, etc., etc. Thus true fame has come to him from his detractors, and his best publicity has been of the wrong kind."⁵⁷ Yet the crisscrossed arguments came from within the art world, too. Not long after he died, the Club sponsored an evening, which we have already heard about, at which people debated the meaning of de Kooning's assertion that Pollock broke the ice. Was this comment friendly or hostile? Was de Kooning saying that Pollock was seminal or merely that he paved the way? James Brooks, who spoke at the Club, later wrote that "perhaps there was no immediate Pollock school of painters because his work acted in a very different way—as a destroyer and a liberator over a wide spectrum, fertilizing seemingly opposite expressions by its disgust with the threadbare and by its strong assertion of life."⁵⁸ This talk of Pollock as a destroyer and a liberator makes him sound like a figure out of *Thus Spake Zarathustra*. There is no other artist of the period who gives quite the same impression that people's responses were not about him so much as they were about their own need to mythologize him. Perhaps because he had no students, no *école*, people were all the more inclined to personalize their reactions. Pollock's dripped surfaces could be whatever you wanted them to be. For his contemporaries he became at last somebody to spin memories about, the glass of vodka in one hand, the cigarette in the other. For younger artists he could be the savior of painting, or the last painter, or the precursor of happenings or mixed media. Allan Kaprow, writing in 1958, in "The Legacy of Jackson Pollock," said that "we saw in his example the possibility of an astounding freshness, a sort of ecstatic blindness."⁵⁹ Blind painters? Well, maybe.

In much the way de Kooning had imagined his old friend in Hoboken crushing together all the different kinds of bread, so Pollock crushed the elements of the romantic-Surrealist heritage—its gothicizing and mythologizing and Americanizing—into a new totality. Parker Tyler, a friend of Tchelitchew's who had initially been skeptical about Pollock in *View*, in 1950 published in the *Magazine of Art* a piece called "Jackson Pollock: The Infinite Labyrinth." Pollock liked this essay, in which Tyler argued that Pollock had in a sense abstracted the myth of the Minotaur and the labyrinth—a myth that apparently interested Picasso even more than Balzac's "The Unknown Masterpiece." Writing of Pollock's allover drip paintings, Tyler said that "the paint surface becomes a series of labyrinthine patinas—refined and coarse types intermingling." For Tyler, the paintings presented a radical variation on the old Greek myth. Pollock's labyrinth was so complex that it was "evident

that a solution is impossible because of so much superimposition. Thus we have a deliberate disorder of hypothetical hidden orders, or 'multiple labyrinths.' " Pollock, Tyler observed, "is saying that his labyrinths are by their nature insoluble; they are not to be threaded by a single track as Theseus threaded his, but to be observed from the outside, all at once, as a mere spectacle of intertwined paths, in exactly the way that we look at the heavens with their invisible labyrinths of movement provided in cosmic time by the revolutions of the stars and the infinity of universes."[60] You might say that Tyler was describing Pollock's allover paintings as a kind of naturalized mythology—mythology returned to nature.

VIII

Even at the time that Tyler's article was published, some would have said that he was trying to force Neo-Romantic interpretations onto Pollock's abstractions. It was true that from the late 1940s onward there was, increasingly, a rejection of symbolic interpretations, yet the fascination with myths and archetypes, at least as a fond old habit of mind, remained an element all through the 1950s. When Fielding Dawson recalled his visit with Kline to de Kooning, he described himself at one point, having lost sight of Kline in the street, as being like Telemachus. Frank O'Hara, who was as attuned to the mood of the 1950s as anybody alive, wrote in his book on Pollock, published in 1959, that "Pollock, alone in our time, was able to express mythical meanings with the conviction and completion of the past. Whatever qualities he saw in these myths, they were not the stereotyped, useful-to-the-present ones, which have made so many playwrights into dons, so many painters into academicians." O'Hara's Pollock was a buried mythologist. This was probably close to the truth. O'Hara wrote of *Cathedral* that it "is brilliant, clear, incisive, public—its brightness and its linear speed protect and signify, like the facade of a religious edifice, or, in another context, the mirror in the belly of an African fetish, the mysterious importance of its interior meaning."[61] In O'Hara's interpretation of the various paintings, the old emblems remained—the cathedral, the fetish, the all-seeing eye—but they were elided, compressed, recombined. And, strangely enough, I think that you find a related, if far more brilliantly complete, version of the same process in the writing of Greenberg, the man who is generally seen as Pollock's greatest expositor and most intrepid demythologizer.

It was Greenberg's intention, when he wrote about Pollock, to wipe away

Jackson Pollock,
Guardians of the Secret,
1943. Oil on canvas,
48⅜ × 75⅜ in.

the encrustations of myth. Reviewing the first one-man show in 1943, with its "not so abstract abstractions," he complained of Pollock's "pretentious" titles—*Guardians of the Secret, Male and Female*—and set out to find his own matter-of-fact language of struggle and transcendence to describe what was going on. Writing of that show, Greenberg ignored Sweeney's allusions to the French Romantic period of Hugo and Sand, but at the same time he argued strongly for Pollock's connection to a home-based romantic spirit. "He is the first painter I know of to have got something positive from the muddiness of color that so profoundly characterizes a great deal of American painting. It is the equivalent, even if in a negative, helpless way, of that American chiaroscuro which dominated Melville, Hawthorne, Poe, and has been best translated into painting by Blakelock and Ryder."[62] Greenberg, a fine writer with a plainspoken style, would not insist further on these connections to nineteenth-century American art. Indeed, years later he would come to be seen as utterly opposed to the view of Pollock as representing a romantic American experience. And yet in the early years it was Greenberg who made the case for the Americanness of Pollock, an Americanness that was grounded in a romantic sense of the individual as being attuned to some broad, national experience—the kind of thing that Victor Hugo, indeed, was felt to have experienced for France.

When, in 1947, Greenberg compared Pollock to the French painter Dubuffet and said that Pollock "is American and rougher and more brutal," or compared him to Mark Tobey and Morris Graves, who was in "Romantic Painting in America," and said that in Pollock's painting "the feeling . . . is

perhaps even more radically American," he was invoking an idea of the artist's heroism as growing out of common experience that goes back to Thomas Carlyle and even earlier. "All speech, even the commonest speech, has something of song in it," Carlyle had observed in *On Heroes, Hero-Worship, and the Heroic in History*, and although "a vein of Poetry exists in the hearts of all men," it is a "man that has *so* much more of the poetic element developed in him as to have become noticeable, will be called poet by his neighbors."[63] Greenberg may have chosen to describe the relationship of artist to neighbor modestly, with the term " 'American-Type' Painting," and yet he was saying that Pollock was a symbol of the United States, as Hugo was of France. In doing so, Greenberg was, more subtly, doing what O'Hara did, when he quoted Pasternak as saying that Aleksandr Blok and Aleksandr Scriabin were "a personified festival and triumph of Russian culture," and "so is Jackson Pollock such an occasion for American culture . . . created in a nation and in a society which knew, but refused to acknowledge, the truths of which Pasternak speaks."[64]

For his discussions of Jackson Pollock, Greenberg created a new kind of stripped-down drama. There was a hero, a quest, and a labyrinth of style. And Greenberg was the plain-talking Baudelairean author, the man seeking out new sensations in the galleries of the metropolis. As Greenberg wrote about Pollock, year after year, he described the artist as a striving spirit. In *Guardians of the Secret*, Pollock "struggles between two slabs of inscribed mud . . . ; and space tautens but does not burst into a picture; nor is the mud quite transmuted." Greenberg spoke of Pollock's "search for style." Four years later "Pollock has gone beyond the stage where he needs to make his poetry explicit in ideographs." "What he invents instead has perhaps, in its very abstractness and absence of assignable definition, a more reverberating meaning."[65] I hear in Greenberg's description affinities with some of Goodrich's observations about Ryder in the 1947 Whitney catalog. Ryder, Goodrich wrote, "used the elements of nature far more freely than any American of his time. He simplified them to their essentials, to what was purely expressive; and he remoulded them and made them obey the rhythms of his instinctive sense of design." And then again, "Ryder had a sensuous passion for form such as most artists have only for color. . . . Every line and shape had a definite flow and was vitally related to every other line and shape. An extreme sensitiveness to interrelations of forms governed his work."[66] There was, both in Goodrich's interpretation of Ryder and in Greenberg's interpretation of Pollock, a sense that purity of form can be achieved only by the artist who has gone through

a romantic struggle. This brings us back to Duncan's observation, in *The Black Mountain Review,* that the idea that "form is Form . . . we owe to the Romantics."[67]

What Greenberg saw in Pollock was the drama of the artistic will, played out in the most intense manner imaginable—and the result was a purified romanticism. Painting itself became the hero, an idea that Greenberg emphasized by anthropomorphizing the painting. "The art of painting increasingly rejects the easel and yearns for the wall." Painting "abandons certain of its former virtues." Greenberg described *Cathedral* as "a matter of much white, less black, and some aluminum paint," and said that it "reminds one of Picasso's and Braque's masterpieces of the 1912–15 phase of cubism. There is something of the same encasement of a style that, so to speak, feels for the painter and releases him of the anguish and awkwardness of invention, leaving his gift free to function almost automatically." This did not sound that far from Hegel writing about romanticism, with its "free and concrete presence of spiritual activity, whose vocation is to appear as such a presence or activity for the inner world of conscious intelligence." At the end of this quest of Pollock's, there was a kind of mysterious cycling backward and forward at the same time, for the artist's search took him back to a *Jackson Pollock,* touchstone of modern art—to the Cubism of 1912–15. Or even *Number 1, 1949. Enamel* earlier. Of *Number 1* in 1949 Greenberg observed, "I do not know *and aluminum paint on canvas, 63 × 102 in.*

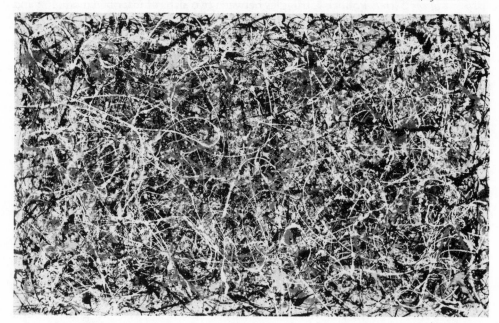

of any other painting by an American that I could safely put next to this huge baroque scrawl in aluminum, black, white, madder, and blue. Beneath the apparent monotony of its surface composition it reveals a sumptuous variety of design and incident, and as a whole it is as well contained in its canvas as anything by a Quattrocento master."[68] Greenberg may have made his points with an all-American bluntness, but when he asserted that Pollock, almost involuntarily, found his way to a perfection that recalled the work of Picasso and Masaccio, who can doubt that Greenberg was describing the hero triumphant?

IX

In a big, brilliant, fast-moving metropolis, even the deepest-running artistic impulses are sometimes given a mass-market spin almost as soon as they surface. Thus there was nothing particularly surprising in the images that were circulating in the early 1950s of Jackson Pollock as a contemporary romantic rebel in blue jeans and a T-shirt, whose stance and demeanor somehow came out of the same crucible as the Marlon Brando of *A Streetcar Named Desire.* Some have even argued that Tennessee Williams—who knew Pollock in Provincetown in the 1940s and remembered him as "boisterous, just slightly drunk, . . . a sturdy, well-built young man, then, just a little bit heavier from beer-drinking than was attractive to me"—used Pollock as one of the models for Stanley Kowalski.[69] Williams himself never said as much, and there is, I think, nothing in Kowalski that will help us better understand Pollock. Years later, when Williams, by his own account, used Pollock and his wife, Lee Krasner, as the models for the husband and wife in a different play, *A Bar in a Tokyo Hotel,* the result was, so far as I am concerned, equally unrevealing, at least for the reader who is looking for insight into Pollock. The interesting point here is, I think, a more general one, not that artists were taking on theatrical airs or that theater people were imitating visual artists, but that the art world was fueled by a deep-running dramatic sense of the artist, a sense that went back to the Surrealists with their mythic journeys, to the urban wanderers of Baudelaire and Gautier, to Delacroix's fascination with Shakespearean passions, to the artist's strange quest in Balzac's "The Unknown Masterpiece."

What has been called the Golden Age of the Theater in New York and what has been called the Golden Age of Painting in New York took place practically simultaneously. True, the Broadway of Eugene O'Neill and Ten-

nessee Williams was somewhat remote from the artists' haunts, something that they admired along with the rest of the population. We have seen, though, that Williams spent a good deal of time in Provincetown, where Hofmann ran his school in the summers, and that in 1948 he published a tribute to this painter who had moved "straight into the light without being blinded by it."[70] In his autobiography, published in the 1970s, Williams observed of Pollock that he "could paint ecstasy as it could not be written."[71] One wonders if Williams thought Pollock's kind of ecstasy could be acted. In the early 1950s, certainly, the theatrical metaphor had a particular urgency because the theater was such a big part of what was drawing people to Manhattan. And for visual artists the experience of having friends, lovers, and acquaintances literally walking the boards was a part of what gave the idea of the romantic act its complicated, metaphorical richness. When Rosenberg remembered Arshile Gorky, who had died in 1948, he lingered over his theatricality, over the fact that "he decided . . . to *look* like an artist. I place great importance on this comic-opera side of Gorky, sustained by his taste for an elegance tuned to the red plush era and by his Du Maurieresque appearance, tall, dark and handsome, with pleading war-orphan eyes." Gorky, Rosenberg wrote, was "always ready to put on the neglected-genius act, especially in the presence of women and important people," and this mystified friends who recognized in him "a relentless thinker and disciplined creator."[72]

The artists and poets knew many of the Off-Broadway actors and writers and directors—sometimes they were lovers, roommates, close friends. Denby, a friend to so many artists, was also the great chronicler of George Balanchine's New York City Ballet, and had published his *Looking at the Dance* in 1949. By then the involvement of painters and poets with modern dance and drama had been cemented in the collaborative events at Black Mountain College in North Carolina, where

Clemens Kalischer, Satie's The Ruse of Medusa
performed at Black Mountain College, 1948.
Merce Cunningham is the mechanical monkey;
the décor is by de Kooning.

lucky artists were invited for the summer sessions that doubled as summer vacations. *Asheville,* named after the nearest town, was the important composition that de Kooning painted at Black Mountain in the summer of 1948, the summer Passlof had heard him speak about Veronese, a painter known for his theatrical sensibility. But de Kooning had also done some sets for a production of Erik Satie's *The Ruse of Medusa,* with a sort of baroque bust painted above a doorway, a theater piece in which Elaine de Kooning and Buckminster Fuller took the starring roles and Merce Cunningham performed his own choreography for the role of Jonas, an elegant mechanical monkey. Two years earlier, in 1946, de Kooning did a curtain for a dance called *Labyrinth,* choreographed by Marie Marchowsky. The roll call of artists who were involved with the theater, and especially the dance, was long. Franz Kline did a backdrop for the Merle Marsciano Dance Company in 1960. Ellsworth Kelly did costumes and a stage curtain for Paul Taylor's *Tablet,* presented at Spoleto in 1960, and costumes for Taylor's 1968 *Lento,* which suggested the bold divisions of the body that Matisse had employed in his designs for Léonide Massine's *Rouge et noir* in 1938. Alex Katz's cutouts—which we will take a close look at later on—were used as sets for Kenneth Koch's *George Washington Crossing the Delaware,* and Katz was also involved with Paul Taylor's company. Robert Rauschenberg was the Merce Cunningham company's resident designer for a decade, starting in the mid-1950s; his dappled sets for the 1958 *Summerspace* were a signal event in the revival of interest in Monet. A decade earlier, in 1947, Cunningham created for Ballet Society, the organization that was one of the forerunners of the New York City Ballet, *The Seasons,* with sets by Noguchi, who had already done a cover for *View* and the next year would work with Balanchine on *Orpheus.* Noguchi, whose long association with Martha Graham had begun

Ellsworth Kelly, study for sets and costumes for Paul Taylor's Tablet, *1960.*

Performance of Merce Cunningham's The Seasons, *with costumes by Isamu Noguchi, 1947.*

in 1935, was interested in compositions that were expansive enough to fill a proscenium stage. His work for the theater flowed into his later involvement with urban parks and gardens, which was surely fueled by an idea of romantic escape, of finding an inner world within an outer world, of resolving the conflict between a New York artist's pastoral longings and populist aspirations.

Frank O'Hara was addicted to the theater, saw Beckett's *Happy Days* three or four times, and described Williams's *Sweet Bird of Youth* to his friend Patsy Southgate with such panache that she found the play itself a horrible disappointment. At O'Neill's *Long Day's Journey into Night,* which O'Hara attended with Denby, O'Hara was "bracing himself for the anguish that lay ahead." He asked Denby—this is according to O'Hara's roommate Joe LeSueur—"Do you want to leave?" To which Denby replied, "If you can stand it, I can."[73] In Cambridge, where O'Hara and Ashbery went to school, the poet Bunny Lang had organized the Poets' Theatre, where poets who were still students produced plays; Edward Gorey was among the Harvard students who were involved. From 1953 to 1956, O'Hara and some of his poet friends, among them Ashbery, wrote plays for a group that had been organized by the director of the Tibor de Nagy Gallery, John Bernard Myers, and his friend Herbert Machiz, and was named, significantly, the Artists' Theatre. As Machiz recalled, this was "one of those few and far between enterprises aimed at a merger of writers, painters, and composers."[74] Among the painters who, on small or nonexistent budgets, did sets were such Hofmann School alumni as Larry Rivers, Al Kresch, and Nell Blaine. For Ashbery's play *The Heroes,* Blaine created a four-and-a-half-foot-high Trojan horse and painted flats that

evoked the gates of the burning city of Troy.[75] In *The Heroes,* Theseus explains to Patroclus, "I realized that I now possessed the only weapon with which the minotaur might be vanquished—the indifference of the true aesthete."[76] This is another example of the presence of mythology among the habitués of Tenth Street. Perhaps Ashbery was thinking of de Kooning's generation as the Picassoesque Minotaurs, and his generation—the generation that came after, the "Cocteau" generation, one might call it—as the "true aesthetes."

No wonder New York felt like a living theater. Everybody believed that to get together and talk was to participate in this play whose scenes and acts took place in real time and real space. On opening nights in the galleries along Tenth Street, there was a rush of people, and the Minotaurs found themselves happily surrounded by the true aesthetes. In her diary, Judith Malina recorded her struggles to start the Living Theatre with her husband, Julian Beck, her involvement with their parents, their son Garrick, money worries, the days in rehearsal, psychoanalysis with Paul Goodman, the late nights drinking at the San Remo with the artists and the poets. Watching performance was an essential element of this New York life, especially the jazz that was changing so dramatically all through the 1940s and 1950s, as the performer became an increasingly singular presence in the expressionist jaggedness of bebop; everybody followed the music of Charlie Parker and Dizzy Gillespie. Not only were the painters aficionados, but some of the young painters in the orbit of the Hofmann School—Larry Rivers, Nell Blaine, Leland Bell—actually played, professionally or otherwise. Weldon Kees, who not only painted but also played his own ragtime compositions—and whom his friend Anton Myrer called "one of the last great romantics"—wrote nostalgically in 1948 in *Partisan Review* about the midtown neighborhood that was "once as devoted to night clubs featuring jazz and jam sessions as Grand Street is to wedding gowns or Bleecker Street to salami," and, in Greenwich Village, he especially mentioned a club called the Pied Piper on Barrow Street.[77]

In her novel *Sleepless Nights,* Elizabeth Hardwick recalled New York jazz in 1943, "the shifty jazz clubs on 52nd Street, with their large blow-ups of faces, instruments, and names. Little men, chewing on cigars, outside in the cold or the heat, calling out the names of performers, saying: Three Nights Only, or Last New York Appearance." Hardwick focused on Billie Holiday, with "the creamy lips, the oily eyelids, the violent perfume—and in her voice the tropical *l*'s and *r*'s. Her presence, her singing created a large, swelling anxiety." Hardwick wondered if she was a figure of "genuine nihilism," but

decided this was not so. And yet "somehow she had retrieved from darkness the miracle of pure style." Pure style: Wasn't that what Greenberg felt that Pollock had achieved with *Cathedral*? And Hardwick's idea of the performer as rising above the confusion of the clubs and the crowds, pushing toward that purity, was also central to John Clellon Holmes's novel *The Horn*. When you listened to Edgar Pool, Holmes's hero, play his horn, you heard a "mindless, dumb, finally humble and unquestioning response just to the chords themselves, which was the result of years of simply trying to manipulate the stops, and further years of the impatient expending of this mastery on worthless tunes, and finally that first astonishing moment when the skill was adequate to the idea."[78]

The purity of the great jazz artists fascinated young painters and sculptors in part because this dazzling improvisational music rose out of such messy conditions, out of all the hurly-burly of the clubs and the city. There was a sense that painting might have an analogous power, that the artist's willpower, concentrated in paint on canvas, could hold the gallerygoer's attention, despite all the distractions that confronted a city dweller at every turn. Leland Bell would always use jazz terms to describe the movements in a painting; and he was fond of comparing André Derain, whom he saw as the great odd-man-out of twentieth-century French art, to Lester Young, another odd-man-out. In *Evil Under the Sun*, Anton Myrer's 1951 novel about the artists who were studying at the Hofmann School, a student announced that the advantage that painting has over writing was this: "Color can't be qualified out of existence; it's either there or it isn't. With a painting, you look at it, and if it's right—if it's really right—it'll move you." And then, Myrer continued, the young man "held his hands forth, cupped the air in front of him. 'There it stands on the wall, big as life itself. The person looks at it and he's instantly involved. Bang: like that—there is a direct reaction, and the spectator's ideas and feelings begin to run.'" Here, in Myrer's novel, the painting itself became a kind of performance. And in a period when artists were besotted with the jazz clubs, the idea of a painting as a performance could get mixed up with the idea of the artist as performer—or alternately with the idea of the artist as a person going through a journey in painting, as Greenberg, no friend of the idea of theatricality, described, year after year in Pollock's work, a journey that might end with style taking on a life of its own, a life that at last, as Greenberg would say, leaves the artist's gift "free to function almost automatically."[79]

X

If classicists look to the theater and its performers for an idealized view of life, romantics value the performing arts as a place where all life's unpredictability is turned into a thrilling spectacle. When Frank O'Hara, an amateur pianist, wrote not once but seven times poems to Rachmaninoff on the composer's birthday, he must have been thinking of the drama of the Romantic piano repertory, especially the concertos, in which the soloist, going out alone against the orchestra, could summon up in a listener emotions that resonated with the experience of being an individual in the midst of the vast city. The idea of a man as an adventurer, a performer, an actor was in the grain of New York, so much so that when Harold Rosenberg, a writer with a nose for the telling phrase, published "The American Action Painters" in *Art News* in 1952, the essay was immediately assimilated by downtown New York because it took a vast amount of complex and contradictory information and experience and boiled it down into a sort of tabloid headline, as slapdash as the headlines on the papers that de Kooning kept around his studio.

So far as most people could see, Rosenberg's essay came down to a couple of lines. "At a certain moment the canvas began to appear to one American

Hans Namuth,
Jackson Pollock, *1950.*

painter after another as an arena in which to act—rather than as a space in which to reproduce, re-design, analyze or 'express' an object, actual or imagined. What was to go on the canvas was not a picture but an event." This essay was not a theory of contemporary painting so much as it was a zeitgeist reading—a summary of the new romanticism, which gave the no-romantic attitude a flashy spin. "The big moment," Rosenberg wrote, "came when it was decided to paint . . . just to PAINT. The gesture on the canvas was a gesture of liberation, from Value—political, esthetic, moral." Rosenberg obviously thought of his artist as an existentialist hero—and this was existentialism of the airiest variety, all quizzical posturing and damned-if-I-know-what-I'm-doing bravado. "The painter no longer approached his easel with an image in his mind; he went up to it with material in his hand to do something to that other piece of material in front of him. The image would be the result of this encounter."[80] Rosenberg's theatrical imagery may well have been precipitated by Maurice Merleau-Ponty's essay "Cézanne's Doubt," in which the French existentialist described painting as an "expressive act" and spoke of "the difficulties" and "the virtues of that act," but Rosenberg turned the artist's experience in the studio into existentialism lite.[81] His essay was all glittering bits—a hot-air construction.

Rosenberg had only really begun his career as an art critic; up until this point he had been better known as a commentator on literary and social matters. And the essay seemed to retreat from you even as you were trying to get a fix on it. One of the questions that was much discussed at the time had to do with who exactly Rosenberg was talking about in this essay, for he did not mention the name of a single contemporary American artist. Rosenberg was known to be close to de Kooning, yet the description of the artist at work sounded rather like Pollock as seen in his studio barn in Springs. Some have argued that the essay, with its dismissive description of paintings that were like "apocalyptic wallpaper," was a slightly veiled attack on Pollock, and art-world insiders could certainly have taken it that way. The bombastic power of Rosenberg's essay, however, had everything to do with the anonymity of his artist, who was less a person than a temperament, the temper of New York in its no-romantic romantic phase. That a canvas should no longer be understood as a picture but as an event was a statement that worried many painters, and with good reason. In the years after "The American Action Painters" appeared, what had begun as an analysis of the feelings that artists had when they approached the canvas came more and more to look like a description of the whatever-happens-happens nihilism that fueled the happenings that Jim

Dine and Claes Oldenburg and others were organizing around 1960. With its super-short paragraphs and zingily enigmatic subheadings ("Getting Inside the Canvas," "Dramas of As If"), Rosenberg's essay put journalism's imprimatur on the new, stripped-down romanticism, and it hardly mattered that he also had some harsh words for the current state of art and criticism.[82]

Hidden behind Rosenberg's hurry-up pose was the spirit of a man who could not bear to say goodbye to the old, feverish, romantic dramas. In 1954, two years after "The American Action Painters" first appeared, Rosenberg published an essay called "Parable for American Painters," which offered a striking historical view of the situation of the American artist, whom he spoke of in terms of "coonskinism." Rosenberg began by recalling the stories that everybody had heard in grade school about how the British were defeated when the redcoats, marching in their neat formations, were ambushed by the Indians and the trappers, in their coonskin hats, who had hidden in the trees. The coonskins were guerrillas, confounding the orderly British plans. Rosenberg argued that "coonskinism," which was "anti-formal or trans-formal," was the key to the greatest achievements in American art. The coonskins knew that "each situation has its own exclusive key." They were determined—dogged—improvisers. They were in search of "the principle that applies, even if it applies only once." But if "Parable for American Painters" had the advantage of setting the contemporary American situation in a historical perspective, it was the sizzling immediacy of "The American Action Painters" that people remembered. Artists and critics kept talking about this essay in which Rosenberg wrote that "the canvas has 'talked back' to the artist not to quiet him with Sibylline murmurs nor to stun him with Dionysian outcries but to provoke him into a dramatic dialogue."[83]

And what might be the substance of this dialogue? It turned out to involve the entire grand sweep of Western culture—"Anything that has to do with action—psychology, philosophy, history, mythology, hero worship."[84] So here we were, back in the worlds of Hegel, Balzac, Carlyle, Nietzsche, Riegl, Worringer, and Breton. "The American Action Painters" had the kind of crude truth that you often find in pieces of writing that achieve a legendary, almost pop status. By giving himself over to the vagaries of improvisation, Rosenberg's artist found that he could be all things to all people. Rosenberg was not wrong to believe that psychology, philosophy, history, mythology, and hero worship could all be part of the drama of American art. But in leaving out of his essay the name of a single contemporary American artist, he was telling his readers that although this was a time for action, he did not

care to put his money on any particular actors. By refusing to go into specifics, by creating a blankly, trashily heroic figure, Rosenberg exposed a fatal romantic flaw—his hunger for a grandiosity that obliterated the specifics. He was riding roughshod through the early 1950s, ignoring all but the most spectacular monuments, when this was in fact a time when what was needed was a searching description, one by one, of the dramatis personae, of the proliferation of actors, each with his or her particular sense of things.

6. A SPLENDID MODESTY

I

The paintings that Philip Guston was working on in the early 1950s, which consisted of little more than delicate expanses of wavering, weaving strokes and counterstrokes, defined a particular mood, a particular temper in American art. If Hans Hofmann, in the canvases he did all through the 1950s and 1960s, was still confronting, with ever greater depth and ferocity, the romantic drama of the 1940s, Guston's work reflected a different act in that drama, a cooling of contrasts that could, perhaps paradoxically, become a way of preserving and even extending the old dialectical tensions. These paintings of Guston's suggested the color of old parchment, of faded terra-cotta walls, of roses on misty mornings. They were dreamy, almost evanescent, with no image to speak of, only those snaking, tentative strokes, strokes that were

Philip Guston, Painting No. 9, *1952. Oil on canvas, 48¼ × 60¼ in.*

worked vertically and horizontally and that tended to concentrate toward the center of the canvas and disperse toward its edges. This was a tamped-down drama, a drama of muffled encounters and mysterious interactions. It was as if the conflagration that had destroyed Frenhofer's paintings along with his studio in the "The Unknown Masterpiece" had died down, and what was left was the quiet glow of Guston's abstractions.

Philip Guston had been born in Montreal in 1913, two years before Hofmann opened his first school in Munich. He was a year younger than Pollock, and he had, like many of the artists who were maturing as painters in the 1940s, been on the WPA, and he had done a mural for the 1939 World's Fair. He had not felt the impact of Picasso and Miró and Matisse, at least not in the deep, stirring sense that many other artists had, and although the allegorical figure groupings that Guston had done before the 1950s, with their mixture of Giorgio de Chirico and Ben Shahn, sometimes had a sinister streak, they could also feel rather tame, like Social Realism with a lacy, commedia dell'arte sugar coating. It was Guston's inclination to hold something back that gave his work a special kind of relevance in the 1950s. In his abstractions, which he first exhibited at the Peridot Gallery in 1952, the abrasiveness of first-generation Abstract Expressionism was gone, replaced by a delicacy of color and line that probably owed something to the Parisian painters Nicolas de Staël and Maria Elena Vieira da Silva. These Gustons were all exquisite equivocation. "In the two *White Paintings* of 1951," Frank O'Hara observed, "there is virtually nothing but the contact of the hand with brush, the brush with canvas, exploring with sparse means the luxurious personal joys of drawing."[1] Guston was a fairly restrained romantic spirit, reluctant perhaps to break all the rules. In a statement for the "Twelve Americans" show at the Museum of Modern Art in 1956, he observed that "even as one travels in painting towards a state of 'unfreedom' where only certain things can happen, unaccountably the unknown and free must appear."[2] Piero della Francesca, the artist who probably always meant the most to Guston, and about whom he published some comments in *Art News,* was a painter who knew how to give enigmas a classical clarity. The art of Piero suggested a dreamy doubling of the weighty heroics of Renaissance art, and in Guston's muted compositions the fierce gestures of Pollock and de Kooning were recapitulated, only as if underwater, with the jaggedness smoothed out into moiré. Guston's interwoven strokes of ochers, grays, reds, and whites added up to silveriness, which is why these paintings are such a perfect symbol of a Silver Age mood that is very much a part of the story of the School of New York.

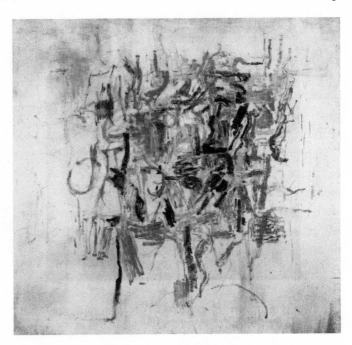

Philip Guston, White
Painting I, *1951. Oil on
canvas, 57⅞ × 61⅞ in.*

If the dominant note of painting in New York in the 1940s had been a burning darkness, then there was certainly a striking quality of beautiful pale color, like streaked skies of early dawn, that ran through the 1950s. The lighter palette had been embraced by Pollock himself in his 1950 *Lavender Mist,* with its pearly aura. The increasing interest in black-and-white around 1950 could, of course, suggest the dialectic at its highest pitch, but black and white could also, in the twinkling of an eye, move into the milder dialogue of whispered gray lines, as in the work of Richard Pousette-Dart, who turned thirty-four in 1950, and was painting his mysterious, nearly white-on-white abstractions, with their scratched and incised lattices and arabesques. For a time in the mid-1950s, the dialectics of chiaroscuro, the light and dark conflict that many said was at the core of Western art, was resolving into a coolness, into delicate flickering effects. Even the fiercely romantic balancing of black and white in the work that Franz Kline began showing at the Egan Gallery in 1950 could have a surprising lightness, as if black were invoked only to be set aside. True, the heaviness of Kline's blacks picked up on the brooding atmosphere of 1940s abstraction, but it was frequently those whites of his that really set the mood, and they suggested a buoyant, open-ended, angst-less void.

Many painters who had been touched by Hofmann's teaching embraced this new, silvery mood. Giorgio Cavallon's canvases had a subdued architec-

tonic power, as if Cubism were being recapitulated through the exquisite white-on-white effects of plaster walls finished by a master craftsman. You feel the silvery mood in the tans and grays and pinks that dominated the work of some contemporary representational painters, among them Nell Blaine. The narrowing of contrasts was there in Joan Mitchell's abstractions, with their evocations of foliage and water and city smog, sometimes submerged in a range of smudged whites. Fairfield Porter was also working with pastel, white-tinged colors in the 1950s. Greenberg felt that this new direction was especially clear in the stained-canvas techniques with which Helen Frankenthaler, who had also studied with Hofmann, was experiment-

Giorgio Cavallon, Untitled, circa 1955.
Oil on canvas, 30 × 24 in.

ing; her floating areas of color, absorbed into the canvas with a watercolor-like ease, gave Abstract Expressionism a bodilessness—a ghostly ebullience. This new lightness was also a factor in the work of geometric artists, for example, in the mild violets and mauves with which Ilya Bolotowsky was assembling the elaborate arrangements of his mosaic-like Constructivist canvases. All these painters were using mixed, nuanced colors—colors that slid away from a definite shade. As Guston said a few years later, "painting *is* 'impure.' It is the adjustment of 'impurities' which forces painting's continuity."[3]

II

Although there was a mildness to the upbeat spirit of the 1950s, this was not complacency. If there was a certain quietism about some of the best work that was being done in the 1950s, the equanimity was grounded in hard experience and careful thought. In 1962 Harold Rosenberg published a monograph about Gorky, de Kooning's old friend, whose delicate lyric style had become increasingly popular since his death in 1948. Rosenberg described Gorky's interest in Leftism in the 1930s, and then his disillusion with it, and argued that Marxism's inability to speak to what was essential in painting was not unrelated to its inability to speak to what was essential in social change. In the end, Rosenberg wrote, "the bankruptcy of a rationale of progress in regard both to art and to social history had to be acknowledged and an appeal addressed to other powers of the mind." The answer seemed to rest with a different view of

history, something closer to that of Picasso, who "taught by example that the artist today ought to be a living embodiment of the entire history of art. In our time each new work must constitute a decision as to what is living and what is dead in the painting of the past. The artist's rumination upon the history of art is thus a rumination upon himself as well, upon his taste, his intellectual interests, social judgments, the symbols that move him."[4]

Rosenberg's view of the nature of the artistic imagination was quite close to the inward-turning vision that Meyer Schapiro emphasized in his lecture "The Liberating Quality of Avant-Garde Art," first given at a meeting of the American Federation of Arts in Houston in 1957. Schapiro argued that the nature of the painter's art, which highlighted the moment-by-moment actions of the artist's hand, led to an extremely intuitive, spontaneous, and thoroughly experimental form of expression. The contemporary painter found few "ideal values" that were "stimulating to [the artist's] imagination," so that it was incumbent on him to "cultivate his own garden as the only secure field in the violence and uncertainties of our time." By invoking Voltaire's eighteenth-century pastoral, Schapiro suggested that the artist needed to move away from the upheavals of the world, and suggested, moreover, that this self-absorption could in fact be liberating. This view was widespread in the 1950s. Hess was one of a considerable number of people who took it for granted that the eclipse of radical hopes had shaped the attitudes of younger New York artists, the painters and sculptors whose careers were just taking off. "There was nothing to do but paint"—so Hess summarized the situation. "The self-directed community became self-oriented. Art replaced revolution

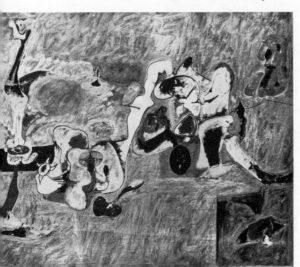

in its eschatology. It was a moment of complete dedication to the revolutionary vocation of painting." And Dore Ashton wrote that "the young artist today need not liberate himself since that has long since been done for him."[5] The tendency to see oneself in historical terms was built into the dialectical sensibility that the artists had absorbed from the Marxists, and in

Arshile Gorky, The Plow and the Song, *1947. Oil on canvas, 52⅛ × 64½ in.*

the 1950s that dialectical sense became compressed, speeded-up, personalized; it was no longer a matter of broad historical tendencies, but of distinctions between one person's style and another's, or the style of this year versus that of last year—or the struggle to wrest from one's own current style something newer, fresher, yet more authentic. The utopian dream remained, but utopia now involved not a radical gesture but a romantic gesture, the gesture of style.

The retreat from any sort of political engagement was a topic of literary as well as of artistic discussions. Lionel Trilling, writing about Henry James's novel *The Princess Casamassima* in 1948, had been fascinated by the young revolutionary Hyacinth Robinson, and his conversion, on a visit to Venice, to the cult of art, an art that Robinson now revered so much that he could forgive or at least accept the inequalities and injustices of the civilization that had produced it. So far as the intellectuals gathered around *Partisan Review* were concerned, the insistence that art had a destiny of its own could be traced all the way back to the 1930s, when they had rejected the authority of the Party. Artists were inclined to agree with the intellectuals in their midst, and say that if politics hadn't worked out there was still art to live for—which is what Hofmann had been saying all the way back in the 1930s. In his essay about *The Princess Casamassima,* Trilling wanted to draw attention to this novel in which James, who had gone as far as any American genius in dedicating his life to a freestanding idea of beauty, tried to grasp the impulses that led good men to dream of overthrowing whole civilizations. Hyacinth Robinson, Trilling wrote, was "torn between his desire for social justice and his fear lest the civilization of Europe be destroyed." Trilling liked the fact that for James's anarchist, art ultimately prevailed. By writing about *The Princess Casamassima,* Trilling found a way to articulate a new American feeling that you might have to compromise some of your political ideals in order to experience the uncompromised glories of art. And certainly postwar American artists and writers would have no trouble understanding Hyacinth's astonished reactions to Venice, that city where Titian had perfected the frankly expressive brushstroke and where, according to James, the world was "raised to the richest and noblest expression." In the 1940s, Robert De Niro had painted *Venice at Night;* and Wolf Kahn, another Hofmann student, had painted a canvas called *Venice in the Autumn* in 1958. Hess, writing about de Kooning, pointed out that Matisse had said that New York light "is most like the 'clear saline light of Venice.' "[6] And of course the new works by Guston and Pousette-Dart, in which mosaicked strokes and architectural fantasies emerged from the painterly atmosphere, could easily suggest Venice's mist and mystique.

Art-for-art's-sake was an old idea whose time had come again. It was the most romantic idea of all. When Trilling wrote about Hyacinth Robinson, he was writing about his own generation, too. "He understands, no less clearly than before, 'the despotism, the cruelties, the exclusion, the monopolies and the rapacities of the past.' But now he recognized that 'The fabric of civilization as we know it' is inextricably bound up with this injustice; the monuments of art and learning and taste have been reared upon coercive power. . . . He finds that he is ready to fight for art—and what art suggests of glorious life— and against the low and even hostile estimate which his revolutionary friends have made of it, and this involves of course some reconciliation with established coercive power." Wrapped in the extraordinary refinement of James's prose, the dream of a radical politics suddenly dissolved. It was dissolving in New York, too. Mary McCarthy, one of the *Partisan Review* crowd, left for Europe, and described her own Italian odyssey in *The Stones of Florence* and *Venice Observed*. And Peggy Guggenheim, who had given Pollock and Motherwell and Hofmann and De Niro and so many New York School artists crucial support and visibility at her Art of This Century gallery, had moved to Venice, where she bought a palace on the Grand Canal and went out in her gondola every evening at dusk to watch the sunset. Guggenheim's European phase was portrayed in a story by McCarthy, "The Cicerone." They were friends, and McCarthy, who was with Guggenheim around the time that she was making her decision to live permanently in Venice, once recalled that Peggy said she would sell her entire collection if she could buy one Giorgione.[7]

III

"The Root Is Man," Dwight Macdonald had declared in his stirring manifesto, and as far as art was concerned, the greatest visions were rooted not only in the work of man, but often in the work of a single man, such as Giorgione, the Venetian painter whom many regarded as the inventor of the lyrical mode in painting, and therefore as the first modern artist. It was this idea of finding the root in man that was drawing some artists to Eastern religions and philosophies—not only Zen but also the ideas of Krishnamurti, whose books De Niro owned and whose lectures he sometimes attended. "There is hope in men," Krishnamurti wrote, "not in society, not in systems, organized religious systems, but in you and in me." There was obviously a certain foolish innocence involved in the appeal of Eastern religions, which some artists saw as

offering an escape from the organized forms of Western belief and in any event generally knew only in the most simplified and perhaps sweetened versions. Zen, which D. T. Suzuki explained called on a man to "cast off all one thinks he possesses, even life," could turn out to be a hard pill to swallow. And yet for the New Yorker the artistic products of Zen—the elegantly coarse calligraphy, the ceramics with their surprising glazes, the paintings with a rustic cottage perched on a remote mountaintop—suggested the stamp of a personal style and maybe the spontaneity of an anti-religion, an anti-academy.[8]

And existentialism was the anti-philosophy. In the texts by Camus and Sartre and Merleau-Ponty that painters and sculptors were reading, the artist was often presented as a man whose fiercely solitary experience gave him an especially intense understanding of the human condition. Writing in "The Myth of Sisyphus," Camus declared that "the true work of art is always on the human scale." And Sartre, in the catalog of the first, epochal show of Giacometti's slender, elongated figures that was mounted at the Pierre Matisse Gallery in 1948, wrote about the birth of sculpture. "For the first time, the idea came to one man to sculpt another in a block of stone. There was the model: man." William Barrett would write in his 1958 book, *Irrational Man,* that "existential philosophy (like much of modern art) is . . . a product of bourgeois society in a state of dissolution." And what Sartre and Camus seemed to be saying was that artists could be depended upon to reveal a human truth that was immune to such social dissolution. When Sartre first spoke publicly in New York, at Carnegie Hall in the fall of 1948, Lionel Abel watched as Duchamp, that aging Dadaist, looked out over the crowd and exclaimed "(in the tone of a tourist guide): 'We are now before Sartre cathedral.' "[9] There was a feeling that existentialism was becoming, all too rapidly, the new philosophic academy. And yet artists could see that existentialism gave new voice to the old romantic necessity of going it alone. Merleau-Ponty's essay "Cézanne's Doubt," which focused on the terrifying autonomy of the artist's labors, was widely read at the time.

As Isaiah Berlin would later write, "The central sermon of existentialism is essentially a romantic one, namely, that there is in the world nothing to lean on." Existentialism could be seen as a call to independent artistic action, which might mean going into the studio and improvising, as Rosenberg had suggested in "The American Action Painters." Speaking of Sartre's "situations"—of the sense a person had of being thrust into independent action—Dore Ashton said that such situations "were understood by most painters of that period to be unstable, difficult to define, fraught with imper-

ceptible hazard, and in constant danger of being unsituated." But if there was an aura of perpetually-on-the-edge excitement about the existentialist attitude, there was also a gravitas about the writings of Sartre and Camus, for as the grand philosophical and historical hopes of the pre-existentialist era dissolved, the artist, this solitary figure, gained a new kind of authority. In his essay "Art and Revolt," published in *Partisan Review* in 1952, Camus suggested that there was a sobriety about the artist's revolt. "Art questions the real, but does not shun it," he said. "Nietzsche was able to refuse all transcendence, moral or divine, by saying that such transcendence led to a calumniation of this world and this life. But there is perhaps a living transcendence, promised us by beauty, which may make us love and prefer to any other our own limited and mortal world. Art thus brings us back to the origins of revolt, in the degree to which it tries to give form to a value escaping in a perpetual becoming; but which the artist senses and wishes to snatch from history." There was, Camus felt, especially to the visual arts—to what he called "the arts of form or color"—a "splendid modesty." And Camus quoted Nietzsche's fervent affirmation of the essential value of art. "Art and nothing but art, we have art in order not to die of the truth."[10]

In Giacometti, Sartre saw an artist who had the "will to place himself at the beginning of the world." To do so was to exit history, to return to the beginning of becoming. The existential artist had escaped from the inevitabilities of isms that fell like dominoes—and from the tyranny of progress. Giacometti, Sartre wrote, "does not recognize such a thing as Progress in the fine arts, he does not consider himself more 'advanced' than his contemporaries by preference, the man of Eyzies, the man of Altamira. In that drastic youthfulness of nature and of men, neither the beautiful nor the ugly yet existed, neither taste nor people possessing it; and there was no criticism: all this was still in the future." In the catalog essays that Sartre published in New York in 1947 and 1948, not only for Giacometti's show at Pierre Matisse but also for Calder's at the Buchholz Gallery and David Hare's at Kootz, we experience the philosopher's excitement on coming into the sculptor's studio. Artists would have been especially appreciative of Sartre's essays on Calder and Giacometti, because the philosopher was so absolutely alive to what these sculptors were doing. He was playing Balzac to Giacometti's Frenhofer. He wrote that Giacometti "does not like the resistance of stone, which moderates his movements. He has chosen for himself a material without weight, the most ductile, the most perishable, the most spiritual to hand: plaster. This he scarcely feels at the ends of his fingers; it is the impalpable reverse side of his movements."

Sartre was describing the way that the plaster-of-Paris powder, mixed with water, turned into form. For Giacometti, sculpture was a fluid medium. And of course the bigger point was that the artist was, quite literally, pulling being out of nothingness as he went on what Sartre called in the title of his essay "The Search for the Absolute." The old monolithic permanence of stone, which had honored so many timeless heroes, was a thing of the past. Giacometti was moving sculpture into the new romantic spirit.[11]

Photograph of Giacometti's studio in Paris, from the catalog of Giacometti's 1948 show at the Pierre Matisse Gallery in New York.

Everything was now in flux, and what better expression of this could there be than the anti-monolith of the Calder mobile? The Parisian avant-garde had been bewitched by this American artist since the 1920s, when he had brought all the charming ingenuity of a New World rapscallion to the performances of the *Cirque Calder,* a toy universe that he unpacked from a series of suitcases. Sartre had seen Calder's mobiles on a visit to New York in the mid-1940s, and in 1947 Calder drew a witty portrait of the philosopher, with the smoke from his ubiquitous cigarette spelling out the existentialist's name as it rose, whirling and twirling, into the air. "If sculpture," Sartre wrote in the Calder essay, "is the art of carving movement in a motionless mass, it would be wrong to call Calder's art sculpture." "Sculpture," he observed a little later, "suggests movement, painting suggests depth or light. A 'mobile' does not 'suggest' anything: it captures genuine living movements and shapes them. 'Mobiles' have no meaning, make you think of nothing but themselves. They *are,* that is all; they are absolutes. . . . A general destiny of movement is sketched for them, and then they are left to work it out for themselves."[12]

Alexander Calder, Jean-Paul Sartre, 1947. Pen and ink, 6 × 4½ in.

Calder was a wonderfully vibrant figure in the postwar years. He was a survivor of the 1930s who was much loved on both sides of the Atlantic, and he knew how to keep his art forever young. The primary colors of his mobiles had been inspired by a revelatory visit to Mondrian's studio in Paris in

Herbert Matter, photograph circa 1943, of a 1936 Calder mobile in motion.

1930. For the artists of the 1950s, who had rejected Mondrian's certainty while still admiring his daring and his reach, Calder's free-form shapes in red and blue and yellow and black and white, swimming through the air, might suggest the liberation of Constructivism in the new, postwar atmosphere. Light, agile, witty, surprising, the mobiles that Calder had been doing since the 1930s personified a certain 1950s spirit. It was as if form were taking off on its own. At least that's what Sartre described. "I was talking with Calder one day in his studio when suddenly a 'mobile' beside me, which until then had been quiet, became violently agitated. I stepped quickly back, thinking to be out of its reach. But then, when the agitation had ceased and it appeared to have elapsed into quiescence, its long, majestic tail, which until then had not budged, began mournfully to wave and, sweeping through the air, brushed across my face. These hesitations, resumptions, gropings, clumsinesses, the sudden decisions and above all that swan-like grace make of certain 'mobiles' very strange creatures indeed, something midway between matter and life. At moments they seem endowed with an intention; a moment later they appear to have forgotten what they intended to do, and finish by merely swaying inanely."[13] If this was the art that an existentialist could respond to, it was surely not anything ponderous or dark or inert. The leap into being was an act of lightness and force and fluidity, and all of that tied right in with what was happening in painting in New York.

IV

If existentialism encouraged the artist "to place himself at the beginning of the world," one of the great questions was of course what there was at the beginning, and how an artist was going to find that beginning. Ultimately, you were

*Will Hamlin, Black
Mountain College,
Lake Eden dining
room and kitchen
building, 1942.*

going to find that beginning within yourself, but it also helped to have a great
teacher, a teacher who knew how to begin, and even as Hofmann was pointing
the way in his schools in New York and Provincetown, Josef Albers was doing
something similar as art professor at Black Mountain College from the 1930s
until he left for Yale in 1949. There was a paradoxical dynamic operating here,
because the generation that came of age in the late 1940s knew that it was liv-
ing in a century of artistic rebellions and looked for older figures, such as
Albers and Hofmann, who could give them the lowdown on that rebellious
spirit. Black Mountain College—which overlooked a lake called, of all things,
Lake Eden—wasn't a place that you could drop into the morning after a night
at the Cedar Tavern, but it was a place that a lot of people at the Cedar knew
firsthand, for in the late 1940s and early 1950s, many of the New York
artists—Willem and Elaine de Kooning, Kline, Motherwell—were visiting
there for the summer sessions. Earlier in the decade Kazin had taught Blake
and Melville. And in the 1950s, Charles Olson was a commanding figure at
Black Mountain, where he initiated a generation of poets into the mysteries of
Melville and Pound.

Black Mountain College and the Hofmann School offered two different
romantic visions of the education of the artist. At Black Mountain a student
was bombarded with a range of experiences—experiences that had to do with
painting and drawing, but also with architecture, dance, ceramics, weaving,
printing, poetry, and the social sciences. And all the while, a student was also

taking part in work programs that involved everything from farm chores to building construction. At Black Mountain the creative act was an act that grew and flourished amid a flurry of crosscurrents and competing ideas and ideals. To create meant to feel the pressure of competing forces and competing personalities and to push through all of that and find yourself. At the Hofmann School, education involved pushing ever deeper into the mysteries of studio practice. Now of course, the student who worked with Hofmann in New York, by virtue of living in a huge, heterogeneous city, was bombarded with experiences far more than the student who was studying at Black Mountain. But at the Hofmann School, creativity was nurtured through the process of turning your back, at least temporarily, on the excitements of the city. That was what Larry Rivers had in mind when he said that the Hofmann School was far removed from any "notion of Art school relaxed bohemia with its sex and good times abounding."[14] Hofmann saw art as emerging from an ever deepening involvement with the time-immemorial particulars of the medium, and he believed that within the very singularity of studio practice a student would discover, or perhaps rediscover, the giddy variety of the world.

Hofmann taught his students that, as Allan Kaprow wrote, "our work was a Destiny"—and Kaprow's capital *D*, with a graphic boldness harking back to the Romantic language of Thomas Carlyle, was a tip-off that Hofmann's extravagant ambitions were not only taking his students forward.[15] Hofmann offered a way back to the beating heart of the romantic past, a past that had given birth to modern art and was now, at the Hofmann School, stripped-down, clean-lighted, renewed. Hofmann himself was beyond figuring out, at once brusque and warm, obscure and crystal clear, an old man besotted with the new, a believer in both theoretical complexity and instantaneous intuition. With his sweeping talk about abstract forces and the spiritual power inherent in the artist's most basic materials, he was—transparently—an avatar of all things modern. Yet then again the way his school was organized was almost antediluvian, what with the students at their easels circling the model, who posed two sessions a day, morning and evening, while the afternoons were devoted to still life. At Hofmann's funeral, Rosenberg explained that the evening before he died

Lillian Orlowsky, Untitled, circa 1937. Charcoal on paper, 25 × 19 in. Orlowsky's drawing was done during her studies with Hofmann.

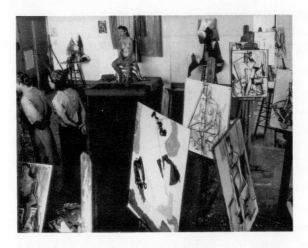

*Tom Milius, the Hans Hofmann
School in the 1940s.*

Hofmann had said to him, "The concepts of my school are fundamental. But a true artist could violate them all."[16]

By the time that Hofmann retired from teaching in 1958, people were, not surprisingly, using the word "academy" to describe his school.[17] Rosenberg referred to the school as an Academy of the New, which was a way of acknowledging that this was an essentially dissident institution. This was a no-academy academy—which was, as it happened, a vision grounded in the dissatisfaction with official, state-run academies and art schools that had begun in the late eighteenth century and had been growing all through the nineteenth century.[18] Back in 1861, two decades before Hofmann's birth, a group of young artists who were fed up with the teaching at the École des Beaux-Arts had approached Courbet, the most radical realist of the day, about opening a school. In a letter to the students (a letter probably written by the critic Jules Castagnary), Courbet offered a vision of the school that foreshadows the dynamic that Hofmann would set up in New York some seventy-five years later. What Courbet said he could do for the students was to explain to them "the method whereby, in my view, one becomes a painter—the one that I myself used from the beginning in order to become one—while leaving it to everyone [to choose] his entirely individual direction, the complete freedom of his own expression in the application of that method." And this pedagogical vision sounded quite a bit like Hofmann's. Nell Blaine might have been writing about working with Courbet when, in describing her experience at the Hofmann School, she observed that Hofmann's "systems of analyzing movement . . . led (in the more talented [students]) to a real person[al] expression; it kept the student free from too much teacher domination." James Gahagan, a

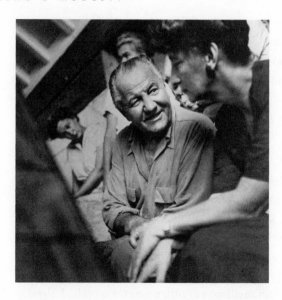

Hans Hofmann teaching in the 1950s.

student in the last years of the Hofmann School, recalls a frustrated student asking Hofmann to explain the corrections that he had done on a drawing—the arrows and heavy lines that had by then mystified several generations of young painters. Hofmann's reply was: "Ah, yes, there *is* a secret, but you must find it for yourself. It does not belong to me."[19]

What Courbet said was needed in the mid-nineteenth century was not a new academy but "the development of a group atelier, recalling the fruitful collaborations of the Renaissance ateliers," which would "certainly be useful and contribute to opening up the phase of modern painting." The idea Courbet was invoking, an idea that was more romantic than realist, went back to the dream of a resurgent medieval or early Renaissance community that had been born in the late eighteenth and early nineteenth centuries in France, in Germany, in England—the vision of the studio or cenacle, where artists or writers gathered freely, sometimes around a great master, creating a new kind of familial bond.[20] Such ideas were reaffirmed time and again in the later nineteenth and the twentieth centuries, by William Morris in the Arts and Crafts movement, and then again by Walter Gropius, in some of the early proposals for the Bauhaus, where artists and designers were supposed to come together to create a cathedral for the modern world. In New York in the postwar years, all the new friendships and free-flowing conversations that went on at the Hofmann School could be a revelation, but it was a revelation that grew out of this strong history of elective affinities. And Hofmann's students instinctively understood that their camaraderie was an extension of those ancient bonds.

When Wolf Kahn wrote about the founding of the Hansa Gallery, one of the first artists' cooperatives, he explained that the gallery's name, which echoed Hofmann's name, "seemed appropriate [not only] because of our debt to Hans Hofmann; also, it was the name of a medieval league of free cities which combined for mutual gain."[21]

The students who came to Eighth Street had as often as not already been through a lot of art education. Many of them already had the fundamentals—and then some. At Hofmann's, they wanted to see things multiply, not just add up. The school's impact sprang from a triangulating dynamic; a student responded to other students as well as to Hofmann. Louisa Matthiasdottir, the young Icelandic painter who had already studied in Paris with the famous teacher Marcel Gromaire, had come to New York in 1942, initially thinking she would attend the Art Students League, but the training there seemed primitive. Soon enough, she was at Hofmann's—and became a lifelong friend of Blaine's and Kresch's. Joe Stefanelli was another painter who had already studied at the Art Students League (and the New School) by the time he arrived at Hofmann's, where he felt as if he actually learned more from some fellow students than from the teacher himself. That was part of what he regarded as the thrilling professionalism and sophistication of the place. Stefanelli recalled Wolf Kahn, Allan Kaprow, Larry Rivers, and Jan Muller as among the "lively bunch, stimulating and advanced in their ideas. . . . I got more from this group than I did from Hofmann, I must confess. It was the atmosphere that, however, Hofmann had created that was so wonderful. He was the core of it. In my stage of development and having had my share of art schools I was tired of art schools and art teachers and Hofmann's fit a need we all required—that one step or stage before completely working on our own."[22]

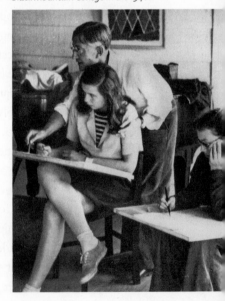

John Campbell, Josef Albers teaching at Black Mountain College in the 1940s.

V

Like Hofmann, Josef Albers had been a teacher with a considerable reputation in advanced European circles before he came to the United States in the early 1930s, where he found a new generation of students that was eager for some tough artistic give-and-take. Albers was said to be an extraordinarily demanding and

sometimes immensely enthusiastic teacher; he was obviously excited by the energy of America's youth. Albers—along with his wife, Anni Albers, the greatest weaver of the century and another immensely influential Black Mountain teacher—saw modern principles as generating not only a new kind of art but a new kind of design. Innovation in decorative or graphic art was something to which Hofmann was indifferent if not downright hostile. Yet Black Mountain was nearly as remote from Madison Avenue ideas of Bauhaus design as the Hofmann School. Where Hofmann thrust students straight into painting, Albers taught courses at Black Mountain on color and composition and materials that echoed the Bauhaus's emphasis on basic principles. Formal principles were not dry principles; for their course on *matière,* students were pushed to embrace unexpected materials, including yarn, mica, wood, egg-shells, doilies, leaves, wire screen. When Albers liked an exercise, he would scrawl *Donnerwetter*—literally, "thunderstorm," but more like a "Wow!"—on the student's work.[23] He pushed students to explore the fundamentals of pattern and rhythm. For Albers such principles were the alpha and omega of art; they were behind all his work, from the beautiful geometric woodcuts that he did at Black Mountain, in which the grain of the wood became an element of naturalistic freedom, to the series of *Homage to the Square* paintings, with their powerful color orchestrations, for which he became so well-known in the 1960s. Among the art students who were at Black Mountain for varying amounts of time were De Niro (who found the atmosphere oppressive and preferred Hofmann's School), Kenneth Noland, Cy Twombly, and Robert Rauschenberg.

Black Mountain, like the Hofmann School, was one of the great Old World–meets–New World experiences available in postwar America. The

Josef Albers, Multiplex D, *1948.*
Woodcut, 9 × 12 in.

Hazel Larsen Archer, the door to the Quiet
House at Black Mountain College, 1948.

responsiveness of students to an older European mentor might be related to a
passivity that has sometimes been seen as a characteristic of intellectual life in
mid-century America. But if there was something conservative about the urge
to turn to Hofmann or Albers for guidance, this was also a sneaky conser-
vatism, for what was being conserved was the radical spirit of early-twentieth-
century Europe. You feel the quiet eagerness of a new kind of American
generation in the prose of Fielding Dawson, the Black Mountain student
whose writing we've already encountered; it was Franz Kline, whom Dawson
met at Black Mountain, who later in New York precipitated Dawson's Balza-
cian encounter with de Kooning. Dawson was one of those American boys for
whom Black Mountain—or the Hofmann School—was the entry point into
the avant-garde. Dawson had a gift for evoking the luminosity of lost
moments. His *Black Mountain Book,* published first in 1970 and again in a con-
siderably enlarged version in 1991, was a sheaf of memories and reflections
that included some beautiful, precise vignettes of this bucolic place—
vignettes that had a Japanese succinctness that connected them with other
writers who emerged in the 1950s, such as Gary Snyder. In Dawson's book
there was a slow, watchful, elegiac quality to the place—a sense of adolescent
waiting, of small events bulking up very large because they were among the
first events in one's life that felt major. That was appropriate to Black Moun-
tain, which was part of the adolescence of New York's 1950s avant-garde.
Dawson offered images—just like that. "A summer evening rain gathering
behind the mountain, and I can see the man yet, a faculty member, coming out
of the Office, walking toward the Dininghall. I was on the small front porch

by the tree and the millstone, and I cried out for him to hurry. He looked over his shoulder and began to run. A gray and silver wall of rain came down the mountain full force, the ground darkened behind him, I held the door open, he flashed by with a laugh of alarm, the rain hit the building like a hard slap, and swept across the lake, and the valley, leaving rivers, creeks and pools in its wake."[24]

The pristine, even slightly precious quality of Dawson's writing was something that one couldn't quite imagine coming out of the atmosphere around the Hofmann School, where students, after a day in the classroom, plunged straight back into New York City, with its jazzy, streetwise, let's-get-on-with-it spirit. But of course Hofmann also preached his own kind of nature poetry, and took his students to Provincetown in the summers. Although Provincetown after the war, with its galleries and bars and artists buying up real estate, was not exactly a pastoral idyll, that was nevertheless where Hofmann satisfied his hunger for the countryside, which had drawn him from Munich to his grandfather's farm when he was a young man. Certainly there was some self-conscious romanticism at work in Dawson's vision of Black Mountain, but that was a part of what Black Mountain meant to New York. Lyricism was built into the place. Kazin, who was not especially happy at Black Mountain, nonetheless was moved by the scenery, and wrote in his diary, "The fall lingered on, but now the cold has set in. The grass I walk to the dining room frozen white, shivery in early morning light and the mist from the river."[25] For the faculty, there day in and day out, worrying about families and futures and the ridiculously low salaries, it could not have been what it was for the students or for the visitors to the summer institutes. But even as it was failing financially in the 1950s, it became a legend in New York, so that Joel Oppenheimer, another student, later told Martin Duberman, the author of an important book on Black Mountain, that "by the *late* fifties he could have walked into the Cedar any Saturday night and signed up twenty kids *with money* for Black Mountain—so great had its legend by then become, and the appeal of a style it had helped to form." At the same time, Duberman observed, "the Cedar Bar crowd, like the Beats in San Francisco, got fed up with hearing about Black Mountain and the superiority of its way."[26]

When people today think of the arts at Black Mountain College, they are often thinking of one particular summer, the summer of 1948. Then, New York came to North Carolina, and the history of this small college became a piece of the story of avant-garde Manhattan. Willem and Elaine de Kooning were there, and Merce Cunningham and John Cage and the sculptor Richard

Lippold and Buckminster Fuller. Fuller was experi-
menting with a new way of sleeping: taking two-
hour "naps" every six hours, day and night. It was
the summer when Fuller first attempted to create a
large-scale geodesic dome, the structure that, in
1959, in infinitely more refined form, would be set up
in the sculpture garden of the Museum of Modern
Art as part of the show called "Three Structures by
Buckminster Fuller." That original dome was made
with metal slats, but the slats were not thick enough,
and the dome wouldn't stand—and thus became
known as the supine dome. Fuller was unfazed—he
saw failure as part of the experimental method—and
the next summer, back at Black Mountain, he suc-
ceeded. One of the students was Kenneth Snelson,
who, no doubt influenced by Fuller's domes and also

Hazel Larsen Archer, Merce
Cunningham dancing, 1948.

by Lippold's sculptures made of concatenations of slender wires, began to cre-
ate pieces in which wood elements were held aloft in tension by nylon strings.
The Bauhaus had based the study of art on abstract values, on the idea that one
could understand color or line as an independent force. And if the way that
architectural principles had been taught at the Bauhaus involved stripping
down older building forms to skeletal essences, then Fuller was taking the ele-
ments of that skeleton and sending them out into the world in a pure, almost
existentialized form. The openness of the geodesic dome related to a new taste
for open forms that would run through the visual arts of the 1950s—in the
paintings of Mitchell and Guston, in Lippold's airy wire sculptures. The dis-
tinction between form and no-form was dissolving, or at least artists were
moving closer to that point of dissolution than they had before.

VI

The urge to cultivate your own garden and establish a personal relationship
with the history of art by folding art's present back into art's past and art's
beginnings—all of this was emphasized in the 1950s as the younger generation
found itself contemplating the achievements of several older generations.
Many artists saw Pollock and de Kooning as giants who had reshaped the very
nature of art. And the sense of living after a watershed moment could provoke
both melancholy and light-headedness—and, ultimately, a changed attitude

toward revolution. "There is too much emphasis, anyway, upon that mythical 'originality,' born of a vacuum," B. H. Friedman wrote in the introduction to an anthology called *School of New York: Some Younger Artists,* that he put together in 1959.[27] And John Ashbery, in a memoir of the early days of his friendship with the painter Jane Freilicher, observed that she, like many of the painters they knew, was developing "a new and earthy reverence toward the classic painting she had admired from a distance, perhaps, before."[28]

In his *School of New York* anthology, Friedman described the relationship between the work of artists such as Mitchell and Frankenthaler and what he referred to as de Kooning's "rough-trade cubism" by citing an observation of Auden's to the effect that the poets of *his* generation had been "in the position of colonizers rather than explorers." Auden was referring to the relationship that his generation had to such early-twentieth-century poets as Yeats, Eliot, and Pound. Friedman said, "The same may be said of the present generation of artists. I don't believe that any artist in this book may yet be classified as an 'explorer,' an original discoverer. But I do believe that each, as a 'colonizer,' went further at an earlier age than those of the previous generation. And I see no reason to preclude the possibility of a search for new frontiers when colonization is completed." Not long after O'Hara died, his young friend Bill Berkson observed in the magazine *Art and Literature* that "since the early 50s every American schoolboy has been taught that the 'age of experiment' is over. I remember Robert Lowell at a party somewhere opining that French poetry had 'ended' with Apollinaire." Berkson believed that it was in reaction to this thought that O'Hara and his friends embraced poets who had emerged later on, including Pierre Reverdy, René Char, Robert Desnos, Breton, Saint-John Perse, and Cocteau. These writers did not yet have the old-modern-master aura of Apollinaire or Valéry or Mallarmé, and by focusing on their work it might be possible to convince people that even after the first grand period of modern experiment was over, there were still possibilities aplenty for invention.[29]

To come after the heroic period, even with *heroic* in Ashbery's quotation marks, was to live in an Age of Silver, or maybe of Lead, and the terms would certainly be familiar to well-educated poets such as Ashbery and O'Hara, for Silver Age was the term that was applied to Latin literature of the period after the Golden Age of Cicero and the Augustans. Behind the idea of the Silver Age of Latin literature lay older ideas about the Five Ages of Man, which appeared in many forms, for example, in Hesiod's *Works and Days,* where the first Age of Gold, a period of pastoral happiness, was followed by an Age of

Silver, when dancing and laughter had been replaced by quarrels and igno-
rance. The Silver Age was followed by an age when men did nothing but fight.
Milton Klonsky, a writer who grew up in New York, published an essay,
"Greenwich Village: Decline and Fall," in *Commentary* in 1948, and observed
of his generation that "it was [strange] to see the new recruits to the Village
come down expecting to find the Golden Age of the 20's or the Silver Age of
the 30's, but hardly prepared for this, the Age of Lead."[30] So one man's Age of
Gold—or at least Silver—could be another's Age of Lead. But if a person
could reshape recent history in these terms, an artist might also enjoy imagin-
ing all the ages mingling and flowing together, for these were not so much his-
torical periods as they were mythical ways of being. To think of the arts in
terms of the Ages of Man was to free art from chronology, to turn the history
of art into a collage of alternative emotional or even moral possibilities. Fair-
field Porter, in an essay on photography, invoked Friedrich Hölderlin's char-
acterization of the Golden Age in his poem "Nature and Art," which he
described as a time when "things had no names." Porter wondered if "the
radiance of such an age" had yet been described in art, and concluded that per-
haps it had been "in fifth-century Greek sculpture, and perhaps sometimes by
Monet"—he was probably thinking of the early, unabashedly spontaneous
Monet rather than the contemplative spirit of Monet's later *Water Lilies*.[31]

New York's younger poets would probably have known that the literature
of Rome's Silver Age was generally characterized by a move away from plain
speech and the direct expression of emotions toward elaboration and artificial-
ity. In the Roman literature of those times,
rhetoric tended to be detached from plain

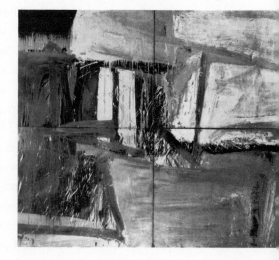

Alfred Leslie, Quartet No. 1, 1958. Oil on canvas, 84 × 98 in.

meaning, and there was an emphasis on strik-
ing, epigrammatic utterances and exagger-
ated colorations. Flash forward from Rome
to New York, and it was not difficult to see a
number of related characteristics turning up
in the art of the 1950s. The boldly scaled
brushwork in the abstract paintings of Alfred
Leslie, for example, could be said to take de
Kooning's rhetorical devices and treat them
abstractly, for their own sake, with little re-
gard for motive or feeling. In Leslie's ab-
stractions, de Kooning's stroke became so
hulking that it was even possible to feel a

slight or maybe even a not-so-slight element of parody. It was interesting that Ashbery, writing some years later about a series of lithographs by de Kooning, observed that they were "a parody of the parody of nature that [Japanese ink] drawings, in a sense, already are."[32] Another example of Silver Age aesthetics was the work of Jasper Johns, his *Flags* and *Targets*. We will take a closer look at Johns later in this story, but for now it is worth pointing out that by removing objects from their ordinary contexts, Johns sought to celebrate the artificiality of all things. If, as Porter observed, the Golden Age was a time when nothing had yet been named, then Johns's *Flags* were all name. Johns, a demon of Silver Age self-consciousness, played with the idea of a canvas as a complex illusion by turning painting into a strikingly simple illusion, one that signaled a light, elegant dismissal of metaphor and mimesis.

Jane Freilicher, After Watteau's *Le Mezzetin*, 1950. Oil on cardboard, 30 × 22½ in.

In his essay *Le Mystère Laïc*, which was one of the classic texts of Silver Age aesthetics, Cocteau, who had a renewed prominence in the postwar years, less as a poet than as a filmmaker, made a telling comparison between Picasso (a Golden Age artist) and de Chirico (a Silver Age artist—and a major influence on Guston). "Chirico," Cocteau observed, "is a painter of mysteries. Picasso is a mysterious painter."[33] The difference was one of experience, the one being an observer and embroiderer on experiences, the other exemplifying the thing itself. Some might find it useful to make a similar comparison between Pollock and Joan Mitchell, arguing that there was a movement from a natural painter (Pollock) to a painter of nature (Mitchell). In a broad sense, the idea of a Silver Age might suggest a detachment from immediate experience and the growing relativism of all things. Such a relativism, which passed easily into the ironies of Rauschenberg and Johns, could look either good or bad, interesting or depressing, depending on what one asked of art. For one of the aspects of the Silver Age idea of detachment and subjectivity was that it could become a positive value in itself. It was possible to prefer the rococo to the baroque—to find the rococo more human. And, of course, it was no criticism of Watteau, the greatest master of the rococo, to say that if Rubens was the poet of the Golden Age of love, Watteau was the supreme poet of its Silver Age—indeed, some would prefer the more equivocal emotions of Watteau's *Cythera* to the

full-bodied eroticism of Rubens's *Garden of Love*. There is a canvas by Philip Guston called *Cythera* from 1957. And Ashbery has written about how his friend Freilicher did "a loose-limbed early 50s homage to [Watteau's *Mezzetin*] add[ing] a note of violence (these were Abstract Expressionist times, after all) to the already odd mixture of weariness and frivolity"; years later, Freilicher would do a whole series of paintings in which Watteau's musician makes enigmatic appearances.[34]

VII

It is no wonder that the art of these years when painters and sculptors were so preoccupied with the layering of ages should have been full of images of digging and excavating, of plunging into the ocean or soaring into the heavens. Pollock gave the title *Full Fathom Five* to a 1947 painting in which he collaged nails, tacks, buttons, keys, coins, cigarettes, and matches; and one of de Kooning's most famous works, painted in 1950, was called *Excavation*. Hyman Bloom, an artist with a gift for impastoed, febrile surfaces, painted *Archaeological Treasure*, an abstraction in which the canvas burst open with bejeweled complications. A Hofmann drawing from the 1940s was titled *Classic Fragments* and gathered on a dark ground some irregularly shaped elements that, with their ribbed, serrated surfaces, suggest pottery shards or architectural elements.[35] Edwin Dickinson finished his *Ruin at Daphne* in 1953, an architectural fantasy in which volumes evaporated and every vantage point suggested an alternative vantage point. Loren MacIver, an artist featured in *The Tiger's Eye*, who had a gently persuasive feeling for thin, evanescent washes of imagery, painted *Etruscan Vases*, a

Hyman Bloom, Archaeological Treasure, 1945. Oil on canvas, 43 × 36 in.

study of ancient forms emerging out of the dim illumination of some museum of the mind. In the wire sculptures of Richard Lippold, with their scatterings of planets and stars, we turn from earth to air and fly through night skies, as we do in some of Joseph Cornell's boxes, with their star charts and twinkling mythological constellations. Artists were celebrating the peculiar instability of things, whether the particular case was Pollock's deep-sea imagery or Cor-

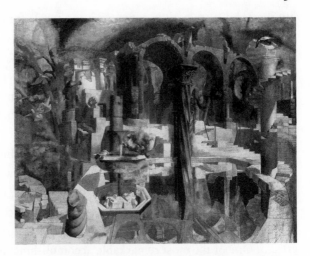

Edwin Dickinson,
Ruin at Daphne, 1943–53.
Oil on canvas, 48 × 60 in.

nell's astronomical fantasies or de Kooning's urban excavations or Bloom's treasure hunt or Dickinson's salute to Hellenistic Greece or MacIver's beautiful old ceramics. Artists were rejecting any fixed view of the past or the future, and the very effort to destabilize the history of art had a way of bringing the monuments of the past closer.

Tradition itself could be provisional, not a solid chain of events, but something more like a constantly present, constantly fluctuating range of possibilities, with the artist always reaching for some new synthesis. André Malraux's extravagant associative explorations in the volumes of his *Psychology of Art*, which were coming out after the war and were discussed at the Club, could seem highfalutin, but they also had their own kind of slowly unfolding existentialist power. Some New Yorkers were attracted to the spectacular, impromptu gatherings of masterworks that Malraux suggested when he announced, for example, that "the greatest painters' supreme vision is that of the last Renoirs, the last Titians, Hals' last works—recalling the inner voice heard by the deaf Beethoven—that vision of the mind's eye, whose light endures when the body's eyes are failing." This was not entirely unlike the highly personal, highly exclusionary lists of great masters that John Graham had included in his *System and Dialectics of Art*. Malraux reveled in the confusions of the artistic imagination. Writing of Monet's *Water Lilies*, he spoke of how the last, most "audacious" compositions were a kind of message sent into the future—a message that Monet himself probably did not fully understand. Malraux observed "how often the relationship between theory and practice has become a kind of comedy played out in the mind! Artists construct theories as to what they would like to do, and do what they are capable of doing;

but their ability, though in some cases too feeble for their theories, is in other cases stronger than those theories."[36] The very approach of Malraux's books shattered theory. As Randall Jarrell wrote in *Art News*, "His work is not art history, exactly, but a kind of free fantasia on themes from the history of art—still, a successful enough confusion of genres is a new genre, and Malraux's book, which now stands solitary as *Alice*, will probably have some dreadful descendants."[37]

If there was an essential idea in Malraux's careening vision, it was an idea about the freedom of the modern tradition, and it was an idea that was very much part of the Silver Age mood. In the magazine *Location*, Hess said that de Kooning had spoken of "re-inventing the harpsichord," which Hess said "involves the daring step of canceling out the whole idea of an avant-garde art. . . . One of the most remarkable accomplishments of New York painting has been its simultaneous renewal and defiance of the past. With its radical assumption that anything can become art and that the artist can do anything, the painters proceeded to drag past art up into the present." Reinventing the harpsichord was a gutsy—existentialist—act; yet it was also an act carried out in the name of tradition.[38] Responding to an *Art News* symposium on the artist's relation to the past, de Kooning observed that "painters are bound to be involved in painting. Old and new are just one thing." "Being anti-traditional is just as corny as being traditional." And some years later, when Rosenberg asked him if anybody "in our period could paint a detailed tableau of figures in the manner of the Renaissance," de Kooning responded, "I think there might be people who could do that." De Kooning's friend Kline told William Barrett that painting deals with "age-old problems." "You work from nature," Kline said, "away from nature, back to nature." As for radical gestures, de Kooning supposed they might be a phase in the lives of artists and movements. "Art shouldn't be fanatical," he said. "People forget how young the Dadaists were when they were saying 'to hell with art.' They were just in their twenties."[39] Everybody knew the opening lines of "Burnt Norton," the first of Eliot's *Four Quartets*, published in 1935, where

> Time present and time past
> Are both perhaps present in time future,
> And time future contained in time past.[40]

Tradition could be like the movement of Calder's mobiles, "a general destiny of movement" to be "worked out" by the artist. For postwar New Yorkers,

Jean Hélion, Pegeen dans l'Atelier, *1954.*
Oil on canvas, 21 9/16 × 18 1/8 in.

this idea suggested a way of mastering history, history as an aspect of the imagination, as a matter of elective affinities, of searching for some theme or temperament that might unite seemingly disparate works of art.

When Giacometti—whose slender, spectral sculptures and intently worked painterly surfaces meant the world to many New York artists—wrote an introduction to an album of what he called his "interpretive drawings," the drawings he had done after the masterpieces in the museums, he said that "all the art of the past rises up before me, the art of all ages and all civilizations, everything becomes simultaneous, as if space had replaced time. Memories of works of art blend with affective memories, with my work, with my whole life."[41] Giacometti's was an attitude that you might also sense in Picasso, but for New York painters who felt that Picasso's influence no longer had quite the hold that it had had ten or twenty years earlier, there was a particular interest in looking at the work of European artists who were closer to their own age and who seemed to have found their own way of picking and choosing among art old and new. There was Morandi, who had been a metaphysical still-life painter in the 1920s and whose small, concise, beautifully brushed canvases, seen in exhibitions at the World House Gallery, were a revelation; his still lifes with a few bottles and his landscapes with sunstruck stucco walls pushed more than one painter back to reality. Other artists were drawn to the work of Jean Hélion, who had been a geometric abstractionist in the 1930s and who was by now painting the entire panorama of Parisian life—with its roofscapes and ateliers and crowded tables and ebullient poets—with a dashingly quicksilver painterly brush. Balthus, who in the 1950s was living in Burgundy, creating light-filled pastoral landscapes, was another artist whose impact was felt in New York; he had his first museum retrospective at the Museum of Modern Art in 1956, at the same time as the museum's first Pollock show. There was also considerable interest in Dubuffet, whose paintings of women were seen by some as having affinities with Klee and de Kooning. Nicolas de Staël's impastoed abstractions and landscapes, with their echoes of Courbet and allusions to Braque, made a

deep impression on some artists, as did Vieira da Silva's intricately geometri-
cized abstractions of the urban scene.

VIII

One of the artists who was provoked by Giacometti's work was Alfred Rus-
sell, a painter with a gift for the magic of spidery lines, who was born in
Chicago in 1920 and went to college at the University of Michigan. By 1945
Russell was studying in New York at Atelier 17, the print shop that Stanley
William Hayter had founded in Paris and then had moved to New York,
where Pollock and Rothko and others did etching and, sometimes, even
engraving. Hayter, a master of looping lines out of which figures were forever
dissolving and re-forming, was without a doubt the essential influence on
Russell. Dark-haired, with a clear, chiseled profile, Russell was a vivid,
provocative figure, who for a time in the early 1950s took a place among the
younger generation of the new American painters; he exhibited at the Peridot
Gallery and was in the important exhibition "Abstract Painting and Sculpture
in America" at the Museum of Modern Art in 1951. All of Russell's finest

paintings, both the abstract ones that he was
doing around 1950 and the congeries of
floating, plunging classical figures from the
1970s, were canvases in which the graphic
elegance of a drawing was extended into
painting without any loss of freedom. For
Russell, color worked best as a secondary
element, a counterpoint to the primary
graphic thrust of his paintings. There was a
wonderful, nervous excitement about the
series of canvases with a central vertical
core of zigzaggy activity that Russell was
working on around 1950. These abstract
compositions, named after Parisian streets,
were all jittery, flowing energy. The force of
those bundled black lines generated little

Alfred Russell, La Rue de Nevers, 1949.
Oil on canvas, 40 × 26 in.

explosions of jewel-like shards of color, and those pats and smears and washes of color bounced around in the pewter-tinted air.[42]

In a 1952 statement, Russell wrote about the "poetry in the drying and deterioration in oil paint" and "an absolute knowledge to be found in the accidents of the studio." In the early 1950s, the silvery, opening-up elegance of Russell's work felt related to what Guston was beginning to do (some think Russell influenced Guston), and to the work of Cavallon and Mitchell and Pousette-Dart and a host of other artists. Russell continued to show abstractions off and on through the 1950s, and contributed an article to Philip Pavia's magazine *It Is* in 1960, "Toward Metaform," in which he discussed the riches of scientific and mathematical ideas on which abstract artists could draw. But perhaps it was inevitable that his labyrinthine fascination with art historical and literary allusions could not always be folded into the seductively enigmatic space of a nonobjective painting. Not unlike John Graham several decades before him, Russell, although never indifferent to the resources of abstract art, came, as he recalled later, "to be absorbed completely by my explorations of the museums, so much so, that I dropped abstract painting altogether." This was not entirely true, but the dialectical drama of abstraction versus representation, even given a bit of hyperbolic exaggeration, was clearly an element for Russell, as it had been for Graham, and Russell brought a literary zing to that drama when he declared, in 1953, exhibiting a figure painting at the University of Illinois, where he had previously shown abstractions: "Now is the time to paint the wrong picture in the wrong century and the wrong place, paint Diana of Ephesus."[43] Now here was a New York "No!"—and a serious attempt at reinventing the harpsichord. And it was a romantic vision, recalling Gautier's reflections on a friend from his youth who was obsessed with medievalism. "It is a case of transportation of times, of a soul born out of season, of anachronism." Such "inexplicable reappearances of ancient motives," Gautier observed, "cause lively surprise."[44]

By the time the 1960s turned to the 1970s, Russell was painting remarkable canvases in which figures with the imposing contours of goddesses on a Roman sarcophagus were pulled into an anti-gravitational universe that retained some strong elements from his 1950s abstractions. These were beguiling images, in which Hellenistic figures and horses that might have escaped from Leonardo's notebooks mingled with complex geometric forms, forms that were as elaborately articulated as the draperies of the goddesses who float and plunge and soar through space. Russell found a way of expressing his own swirling imagination, with its eddying historical allusions and

dizzying abstract speculations and nuggets of melan-
choly poetic truth. His classical figures and horses
came out of some wonderfully mad copybook of the
history-besotted imagination; they suggested gran-
diose sketchbook pages. The general monochrome
was sometimes broken up with touches of seductive
color. And the sense of scale was striking; these
panoramic visions were presented with a certain inti-
macy. In 1953, in a symposium on the human figure in
the *Magazine of Art,* Russell was at pains to explain
that "the potentialities of abstract painting or of any
other kind of painting have not been exhausted"—
indeed, that was how he began. And he wanted to
distance himself from "the shabby minds entrenched
in contemporary pseudo-academic, realist and other
forms of figure painting." "I believe," he wrote, "the
language of traditional painting can only be revived
by painters who have been absorbed in the non-
objective world for several years but who return to
the human figure and find it as elusive a mystery as
non-objective form."[45]

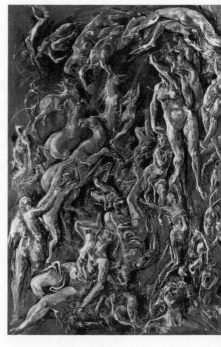

Alfred Russell, The Fall, *1968.*
Oil and tempera on canvas, 50 × 36 in.

"For a few years," Russell recalled, "the nude, the portrait, still life and
landscape were abstract problems to be solved as such but, when I became
familiar with them, certain unknown quantities began to appear: the sugges-
tive power of the image, the tragic undertones of a face or gesture." In these
strange paintings, you feel that an artist is searching for the myths that will
really mean something to him. The modern artist, the scholar Harry Slo-
chower suggested in an article titled "The Import of Myth for Our Time" in
trans/formation, "*chooses* his tradition, rejecting the stultified in favor of the
creative roots of the past. His choice of tradition is a recollection of man's
native genius."[46] Russell's troubled classicism has a cranky American power
that recalls the unpredictable lyricism of Pound's *Cantos.*

IX

Russell was reversing the thinking of the Hofmann School, where nature had
often been regarded as a resource from which abstract principles might be
deduced. Now it seemed possible to take those abstract principles and use

them as the foundation for a newly force-
ful representational art. This was an idea
that was on quite a few artists' minds,
including some painters who had been in
Hofmann's sphere, but no one in New York
made the case with more free-spirited exu-
berance than Leland Bell. Although Bell
was not exactly a Hofmann student, he was
close to Blaine and De Niro, and was mar-
ried to another Hofmann student, Louisa
Matthiasdottir. He had studied with Karl
Knaths, a painter who like Hofmann was a
figure in the Provincetown world. They
had met at the Phillips Collection, where
Bell, who grew up in Washington, D.C.,

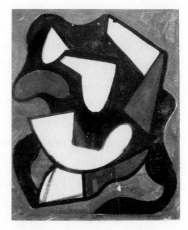

Leland Bell, Abstraction (III), 1942–45.
Ink and gouache on paper, 16½ × 13¾ in.

was a frequent visitor, and where Knaths's paintings, with their forceful black
lines and angled, simplified natural forms, were well represented. (Duncan
Phillips, the museum's founder, had also been a strong supporter of John Gra-
ham.) In the 1940s Bell painted concise abstractions with singular biomorphic
shapes set off with black outlines; they recalled the work of European abstrac-
tionists such as Arp and Klee, whom Knaths had encouraged Bell to study. By
the 1950s, however, Bell was working on a series of self-portraits and figure
studies that were constructed of a loose-knit web of
strokes of light terra-cotta, gray-blue, and gray-
green paint. Bell's face was wonderfully distinctive,
a face that had nothing of conventional good looks
about it but that nevertheless projected a stirring
power, a buoyant self-possession. And he enjoyed
playing variations on classical themes, such as the
Three Graces, which he rendered with telegraphic
immediacy. Looking at the paintings that Bell was
doing in the 1950s, you cannot miss his admiration
for Giacometti, an admiration that was reflected in
the austerity of some of his self-portraits, in the
iconographic, emblematic gestures of some figure
compositions, and in his generally energetic, calli-
graphic brushwork.

Bell praised "Giacometti's attitude toward tra-

Leland Bell, Three Figures, 1959.
Oil on canvas.

dition" in an essay published in *Art News* in 1960, an essay that was actu-
ally about another artist whom Bell—and Giacometti, too—admired: André
Derain. For Giacometti, Bell wrote, tradition "is an open question, free, so
that Watteau's *Shop Sign* . . . remains as contemporary for him as Mondrian's
Trafalgar Square, or more so."[47] Here was Watteau again, that Silver Age
hero. Bell emphasized the artist's freedom in this essay, which bore the rousing
title "The Case for Derain as an Immortal." He especially admired Derain's
later works, singling out for praise some small, darkly luminous paintings of a
landscape or a group of figures that most people believed reflected a decline
that had set in with Derain's work after World War I. Of course Derain, who
was almost universally admired for his Fauve paintings, had had a consider-
able reputation as a Neoclassicist in the 1920s and 1930s, both in Paris and in
New York. But for Bell, Derain's greatness was not that of an academic mas-
ter but that of an uncategorizable figure, a man who stood his own ground
amid the overwhelming confusions of his time, making the difficult choices
about what counted in the art of the past. "Derain," he wrote, "was suspended
in time, standing alone, letting it flow around him and meditating on the mys-
tery of reality."[48] The artist that Bell described was an existential hero, mediat-
ing between past and present, creating a synthesis all his own.

Leland Bell,
Two Figures with a Cat,
1972. Oil on canvas.

In Bell's most original paintings, which began to emerge from his studio around 1970, the frantically gesticulating figures—a man and a woman, or a man and two women—were turned into iconographic signs. These compositions, with their astonishingly streamlined summations of complex everyday experiences, had a hard-edged punch and an underlying lyric force. When Bell painted a man and a woman and a cat and a bird, he discovered a new kind of subject, because the quotidian was formalized—almost ritualized. The snaking arms and solid torsos, outlined in black, could feel at once delicate and monumental—and that was a marvelous combination. In the painting on the announcement for Bell's 1972 show at the Robert Schoelkopf Gallery, the couple in their bedroom perform a slow-motion dance that has the timelessness of an image on a Roman sarcophagus, while through a window we catch a glimpse of New York City buildings and sky that pulls us straight back into the present. As Bell worked on a series of closely related paintings over a period of decades (he was only sixty-nine when he died of leukemia in 1991), the brick reds and deep blues and acid yellows that he had begun to favor took on a high-keyed fervor that sometimes suggested Mondrian's primaries, but a Mondrian with unhinged emotions, emotions that shifted from saturnine to gleeful as rapidly as a jazz musician could run his fingers across the keys. These paintings were the product of a personal dialectic, a synthesis of the anatomical tensions of baroque figure composition and the summary structures of Constructivism. Bell, who was a great jazz aficionado, spun a visual artist's bebopping riffs on classical tunes. A few of the paintings that he completed shortly before his death are among the finest works produced by an American in the second half of the twentieth century.

In a sense, Bell's attitude toward the past was not all that far from that of de Kooning when he spoke of reinventing the harpsichord. In the lectures that he gave to enthusiastic crowds in art schools in the 1960s and 1970s, Bell spoke about the need for synthesis, and he did so in a not entirely un-Hegelian way. A friend of Bell's from the 1940s remembered his art talk as having "a decidedly religio-moralistic tone (Swedenborg, Kierkegaard, 'purity of heart')," and Bell never lost his extremist fervor.[49] He always believed that painting involved uniting the unpredictable excitement of nature and the more modulated pleasures of art. "To work formally, structurally," he observed in a lecture at the New York Studio School, probably in the early 1970s, you had to find "an equivalent of nature," and this involved "a synthesis." "Derain and Balthus and Giacometti," Bell explained, "wanted to deal with the appearance of things as part of a great tradition. It wasn't a question of going back, but of

wanting some of the same things." And the result was *un*like the art of the past, because this was a synthesis that evolved in the present. Responding to the argument that Derain merely recapitulated traditional forms, Bell had this to say: "Derain takes off from Corot [but it's] immediately Derain—immediately part of the twentieth century. In terms of the speed, velocity, brevity, sharpness—it's all twentieth century—it's [a] kind of rhythm [that's] not native to the nineteenth century—[you] can't find this kind of thing in the nineteenth century."[50] Derain's forms might recall Corot's, but his will-to-form was a twentieth-century will-to-form.

When John Ashbery wrote about Bell in *Art News* in 1970, he made it clear that he admired Bell's stirringly independent spirit, and he suggested that by the time you had taken the full measure of this artist, the old Darwinian survival-of-the-fittest view of art history no longer made sense. "Seeing him in his studio," Ashbery began, "vigorously at work on a number of canvases and meanwhile sounding off on his various pet peeves and enthusiasms, one has the feeling of coming upon an almost extinct variety of whooping crane, alive and well in its environment."[51] Ashbery had, like Bell, spent time in Paris, and he was also attuned to the alternative traditions that had been suggested by Hélion, by Giacometti, and by the later Derain. He lingered over the gleeful originality of Bell's opinions about art. And people who were familiar with some of Ashbery's tastes—with, for instance, his enthusiastic support for the legendary eccentric French author Raymond Roussel—could begin to sense an affinity between Ashbery and Bell, an affinity that was grounded in the Silver Age of the 1950s, in its changed sense of the past. As Ashbery pointed out, Bell was altogether secure in his own go-my-way sense of things. He was wildly enthusiastic about artists whom Ashbery said people generally regard as belonging to "the Silver Age of modern art," among them Raoul Dufy and Georges Rouault. Ashbery observed that "for one so articulate about the painting of others, he is relatively uncommunicative about his own work." Yet his fervent advocacy of other artists was a way of announcing where he stood. Bell liked the odd man out. Ashbery wrote that "he likes underdogs, and, one supposes rather relishes being one himself—defense sometimes being the best form of offense."[52]

X

Leland Bell embraced a tradition that was not the generally agreed upon tradition but was his own alternative tradition—a garden that he cultivated, if you

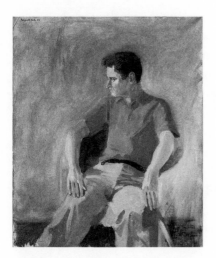

Fairfield Porter, John Ashbery, *1957. Oil on canvas, 38 × 32 in.*

will. And this thought brings us, I think, straight to Ashbery's own vantage point, both as a poet and as one of the most interesting art critics of the 1960s and 1970s. Ashbery's journalistic career began in 1960, when he took over the beat on the *Tribune* in Paris from a friend. Although he ultimately wrote art criticism for a living for going on twenty-five years, including stints at *Art News, New York,* and *Newsweek,* he has sometimes spoken of this side of his career as if it were an accident. Yet Ashbery's criticism does add up, and it is very much a part of the story of art in New York.

Decades later, when Ashbery came to give the Norton Lectures at Harvard, he chose to speak, to quote his title, about *Other Traditions*—an idea grounded in the Silver Age experiences of the 1950s. At the opening of those lectures, Ashbery remarked, "As I look back on the writers I have learned from, it seems that the majority, for reasons I am not quite sure of, are what the world calls minor ones." Ashbery went on to wonder whether he had some "inherent sympathy for the underdog," much as he had once thought Bell might. In *Other Traditions* he urged readers to look at writers they might not otherwise have even heard of: the poets John Clare, Thomas Lovell Beddoes, John Wheelwright, Laura Riding, and David Schubert, as well as Roussel. And in doing so, he suggested *his* elective affinities, his unique world. Ashbery's assertion that a number of poets who "are not poets of the center-stage . . . have been central for me" might suggest that he too was "off-center."[53] To be off-center was to refuse to enter into the standard dialectic—to say that the buck stops here, with me, with my ideas.

In a long poem called "The Skaters," which was published in 1964 in the little magazine *Art and Literature,* Ashbery exulted in the thought that each of us takes an individual path, although he also speculated that in the end we may all find our way to the same essential place. In Ashbery's poem, the skaters, spinning their "lengthening arches," are an image of almost Abstract Expressionist spontaneity. I am reminded of Hess's observation that de Kooning's lines can have "a razor-thin edge that suddenly swerves into a curving, slipping shape, like the mark of a skate on ice. And the smooth, slippery, white paper receives it like ice—which may be an appropriate simile for this artist,

one of whose happiest childhood memories is skating along the canals around Rotterdam." For Ashbery, the "distances" and "separate lines" that mark each skater's individual path are also part of some grand design. Here in "The Skaters," everything begins and ends in the image of a silvery landscape.

> Lengthening arches. The intensity of minor acts. As skaters elaborate
> their distances,
> Taking a separate line to its end. Returning to the mass, they join each
> other
> Blotted in an incredible mess of dark colors, and again reappearing
> to take the theme
> Some little distance, like fishing boats developing from the land
> different parabolas,
> Taking the exquisite theme far, into farness, to Land's End, to the ends
> of the earth![54]

You feel a similar sense of the ways in which minor acts can push artists forward in the critical writing about painting and sculpture that Ashbery was beginning to produce in substantial amounts in the early 1960s. When Ashbery wrote about Freilicher, he invoked Baudelaire in a way that might describe his own criticism (and some of his own poems) as well: "*luxe, calme,* and *volupté* are where you find them."[55] For Ashbery the improvisatory nature of journalism meshed with an evolving aesthetic, an aesthetic that sought illumination within the ragtag of the everyday.

Ashbery's originality had everything to do with the uncategorizable ways in which a person of sensibility attempted to give art and life their due and get on in a world where, as he wrote from Paris in 1961, "with an average of ten vernissages a day, not to mention all the theatrical and sports events, the professional spectator has

Cover of Art and Literature 3 *(Autumn–Winter 1964). John Ashbery's "The Skaters" was published in this issue.*

his work cut out for him. Dilettantism is now more exhausting than creativity." Ashbery was trying to juggle the two. Out of that juggling act came extraordinary passages, lines in which Ashbery's plain style lit up all of a sudden. On the collages of Max Ernst: "Surprises and shocks descend in an avalanche as in the tragedies of Seneca." On Bonnard's paintings: "The joy is there, certainly, but it remains potential, modulated by something dark and serious." On the still lifes of Redon: "The deep cerulean shadow on the brown jar in the latter picture is a color no one has ever seen in nature, yet it is both romantic and right." On the late work of Braque: "His work has the bareness and simplicity we associate with the Tao, and the abrupt insights of Zen. One has the impression of the form's being suddenly *there,* of its having arrived with the swift inevitability of an event." On the etchings of John Cage: "The show is like a marvelous overdose of spring tonic. After you come out of it, everything and everybody you see looks like a new percussion instrument." And on the landscapes and flower paintings of Nell Blaine, one of the essential figures of New York's Silver Age: "The sensuality in these works is backed up by a temperament that is crisp and astringent, which is as it should be, since even at its most poetic, nature doesn't kid around."[56]

In a poem called "Ode to Bill," Ashbery spoke of writing as "getting down on paper / Not thoughts, exactly, but ideas, maybe: / Ideas about thoughts." Then he hesitated: "Thoughts is too grand a word. / Ideas is better." While he would not presume to sum up his philosophy as a critic in so many words, Ashbery *was* presenting an idea about the nature of art when, writing about his friend Jane Freilicher's early works, he observed that "most good things are tentative, or should be if they aren't."[57] What Ashbery chose to emphasize in the art of his time was neither the completeness that Greenberg described in his essays nor the existential drama that fascinated Rosenberg. I sense in Ashbery a desire to distance himself from the heroism of Abstract Expressionism, which he expressed not with an ideological fervor, but as a matter of instinct and intuition. For Ashbery, art was a series of improvisations that could go on and on. In his criticism he was spinning out—extending—the improvisatory spirit of the 1950s. In a sense his subject was all the misfits of American art. Ashbery's essays include some of the wisest words ever written about such odd figures as Jess, the mystical San Francisco Surrealist, and that master of the packed allegory, R. B. Kitaj, who was also a friend of John Graham's in the last years of Graham's life, when he was dying in London. Ashbery's go-with-what-amuses-you attitude made him an amazingly acute interpreter of the lighter tenor of second-generation Abstract Expressionism, whether the work

of Grace Hartigan (about whom he was far too kind) or Joan Mitchell (about whom he was brilliant).

Ashbery did not reject the characterization of Abstract Expressionism as a high classical moment, as a Golden Age, so much as he gave his readers the impression that as a personal matter he would prefer to look elsewhere. He could not help but be conscious of the aftermath—of the movement's tendency to deteriorate into bombast and academicism. I'm not sure that Ashbery cares all that much about classical moments. Maybe they are something best left for the fathers to worry about, while the kids happily skate across the silvery frozen lake.

7. PASTORALS

I

There was a spiraling, back-to-the-future fervor about much of the artistic thinking and feeling of the early 1950s, and if the farthest back that anybody could go was a vision of nature primeval, Monet's panoramic *Water Lilies* struck many New Yorkers as being such a vision. These scintillating modulations of near-infinities of diffused color, which were painted in the 1910s and 1920s, represented a Silver Age of Impressionism that was now beginning to look like a Golden Age. It was odd how things happened. De Kooning put it this way: "The artists keep influencing the old masters. Maybe some of the young painters take things from Monet. But it was some one like Clyfford Still, who probably never looked at Monet, who got them to see it."[1] Suddenly, Monet was a part of the past that felt alive in the present. Such revaluations are never an easy process to pin down, and while what happened in New York was certainly related to the sudden appearance, in the mid-1950s, of significant late Monets in the Museum of Modern Art, those acquisitions may have been triggered by the curators' response to a new orientation among the artists. While Cézanne had been in the Modern's collection since 1934, practically the museum's beginning, there had not been a single Monet at MoMA prior to 1951. In 1955 the museum acquired an immense *Water Lilies*, eighteen feet wide by six-and-a-half feet high. Before this was destroyed in the catastrophic fire that swept through the museum on April 15, 1958, it had become the talk of New York (two smaller, also very late paintings were acquired in 1956, and another huge *Water Lilies* was acquired after the fire).

In March 1956, Louis Finkelstein, who would later write about his friend Earl Kerkam, published an essay in *Art News* called "New Look: Abstract-Impressionism." He remarked that "it was only a few years ago that Monet was considered pretty much a dead issue among most abstract painters. Yet in the Museum of Modern Art we now have the great delicious expanse of the

Nymphéas looking for all the world like something hot out of a New York studio. The label comments on how abstract (unreal) it looks, yet it seems also to work in reverse—making a number of abstract paintings look more real, and itself looking real by virtue of the vision created by Abstract-Expressionist works." Greenberg, writing in the *Art News Annual* the next year, had almost an identical reaction, observing, "Right now any one of the *Waterlilies* seems to belong more to our time, and its future, than do Cézanne's own attempts at summing-up statements in his large *Bathers*." Late Monet was New York's great acquisition in the mid-1950s. The Impressionist's work affected Philip Guston, Ellsworth Kelly, Joan Mitchell, and countless other artists. You might reject the influence, as Mitchell did when she observed of the artists who had been important to her that "Monet just wasn't there." And yet the point was that even if you hadn't walked toward Monet (and who had?), you had stumbled into him. The process was unpredictable, a falling back into history.[2]

Monet's *Water Lilies* were the essential pastoral vision of twentieth-century art. This was, however, a peculiar kind of pastoral, for there was no human presence in the *Water Lilies*. They were pastorals that looked back to a primordial time, to the very beginnings of nature. For decades, Monet had painted landscapes and cityscapes in which the figure, although sometimes reduced to a quick notation, was a part of the scene, an animating factor, filling the city streets and suburban waterways and coastal beaches. In the works of his last years, however, as the critic Roger Shattuck has pointed out in an essay published in 1982,

Claude Monet, Water Lilies, *circa 1918. Oil on canvas, 40 × 80 in.*

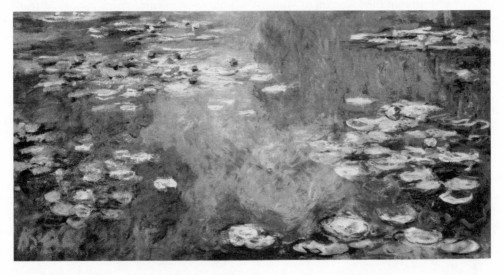

"Monet restricted himself to the forms and colors of nature without people, cleansed of the human presence." Thinking of the overgrown wisteria vines and generally opulent vegetation in so many of Monet's later compositions, Shattuck argued that "at the end he was painting Eden after the Fall, when the garden was growing up to obliterate all traces of earlier occupancy, a wistful paradise which eventually came to have a new relation to mind and to appearance."[3] Leaving behind the visions of Claude Lorrain and Poussin, in which the figures lived in a kind of harmony with the nature that surrounded them, Monet developed a pastoral that was wilder and more primitive than the often cultivated vistas of the seventeenth-century masters, but that was also more personal, for the only human presence was now the eye and the hand of the artist, experiencing nature, putting nature on canvas.

In the 1860s the Impressionists had begun to toss out all the old ideas about composition and color and line in favor of a new, hell-bent improvisatory method based on immediate sensation, and their freedom from convention fascinated New York. Newman, who rarely had a kind word to say about European painting, revered the Impressionists for their directness and their daring. Hofmann wrote that "the Impressionists led painting back to the two dimensional in the picture through the creation of a light unity." And Schapiro, that friend of so many artists, devoted some of his most sustained thinking and writing to the Impressionists' work and ideas. He had given courses and lecture series on Impressionism since the 1930s, and a major series of lectures at Indiana University in 1961. In "The Nature of Abstract Art," an essay first published in 1937, Schapiro had written about the "moral aspect" of Impressionism, and described a dimension in the paintings of Monet, Sisley, and Renoir that dealt with man's pleasure in the natural world. "It is remarkable," Schapiro observed, "how many pictures we have in early Impressionism of informal and spontaneous sociability, of breakfasts, picnics, promenades, boating trips, holidays and vacation travel." He referred to these as "urban idylls," and he spoke of "the cultivation of . . . pleasures as the highest field of freedom for an enlightened bourgeois." Obviously the freedom of the new paint handling and composition and color was mixed up with the idyllic nature of these paintings; the new technique offered, as Schapiro put it, "conditions of sensibility closely related to those of the urban promenader and the refined consumer of luxury goods."[4] Now Schapiro did not use the term *pastoral* to describe these scenes of pleasure in parks, along riverways, at the beach. But who can deny that however they struck their first audiences, by the mid-twentieth century they were seen as images of a magical,

lost world where men and women lived in a quickening harmony with their surroundings—as, in other words, nineteenth-century pastorals?

That the word *pastoral* might be applied to modern and even urban situations was not unheard of in the 1930s. One of the decade's most widely discussed books of literary criticism, William Empson's *Some Versions of Pastoral*, opened with a chapter titled "Proletarian Literature," in which Empson asserted that "good proletarian art is usually Covert Pastoral." Empson's book remained immensely influential. Paul Goodman may have had Empson in mind when he titled one section of his novel *The Empire City* "An Urban Pastoral Romance (After Longus)," and set some of his scenes on the piers along the Hudson River, with their hardworking seamen and watery vistas and erotic possibilities. When Auden gave a series of lectures on Shakespeare at the New School—where artists often attended lectures—and devoted an evening to *As You Like It* and pastoral conventions, he began by acknowledging a large debt to Empson. The pastoral, Empson argued, put "the complex into the simple," and the connection with proletarian literature would thus seem to be that the novel or poem presenting the workers' frequently harsh day-to-day experience aimed to create a romantic union of man and his environment.[5] Auden, in speaking about *As You Like It*, said that "any idea of pastoral involves a conception of the primitive," and he cited three categories of the primitive discussed by Erwin Panofsky in his *Studies in Iconology*, including " 'soft' primitivism," " 'hard' primitivism," and "the Hebraic idea of the Garden of Eden," which Auden argued "is prehistoric and has to be told in mythical as well as historical terms"—and which we have already seen Shattuck alluding to in relation to Monet's *Water Lilies*.[6]

Here, I believe, we can begin to understand the importance that Monet's *Water Lilies* had in the 1950s. For artists who were in revolt against the textbook view of art history, the realization that Monet was cultivating his own Eden at Giverny long after Cubism had precipitated abstraction suggested an escape not only from human history in general but also from art history specifically. If Greenberg found that Monet's *Water Lilies* were now more significant than Cézanne's *Bathers*, this had to do, paradoxically, with Monet's ahistoricism, for Monet had leapt beyond Cubism even as he ignored it.[7] Of course Cézanne's *Bathers*, which were done as much as two decades before the *Water Lilies*, were paintings in a more traditional pastoral manner, a joining of the figure and the landscape in a lyrical unity that went back to Poussin and Claude. They were about man in history, about people living in a harmony with nature that would later be destroyed. But Cézanne's *Bathers* also referred

to man in history in another, more purely pictorial sense, for they announced the coming of Cubism—announced it through the shattering of contours and the reimagining of the human figure as a concatenation of discrete planes. If in Cézanne's *Bathers* the classical figure had begun to dissolve, in Monet's *Water Lilies* it had vanished entirely. Monet had eluded Cubism, and simultaneously retreated into Shattuck's Garden of Eden after the Fall. This was a pastoral outside of human history, a mythic pastoral that, as the swervings and gesturings and unfurlings of Monet's brush became ever wilder, passed into a near-abstract pastoral, a pastoral of sensation materialized into a dispersed, personalized painterly calligraphy.

II

Among the first artists to talk about Monet after World War II was André Masson, the French Surrealist who was one of the subtlest, most profound artists of his time, and who had lived in America in the 1940s, where his work had been a major influence on a number of artists. Returning to France in 1945, Masson, who through the dazzling iconographic explorations in his work had already traced Surrealist ideas back to Blake and other nineteenth-century Romantics, was now turning his attention to J.M.W. Turner and Monet. Here again we see a mid-twentieth-century artist reasserting his essentially romantic spirit in the postwar years, now through radically different expressive means. From the thesis of Blake, Masson turned to the antithesis of Monet's Venice and Giverny, and where he might go next he clearly did not know and did not feel he needed to know. Masson's paintings, which in the 1940s had been labyrinthine and dark, with jewel-brilliant bursts of color, turned light,

André Masson, The Storm Winds in the Pines, *1954. Mixed media on canvas, 28¾ × 36 in.*

almost watercolor-like, in the early 1950s. He painted water and clouds and air currents in feathery, prismatic tones. He spent time in Venice, painting the city that Hyacinth Robinson had loved. He wrote about Monet's *Water Lilies* in the magazine *Verve* in 1952. The next year, for the catalog of his exhibition at the Curt Valentin Gallery in New York, he described his new paintings as being about "boundlessness, expansion through light. . . . A delicate sensualism makes me burst the last chains that still bind me to the 'spirit of weightiness.' I learn to know the genuinely open and discontinuous form." These fascinating compositions, with their floating power, are still too little known and too little loved.[8]

A quarter century earlier, Monet had already understood everything about openness and discontinuity and allover-ness that Masson, along with some younger American artists, was beginning to grasp in 1950. And the Museum of Modern Art, by acquiring a vast *Water Lilies*, was giving the artists what they most needed from a museum—an exemplary Old Master. Monet's was rhapsodic, symphonic painting; his idea of orchestrating everything into a grand whole could be related to Pollock's *Autumn Rhythm* (1950) and Hofmann's *Orchestral Dominance in Green* (1954). Without ever exactly rejecting his original perceptual discoveries, he had become, in the years after World War I, a different and more conceptual kind of artist—an improvisational conceptualist, one might say. In place of the classic Impressionist crystallization of a moment, Monet developed a process of fragmenting, melting, intermingling, transforming. "The Artist and the Atom," an article in the *Magazine of Art* in 1951, made a connection between the Impressionist's fracturing of the object and the interest in atomic theory in the 1860s, and certainly there was a sense in the 1950s—albeit a vague sense—that the openness of the new American painting might be related to the coursing energies of atomic theory.[9] Monet's *Water Lilies* evoke light on water and sensations of floating and plunging, but they are also vast meditations on the heaviness and lightness of paint, on the properties and possibilities of pigments mixed with oils, and therefore of matter in general. There could even be an interesting element of nihilism in Monet's persistent atomization. Paint, like water, became a substance into which everything else vanished. For Greenberg, Monet provided a valuable confirmation of some of the discoveries of Pollock and de Kooning, namely "that a lot of physical space is needed to develop adequately a strong pictorial idea that does not involve an illusion of deep space."[10]

But even as the *Water Lilies* struck Greenberg as defining allover-ness— a new canon—they struck Louis Finkelstein as suggesting the way beyond

allover-ness. At the instant when everything had dissolved into Monet's paint, the paint was resolving, rematerializing into something more substantial, into bits and pieces that evoked the things of this world. In Monet, paint was paint, but it was also light and water and air and leaves and flowers. The term *Abstract Impressionism*—which itself suggests a turning back, since Impressionism is of course a nineteenth-century movement—in fact predated Finkelstein's "Abstract Impressionism" article by quite a few years. In June

Cover of Abstract Impressionism, *Arts Council of Great Britain, 1958.*

1958, when the Arts Council of Great Britain sponsored a show in London that was also called "Abstract Impressionism" (and included French and English as well as American painters), Lawrence Alloway wrote that according to Hess, it was Elaine de Kooning who had first spoken of Abstract Impressionism, at the Club in 1951. This was not so long after Masson, back in France, was beginning to think about Monet. Another painter who was receiving renewed attention was Bonnard, who had known Monet and adopted "the nacreous quality of Monet's pigment," as John Rewald put it in the catalog of the landmark Bonnard retrospective mounted at the Museum of Modern Art in 1948, the year after the artist's death.[11] The at-an-angle luxuriance of Bonnard's surfaces—and the extent to which Bonnard's landscapes and interiors sometimes approached a resplendent abstractness—became part of a genealogy that the New Yorkers felt linked them back to Monet. As De Niro would write some years later, there was to Bonnard's work an "opulent restraint" and "a kind of indolent off-centered charm, more languorous than voluptuous."[12]

Finkelstein's argument was subtle, with paragraphs that were abstract and philosophical and sometimes hard to follow, but the main point was that there had been too much of an ideology of abstraction as abstraction, and that this had closed down some possibilities. Mitchell and Guston were among the artists included in Finkelstein's article, along with Hyde Solomon, Blaine, De Niro, Jan Muller, Gretna Campbell, Wolf Kahn, Rosemarie Beck, Charles Cajori, and many more. All of these painters moved the brush across the canvas with an openness that Finkelstein clearly felt would be unimaginable if not for the examples of Pollock and de Kooning. Yet the greater or lesser extent to which their various works connected with nature—and some of their pictures

were forthrightly landscapes and still lifes—
suggested to Finkelstein a "growing towards
rather than receding from reality [that] con-
tradicts that view of modern painting which
regards it as dealing with a world 'com-
pletely incompatible with the world of ex-
perience.'" The quote was from André
Malraux's *Voices of Silence,* that elaborate
meditation on the many ways in which the
will-to-form plays itself out through history.
What was fascinating in Finkelstein's argu-
ment was that the force of history was now
operating in reverse, at least from the point
of view of the modern move from represen-
tation to abstraction. Or perhaps the idea
was one of simultaneity, abstraction and rep-

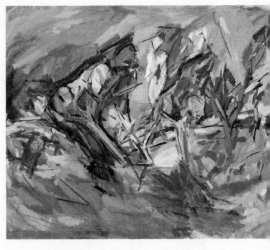

Gretna Campbell, Remembrance of Provence, *1954.*
Oil on canvas, 51 × 64 in.

resentation existing in a kind of perpetual tension, which was something like
Worringer's idea in his book *Abstraction and Empathy.* "I do not think,"
Finkelstein remarked, "that all abstract painting actually has gone as far from
the world of the senses as might be assumed. Problems of description of new
experience may pose themselves as formal, but only as temporary focuses of
attention. Our valuations in the long run are not of purely esthetic or stylistic
elements, or of excitation as such, but rather of the completeness of seeing that
which is manifest in a given work."[13] The painting of the 1950s was turning
out to be more alive to nature, more *natural* than might have been expected;
this is what Finkelstein celebrated.

III

Among the signal achievements of the Monet revival was *Summerspace,* the
dance created in 1958 by Merce Cunningham, a choreographer much influ-
enced by painters, with sets and costumes by Robert Rauschenberg and music
by Morton Feldman. In *Summerspace* the pale-toned, speckled design, cover-
ing backdrop and dancers' leotards equally, created an allover Monet effect
amid which the performers, camouflaged to sink into the background,
emerged as markings and exclamations, as staccato events that were continu-
ally reabsorbed into the enveloping mood, into the vast, lyric canvas. The
dance critic Arlene Croce has written of *Summerspace* that it "is a highly con-

scious reconstitution of several very old ideas about classicism. Its subject moves as far back in time as a Poussin landscape peopled by nymphs and fauns (and even farther, for that idea was itself a reconstitution) and as far forward as the thousand dells and glades of Denishawn."[14] Cunningham's dance helped to define a new kind of American pastoral sophistication. The United States, often interpreted as a country whose psychology was grounded in the existence of an expanding frontier, no longer had a mystique of the frontier that could interest artists. The Southwest, an aesthetic revelation for Georgia O'Keeffe and many others, had evaporated into Art Deco and tourism, and the Stieglitz circle, which had interested itself in a somewhat anthropological view of America, had already in the 1940s been rejected by Clement Greenberg, who observed, "There is about [Stieglitz] and his disciples too much art with a capital A, and too many of the swans in his park are only geese."[15] The artists now felt about New York, as Balzac had felt about Paris, that it was the head of the world, and so travel was no longer a search for the heartland so much as it was a vacation, an amusement, a temporary escape, but also an experiment, a look inward, a search for the self—a psychological pastoral.

The city and the country had become almost a psychological attraction of opposites, a conflict between one's extrovert self and one's introvert self, a conflict that was always in a state of flux. The pastoral, a place outside of time, was also often a place that you actually had to leave the city to get to, and the

getaways were becoming infinitely easier, for money was more readily available than it had been a decade earlier, European travel was becoming much, much easier, and many of the downtowners were able to spend summers on Long Island, or perhaps in Provincetown or somewhere else in New England. Many people who dreamed of coming to the city and becoming artists found, almost as soon as they arrived, that they had to escape, at least temporarily, to the country. Blaine, a child of Virginia, in New York to study with Hofmann, was soon spending summers in Gloucester, Massachusetts. In a

Richard Rutledge, Merce Cunningham's Summerspace, *with Carolyn Brown and Viola Farber, 1958.*

journal entry, she wrote of the pull of Gloucester, and related it to the age of Melville, and to romanticism. "One of the marvelous things about Gloucester, it seemed to me, was that the fishing was its early settlers' life & that it was still authentically alive. I've always loved fishermen & considered the trade romantic which of course it was by all of our great early American litera-ture."[16] Gloucester, too, was a pastoral locale. But even a major metropolis could take on a pastoral character, if a painter or photographer chose to emphasize the city dweller's easy, rhythmic, almost primitive relationship with the place, as Joseph Cornell did in several films of peaceful New York City parks that he created with Burckhardt as the cameraman, and as Burckhardt himself did in his photographs and films of the urban scene.

One of the finest passages in Frank O'Hara's poetry is about the prepara-tions for a pastoral getaway, albeit nothing more than the train ride out to Long Island for the weekend. "It is 12:20 in New York a Friday," 1959, and O'Hara described rushing around on his lunch hour, preparatory to taking the 4:19 to Easthampton. He had his shoes shined, bought "an ugly NEW WORLD WRITING to see what the poets / in Ghana are doing these days," withdrew money from the bank where the teller, Miss Stillwagon, "doesn't even look up my balance for once in her life," bought "a little Verlaine / for Patsy with drawings by Bonnard although I do / think of Hesiod, trans. Richmond Lat-timore." It is worth lingering for a moment over this mention of Hesiod, who had written about the Ages of Man. And over the mention of Bonnard, whose late work was a continuation of Monet's bejeweled expressionist vision. But we cannot linger for long, because O'Hara has already left the bookstore. "For Mike I just stroll into the PARK LANE / Liquor Store and ask for a bottle of Strega." After that, O'Hara was back on the street, to "the tobacconist in the Ziegfeld Theatre" where he "casually ask[ed] for a carton of Gauloises and a carton / of Picayunes, and a NEW YORK POST with her face on it"—the face being that of Billie Holiday, whose death gave this poem its title, "The Day Lady Died."[17] O'Hara could turn a few blocks of midtown Manhattan into a picaresque adventure, but even when he and his friends went farther afield, they carried with them a not unrelated bemused, narcissistic attitude.

In 1956 the magazine *Folder* offered a sheaf of art songs, including Ben Weber's "Song: Opus 44," with a lyric by O'Hara. "Here we are again," O'Hara wrote, "together as the buds burst over the trees their light cries. Walking around a pond in yellow weather." Two years earlier, also in *Folder,* O'Hara published an essay titled "Nature and New Painting," in which he spoke of de Kooning and De Niro and Freilicher and others, and observed that

Grace Hartigan, cover of Folder 4, 1956.

the artists he knew were doing "paintings of and about nature, paintings which are permeated by the feeling of nature and which represent the perfected observation of nature's detailed structures and even selflessly proclaim principles of nature which the artist has perceived."[18] From the 1950s onward, landscape painting was produced in great quantities by the artists of New York City. Much of de Kooning's work of the 1950s and 1960s was fueled by rural motifs and themes of one kind or another; he painted *Pastorale* in 1963, a canvas full of agitated, light-drenched yellows. Hess, thinking of some of the work that de Kooning did after beginning to spend summers on Long Island in 1951, put it this way: "Remembrance of the woods or the beach is summoned up in a room looking out on Broadway's filthy sidewalks where old newspapers caked with soot fly up against the urine-stiffened pants of bums trying to dodge the trucks banging downtown with their loads of scrap iron and mattresses."[19] And there were whole careers, such as that of Fairfield

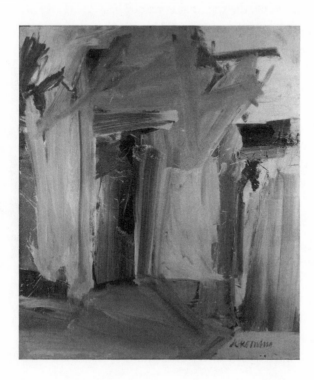

Willem de Kooning,
Door to the River, 1960.
Oil on canvas, 80 × 70 in.

Edwin Dickinson, Rock, Cape Poge, *1950.*
Oil on masonite, 11½ × 14¼ in.

Porter, that took as their main subject country or at least suburban life. The best nature painting of the New York School, including the work that Porter did on Long Island and in Maine and the work that Blaine did during summers in New England, presented the natural world with something other than complete relaxation. While the subjects themselves might have been serene, the way that Porter or Blaine put on paint, in aggressive strokes that could look jumpy or could push against one another in unsettling ways, gave their paintings an air of unease, as if the country were to some degree only another arena in which to enact the New Yorker's experience of life in overdrive. This anxious, hyper-alert quality in the paintings corresponded to something in the work of the New York poets—in all those poems and journals by Ashbery and Schuyler and O'Hara that intermingled the pure pastoral high with a wry sense that really all one ended up discovering outside of the city (on Long Island, in Vermont, in Maine) was a regrouping of the same troops, a different backdrop but the same old *us*.

There were artists discovering a range of pastoral worlds. Edwin Dickinson, working on Cape Cod, brought a gift for razor-sharp graphic effects to his drawings of old clapboard architecture, and gave his small paintings of beaches and dunes a blurred brilliance. And John

John Heliker, Pertaining to Rome, *1949. Oil on board, 26½ × 18 in.*

Heliker—who had painted a moving portrait of Merce Cunningham in the 1940s, with the dancer appearing as an acrobat out of Picasso's Blue period—was returning from Rome with canvases that united Corot's immediacy and Lyonel Feininger's casual geometries to give the ancient city's geological and archaeological layerings a flickering delicacy. In later years, Heliker's finest works were often glimpses of the Maine coast or of young people visiting the artist's studio, works in which he punctuated his veils of blue-green-gray oil paint with dashes of impetuous calligraphy.

IV

To travel was to gather images, to fill the pages of one's own back-to-nature album. The great, classic 1950s account of touring the country came from Vladimir Nabokov in his 1955 *Lolita,* where Humbert Humbert romanced motel culture—a tongue-in-cheek pastoral. "We came to know—*nous connûmes,* to use a Flaubertian intonation—the stone cottages under enormous Chateaubriandesque trees, the brick unit, the adobe unit, the stucco court, on what the Tour Book of the Automobile Association of America describes as 'shaded' or 'spacious' or 'landscaped' grounds."[20] Nothing else had Nabokov's clarity and knowingness, but being on the road was a subject that many would embrace—Beat poets and novelists, painters who were discussed in Finkelstein's "Abstract Impressionism" article, and a new generation of photographers. The work of Monet suggested to some a way back from total abstraction to a pastoral naturalism, not a desire to master structure so much as a way to give oneself over to the flow of sensation, and that in turn could be related to a new interest in Zen and other Eastern religions. Zen has sometimes even been related to Henri Cartier-Bresson's immensely influential vision of the decisive moment in photography—which was a kind of immediate, indissoluble revelation. Asian art, in any event, especially Japanese prints and screens, with their asymmetrical compositions, had been a major influence on Monet. Asian ideas about chance, about randomness, could seem to be integral to the appeal of travel, for you never knew what was going to happen next or what you were going to see next—even if that was something as minor as the difference between a stucco unit and an adobe one.

Gary Snyder, whose work Robert Creeley published in the last number of *The Black Mountain Review,* lived in San Francisco, and had traveled through Japan in the 1950s and kept a journal in which he sought to grasp a new "key to evolution adaptability: the organism alters itself rather than continue fruit-

less competition." A decade later, writing of some
days spent hiking with friends, he felt as if he were
slipping into an Asian pastoral world. "Going along
the trail traveling HIGH. Step, step, flying paces
like Tibetans—strangely familiar massive vistas—
the trail is *Right*. All the different figures one
becomes—old Japanese woodcutter; exiled traveler
in a Chinese scroll." For Snyder, the Silver Age
might have been the age of the Japanese poet-
painters, who wandered in distant provinces and
painted themselves as tiny figures in the vast pan-
orama. Noguchi, working on ceramics in Japan in
the early 1950s, created a small, ebullient figure to
which he gave the name Buson, the great Japanese
poet-painter; in Noguchi's rendering the legendary
lyric artist is a tiny figure standing beneath the
arched roof of his rural cottage retreat. Noguchi

Isamu Noguchi, Buson, 1952.
Unglazed stoneware, 8¼ in. high.

made this and other ceramics—which were shown at the Stable Gallery in
1955—in a rural Japanese studio, Kita Kamakura. And these works, with their
rough, casual surfaces, suggested the exuberant easygoingness of a life lived
far from the pressures of an urban center.[21] Indeed, the general upsurge of
American interest in ceramics and in weaving—both of which were strongly
encouraged at Black Mountain College—signaled a gathering rejection of
industrial production methods that tied right into the postwar pastoral view-
point. In his *Maximus Poems*, Charles Olson, the presiding literary figure at
Black Mountain, offered epigrammatic evocations of the New England sea-
coast, with the endlessly changing skies and "the sea / stretching out / from
my feet." And in William Carlos Williams's epic poem, *Paterson*, which
appeared in five books between 1946 and 1958, the drama of the Passaic Falls
and the Passaic River came to reflect, so Williams said, the trajectory of his
own life, "with the roar of the river / forever in our ears (arrears) / inducing
sleep and silence."[22]

 An Asian sense of pastoral—with surprising leaps in scale, with off-center
juxtapositions—may have had a particular interest in San Francisco, where
the California School of Fine Arts had been a center of interest in Abstract
Expressionism since the 1940s, and where Still and Rothko had taught.
Richard Diebenkorn was one of a loose-knit group of young Bay Area artists,
including David Park, Elmer Bischoff, and James Weeks, who had all been

turning from Abstract Expressionism to a representational art of one sort or another by the late 1950s—and were receiving a good deal of attention in New York, where Diebenkorn showed at the Poindexter Gallery. For more than a decade, beginning in the mid-1950s, Diebenkorn was doing landscapes and interiors and figures of the Bay Area and a few of Southern California, in which he created an acerbic, melancholy atmosphere, filtered through his interest in Matisse and Bonnard, yet with harsh colors and awkward juxtapositions of forms that seemed to come out of the rough-edged beauty of California. There were small still lifes, of a knife, a glass, a tomato; scenes of bits of freeways and modern houses; a wrought-iron balcony and folding chair; figures in interiors. Among the most beautiful works that Diebenkorn ever did were a series of small etchings and drypoints of still lifes and interiors and figures and landscapes, mostly around Berkeley. Intimate and introspective, with a woman in a low-slung chair or a few ordinary objects arranged on a table, they exuded a California mystery. The grays and blacks of the printer's ink came straight out of the fogbound atmosphere. Diebenkorn brought elements of narrative and emotional complication into his prints; his women deep in conversation suggested a Northern Californian echo of Vuillard's muted genre scenes, so that Diebenkorn seemed less a part of some modern mainstream than he perhaps aspired to be, as if he was being pushed to a more eccentric position by the mood of Berkeley in the early 1960s, by its informal sophistication. Diebenkorn created luxurious elegies for the casual beauties of contemporary California. He caught the romanticism of Northern California, with its quietly cosmopolitan mood. And his work connected with an idea that had considerable appeal among New York travelers, namely that a place could be treated as a mood poem, as a sort of symbolist reflection of a personal temperament.

Richard Diebenkorn, from 41 Etchings Drypoints, *1965. Soft ground etching, 8³/₁₆ × 7³/₄ in.*

I think this poetic quality is also felt in the work of Robert Frank, a photographer who had arrived in New York from Switzerland in 1947 at the age of twenty-three. In the photographs of America that he was doing a few years later, there was a sense of a dark-toned pastoral vision—of dramas caught at an angle, of mysteries in the air—that was not unlike the quality of some of Diebenkorn's etchings. Frank was a commercial photographer, a successful one, and then in 1955–56, the time of *Lolita,*

he traveled across the country on a Guggenheim grant. Two years after the trip was over, *The Americans,* a selection of eighty-three of Frank's photographs, was published in Paris. It came out in an American edition, published by Grove Press, in 1958. *The Americans* is full of strangely cropped, closed-off, disrupted views, of faces that are obscured by bodies, of windows and walls and cars. In one photograph, perhaps the most lyrical in the book, we look into a barbershop through a screen door, and the reflections on the glass and the overlay of mesh screen make the image feel dreamy, unreal—give it, almost, a Monet effect. Taken one by one, the subjects of Frank's photographs might be said to be frustration and seduction—our frustration at not being able to see more, and our seduction by the little that we do see. But when the photographs are experienced as they are meant to be, as a series of images to be absorbed in quick succession as the pages of the book are turned, then the effect is entirely different. As the images multiply, the result is not more incompleteness but rather a sense of fullness, a sense that things are coming at us very fast, so fast that we can't take them all in. We see the styles that people wore, the ways that they relaxed, the political posters that hung in shop windows. The feeling is one of unpredictable exuberance—"That crazy feeling in America when the sun is hot on the streets and the music comes out of the jukebox or from a nearby funeral" is how Jack Kerouac described it in the introduction to the American edition.[23]

Robert Frank, Barber Shop Through Screen Door—McClellanville, South Carolina. *From* The Americans, *1958.*

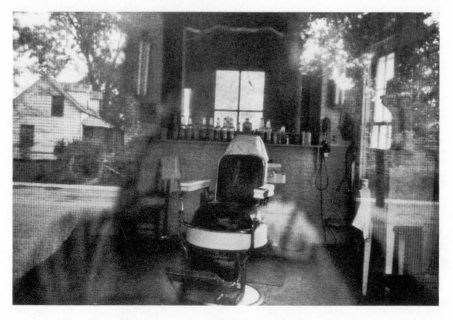

Frank's America was a mad carnival, and the book was less a portrait of the country than a portrait of the avant-garde artist (who now had a Guggenheim fellowship) looking at the country. It was a hipster's pastoral dream. The highways and diners and public parks and cars and motels weren't presented as ordinary; for Frank (as for Nabokov) they were bizarre, they were a show. Walker Evans, who'd toured the South taking photographs for the Farm Security Administration twenty years earlier, praised Frank's photographs in the *U.S. Camera Annual 1958* for their "American scale and space," for their "bracing, almost stinging manner." This was three years after the Museum of Modern Art had mounted "The Family of Man," an immensely popular compendium of photographs organized by Edward Steichen, then director of photography at the museum. What was presented in this huge, sentimental show was not an America—or a world—that the downtown artist wanted to know, and in 1958 (when "The Family of Man" was in the midst of its endless tours) Evans alluded to the difference between Steichen's family and Frank's family. *The Americans,* Evans wrote, "is a far cry from all the woolly, successful 'photo-sentiments' about human familyhood; from the mindless pictorial salestalk about fashionable, guilty and therefore bogus heartfeeling."[24] In part, Frank was involved in a response to Walker Evans, much as Joan Mitchell or Fairfield Porter was involved in a response to Pollock or de Kooning. Frank was riffing on Evans's classic view of America, with its almost Constructivist compositional clarity; he was offering something darker, murkier. What Frank had discovered as he traveled around the country was an America that jibed with the New York that he knew and loved—with the Tenth Street of the galleries, with jazz, with late-night talk, with black-and-white abstractions. Robert Frank reinterpreted America in the light of existentialism—a fascinating, peculiar achievement.

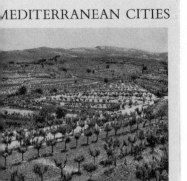

Rudy Burckhardt, cover of Mediterranean Cities, 1956.

Another connoisseur of the ordinary-extraordinary was Rudy Burckhardt, who had been photographing the striking street imagery of New York since the 1930s, and who in the 1940s and 1950s was going farther afield, to Europe and South America; in 1945 *View* carried his "Scrapbook: Tropical Americana." In 1956 Burckhardt and Denby collaborated on *Mediterranean Cities,* a book in which Denby's sonnet sequence about travel was joined to an album of Burckhardt's black-and-white photographs of Italian places. These photographs have, some of them, a snapshot

informality, only the layout is so cool and precise that the informalities are intensified, given an oddball splendor. We are struck by the abstract patterns that people make as they move through the piazzas; we notice the way the casually dressed natives lean against the grandly carved old façades. The photographs match the offhand clarity of Denby's sonnets. In one of the poems, Denby and Burckhardt are in Sicily, and he tells of a conversation.

> Are you Russians the boys said seeing us strange
> Easy in grace by a poster with bicycles
> Soft voices in a Baroque and Byzantine slum[25]

Photography was just one of the media that preoccupied Burckhardt; he also produced dozens and dozens of films and a good many paintings. The paintings, in a straightforward, rather careful style, are of New York City buildings and Maine woods. The films range extraordinarily widely. In 1955, when he was in Europe working on *Mediterranean Cities*, he filmed *Verona*, which began with close-ups of churches that had an almost nineteenth-century clarity; after that there were images of public statues, and of a traffic policeman in white, who moved his gloved hands with the choreographed elegance of a dancer.[26]

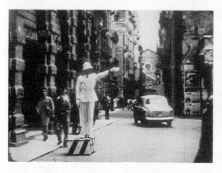 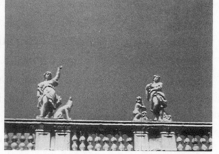

Rudy Burckhardt, stills from Verona, *1955.*

V

The pastoral tradition was first and foremost a literary tradition, which in English literature began with Sidney's *Arcadia*, Shakespeare's *As You Like It*, Jonson's *Sad Shepherd*, Milton's *Comus*. Perhaps no work created in the bohemian 1950s suggested the persistence of this pastoral tradition more clearly than the verse play *I Too Have Lived in Arcadia*, which V. R. Lang, the guiding force behind the Poets' Theatre in Cambridge, Massachusetts, who

Edward Gorey, illustration for V. R. Lang's play I Too Have Lived in Arcadia.

was known to one and all as Bunny, wrote after the breakup of her affair with New York painter Mike Goldberg. The Poets' Theatre was a gathering place where Ashbery, O'Hara, Koch, and James Merrill had worked and had had plays produced; Edward Gorey, whose later graphic output would suggest an Edwardian pastoral, was also deeply involved there when he was a Harvard undergraduate. In Lang's play, Goldberg was Damon, who was in love with Chloris, a love affair that was complicated by the presence of Phoebe. They had come to live in a place where the marsh turns "silver . . . and early green, and carmine" and where there were "giant violets" in the woods. Damon and Chloris wanted to start "a sort of ideal community"; they wanted "to find the *Fête Champêtre* beyond / The City Limits." But this was not simple for Damon, who was "cut off from everyone who could sustain him." He had been "on his way. / Everybody knew him. He knew everybody." Phoebe kept reminding him of the city, but Chloris argued that before she came,

> He went down,
> All the way to the beginning,
> Down until he touched.
> Then, for the first time,
> He reached for what he was.[27]

The play did not come to any clear conclusion—it was an ambivalent pastoral. And not too long after it was produced, Lang died, still a young woman. In a beautiful memoir, Alison Lurie recalled the funeral, and walking in Mount Auburn Cemetery. "I was reminded of the change [Lang] had made in the title of her play, originally called ET IN ARCADIA EGO. Before the posters were made, a learned graduate student called her attention to the fact that the original meaning of this phrase, as it appears in paintings by Poussin and Cipriani (where shepherds gaze, frightened, at these words on a tomb), was 'Death, too, is in Arcadia,' " with a nod to Erwin Panofsky's famous essay on the Poussin. But Lang, as Lurie recalled, wanted to make not a nostalgic but an exultant pastoral impression. "Annoyed, she put the words into English, so that no one could mistake her meaning."[28]

For painters, the origins of the pastoral tradition went much farther back than Poussin, back to the beginnings of painterly painting—which was, so many people believed, now reaching its apotheosis in mid-century New York. If you traced this visual tradition back from Poussin and Claude, you would eventually find yourself in early-sixteenth-century Venice, contemplating the art of Giorgione. Peggy Guggenheim, we recall, had said she would trade her entire collection of modern art for a single painting by Giorgione, who painted men and women in lush, green-on-green landscapes that were miracles of evocative, layered brushwork—and that could feel like a first flash of the exultant calligraphy of Monet and the New York School. In an essay titled "Giorgione, Venice, and the Pastoral Vision," the art historian David Rosand, a student of Schapiro's, has pointed out that in "Giorgione's art . . . landscape confirmed its role as both setting and protagonist in painting. Especially on the intimate scale of small images, landscape presented a field for special delectation, often transcending the interest of whatever narrative it hosted." The brushwork, Rosand explained, "begins to be broken up, the individual stroke assuming a greater visual and expressive weight."[29] Such tendencies would be familiar to anybody who had spent time around Hof-mann, for whom the improvisational nature of life was related to the vitality of art, and all of this could hark back to the beginnings of the pastoral landscape in fifteenth-century Venice, where the effort to catch the immediate pleasures of a bucolic world pushed the artists to feats of painterly virtuosity.

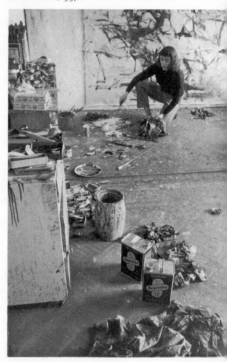

Rudy Burckhardt, Joan Mitchell in her studio, 1957.

In 1959, when Irving Sandler, who was then running the programs at the Club, wrote about Joan Mitchell for Friedman's book *School of New York: Some Younger Artists,* he observed that "Mitchell considers herself a 'conservative' in that her pictures are in the tradition of de Kooning, Kline, etc." Sandler hastened to add that "the word is not without ironic implications, considering that Abstract Expressionism is some fifteen years old," but he probably also understood that this was Mitchell's way of acknowledging a new kind of confidence, the confidence born of knowing that there is something behind you, pushing you forward.[30] Great modern forebears were nothing new to Mitchell. Her mother, Marion

Strobel, had been involved with the legendary magazine *Poetry;* T. S. Eliot himself had visited Mitchell's parents' home. It was a commonplace, stated at the time, that the postwar generation was not a pioneer generation, but instead a generation that was aware of its advantages, and took much for granted. Mitchell was always inclined, at least in conversation, to distance herself from Monet. This was the case even in later years, when she lived north of Paris at Vétheuil, which is not far from Monet's Giverny. Perhaps the truth was that Monet had been so familiar to her since she was a child that she needed to make him feel unfamiliar. In the sophisticated Chicago circles where Mitchell grew up, Monet was not just well-known; his later work must have been understood as exemplifying a moment when naturalism was melting into symbolism. But in the world around *Poetry* magazine, which was the world Mitchell knew as a child in her parents' house, a symbolism related to Monet's fin de siècle ethos had long ago been swept away in favor of the harder contours of Eliot and Pound. Growing up in this literary Chicago household in the 1930s, a smart young kid obviously would be saying goodbye to Monet and hello to Cézanne. Yet Mitchell knew as well as anyone that Monet mattered.

Mitchell's literary responses were grounded in childhood experience; and maybe, even more specifically, in her mother's poetic language. In "Tropical Pool," a poem by Strobel that was published in *Poetry* in 1924, two years before Mitchell was born, we are not far from Monet's watery world—or from the mood of Mitchell's later paintings, with their purple and green oppositions and silvery pinks and darker harmonies.

> This pool glistens too deep with shadows—
> Only the white
> Petals of water-lilies
> Close at twilight:
> Shadows open still more wide.
>
> Purple shadows slide in circles sleek
> And wide, and where
> The red poinsettias make
> The pool fade to
> A glistening pink and cool,
>
> The night comes in.[31]

It is interesting that Meyer Schapiro, in discussing Monet's *Water Lilies,* made a connection to fin de siècle symbolist poetry, specifically to a work by the Belgian poet Georges Rodenbach that suggests not only Monet but also Strobel's "Tropical Pool."

> What do we know of our soul but the surface?
> It is what the lily in the pool knows of the water . . .[32]

And just as it was possible to see a connection between Rodenbach's poem and Monet's paintings, so one can see how Marion Strobel was influenced by earlier strains in Symbolist poetry, and how all of that might have influenced Mitchell.

Certainly Mitchell had great friends among the writers all her life. During the early years in New York, she was married to Barney Rosset, who became the publisher of Grove Press; it was at her suggestion that he selected, for his first title, *The Golden Bowl,* in which Henry James's exquisitely elaborated psychological insights produce a mysterious atmosphere—a verbal abstraction. Poetry was always important to Mitchell, and she was especially sympathetic to the continuation among the writers of the New York School of an older kind of nature poetry. She did some beautiful pastel illustrations for a few of James Schuyler's poems. The relationship between poem and picture was emphasized by the presentation; a Schuyler poem would be typed out, and Mitchell literally worked her pastel strokes around the words. The effect recalled nineteenth-century Romantic book illustration, where the unframed, irregular edges of an engraving after a drawing by Turner melted straight into some lines of poetry. Mitchell's connection to nature poetry went deep; she responded to an artist such as Schuyler in much the way that Turner responded to Byron's *Childe Harold;* the painters felt that the poets were reading their minds. A line of Schuyler's that Judith Bernstock quotes in her book on Mitchell suggests how the pictorial effects of New York poetry, with its close-ups and blurs and profusion of images, which were influenced by the painters in the first place, could in turn influence a painter. Schuyler's "Thin green stems with thin/green leaves" was a verbal equivalent to the airy interweave of

Joan Mitchell, Untitled (from James Schuyler's "Sunset"), circa 1975. Pastel and typed text on paper, 14 × 9 in.

one of Mitchell's compositions.[33] O'Hara's "To the Harbormaster," a poem full of water and waves and wind, inspired a 1957 painting, which borrowed O'Hara's title.

Mitchell's career moved very quickly. She had painted since she was a child and had gone to Smith College, and she then returned to Chicago to study at the Art Institute. In 1947 she was living on Fulton Street in Brooklyn with Rosset. She was one of the few women who became a card-carrying member of the Club. She participated in the "Ninth Street Show" of 1951, and before she was thirty she was showing regularly at the Stable Gallery, Eleanor Ward's establishment in a converted stable on Seventh Avenue at Fifty-eighth Street. The Mitchell paintings that New Yorkers were getting to know in the mid-1950s had an easy confidence, a quality of suspension, of strokes of paint that had weight to them but were nonetheless held aloft against the weightless white of the canvas, a white that showed through the loose netting of strokes. In Mitchell's first mature pictures—they dated from the second half of the 1950s, when she was entering her thirties—the colors were not the tender, alive greens and blues and purples of her later work, but more a range of strident reds and blues mixed with browns and tans, not exactly nature colors but colors that had been intensified or grayed over in ways that suggest something urban, man-made. Mitchell's paintings sometimes had urban titles: *Cross Section of a Bridge, Hudson River Day Line, Evenings on Seventy-third Street,*

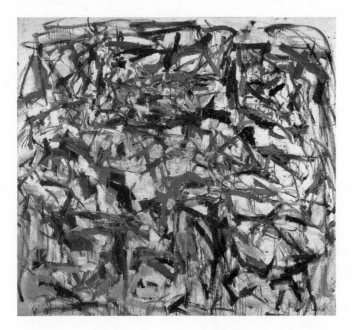

Joan Mitchell,
Evenings on Seventy-
third Street, *1956–57.*
Oil on canvas,
75 × 84 in.

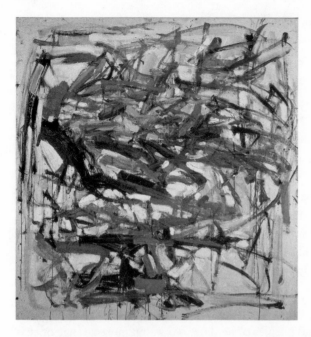

Joan Mitchell,
Untitled, 1958.
Oil on canvas,
56¼ × 54 in.

Metro. The titles didn't necessarily quite jibe with what one saw in the paint-
ings, yet one felt a loose-knit, intuitive relationship between word and image.
In some of the paintings, the strokes had a bit of a sharp independent attack to
them, but in the end these strokes pulled together into grand translucent
screens that were delicate as well as definite. The mesh of strokes, casual yet
essentially geometric, was a spirited meditation on the underlying rectilinear
character of the canvas. The smudged grays and dirtied tans added up to an
urban pastoral—an abstraction of all the days and nights lived in the chaotic
yet comfortable city, with its inexpensive lofts and ramshackle street corners.

These paintings brought to mind the finale of the play that O'Hara and
Rivers set in the Cedar Tavern. "Greatness in art isn't heavy," the Kenneth
Koch character exclaimed, "it's light. It strains to leave the earth but it's light.
Rubens' entire production is like a balloon, it makes me feel like a lark!" And
that was exactly what these Mitchell paintings did. It was that paradoxical new
quality of lightness as force, indefiniteness as definition, that characterized
Mitchell's art. Commenting about the complex relationship between the
abstract artist and nature, Ashbery wrote of Mitchell that "the relation of her
painting and that of other Abstract Expressionists to nature has never really
been clarified. On the one hand there are painters who threaten you if you dare
to let their abstract landscapes suggest a landscape. On the other hand there
are painters like Joan Mitchell who are indifferent to these deductions when

they are not actively encouraging them." Ashbery's conclusion was that the ambivalence relates to our most essential reactions, that the not-quite-abstract abstractness of painterly painting could be related to the very confusions that were involved in our experience of nature. "One's feelings about nature are at different removes from it. There will be elements of things seen even in the most abstracted impression; otherwise the feeling is likely to disappear and leave an object in its place. At other times feelings remain close to the subject, which is nothing against them; in fact, feelings that leave the subject intact may be freer to develop, in and around the theme and independent of it as well."[34] The romantic strain in these thoughts of Ashbery's could be traced back, through the Baroque, to Venice, and to Giorgione.

Writing about Mitchell in 1955, Frank O'Hara looked at a painting from a couple of years earlier and remarked, "It is strikingly vital and sad, urging black and white lights from the ambiguous and sustained neutral surface, reminding one of Marianne Moore's remark on obscurity: 'One must be only as clear as one's natural reticence permits.' " Mitchell's paintings were less about the world around us than the sensations that the world around us provoked; they presented an at-an-angle relationship to experience—they distilled it, gave it a pastoral coherence. Like so many Abstract Expressionist paintings, her work suggests tumultuous experiences, but it is probably more accurate to say that Mitchell evokes one's memories of the tumult. "I paint from remembered landscapes that I carry with me," she said in 1958, "and remembered feelings of them, which of course become transformed."[35] When Mitchell is at the height of her powers, she evokes the memory of visual experience so decisively that she gives form to a mystery.

VI

New York School history was already becoming a fairly complicated business. There were overlapping generations of artists in the city, and there were rapidly shifting demographics. There were more young artists with college degrees, there were more women who were trying to be artists. An installation shot of the 1953 Stable Annual, printed in *Art Digest* in February 1954, included nine paintings, five of which were by women. In 1957 Mitchell was one of a group of five artists who were included in a photo essay in *Life* magazine titled "Women Artists in Ascendance"; the others were Frankenthaler, Blaine, Jane Wilson, and Grace Hartigan. *Life* was doing a lot of art coverage at the time—a few weeks earlier the magazine had profiled Hofmann. Most of

the photographs were taken by Gordon Parks, who set the artists in the context of their own studios. "In the art-filled centuries of the past," the magazine explained, "women rarely took up serious careers as painters or sculptors. Of the daring few who did, barely a handful achieved any lasting stature. . . . Today the picture has changed. A sizable and remarkable group of young women is resolutely at work and their art is being sought by leading museums, galleries and collectors." The editors at *Life* went on to point out that the five painters selected for the article had "won acclaim not as notable women artists but as notable artists who happen to be women."[36]

Nell Blaine in her studio, circa 1950.

These fast-breaking careers don't fit especially neatly with some of our preconceptions about those years. In accounts of the arts in the 1950s and early 1960s, it's common to see women as relegated to the background, as shadowy presences, going out to work so the man can become an artist. Certainly that's part of the story.[37] But the gathering prosperity and concomitant social transformations of the postwar years created a situation that had its share of surprises where women were concerned. In spite of the fact that painting was widely regarded as men's work, it was an increasingly open situation for women. Numbers do not really tell the story. For a man, the idea of being a bohemian and an artist was becoming, after the war, almost conventional. It was something that many young men wanted to try out, at least for a time, so lots of them came to Manhattan and gave painting a couple of years. For women, the artist's life remained more difficult to imagine, so that as it turned out the women who gave it a serious try were sometimes more determined than a lot of the men. And it may be that a pastoral vision had a special appeal for such women, suggesting an escape from contemporary realities through the immersion in an older utopian form of art. Such an idea goes back to Sappho's Lesbos, and it had flared up in the seventeenth century, when La Grande Mademoiselle Anne-Marie-Louise d'Orléans, arguably the most powerful woman in France, wrote about a utopian community where women would control their own lives.[38]

Of course the freer erotic climate of the postwar years had its dangers for women—they could become bohemian playthings. But the homosexual world, in which O'Hara played a large role, also threw the machismo atmo-

sphere a little off balance, though O'Hara was intent on turning the grand men of Abstract Expressionism into macho idols, as he did in his adoring, mythologizing book on Pollock. The situation wasn't simple, but for women who had the temerity, this period, when it was taken for granted that the social conventions were at best wobbly, presented the possibility of a woman's self-invention or re-creation. The best a woman could do was turn herself into an oddball, an exception, and the fact that you were an exceptionally talented young artist could be a help. Hofmann took his women students very seriously; and when younger men such as Greenberg and Schapiro began to organize exhibitions, they included some of the women who had come within Hofmann's orbit. Did these guys believe that a woman could turn out to be a truly important artist? Perhaps never quite so important as some men. But their encouragement gave women the wherewithal to strike out on their own and consider the possibility for themselves.

VII

Nell Blaine was a fast starter in the 1950s. Born in Richmond, Virginia, in 1922, she made a living from an early age in advertising, doing layouts and drawings, and would continue to do so in New York; she designed the first logo for *The Village Voice*. She had heard of Hofmann through Worden Day, a painter with whom she studied in Virginia, who'd studied with Vaclav Vytlacil, an early student of Hofmann's. This tells us something about how Hofmann's message was moving through the country; how the word could spread and make New York a greater and greater attraction. Blaine arrived in New York in 1942. We see her in a snapshot, taken at a costume party. John Ash-

*John Ashbery and Nell Blaine
at a costume party, circa 1950.*

bery, young and sweet in a costume with lacy collar and sleeves, had his arm around her, and Blaine, a big goofy smile on her bespectacled face, was got up like some madcap eighteenth-century courtesan, with a hat like a pile of leaves atop her head and a fancy satin dress cut very low across her chest. Talk about Silver Age fun. The two of them were looking down, avoiding the camera, and their expressions, which mingle slight embarrassment and total confidence, were unforgettable. These two would never be the wallflowers at any party.

Nell Blaine, Red and Black, 1945. Oil on canvas, 23 × 20 in.

Blaine was one of those fortunate painters who seem to have been born with a feeling for what will and won't work on a canvas. Her early paintings were hard-edged and vivid, with flat shapes suspended on a white ground, like the letters of a fascinating, clear yet mysterious alphabet. In 1945 she participated in a show called "The Women" at Peggy Guggenheim's Art of This Century gallery. At that time her work was connected to the purity of Constructivism; she was very interested in Mondrian, and in the work of Jean Hélion—the youngest of the founders of the French Abstraction-Création group—who knew Mondrian and Léger and was part of the Guggenheim entourage and showed at Art of This Century (and would a little later on marry Peggy's daughter Pegeen). It was Hélion who in the 1930s wrote in *Cahiers d'Art* about the Le Nain brothers. By the late 1940s, Hélion had himself turned from Constructivist abstractions to increasingly naturalistic paintings of the figure; Hélion would be a major influence on Blaine, and a good friend as well. As things turned out for Blaine, Constructivism mostly functioned as a tradition, a basis, a starting point. By the time Blaine had an exhibition at the Tibor de Nagy Gallery in 1953, a reviewer in *Art Digest* was provoked to observe that while "chronologically, painting has passed from impressionism to abstraction, . . . Blaine has reversed this sequence in her own work, going from abstraction to impressionism."[39] Certainly she exemplified the decade-long move from Mondrian to Monet; she saw reality not as a reaction against the tradition of the new, but as an extension of the modern experiment.

Almost all of the students who came within the orbit of the Hofmann

School in the 1940s and 1950s had at one time or another painted interiors. They wanted to transform old tables and chairs and big windows and perhaps a friend seated to one side into allover compositions. They wanted to turn the room's plunging space into wonderfully diverting movements across the surface. Their work could echo the interiors that Hofmann himself had done in the 1930s and 1940s, although it was not clear that they would have known those canvases, many of which were done before Hofmann was exhibiting regularly. And Blaine took what had begun as a classroom problem and made it into an authentic personal statement. By the late 1950s, she was giving big interiors a dancing animation with small, staccato brushstrokes. Stylistically, the new work looked worlds apart from her abstractions of the 1940s, but formally there were connections. The great spill of brushstrokes in the representational work, covering the canvas from end to end, was another idea about the unity of the canvas, and in its own way as decisively planar as the white expanse of the earlier paintings, which she had covered with hard-edged, enigmatic forms. In 1958 Blaine was the subject of an article in the *Art News* series in which a writer and a photographer watch an artist paint a painting. Lawrence Campbell wrote the text and Burckhardt took the photographs in Blaine's sixty-foot summer studio in Cape Ann, Massachusetts. The big canvases that came out of those sessions showed plain chairs around a simple table, and a bank of squarish windows looking out on the bay; it was an all-American version of the French *luxe, calme, volupté*. There was a winning

Nell Blaine, Harbor and Green Cloth II, *1958. Oil on canvas, 50 × 65 in.*

pragmatism about the way Blaine used an easy painterly technique to achieve a lyrical shimmer. The get-the-job-done efficiency of her brushwork only added to the snappy, felicitous mood. The color recalled some of Hofmann's giddy greens and pinks, now given a cooler, silvery tone.

In Burckhardt's photographs, Blaine paced the studio, bespectacled, businesslike, and boyish in her bermuda shorts and high socks. A year later, living on the Greek island of Mykonos, she contracted polio. Through the heroic efforts of friends in Europe, she was airlifted to a military hospital in Wiesbaden, Germany, and her life was saved. She was in an iron lung for months. Back in New York, during her long stay at Mount Sinai Hospital, some assumed that she'd never paint again. Elinor Poindexter's gallery, where Blaine had been exhibiting since 1956, mounted a benefit show. Seventy-nine artists contributed, Hess wrote the catalog, and Blaine's medical bills were paid for two years. In 1960 she rented an apartment on Riverside Drive and, now wheelchair-bound, with only partial use of her right arm but somewhat more use of her left, went back into painting. And she defied the odds. Her cataclysmic illness was something that you could hardly guess from her work. She refuted the idea that it was a tragedy. Both Renoir and Dufy did their greatest painting while suffering from crippling arthritis, and the pure joy of the strokes of paint that they managed amid the most urgent physical disabilities could not but be an act of resistance, the visual bliss of the painting being a rebellion against physical trouble. It must have been some similar act of rebellion that propelled Nell Blaine. In the years after 1960, she achieved a full-out lyricism rare in American art.

The windows overlooking Riverside Drive became, because it was so hard to go far afield in the wheelchair, the setting for much of her mature art. In summers she would go to a house in Gloucester, Massachusetts; sometimes to a house in Austria that a friend had left to her. In New York her poet friends came to visit. In a number of essays about Nell Blaine, this setting on Riverside Drive became a part of the story. James Schuyler's "The View from 210 Riverside Drive," published in *Art News* in 1968, had the poet visiting the artist on a winter afternoon. "The Palisades looked shriveled, the wind had driven the broken ice into a wide band along the near shore, buildings—and the monument—were a grey charged with blue, flat and without detail. A view with a tremendous sweep to it, and one for once with something alive in it, the river, that gives a feeling of unending and impersonal force: a change from the usual ailanthus. The sun streamed into the studio: 'It's great for living but for painting it's a problem.' All afternoon, despite the white blinds,

Nell Blaine,
Three Friends at
a Table, 1968.
Oil on canvas,
46 × 67 in.

one spot of light or another would unexpectedly slide onto a painting with a mild strobe effect." One of the paintings illustrated in Schuyler's article was rather unusual for Blaine. *Three Friends at a Table* was an almost novelistic view of the artist's life, with the table covered with mugs and pots and flowers, and the three friends framed by the plain white shades that expose neat rectangles of night city. Each of Blaine's friends was caught in his or her own individual reverie. The color here was soft, a little fruity, with the green tablecloth setting the tone. There was a sense of the isolation of the figures, each in his or her own space, not unlike in the figure groups by the Le Nains. "Each," Schuyler observed, "is someone, a particular 'someone,' but each is without that individualizing slight overstatement that gives a subject a face, like a recognition token, much as a barber holds up a mirror. . . . Here, there is an effect of reticence which is not so much respect of privacy, of something hidden, as an awareness that any one life is an indissoluble entity, not an accretion of myriad details."[40] This was undoubtedly true, and yet at the same time Blaine's paintings would seem to prove that that entity was made of myriad details, at least if we understood those details to be strokes of paint.

People, in any event, were the exception in Blaine's work. When she wasn't painting the landscape, what she especially enjoyed was surveying a crowded tabletop—or zooming in on a bouquet. And as she labored, year after year, to do justice to those flowers, her colors came to resemble the old Fauve palette of blues and oranges, reds and greens, purples and yellows—a fanfare of complementary hues that she presented with a dazzle and animation that felt almost alarmingly urgent. Her individual strokes, bundled

together to capture the velvet force of an anemone or a daisy or a lily, redefined the reckless joy of Hofmann's work. Blaine's paintings started from a position of mildness, even reticence. She painted things that one thought of as ordinary albeit lovely—the anemone in all its glory, the interesting book lying open by the cup of coffee—with such fervor that these domestic subjects were shocked out of their normality into a kind of supernormality that was poetry.

VIII

Both Blaine's and Mitchell's paintings, as well as the writing about them by poets such as Ashbery and Schuyler, bring to mind the thinking of the early romantics, especially the ideas about pastoral poetry of Friedrich Schiller, who died in 1805. He spoke of two kinds of pastoral poets, the naïve and the sentimental. "Nature has granted this favor to the naïve poet, to act always as an indivisible unity, to be at all times self-sufficient and complete, and to represent, in the real world, humanity at its highest value. In opposition, it has given a powerful faculty to the sentimental poet, or, rather, it has imprinted an ardent feeling on him; this is to restore, from out of himself, this first unity that abstraction has destroyed in him, to complete humanity in his person, and to pass from a limited state to an infinite state."[41]

Schiller was of course writing about the literary arts, and writing long before the advent of abstract art; he would have known the overtly pastoral

Nell Blaine, Sunset and Sailboat near Stage Fort, *1974. Oil on canvas, 20 × 24 in.*

Nell Blaine,
The Red Tablecloth,
1972. Oil on canvas,
20 × 22 in.

painting, with its neoclassical shepherds, that had begun with Poussin and Claude. Yet it is also possible to interpret his types more generally, and to think of Mitchell as the sentimental poet and Blaine as the naïve one. "They both," Schiller wrote, "propose to represent human nature fully, or they would not be poets; but the naïve poet has always the advantage of sensuous reality over the sentimental poet, by setting forth as a real fact what the other aspires only to reach." "Sentimental poetry is the offspring of retirement and science." Surely this was the case with Mitchell, who worked in the retirement of the studio. Mitchell's grand, screenlike abstractions were a filtering of naturalistic experience, a transformation of immediate phenomena into the formal realm of an Abstract Expressionist canvas. As for Blaine, was she not, like the naïve poet, "inspired by the spectacle of life," which she "brings back [to] life?"[42] Blaine was, of course, as much as Mitchell, a sophisticated artist using all the tricks of the trade, but she employed her sophistication to achieve a guilelessness, a directness, as if no formal idea was coming between her and the world before her. Schiller's ideas help to explain the exciting grandeur that Blaine was sometimes able to wrest from the most ordinary and even modest subjects. Painting nature's most familiar beauties, she sometimes approached the ecstatic experience that Andrew Marvell described in "The Garden." She was "Annihilating all that's made / To a green Thought in a green Shade."

In a 1958 notebook entry, Nell Blaine wrote, "True purity is fullness &

overflow even as the Baroque is." And she went on to say that she "would like to do great bacchanals in the tradition of Delacroix and Veronese." Blaine wanted "baroque rhythms interweaving with the complexity and verve of a Rubens. All expansive, all sensuous."[43] And she managed to reframe these overflowing rhythms within the more modest dimensions of a bouquet of flowers or a view of a summer garden. Blaine's paintings are blazingly sensual. The color is hot. She loves the drunken yellows and oranges of autumn foliage and the voluptuous reds and purples of the anemone. She lays in paint with nervy, playful, excitable passes of the brush. The close-up feeling of her bouquets, and of her landscapes, too, puts viewers at ease. But this frankness does not preclude a secretive, almost subversive element. I think Blaine wants both familiarity and shock; she wants to find the crazy twist in the predictable motif. Her subject is the wildness of ordinariness. She is Schiller's "naïve poet." But of course this is the most exquisitely cultivated naïveté; Blaine had been the ticket taker—receiving a free audit—when Auden gave his mesmerizing Shakespeare lectures at the New School and spoke of the pastoral tradition.[44] No wonder, then, that Nell Blaine's sturdy country garden flowers flash sneaky afterimages of the city's jarring rhythms and in-your-face impact. At first, you may look at one of her paintings and think, "Ho hum." A split second later, you're riveted.

A GRAND COLLAGE

8. JOSEPH CORNELL IN MANHATTAN

I

"The sidewalk," Harriet Janis and Rudi Blesh declared, "was preexistent collage—an expanding image, vast in space and inexhaustible in variety."[1] Blesh and Janis, who had written one of the early books on de Kooning, were discussing the work of the early-twentieth-century German artist Kurt Schwitters in their book *Collage,* but the connection that they were making between the artist's assembling bits of found material and the unfolding juxtapositions of the city brought anybody who opened their book around the time of its publication in 1962 straight back to the New York of the present. A considerable number of New York artists were doing collage or assemblage in the late 1950s and early 1960s, and shows of work both contemporary and historical abounded. It was not difficult to see a connection between what all these artists were doing and the look of the melting-pot city, which was itself a matter of contrasts and juxtapositions, of the knitting together of many variegated and even dissonant strands.

If the New York artists were dialecticians first and last— instinctive students of the histories of styles, which they spliced and diced, accepted and rejected—who can wonder that collage itself and the image of New York as a grand collage were so dear to their hearts? The city had been experienced as juxtapositions, overlaps, competing pressures for a hundred years, at least since Walt Whitman had sauntered the pavements and taken the ferry and watched all the faces, all the men and women who represented so many profes-

Rudy Burckhardt, stills from Climate of New York, *1949.*

sions, so many attitudes toward life. And the juggling act that Whitman used
to convey the city's cascading, churning variety had been echoed and built
upon in a whole variety of ways by Hart Crane, by Charles Reznikoff, by
Edwin Denby and Allen Ginsberg and James Schuyler and Frank O'Hara and
many others. Sometimes the city took on a surrealist tincture in the work of
the postwar poets, especially in certain poems that O'Hara wrote in the fall
and winter of 1960. O'Hara's Manhattan was as funny as "Ginger Rogers in
Swingtime," and the idea that the slant of the light on a church steeple on a
particular day might kick off thoughts of old Hollywood musicals told you
how hopelessly mixed up nature and culture had become. The city was a the-
atrical extravaganza, from the moon "gliding broken-faced over the bridges"
to the "reverential" windows of Tiffany's, where the diamonds were cleverly,
elegantly displayed among cobwebs or falling leaves. After walking along
Fifty-seventh Street, Frank O'Hara would write:

> 57th Street
> street of joy
> I am a microcosm in your macrocosm
> and then a macrocosm in your microcosm[2]

Quick switches were, of course, the stuff of collage, for inside and outside,
large and small, could be reversed by simply shifting the positions of a couple
of pieces of paper, by putting the scraps of newspaper here and the ticket stub
there.

Over and over again in postwar writing about New York, we find the city
described as a collage, a patchwork of startlingly variegated elements. We
have already seen Mary McCarthy considering what aspects of New York she
wanted to show to a European, how she hoped that the visitor would notice
"sukiyaki joints, chop suey joints, Italian table d'hôte places, French provin-
cial restaurants with the menu written on a slate, Irish chophouses, the Jewish
delicatessens"—a panoply of styles. And there was Harold Rosenberg's
description of Tenth Street, where everything was "one of a kind"—"a liquor
store with a large 'wino' clientele; up a flight of iron steps, a foreign-language-
club restaurant; up another flight, a hotel-workers' employment agency; in a
basement, a poolroom; in another, something stored." Rosenberg's essay,
published in 1964, echoed interestingly some lines from Saul Bellow's novella
Seize the Day, published in 1956, in which Dr. Adler, the father of the eternal
adolescent Tommy Wilhelm, sat in the hotel dining room on upper Broadway

and saw, across the street, "a supermodern cafeteria with gold and purple mosaic columns. On the second floor a private-eye school, a dental laboratory, a reducing parlor, a veteran's club, and a Hebrew school shared the space." And Ralph Ellison, toward the end of *Invisible Man*, published in 1952, gave the Harlem riots the weirdness of surrealist collage. He wrote of a man among the looters wearing "three hats upon his head," of the crowd rushing a store, and of "a fusillade of canned goods, salami, liverwurst, hogs heads and chit-terlings belching out to those outside and a bag of flour bursting white upon them." Hanging from a lamppost, the narrator saw what he first took to be a body "white, naked, and horribly feminine. . . . I whirled, still moving by reflex, back-tracking and stopped and now there was another and another, seven—all hanging before a gutted storefront. I stumbled, hearing the crack-ing of bones underfoot and saw a physician's skeleton shattered on the street, the skull rolling away from the backbone, as I steadied long enough to notice the unnatural stiffness of those hanging above me. They were mannequins—'Dummies!' I said aloud."[3]

Ellison's Harlem was an apocalyptic-nightmare collage, but collage was everywhere in the 1950s, to be discovered in the most ordinary of circum-stances. Speaking to dance students, Denby, de Kooning's old friend, wanted them to understand why it might be important to notice "the momentary look of the street, of 106th and Broadway." Although Denby never said in so many words why it was important for dancers to study their surroundings, he urged them to notice all the contrasts, because, for the New Yorker who cared about the arts, this was the basic lesson in how to see. Denby urged his listeners to turn their attention to "the sometimes extraordinary delicacy of the window framings, but also the standpipes, the grandiose plaques of granite and marble on ground floors of office buildings, the windowless side walls, the careful, though senseless, marble ornaments. And then the masses, the way the office and factory buildings pile up together in perspective. And under them the drive of traffic, those brilliantly colored trucks with their fanciful lettering, the violent paint on cars, signs, houses, as well as lips." The city was both more planned and less planned than any classical idea of composition would permit. The grid was too absolute to be the stuff of art, at least of art as it had been known. And against this grid there was the helter-skelter building, unplanned, abrupt, a crazy quilt of stuff—the streetscape with its unexpected relation-ships. A French composer whom Denby knew had commented on "the differ-ences in height between the buildings" and found that he had "never seen streets so diverse one from another."[4]

II

The fascination of collage, at least for artists, was twofold. Collage was almost the inevitable expression of democratic experience, of the constantly decomposing and recomposing experience of the city. Eulogizing his friend Romare Bearden, an artist whose collages added up to an intricate narrative of African-American experience, Ellison declared that "we are a *collage of a nation*, and a nation that is ever shifting about and grousing as we seek to achieve the promised design of democracy."[5] Bearden's work had a tapestried richness, an *Arabian Nights* complexity of color and pattern that came straight out of the jangling abundance of African-American culture. But as Bearden knew as well as anyone, collage was also a process that had a history *as* art, a history that stretched back at least to the beginning of the century and embraced various kinds of formal and thematic decomposition and recomposition, and had

Romare Bearden, Black Manhattan, *1969.*
Collage on paper and synthetic polymer
paint, 22½ × 18 in.

generated different, even contradictory styles—everything, indeed, from Surrealism to Constructivism. Collage was, in a far more visceral way than painting, a mirror of the city. But it was also a New York art form in which Old World ideas were turning into New World ideas.

By the early 1950s, there was a public in New York that understood that it was "artistic" to regard the world as a sort of grand collage. The designers Charles and Ray Eames were using photographic montages to create a brilliant toy, their 1952 *House of Cards,* a set of slotted cards emblazoned with photographic images of everything from pebbles and shells to folk art and straight pins. The Eameses were also beginning the long series of films and slide shows

Charles and Ray Eames, House of Cards, *1952.*

in which they would assemble all of the visual world into a kind of collagist's dictionary or encyclopedia. In 1954 the filmmaker Sidney Peterson was working at the Museum of Modern Art, among other things on a series of short films, under the rubric Point of View, designed to suggest how people approach the city, and perhaps done with an eye on some of the Eameses' work (they were also involved at the Modern, where they designed the first "Good Design" show in 1950). Two short films about New York—*Manhole Covers* and *Architectural Millinery*—were produced at the Museum of Modern Art, the second filmed by Peterson. Both opened with shots of the city from the museum's rooftop restaurant, and the narrator, Henry Morgan, suggested that the city was a kind of museum—a grand collage that New Yorkers were being taught to appreciate the way they might appreciate a painting. *Manhole Covers* urged people to look down, *Architectural Millinery* to look up. Both movies encouraged the walker in the city to pay attention—to examine familiar sights from unfamiliar angles, to play with the idea of taking elements out of context, to regard the design of a manhole cover or the top of a Victorian row house as a singular object, and to join that object with other objects and create one's own imaginative sense of the city.[6]

These films were examples of the Museum of Modern Art's educational outreach, and as such they reflected a widespread feeling that you could not do justice to New York if you regarded the city as a homogeneous image, knit together in the way an oil painting might be. If oil paint was tradition, collage was revolution, but of course the kind of painting that was done on Tenth Street was very much related to the revolution of Cubist collage, and so the connection between painting and collage was complicated, part of the loopy history of modern art. What further complicated this history after the war was the fact that the catalytic experience of Cubist collage had had as much impact on Madison Avenue as it had had on the artists at the Club. Paul Rand, who was perhaps the most sophisticated graphic designer of the postwar years, and had created covers for Wittenborn, Schultz's Documents of Modern Art series, and for Museum of Modern Art publications, was designing logos and packaging for IBM and Westinghouse and El Producto cigars, and had helped to give the most sophisticated ideas about abstract juxtaposition a powerful presence in commercial design. To define the limits of collage was almost to violate it. Collage was high art. It was also popular art. It could be two-dimensional. It could also be three-dimensional, as Picasso had first demonstrated when he began making sculptures of guitars out of bits of paper, wood, and sheet metal in the early years of the century. Collage, indeed, was too

Paul Rand, box for El Producto
cigars, 1953–54.

restrictive a term to define such a sprawling subject. A more expansive term might be that which the Museum of Modern Art took as the title for its 1961 survey of these developments, "The Art of Assemblage." In the catalog of that show, the curators explained that the term had been adapted from the writings of Jean Dubuffet, and also suggested the full range of terms that might be applied to this material: collage, papier collé, assemblage, *décollage* (said to be the opposite of collage), découpage, photomontage.[7]

In any event, after 1955 there was an upsurge—a sweep—of shows that attempted to articulate this history. The artists were hard at work, but the public was also obviously ready for this material. There was the "International Collage Exhibition" at the Rose Fried Gallery in 1956, and "Collage in America" at the Zabriskie Gallery in December of 1957, which then traveled to nine colleges and museums under the auspices of the American Federation of Arts. Meanwhile, there was a Schwitters show at the Phillips Collection in Washington, "Beyond Painting" at the Alan Gallery in 1958–59, "Out of the Ordinary" at the Houston Contemporary Arts Museum in 1959, and "Collage: Art in Scraps and Patchwork" at the Newark Museum in 1960. It all culminated with the Museum of Modern Art show in October 1961. Two weeks after "The Art of Assemblage" opened, another pasted-paper show opened at the Modern, this one "The Last Works of Henri Matisse." In these heart-stoppingly

Ivan Chermayeff, cover of catalog for
"The Art of Assemblage," 1961.

original cut-paper compositions, with their wildly curved and angled edges and their dashingly brilliant colors, Matisse carried the discoveries of his old rivals, Picasso and Braque, into a realm of jazzy distillation that could remind museumgoers of the streamlined visual spectacle of midtown Manhattan.[8]

III

To move through the city was to find that you were relating to an astonishing range of experiences. Places you went, people you encountered, pictures you saw, music you heard, the books and magazines you read: This variegated material suggested dozens of interwoven narratives, and the collagist had access to all of this. Surely no artist had a fuller sense of the possibilities than Joseph Cornell, who was forty-seven in 1950. He had by then been exhibiting his enigmatic, boxed assemblages for more than a decade, including a group entitled "Aviary," at the Egan Gallery in 1949, and, a year later, also at Egan, compositions that he gathered under the title "Night Songs and Other Works." Cornell, who understood as well as any artist the extent to which all the different styles and attitudes and values that existed in both time past and time present had a kaleidoscopic relationship in the city, wrote of the dialectical aspect of this experience in a diary entry in the 1950s. In thinking about the days that he spent in the used bookstores along Fourth Avenue, looking for books and prints and old programs relating to the men and women who had been involved with the nineteenth-century Romantic ballet, for which he had an obsessive fascination, Cornell came to believe that he was living in two periods at once. "By itself," he explained, "this material would have only a

Aaron Siskind, Cornell's installation "Aviary by Joseph Cornell" at the Egan Gallery, 1949.

static museum value—this nostalgia is given a dialectic or overtone from the modern interpretation."9 Contemporary New York was one side of an interpretative dialectic. The jangling, hard-edged city of the present was the thesis that gave a particular life and piquancy to the antithesis that was provided by the meltingly romantic expressions of the past.

Joseph Cornell was a slim, ascetic, and on the face of it apparently unassuming man. He was a loner, but then that has often been one of the best vantage points from which to contemplate a great city's giddy variety. In the midst of his days in Manhattan, where he visited libraries and galleries and museums and record shops and bookshops, Cornell would take a break for donuts and coffee in a Bickfords' or a Nedick's, and he probably didn't look all

Joseph Cornell, circa 1940.

that different from the rest of the middle-aged men who frequented those places. After a day in Manhattan, he would return to his modest house on Utopia Parkway in Queens. He had lived there since the 1920s with his mother, Helen, and a brother, Robert, who had cerebral palsy and whose care was in large part Joseph's responsibility. His father had died in 1917, when Joseph was an adolescent; he also had two sisters, Helen and Betty, who were married in 1929 and 1931. The house in Queens might suggest the lower middle class, but the reality of Cornell's family was closer to shattered gentility. Like the photographer Walker Evans and the painter Fairfield Porter (both of whose lives and careers crisscrossed Cornell's in a number of ways), Cornell had grown up in a cultivated upper-middle-class world, had gone to a good prep school (Andover in Cornell's case—and also in Evans's), and treasured as perhaps the last of his almost Edwardian youth the right to be quietly eccentric, to take a subtly ironic attitude toward a world that he observed with the friendly caution of a man who was glad to be here but also suspected that he was meant for another time and place.

Cornell's diary entries were filled with anxieties. He complained of neck pain; he was always relieved when he was able to observe that he actually felt calm. And at the same time, he had an aristocratic certainty that enabled him to move into the Manhattan world, to have significant friendships with Pavel Tchelitchew and Marianne Moore and to get to know favorite ballerinas, espe-

cially in his later years Allegra Kent, for whom Balanchine composed *The Unanswered Question*, one of his strangest creations, in which the woman, her body carried across the stage and turned this way and that by a phalanx of men, never touches the earth. By 1960, after Cornell had been considering the enigma of collage for nearly three decades, he had become, loner or not, a legendary figure in New York's bohemia. In "The Art of Assemblage," in 1961, there were fourteen works by Cornell, a number exceeded only by that of Schwitters. And the next year, the Whitney Annual, devoted to sculpture and drawing, had a special Cornell section, consisting of nineteen boxes. After his own fashion, he was becoming famous. He was an avant-garde icon, a figure out of another time and place who had read Susan Sontag's essay "Against Interpretation" and was glad to entertain the author in his Queens home.

Cornell was a beachcomber in the city, scavenging the used bookstores and print shops for the flotsam and jetsam of Europe and an earlier America, which had washed up on these shores. In his diaries he recorded his impressions of his days in the city, even as he was also eager to remind us that "these jumbles of scribblings on the spot and recollected are diametrically opposite to the natural unfoldment of the day." Cornell never lost a wary confidence that one associates with adolescents. He was always the man who was watching from the corner. Mirrors, glass, reflections were motifs in Cornell's diaries. These elements brought some of the entries close to the spirit of the boxes, where we look through sheets of glass, turn our head to see a side panel, find a slice of mirror. In the diaries, Cornell often saw two—or three—things at once, as a collage or montage. "Cappuccino coffee (Grand and Mott?) shot of workman in mirror & pendulum clock." The year was 1956. Whatever he might have thought about the "natural unfoldment of the day," his diary recorded an intricate indirectness. "Reflection of clouds over old buildings on Broadway in black painted plate glass on 4 Ave." The diary pages were filled with the jumble and layering of impressions, so much so that for Cornell, a day in New York City in the mid-1950s could also feel like a day in the mid-nineteenth century. In an entry from 1949, he described how he had bought a volume of Rilke's letters and went into a cafeteria for a snack. "Glass of weak iced tea and liverwurst sandwich on the balcony about 4 o'clock overlooking 42 and 3rd Ave. with its typical stream of motley N.Y. humanity this sunny afternoon—right against the window with a ledge where I could open the RILKE in unhurried leisure and enjoy it along with all the minutiae of commonplace spectacle that at times like this take on so much 'festivity'—a real 'happiness' here in the sun, although too nervous to do justice to the Rilke

text—a real glow in the lines of 'the Paris of Gérard de Nerval,' also the note to p. 103 re: poètes maudits including Marceline Desbordes-Valmore whose poems were recently enclosed by Hildegard Nohring from the Russian zone—the preoccupation with the crowds below formerly a morbid obsession in the infinity of faces and heterogeneity—in particular a black robed nun with a rope or chain conspicuous for lack of usual immaculateness and a real type of uniquely unusual encountered only in a city like N.Y. or the large metropolises."[10]

In Cornell's New York, time and place flowed, reversed, overlapped. In his imagination, the city was transformed into an urban pastoral—a city that was both in time and out of time. As he sat in a cafeteria in New York in 1950, Cornell's mind drifted to Paris in 1850. One might imagine that that would have made him seem like a distant, nearly irrelevant figure in the art world of the 1950s, and yet precisely the reverse turned out to be true. Of course the romantic-surrealist spirit of Cornell's boxes had its origins in a 1930s New York that had still looked almost abjectly toward Europe. And yet by the 1950s, Cornell was such a master of layered allusions that he could give post-war New York what the artists themselves regarded as a kind of memory picture, in which their raw romantic youth was simultaneously acknowledged and bid farewell. Cornell's boxes, these elaborate homages to a Europe that he himself had never seen—to the decrepit hotels where poets and painters stayed in the months and years that changed their lives; to the Pierrots and ballerinas who were heroes and heroines in the theaters with their red and gold décor; and to the youthful, impossibly beautiful Florentine aristocrats who had been had painted in the sixteenth century—were embraced in New York, not as idiosyncratically selected fragments of a lost world but as the essence of that world.

IV

Cornell belonged to a generation whose members, born in the first decade of the new century and coming of age when modern art and literature were gaining wide recognition, were especially conscious of the fissure between the nineteenth and the twentieth centuries. Cornell and de Kooning were part of this generation, but then so were tastemakers such as A. Everett "Chick" Austin, the director of the Wadsworth Atheneum in the 1930s and 1940s, and Alfred H. Barr, Jr., the founding director of the Museum of Modern Art, and the gallery owner Julien Levy, and Lincoln Kirstein, who had brought Balan-

Joseph Cornell, Untitled
(Soap Bubble Set)*, 1936.*
Mixed media, 15¾ in. high.

chine to America. The closeness of all their birth
dates is worth noting: Austin in 1900, Barr in 1902,
Cornell in 1903, de Kooning in 1904, Levy in 1906,
Kirstein in 1907. All of these men had a sense of the
grandeur of nineteenth-century art, yet they also
saw how that had been broken, and the idea of col-
lage, of montage, of recomposing broken materials
into a new order came naturally to them. If Cornell
and de Kooning sought to reassemble the fractured
pieces of traditions both modern and otherwise, so,
in their different ways, did these other men, who
regarded European modernism as a series of mon-
uments, or as a twentieth-century equivalent of a
Grand Tour. Cornell had ties to all these people,
and many of them, not unlike him, approached
modernism with the eye of an Edwardian connois-
seur. Barr included Cornell's *Soap Bubble Set* in the
pioneering "Fantastic Art, Dada, and Surrealism"
exhibition at the Modern in 1936. As director of the
Wadsworth Atheneum, Austin was the first mu-
seum director to buy Cornell's work. Kirstein sponsored *Dance Index,* a mag-
azine for which Cornell did covers and to which he also contributed special
issues devoted to material from his own collections. And Levy, who ran a
gallery in New York that spearheaded interest in photography and showed
Surrealist and Neo-Romantic painters, was Cornell's first dealer (as well as
Gorky's—who had been born not long after de Kooning, in 1905).

What Cornell shared with Barr, Austin, Kirstein, and Levy was something
deep, quite basic. While they had all embraced the modern idea that artistic
expression was lodged in the bones and muscles of style, they had not gone on
to conclude that art should therefore be all bones, all muscles. In fact, they
believed the reverse, namely that the essential unity of artistic expression
freed them to appreciate many different styles, so that Barr took an interest in
practically every modern form and Austin admired both the Bauhaus and the
Neo-Romantics. The history of art since the late nineteenth century was, in
short, a grand collage, a collage with an underlying consistency. This idea of
variety born of unity, of abundant invention born of classical fundamentals,
was the key to Hofmann's teachings, and could also help to explain the art of
George Balanchine. When Edwin Denby described the essential fascination

of Balanchine's ballets, it had something to do with a tension between over-
whelming variety and underlying unity, in that dances as different as a waltz, a
frug, and a minuet were each made up of movements that were in some sense
abstract, and yet each had "a character, a dance range different from the
rest."[11] Within the infinitely smaller compass of Cornell's boxes there was also
a panoply of styles, and that panoply achieved a coherence because Cornell
understood that behind all those styles there was the secret of an underlying
structural logic—some sense of significant form, some *Kunstwollen* that pulled
together divergent impulses.

In the 1940s, one outlet for Cornell's fascination with ballet was his
involvement with *Dance Index*, which was published in a small, squarish for-
mat and often drew on material from the Dance Archive that was then the
Dance and Theater Collection of the Museum of Modern Art. Cornell
designed covers for *Dance Index*, and, on several occasions, organized entire
issues; one dealt with Hans Christian Andersen's interest in the dance. For the
cover of a *Dance Index* devoted to a "bouquet of varia" related to Cornell's
fascination with the Romantic period, he took an illustration of the four great
Romantic ballerinas, Marie Taglioni, Carlotta Grisi, Fanny Cerrito, and
Fanny Elssler, and had it reproduced as a negative (a common reproductive
technique in the days before Xerox) so that the engraved black lines now reg-

Joseph Cornell, cover of Dance Index,
July–August 1944.

Joseph Cornell, cover of Dance Index,
March 1942.

Joseph Cornell, Untitled (Hôtel du Nord),
circa 1950. Mixed media, 18½ in. high.

istered as white.[12] Then he collaged together the page's essential elements—the vignette of the ballerinas, their names, the misspelled caption *Le Quatuor dansè à Londres*—and laid it out on a surface decorated with a fine figured pattern. The key operation here was the negative, and this was an essential dialectical process, a way perhaps of saying that, with all due respect to the nineteenth century, Cornell was no longer there, that these were modern times. You might say that Cornell was showing romanticism in reverse. Collaging was a way of analyzing and categorizing and rationalizing experience. In 1942, when *Dance Index* devoted an issue to Loie Fuller, the turn-of-the-century performer who used elaborate draped costumes and adventuresome lighting to create performances in which she incarnated, say, flames or butterflies, Cornell did a cover based on some sequences from a hand-colored 35mm film of Fuller that he had found on one of his foraging expeditions. Cornell presented these images of Fuller in her *Fire Dance* simply, in seven columns of nine each. Looking down the columns, you could feel the dancer moving. Then he broke the grid with two enlarged photographs, each occupying four units of the grid, to give a better view of Fuller. Fuller, with her fluttering costume, was the epitome of Art Nouveau; and Cornell organized her glittering effects into a Constructivist space, something that recalled the most pared down of Bauhaus designs. The coolness of the layout framed the feverishness of her dancing—the cover was romantic and classic, all at once.

Cornell was a romantic. But he also contextualized romanticism; he framed it and gridded it off. He was thus an intelligence, a poetic intelligence, moving dialectically through European culture, and his way of treating that world as an idol, a lost religion, answered some mysterious need in avant-garde New York. Cornell was uncategorizable. His fondness for grids and asymmetrical juxtapositions of vertical and horizontal elements placed him in the Cubist tradition. His Surrealist credentials were never in doubt. And no artist of Cornell's time expressed his feelings for the Old Masters more directly. He was especially drawn to images of young people in European art,

and you find in his boxes many reproductions of paintings of smooth-skinned child-aristocrats by Renaissance masters. Dürer's earliest self-portrait drawing, the image of a child-genius whose youthful features are tenderly and incisively described, appeared in a white-on-white box that dates from around 1950. Cornell's fascination with cracked, paint-incrusted surfaces and star- and planet-filled heavens can be seen as having its origins in Leonardo's comments about the peculiar images that one can observe on stained walls and in cloud-filled skies. Cornell's boxes are memory theaters, a personal way of packaging, of boxing, the past.

V

Cornell regarded collage as the essential expression of a sense of tradition, a sense of tradition that stood apart from the homogeneity of painting and connected with some of the anarchic, provisional, improvisatory elements in early photography and film. The world that you saw in those old photographs and films had a pastoral mysteriousness; it was the Golden Age of the modern world. For Cornell, who was perhaps more interested in nineteenth-century styles than in twentieth-century styles, there must have been a sense that the first great phase of modern culture had already passed, and that the early modern city where that culture had flourished was itself by now a museum. Cornell's nostalgia-tinged interests may bring to mind the essayistic meditations of Walter Benjamin, who in the 1930s was exploring the dramatic changes in the modern city and sought out the aspects of nineteenth-century life—old shopping arcades on the Right Bank of Paris, for instance—that remained as dissonant elements in the modern urban collage. "The street," Benjamin wrote, "conducts the flaneur into a vanished time."[13] While the moody, Baudelairean dialectic of Benjamin's writings was probably unknown to Cornell, the two men were being influenced by the same Surrealist books and images. A New Yorker would have little trouble believing that the Victorian era or the Romantic era was the childhood of modern man—and that the artist was now caught in some strange clash of historical styles. Looking at Atget's photographs of Paris, we are held, as Cornell was when he saw these images at the Julien Levy Gallery in the 1930s, by the immediate beauty of the artist's formal designs, but also by the pastness of the objects and vistas that his camera has preserved.

Cornell collected old films, and he occasionally showed them in galleries and other places. In January 1949, he organized an evening, including exam-

ples of Méliès and Chaplin, at Subjects of the Artist, a gathering place for
artists that was in some respects the precursor of the Club. Photographs were
always an important part of the collections of memorabilia that Cornell cre-
ated to salute the actresses he revered—he called these dossiers. And Cornell
made a fair number of films out of footage from old movies that he bought
from junk dealers; and in other instances he persuaded filmmakers, among
them Burckhardt and Stan Brakhage, to act as his cameramen, shooting films
that he directed around New York. A curatorial spirit was at the core of much
of Cornell's work, and like so many 1950s attitudes, this one had its origins
several decades earlier. There were affinities and echoes of Joseph Cornell's
interests in a number of other artists who started out then or were influenced
by artists who had. Walker Evans was fascinated by film as well as photogra-
phy, and was like Cornell a collector, in Evans's case of old commercial sign-
age. Burckhardt was a painter as well as a photographer and a filmmaker, and
he did a series of astringent still-life photographs of barren rooms with vistas
of Brooklyn that have a collaged-together quality. Cornell's sense of Victori-
ana as being the basement or attic of modern art was echoed in Evans's and
Burckhardt's interest in the architecture of the nineteenth century; for them
Victorian architectural ornament was what elaborate engravings were for
Cornell. Evans had contributed photographs to *Dance Index,* and he had also
received significant early support from Kirstein, who had encouraged his pho-
tographs of nineteenth-century architecture, which formed the core of the
first Evans exhibition at the Museum of Modern Art. Victoriana, itself an
eclectic style or maybe really a mélange of styles, was perhaps for that reason
a characteristic interest of the collagist; this interest wound back to Max Ernst,
and was continued not only in Cornell's work, but also in the work of the San
Francisco artist Jess, who did paintings as well as puzzlelike collages using
hundreds of scraps clipped from magazines, and was a friend of Brakhage's,
who worked for Cornell. Victoriana was also one of the fascinations of the
filmmaker Harry Smith, especially in his *Heaven and Earth Magic,* an hour-
long animated movie in which the weird figures and devouring giants were
often composed of fragments of nineteenth-century woodcuts and engravings
as well as some early-twentieth-century picture postcards.

Nobody can wonder that painting dominated the dreams of New York's
artists, because in the past several hundred years, this was the visual art form
that had achieved a surpassing richness and complexity. And yet by 1950 there
were people who were beginning to believe that you ought to take photogra-
phy and film every bit as seriously as painting and sculpture. At the Museum

of Modern Art, film and photography were both being exhibited as early as the 1930s, and everybody was familiar with European avant-garde magazines, such as *Cahiers d'Art,* in which photographs by Brassaï or Atget were mingled with paintings and sculptures. In February 1941, when Fernand Léger was at Black Mountain College, he lectured on the relationship between painting and architecture and showed his *Ballet mécanique,* the experimental film with its famous Charlie Chaplin marionette, which he had done in the 1920s. In Europe, Léger and a number of other artists had been arguing that the lines between painting and sculpture and graphic design and photography and film were all coming down, replaced by newer, overarching principles of collage and montage. And yet these fascinating linkages could also pose a danger, in that they made the various media seem deceptively alike. In painting, whatever an artist had experienced directly was constantly reabsorbed into age-old practices involving pigments and oils and brushes and the preparation of canvases. In collage, reabsorption was never complete, at least not in the same sense. Collage was not synthetic but syncretic. The four edges of the canvas framed a moment out of time. Film and photography and collage, because they were quintessentially art forms associated with modern times, were vulnerable to the passage of time, to the sense that a particular image or element was associated with what was only yesterday the present but was now the not-too-distant past. Cornell treasured that sort of sensation.

The spirit of the collagist was passive-aggressive to a large degree, a response to the world that both succumbed to the whirl of events and tried to reorganize it. As a filmmaker, Cornell pointed at things, and just left them to go on as they would. Yet the intentness with which he regarded the world changed things—slowed them down, magnified them. In the 1950s, when he did a series of films with Burckhardt, Cornell wanted the camera to function passively, to linger over the bare trees and playing children in Union Square Park. When Cornell and Burckhardt worked together on a film about Mulberry Street, Cornell felt that Burckhardt allowed the camera too much movement, too much of a willfulness. The Cornell-Burckhardt films that most truly reflect Cornell's view of things are *Aviary* (1955), filmed in Union Square Park, and *Nymphlight* (1957), filmed in Bryant Park. In both movies the park in the city—that place where our story began, with Hofmann and Mitchell meeting early in the morning—took on some of the quality of an enclosed dreamworld that you find in Cornell's boxes. In *Nymphlight,* we see a woman in a white dress running into the park, but aside from that flashing moment, both *Aviary* and *Nymphlight* have a quietistic, slow-moving poetry. The cam-

era holds nearly still, transfixed by these scraps of nature in the city. Cornell lingers on the trees, the birds, a fountain, the water in the basin of the fountain. There is an almost Japanese asceticism to some of the shots of birds in bare branches in *Aviary*. And, perhaps, a Monet-at-Giverny quality. The images never feel contrived. Cornell brings the neutrality of a newsreel cameraman to his shots of a person sitting on a bench, eating lunch or watching a child or just relaxing. He lingers over the most ordinary things. And the ordinariness melts into the silveriness of the images, takes on a mysterious dimension.

*Joseph Cornell and Rudy Burckhardt,
stills from* Nymphlight, *1957.*

There is another group of films, films that Cornell made from old movie footage, much of which he acquired from dealers in scrap materials, and here he pushed this idea of the passivity of the director to an unusually extreme degree. Like the cover full of images of Loie Fuller that Cornell did for *Dance Index*, the effect in the collage movies is hands-off but also Olympian, for although he has not filmed this footage of acrobats, of a children's party, or of a 1930s adventure movie, he is determined to control the way the images appear before us. *Rose Hobart*, from about 1936, is the most striking of the films, a nineteen-minute montage of scenes from George Melford's *East of Borneo*, a 1931 Universal Pictures production. Cornell has taken a conventional 1930s movie narrative, in which a woman, played by the delicately attractive actress Rose Hobart, goes to a fictional Indonesian principality, Marudu, to rescue her husband from the clutches of a mysterious prince who of course has designs on Rose—who is a phlegmatic beauty, a boyish ingénue. In the film, Cornell scrambles sequences from the movie, so that we are confronted with a shattered, warped narrative, composed of close-ups of Hobart's oval face, of brief encounters between her and the prince, of tropical foliage, of massing native crowds, of the vista through the prince's picture window of Marudu's huge volcano, perpetually on the verge of eruption. By replacing the movie's soundtrack with Brazilian nightclub music by Nestor Amaral and Orchestra, and running the images through a blue filter, Cornell

turns *East of Borneo* into a meditation on some of the appeal of old movies—
on the fascination that can be exerted by the faces of certain actors or the
exoticism of certain locales, even when the plot is a silly potboiler. Back in the
1920s, Léger had observed that the avant-garde film ought to "offer *imagina-
tion and play* in opposition to the commercial nature of the other kind of
film."[14] The idea was a dialectical one, and this is exactly what Cornell does in
Rose Hobart, except that he teases the imagination and play out of the com-
mercial film, achieving in the process a cool subversion.

In later years, Cornell worked on a whole group of films, composed of
found footage, to which he never gave definitive forms. There are scenes of a
rather awkward acrobatic act, with a man who balances stuff like a bicycle in
his mouth and a girl who hangs from a wire by her mouth and acts like a kind
of angel. The sequences in these collage films are presented without explana-
tion, so that Cornell simply seems to be telling us that this is some material
that appealed to him. In the scenes of acrobats, you feel his sense of the com-
edy of the absurd, and what saves the material from sentimentality is Cornell's
hands-off approach. He lets us linger over the literalness of the footage of
these illusionists, over the way that the rather primitive filming gives their
little acts of daring an everydayness. He
uses shots of a children's party, with an
old-fashioned apple-dunking. There is also

Joseph Cornell, stills from Rose Hobart, *circa 1936.*

some industrial footage, of liquid metals
being poured and sparks flying, which recall
work by a German modernist photographer
such as Albert Renger-Patzsch. Cornell pre-
sents images upside down or slowed down
to a crawl, or he repeats them over and over.
The films offer an abstraction or formaliza-
tion of kitsch. And yet there's more to it, for
Cornell not only collects images but also
ideas—ideas about childhood, cities, travel,
which in turn suggest the grand old ideals of
Romance, Spirit, Will, Growth. Film was a
modern medium that had absorbed much
of man's age-old obsession with ritual and
pageantry and spectacle. The avant-garde
film was shattered, reconfigured spectacle—
personalized spectacle.[15]

VI

In the 1940s, in the pages of *View* and other magazines, the mysteries of alchemy and the Kabbalah and other encoded systems of meaning had been enthusiastically embraced, as ways of linking the mysteries of modern art to some wider historical context. But in the 1950s, when painters for the most part came to regard all those crazily elaborate ideas as nightmares best forgotten, an almost fin de siècle esotericism reasserted itself in the margins of the art world—in Cornell's boxes, in the paintings and collages of Jess, who lived with the poet Robert Duncan in San Francisco, and in the wildly eccentric animated films of another Westerner, Harry Smith.

Jess, who was born Burgess Collins in 1923 in Long Beach, California, had studied with Clyfford Still and Edward Corbett at the California School of Fine Arts in the 1940s, and in his early paintings there was a sensitivity of touch and a fondness for muted, surprising color combinations that drew on those abstract artists. The pleasure of the play of materials was something that Jess never lost, whether he was building up oil paint into patterns of cake-icing thickness and luxuriance or composing elaborate collages. Jess labeled some of his early works "romantic" paintings, and writing of one of these, *Valerie: A Reminiscence,* Ashbery found himself thinking of "the blurred 1920s style of Pavel Tchelitchew or Christian Bérard, but what is happening? In the foreground a girl seems to be jabbing at a vase of flowers with a feather duster, while in the background a nude androgynous figure is aiming an arrow at the ceiling." A key group of oil paintings formed a long series called *Translations,* for each of these paintings was a reinterpretation of some image that had held Jess's attention. It might have been a nineteenth-century book illustration, an old family snapshot, or a photograph of his friend Duncan next to a set of the Zohar. Ashbery described these curious works as "literal translations of old illustrations and snapshots into a strange medium whose built-up pigment at first seems highly inappropriate and tinged with allusions (subversive, perhaps) to Abstract Expressionist and *matière* painting. But the neat, workmanlike transpositions ignore the anomalies of surface, as though a magic lantern slide were projected on a lunar landscape."[16] That lantern slide image was just right. It gave you the feel of the painting, but it also suggested connections with the prehistory of the movies. Jess's *Translations* gave a painterly importance to images that had an offhand or oddball significance, and the weight of

Jess, The Enamord Mage:
Translation No. 6, *1965.*
Oil on canvas mounted on
wood, 24½ × 30 in.

Jess's pigment became a way of mythologizing the oddball and even the merely ordinary. No wonder Duncan, writing about the *Translations,* gave these curious creations some of the swirling historical importance of the works in Malraux's *Psychology of Art.* "The whole sequence," he argued, "is a picture book, belonging . . . to the great primary tradition that extends from the illustrated walls of the Cro-Magnon man's galleries to the emblematic and magical art of the Renaissance and the revival of enigma and visionary painting in the Romantic movement."[17]

Jess and Robert Duncan shared a Victorian house in San Francisco that has come to have some of the legendary bohemian fascination of Vanessa Bell's and Duncan Grant's Charleston—or of Cornell's house on Utopia Parkway in Queens. And it was in the packed studio of this Bay Area home that Jess eventually stashed the old magazines and jigsaw puzzles from which he had begun, in the 1950s, to put together the compositions that he called his "paste-ups." "The paste-ups," Duncan wrote, "are assemblages, as the present world assembles itself in the congress of all its events and persons and things."[18] Jess's collages feel both terrifyingly shallow and infinitely expandable. The color is extravagant; it is glitteringly artificial, with the shrill blues and oranges of the halftone reproductions that Jess snipped out of the magazines melting together into an eerie shimmer. These are unsettling, paradoxical pictures. It is haunting how Jess juxtaposes inert figures for cinematic effect. Your eye zooms from pasted figure to pasted figure and from one odd event to the

next, until you are lost in the interpenetrating characters and anecdotes that are presented as a series of constantly shifting and reversing scenes-within-scenes. His homoerotic interests are reflected in the clippings of scantily clad figures from the popular magazines and the photographs of classical sculpture. Jess has vantage points on vantage points. The titles—*Hera Closing with Herakles* (1960); *The Chariot: Tarot VII* (1962)—hint at complex, encoded meanings.

Eastern religion and occult systems are also mixed up with the Victorian images and the modern collage techniques in the work of Harry Smith, a filmmaker who, like Jess, started out in Northern California in the 1940s, making short abstract films, often with geometric forms. Smith's flashing and jumping, appearing and disappearing shapes, laboriously hand-painted, have a comic purity that relates to elements in Kandinsky and to the reflected light compositions that Ludwig Hirschfeld-Mack created at the Bauhaus, and that were included in the Museum of Modern Art's 1938 Bauhaus show. By the late 1940s, Smith had hooked up in New York with Hilla Rebay, the curator of the Museum of Non-Objective Painting, later the Guggenheim, and received a grant from the museum and the use of a studio. The Guggenheim was of course devoted to Kandinsky, and Smith obviously shared some of Kandinsky's—and Rebay's—feeling for mystical, romantic ideas. Some of his abstract forms could be seen as animated versions of Hofmann's push-and-pull. What was remarkable about Smith's work during the 1940s was that the ideas weren't presented in a show-offy, amorphous way, as they often were in

Jess, Hera Closing with Herakles,
1960. Collage, 19½ × 23½ in.

the films of experimentalists such as Maya Deren and Sidney Peterson, whose symbolism was half-baked at best. Like Cornell, Smith contributed a particular kind of homegrown quality to modern ideas. He gave his romantic esotericism a personal stamp. And Smith's relation to New York could also suggest Cornell's. His friend Raymond Foye has recalled that "Smith mostly spent his days at various New York libraries, copying out alchemical manuscripts and studying occult philosophy." He haunted the legendary occult bookstores, and "was also a familiar character in jazz clubs. He would order a glass of milk and sit in the corner with his sketchbook."[19]

Smith's most important film, *Heaven and Earth Magic,* which he worked on from 1957 to 1962, is a dazzlingly elaborate Rube Goldberg contraption of a movie that floats along on a sea of esotericism—of kabbalistic history and ideas. *Heaven and Earth Magic* opens with two mummies framing a postcard of watermelons. One can see the themes of death and regeneration right here; but they are presented in an amused spirit, beginning with those mummies, then eggs, then crazily elaborate machines out of which pop fragments of figures. There is a Constructivist comedy to the elegantly collaged animation, with bits of nineteenth-century engravings put together to create amusing figures and brilliant comic jumps in scale and narrative activity. Smith loves the little figures doing calisthenics that you find in nineteenth-century health manuals; Cornell also liked them, and I wonder if Smith knew the homage to the dancer Serge Lifar that Cornell did around 1933, for the profile figure with his forward-reaching arms in that collage is very much like figures in Smith's *Heaven and Earth Magic.* At one point in the movie, a gigantic head begins to devour everything that Smith has created, and you feel the filmmaker ribbing his own creativity. And

Harry Smith, stills *from* Heaven and Earth Magic, *1957–62.*

when you find out that that gigantic profile is the head of Max Mueller, author of a book called *Kabbalah Unveiled,* it only makes the whole thing funnier. The esotericism is handled with a wink. As Smith clips and snips his collage bits and puts them together into mad conundrums, you feel that he is skating over the nineteenth-century material—or using it as a trampoline for his own imaginative flights.

VII

Esoteric forms of knowledge have had a special appeal for modern artists because they could provide a mystery or complexity that was otherwise felt to be missing in twentieth-century life, and these esoteric forms of knowledge were often most appealing when they were hyper-personalized, presented obsessively, paradoxically, so that esotericism became an especially stylized kind of individualism. Harry Smith's *Heaven and Earth Magic* has this quality; so does some of the work that Jess was doing in San Francisco; so do the paintings of cross-eyed grandes dames decorated with geometric emblems that John Graham, that old friend of de Kooning's, was exhibiting in the 1950s. Looking at Graham's paintings and drawings, you do not really know why there is a model of a dodecahedron placed right next to a particular woman, or why another woman's face is covered with a grid and images of suns and moons. And yet this seems to be the way it has to be for Graham, and you may feel that this is the only explanation that is needed.

No artist carried a personal brand of esoteric thinking to anything like the lyric heights of Cornell. The power of Cornell's art resides in a miraculous quality of simplicity that he managed to bring to his labyrinthine imaginings; he gave esotericism a contemporaneity by suggesting that these were the thoughts that might come to any twentieth-century man as he ambled the

John Graham,
Aurea Mediocritas, 1954.
Ink, pencil, and crayon on
paper, 16½ × 13⅜ in.

streets of a democratic city and gathered curious images and bits of information. Cornell's was a homemade esotericism, much as Clement Greenberg would later think of writing a book called *Homemade Esthetics*. Cornell's understanding of nineteenth-century ballet, of the city of Paris, of astronomy, both as science and mythology, was astonishingly deep and wide, and yet to him all of this was merely what a man might pick up here and there.[20] The novelist Donald Windham, who was editor of *Dance Index*, recalled that Cornell "never ceased to be amazed that so much he knew was unknown to me. He couldn't understand how someone who knew as little as I did could be the editor of a magazine."[21] This was not egotism on Cornell's part; it was merely a measure of how natural he felt the acquisition of knowledge was. He learned about the stars at Hayden Planetarium; he subscribed to the planetarium's publication, *Sky Reporter*. Much of his knowledge of ballet came from books checked out of the library, or from the things he happened to find in bookstores. And this gradual, informal accretion of a vast range of knowledge became a story unto itself, a personal myth that mingled with the mythology of the ballet, with the mythology of the stars.

The more you know about Cornell's thinking, the more his interests crisscross and interpenetrate. As is the case with most artists, his mind operated in an immediate, graphic way, and for him ideas such as romanticism were attached to the specifics of personalities, faces, biographies. He was in some respects the old-fashioned fan in relation to his romantic ballerinas, admiring Cerrito for her sweetness, Elssler as the most beautiful, Marie Taglioni as the most ethereal. Yet just as when Hans Hofmann used a color, he would be aware both of its immediate character and some larger import, some import that related to ideas about the meanings of colors, so for Cornell the ballerinas were connected to roles with metaphoric implications.[22] Cerrito was associated with *Ondine*, in which she played a sea crea-

Joseph Cornell, Homage to the Romantic Ballet, *1942. Mixed media, 4 in. high when closed.*

ture, and was, as Cornell wrote in his diaries, "something quite universal and timeless just by itself." Romantic ballet by its very nature went from the particular to the general—the particular ballerina became a generalization of a woman, became an idea and an ideal. For Tamara Toumanova, a ballerina Cornell actually knew, he wrote an imaginary scenario, *Nebula, the Powdered Sugar Princess,* in which the ballerina ended up, in the third section, "Aerial (The Milky Way)," being "transformed . . . into a constellation & clouds of fantastic shapes resembling swans, fish, ballerinas float by, meteors flash by in the distance. The bal[lerina] seems perf[ectly] at home with the heavenly bodies."[23] When Cornell was introduced, at the Julien Levy Gallery in 1940, by Tchelitchew to Toumanova and Balanchine, Tchelitchew explained that they were "Cerrito" and "Perrot," Perrot being the legendary choreographer who had worked with Cerrito, as Balanchine worked with Toumanova. There was no end to the looping mythologies that Cornell derived from his piled-high nuggets of information. And in his assemblages, he preserved the fluidity of these connections, their sense of propinquity, of serendipity. In the early years, his boxes were designed so that elements could be picked up, played with, held one by one, as in the 1942 *Homage to the Romantic Ballet,* which included seven plastic cubes that are like bits of ice.

Joseph Cornell, Untitled (Hôtel de l'Étoile), 1954. Mixed media, 19 in. high.

Cornell's works of the 1930s and 1940s had a bit of the feeling of pack-rat collections, with some of the brownishness of an Edwardian hobbyist's projects gone mad. But by the 1950s, he was able to achieve an extraordinary lightness. Within the circumscribed dimensions of the boxes, there was a sense of expansive possibilities—and a tendency toward increasingly abstract effects. *Untitled (Hôtel de l'Étoile),* from 1954, is one of Cornell's most enchanted visions. The interior, with its cracked white paint, is shabbiness distilled, so that the whiteness has a natural beauty, like snow crisscrossed with animal tracks, or the surface of the moon. At the left of the box, running top to bottom, is a wooden dowel that generates an architectural space with the abbreviated power of a bit of décor on an avant-garde stage. To the right, Cornell has stamped the white wall with a rendering in

black of the constellation Auriga, from a seventeenth-century engraving, as if it were a Baroque tattoo. At the very center of the composition, a fictive window reveals a vertical sliver of night sky dotted with paint-splash stars. And above that, in old-fashioned serif type, is the name of the hotel—one of those generic French hotel names that fascinated the stay-at-home Cornell. Each of the elements is inscrutable. Taken together, however, they begin to speak. In 1955, when Cornell showed several boxes containing the constellation Auriga at the Stable Gallery, a note on the announcement explained that this figure of Auriga, a man carrying a goat and her two kids in his arms, was "looked upon as a beneficent constellation, and the goat kids were believed to be on the watch to rescue shipwrecked sailors."[24] The promise of hope in that ancient image—as well as the touch of fantasy in the night sky—lends a welcoming flash of sentimental poetry to the stark, nobody-knows-you-when-you're-down-and-out decrepitude of the old hotel. *Untitled (Hôtel de l'Étoile)* is at once coldhearted and wistful, and that climate of feeling is Cornell's alone, at least in the annals of American art.

In Cornell's work of the 1950s, there was randomness and strict order, there were Old Masters and pinups and Old Masters as pinups and typography and geometry and birds and toys. All of New York, high and low, geometric and surrealist, was stuffed into his compartments. Sometimes a box would be divided into regular compartments, as many as thirty of them, filled with balls or glass objects, arranged in a perhaps irregular, contrapuntal pattern. And so Cornell spun a romance of abstract articulation, a distant dream of the discipline of Constructivism, a meditation on anonymity, or perhaps it was simply an apartment-building façade seen at night. Cornell could be seen as a Silver Age Malevich—a sentimental minimalist. This feeling for the poetry of near emptiness led Fairfield Porter to praise Cornell's "sense of how little is enough, like an actor's sense of timing or the Japanese sensitivity to the value of emptiness and the isolated object."[25] Thinking of the whiteness and the openness of the boxes of the 1950s, Cornell himself spoke of a "final distillation wherein the subject is almost lost sight of in a literal sense or glimpsed briefly in a doorway by de Chirico or a

Joseph Cornell, Untitled ("Dovecote" American Gothic), *circa 1954–56. Mixed media, 17 7/8 in. high.*

window by Apollinaire."[26] But perhaps distillation did not quite catch the tough urbanity of these silvery visions, for Cornell was always careful to introduce a complicated mix of partial and obstructed views, and thereby suggested the mind of a man who was capable of taking in a great variety of things. The freedom with which our eyes move around Cornell's boxes suggests the democratic spirit in which he acquired all this esoteric knowledge, suggests that Cornell felt free to emphasize this and de-emphasize that and damn what any so-called experts might say. The boxes are hyper-refined. But there is a binge-mentality eclecticism about them, too.

VIII

You might expect Cornell's delicate romanticism to have looked marginal in the postwar years, when there was so much emphasis on largeness of utterance and bold individuality. Yet there was Cornell, exhibiting at the Egan and Stable galleries, Abstract Expressionist strongholds. Cornell had five one-man shows in New York between 1949 and 1957, and a show at Bennington, another Abstract Expressionist stronghold, in 1959. In 1953 Robert Motherwell observed that Cornell "errs aesthetically more rarely than any of us," the "us" being the Abstract Expressionist crowd. And Motherwell went on to proclaim, in this appreciation prepared for a Cornell show at the Walker Art Center in Minneapolis, "So long as he lives and works, Europe cannot snub our native art."[27] Perhaps part of what Motherwell meant to say was that Cornell was the part of us that Europe would most easily comprehend, but the homage was impressive nevertheless, and the European connection was made all the more delicious because Cornell—like Wallace Stevens, another American aesthete—had never been there. John Ashbery put it this way: "This is the secret of his eloquence: he does not re-create the country itself but the impression we have of it before going there, gleaned from Perrault's fairy tales or old copies of *L'Illustration* or whatever people have told us about it." Cornell was the eulogist of a European civilization that was becoming dimmer as New York became more successful, for only the man who had never been to Europe could express what Europe would never again mean. Ashbery said that Cornell, like Pollock, understood a work of art "as a phenomenon, a presence, of whatever sort."[28] His boxes, chockablock with impure elements, achieve a pure emotion.

Cornell is one of America's surprises. And that surprise brings to mind Ralph Ellison's discussion, in the essay "The Little Man at Chehaw Station,"

of the relationship between art in America and democracy in America as hav-
ing to do with "a collectivity of styles, tastes and traditions." At the beginning
of the essay, Ellison recounts the warning that he received from Hazel Harri-
son, his piano teacher at the Tuskegee Institute. Ellison had been dressed
down by some other faculty members for a poor showing at a recital. And
Harrison, who had studied with Ferruccio Busoni, said to him, "You must
always play your best, even if it's only in the waiting room at Chehaw Station,
because in this country there'll always be a little man hidden behind the
stove." Chehaw, Ellison explains, was a "lonely whistle-stop" railroad station.
"There'll always be the little man whom you don't expect," Harrison contin-
ued, "and he'll know the *music,* and the *tradition,* and the standards of musi-
cianship required for whatever you set out to perform!"[29] This became the
starting point for a long essay about the openness of American culture, about
the country's unexpected imaginative riches, about the imaginative richness
of the many people whom you might not expect to have much imagination at
all. And in a sense, Joseph Cornell, going to the public libraries and museums,
browsing in the bookshops, eating in the coffee shops, and then going back to
Utopia Parkway on the subway in the evening, was the northern, big-city ver-
sion of that little man at Chehaw Station, who came out of nowhere and knew
the music, the traditions, the standards. The peculiarity of Cornell's boxes,
their inveterate, unresolvable eccentricity, has to do with the unexpectedness
of his knowing all of this, of his knowing about the ballerinas he had never
seen, about the constellations he had never studied in school, about the French
hotels he had never visited. He knew everything that he had never been
expected to know, and, living in that house in Queens, a place as unexpected as
Chehaw Station when it came to modern art, he found a way to incorporate all
of that knowledge in a grand, enveloping personal collage.

9. WELDERS AND OTHERS

I

David Smith is an alchemist. Whether he works with brand-new sheets of stainless steel or with the exquisitely forged iron tools abandoned in an Italian factory, he is a master of poetic possibility, removing materials from their ordinary contexts and giving them a metaphoric sizzle. Both Smith and Joseph Cornell, in their very different ways, offer lyric variations on life's hurly-burly. Their relationship with the city is so intuitive as to sometimes feel uncanny, and that feeling is only underscored when we consider that the very locations where they worked in New York had been given, well before they arrived, names that suggest the stamp of their personalities. Everybody who has ever thought about Cornell has noted the serendipity of his having lived on Utopia Parkway. As for David Smith, born three years after Cornell, in 1906, he had a similarly propitious encounter with a certain name in the boroughs of New York, this one on the Brooklyn waterfront, where the artist and his wife, the sculptor Dorothy Dehner, one day in the fall of 1933 came upon what Smith described as "a long rambling junky looking shack called Terminal Iron Works."[1]

Years later, in a memoir, Smith recalled that Dehner said, "David, that's where you ought to be for your work." "Next morning," Smith went on, "I walked in and was met by a big Irishman named Blackburn." Smith later named a sculpture after his friend: *Blackburn—Song of an Irish Blacksmith*, a meandering, openwork construction punctuated with circular forms like the notes on a page of music. Smith remembered saying to Blackburn, " 'I'm an artist, I have a welding outfit. I'd like to work here.' 'Hell! Yes—move in.' " Nine years later, when Smith had shifted his base of operations to upstate New York, not far from Lake George, and had built a studio, he "christened [it] the Terminal Iron Works—partly because *the change* in my particular type of sculpture required a factory more than an 'Atelier.' Partly because I had

David Smith, Blackburn—Song
of an Irish Blacksmith, *1949–50.*
Iron and bronze, 38¼ in. high.

already established credit thru the Terminal Iron Works in Brooklyn and
because I had become the Terminal Iron Works after [the previous owner] had
sold out the equipment and gone to work for a government agency. The last
year I was in Brooklyn, until spring of 1940 when I moved up to Bolton, I was
the Terminal Iron Works."² Who can doubt that Smith was playing with the
metaphoric possibilities of this name. "I am the Terminal Iron Worker," he
seemed to be saying, "I am the iron worker to end all iron workers." Just as
Cornell was the man who walked down Utopia Parkway, and found utopias
there.

Smith, who was born in Decatur, Indiana, was in many respects the oppo-
site of Cornell. Frank O'Hara recalled that "at a party or a *vernissage* in New
York he appeared a great, hulking, plain-spoken art-worker out of Whitman
or Dreiser, neither impressed nor particularly amused by metropolitan 'light
weight' manners, somewhat of a bull in a china shop."³ Physically large, with
an expansive and extrovert personality, he was an on-the-go sort, was known
as a good cook and a connoisseur of wines, and generally impressed people as
a larger-than-life personality. While Cornell never made it to Europe, Smith
had already been there in the 1930s. In Paris he was taken around by John Gra-
ham and worked in Hayter's print studio. While Cornell lived with his mother
and his brother, Smith married, divorced, then married and divorced again; in
photographs from the later years of his life, his two young daughters are often
playing amid the sculptures that fill the fields around his house near Lake
George. And yet for all the ways in which Cornell and Smith were as different
as night and day, they were both collectors and assemblers of found objects

who started out in New York in the Surrealist 1930s and who later, without ever exactly disavowing their Surrealist tastes for the unexpected and the serendipitous, became Constructivists or purists of a sort. There may also be a connection through the Julien Levy Gallery, where Cornell showed, for although Smith's name does not appear in the published lists of exhibitions, he wrote in his chronological memoir of having several sculptures there in the 1930s.

For Smith, as for Cornell, the romance of collage and assemblage was tumbled together with the spirit of place; both artists liked to imagine themselves as heroic figures in the grand collage of modern life. Cornell's journals may not have been intended for publication, but there was no doubt that when he put pen to paper, he was writing himself into the story of New York. And Smith, in his own, blunter way, liked to write about himself as a romantic figure in the city. When Smith was living near Lake George, he recalled how the Terminal Iron Works in Brooklyn "was surrounded by all-night activity— ships loading, barges refueling, ferries tied up at the dock. It was awake 24 hours a day, harbor activity in front, truck transports on Furman Street behind." Now living upstate, he enjoyed the quiet, but commented that he also enjoyed "the harbor lights, tug boat whistles, buoy clanks, the yelling of men on barges around the T.I.W. in Brooklyn. I sit up here and dream of the city as I used to dream of the mountains when I sat on the dock in Brooklyn." This world of which he dreamed was the world of Hart Crane—and of Walt Whitman as well. In a speech given in 1959, Smith said, "I now know that

David Smith at the
Terminal Iron Works in
Brooklyn, circa 1937.

sculpture is made from rough externals by rough characters"—not something Cornell would have said. But there was something of Cornell's fascination with the quotidian origins of his materials in the way that Smith observed that "the mystic modeling clay is only Ohio mud, the tools are at hand in garages and factories. Casting can be achieved in almost every town. Visions are from the imaginative mind, sculpture can come from the found discards in nature, from sticks and stones and parts and pieces, assembled or monolithic, solid form, open form, lines of form." And in a sort of poem, written around 1950, Smith evoked the influences on his work:

> the memory of 1 Atlantic Avenue, the odds on the wall,
> the ship's ventilators that hung from the rafters, the
> rusty rows of forging tongs
> the banks of hardies, the forging beds, the babbit ladles
> the stacks of buffalo horn[4]

II

For Smith, as for Cornell and many artists of their generation, the anti-naturalistic conjunction of unexpected elements was virtually a given, the lingua franca of the modern world. Smith always spoke with gratitude of his painting studies with Jan Matulka, a student of Hofmann's who, Smith said, had given him the "Great Awakening of Cubism."[5] And Smith was familiar from a relatively early age with the collage and assemblage that had been among the fruits of that awakening: with the welded sculpture of Picasso and Julio González; with Picasso's *Artist in His Studio* series, in which the criss-crossing black lines evoke wrought-iron sculpture; with Giacometti's light-framed assemblage *Palace at 4 AM;* and, perhaps, with works by Calder and Noguchi. Some of Smith's early sculptures, done in 1932 in the Virgin Islands, where he spent eight months with Dehner, were made of wood, shell, and wire. The works of the 1930s had a playful, experimental quality; the welded metal constructions represented men and animals and also landscapes, and sometimes these things were evoked more or less simultaneously. The variety of media and materials with which Smith worked could suggest a one-man kindergarten class; there were thickly worked mixed-media abstract canvases; there were painted constructions of wood and plaster, like studies for architectural follies. Smith was also interested in the traditional processes of cast metal, producing, at the end of the 1930s, a series of works called *Medals for*

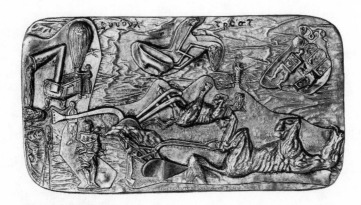

David Smith, Medal
for Dishonor: Food
Trust, *1938. Bronze,*
7½ in. high.

Dishonor, in which he surveys a world that was descending into war and fascism. These sharp, vehement, low-relief compositions, in which figures were juxtaposed with an almost collagelike syncopation, were done in a style that suggested Picasso filtered through the Mexican muralists. Smith brought reserves of sculptural delicacy to the *Medals for Dishonor;* they had a finespun gracefulness. The nightmare world was summoned up with a clarity that recalled Pisanello, whose medals, with their immaculate profile portraits, are among the most exquisite small sculptural works of the Renaissance.

In the 1930s, Smith was leafing through the pages of French magazines such as *Cahiers d'Art* and *Minotaure* and was learning about Cubism and abstraction and Surrealism at the Museum of Modern Art. He took it for granted that one would see collage, construction, and assemblage as part of a dense, hyperbolic climate of artistic experience. And as Smith matured as an artist in the 1940s, this brew only thickened. He was reaching for an increasingly florid, wracked imagery—a full-blown, gothicizing Surrealist mood, as if the onslaught of impressions could only get stronger and stronger, more and more sharply spiced. When Smith wrote about González in 1956, he associated the great Spaniard's modern style with Romanticism. "Thus Barcelona awoke to the romanticism of the age," Smith wrote. "Art Nouveau, the Gothic Revival, Wagner's music, Lautrec's presentation of Paris and the bohemian life, Maeterlinck's drama, the Pre-Raphaelites, and the climaxing monument to the new art, Gaudí's cathedral."[6] And surely Smith knew full well that some of that Romantic spirit, now distilled into cleaner, sharper, more thoroughly abstract forms, lived on in the art of the 1930s and 1940s. By the mid-1940s, in works such as *Home of the Welder* and *Pillar of Sunday,* you could feel the pressure of disparate formal vocabularies, of a kind of juggling competition of moods and modes. In *Welder,* Smith's studio was a hyperbolic dollhouse, a

corner with sculptures in progress, chains and stuff, and on the wall a drawing of a nude woman that recalled graffiti on the walls of the Terminal Iron Works in Brooklyn. In *Pillar of Sunday,* from the same year, the treelike construction held a sort of mermaid and a bird that might have been based on an American Indian image.

In these works we see the Constructivist or assemblagist sensibility in overdrive; there is almost too much to take in. Collage had become heated up, pushed into an ever more complex heterogeneity, an ever more dizzyingly intricate patchwork. In the work of the mid-1940s, Smith's style reached a high pitch of visual intricacy. And after that, something curious, perhaps unexpected, began to occur. Apparently the urge to meld everything together, when carried to such extremes, contained the seeds of a different impulse, of a search for the alpha of assemblage. The process of addition and multiplication began to reverse, began to turn into a process of subtraction and division, as if the collagist, having assembled his fantastical world, now wanted to anatomize it, to return to its constituent parts. This was yet another instance of the New York "No!"—of the impulse to contradict or foil any overly complex view of historical development. There was a desire to separate things out, to see things in isolation, not the whole pattern but the individual element. Smith's *Voltri-Bolton* and *Volton* sculptures, from the early 1960s, stood at the far end of this process. He had worked in Italy in the summer of 1962, at an old foundry, and when he returned to the United States, he brought what Clement Greenberg described as "a crate of massive old tongs, pincers, wrenches, and other tools."[7] In the series of sculptures that Smith began that fall, these elements appeared, often one per work, almost as isolated forms. He was picking out, one by one, the elements in the collagist's melt-

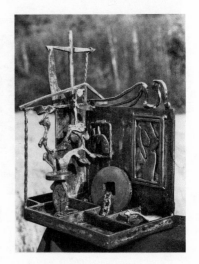

David Smith, Home of the Welder, *1945. Steel and bronze, 21 in. high.*

David Smith, Volton XII, *1963. Steel, 95¼ in. high.*

ing pot; he was seeing how the gestalt of collage had been arrived at in the first place. You can track a similar development in Cornell's work, in the increasingly simplified presentation that he gave to his found objects in his later boxes. And to understand this new need for simplicity and what it meant, we need to look back at the origins and even the ideology of collage.

III

"Material," Harriet Janis and Rudi Blesh announced in their 1962 book *Collage,* which traced developments from Picasso and Braque to the happenings that Claes Oldenburg was producing at the beginning of the 1960s, "is important in collage as in no previous art medium, because it *is,* it does not pretend to be." If the romance of painting was that it could be turned into anything—a landscape, a still life, a figure, an abstraction—the romance of collage was that each element remained exactly what it was, even as it could simultaneously become something else. "Traditional painting," Janis and Blesh explained, no doubt thinking of the work of the Old Masters, flowed straight "from the artist's vision and intent in semiliquid paint from brush to canvas where it might dry slowly into permanent form." Collage was very different, for it derived from Cubist painting, which "did not 'flow' in this way from artist's consciousness to canvas. Real appearances were broken up into parts and then, through an imaginative 'constructing,' were assembled in the picture."[8]

When Albers taught at Black Mountain College, he put a good deal of emphasis on the collaging together of found objects; he even singled out for praise a student who had managed to do something interesting with cow dung. Rauschenberg, who studied with Albers at Black Mountain, often acknowledged a debt to the older man, an artist best known for his purist paintings of squares within squares. And the impact in the United States of Albers and other former Bauhaus teachers and students gave the collage sensibility, with its emphasis on breakups and fortuitous connections, a slow-building power in American thinking about art, a power that would ultimately have explosive results. Albers had been speaking, since he taught at the Bauhaus in the 1920s, about collage as a way of finding new orders in art, new varieties of complementary forces. He complained that in the Renaissance, people "began to build facades entirely of one material, and garments . . . entirely in one type of fabric." That was a kind of unity from which collage provided an escape route. Albers spoke of finding new complementaries, not just red and green, but "bricks and burlap, glass and wax, aluminum foil and wool, cotton and thumb-

tacks."[9] For Albers, these complementarities involved oppositions of materials, but such complementariness could also be expressed in terms of the oppositions of styles within a medium (classic and romantic, say) or the opposition between several media (photography versus painting). Indeed, Léger, who made a brief appearance at Black Mountain College, where he was considered for a job, had in the 1920s written about the juxtaposition of objects in a modern shop window and said that this suggested the liberation of style from convention, a free commingling of complementary elements.

Matière *study done by a student in Josef Albers's class at Black Mountain College, using yarn, mica, and other materials.*

There was a paradox at the heart of any collage aesthetic, however, for even as the collagist was dealing with real stuff—with concrete materials—he was also creating an abstraction. This paradox gave collage its unstable, catalytic power. When Picasso and Braque, the founders of collage, pasted those first pieces of paper or oil cloth decorated with patterns of wood grain or caning onto a handmade image, they were beginning a development that ultimately led in two directions. The complicated Cubist game of naturalistic puns and metaphoric allusions functioned as a prologue to certain aspects of Dadaism and Surrealism, inspiring a whole range of startling juxtapositions and labyrinthine dreamscapes. Cornell was the outstanding American figure in this effort to look back at the nineteenth century with a collagist's eye, so that everything from the juxtapositions of the folk artists to the overstuffed arrangements of image and text in nineteenth-century graphics suddenly appeared fresh. This was one of the aspects of Cubist collage that Greenberg, in an essay called "The Pasted Paper Revolution," published in *Art News* in 1958, was at some pains to dismiss. He complained of "the traps of collage," of its decline "into montage and stunts of illustration, or into decoration pure and simple," while excluding from this criticism certain works by Schwitters, Miró, and Arp. What excited Greenberg about Cubist collage was the degree to which all the pressures and counterpressures of paper against paper, of color against texture, had a classical, architectural power that led the way to Mondrian and Constructivism. Greenberg wrote that the "point" of collage, "as I see it, was to restore and exalt decoration by building it, by endowing self-confessedly flat configurations with a pictorial content, an autonomy like that hitherto obtained through illusion alone."[10]

In the midst of such debates about the nature of collage, one artist who was on a lot of people's minds was Arp, an old modern master of collage who in 1958, at the age of seventy-one, was having a retrospective at the Museum of Modern Art. In the curving contours of his enigmatic, forceful shapes, purism and Dadaism were united, and there was a resolution of conflicts—a cool seamless wrapping up of all the confusions, a classical-romantic alliance. Decades earlier, Arp had shown what a beautiful thing chance could be when he made small scraps of paper, dropped them from some height, and then affixed them permanently in the places where they had fallen, and somehow ended up with images of a dazzlingly lucid balance and beauty. As Carola

Giedion-Welcker observed in the catalog of the Modern show, "Arp developed the severe—one might almost call it the classical—*collage* in 1916, in the very midst of the revolutionary Dada period." That was very interesting, this idea that so many things could be happening simultaneously. Giedion-Welcker saw Arp's work as related to "the other side of the Dada world, in which the focus was not only upon a condition of wild upheaval, but also upon a mystical world-view."[11] Arp's collages, with their elegance and randomness—their torn edges, their chance arrangements, and their absolute sureness of design— suggested the fortuitous commingling of several wildly divergent streams of modern art.

Jean Arp, Torn Paper Collage, *1932.*
Paper collage, 11⅘ × 9¼ in.

IV

Collage or assemblage has a distinctively architectural or at least architectonic dimension. The artist builds the image in something like the way a carpenter builds a house, except that the act of construction is for its own sake, an abstraction of the idea of putting things together. This idea of collage as epitomizing art's constructive dimension was a core belief of modern art, going back to the early Cubist works of Picasso and Braque, and it had been given a curious twist by Mondrian, during the early 1940s, when he was living and working in New York. As many artists were aware, from the reminiscences of people who had been in his studio and from some of his unfinished paintings, Mondrian had discovered in New York colored paper tape, manufactured by Dennison. And he had begun to use lengths of this tape as a means of "sketching" on his canvases, trying out colored lines and squares,

moving them around, studying them, moving them
again.

Janis and Blesh pointed to this practice in their
book *Collage,* writing that "in his last years, Mon-
drian used a collage variant to develop his classically
severe, rectilinear abstractions. He placed color tapes
on plain canvases, as shown in the painting *New York
City 2,* left unfinished at his death. . . . When finally
satisfied he painted actual lines in place of the
tapes. . . . He made true collages with removable
tape, then removed the tape before the final paint-
ing."[12] The tape was, for Mondrian, an artist's
behind-the-scenes technique, a rehearsal for a grand
performance that would depend on the time-tested
verities of oil paint and canvas. Yet that colored tape
of Mondrian's was also a found object, and to have
found and used that tape, available in primary colors
in New York, only emphasized a collagist element at
the core of Constructivism, or was it a Constructivist

Piet Mondrian, New York City 2
(unfinished), *1941. Charcoal and painted
paper strips on canvas, 45⁹⁄₁₆ × 39 in.*

element at the core of collage? Part of the gathering appeal in the late 1950s
and early 1960s of the hard-edged clarity of Constructivism was in the way
that it could strengthen an artist's impulse to say "No!" to the excesses of the
collagist's Surrealist-Baroque imagination—or to see the classical logic
behind Arp's Dadaist shenanigans. The Constructivist sensibility could by
now have the aura of an almost antediluvian modernism, and everybody was
far enough away from that period that there could be a pleasurable shock in
falling back into—or was it falling forward into?—the geometer's ABC's.

There was something unencumbered about Constructivism. László
Moholy-Nagy, the Bauhaus-trained artist who was now an influential teacher
in the United States, had declared that Constructivism was "neither proletar-
ian nor capitalistic . . . without class or ancestor."[13] Perhaps this explained
why there was a growing interest in Constructivism in New York in the late
1950s, an interest that was reflected in a number of shows that attempted to
play catch-up with this ancient modern history. The most interesting of these
was "Construction and Geometry in Painting: From Malevitch to 'Tomor-
row' " at the Galerie Chalette in 1960—a gallery, not insignificantly, that also
exhibited Arp. Chalette was a cool, modernist space, run by Madame
Madeleine Chalette-Lejwa and her husband, he rather professorial, she chic

with her dark hair pulled back. Galerie Chalette produced elegant catalogs, with a square format and clean typography. The one for the Constructivist show had a black cover, with the title printed in bold yellow and white lettering. Inside, there was a quotation from Apollinaire: "But it may be said that geometry is to the plastic arts what grammar is to the art of the writer." In her introductory remarks, Madame Chalette-Lejwa observed that the show "is an effort to review one major facet of abstract art which originated two generations ago and continues vigorously to this day."[14] Madame Chalette-Lejwa was concerned not only with clarifying history. She also wanted to make an important point about the present, insofar as she was demonstrating the persistence of geometric art in a time and a place where painterly painting was believed to rule. The American artist Burgoyne Diller, who had been a part of the New York scene since the 1930s but had not shown since the beginning of the 1950s, was now associated with her gallery, and he was regarded by many as the most persuasive of the Americans who had taken to heart many of Mondrian's ideas. In 1957, when the painter Pat Passlof organized the show at the Poindexter Gallery that presented the work that the New York painters had done in the 1930s

Cover of catalog for "Construction and Geometry in Painting," at the Galerie Chalette in 1960.

(it was the show for which Denby wrote his reminiscences of those years), paintings by Diller and Gorky were featured, side by side, near the front of the catalog, as if Gorky's biomorphism and Diller's purism, a purism to which he had remained steadily committed, were at the dialectical beginnings of the New York School, as thesis and antithesis.

By the time that Diller had his first one-man show in a decade at Chalette in 1961, there was a quiet but steady drumbeat of interest. In 1959, the young painter and critic Sidney Tillim had published an important exploration of the Constructivist tradition, called "What Happened to Geometry?" Tillim was glad to be able to tell his readers, who were probably by and large admirers of painterly painting, that Diller's art was not all smooth surfaces and razor-edged forms. Diller, like Mondrian before him, did casual preparatory sketches, which had loosely limned areas of color, and some of which even contained collage elements. "A great many of his ideas," Tillim wrote, "are

Burgoyne Diller, Untitled (First
Theme), 1961. Tempera,
crayon, graphite, and collage
on paper, 4½ × 4¾ in.

invested in extremely sensitive sketches which have to be seen to be understood as the purest distillation of the ambitions of an entire generation."[15] This pregnant phrase—"the ambitions of an entire generation"—was left to hang there in the air. Did Tillim simply mean that Diller was the best of all the geometric artists who had started out in the 1930s? Or was there something more to it? Was his work a purification or essence of the New York School's expressionist intensity, much as the black-and-white photography of New York might be said to be an essence of the city's vitality?[16]

Diller had been born in New York in 1906 and had taken part in the early activities of the American Abstract Artists group in the 1930s. He had co-directed the Federal Mural Project in New York, where he encouraged some of the first abstract murals done anywhere in the world. He taught at Brooklyn College for years. He kept a bit apart from the Abstract Expressionists, but he had always been respected by them; David Smith regarded Diller as a friend. He was a presence all through the 1950s, an attractive, self-contained man, the proverbial cigarette in his hand. In the 1950s Diller had built himself a studio in New Jersey, modern and severe in design, where he pursued, amid the American woods, the old modern European dream of an art of perfect ideal-ism in which all emotion was submerged in the pressures and counterpressures of nonobjective form. There was something in the anonymity of the Neoplas-tic style that rang true with this hard-drinking but handsomely composed man, a man who wanted emotion, but emotion under pressure. In place of Mondrian's strong yet skeletal structures, Diller offered a percussive boldness. And when Diller allowed his rectangles to float free, which he had been doing since the 1930s, there was a shudder of almost existentialist angst.

Visitors to Diller's show at Chalette in 1961 would have found, amid the relatively restricted vocabulary of right angles and primary colors, a wide range of expression. There were paintings with a few floating rectangles. There were paintings with a dense complication of small rectangular areas. And there were also twelve painted wood constructions. The work on display spanned three decades and did not suggest a linear development so much as an

Burgoyne Diller, First Theme, 1959–60.
Oil on canvas mounted on panel, 50 × 50 in.

alternation between several modes or moods. Diller himself provided, in the exhibition catalog, a diagrammatic overview of his work and suggested that simplification and complication were not points in an evolution so much as they were manifestations of variegated human impulses. In the two pages from Diller's notebooks that formed the catalog introduction, Diller observed that "the work presented—from 1933 to 1961—has not been developed on a basis of regular progression from one stage to the next—rather it could be best expressed by saying—Tangential development based on three visual themes." Diller's three themes contained an ever increasing number of elements. The first-theme paintings consisted of free-floating elements, and generally only a few of them. In the second-theme paintings, there were "elements generated by continuous lines." In the third-theme works, "elements [were] submerged in activity" for an effect that was reminiscent of Mondrian's *Boogie Woogie* compositions. Diller's themes did not evolve one from the other so much as they kept appearing and reappearing. In one diagram, he suggested that the first and third themes were thesis and antithesis. He called them the "extremes," and between them one found the second theme, not exactly a synthesis but a sort of mediating position.[17] There was less a stylistic evolution than a movement between a variety of stylistic possibilities, a cycling among some varieties of Constructivist experience. It may at first have seemed odd that this vision, in which simplification and complication were perpetually present possibilities, should have been derived from Mondrian's art of radical simplification, but of course Mondrian's own later development, especially when he was in New York, had confounded certain fixed ideas about the evolution of modern art, for after reaching a point of absolute reduction in some works of the 1920s, he had moved toward increasing complication and even, in his latest works, a naturalistic rhythmic pulse.

Diller was not the only artist who now saw Mondrian's achievement as suggesting a tradition within which one might find some personal form of expression—some way of reinventing the harpsichord. By the early 1960s,

Burgoyne Diller,
Third Theme, *1946–48.*
Oil on canvas,
42 × 42 in.

Ilya Bolotowsky, another American painter who had admired Mondrian since the 1930s, was bringing a vast range of colors into the universe of Neoplasticism, with its rectilinear forms and search for symmetry within asymmetry. In 1963 Bolotowsky painted a narrow, immensely long mural for the entrance to a movie theater on the East Side, a work two feet by forty-five feet that snaked along a wall like an unwinding roll of film, unfurling a roller-coaster ride of jittery rectilinear forms, evolving from deep purples and blues through oranges and yellows to deep reds. The rhythmic dazzle of Bolotowsky's work of the late 1950s echoed *Broadway Boogie Woogie,* as did Diller's *Third Theme* compositions. But Bolotowsky's work had a delicate sparkle that was his alone, with its dizzying color and syncopated juxtapositions of skinnier and heavier rectangles, and white and black shapes kicking off a counterpoint of abstract chiaroscuro. Like Diller, Bolotowsky saw Mondrian's Neoplasticism as a style with a logic that eluded the forward march of time. In an essay published in the late 1960s, Bolotowsky worried about the application to art of "too mechanical an historical approach, with its nineteenth-century idea of progress," because it "may . . . be responsible for the 'tradition of the new' and the resulting idea of 'obsolescence in art.' " Bolotowsky complained about the tendency "to search for a monolithic, one-goal development among

Ilya Bolotowsky,
Vertical Oval, 1956–57.
Oil on canvas,
45¼ × 35¼ in.

our more important artists, as a sign of their greatness. The nature of the creative process is quite different."[18] The monolith might have its value, but only as a mode among modes. Bolotowsky's magnificent achievement, which stretched from the 1930s all the way to his death in 1981, brought a delicate, powerful, revivifying, and at times almost rococo variety to the austerities of the Constructivist world.

For Bolotowsky and Diller, Neoplasticism was a vocabulary, a discipline, a tradition, and an artist could find his own kind of freedom within that. They wanted to explore all the possibilities of this tradition. Bolotowsky, like Diller, made three-dimensional constructions, in his case columns that he painted with compositions that echoed those of his paintings. By the 1940s, Diller had developed what Philip Larson, the curator of a show mounted after his death at the Walker Art Center in Minneapolis, called "a quasi-collage method." "To begin a painting, he drew a charcoal grid on the canvas and decided on color areas by pinning strips of construction paper. After considerable cutting, shuffling, and even painting the strips before removing them, he began to work directly on the canvas. Each strip was replaced by a painted area and in many unfinished works colored paper tags were left attached to the surface." Sometimes, for his largest paintings, Diller used large sheets of black tag-

board.[19] To work in this way was to recapitulate the early methods of Picasso and Braque, with their sheets of paper, and thereby to turn their revolution into a tradition. To cut elements and move them around was to affirm a modern tradition, a tradition that now ran parallel to that of painterly painting. But of course Diller was acknowledging not only the essential link back to Cubist construction, but also the link back to Mondrian's last years, when he was composing his love poems to New York City with those bits of colored tape.

While it was in the *Third Themes,* with their wild pileup of tiny rectangular areas, that Diller most self-consciously evoked Mondrian's New York, the *First Theme* paintings, from the years around 1960, may well count as Diller's tenderest and most powerful compositions. A real beauty, reproduced full-page in the catalog of the Chalette show, contains four rectangles on a gray ground; there are two vertical rectangles, one of yellow, one of white; a blue square; and, in the upper right, a black horizontal. Diller's rectangles floating in a sea of grayness or blackness are broad and yet somehow impalpable—Constructivism transformed into a magnificent shadow play. His surfaces are very thin, very shallow. His primaries don't have Mondrian's pizzazz; they can suggest the quieter richness of pewter surfaces. And yet everything is boldly conceived. The few big forms have a tremendous authority. And the contrast between the boldness and the mutedness creates a mysterious loveliness that is Diller's alone. The 1961 show was Diller's great New York moment. He died four years later. Many of the works that he completed after the Chalette show, larger and more implacably symmetrical than the paintings from around 1960, were overly streamlined—dishearteningly sleek. At Chalette in 1961, the dry impersonality of Diller's surfaces still had a delicacy, a quality of discretion offered not as an attitude but as an achievement. Diller's modestly painted surfaces were a self-assured man's response to the endless juxtapositions of a city where experience was always leaping from the arithmetic to the geometric, where a person was constantly registering the pressure of body against body and man against architecture. He embraced the grand collage of the city, but as a memory rather than a reality.

V

If Diller's show at Chalette in May 1961 was to be the most widely admired appearance by a Constructivist artist of the Abstract Expressionist generation, those were also the years when Ellsworth Kelly, the most widely admired artist

of the next generation to take an interest in the Constructivist tradition, was
beginning to be known. Kelly was in the Museum of Modern Art's "Sixteen
Americans" in 1959, and he had his third and fourth one-man shows at Betty
Parsons in 1959 and 1961. Kelly, who was born in 1923 in Newburgh, New
York, had come of age as an artist between 1948 and 1954, when he was living
in France, and his development there and then back in the United States is one
of the clearest examples that we have of an artist finding his own way to
embrace the future through an immersion in the past.

Photographs from the Paris years show a young man with a shock of light,
curly hair, who exuded the offhand confidence of an all-American boy. For six
years, most of the time supported mainly by the seventy-five dollars a month
that he received on the GI Bill, this kid from upstate New York walked the
streets of Paris and explored the city's museums, went off with friends to
spend weeks and months in Brittany and along the Mediterranean coast, vis-
ited cathedrals and everything else he could around the country, and was
apparently bewitched by much of what he saw. This included not only the
masterworks of ancient and modern Europe, but also the little things that logic
tells us are trivial but that nonetheless hold the attention of an American in
Paris: the stains and irregularities on old walls, the patterns of modern iron
grillwork, the piled-up café chairs, the profusion of posters in the Metro.

Kelly made drawings of many of the things that
he saw; occasionally, he photographed them,
too, as aide-mémoire. And in those postwar
years, when modern art still cast its cool bril-
liant glow, when Matisse was cutting figures
out of blue-painted paper and Arp was carving
white marble into enigmatic classical nudes,
Kelly managed to transform the picturesque
details of French life into a unique, elegant, and
ascetic kind of abstract art. He chased collage
back to some of its essential sources and possi-
bilities, in Braque and Arp and Dada. And all
of this curiosity had its Silver Age or pastoral
quality, its sense of immediate experience being

*Self-portrait by Ellsworth Kelly, at the
Hôtel de Bourgogne in Paris, 1949.*

Ellsworth Kelly, Saint-Louis II,
1950. Oil on cardboard
mounted on wood, 22 × 39¼ in.

distilled through the artist's allegiance to an idea that is just out of reach, just offstage. Kelly was an admirer of Monet's *Water Lilies;* in 1952 he painted *Tableau Vert*, a small composition that was nothing but a surface of wavering, quivering green brushstrokes.

Kelly's art was the art of the flaneur, but of the flaneur who was immersed in his own empyreal imagination and distilled each fragment of the world into an exquisitely enigmatic form. Looking at the grandest of Kelly's early abstractions, you are probably not aware that the kernel or germ of many of these images was a fragment of the man-made world, for the found object has been given a new significance, at once forthright and arcane. *Saint-Louis I* and *II* (1950) are constructions in low relief. Kelly had taken an interest in the unprepossessing look of a wall on the Île Saint-Louis, a wall whose surface was subdivided into rectilinear units by a few incised lines. Years after he had completed these cool, serene works, Kelly photographed the actual wall that had inspired them, and when we turn from the reliefs to the photograph, we can see how Kelly, by adapting the marks on that wall, generated the structure of his work. Yet the reliefs, while derived from perception, don't ultimately seem to have anything to do with the world around us. The suppressed, almost covert relationship between the artwork and its quotidian subject gives these images their quietly equivocal power. The experience of nature is masked as it is given an abstract force, so that these reliefs turn out to be about something as bravely, thoroughly abstract as the idea of filling space without filling it. The collage or construction, far from being the metaphysical lost-

and-found that it was for Schwitters or maybe even for Cornell, becomes a site on which the found object, in this case the Parisian wall, is lost as it is transformed into a work of art.

Saint-Louis I and *II*, with their white-on-white purist look, are triumphs in a mid-century neoclassical mode. In *Saint-Louis I* the wooden surface is ornamented with a few straight lines, many in a gun-metal blue and an orange. In *Saint-Louis II* there is no color, only incised lines, suggesting a façade and the outlines of a few mansard roofs. You feel the pressure of an architectural and urban metaphor, and yet what holds you is less the subject than the delicacy with which Kelly uses incised or painted lines to mark off space and to create a beguiling play of shadows. Kelly had admired an Egyptian First Dynasty stele in the Louvre, with a bird standing atop a sort of temple, and you recognize how attuned he is to the refinements of Old Kingdom carving. The cast shadows on the low relief of *Saint-Louis I* and *II* have a cool elegance; we enjoy the way Kelly manages to tease a slow-building dynamism out of what at first feels like an almost static situation. The *Saint-Louis* reliefs don't recall anything in nature so much as they echo a whole Constructivist tradition—of works by El Lissitzky, Moholy-Nagy, Arp (whom Kelly knew in France), and his late wife, Sophie Taeuber-Arp (whose work Kelly saw at Arp's). And yet what these works may finally reveal is the paradoxical impurity of that tradition, for Kelly's supple Constructivist vision suggests no grand design but rather an impassioned distillation of personal enthusiasms.[20]

Kelly's abstractions are based on the urban or suburban scene; they're abstractions of man-made forms, which are abstract to begin with. What I believe is the best single work that Kelly did in those years, a folding screen made of nine narrow vertical panels, called *La Combe II* (1950–51), derives from a drawing of shadows on a staircase. Those shadows register as the ghost of the flaneur—the record of a journey up those stairs. In a pencil drawing done on the spot—and in a photograph taken around the same time—we see how the shadows are broken by the steps, so that a single shadow appears as a sequence of shadows, and we can still see all this in the screen and in a related group of paintings. The shadow shapes are singular and curious and strangely beguiling. In *La Combe II*, Kelly uses the Olympian impersonality of oil paint to give these jagged, angled "found" forms a freestanding beauty. If we think of nature as the thesis and the drawing as the antithesis, then the painting, in brilliant black and white, is the synthesis. The painting has its own kind of life. Kelly bounces off reality; he transcends it. *La Combe II* is stark, lyrical, compelling—an army of jaggedly angular lines parading across an expanse of

Ellsworth Kelly,
La Combe II, 1950–51.
Oil on wood,
nine panels,
each 39 × 5³⁄₁₆ in.

white. There is an extravagance, cheerful yet chaste, about this painting. The forms make a pleasantly clattering kind of visual noise; the composition suggests the clang-clang of feet on metal stairs, or the clickety-clack of falling dominoes.

VI

The mysterious power of Ellsworth Kelly's early paintings reflected not what the man had seen but what he had seen fit to do with it. This was a very controlled kind of art, and there was no lessening of control when, during his Parisian years, Kelly created compositions based on ideas of randomness or chance. Of course chance always played a part in his work, for to draw shadows was to give an artistic inevitability to "accidental" shapes, and to base an abstract painting on such a drawing was to allegorize chance. The very idea of the found object was a celebration of chance, considering how much dumb luck was involved in finding this thing or that thing. But Kelly, who like every flaneur was a connoisseur of accidents, wanted to go further and explore what you might call the essential nature of chance. He was surely encouraged by the thinking of John Cage and Merce Cunningham, who in 1949 were in Paris and met Kelly, and they all wandered through the city together. Behind the art-and-life discussions that we know these three men were having at the time,

Ellsworth Kelly, Meschers, *1951.*
Oil on canvas, 59 × 59 in.

Ellsworth Kelly, City Island, *1958.*
Oil on canvas, 78 × 57 in.

there were the Dadaists' and Surrealists' experiments with chance. And for Kelly there may have also been a feeling that chance was an aspect of art's essential enigma, and that the qualities that hold us in a work of art are always chancy, open to widely and wildly varied explanations. When Kelly cut up a drawing or collage into rectangles and then randomly reassembled them in order to make a painting such as *Meschers* (1951), an astonishing labyrinth of oddly interlocking forms, he was putting parameters around accidents, he was controlling the uncontrollable. It was all very Parisian, this idea that anything goes just so long as certain conventions have been taken into account. In some of Chardin's paintings, a young man builds a house of cards or blows a soap bubble, and we're confronted with pictorial structures that are absolutely solid even though they are based on the most ephemeral experiences.[21]

The elegant astringency of Kelly's work of the early 1950s grew out of his sense of being absolutely free of classic Constructivism (he was the modern American boy) even as he obviously could not exist without it (he was the American boy in love with Europe). Beneath the beautiful, impassive surfaces of Kelly's paintings, a struggle was simmering, between the Old World and the New World of modern art. To be in Paris in those years was to live between two worlds, and Kelly did something with that paradoxical position. When he came back to New York in 1954, it was, he later said, in part because he was fascinated by what he had read about an Ad Reinhardt show at Betty Parsons. He found a place to live way downtown, near Coenties Slip, where Agnes Martin and Jack Youngerman and others also found lofts. From Dutch times until the 1880s, Coenties Slip had been a deep canal that ran to Fulton Street and

offered a landing place for sailing ships. The abandoned lofts around the Slip that artists began occupying in the 1950s were redolent of many New Yorks, especially the mercantile New York of the nineteenth century. As soon as Kelly moved down there, images of the city by the sea began to sift into his work, though of course always in a transformed, hidden way.

If Kelly's Parisian work could be regarded as an abstraction of Baudelaire's Paris, his New York work was an abstraction of the city of Melville and Whitman, suffused with the sharp radiance of Manhattan's bridges and rivers and skies. The shadows and reflections were clarified, turned into signs and enigmas, abstract designs with a naturalistic underside that was their Dadaist secret. Many of these canvases, with their elegant symmetries that suggested animation-within-stasis, were like semaphore flags conveying mysterious messages. Writing in 1962, Lawrence Alloway observed that "Kelly's taut displays are both simple and involved, like armorial bearings." Alloway went on to speculate that just as "heraldic insignia announced status and honors," so "in Kelly's earlier work the city was used analogously to the social code stylized in heraldic conventions."[22] The shapes in Kelly's New York paintings were larger and simpler than the shapes in the Parisian paintings, and that made them a perfect emblem for the brash spirit of the new city of art. *South Ferry* (1956) is a two-panel work in black-and-white, with singular, symmetrical forms joined to create a shape like a mysterious mausoleum. *City Island,* from 1958, is a yellow quatrefoil on a white ground, like a flower whose petals are opening up right before our eyes. The paintings are the genially mysterious emblems of an artistic society—a society called the School of New York.

In 1956, Kelly received a major commission, for a mural some sixty-five feet wide, made of aluminum panels mounted on horizontal rods, for the Transportation Building in Philadelphia. *Sculpture for a Large Wall* is a panoply of four-sided, anodized aluminum forms punctuated by a few panels in

Ellsworth Kelly,
Sculpture for a Large Wall,
1956–57. Anodized aluminum,
136 in. high.

deep, pungent colors. It is a powerful yet serene thing. Some of the panels have convex or concave sides, others have angled sides. Arranged between two rows of metal rods, Kelly's forms have a tipped forward-and-backward, folding-and-unfolding adventurousness that recalls *La Combe II;* it is almost as if Kelly has returned the staircase from his photograph to its original three-dimensional state. *Sculpture for a Large Wall* is a play of related forms with a musical lilt and drive. Purity and accident, unlikely yet impassioned allies from the early days of Cubism, are here mingled with a spontaneity that makes this audacious abstraction one of the finest works of public art created in twentieth-century America.[23]

VII

An artist's estimate of what counts in the past always doubles as a view of the future. There are those who are reluctant to linger on Kelly's ties to Arp or Constructivism, as if that would reduce the value of what he did, and yet looking back, like looking forward, is an action that must be judged by the quality of the artist's attentiveness. I would argue that Kelly is an artist with far more force and weight than, say, Louise Nevelson, who first exhibited wall-sized black-painted structures of boxes filled with assemblages of found wood in the late 1950s. And I would further argue that this is not because Kelly plays faster or looser than Nevelson with the old Constructivist or assemblagist

ideas; the point may in fact be precisely the reverse, namely that Kelly goes further back, digs deeper.

Nevelson had been doing black-painted wood constructions for a number of years, but her *Sky Cathedral,* exhibited in the late 1950s, was unimaginable without Cornell's increasingly geometric boxes. This was a Cornell box exploded to the size of the wall and given a cooler, more formal character. Nevelson gave us a fractured kind of architectural gingerbread, a crushed Victoriana; but hers was a mild, all too stylized nostalgia,

Louise Nevelson, Sky Cathedral,
1958–59. Wood, 98½ in. high.

without Cornell's obdurate radicalism. There was an underlying decorative instinct to Nevelson; her junk constructions had their elegant distinction, but they strike me as ultimately describing far too safe a New York synthesis of found objects and geometry. For Nevelson, the junk heap seemed to have a vaguely emblematic character. She squinted and saw in her demolition site the tomb of an Egyptian prince or the glorious sediment of some civilization or other. She might have agreed with Smith, who wrote in his article on Julio González that "you can find more art in paper scraps than in crafted gold," but she did not find enough there, and she had a habit of deciding to change scraps into gold, literally so in the gold-painted wood sculptures she began producing around 1960. Her symbolist ambitions, her suns and moons and skies, feel like a slightly remodeled version of 1940s Neo-Romanticism; she didn't dig as deep into the symbolic or emblematic or historical possibilities of the assemblagist's scrap heap as either Cornell or Smith.

Smith, in his essay on González, published in *Art News* in February 1956, the month when the first United States show of González's work opened at the Museum of Modern Art, emphasized the rootedness of the welding technique in the particulars of a time and a place. "Critical accent has been placed upon who was first in iron or welding. This speculation is no more valid than the Renaissance oil paint controversy. González was an apprentice in his father's shop, his work with metal starts in childhood. It is not innovation that makes art but inspiration."[24] What had by 1960 come to seem the most typical of modern sculptures, the openwork metal construction, had its origins in the iron-mongering tradition of Catalonia, in the love and care given to the creation of gates, balcony railings, tools, and hardware. This crafts tradition had infused workaday functions with a beautiful artisanal power, and now, when iron-mongering was as much about an artistic vision as sculpting with clay, sculpture was no longer a stone volume in the landscape, but a metal arabesque, an Iron Age gone pastoral. If sculpture had begun with a man taking a rock and standing it upright, the new sculpture had to do with taking a piece of iron and silhouetting it against the sky. Among the younger artists who were beginning to make reputations for themselves in New York in the 1950s, Richard Stankiewicz was king of this pastoral genre. As Ashbery said, he was the "Audubon of junkyards," the man who, in the terms of Hess's description of de Kooning shuttling back and forth between Long Island and Manhattan, might look out the window of the New York loft and see the truck with the scrap iron and the mattress going by, and think of doing something with that.[25]

Born in 1922 in Philadelphia, Stankiewicz had grown up in Detroit, been in the service during the war, and arrived at the Hofmann School in 1948. In 1950–51 he was in Paris, where he studied at the ateliers operated by Léger and the sculptor Ossip Zadkine. He was, like Kelly, going back to the sources of modern art. Returning to New York in 1951, he made a living through most of the decade as a freelance mechanical draftsman, working for patent attorneys whose clients included Buckminster Fuller. At the cooperative Hansa Gallery, where he was a member along with many Hofmann grads (the gallery's name was, as we have seen, an homage to Hofmann), he showed his welded personages, generally vertical constructions that turned junk metal into peoplelike structures. Porter wrote about Stankiewicz on several occasions, always invoking a pastoral metaphor. In Friedman's book about the younger artists of the New York School, Porter began by quoting Wallace Stevens's "The Man on the Dump," who might "sit among mattresses of the dead, / Bottles, pots, shoes and grass and murmur *aptest eve*." Another time, Porter observed that "the materials used by Richard Stankiewicz for his sculpture come from the street, often from his own doorstep, as though the city were the sea, and he had a studio on the beach. Friends bring him things they have found. He buys from junk yards." When he lived on Bond Street, he actually found junk that he could use in his work in the backyard while digging for a garden.[26] The cityscape was a landscape of junk, and out of this horizontal world of refuse Stankiewicz created his standing-tall figures.

Some of Stankiewicz's people, these three-dimensional constructions of

rusty iron lace work, can feel overly literal. When two figures become a king and queen, or playful bathers, or a figure with a typewriter is the secretary, there is humor to the transmogrification of junk into human presence, but some of the humor is overly localized and somewhat cartoonish.[27] The metaphors are nowhere near as surprising or wild or exact as in the constructions that Picasso was doing after the war, like the *Baboon with Young* and the *Woman Wheeling a Baby Carriage*. In Stankiewicz's best work there is a formal play that grows out of the ever expanding abstract possibilities of assemblage. Stankiewicz knows how to give bulky forms an

Richard Stankiewicz, Playful Bathers, *along with other works installed at the Stable Gallery, early 1960s.*

amusing lightness; his floating volumes can have the paradoxical appeal of heavyset people who are terrific dancers. He likes oddly gyrating internal movements, a rhythm at once centrifugal and centripetal. Though the works have no moving parts, they sometimes suggest the pulsing movements of machinery, with pieces going up and down and working one against another in a three-dimensional version of Hofmann's push-and-pull. Often there is some heavy, maybe cylindrical volume that is borne aloft, and we wonder at its gravity-defying beauty. Our eyes move eagerly and happily through the openness of these pieces, around the boisterous volumes. Stankiewicz sketches his own lunging, careening, spinning version of the dance of life. And even in the untitled pieces, there is that hint of a personage—of the surreal totem, the vertical being.[28]

Richard Stankiewicz, Untitled, 1960. Steel, 41 in. high.

VIII

We are told that sculpture is an art that dates back to before the beginnings of time, when gods made men of clay. And sculptors, acknowledging that primordial tug, have often taken an especially close look at ancient myths and symbols. In a progress report written for the Guggenheim Foundation in 1951, Smith explained that he had been doing "research in cuneiform, the Sumero-Akkadian style of writing, and other Mesopotamia Valley cultures; the origins of Chinese writing; my own interpretations of Polynesian symbol writing or records. This has not been scholarly research or scientific, but romantic, an interest of relaxation from labor; but like every influence of an artist's life— interpreted into his own creative outlook." All of this recalls some of the interests of Smith's old friend John Graham, who would fill notebooks with examples of foreign writing, with odd signs and symbols. Smith said he wanted "object identity by symbols, demanding the return to symbol origin before these purities were befouled by the words."[29]

Smith's work was full of afterimages and echoes of totems and glyphs and enigmatic ancient symbols, and yet he also wanted people to understand that his artistic origins were modern in the most traditional sense of the word. "I date my aesthetic heritage from Impressionism," he explained in the magazine *Arts and Architecture* in 1952. "Since Impressionism, the realities from which

art has come have all been the properties of ordinary man; the still life has been from the working man's household; the characters, environment, landscape have been of common nature."[30] Speaking of the working man's surroundings, Smith sounded almost like Léger, and the art of assemblage turned out to be a natural extension of the activities of the painter of modern life. Explaining how all this worked to Hess, Smith said, "I find many things, but I only choose certain ones that fit a niche in my mind, fit into a relationship I need, and that relationship is somewhat of a geometric nature." And yet it wasn't all geometry, for Smith admitted that "there is a certain romantic relationship in my mind to the old hand-made objects that have ceased to function." This is a statement worth considering, for the way that the geometric and the romantic were casually tumbled together. When Hess asked Smith about his use of found objects, and about the Surrealist idea of "a metaphysical jump between the reality of the object and the idea of a work of art," Smith's response was to turn Hess's questions into a metaphysical merry-go-round, by the end of which there were nothing but found objects in art. "First of all," he said, "these things have a basic geometric form that's already 'found.' In a recent work, I made one wheel and the other three wheels I bought by ordering them from Bethlehem Steel Co. They weigh 275 pounds apiece. They are blank forgings made by Bethlehem for 100-ton overhead trolleys. You might say they are 'found' objects. I found them in a catalogue and chose them because they fitted a particular need. Are triangles, circles and spheres 'found'? They have always been there."[31]

In the summer of 1962, three years before he died, Smith was in Italy, invited by Gian Carlo Menotti to do something for the Spoleto Festival, where Kelly, two summers before, had been represented by sets and costumes for Paul Taylor's *Tablet*. An Italian company, Italisider, gave Smith the run of some recently abandoned workshops and factories in the town of Voltri. The metal objects that filled these vast old industrial spaces were going to be melted down, and Smith was welcome to take whatever he liked. While working there on a series of compositions that would be shown in the old Roman theater at Spoleto, Smith fell into a kind of rapt fascination and sympathy with the whole earlier industrial world that those factories represented. He wrote a series of notes about working at Voltri. "The first Sunday alone in these factories—functional in an era long past, abandoned only a few months—were like Sundays in Brooklyn in 1934 at the Terminal Iron Works, except that here I could use anything I found, dragging parts between buildings to find their new identity. . . . The first two Sundays—not even a skeleton crew around—

*David Smith,
Voltri XVIII (left)
and Voltri V
(right) in the
amphitheater
at Spoleto, Italy,
in 1962.*

the great quiet of stopped machines—the awe, the pull, exceeded that of visits to museums in Genoa or even the ancient art in other cities." Smith was fascinated by the culture of these factories—by the kind of men who worked in these buildings and their relations with the place. "The yards had flowers and fig trees planted by yard workers. Now deserted by automation, these factories were from the handmade days, the 10–11–12 hour days when working was living. In the new automated plant, the hours are shorter, the man is a machine part."[32]

Smith's tough yet rhapsodic description suggests an infatuation with the afterimages of material culture that had been gathering force since the 1920s and 1930s, when the Surrealists had sought out the dustiest corners of nineteenth-century Paris and studied Atget's photographs of the early-twentieth-century city, and Walker Evans and Lincoln Kirstein had turned their attention to the gingerbread houses and brick factory buildings of nineteenth-century New England. In the years when Smith was making these remarks, Evans was composing portfolios for *Fortune* magazine, combining image and text, in which he saluted old industrial sites and offices and facto-

ries. In 1960, for "On the Waterfront," a study of old New York warehouses, Evans observed that "under sunset illumination, these gaunt, exhausted boxes, dotted with their iron shutters of old blue or splotched russet, are a delight to lovers of paradigmatic Americana." Evans moved in close to examine the extraordinary detailing on these structures that seemed to have been built for the ages. "Their very hardware," he wrote, "has style and patina—great wrought-iron hasps; fanciful metal stars that are the cross-support termini; ponderous door fittings that would suit a prison."[33] Evans's photographs of old factories along the New York waterfront, where Smith had worked years earlier, conveyed a sense of the unity of that vanishing world that matched Smith's eye at Voltri. The integrity of these old working environments, their very physicality, gave off a perfume, the perfume of a world gone or nearly gone. They had a proletarian pastoral charm. Smith loved the rough-hewn unity of the premodern world. When one of the Voltri pieces was mounted in front of a fourteenth-century church in Spoleto, he commented on the combination on the façade of that church of "Roman blocks and seventeenth-century restorations, [which] might seem odd in description, but looked fine."[34] This reminds me of Josef Albers's comment about the homogeneity of

Walker Evans, page from "On the Waterfront," Fortune, *November 1960.*

building materials beginning in the Renaissance, a homogeneity that denied one the pleasures of the complementariness of textures, the complementariness that Smith responded to in that Spoleto façade. And that his welded metal construction, set before the façade, could only increase.

The fascination of the old factory or the half-restored church was in the way that the actuality of the materials, with their crazy, collaged-together effect, reflected the life of a community over a long period of time. For eyes such as Smith's or Evans's that had been trained in the 1930s, the juxtaposition of diverse elements in the man-made world cried out to be understood in Hegelian terms, which meant that culture was nothing less than the materialization of the spirit. And for Smith the fascination of the factories and workshops in Voltri was in the way that all the details of the place—the fig trees in the garden, the finely wrought tongs—reflected the essential rootedness of the people who made something beautiful, anything beautiful, in the world. "The stream of time and flow of art" were connected for Smith, and no matter how independent the sculptor's vision might be, he could not conceive outside his time. Once again, you need to go back to Marx's great statement in *The Eighteenth Brumaire of Louis Bonaparte:* "Men make their own history . . . , but under circumstances directly encountered, given, and transmitted from the past."[35] For "no object he has seen," Smith said, "no fantasy he envisions, no world he knows, is outside that of other men. No man has seen what another has not, or lacks the components and power to assemble. It is impossible to produce an imperceptible work."[36] The old workshops at Voltri became a symbol of the brute physicality of the imaginative act. And if the workingman's world was an expression of social forces, the artist who adopted some of the workingman's methods or technique—who welded or used scrap metal or ordered from industrial catalogs—was personalizing that world, giving its methods his own artistic stamp.

IX

By the late 1950s, visits by artists and critics to Smith's home and studio not far from Lake George had become fairly common. Frank O'Hara described Smith as a large no-nonsense man with a mustache and a " 'plain' manner." He "prepared delicious meals himself, offered excellent wines and cigars, and spoke of his love of Renaissance music (particularly Giovanni Gabrieli) and Mozart and the writings of James Joyce, of his interest in the musical ideas of John Cage, in the dancing and choreography of Merce Cunningham."[37] And

even as Smith's personality held visitors in thrall, they were wondering at the extraordinary outpouring of new work, which continued uninterrupted from the early 1950s until his death in 1965, when the truck he was driving ran off the road.

Like de Kooning, Smith had learned about the School of Paris from the great eccentric figure John Graham. And, like de Kooning, at least like the de Kooning who was spending more and more time on Long Island in the 1960s, Smith was an artist in whose imagination the pastoral and the urban had their places, side by side. Considering the uses to which Smith put scrap iron, it might be said that in his work the pastoral and the urban converged. The fields around Smith's Bolton Landing home offered spectacular vistas of mountain, timber, and meadow. Hilton Kramer described the situation dialectically, as "a machine shop in a landscape," and Smith's Terminal Iron Works, relocated from Brooklyn to upstate New York, demonstrated the survival, as a matter of artistic choice, of the lost childhood of the Industrial Revolution.[38] Visitors saw arrayed in the fields a vision that was at once old and new, artisanal and experimental—ranging from the expansive linear arabesques of such early 1950s pieces as the rapidly unfurling *Australia* and the somewhat slower-moving *Hudson River* to construc-

Dan Budnik, the upper field at Bolton Landing during snowfall, 1963.

tions of steel rectangles and cubes from the 1960s. There were rows of the *Voltri-Boltons* and *Voltons,* skeletal images, generally with a slim vertical human look, many of which seemed to act as frames or mounts for the beautiful, handmade tongs or pincers that Smith had brought back from the factories at Voltri. Next to these weird presences, which still had the afterglow of Surrealist-Baroque scribbles, were the *Cubis,* constructions of sleek steel boxes assembled into gravity-defying pileups, like children's blocks gone mad. And then there were the *Circles* and *Primo Pianos,* broad flat forms cut out of sheets of steel and often painted white, a kind of three-dimensional rendering of flat-shape painting, with circles that were said to be inspired by Smith's interest in the early canvases of Kenneth Noland, but that also suggested an affinity with the general upsurge in hard-edged Constructivist work in the late 1950s, of which Diller and Kelly were a part.

What provoked visitors to Bolton Landing were of course single works, but more than that it was the ensemble, the long rows of variations on themes, which, taken together, suggested an assemblage sensibility, a vast three-dimensional diagramming of the interaction of divergent styles. Kramer, writing in 1960, before Bolton Landing had taken on quite the dramatic look of juxtaposed manners that it would a couple of years later, described Smith's achievement in terms of a response to the historical interweaving of styles in modern art. He spoke admiringly of "Smith's refusal to choose one branch of modernism over another—to become purely a Cubist *or* a Surrealist *or* a Constructivist." And he went on: "One must add that such a freedom of choice was possible because European modernism itself had become fragmented and

David Smith, Hudson River
Landscape, *1951.*
Painted steel, 49¹⁵⁄₁₆ in. high.

split into isolated impulses by the early thirties."[39] This idea of Smith's not becoming "purely" one thing or another was further elaborated by Clement Greenberg in his writings about the sculptor. What Greenberg suggested was a personal dialecticalism. In *Art in America* in the winter of 1956–57, he had already observed that "it was once plausible to characterize Smith's art as baroque, but it has become equally plausible today to call it classical." And a few years later, Greenberg characterized these reversals and switches in a closer way, as if the moves that were once echoing through history were now the expression of one man's will. "Contradictory impulses are at work," Greenberg wrote, "and the triumph of the art lies—as always—in their reconciliation. Hardly a piece in the *Voltri–Bolton Landing* series makes the impression of geometrical regularity as a whole. If there is geometry here, it is geometry that writhes and squirms." After Smith's death, *Art in America* presented an album of photographs of the work of the 1960s, and Greenberg wrote a series of captions in which he again spoke of the easygoing commingling of styles. The *Cubis,* he wrote, "are strictly geometrical in form, yet do not belong to what we know as geometrical art—it was Smith's faculty to use geometrical elements without getting himself captured by the doctrinaire notions attached to geometrical art or anything like it; it was as though he used the geometrical only in order to negate it." Many of Greenberg's descriptions

David Smith, Cubi XXVIII, 1965.
Stainless steel, 108 in. high.

were dialectically oriented. "*Wagon II* tellingly marries squatness with openness, rawness with cleanness." And of an untitled work from 1965, Greenberg observed that "both the pictorial and sculptural seem here to transcend themselves in a new kind of unified medium."⁴⁰

In his "Notes on My Work," Smith had made a virtue of practicality. "Rarely the Grand Conception," he remarked, "but a preoccupation with parts." With this striking observation, Smith raised the possibility that there might be no final unity, and suggested his own skeptical view of the dialectic. The social or intellectual ferment of the 1930s, the decade when Smith began his life as an artist, was still simmering in the artist's imagination, but by now what all his shifts in mode and manner and material mostly suggested was an intellectual workingman's absolutely private equivocations. There was no idealism involved, only the artist making the geometrical not geometrical, or giving geometry the saving painterly grace, or whatever he felt like doing at a particular time. Smith said "Yes!" and he said "No!" "The view is not so important, nor the ideal," Smith wrote, "but the inner conviction which sparks the drive for identity." And again, "When I work, there is no consciousness of ideals—but intuition and impulse."⁴¹ These remarks were very important, coming in the early 1960s from a veteran of not only the 1950s and the 1940s but also of the 1930s. They signaled the final rejection of the old idealism, a rejection that Smith had already suggested in the *Medals for Dishonor,* those early panoramic views of the horrors of modern life. By the end of his days, Smith believed that an artist must make his own private peace with the turmoil of his times. And to the extent that art in America was a product of melting-pot dialectics, Smith knew that he had to stir the pot for himself. All the breakups and scramblings, all the chaotic discussions at the Club about the potato of van Gogh and the pebble of Arp and the romantic and the classic were reconciled in the new, grandly casual unity of the sculpture arrayed in the fields of Bolton Landing. These works suggested the sculptor's easygoing aplomb, his daring indifference to all the strife, whether personal or artistic or historical, that preceded this moment when his sculptures were standing, like wonderful overgrown toys, in the fields beneath the huge sky of upstate New York.

"No consciousness of ideals." The very idea isolated art from the Hegelian realm. And yet Bolton Landing was all about a sense of Hegelian grandeur, about the artist as the Terminal Iron Worker. In the early 1950s, Howard Nemerov contributed a poem about a sculpture of Smith's called *Four Soldiers* to an exhibition catalog. He spoke of Smith's curious figures as

David Smith,
Wagon II, 1964.
Steel, 107⅝ in. high.

> Piece by piece recruited from the odd
> Detritus of an iron age gone wrong—
> Turnbuckle, poke, unidentified
> Flanges and bolts—so soldiers get along.[42]

Four Soldiers was a work in Smith's satiric mode, with echoes of Daumier. Located somewhere between the social comment of the *Medals for Dishonor* and the lyric expansiveness of *Hudson River Landscape* and *Australia, Four Soldiers,* this study "of an iron age gone wrong," suggested how much went into Smith's art, and what struggles were involved in turning an Age of Iron into an Age of Gold. As for the visitors to Bolton Landing, they found that in the work that was unfolding right before their eyes, all the strands of modern style were at long last encompassed in one grand, individualistic American avowal. What Greenberg perceived in the later Smith was an oratory freed from the intricacies of generally agreed-upon word choice or accent. Geometry, that old-fashioned, textbook stuff, had retreated from ideal to intuition. The will-to-form—the will-to-form of all modern art—had become something inward-turning, self-reflexive. Smith embraced all styles, and they all became him, in both senses of the word: All styles looked good on him, and all styles belonged to him. There was a paradoxical lightness about even Smith's

largest works, no doubt because the weight of style had been rejected. The perfume of the past that had clung to the old tools from Voltri was now just a memory. Everything that art had ever been—baroque, classic, painterly, linear, more or less representational—was encompassed by this one man. The past was distilled.

10. FROM READYMADES TO CUTOUTS

I

The found object is the baseline in the grand collage. You see these objects in the living area of David Smith's Bolton Landing home: an old mirror with a curved top, displayed on its side to render the symmetry amusingly asymmetrical; a manhole cover from Brooklyn; a Spanish spur. Working in his Terminal Iron Works studio in upstate New York, Smith knew better than anyone that when you combine one found object with another, you have the beginning of a sculpture or an assemblage—of a composition with some internal tension or dynamic that suggests a mood, a theme, a metaphor. But leave the found object as it is, leave the baseline as the baseline, what then do you have? What if you isolate—place on a pedestal, metaphorically or otherwise—a single object, one that is perhaps not charmingly worn but rather has been purchased brand-new from the hardware store?

Marcel Duchamp had an answer to this question. He believed that when the found object was saluted for its own sake, you might in fact have a great deal. In 1915, at a time when Joseph Cornell and David Smith were still only children, this Frenchman who had just arrived in New York, where he would spend a good deal of his life, had given a name to the found object. He came up with what he called a "readymade." This new category of object was inaugurated with a snow shovel, which Duchamp bought in a hardware store in New York and titled *In Advance of the Broken Arm*. He had already, back in Paris a cou-

Marcel Duchamp, In Advance of the Broken Arm, *1915 (original lost, replicas made in 1945 and 1964). Wood and galvanized-iron shovel, 47¾ in. high.*

ple of years earlier, displayed a bicycle wheel and a bottle rack in his studio, but they had remained, until Duchamp arrived in New York, unnamed, uncat-egorizable. The bicycle wheel and the bottle rack became readymades only retroactively, when Duchamp wrote to his sister Suzanne from New York in January 1916. "Now, if you have been up to my place, you will have seen, in the studio, a bicycle wheel and a bottle rack. I bought this as a sculpture already made."[1] As it turned out, Suzanne had thrown the bicycle wheel and bottle rack away when she cleaned out the studio, assuming they were junk, so she could not sign and inscribe them for Duchamp, as he had asked her to do.

The readymade was a New York story, no question about it. You can see them in the various photographs that survive of Duchamp's early New York studios: the snow shovel hanging from the ceiling around 1920; a second ver-sion of the bicycle wheel in his studio at 33 West Sixty-seventh Street, circa 1918. "Here, in New York," Duchamp wrote to Suzanne, he had bought some objects in the "vein" of the bicycle wheel and bottle rack. "I treat them," he explained, "as 'readymades.' You know enough English to understand the meaning of 'readymade' that I give these objects. I sign them and I think of an inscription for them in English."[2] There is something worth considering in the fact that Duchamp chose to name his new discovery in the language of his new country. It was not, after all, as if he never used French titles during his later years. But for the most radical discovery of his career, a New World name was important. Almost immediately after arriving in New York in 1915, Duchamp had regaled journalists with his enthusiastic reactions to the city; he was already a celebrity of sorts as the creator of *Nude Descending a Staircase,* the painting that, with its futuristic overlapping legs and arms, had caused such a scandal at the Armory Show two years earlier. To one interviewer, Duchamp had explained that "the art of Europe is finished—dead." "America," he said, "is the country of the art of the future." Duchamp, who did nothing casually, who was inclined to underline and boldface even his most trivial thoughts and actions, might have wanted this new discovery to speak American, the language of the country where art had a future. And the term, in the sense that Duchamp was using it, was a mid-nineteenth-century coinage. James Russell Lowell, in the *Moosehead Journal* in 1853, had spoken of "a Ready-made Age."[3]

That Duchamp, a Frenchman, chose to name this new kind of found object in English did not, of course, limit the impact that the readymade idea would have far beyond New York. Indeed, the Made in USA mark could have a spe-cial appeal for Europeans, who were inclined to look to America as the land of

Waintrob-Budd, Marcel Duchamp in his West Fourteenth Street studio, circa 1956.

the new. Surely after World War I the idea of the readymade was more easily assimilated into Europe's large avant-garde than into Manhattan's small one; many of the almost endless series of Surrealist objects were descendants and relatives of the readymade, to one degree or another. Some forty years later a show such as "The Art of Assemblage," at the Museum of Modern Art in 1961, would suggest that the found object, whether purchased in a store or picked up in a junk heap, was as much a favorite among European artists as among the Americans. Yet in the years when New York artists were becoming increasingly self-conscious about their place in the world and in the history of art, the readymade could have, at least for some, a kind of talismanic fascination. In a hurry-up art world—where, as a character in Gaddis's *The Recognitions* observed, "everything you pick up is ready-made, everything's automatic"—the readymade made sense.[4] This was instant art. But the readymade also had a way of confounding the idea of progress in art, for if it was true that the readymade preceded all art, some were also inclined to argue that, to the extent that art was becoming progressively simplified and stripped down, the readymade might be the ultimate art form. Duchamp, an avatar of the new, was suggesting that what was really new was also deeply, thoroughly old hat—just plain banal, like a ready-made suit.

There is no wonder that Duchamp himself, who was an at-the-side presence in New York from the 1910s all the way into the 1950s, had such an ambiguous kind of power. He was there in the distant prehistory of the New York School, the man who had, albeit anonymously, caused an uproar at the Society of Independent Artists in 1917 by submitting a urinal as a sculpture, inscribed with the fictitious name R. Mutt. Yet by the 1950s it could also seem to some that Duchamp was the fixed point toward which everything else was leading, and for some his position was all the more intriguing because he encouraged the impression that he had more or less given up art for chess decades earlier. This chess-playing semi-retired artist acted as an adviser to wealthy American collectors—including John Quinn, Walter Arensberg, and Katherine Dreier. He prepared the groundwork for the acquisition of many

major works of art, and these in turn became the cornerstones of important museum collections devoted to twentieth-century art. In the mid-1940s, *The Bride Stripped Bare,* his elaborate composition on glass, was a presence at the Museum of Modern Art, where it had been put on extended loan by Katherine Dreier. One of the first major turning points in Duchamp's reputation came after World War II, when the art museum at Yale organized an exhibition to celebrate the acquisition of Dreier's collection. Dreier had, with Duchamp's assistance, created a sort of avant-garde club called the Société Anonyme, and its collection, given to Yale, contained many Duchamps. By then, however, the original shovel had disappeared, and Duchamp authorized George Heard Hamilton, the curator at Yale, to buy another, again in Manhattan, which Hamilton later recalled that he brought back on the train from New York one fine April evening, "startling the commuters who thought I must have heard a dire report about our fickle New England weather."[5]

Marcel Duchamp, The Bride Stripped Bare by Her Bachelors, Even (The Large Glass), *1915–23. Oil, varnish, lead foil, lead wire, and dust on two glass panels, 109¼ × 69¼ in.*

II

Duchamp found *Life* magazine knocking at his studio door on Fourteenth Street in 1952, the year after de Kooning, in his lecture at the Modern, had dubbed him a one-man movement. There were eleven pages in *Life,* written by Winthrop Sargeant. Duchamp, Sargeant said, was "a wiry, genial, grey-eyed Frenchman who gesticulates rapidly with long lean hands as he talks. He is 64 years old, but looks ten years younger." The dominant note in everything he did and said was laconic—apparently laissez-faire. The man had a mixture of passivity and force that quite a number of women seem to have found immensely attractive; he was the self-satisfied gigolo ascetic-aesthete, leaning back and enjoying whatever came his way. And his studio—in an unprepossessing space on a commercial street—was his bachelor hideaway. The rent was forty dollars a month, and he didn't have a phone. "My capital is

time, not money," he told Sargeant. "Sitting quietly in his studio," Sargeant continued, "smoking pipeful after pipeful of strong Cuban tobacco, Duchamp can talk interestingly by the hour, allowing an amazing stream of esthetic, philosophical and purely Dada ideas to filter through his detached, ironic mind. But no sooner has he ventured into a definite statement than, like a true Dadaist, he retreats from it under a smokescreen of ridicule." Still, Duchamp made certain of his views very clear. He did offer a critique of the Abstract Expressionists—who were just moving into their heyday. "I have always had a horror of being a 'professional' painter. The minute you become that, you are lost. Besides, I was never passionate about painting. I never had the olfactory sensation of most artists. They paint because they love the smell of turpentine. Personally, I used to paint for two or three hours a day, and I couldn't get away fast enough." He was not a fan of contemporary painting. "In my estimation, there is no hope for the future of art at least for the next 25 years."[6] This was a statement that Duchamp, a decade later, might have chosen to revise, considering the central position that he himself was turning out to have. This striking, angular figure seemed to sleepwalk his way through much of the twentieth century, and yet there was something about this approach that pleased an ever growing public for avant-garde art.

What was most interesting about Duchamp's comments about his lack of passion for painting was that they were framed not in terms of the painting as a finished work of art but in terms of painting as a process. He emphasized painting's "olfactory" appeal, something artists do speak of, but not as the be-all and end-all. Obviously, he was winking at the whole idea of art when he spoke not of how it looked but of how it smelled. This scrambling of the old relationship between the arts and the senses would culminate in Duchamp's persistent attacks on the "retinal" aspects of the visual arts—as if the visual arts could be anything but retinal. In selecting his readymades he said that "it was always the idea that came first, not the visual example," but of course in the end there was the object before your eyes.[7] Speaking to the curator James Johnson Sweeney in 1946, he explained that "the great trouble with art in this country at present, and apparently in France also, is that there is no spirit of revolt—no new ideas appearing among the young artists." So there he was, at the beginning of the decade when New York's romance with paint was more intense than ever before, a charming disabuser waiting for the end of the romance. Then again, it was perhaps a mistake to take anything Duchamp said overly seriously, for this iconic avant-gardist was quite content to pull the rug out from under the avant-garde. "Art," he told Sweeney, "is produced by a

Marcel Duchamp, The
Box in a Valise, *1935–41;
this copy from Series G,
1948. Mixed media.*

succession of individuals expressing themselves; it is not a question of progress. Progress is an enormous pretension on our part."[8]

When Winthrop Sargeant visited, Duchamp was still at work on his version of the end of the romance, the boxes full of miniature reproductions of his work that he had begun to produce a decade earlier. "Around him," Sargeant wrote, "lie piled the materials with which he carries on his present task, that of stuffing his life work into small suitcases"—a lifework that, of course, included a good many paintings, now rendered as collotype reproductions. Sargeant observed that this "is, rationally considered, a rather mad process, calculated to astound the onlooker. The onlooker naturally seeks an explanation: Why a suitcase?" The boxes—called *from or by Marcel Duchamp or Rrose Sélavy,* a pseudonym he sometimes used, or *The Box in a Valise*—eventually numbered in the hundreds, with a small deluxe edition in a pigskin valise each of which contained a hand-colored collotype. Peggy Guggenheim was the first purchaser, and the first place that the *Box* was publicly exhibited was in New York in 1942, at Guggenheim's Art of This Century, the gallery that sponsored Pollock, exhibited many Abstract Expressionists, and began showing such Hofmann students as De Niro and Blaine. The gallery also appears to have been involved in selling boxes. Of the *Boxes,* Duchamp explained to Sargeant, "Everything important that I have done can be put into a small suitcase." And the reporter went on: "It is obviously ready to be carried off somewhere. Is he implying an ironic thrust at his own art? If so it is obviously an ironic thrust at an ironic thrust, for his own art is pure irony. Wheels within wheels."[9]

The idea for *The Box in a Valise* probably came from the cases that were produced commercially around the turn of the century to hold "a variety of

household products—toiletries, sewing equipment, stationery, magic tricks, watercolors, and toy dishes." These boxes, as the historian Francis Naumann has explained, "could be found in most any Parisian department store."[10] Like Walker Evans's fascination with Victorian gingerbread architecture and David Smith's interest in reusing old iron objects, Duchamp's *Box in a Valise* suggested a nostalgia for a lost late-nineteenth-century or early-twentieth-century world. There were reproductions of his paintings, a pint-sized version of his magnum opus on glass panels, *The Bride Stripped Bare*, printed on celluloid, and a tiny urinal that reprised his scandalous submission to the Society of Independent Artists exhibition in 1917. These small, made-to-order, virtually handmade objects were, in some sense, the opposite of found objects; they were elaborate contrivances, the work of a man who certainly knew how to charm, how to beguile. *The Box in a Valise* had the fantasy appeal of an elaborately miniaturized construction; it was a dollhouse for intellectuals. But as he turned out the *Boxes,* year after year, in a kind of cottage-industry assembly line—which sometimes involved assistants, among them Joseph Cornell—Duchamp may have also been commenting on what he saw as the shrinking possibilities of the found object. With *The Box in a Valise,* Duchamp's entire achievement was transformed into a collection of toys and baubles and packed away in a case that looked a lot like a piece of luggage on a shelf in some god-forsaken lost-and-found.

Marcel Duchamp, cover of special issue of View *devoted to Duchamp, 1945.*

III

In 1945, *View* magazine published a special issue devoted to Duchamp, for which he designed a cover with a bottle floating against a dark blue sky while sending out puffs of smoke. This could have suggested many things: a Molotov cocktail or perhaps the christening of a spaceship. Among the articles and tributes by authors including André Breton and Man Ray, there was an essay titled "Marcel Duchamp, Anti-Artist," written by Harriet and Sidney Janis. In the 1950s Sidney Janis would become one of the key dealers in Abstract Expressionist painting, and in 1953 he mounted a Dada show organized by Duchamp. The combined catalog and announcement that Duchamp

designed for the exhibition became a legend in its own right. This poster-sized typographical wonder, printed on tissue paper, had been crumpled into balls, which visitors could pull out of a trash can in the gallery. It was prefabricated trash. Organizing exhibitions was becoming something of an avocation for Duchamp. A decade earlier, in 1942, not long before the opening of Guggenheim's Art of This Century, Duchamp had been designing the installation of an exhibition called "First Papers of Surrealism," which involved crisscrossing the gallery with a mile of string and thereby obstructing some of the paintings on display. The curatorial role fit in with Duchamp's proudly disinterested attitude.

The Janises began their essay by commenting that Duchamp's "works are scarcely recognizable as the products of creative activity: they are so unorthodox, and so far removed from patterns, centuries-old, of the material and conceptual substance of painting and sculpture." Yet the Janises did find patterns here. Much in Duchamp's art, at least as described by the Janises, could be said to be attuned to the idea of perpetual, often almost involuntary change. His work, they wrote, "falls into categories of threes, intentionally or otherwise: movement, machine concept, and irony. Irony subdivides into three groups: selection, chance and the ravages of time." So Duchamp's irony had something to do with history as happenstance. "Possessing a revolutionary attitude of mind, Duchamp postulates his responsibility to himself and to society, but, under the influence of his own philosophic detachment, disclaims such a responsibility. Here is the core of the inner drama, the conflict between acceptance and rejection that is the basis of Duchamp's philosophic and esthetic rationale." The result of this "inner drama" was an ironic dialectical game. Thinking of Duchamp's *Coffee Mill,* an image of an ordinary early-twentieth-century household object presented with the cool efficiency of an architectural rendering, they saw a quiet comedy, reminiscent of Rube Goldberg's "humorous play on mechanization" and Chaplin's *Modern Times.* The Janises' argument was a little airy and abstruse, a little hard to follow, but then what else was there going to be to say about the laid-back master of Dada? "Instead of accepting the alternatives of annihilation or of living in a vacuum," they explained, Duchamp "has worked out a system that has produced a new atmosphere in which irony functions like an activating element, causing a pendulum-like oscillation between acceptance and rejection, affirmation and negation, and rendering them both dynamic and productive."[11] Here, in some carefully chosen words about Duchamp published at the end of World War II, we are face-to-face with a vision of artistic development as amusingly slippery

or ironically aimless that would become commonplace a little more than a decade later. It's a poisonous attitude, so I believe.

Duchamp might have looked like a pleasingly modest figure as he received guests in his studio on Fourteenth Street. And yet this aging sphinx was guarding the entrance of a cavern where Dada, the anti-art ethic that dated from the years around World War I, was simmering like a volcano that might appear extinct but was in fact only dormant. Dada had had an earlier New York moment, beginning in 1913, when Alfred Stieglitz had exhibited at his 291 Gallery the work of Francis Picabia, who gave Cubism's sweet conundrums a diagrammatic chill. For a time Dada's damn-everything appeal was welcome in some of the experimental magazines coming out of New York, such as *Broom* and Stieglitz's *291*. A small New York avant-garde was playing catch-up with Europe's desire to make everything new—and, maybe for a moment, New York was getting ahead of Paris. By the 1930s, though, the riches of Surrealist iconography had thoroughly trumped Dada's to-hell-with-everything gestures, and it would be deep into the 1940s before there was a renewed interest in Dada's cooler moves and nihilistic glamour, although as an undercurrent Dada never went away. During the six years that Robert Motherwell was working on his seminal anthology, *The Dada Painters and Poets*, which Wittenborn, Schultz published in 1950, he found that a veritable parade of current or ex-Dadaists who were either living in or visiting New York were eager to offer their opinions. Those mostly middle-aged men—including Arp, Breton, Duchamp, Ernst, Hans Richter, and Richard Huelsenbeck—had long ago considered the possibility that experimentation and the breaking of tradition might lead not to new formal resolutions but to the collapse of form, and beginning in the 1950s that thought had an increasingly perverse fascination.[12] By the 1960s, when Dada was again center stage, Harold Rosenberg found himself speculating that "in societies of advanced industrialization and mass media the arts tend to lead a parasitic existence, and that this was first divined by the shocked generation of World War I"—the generation that had given birth to Dada. If there had been in 1920s Europe a sense that art had become too easy, that high art had become kitsch for the bourgeoisie, certainly in the easy atmosphere of the postwar United States, with its culture vultures and rising museum attendance and high-toned TV specials, the lessons of the old Dadaists could once again appear relevant. "Under these conditions," Rosenberg argued, "art can overcome its intellectual debasement only through an expressed hostility to art, or, at least, a show of indifference to it. In the process of re-orienting itself on this negative axis,

art has lost its traditional public of devoted art lovers and has acquired a new one defined as an avant-garde by its habit of seeing art in a self-defeating context—from paintings splashed with pigment or consisting of a sheet of single-colored fabric to blinding light exhibitions or the inaudible poetry readings of original Dada."[13]

The story of Duchamp's apotheosis in the decade leading up to his death in 1968 cannot be understood except in the context of the new audience for art, which, as Rosenberg said, had the "habit of seeing art in a self-defeating context." The forced ebullience of those years gave Duchamp's by now almost fossilized cynicism a new fascination and urgency. And younger artists embraced Duchamp and even, sometimes, got to know him, beginning with Jasper Johns and Robert Rauschenberg, those two cheerfully self-absorbed nihilists, who were quickly followed by a generation of whatever-the-market-will-bear nihilists, the generation of Andy Warhol and Roy Lichtenstein. In the end the difference between Johns and Warhol did not amount to very much, for they were all bad boys dressed up as respectable habitués of the museum, and Duchamp had been there before any of them. In 1951 Rauschenberg asked de Kooning for a drawing, which Rauschenberg then erased, and this imperious gesture—which oh-so-cleverly betrayed a parasitic dependence on the very mechanisms of art that he was dismissing—set the stage for the rip-roaring success of Pop Art a decade later. But it was Duchamp who had prepared the way for the artistic gesture to which there was no response. As Hess wrote in *Art News* in 1965 in a piece called "J'Accuse Marcel Duchamp," the old Dadaist had "over the years brilliantly . . . consolidated a position that is practically invulnerable to serious criticism. On the one flank, he is the yearning vanguard's blue-eyed pride." And "on the other flank, Duchamp is a favorite whipping-boy of the philistines."[14] And the two flanks reinforced each other. And Rauschenberg and Johns looked at Duchamp—who managed to be all things to all people—and they saw their chance.

Rauschenberg had been born in Port Arthur, Texas, in 1925, and Johns five years later in Augusta, Georgia. They first met in 1954. Not too long after that, they were living in the same loft building on Pearl Street; they were very close for the rest of the 1950s. In photographs from those years, they both give off a quiet, shy-ingénue manner, although friends from the period remember Rauschenberg as a fast talker. They're Duchampians in training. Rauschenberg, who had some Cherokee blood, was darker. Johns was light-haired and light-skinned, with large, impenetrable eyes. Johns and Rauschenberg worked together as window designers, producing for Tiffany's a now legendary series

Jasper Johns, Large Target with Plaster Casts, 1955. Encaustic and collage on canvas with objects, 51 × 44 in.

of pint-sized dioramas consisting of hyperrealistic land-scapes or still lifes wittily scattered with diamonds. It was nothing new for artists to be involved in the graphic or advertising arts as a way to earn money, but Johns's and Rauschenberg's interest in the art of the commercial shadowbox took on a weight and import of its own, for their time at Tiffany's seemed to usher in the pop aes-thetic. The grandeur of art, so Johns and Rauschenberg agreed with Duchamp, was no longer a force that by pushing artists forward granted them their freedom. Art had become something closer to a conundrum or a para-dox. To be artistic was to be abstruse.

Johns's big year was 1958, when Leo Castelli gave him his first show at the gallery that was still in the dealer's Upper East Side apartment. Alfred Barr came and bought three paintings for the Museum of Modern Art, and Hess put *Target with Four Faces* on the cover of *Art News* that January. Rauschenberg had his first show at Castelli two months later, in March. But for a few years there was far more response to Johns than to Rauschenberg. The paintings with which Johns leaped into the limelight were the American flags and targets and alphabets that have become some of the best-known and immediately recognizable works pro-duced in this country in the past fifty years. Done in encaustic, a wax medium that gave the surface a sumptuous, decorator-friendly density, some of them also included collage elements, such as the series of compartments at the top of the *Large Target with Plaster Casts,* which contained casts of body parts, including a mouth, an ear, and a penis. Johns liked to give his surfaces a beguiling complexity, often with glued-on layers of newspaper. The surfaces were worked over—worried over. In all of these paintings, there was a sug-gestion of the collage or the readymade, for Johns's sensitized surfaces became a mocking echo of the pancake-flat object—a flag or a target or a map—that he had taken as his subject. He used his slurpy encaustic paint to make painterly love to his quotidian subjects. He was slumming—oh so elegantly. And the colors were either primaries, as in the *Large Target,* or else creamy whites and grays, as in some of the flags and slightly later maps, which had a sort of hipster Silver Age look.

Johns was an ironic dialectician—he was simultaneously going toward

painting and sculpture and backing off from painting and sculpture in a way that recalled the Janises' "pendulum-like oscillation between acceptance and rejection, affirmation and negation." Johns's spare published comments had a tone, a combination of laconic presentation and obscurantist implications, that echoed Duchamp's published remarks. In his "Sketchbook Notes," published in *Art and Literature* in 1965, Johns wrote: "Something which has a name. Something which has no name." And: "Take an object. / Do something to it. Do something else to it." And: "Take a canvas. / Put a mark on it. / Put another mark on it." The matter-of-factness of the remarks hid a nihilistic vehemence. What dominated Johns's writing was not so much what was said as the very act of ratiocination, an on-the-one-hand-on-the-other-hand kind of movement that seemed meant to go nowhere in particular. And nowhere, so it seemed, was the place to go. The writing was all domino-like successions of propositions. In a statement for "Sixteen Americans," at the Modern in 1959, Johns began by observing, "Sometimes I see it and then paint it. Other times I paint it and then see it. Both are impure situations, and I prefer neither." Max Kozloff, in his book about Johns, suggested that there is a connection between Johns's thinking and that of Joseph Heller in *Catch-22*, "an image of human will hobbled by lucidity because it is based on the learning that experience itself makes no sense."[15]

The slyly ironic artist met his match in a slyly ironic young art historian, Leo Steinberg, who enjoyed splashing around in the puddle-deep aesthetics that Duchamp had inaugurated. Speaking at the Museum of Modern Art in 1960, Steinberg said that his reactions to Johns's first show at Castelli had been "normal." "I disliked the show, and would gladly have thought it a bore. Yet it depressed me and I wasn't sure why. Then I began to recognize in myself all the classical symptoms of a philistine's reaction to modern art." Two years later, in an essay called "Jasper Johns: The First Seven Years of His Art," Steinberg began by writing about a gray painting bearing the word LIAR. Steinberg offered a battery of rhetorical questions: "*Does it mean anything?* To whom? To the schoolboy learning to read? To posterity?" And to all these questions there weren't really any answers, or so Steinberg believed. "The elements of Johns's picture lie side by side like flint pebbles. Rubbed together they could spark a flame." But Johns chose not to. "He merely locates the pebbles." The questions went on and on. "WHAT IS A PAINTING? You don't just ask; you advance a hypothesis. The question is, What is a Picture? or What sort of presence is the Picture Plane? And the hypothesis takes the form of a painting." Steinberg's inquiries had an intellectual flair, but when he stopped

Jasper Johns, Flag, *1955. Encaustic, oil, and collage on fabric, 42¼ × 60⅝ in.*

for a minute to actually write about what he was seeing, he did so in a startlingly sentimental way. Johns's works were, it turned out, "tokens of human absence from a man-made environment. Only man's chattels remain, overgrown by paint as by indifferent vegetation."[16] And then, perhaps horrified by the bathos, Steinberg retreated to his questions-without-answers games.

Johns's paintings, with their clever, anti-painterly use of a painterly Abstract Expressionist technique, inspired a raft of commentary, but I think that it was only one writer, the painter Fairfield Porter, who really got at the essence of Johns, in an article published in *Art News* in 1964, at the time of the artist's retrospective at the Jewish Museum. Porter's "The Education of Jasper Johns" had an elaborate hairsplitting tact that was worthy of the late Henry James, for the critic managed to suggest in the pages of a powerful art magazine that Johns was not all that he was cracked up to be, although the message would probably have gotten through only to those who were already attuned to the drift of Porter's argument. "He manipulates paint strokes like cards in a patience game," Porter observed, and wondered, "What does he love, what does he hate?" And for Porter, unlike Steinberg, the question required an answer. The Jewish Museum retrospective followed "the course of an education that has been carried out in public. It shows the reaction to his education of an individual intelligent enough at first to take in all that he is being taught while giving it only part of his attention." Porter was reminded of a story about a dying rabbi, who said to his disciples, "Life is like a bagel," but when the village idiot asked, "Why?" the rabbi responded, with his last breath, "So it's not like a bagel."[17] In other words, Johns was merely playing to the audience's confusions, turning banalities into elegant but empty enigmas. It was

difficult to imagine that Porter's essay was not a response to Steinberg's ideas. This was one of Porter's marvelous, cool attacks. He obviously believed that Johns was a good student, a boy-man who had completed his lessons and put them together into an accomplished essay form that challenged his teachers, but just so much. Of course this is precisely the kind of student who often gets the best grades—the one who doesn't question too deeply. To Porter these paintings were a job all too neatly done. They were the all-too-perfect products of a Silver Age in their competent balancing of influences. This was what Alfred Barr felt the lessons of modern art had led one to expect from contemporary art. A little Duchamp. A little de Kooning. And so Jasper Johns went straight to the top of the class.

Rauschenberg's work took longer to be embraced by the public. Basically nothing sold from his first show at Castelli, and less was written about his work in the early years. The very nature of what Rauschenberg called his "combines" was that the elements never really cohered, but for his admirers that was the point, because the incoherence of the work was said to echo an explosively crazy, falling-to-pieces universe. Rauschenberg treated found objects casually, in a take-it-or-leave-it mood. The quilt that filled the surface of the 1955 *Bed*, the stuffed rooster perched atop *Odalisk*, the tire and stuffed goat in the notorious construction called *Monogram:* They struck gallerygoers with their lack of inevitability, with their arbitrariness. These works acted not as spurs to thought, the way Schwitters's found bits did, but almost as inhibitions to thought—they were so dissociated that they left you marooned. What Rauschenberg had done was to put found objects together in a composition and yet to simultaneously allow them to retain their baseline, readymade status. Speaking at a panel at the time of "The Art of Assemblage" at the Modern in 1961, Roger Shattuck made a distinction between two kinds of juxtapositions that appear in modern art. "In certain cases," he said, "juxtaposition cancels out . . . and in other cases it keeps its level of tension." In the first category he put "the fur-lined tea cup [by Meret Oppenheim] or the lumps of marble sugar [by Duchamp]." I would imagine that Shattuck would put Rauschenberg's work in this category, and it is amusing to remember that Rauschenberg was in fact a participant on this Modern panel, as was Duchamp. These items, Shattuck said, "illustrate the association of two elements that cancel each other out and return us—spiritually and aesthetically—to zero." We were right back at the base level of the grand collage. "The process is essentially self-consuming," Shattuck continued, "a reversion to dead level after an initial shock. A second form of juxtaposition—and I'm

Robert Rauschenberg, Bed, *1955. Combine painting, 74 × 31 in.*

just making a distinction here—brings together two components whose conflict does not cancel out, but persists. The Cubists, and more erratically, the Surrealists, contrived to achieve this condition." And what should be done with art made of juxtapositions that cancel out? Shattuck speculated that "as the Smithsonian Institution houses airplanes that no longer fly, we may soon need a repository for works that have lived for a day. That would be a museum without art."[18] This was brilliant, and exact. Except that Robert Rauschenberg's *Bed,* the old quilt and pillow spattered with paint, would eventually become one of the treasures of the Museum of Modern Art.

Johns's work could be accepted as visual art in the old modern sense. Rauschenberg's could not. His juxtapositions were not exactly gauged to have a visual shock; it was more a kind of mental shock. But along came Leo Steinberg, in 1968 in an essay that was later published as "Other Criteria," to pump up the historical claims, to argue that "the pictures of the last fifteen to twenty years insist on a radically new orientation, in which the painted surface is no longer the analogue of a visual experience of nature but of operational processes." This new kind of picture, Steinberg explained, had a "flatbed picture plane," a kind of "receptor surface on which objects are scattered, on which data is entered, on which information may be received, printed, impressed—whether coherently or in confusion." Steinberg referred back to Duchamp's *Large Glass* and *Tu M'* as precursors. Such works could hang on a wall or they could be, like Rauschenberg's *Monogram,* with goat and tire, mounted on a collaged platform on the floor. Steinberg's argument was clever—it had a ring. Yet when Steinberg attempted to explain what such a work of art might mean, his argument became rather amorphous. "Rauschenberg's work surface," he explained, "stood for the mind itself—dump, reservoir, switching center, abundant with concrete references freely associated as in an internal monologue."[19] There was an avant-garde soft-headedness to Steinberg's writing. What he liked

about Rauschenberg's work was the mushy meanderings that the combines kicked off in *his* mind.

IV

There are few ideas that do not contain or imply their opposite, and in the late 1950s a number of artists and critics wanted to push this paradoxical phenomenon in an especially confusing, things-melting-into-one-another direction. There were others, however, who argued against such intellectual sleight of hand—and among the protesters was Ad Reinhardt, a veteran of many battles for modern art who was devoted to a highly reduced form of abstract painting. Watching Reinhardt take on the Duchampians can be rather strange, for if he had no patience with the new breed of slippery contrarians, some of his vehemence was fueled by an awareness that many saw Dadaist undertones in his own black-on-black canvases. Not too long before his death in 1967 at the age of fifty-three, Reinhardt was speaking to young artists at the Skowhegan School in Maine, where he commented, "I've never approved or liked anything about Marcel Duchamp. You have to choose between Duchamp and Mondrian."[20] This was Reinhardt's response to a discussion that had been simmering for a quarter century, perhaps beginning with the Janises, who had written that Duchamp's "asceticism . . . is akin to that of Mondrian," although they immediately acknowledged that whereas Mondrian's asceticism pushed him to purify painting, Duchamp's pushed him away from painting. Not too much later, Robert Motherwell had asserted that "both dada and strictly nonobjective art are trying to get rid of everything in the past, in the interests of a new reality." And in "ABC Art,"
published in *Art in America* in 1965, Barbara Rose had argued, substituting Malevich for Mondrian, that "it is important to keep in mind that both Duchamp's and Malevich's decisions were renunciations—on Duchamp's part, of the notion of the uniqueness of the art object and its differentiation from common objects, and on Malevich's part, a renunciation of the notion that art must be complex."[21]

Reinhardt was a cutup and a philosopher, a gadfly and a pontificator. But he

Ad Reinhardt with his daughter Anna, 1958.

was no Duchampian. In photographs, he had the look of a man on the move; his body was compact, his big round face was active, mobile, with a quick smile and flashing eyes. From the 1930s to his death, he was an essential figure in the New York avant-garde. He entertained his friends with his gossipy art-world cartoons, which he collaged together out of bits of old-fashioned type and printed images. He painted red-on-red and blue-on-blue and black-on-black compositions, all of which were startlingly severe. And he could not countenance the idea that all forms of asceticism were equal, that the asceticism of Duchamp's anti-art had anything to do with the asceticism of his own art-for-art's-sake. The cracked Victorian style of his cartoons could be traced back, like that of Cornell's boxes and Harry Smith's films, to Max Ernst and the early days of Surrealism. His paintings built on the discoveries of Malevich and several generations of Constructivists. The cartoons may have been the things that his paint-bespattered Tenth Street artist friends liked best, but Reinhardt worked hard at getting people to accept his austere, ultimately black-on-black canvases. One thing that Reinhardt would never do was make nice or curry favors. "The whole art world is whorish," he told an interviewer in 1966. "Everyone now wants to be a 'howling success' and a celebrity. Everyone now wants to be like Elizabeth Taylor."[22]

If there was always a suspicion among Reinhardt's artist friends that he might in fact not be entirely serious about his black paintings, that impression was something that he certainly encouraged by being such a joker. Even as he was working toward visual effects of an ever more extreme reduction, he was following an alternative, more-is-more path in those hilarious art-world collage cartoons. The paintings and cartoons were opposites—yin and yang. But you could also argue that the opposites were meeting, for both the paintings and the cartoons were about pushing visual experience to an extreme. And in both cases the images tended toward a hieratic symmetry, although of course it is a far busier kind of symmetry in the cartoons. These collages that Reinhardt first created in the late 1940s for *PM*, an idealistic daily newspaper that ran through much of the decade, added up to a picaresque vision of the New York art scene in the couple of decades after World War II. The weird juxtapositions of engravings of sentimental sculptures and paintings and nineteenth-century ladies and gents generated some dazzling lampoons. In a cartoon published in *trans/formation* in 1952, Reinhardt the joker really got going. He was telling his friends that there was a lot of bull at the Club. He sent up the whole Club atmosphere, he exposed the hollowness and blind ambition amid the talky seriousness. A many-headed monster was spewing

ART OF LIFE OF ART

Be a martyr to art and be a sure sell-out.

Make yourself a myth and make a pile and clean up.

Be a dope and someone will push you and someday you'll cash in

Be a romantic and let your divine spark defray expenses

Make eyes at the elite until they pay through the nose

Let your monstrous subconscious make a quick buck for yourself

Chew the fat with the swells and get the lowdown on the art-dough around the high-life

Be a primitive ..a jackpot's in your throwback

Be a realist and sling that rehash

Be democratic and make everyone cough up

Use art as a means to an end and work both ends to make ends meet

Be a professional and pump your own private pipeline to painting's muse

Paint the way the wind blows and get your finger in the pie in the sky

Woo a money-bag and let true luck run its course

Build a wagon and beat the band with an art-club and be a big boom

Be a creep and a critic will cluck for you and feather your nest

Sweat and suffer or people will say you're surviving and living swell

Woo a wind-bag and let kind fate bring you fame and lay away a tidy sum

Be a prize-pauper and a plutocrat will patronize and purchase you

Join equity and be a prize-package in cross-sections at popular prices

Holler "Hang the museums!" until they hang you, then clam up and collect

"Art i

trans/formation: 1 ³ 1952

Ad Reinhardt, detail of a cartoon in trans/formation, 1952.

career advice. "Be a romantic and let your divine spark defray expenses." "Be a martyr to art and be a sure sell-out." "Make yourself a myth and make a pile and clean up." "Let your monstrous subconscious make a quick buck for yourself." "Be a primitive . . . a jackpot's in your throwback." "Be democratic and make everyone cough up." Many of the cartoons, which date from around 1950, have a visionary power; their hilariously bitter characterizations of the New York art scene may in fact present a more accurate picture of 1965 than of 1950.[23]

This painter who had such a marvelous comic eye for life's losses and absurdities had, like so many of the artists who made their mark in New York after the war, been the child of poor immigrants; his father had left Russia in 1907, his mother Germany in 1909. It was a story of starting out in the 1930s—of Columbia College, public arts projects during the Depression, wartime service in the navy. In the tongue-in-cheek chronology that Reinhardt prepared for his first retrospective—at the Jewish Museum in 1966, two years after Johns, the much younger man, had had his—Reinhardt said that he

was born in 1913 on "Christmas Eve, nine months after Armory Show"—the show that threw an American spotlight on the work of Matisse and Picasso and, of course, Duchamp. The chronology juxtaposed the events in Reinhardt's life (in bold type) with international events (in a lighter typeface) and gave a storybook view of the hometown kid taking on the big guys of modern art. As Reinhardt, age two, "gets crayons for birthday, copies 'funnies,' Moon Mullins, Krazy Kat and Barney Google," Mondrian "begins 'plus-minus' paintings" and "Juan Gris paints 'Dish of Fruit.' " After a 1951 entry in the chronology, stating that "Matisse cuts up colored papers," there were no more European artists mentioned. Reinhardt was telling us that the action has definitively moved to New York.[24] The kid who was copying Krazy Kat had caught up to Mondrian—maybe gone beyond him. And what were the Europeans doing? Well, Matisse was cutting up pieces of paper. He was, Reinhardt sardonically implied, back in kindergarten.

In the early 1940s, Reinhardt did bright, jigsaw-puzzle-like Cubist abstractions; and, in the later 1940s, there were moments of delicate painterliness. In the early 1950s, he began to suffuse the canvases with variations on a single hue, and he achieved some of his most eloquent effects. The red paintings of this period are both romantic and classical—it's that mixing of opposites that holds us. The color is expansive, hedonistic. The composition is symmetrical and restrained. And the intermingling of hot color and cool composition creates here a powerful yet inward-turning emotionalism—a quietly throbbing impact. These could be the paintings of Reinhardt's that touch people most directly. Yet if Reinhardt was an artist who did a number of different things, at heart his career involved a process of ceaseless, imperious reduction. "The drama of Reinhardt's career," so William Rubin has written, "is in this focusing down, which required not only an intense concentration, but an almost manic will."[25] Will: There it is again, that old, Nietzschean idea. Those black works with which Reinhardt's career came to a close were disturbing—they struck a blow at the most basic pleasures of sight. True, what at first looked like an uninflected black turned out, after you had looked at the painting for a minute or two, to be a symmetrical arrangement of lighter and darker darks. You were confronted with an experience that

Ad Reinhardt, Abstract Painting, Red and Blue, *1952. Oil on canvas, 16 × 12 in.*

was not quite like any that you'd ever had in front of a
work of art.

Reinhardt wanted this cool, meditative art to hold view-
ers with "its timelessness, its clarity, its quietness, its dignity,
its negativity." I'm quoting from an article about sculptures
of the Buddha, called "Timeless in Asia," that he published in
Art News in 1960. He had a great passion for non-Western
cultures. He had studied Eastern philosophy and traveled
widely. Returning from his trips with thousands of slides,
he would show them at the Club in marathon sessions—a
cosmic-comic collage of world art. While he rejected all reli-
gious interpretations of his work, Reinhardt saw the stillness
and iconic repetitions of Oriental art as a model for whole-
ness, for completeness. Looking at the Buddhas, he observed
that "the intensity, consciousness, and perfection . . . come
only from repetition and sameness." Yet there was a danger
in his proposing that a single person do all of what history
had done; it was a little like proposing that David Smith

Ad Reinhardt's studio, 1958–59.

could embody every side of the Wölfflinian dynamic of art. A roomful of late
Reinhardts offered a New Yorker's very personal definition—all-too-
personal definition—of the absolute. "Any meaning is a demeaning," he
wrote. When you stand in a room full of his black-on-black paintings,
you may wonder whether this vision of the future is one you really want to
know. There's a crazed insistence to the art—an insistence that can open a
trapdoor, perhaps inadvertently, into despair. "Real freedom in art," Rein-
hardt remarked, "can be realized only through the formula."[26] It was the
search for total freedom within total denial of freedom that gave Ad Rein-
hardt's art its icy sting.

Reinhardt favored an extremist vision of the gap between art and life. He
saw life as a slapstick comedy, and art as a quest for "irreducibility, unrepro-
ducibility, imperceptibility."[27] He might tell students that they had to choose
between Duchamp and Mondrian, but he himself may have feared the messy
striving spirit that fueled all great painting. When he argued that art required
a formula in order to achieve freedom, he might have believed that he was
thinking of Mondrian's Neoplasticism. But there was an unbridgeable distance
between Reinhardt's darkening symmetries and the art of Mondrian, which
had been based on improvisatory principles, on moving around those bits of
colored tape for weeks and months, until a truly compelling rhythmic image

began to emerge. Arguing over and over for that gap between art and life, Reinhardt was rejecting the very idea that an artist had to reimagine life within the forms of art. He ended up making art-for-art's-sake sound all too much like anti–art-for-art's-sake. Reinhardt, perhaps unwittingly, was helping to create the space in which Rauschenberg proposed to act as an artist when, in a statement in 1959 for "Sixteen Americans," the young assemblagist argued that "painting relates to both art and life. Neither can be made. (I try to act in that gap between the two.) A pair of socks is no less suitable to make a painting with than wood, nails, turpentine, oil and fabric."[28] Rauschenberg looked at what Reinhardt had wrought and concluded that if a work of art could have next to nothing in it, then why not go all the way in the other direction and argue that a work of art could have just about anything in it?

Reinhardt's writings on art and aesthetics, which fill a substantial volume, are so belligerent that a reader can be left wondering if some irony is not in fact intended. In what is perhaps the definitive statement of his objectives, an essay called "Art-As-Art," originally published in *Art International* in 1962, he concluded that "the one standard in art is oneness and fineness, rightness and purity, abstractness and evanescence. The one thing to say about art is its breathlessness, lifelessness, deathlessness, contentlessness, formlessness, spacelessness, and timelessness. This is always the end of art." Talk about paradoxes! The "one thing" is in fact seven things, and these are based on a dialectic—the lifelessness that reacts against life, the formlessness that reacts against form, and so forth. And what does he mean by "the end of art"? "End" might mean goal or conclusion, but perhaps he is inclining toward the latter, considering that in another context he spoke of wanting to make "the last painting which anyone can make."[29] No wonder that, as Harold Rosenberg recalled, "a joke went the rounds to the effect that Newman had closed the door, Rothko had pulled down the shades, and Reinhardt had turned out the lights."[30] This was, of course, a comment on the way these artists now brought to a conclusion the Renaissance idea of the painting as a window or a mirror, and, while fiercely devoted to painting, found their work looking not unlike Duchamp's *Fresh Widow* of 1920, a model of a French door, painted green, with the panes of glass blacked out.

V

If Reinhardt, a macho aesthete, was the New York School's biggest joker, Jasper Johns used jokey subjects to strike the pose of an aesthete. If Rothko

Rudy Burckhardt,
Alex Katz cutouts,
1962.

had pulled down the shades and Reinhardt had turned out the lights, Jasper Johns knew exactly what to do next. He created, in 1958, sculptures of a light-bulb and a flashlight, and, a year later, a painting with a window shade attached to the canvas. There can be no question but that a lot of people believed that painting was in trouble, and one of those people was Alex Katz, a painter with a nose for the shifting moods of artistic Manhattan, who zeroed in on the new, painting-is-most-itself-when-it-is-least-itself attitude when he turned from paintings to painted cutouts for a show that opened at the Tanager Gallery, on East Tenth Street, in February 1962. The cutouts were of figures, somewhat less than life-size, painted on wood, so that they could stand in the gallery. Painted smoothly and fluidly, with the brushwork showing but not showy, they were suave and amusing, also a little spooky, these standing or sitting figures of Alex's wife, Ada, and quite a few other people. The announcement for the show was a photograph by Rudy Burckhardt of the cutouts gathered together, probably in the artist's studio—a gathering of artists, poets, wives, lovers, and a few kids. That announcement conveys, even now, several generations later, some of the excitement of the Tanager show, a show in which painted figures took up real space and a whole bohemian world encountered itself in frozen, cutout form. In short, Katz was turning people into readymades—or, considering that they were painted figures, into "readymades aided." That spiffy term had been dreamed up by Duchamp himself, for the symposium organized at the Museum of Modern Art at the time of

Alex Katz, Frank O'Hara, *1959–60. Oil on wood, 60 in. high.*

"The Art of Assemblage." "Since the tubes of paint used by the artist are manufactured and readymade products," Duchamp said, "we must conclude that all paintings in the world are 'Readymades Aided'—and also works of assemblage."[31] Which turned painting inside out.

Edwin Denby was at the Tanager opening, white-haired, thin, with a head that was all skull—a gentle, feeling skull. Everybody—the artists, the downtown crowd—was "in good humor"; at least that was Denby's impression. Denby had already seen most of the cutouts in Katz's studio, so Katz suggested he go into the office in the back and look at some collages that were stored in the racks. Denby began to look at the collages, and then noticed—he recalled all this in a piece written a few years later—"that Frank O'Hara had come in and was standing a few feet away, absorbed in the show. I quickly turned to speak to him. But he wasn't there; it was the cutout of Frank that had fooled me. A moment later with a deeper misgiving I realized that the Frank who had fooled me was only three-quarters life size. The joke—Katz's—wasn't nice at all."[32] The O'Hara who fooled Denby was young and earnest, dressed in jacket and tie, hairline receding, hands to his sides, legs together, body cantilevered a bit forward, as if he were the figurehead of a ship—a ship called the School of New York. Denby's observation that it "wasn't nice at all" suggests the touch of acid that was built into the cutouts, into their ironic take on the roles that people play. The cutouts turned the artist and his friends, Denby among them, into poseurs, dummies, two-dimensional men and women. "Like the flat figures imported into England from Vienna to scare off burglars from the hearth," O'Hara wrote, "they assumed a presence so extreme that one painter who purchased a cut-out was terrified each morning that a thief was standing beside her bed and was relieved to lend it to an exhibition."[33] A readymade thief. The cutouts were works of art dropped in the midst of life. But the cutouts (at least these early ones) were painted with such deadpan ease that the spookiness didn't hurt much. And if there was some sort of social comment implied—a suggestion that all the artists and poets and lovers were just dummies, part of the scenery—that comment could be taken as nothing more than terrific downtown repartee.

Katz was thirty-four at the time of the Tanager show, a slim, angular, dark-

haired guy with the jutting profile of a figure on
an Egyptian bas-relief. He was a person with lots
of energy, a good basketball player and a good
dancer, and in bringing together these cutouts he
was styling himself a downtown impresario trans-
forming bohemia into a chamber theater for adults.
The lightheartedness of Katz's cutout show was
grounded in careful calculation. Katz understood
that the downtowners were now self-confident
enough to get a kick out of this exhibition in which
they were themselves the comic subject matter.
"The New York School is a fact," Frank O'Hara
and Larry Rivers had announced in a humorous
guide to "How to Proceed in the Arts," published
in *Evergreen Review* in 1961.[34] And among the
facts, one might count the dramatis personae of
Alex Katz's cutout show. Here was the painter Philip
Pearlstein, a short, bespectacled man, in shirtsleeves
and tie (artists still as a rule wore ties), his arms
folded in front of him. And here was Maxine Groff-
sky—a familiar figure in the downtown bars and on
the beaches of artistic Long Island—standing, stat-
uesque in a bikini, her hair in a flip just grazing her

Alex Katz, Maxine, 1959.
Oil on wood, 64½ in. high.

shoulders. When a gallerygoer went around to look at Groffsky's back, it
turned out that she was undressed, a jokey reference to her many romantic
alliances. Years later, Terry Southern remembered an occasion when O'Hara
exclaimed: "Maxine! Oh dear Mary, how can we *ever* think of anything to
shock Maxine?!?"[35]

 To artists of Katz's age, the 1950s had been incredible, a time of entrances,
performances, public triumphs. At the Cedar Tavern, theatricality was an
aspect of everyday life. "If Jackson Pollock tore the door off the men's room
in the Cedar," O'Hara wrote, "it was something he just did and was interest-
ing, not an annoyance." And Larry Rivers said that "Pollock was the first
artist in America to be 'on stage.' "[36] Katz's cutouts were a natural extension of
all the delicious, alternately histrionic and goofy playacting that was going on
downtown. The people in Katz's portraits had walked out of the paintings into
the gallery; they were on the verge of striking up conversations with the peo-
ple that had come to see the show. The story of how Katz came to do the

cutouts goes as follows. Katz, in the late 1950s, was painting figures in a space as flat and ambiguous as that in a painting by Rothko. One of the compositions wasn't working to the artist's satisfaction, and so he just cut out the figure and mounted it on a board. Thus it was a formal problem that sent the person in the painting out to rub shoulders with the person looking at the painting. Whether or not the story is true, it clicks as a little allegory of the artist's dramatic break with the flatness of Abstract Expressionism. The leap off the wall into the space of the studio or the gallery was convincing because it was motivated by something more urgent than a clever reaction to the enigmatic depthless depths of abstract art. Painting, abstract or otherwise, necessitates a belief in the reality of a fictional universe that Alex Katz may not be willing to embrace. For Katz a canvas is somehow never more than a flat surface, a spectacular backdrop. He is an artist who doesn't see the limitless metaphoric possibilities of flatness, which explains his eagerness at least to experiment with this flight from flatness. It was a good move for him. It is only in the cutouts, where Katz's work approaches theater, that he is really first-rate.

The occasional Katz paintings that are nearly as engaging as the cutouts are those in which he frankly adopts some of the spirit of décor—whether of small heraldic devices or of Times Square–scale billboards. One of the best of the smaller paintings is a diptych of two heads, called *Marine and Sailor,* from 1961, around the time that Katz was working on the cutouts for the Tanager show. It shows O'Hara at left as the marine and his young poet friend Bill Berkson at right as the sailor. Formally, this picture is nothing much. But there is a poker-faced humor about it, owing at least in part to the pleasingly unemphatic paint handling. Here Katz evinces a complicated wit by painting the two friends in costumes that hark back to the 1940s, to Jerome Robbins's ballet *Fancy Free* and the romance of sailors and strange ports of call. The paint-

Alex Katz,
Marine and Sailor,
1961. Oil on canvas,
19 × 44 in.

ing is nostalgic for 1940s nostalgia, but it's nostalgic in a new, 1960s way that makes fun of the nostalgia by presenting it as something flat, posterish, hard, detached—"disconcertingly calm," as John Ashbery observed of Katz's realism.[37] This is nostalgia without depth, nostalgia as an ironic gesture. And then the irony becomes a kind of feeling because O'Hara and Berkson, their profiles as imperturbable as profiles on two Renaissance medallions, are also attractive men, casting veiled but romantic looks at each other. The painting, after everything else, is about the romantic friendships of bohemians, and this friendship is both masked and revealed by the costumes, because these disguises turn O'Hara and Berkson into other people even as the maritime theme suggests their lives of erotic adventure. No other painter of the time captures the romantic beauty of men as well as Katz.

VI

Katz's paintings and cutouts add up to a portrait gallery of the people of his time. Getting into the work involves getting into the connections between the people and the pictures—it is high-level downtown gossip. The connections among the actors are so thick that they overwhelm analysis. Here are Denby, his friend Burckhardt, Katz's wife, Ada, and the dancer Paul Taylor, who would, initially at Denby's suggestion, use many sets by Katz from 1960 onward, including some with cutouts. One of Katz's portraits of Taylor is on a flat but somewhat loosely brushed field of color—the dancer in white tights in a void of gray. The affectless look of so many of Katz's faces relates to a kind of affectlessness that Taylor had experimented with in his early dances. The first solo that Taylor made for himself was the 1957 *Epic*, in which he wore a business suit and performed abrupt but ordinary movements that he later referred to as "interesting street gleanings."[38] The dance was commemorated in a photograph by Rauschenberg in which the stiff, blank-faced Taylor resembles nothing so much as an Alex Katz cutout. *Epic* was readymade dance, with its off-the-rack costume and ordinary movements. Katz collaborated with Taylor on quite a few occasions, beginning with sets and costumes for *Meridian* at the Festival of Two Worlds in Spoleto in 1960, where Smith worked several years later. In 1963 they were back in Spoleto, to create the elaborate *Red Room*. In a program note written for Taylor's 1964 appearance at Spoleto, Denby recalled the avant-gardism of Taylor's first dances, especially *Epic*, which was "set to a tape of the voice on the telephone, 'When you hear the tone, the time will be . . .' " Now, "ten years later, Taylor is choreo-

graphing to Ives, Schuller, Haendel, Haieff. The action, though different from classic ballet, is no more avantgarde than the music." Then Denby proceeded, as if it were a necessary non sequitur, to remark that "today's avantgarde is as engaged, now as in the past, with anti-music, anti-dance, anti-theatre, and everybody agrees it is a good thing to have around."[39]

That "everybody" floated in the air, an anonymous body of opinion to which Denby did not exactly explain his relationship. The point was that, at least in Taylor's case, anti-dance had nourished dance. Something similar could be said about Katz and anti-painting. The Alex Katz cutouts came out of an anti-painting sensibility, but of course they were also painting that was rescued from the end of painting and returned to its trompe l'oeil roots (reinventing the harpsichord yet again). The idea of the readymade, of the found object, was very much in the air. The exhibition was an imitation of a readymade, a careful reconstruction of a found crowd, and in that sense not unlike Duchamp's careful reconstruction of a suitcase for his *Box in a Valise*. And one might go a step further and argue that Katz's meticulous, realist painterly technique had a readymade quality as well, for this was the impassive naturalistic kind of painting that was the man in the street's idea of how a painting ought to look. If, as Rosenberg had observed, the painters had pulled down the shades and turned out the lights and left artists with Reinhardt's black-on-black surface, then Katz's response was that the men and women in his paintings had to escape into the three-dimensional world, where, strange to say, they would appear in the guise of more or less traditional although very oddly cropped paintings.

Denby's slim article about Katz, published in *Art News* in 1965, was a sheaf of impressions rather than an essay, but it was significant as one of the few pieces that this legendary dance critic and poet wrote about painting, though he passed his life among painters. I think what attracted Denby to the subject of Katz was what had inspired him, several times, to write about de Kooning: his interest in each artist's ambience. For Denby, de Kooning was the spirit of New York in the 1930s, the long nights talking over cups of coffee in the cafeterias, the walks through the streets where the painter would point out the beauty of the patterns of stains and graffiti on the sidewalks. Katz was a different matter. He was not so much the embodiment of a period as of a shift from one period to the next—from the 1950s to the 1960s. Denby may well have chosen to write about the cutouts rather than the paintings because the cutouts were the best of Katz's work, but I think that Denby focused on the cutouts also because he understood that the reception of the cutouts

signaled a sea change. Denby recalled how, in 1959, when Katz had shown some humorous collages at the Tanager Gallery, "good painters of his generation looked at them sourly. They pointed out that they were not collages in any deep sense. They even suspected them of making fun of Abstract Expressionism." But three years later, "everybody was in good humor."[40] Everybody was ready for a readymade. Katz's February show, where Denby found his friend O'Hara transformed into a comic icon, was a signal event. Of course Katz's show was not widely publicized, at least not in the sense that one would think of publicity a few years later, but so far as Denby was concerned, the cutouts, with their abruptness, were saying "Cut!" to a whole Abstract Expressionist era.

THE ARTIST AND THE PUBLIC

11. GOING TO THE MODERN

I

The Temple of Culture, for centuries a linchpin of city life, was on New Yorkers' minds in the years around 1960. Frank Lloyd Wright's Guggenheim Museum, nearly twenty years in the works, opened on Fifth Avenue and Eighty-ninth Street in 1959, just as the directors of the New York City Ballet, the New York City Opera, the Metropolitan Opera, and the New York Philharmonic were beginning construction on Lincoln Center, which would go up in increments throughout the 1960s, across town, in the West Sixties.

The role of patron that Nelson Rockefeller, the governor of New York, played in the creation of a theater for George Balanchine, the greatest choreographer of the age, was not strictly financial in the sense that Solomon R. Guggenheim's role had been in bankrolling the only freestanding building in New York by Frank Lloyd Wright, the greatest architect of the age. But there was reason to see, in these structures rising diagonally across the city from each other, the culmination of an especially American and even New York City saga involving the union of turn-of-the-century fortunes and twentieth-century art. And this was hardly the end of the upsurge in cultural construction projects in the early 1960s. Nelson Rockefeller was the second son of Abby Aldrich Rockefeller, Mrs. John D. Rockefeller, Jr., one of the founders of the Museum of Modern Art in 1929. In the early 1960s he and his family were deeply involved in the expansion of the Modern. Nelson, David, and John D. Jr. gave more than a million dollars each. Combined with sources from other relatives, the total Rockefeller contribution came to something like half of the twenty-five million dollars that the museum raised to expand in a number of ways. This included a new building at the northeast end of the Modern's site, designed by Philip Johnson, who was also designing the New York State Theater at Lincoln Center, where Balanchine's company would have its first permanent home.

David Hanson, the New
York State Theater,
designed by Philip
Johnson, 1964.

New York's old public spaces, such as the Metropolitan Opera House, were proving inadequate for a growing population with a growing appetite for cultural experience. This was a decade that would see the beginnings of the preservation movement, with its defense of the unrecoverable grandeur of old buildings. Arthur Drexler, a man with a passion for all things modern who headed the design department at the Modern, said of the impending destruction of McKim, Mead and White's Pennsylvania Station, "The next thing we know, someone's going to suggest that the Statue of Liberty doesn't pay its own way."[1] And yet there was still an optimistic hope that architects and planners and patrons would add something significant to the urban picture. "The two decades before 1970," wrote Henry-Russell Hitchcock, who with Johnson had organized the groundbreaking show of International Style architecture at the Modern in 1932, "saw the production of a great part of the urban and suburban settings in which we will probably be living for the rest of this century." The buildings that went up were not always of the highest quality, Hitchcock wrote in an edition of his history of twentieth-century architecture published in the early 1970s. Still, thinking of the postwar skyscrapers, he observed that "the post-war years—and particularly the sixties and early seventies—saw the realization of many urbanistic ideals that seemed fantastic or Utopian when they were first proposed some fifty years ago."[2] What Hitchcock had in mind were the great commercial towers rising in many cities, but the new temples of culture were part of the same surge, and his old friend Philip Johnson's move away from a severe modern style definitely reflected the mood of the moment.

Lincoln Kirstein, while acknowledging that some would always regret the

departure of the New York City Ballet from City Center, the former Mecca Temple on Fifty-fifth Street, where W. H. Auden had liked to frequent the bar across the street, had high hopes that a great building might be created in the West Sixties. He saw in the plans for a grand rectilinear lobby for the State Theater that he was working on with Johnson a space that would "serve as parlor for the metropolis," a "space suitable for welcoming heads of state, conquering heroes, astronauts, and international cultural ambassadors." He hoped it would be "the most splendid interior our city possessed since the great waiting rooms of the Grand Central and Pennsylvania railroad stations, now defaced or doomed."[3] Writing in *Art in America* in 1960, the architecture critic Ada Louise Huxtable discussed a resurgence of what she saw as romanticism in architecture, and located Johnson at the center of this move. "All great architecture," Huxtable observed, "is romantic architecture," romantic in its "realization of a dream or an ideal," whether that is "the calculated classicism of a Mies van der Rohe or the exuberant fantasy of an Antoni Gaudí." Huxtable singled out Johnson as "the most serious exponent of Romantic Classicism," with its echoes of the late-eighteenth- and early-nineteenth-century fantasies of Karl Friedrich Schinkel and Claude-Nicolas Ledoux. She wrote of Johnson's "sensitively modeled, symmetrical arcades," and observed that Lincoln Center, as a totality, was developing "in the modern image of Romantic Classicism."[4]

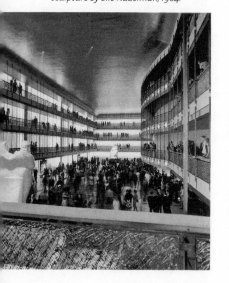

Ezra Stoller, lobby of the New York State Theater with sculpture by Elie Nadelman, 1964.

Kirstein and Johnson had been to Japan, where, Kirstein said, they had admired "the Japanese rectilinear modular systems" and the "fanciful polychromy" of "the Momoyana baroque and the lacquered glories of Nikko's shrines and Kyoto's Nijo Palace." Johnson had finally distilled or transformed all of this into a Romantic-Classic vocabulary of "champagne-colored travertine, gilt bronze, rose marble, a fourteen-carat-gold ceiling, and gilt anodized bead curtains for the large front windows." There was art by rising talents of the day, including Lee Bontecou and Jasper Johns, who had used a tracing of Merce Cunningham's foot as the modular unit for his painting. And there were marble enlargements of circus women by Elie Nadelman. And it all added up to "a festive visual fanfare for whatever spectacle was held within."[5] This slim, tall rectangular box of air, an indoor piazza encircled

by row upon row of gold balconies, was about as good as architecture could be when it was done by a brilliant man who had not a smidgen of genius. And a big crowd could turn the New York State Theater into one of the most thrilling places in the world. Compared with Frank Lloyd Wright's Guggenheim, that other indoor piazza encircled with balconies, the New York State Theater was an inert space, but both interiors were in their own ways places in which the walking and standing and looking that are the essence of New York were channeled, refocused, and if possible made even more theatrical than they are on the streets themselves. It may even be that Johnson's design owed something to the plan for the Guggenheim, where, as Lewis Mumford wrote in *The New Yorker* in 1959, the "dynamic flow is accentuated by the silhouettes of the spectators, who form a moving frieze against the intermittent spots of painting on the walls."[6]

II

The story of Frank Lloyd Wright's Guggenheim wound back nearly two decades, to 1943. Hilla Rebay, the curator of what was then known as the Museum of Non-Objective Painting, had written to ask Wright if he would consider designing "a building for our collection of non-objective paintings. I feel that each of these great masterpieces should be organized into space and only you so it seems to me would test the possibilities to do so." Rebay was Solomon R. Guggenheim's lover, and it was with his money that she had built this formidable collection of modern art, with its emphasis on the sublime Kandinsky and his very minor follower, Rudolf Bauer. In 1938 and 1939, John Graham was employed by Rebay, as the collection was opening to the public. Housed in rented midtown quarters, "all in silver gray," as Rebay described them, with "soft carpets and Bach's music," the museum had been an invaluable primary source for the understanding of modern art.[7] But there was also about Rebay's museum a crackpot mystical fervor and a posh exclusivity that appealed far less to many artists than the Museum of Modern Art's more pluralistic, more straight-talking viewpoint.

Rebay's introduction to a 1939 catalog proclaimed, "Genius is a special gift of God to the elite of a nation."[8] Jackson Pollock was one of the young geniuses (although not by Rebay's lights) who worked at the museum in the 1940s, doing anything from running the elevator to helping hang shows. These young artists might have agreed with Rebay that creative people were God's gift to mankind, but her language was pitched too high, too narrowly

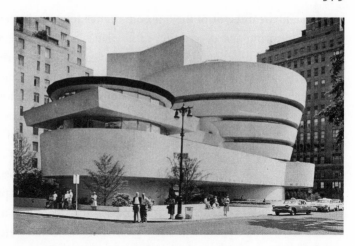

Solomon R. Guggenheim
Museum, designed by
Frank Lloyd Wright, 1959.

for their taste. Leland Bell worked there briefly as a guard, but was fired for suggesting that a visitor go and see a Mondrian show. The presentation of modern art at the Modern was more plainspoken and infinitely more wide-ranging. The presentation at Art of This Century, the gallery that Guggenheim's niece Peggy opened in 1942, and where Pollock and many other Americans were able to show their work, was more crazily amusing, infinitely less predictable. True, Rebay's museum had a cache of early Kandinskys that fascinated the Abstract Expressionists; the term *Abstract Expressionism* had been applied to Kandinsky by Alfred Barr in the catalog for "Cubism and Abstract Art" all the way back in 1936. But the Museum of Non-Objective Painting, which moved to 1071 Fifth Avenue in 1947 and became the Guggenheim Museum in 1952, was felt by many artists to have less to do with the excitement of modern art than with its oppressive orthodoxies. And for many artists, the Frank Lloyd Wright building, as it finally began to come into focus in the 1950s, was only the most glaring example of Rebay's obtuseness, of her insistence on turning the open-endedness of modern art into a mad labyrinth of intertwining circles, a knotted mystical behemoth.

The Guggenheim, that spiraling drumroll of a museum, with its surprising mix of buoyancy and weightiness, had an immediate iconographic power. Even before the museum was going up on Fifth Avenue, you could feel that power in the architectural renderings that were appearing in the press. By the time the Guggenheim was in the final planning stages, Pollock was already dead, but among those who protested the unsuitability of Wright's design for a museum of modern art were many artists of his generation, including de Kooning, Guston, Kline, Motherwell, and Milton Avery. In a 1957 letter to the

trustees and the director of the museum, James Johnson Sweeney, they wrote that "the drawing and description of its plan that have appeared in the New York papers and other publications make it clear that the interior design of the building is not suitable for a sympathetic display of painting and sculpture. The basic concept of curvilinear slope for presentation of painting and sculpture indicates a callous disregard for the fundamental rectilinear frame of reference necessary for the adequate visual contemplation of works of art." What the artists were comparing the Guggenheim to was of course the cool, seemingly dispassionate setting that Alfred Barr and the Museum of Modern Art had perfected, and which had nothing to do with Rebay's piped-in Bach or grandiose pronouncements, or with Wright's insistence that a museum could be a space with a dynamic poetic power that carried all before it. Wright's response to the artists was that architecture was "THE MOTHER ART," an idea that involved an image of ancient worship that was exactly the kind of artsy, religiose thing that the artists had rejected a decade earlier. "THERE IS NO 'RECTILINEAR FRAME OF REFERENCE' WHATEVER FOR THE EXHIBITION OF A PAINTING," Wright telegrammed his "FELLOW ARTISTS," "EXCEPT ONE RAISED BY CALLOUS DISREGARD OF NATURE, ALL TOO COMMON TO YOUR ART." Expanding on this idea, Wright argued that museums had in fact been denying the "FREE NATURE" of modern painting through the "CONVENTIONAL, STATIC MANNER" of their design.[9]

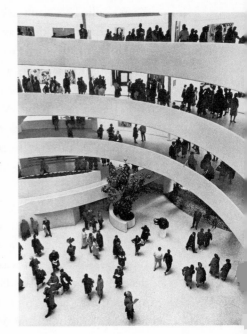

What Wright believed to be a space that celebrated the free-flowing beauty of modern art struck many New York artists as anything but. Hess, executive editor of *Art News* and a friend of many of the artists who had signed the protest letter, described the museum at the time that it finally opened in 1959 as "giant, inhuman," a machine that "shoots a crowd up in an elevator that ejects it on level five; then it rolls down the ramp past a third of a mile of art."[10] "You leave the museum," Hess concluded, "as Charlie Chaplin left the revolving door, still spinning, around the sales desk, by the columns, out to the sidewalk." Remembering what the Janises had said about some of Duchamp's

*George Cserna, interior of the
Solomon R. Guggenheim Museum, 1960.*

images as having a mechanistic aura reminiscent of Chaplin's *Modern Times,* one might think of the Guggenheim as turning artists and museumgoers alike into victims of an absurdist, even Dadaist drama. But it was Mumford, in *The New Yorker,* who was the most exact of all the critics of the building. He found the exterior "elephantine" and "formidably *im*pressive, but it is not *ex*pressive of anything except the desire for monumental solidity." Mumford, who believed that the key to architecture was its humane relationship with ordinary experience, agreed with the artists that, considered as a place to look at paintings and sculpture, which was, after all, its purpose, the Guggenheim was "an audacious failure."[11]

And yet the experience of entering the building had an undeniable power. "Wright has you in his hold," Mumford wrote. While the building was surely a gigantic architectural ego trip, there was also an extraordinary restraint in this composition, at least when considered as form pure and simple. "Wright, like a good disciple of Lao-tse, dramatizes its essential element—the central void, filled with light." And he wondered, "What other monumental interior in America produces such an overwhelming effect?"[12] For Mumford, the feeling for space that Wright demonstrated was, on its own terms, masterful, definitive. Mumford's estimate was seconded by Frederick Kiesler, the architect who had designed the wildly biomorphic interior of Peggy Guggenheim's Art of This Century gallery in the early 1940s and whose idea for that gallery of exhibiting paintings not flat on the wall but protruding out from the wall may be seen as a precursor of the original hanging method at the Guggenheim. Hess, in his account in *Art News,* reported that Kiesler had suggested that all the paintings be removed and the entire building be filled with a "gigantic statue of Wright." In *It Is,* the magazine edited by Philip Pavia, one of the founding members of the Club, Kiesler admitted that Wright "den[ied] to a building the very function it is built for, in this case for exhibiting contemporary art, so completely that it is the ultimate achievement in non-functional architecture." But that was not the end of it. "The man who hated abstract art," Kiesler concluded, "produced the only abstract building of our time."[13]

It is worth pointing out that the paintings that look best in Wright's Guggenheim are in fact the works by Kandinsky and other early moderns that were at the core of the museum's collection. Which suggests that Wright was more sensitive to the original purpose of the museum than has often been acknowledged. Nevertheless, the Guggenheim would prove to be a problematic building, unfriendly to much sculpture, to many kinds of painting, and short on office and storage space. After Solomon Guggenheim's death, Harry

Guggenheim, a nephew, began running the foundation; Hilla Rebay's role was reduced; and James Johnson Sweeney, who had earlier been at the Museum of Modern Art, became director. Throughout the final design processes of the 1950s, Sweeney and Wright were locked in an increasingly acrimonious series of battles, with Wright accusing Sweeney of wanting to turn his visionary structure into an utterly conventional exhibition space. They battled over everything from storage room to the beige walls that Wright wanted but that Sweeney felt were unfriendly to paintings. Certainly the Guggenheim would prove to be all wrong for Abstract Expressionist paintings, with their oversized dimensions and singular power. The building had a showman's futurist bravura that would never sit well with the kind of back-to-basics ethos that downtown artists favored and saw as their kind of elegance.

What Wright had done at the Guggenheim was to create a startlingly modern building that made a direct, dramatic connection with the public. And behind all the specific disagreements that Wright had with Sweeney and the artists, there was probably a far broader disagreement about the nature of the experience of modern art and what it might mean to the public. When the Guggenheim finally opened on Wednesday, October 21, 1959, the story of what was called "the most controversial building ever to rise in New York" was front-page news in *The New York Times* for two days. And the following Monday the museum was again on the front page, where the *Times* ran a photograph of a crowd-packed Fifth Avenue and reported that the Guggenheim was such an enormous success that people had to be turned away. The caption announced: "There Just Wasn't Enough Room."[14] For a museum that had for much of its life been an extremely private and inward-turning institution, this was an astonishing turnaround—and a testament of some sort to Wright, whom Mumford had called "one of our giant redwoods" when he died just a few months before the official opening.[15] Wright's Guggenheim might be a throwback, but its biomorphism, its fantasy element, though grounded in Wright's own thinking of the 1930s, excited a broad public in 1959. In his own way, Wright was embracing an idea of the museum as a dramatic exhibition hall that recalled the dizzyingly glamorous international expositions of another era, expositions that had had much to do with bringing new art to the attention of the public.

In *Art News*, Hess observed of the Guggenheim that "this is an Art of the Future of thirty years ago, when being Modern meant thinking in terms of this sort of tub-thumping optimism." Hess was right to see echoes of the City of

the Future. Indeed, among Wright's countless earlier designs for the museum were a blue hexagonal design and ziggurats in pink and orange and black marble that looked like nothing so much as the extravaganzas at a world's fair. Wright knew how to give his brand of modern style a popular tingle. And New York artists were uneasy about that, to put it mildly. Of course they hungered for success, but many of them were nevertheless dead set against modern art's being presented as a form of pop futurist agitprop. Wright's optimism was grounded in the aesthetics of the 1920s and 1930s, but that optimism was once again relevant after World War II, when world's fairs in Europe and then New York brought forth a new round of extravagant architectural conceits. By the late 1950s, people were thinking that modern design should unbutton, should let down its hair. When the poet Denise Levertov visited Wright's new museum, she wrote to Robert Duncan, "I can't see why so many people object to it. . . . It *is* an imaginative & essentially a *romantic* work & as such a great relief in N.Y.'s architectural swamp."[16]

It was in the 1950s that the true believers in the International Style began to reconsider Art Nouveau—which was modern design's romantic, intoxicated past. The old purist Le Corbusier used unpredictably curved forms in the Ronchamp Chapel (1950–55) and wrote an introduction to a picture book about Gaudí, while at the Museum of Modern Art there were shows devoted to Gaudí (in 1957) and Art Nouveau (in 1960) that stand as landmarks in the

history of taste; Levertov's friends Duncan and Jess were enormous fans of Art Nouveau. The slim, elegant catalog of the Modern's Gaudí show, which was written by Henry-Russell Hitchcock, Philip Johnson's friend and collaborator on the International Style show a generation earlier, predated by scarcely a decade the discovery of Art Nouveau by the psychedelic generation. And all of this related to Ada Louise Huxtable's ideas about a resurgence of romanticism in architecture, in what she called the structural romanticism of Eero Saarinen's TWA terminal at what is now Kennedy Airport, and in Philip Johnson's New York State Theater, but perhaps even more so in Johnson's designs for the New York State

*Ezra Stoller, New York State Pavilion, New York World's Fair,
designed by Philip Johnson, 1964.*

Pavilion at the 1964 World's Fair, an extravaganza of echoing circles that suggests Wright's late style. Architecture was returning to older ideas of showmanship as it reached to answer the public's new interest in showmanship, which at Johnson's New York State Pavilion was suggested by the huge mural by Andy Warhol of *Thirteen Most Wanted Men* that was mounted on the façade, at least temporarily, before an uproar led to its removal.

III

Projects such as the Guggenheim Museum and Lincoln Center reflected an old-fashioned public spiritedness about cultural matters, no question about it. Artists, along with other sophisticated New Yorkers, might complain about the designs of these buildings and worry more generally about the transformation of avant-gardism into an overly formalized, travertine-clad kind of high culture, but there was also something thrilling in the publicness that had been achieved by mid-century by the Abstract Expressionist paintings and the abstract ballets of Balanchine. That a public spiritedness could be put in the service of modern art was already an idea that was a generation or maybe two generations old in the United States. Efforts to found a ballet company for Balanchine went back to the 1930s. The Modern had been founded in 1929, the Whitney in 1930, the Guggenheim in 1939. Yet the relationship of contemporary art institutions to contemporary art in New York had always been a vexed one, with the artists frustrated at a reluctance to embrace homegrown developments even at institutions such as the Modern or the Guggenheim, which were often more assiduous about following avant-garde developments in Europe than at home. Now, at long last, the situation was changing, and the museums were inclined to agree with the artists that New York had become the first city of modern art. Artists were happy about this, even as they worried about their ability to master a rapidly expanding cultural scene.

"With rising educational levels," Daniel Bell wrote in *The End of Ideology*, published in 1960, "more individuals are able to indulge a wider variety of interests." In Bell's book a record salesman is quoted as saying: "Twenty years ago you couldn't sell Beethoven out of New York. Today we sell Palestrina, Monteverdi, Gabrieli, and Renaissance and Baroque music in large quantities." *The End of Ideology* was a critique of European theories of "mass society," it was a plea for a more empirical, less grandiose view of the human condition, and the thrust of Bell's book was that the new middle-class world, a world that was happy to believe in the here and now, had its advantages. "One

hears," Bell wrote, "the complaint that divorce, crime, and violence demon-
strate a widespread social disorganization in the country. But the rising num-
ber of divorces may indicate not the disruption of the family but a freer, more
individualistic basis of choice and the emergence of the 'companionship' mar-
riage."[17] Art was one of the aspects of life in which a person might choose to
be interested; the Abstract Expressionist artists and what they were doing
were beginning to fascinate even the man on the street. And about the new
museums and theaters and concert halls going up in New York, which had to
them elements of an old-fashioned high-culture solemnity, there was also an
aura of populist festivity, of giddy, publicity-conscious high spirits. Already
during World War II a new audience had been gravitating toward the avant-
garde, when the Museum of Modern Art became a top tourist attraction for
soldiers visiting New York.

The new, easygoing approach to cultural life could be exhilarating, liber-
ating, and also strange. The visit of the *Mona Lisa* to the United States in
1963—in less than a month the painting was seen by more than a million peo-
ple at the Metropolitan Museum—was only one of a large number of events
that suggested dramatic shifts in cultural expectations. When Old Masters
could pull in pop-concert-sized crowds, one might begin to wonder about the
distance between the dime store and the museum. Around the time that
Leonardo's smiling portrait was visiting America, there was also a good deal
of discussion about plans to send Michelangelo's *Pietà* to New York for the
1964 World's Fair. Culture was big business, museums were breaking their
attendance records, and modern art was part of the mix. On Sunday, Novem-
ber 19, 1961, 6,300 people jammed the Museum of Modern Art to see Chagall's
stained-glass windows depicting the twelve tribes of Israel, which were in
New York for a brief visit before being permanently installed in the Syna-
gogue of Hadassah Hospital in Jerusalem. A week later, 86,770 people filed
through the Great Hall of the Metropolitan Museum of Art in the space of
four hours to contemplate the Met's new $2.3 million masterpiece, Rem-
brandt's *Aristotle Contemplating a Bust of Homer*. In June of 1962, *Time*
reported that 140,000 people had paid to go to nine galleries in New York that
mounted an homage to Picasso, who'd turned eighty in 1961.[18]

All of this could feel like the ultimate triumph of nineteenth-century cul-
tural populism—and then some. At the end of 1961, the Samuel H. Kress
Foundation distributed its enormous collection of Renaissance art among sev-
eral dozen museums around the country. As Guy Emerson, director of the
foundation, explained, "With the same insight that had enabled [Samuel H.

Joachim Schuppe, crowds
viewing Rembrandt's
Aristotle Contemplating a
Bust of Homer at the
Metropolitan Museum of
Art in November 1961.

Kress] to recognize . . . the need in the Southern States for popular stores, he now recognized the need in America for more of the cultural advantages that art could afford and he set himself the goal of meeting that need in the domain of Italian art."[19] A year later, Sears, Roebuck and Co. opened a series of in-store art galleries; the company wanted to prove that popular commerce could actually provide cultural advantages. The buyer for this new enterprise was the actor Vincent Price, a star of horror movies who also happened to be an art collector. He purchased some "2,700 paintings, watercolors, drawings, etchings, and lithographs to stock twelve Sears stores—mostly with items under $100." "Snapped up at a fancy preview" at the gallery in the new Oakbrook Shopping Center outside Chicago, *Newsweek* reported, "before the working-man was given his chance to put $5 down, were five Rembrandt etchings (one for $1,500), and works by modern artists, from Marc Chagall to the New York painter Reginald Pollack."[20]

" 'I've been to some art galleries downtown,' commented a sales engineer visiting the store's art display. 'But here, with Vincent Price picking them out, you can feel a little surer. And I feel more at home in Sears than in an art gallery.' " "One befurred lady who dropped in at the store with the general public bought a Hogarth engraving for $30. 'I go to art galleries sometimes,' she said, 'but this is better. Wrap it up,' she said to the sales clerk, 'I'll take it with me.' "[21] Somewhere between the 1950s and the 1960s, high culture

became, in many people's minds, a dimension of popular culture. This was not an idea dreamed up in an artist's studio or a scholar's study; it was a sea change in the middle-class imagination, a result of changing opportunities and aspirations. And to the extent that these transformations thrust the arts into an increasingly exposed position, artists were, willy-nilly, going to have to deal with it.

IV

In the late 1950s and early 1960s, there was a gathering crisis around the whole question of who led and who followed in the visual arts, and of who would or indeed could describe what the past meant to the future. The letter that de Kooning, Guston, and other artists wrote to the trustees and director of the Guggenheim protesting Wright's design was one small element in this ever growing controversy. What was developing was a perplexing situation, for the heightened profile of all art and especially of modern art was beginning to affect the ability of artists to shape the future that they believed was theirs. When Wright argued that architecture was the mother art, he was offering a view of modern art as the experience not of an individual artist but as a vast communal experience to which Wright would give an ultimate visionary form. And with the Guggenheim going up on Fifth Avenue, he seemed to be getting his way. But for many New York artists, the truest experiences of the modern spirit remained inward-turning, private, art-for-art's-sake, not art-for-society's-sake.

Nobody could exactly be unhappy about the ever growing attention that the public was paying to artists and the ever growing eagerness of museum people and dealers and critics to tell each group what the others were up to. Nobody who had really lived downtown in the hardscrabble years of the 1930s and 1940s would have wanted to return to those times, and yet the question of gains and losses was a real one. The obscurity of the artists had allowed them to decide or to at least feel that they were deciding what was what and where they were going. Sitting late at night, drinking coffee in the downtown cafeterias, they could come to some at least temporary agreement about what the past meant, and what the present looked like. And that freedom among artists to judge things for themselves was beginning to be regarded nostalgically. As we have seen, when the painter Pat Passlof organized "The '30s: Painting in New York" at Poindexter in 1957, the first double-page spread in the catalog, with its juxtaposition of a vigorously curvilinear Gorky and a composition of

four rectangles on a dark ground by Diller, seemed to say, "This was the range of our thinking back then." From the perspective of that complex dialectic—the biomorphic and the geometric, the romantic and the classic—"the general look of painting today," at least as Denby observed in his essay for Passlof's catalog, was merely "seductive. It makes the miles of New York galleries as luxurious to wander through as a slave market."[22] This remark, which we've read before, bears repeating. The artists were becoming famous. But they were no longer exactly free.

While in the 1930s the artists had had a sense that they were acting in history, that had been stealth acting—a cenacle, behind the scenes. By the end of the 1950s, success was no longer an abstraction, a daydream, a compact between you and your friends. Success was now something that a lot of people rubbed up against and of which many got at least a taste. There were more artists, the stakes were higher. Nobody would ever again know that mildly easygoing and mildly depressed quality that the artists had known in the 1940s. And the effect could be damn confusing. One day, Fielding Dawson went down to Philadelphia on a crowded commuter train with Kline, who was visiting his mother in the hospital. Another painter had come along, a friend of Kline's who now taught in the Midwest. Perhaps no artist of the 1950s made quite so strong an impression as Kline, whom Denby had remembered as an "adorable hero" with a "wide chest." As Kline, his friend, and Dawson were sitting on that train to Philadelphia, surrounded by all the nine-to-fivers, Dawson noticed how Kline's demeanor "puzzled the businessmen." They were, Dawson felt, conflicted by this man's aura of independence. "They watched jealously, curiously, and, if they wanted, with contempt, or open hostility."

But there were other reactions, too. Kline and his buddies were drinking on the train when a man in a suit, obviously a businessman, came up to Kline, who was in "paint pants with the suit jacket and white shirt and tie." And he "quite shyly said to Franz, 'Are you Franz Kline?' Franz nodded. The fellow said, 'You don't know me, I'm a friend of your brother's. I remember you in high school; I was younger than you were.' Franz smiled. The man smiled, again shyly, and said, 'I just wanted to see—if it was—you. I've seen your paintings, in magazines.' " Now this was new, this kind of recognition. Then he "stopped, embarrassed. But before he turned to go, put out his hand and introduced himself. They shook hands, and the fellow said, marvelously, 'Good luck with your art.' " This homage from a straight-arrow commuter to an avant-garde artist obviously got to the other artist. It was understood that

John Cohen, Franz Kline at the
Cedar Tavern, 1959.

Kline would be recognized at the Cedar, but the very idea that here, in a busy commuter train, an artist would be recognized, that suggested an escalating level of fame. And as the three of them kept drinking beers, the mood of the unknown painter got darker and darker, until he finally sneered at Kline, "Oh yeah, . . . you think you're the nuts, you're—you are nuts, you think *you're* the best, you and Jackson and Bill, well the whole bunch of you are a bunch of creeps—*you* never liked my painting. . . . I'm better than you—ALL of you."[23] For the young, adoring Dawson, the salute that that commuter had paid to Kline was something wonderful, and left him hoping that someday it might happen to him. The success of the Abstract Expressionists could create giddiness and exuberance among the younger generation. It was also sobering.

The possibility—the reality—that modern art would have an ever increasing public role was not lost on the artists, but they didn't necessarily know what to do about it, either. Artists who had been around since the 1930s or 1940s could be stunned by the attention, unsure of what to do next. Some were intoxicated; others could end up feeling depressed. Younger artists tended to be somewhat better prepared for whatever came; they adjusted more easily to a new kind of success and visibility. By and large, though, New York artists were unprepared for the public role, and it was not merely a question of insufficient psychological preparation or of an emotional inability to deal with the spotlight. The image of the romantic heroism of the artist that had absorbed American artists since the 1930s had had everything to do with the private enigmas of Balzac's Frenhofer, who had worked in seclusion. Frenhofer's great stylistic synthesis was so ultra-personal that even his admirers could not comprehend it. The Abstract Expressionists, even as they dreamed of fame and fortune, had also been determined to dwell in that mysterious ivory tower of Frenhofer's. And that was equally true of many mid-century artists who were not painting abstractly.

American artists were unable to take on the kind of large public role, as leaders and spokesmen, that Ingres and Delacroix and Courbet had taken in the nineteenth century, and that Rodin had taken at the turn of the century, and perhaps that Picasso had taken later on. Modern art had, it was true, in some respects discouraged that stance. And American artists, coming of age in

an environment that lacked the institutional structures of art schools and exhibitions that had once helped to define the battle lines of modern art, were never entirely clear as to how artistic ideas might achieve a public visibility. In New York, even as the public hungered for an artist who would show them the way, no such figure emerged. Even the artists who had been leaders in the 1940s or early 1950s were retreating, or maybe being edged out. De Kooning was increasingly seen in the 1960s as a figure with little relevance; perhaps he himself was aware that there was a danger that his deliberately ambiguous viewpoint would dissolve in the strong new atmosphere. He was, in any event, spending more time on Long Island; he was quite simply less a part of the scene. And Hofmann, an electrifying teacher for decades, had closed his school in 1958, in order to devote himself to his own work; he had persuaded several generations of the centrality of the paint-spattered studio, with its harrowing private struggles, but now that very centrality was beginning to wane.

By the end of the 1950s, it seemed that the public nature of art might be left to be defined by Duchamp. And his view was a curious and savvy one, for this man who had thumbed his nose at the public turned out to take the public seriously indeed, which was not, when you think about it, very strange. At a conference of the American Federation of Arts in Houston in 1957—the same conference where Schapiro made his comments about the artist cultivating his own garden—Duchamp announced that "the artist acts like a mediumistic being who, from the labyrinth beyond time and space, seeks his way out to a clearing." Some might say that when Duchamp said that "the creative act is not performed by the artist alone," he was only stating the obvious. Our understanding of what a work of art means

Rollie McKenna, lobby of the Museum of Modern Art, 1958.

evolves over time, there is no question about that. Duchamp, however, surely meant his remarks as a provocation. He wanted to emphasize that the artist was at the mercy of forces that were way beyond his control. "I know," Duchamp said, "that this statement will not meet with the approval of many artists who refuse this mediumistic role and insist on the validity of their awareness in the creative act—yet, art history has consistently decided upon the virtues of a work of art through considerations completely divorced from the rationalized explanations of the artist."[24] Duchamp's vision of the artist as playing a mediumistic role did not gainsay the artist's importance. Mediums, we know, are powerful people—and, sometimes, they become legendary figures. Mediums, however, are also passive figures; they do not act in history so much as they allow history to act on them and through them. And in the end there was not going to be all that much difference between Duchamp's mediumistic being and some of the go-with-the-flow art stars of the 1960s.

V

The Museum of Modern Art, located in the midst of a booming midtown Manhattan, was absolutely at the center of the evolving visual-arts scene of the 1950s. This museum had been founded on the belief that modern art had a history that could be made comprehensible to a fairly wide swath of the public, and indeed by 1950 the museum had already had an immense amount to do with educating a public that was increasingly responsive to modern art. You might even say that the museum had had something to do with the growing number of artists in New York, for its education programs and traveling shows had been encouraging a wider awareness of modern art across the country for twenty years. Artists were excited by what the museum was doing. They depended on the museum for much of their information—and for access to great paintings and sculptures. And yet there were aspects of the Museum of Modern Art that also worried the artists. The picture it offered of twentieth-century art could look almost comically neat. De Kooning, in his talk on modern art at the museum in 1951, had to some degree been thumbing his nose at a view of modern art that, like the Modern's, emphasized a succession of isms, a stylistic evolution that was bigger than any particular artist, that could be plotted, charted, explained. And many artists were also out of sympathy with the museum's inclination to consider painting and sculpture in relation to the graphic and decorative and industrial arts. The painter Carl Holty, going through the museum in 1962, described "the overcrowded rooms

of the permanent collection in which one can get a chronological vertigo, so compressed are the time styles to be seen in a handful of rooms (one goes from Cézanne to chairs by Mies van der Rohe and Marcel Breuer in a jiffy)."[25] The museum's powerful arrangements seemed to overwhelm the art, and certainly many artists felt that the museum might be encouraging the public to second-guess the artists. What did it matter if Cézanne had nothing to do with Marcel Breuer? They were both there, in the museum's permanent collection.

The museum had been in midtown since it opened in 1929, and had in 1939 opened on West Fifty-third Street one of the first generation of International Style buildings to be seen in New York, a building that was now almost a period piece, overshadowed by descendants funded by corporate America. In 1953 Dwight Macdonald was working for *The New Yorker* and wrote a profile of Alfred H. Barr, Jr., then the director of collections. The museum was on the verge of celebrating its twenty-fifth anniversary, and the building struck Macdonald as "predominantly white and flat on the outside and rather more bright, warm, and sumptuous inside—a glass-and-chrome-and-colored-marble surprise package that may contain anything from a Picasso to a Pierce-Arrow, a Matisse to a potato masher, so long as it is in the modern style." What held many people about the museum wasn't the art so much as it was the entire building, with its suave, up-to-the-minute feel. "Someday we *must* get off and look at the pictures," Macdonald reported hearing "one matron . . . saying to another one afternoon not long ago as they went down in the elevator from the penthouse."[26]

It was easy to satirize New York's culture vultures, and yet even the city's most sensitive observers could find themselves thinking that the museum was purveying a view of modern life in which the artists played nothing more than a supporting role. In May Swenson's poem "At the Museum of Modern Art," published in her 1963 collection *To Mix with Time*, the museum provided an experience that had more to do with modern life than with modern art. Sitting in the museum's lobby, the narrator observed that

> you can rest and smoke,
> and view whatever the revolving doors express.
> You don't have to go into the galleries at all.

You saw how "The shifts and strollings of feet / engender compositions on the shining tiles," and as for the thought of going to see a movie at the Modern,

> You can see contemporary
> Garbos and Chaplins go by right here.
> And there's a mesmeric experimental film
>
> constantly reflected on the flat side of the wide
> steel-plate pillar opposite the crenellated window.
> Non-objective taxis surging west, on Fifty-third,
> liquefy in slippery yellows, dusky crimsons,
>
> pearly mauves.[27]

The Museum of Modern Art suggested a certain kind of attitude toward experience—a jangling, witty, collagist's attitude—and once you had experienced the world in this way, you hardly needed to look back to the works of art in the museum. In 1949, as part of the Modern's twentieth-anniversary celebrations, there was a show called "Modern Art in Your Life" that was at once a description of how modern art came to be the same thing as modern life, and, for those who were skeptical about the process, a symptom of an epidemic of oh-so-tasteful conformist thinking. Organized by Robert Goldwater, who would take a good deal of interest in the goings-on at the Club, this show described the complicated impact that modern painting and sculpture had had on advertising, architecture, and home furnishings. While Goldwater

surely had no intention of presenting the artist as a cog in a machine, the show could make things look that way. The cover of the catalog, by Paul Rand, a graphic designer who himself wrote about the impact of Klee and other artists, represented a table setting, with not a plate but a palette between the knife and fork—as if the artist's invention could become a feast for designers and, eventually, for the whole world. Goldwater, who had already in the 1930s in his book about primitivism written about Riegl's ideas, spoke here of the

Paul Rand, cover of catalog
for "Modern Art in Your Life," 1949.

"pervasive unity" that we see in the arts of earlier periods. He wrote that "for the older periods of the world's art we take this pervasive unity for granted. We assume a natural relation between the Greek vase and the Greek temple. We enjoy the similarities among the Gothic cathedral, sculpture, tapestry and chest. We admire the unity in the architecture, pewter ware and portraits of a New England house. Belonging to the same world, we expect them to have certain essential likenesses; the same spirit infuses them all, creations of the artist, artisan, or designer, and as we recognize it we call it the 'style' of the time."[28] The point of "Modern Art in Your Life" was to describe how this process worked at mid-century, how the linear networks in works by Paul Klee and Picasso's illustrations for Balzac's "The Unknown Masterpiece" (there it was again) were echoed in contemporary textile designs and book covers and an advertisement for Columbia Broadcasting System by Ben Shahn. The show suggested that the *Kunstwollen* was getting away from the artists.

The Museum of Modern Art upheld a high, at times almost mysterious idea of artistic quality, but contemporary artists knew full well that the museum was also promoting modern art and design as a symbol of the postwar boom. As Hess wrote in 1957 in *Art News*, "The Museum is the sum of its Christmas-cards and upholstery-fabric competitions, Mondrians, automobiles and Pollocks, Latin-American watercolors and Picassos."[29] To Macdonald, writing in the early 1950s, the museum was not a bastion in the midst of the city but a place that was breaking down the boundaries between the museum and the broader world. This was a subject that was right up Macdonald's alley. He was a product of the intellectual and political controversies of the 1930s, a writer for *Partisan Review*, editor in the 1940s of his own magazine, *politics*, where he had published "The Root Is Man," and now he was at *The New Yorker*, where his profiles and essays brought a mandarin viewpoint to the cultural tastes of the middle-class public. He wrote about a translation of the Bible, a new dictionary, movies (for *Esquire*), and in the essay "Masscult and Midcult" presented his working definition of middle-class taste in the postwar period, where he saw a kind of downward drift of avant-garde ideas, until those ideas had been turned into mid-cult gimmicks. Macdonald observed in his *New Yorker* piece that "the cultural climate in which modern art and its Museum exist is tropical, superheated by controversy, blazing with broad affirmations and equally sweeping denunciations, shimmering under the hot sun of the absolute." "In the simple old days," he wrote, "an art museum was a dignified place, with columns, that displayed, in an elegant hush, such works

Museum of Modern Art
brochures designed by
E. McKnight Kauffer
in the 1940s.

of art as it owned. Attendance was, so to speak, optional; the stuff was there, if anybody cared to come and look at it. This passivity has pretty much disappeared, along with the hush. If people are not actually dragged in off the street, as into a Houston Street clothing store, they are lured in by ingenious showmanship and by appeals to appetites that are a lot more mundane than a desire to contemplate works of art."[30]

The Modern led in this move. Macdonald quoted John D. Forbes, in the *Journal of Aesthetics and Art Criticism* in 1941, as writing, "The Museum of Modern Art has grown up and in a few short years established a sort of factory for the mass production of art 'features,' motion pictures, travelling displays, and quantities of printed matter. . . . The urge to *do* something has been very widespread among museums." And, again in Macdonald's article, Agnes Mongan, a curator at the Fogg Museum at Harvard, was quoted as writing in 1944 in *Art News* of the Modern: "In no other museum in the world has a schedule as heavy as that in 53rd Street been attempted. One can but wonder if it is humanly possible to maintain it." Macdonald went on: "After observing that even though the Museum's staff seemed able to keep up the killing pace, perhaps the public couldn't, and that 'there is also a saturation point in the power to consume,' Miss Mongan gently suggested, 'Might it not be wiser to offer us artistic sustenance at more widely spaced intervals?' This thought fre-

quently, indeed chronically, occurs to the members of the Museum staff; every year they resolve to cut down on shows, and every year they fail to do so. The joint has been jumping for twenty-five years."[31]

Alfred Barr, the subject of Macdonald's profile, had been there from the beginning, and by 1953 he was the survivor of complicated internecine warfare. He'd been the founding director, in 1929 at age twenty-seven. In 1943, at a time when the museum's trustees were increasingly inclined to see him as unreliable and to find some of his interest in naïve or primitive art bizarre, he was asked to step down as director by Stephen Clark, the president and chairman of the board. He was given the title of advisory director with the hope that it would be the last of him. But he refused to leave, setting up in a small office in the library, and in 1947 he made his return, being named to the new

Homer Page, Alfred H. Barr, Jr. in 1953.

and powerful post of director of the museum collections, back in place in time to preside over the museum as it moved into the postwar period. Barr was a delicate-looking man. Macdonald described him in 1953 as "shy, frail, low of voice, and scholarly of mien, the austerity of his beak-nosed, bespectacled face relieved only by the kind of secret smile one sees on archaic Greek statues or on the carefully locked features of a psychoanalyst."[32] He combined an immense appreciation for what was rare, marvelous, and difficult in art with an equally great curiosity about the ways in which art fit onto the broader social canvas. Barr had visited Moscow in 1928 and met El Lissitzky, Aleksandr Rodchenko, Varvara Stepanova, and Vladimir Tatlin; he knew the experiments of the Bauhaus firsthand; and not surprisingly for a man who had been young when radical art and radical politics were still intertwined, Barr was always attuned to the interesting relations between the inventions of modern art and the broader movements of society. In his best-selling introduction to the mysteries of modern art, *What Is Modern Painting?,* Barr wrote that even Mondrian, pursuing "the image of perfection," has had, it turns out, "practical results," in that his work has "affected the design of modern architecture, posters, printing layout, decoration, linoleum, and many other things in our ordinary everyday lives."[33]

It was no surprise that the museum that Barr would have a large part in cre-
ating would seek to present painting and sculpture in a broader cultural con-
text. He had, after all, been excited by the program of the Bauhaus, where
painting and sculpture were only a part of the complicated fabric of modern
visual experience. The Museum of Modern Art was the first museum to have a
photography department, and it had a film department, and took architecture
and design seriously, too, and by the 1950s these departments were a signifi-
cant part of what gave the museum its broad, public profile. In 1959, in his
text for Richard Avedon's collection of photographs, *Observations,* Truman
Capote wrote of Mae West's response when "an intense young girl" told her
that she had just seen *Diamond Lil.* "Wheredja see it?" West asks. "At the
Museum. The Modern Museum," comes the girl's reply. "And," Capote con-
tinues, "a dismayed Mae West, seeking shelter in the sassy drawl of her
famous fabrication, inquired: 'Just waddya mean, honey? A *museum?*' "[34] In
1953 the museum struck Macdonald as "just about the biggest club in town. Its
sixteen thousand members are divided almost equally between residents of
New York City, who pay dues of fifteen dollars a year, and non-residents, who
pay twelve-fifty." There were two showings daily of movies. No museum was
so assiduous about education—both in an immense publications program (183
books as of 1953), its circulating exhibitions (approximately fifty a year), and
its educational programs. "The Museum runs the People's Art Center, which
occupies two floors of the Rogers annex and offers classes—both day and
evening—in painting, sculpture, woodworking, jewelry making, and ceram-
ics. There are three terms a year, each with an attendance of some five hun-
dred adults and seven hundred children."[35]

Barr and the Modern had started or encouraged a revolution in taste, and
they were now, willy-nilly, carried along in a revolutionary period—or in its
aftermath. Macdonald had written that "in the old days, [the museum's] open-
ings were smart and crowded, with lots of white ties, orchids, and celebrities.
Today they are just crowded. (There is a rumor that pre-opening openings are
sometimes held, like the furtive balls of French aristocrats during the Terror,
where the élite relive the dead past for the evening.)" Macdonald had a wry
attitude toward the doings at the Modern, yet what he described could also be
said to be a sincere desire to include more people in an especially esoteric kind
of experience. "The Museum's snobbishness, furthermore, has always been
democratic after a fashion—the peculiar American fashion in which the aim is
not to exclude *hoi polloi* but, on the contrary, to attract them with snob appeal,
along the lines of the 'Men of Distinction' whiskey ads and the Aqua Velva

After-Shave Club. Which, again, might be justified as a peccadillo in a good cause."[36]

How could New York artists not be ambivalent about this circus of a museum? In the 1960s Hess was still complaining about all the New York artists whom he felt the museum was overlooking. These included, according to Hess, Leland Bell, Milton Resnick, Joan Mitchell, Nell Blaine, and Al Held, many of them heroes or demi-heroes of the Silver Age of the New York School. In 1964, in *Location,* the short-lived magazine that he edited with Harold Rosenberg, Hess observed that "the Museum of Modern Art is a useful indicator of the fluctuations in official, big-money taste (which it leads)."[37] That remark, clearly, had more than a bitter edge. Yet in 1957, when Hess was already criticizing Barr's record on American art, Barr was able to respond that the record of *Art News,* of which Hess was then an editor, was no better. Barr pointed out that the museum had bought Gorky in 1941, Pollock in 1944, Motherwell in 1944, de Kooning in 1948. In 1948 the museum had published a collection of essays by James Thrall Soby, *Contemporary Painters,* which contained a chapter called "Some Younger American Painters" and included discussions and illustrations of Pollock, Rothko, Motherwell, and Gottlieb, among others. Barr, when responding to Hess's criticisms in 1957, might have added that the artists were not exactly hostile to Barr. In 1950 they not only invited him to join in the three-day conference at the nascent downtown discussion and education center Studio 35, they made him one of the moderators, a strategic move, no doubt, but still significant. And Barr might have also pointed out that Hess, who had focused on seventeenth-century French culture when he was an undergraduate at Yale, made his entrance into the world of modern art in the summer and fall of 1942, when he worked for Barr and the curator Dorothy Miller at the Museum of Modern Art.[38]

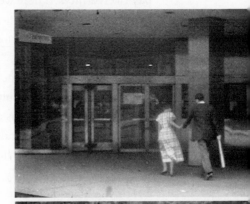

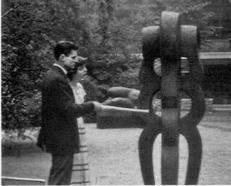

Rudy Burckhardt, stills from Mounting Tension, *1950.*
A slapstick comedy in which the boy going to the
Museum of Modern Art is played by John Ashbery
(carrying his baseball bat).

By the 1950s many artists had been grumbling about the Modern for so long and the Modern had begun to give them so much attention that the relationship between painters and curators could seem more easygoing than tense, more playful than confrontational. Rudy Burckhardt, whose attitude toward the art world of which he was so essential a part always had a smiling, even mocking element, dealt with these conflicts in a short slapstick comedy, *Mounting Tension* (it was shown at Cinema 16 during the 1954–55 season). Here the Modern was a kind of institutional authority to be undercut by unruly spirits in much the way that the police or the bigwigs in city hall had functioned in the silent movies, and indeed Burckhardt's work had the improvisational immediacy and clarity of early Hollywood. *Mounting Tension* was a story of art and love; Jane Freilicher played a psychiatrist, Larry Rivers the young artist, and John Ashbery the young jock. Rivers was marvelous—with his slender build and masklike face he could have been a young Jean-Louis Barrault—but a young woman, played by a friend of Burckhardt's, fled his studio because in the midst of showing off his paintings of the nude he couldn't keep his hands off her. He'd been giving her a capsule course in modern art, with the assistance of a Museum of Modern Art catalog, and when she left she took the catalog with her. She headed up to the park, where she met Ashbery, a young guy fooling around with a baseball bat. And she immediately took Ashbery off to the Museum of Modern Art to get some culture. He just breezed right into the museum with his baseball bat, which he brandished in a friendly way as he looked at the works on display. Finally, a guard confiscated the bat, but the point had been made. The Modern was part of the harum-scarum excitement of mid-century art, a power structure to be tickled and teased, to be revered, but also joked about.

VI

It has often been pointed out that Barr came from a family of Presbyterian ministers; his father as well as two uncles were graduates of Princeton Theological Seminary. And there can be little question that some of the family's evangelical spirit energized Barr's work on behalf of modern art. Barr, however, did not so much bring this evangelical spirit into modern art as he understood that an educational or evangelical dimension had been built into modern art itself, which had a message for the public, often initially unpopular or even incomprehensible, and perhaps to some degree spiritual. Barr was intimately acquainted with the extraordinary outpouring of manifestos, magazines, exhi-

bitions, and polemics that the early European moderns had used to explain themselves to the public. And he was interested in bringing some of the writings of the European moderns to the attention of American museum-goers. In the first book that he published on Matisse, in 1931, he included the first English version of the artist's 1908 "Notes of a Painter," translated by Barr's wife, Margaret Scolari Barr, an art historian. The texts, the chronologies, and the bibliographies in the museum's publications were almost invariably pioneering works of scholarship. And the graphic style of the museum's publications followed the latest European models in book design. The composition of double-page spreads in the 1936 *Cubism and Abstract Art* catalog, with, say, a large single reproduction of a Miró or a Calder or a Jacques Lipchitz on one page balanced by two smaller reproductions on the opposite page, echoed such European productions as *The Isms of Art*, El Lissitzky and Arp's 1925 book. Artists looked to the museum's frequently slim, always densely packed volumes; and meanwhile the work that Barr and his colleagues were doing was setting the stage for the serious study of the history of modern art within the academy—a study that in the 1950s had hardly begun.

Barr has frequently been viewed as a man who admired the most severe, most self-consciously enigmatic forms of modern art. This is not hard to understand, considering that he gave America its first truly coherent view of the history of abstract art with the 1936 exhibition "Cubism and Abstract Art," and went on to amass what remains by universal agreement the grandest collection of classic abstract art in the world. Responding to the exhibition's catalog, which he did rate "the best . . . that we have in English," Meyer Schapiro, then a young art historian, complained that no "connection is drawn between the art and the conditions of the moment. He excludes as irrelevant to its history the nature of the society in which it arose."[39] This observation, published in the 1930s, is sometimes regarded as the first shot in what has turned out to be a half-century critique of the museum's passionate advocacy of a formalist approach to art. And yet Schapiro's view—which he had considerably revised by the time of Barr's death, some forty-five years later—may have missed the central social fact of Barr's great exhibition. What Schapiro underestimated was the extent to which Barr, through the very act of presenting a coherent picture of Cubism and abstract art to New York artists and to the public at large, was acknowledging the need for a context. Schapiro might have criticized Barr for neglecting the relationship between art and society, but Barr, as the youthful director of a museum devoted to modern art,

was himself defining that relationship. He was bringing abstract art to the American people.

Barr's taste, particularly his sympathy for the most pared-down and near-abstract of works by Matisse and Picasso, brought him into harmony with the downtown artists. When he gave Miró his first museum show in 1941, he was offering New York artists a close look at the work of a man who had taken painting further into non-composition than anyone else had managed to do while remaining a painter. It would take the New York artists much of the decade to catch up with Miró—and the case can probably still be made that some of Miró's open-ended paintings of the 1920s are more casual, more truly improvisational than anything ever done in New York. And yet Barr's relationship with the downtown scene remained ambiguous. The artists might agree with him about the first quarter of the century, but they did not agree about what that past implied. From the 1930s onward, America's abstract artists had argued that Barr had a double standard, taking an interest in Cubism and Constructivism in Europe, but favoring realism, either Surrealist-tinged or socially aware, when he turned his attention to the United States. Barr's view of the current American situation in the 1930s and 1940s reflected a feeling among many observers that the great experiments of abstract art had perhaps run their course and that the vital art of the current movement was romantic, and increasingly representational. James Thrall Soby's 1935 book, *After Picasso*, which featured de Chirico, Berman, Leonid, and Tchelitchew, was not published by the Modern but was indicative of the museum's view of the future. De Kooning and his friends, starting out in New York, had their own idea about what would come after Picasso. Yet Barr's—and Soby's—view was not theirs alone. The Modern's position at this time jibed with the idea of the return to order, which was popular in France, with ideas discussed in Waldemar George's *Formes* magazine, among the Neo-Romantics in England, and among New York's fashionable Surrealists. It was this viewpoint that in fact gave the museum one of its most enduring crowd-pleasers, Tchelitchew's *Hide and Seek*.

At a memorial service at the Modern after Barr's death, Schapiro observed that Barr believed that "far from appearing esoteric and beyond ordinary understanding, this new art could be described and characterized and, in part, illuminated through knowledge of its place in history, of its relation to preceding art, and of new experiences of the artists and the community at large."[40] Barr's clearest presentation of this idea was in *What Is Modern Painting?* The best-selling pamphlet, first published in 1943, was surely an example of the

man's desire to give modern art a general popular appeal, but even if we acknowledge that Barr was broadening and perhaps even coarsening certain of his beliefs in an effort to get them across to a big public, I do not think we can wonder at the sincerity of what he said. In the opening pages of *What Is Modern Painting?*, Barr wrote that readers might perhaps "feel that these pictures have little to do with our everyday lives. This is partly true; some of them don't, and that is largely their value—by their poetry they have the power to lift us out of humdrum ruts. But others have a lot to do with ordinary life: vanity and devotion, joy and sadness, the beauty of landscape, and animals and people, or even the appearance of our houses and our kitchen floors. And still others have to do with the crucial problems of our civilization: war, the character

Cover of Alfred H. Barr, Jr.'s What Is Modern Painting?, 1943.

of democracy and fascism. . . . The artist is a human being like the rest of us," Barr said. "He cannot solve these problems except as one of us."[41] In Barr's writing—here and, more subtly and elusively, in his great book on Matisse—there was a constant going back and forth between the autonomy of the artist and the forces that worked on the artist, between the value of form in and of itself and the value of form as a carrier of narrative and metaphoric complexity.

In the opening pages of *What Is Modern Painting?*, when Barr was comparing a fully modeled landscape by Dean Fausett with a Stuart Davis or a Whistler with an Arthur Dove, it was possible to feel that his view was somewhat schematic, and it was. But the idea of multiple artistic possibilities was one that he treated seriously. He spoke of "two parallel ways toward abstraction: the logical, structural, architecture-like progress which we have just followed from Cézanne and Seurat through Picasso and Gris to Mondrian; and the other path of 'musical' color harmonies from Gauguin through Matisse to the spontaneous freedom of Kandinsky."[42] Barr was surely attracted to a starkly progressivist vision of the history of art, as you can see by looking at a number of diagrams that he developed to underscore that idea. There was the famous diagram on the dust jacket of *Cubism and Abstract Art,* with its arrows leading sideways but mostly forward, through a succession of marquee-famous artists and isms, as the half decades from 1890 to 1935 are ticked off along the outer edges of the design. And there was a diagram that Barr

designed for an inter-museum presentation about the permanent collection, in which the history of modern art was shaped like a torpedo, moving forward, with the nineteenth-century masters at the back, Paris in the middle, and America and Mexico in the front, approaching 1950. Nevertheless, there was also in Barr's thinking, especially in the 1940s, a sense of abstraction and representation as held in some kind of counterpoint of styles and cycles, of action and reaction and action. In the 1940s—with America at war, soldiers flooding into the museum, and an ever more heterogeneous museumgoing public—Barr reached for a more knitted-together idea of different styles, a vision hardly of singular progress toward absolute abstraction, but of a constant return to various, timeless forms of complexity and paradox. Abstraction was just one impulse among others.

At times Barr favored a model of art history as a circle or a spiral, returning to earlier points even as it moved forward. In *What Is Modern Painting?* he devoted a page to Peter Blume's *Eternal City,* a tightly rendered allegory of modern Italy, with Mussolini as a grotesque jack-in-the-box in the midst of the ruins of Rome. In writing about Blume, he observed that people who were interested in art no longer necessarily believed that "ideas of simplicity, spontaneity and artistic purity" were revolutionary; such ideas could, in fact, seem "orthodox and academic." Barr referred to "the revolutionary return to subject interest." And he moved, in his 1943 text, from Blume to a more enduringly important example of that return to grand subject matter, Picasso's *Guernica,* with its black, white, and gray synthesis of old-style narrative complexity and new-style shattered abstract forms. *Guernica* would of course become a key monument at the Modern, where Picasso eventually left it on permanent loan with the understanding that it would be given to Spain when Franco was no longer in power. Writing of *Guernica,* Barr explained that Picasso had used "modern techniques not merely to express his mastery of form or some personal and private emotion but to proclaim publicly through his art his horror and fury

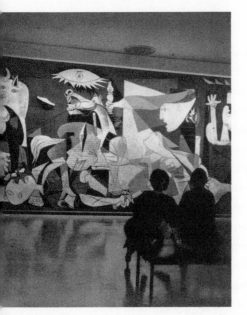

Kees Scherer, Guernica *at the Museum of Modern Art, circa 1960.*

over the barbarous catastrophe which had destroyed his fellow men."[43] Here the distortions and simplifications and geometries of modern art were plowed back into a supercharged account of contemporary experience, or so Barr believed.

Barr told the story of a German officer who had visited Picasso during the occupation and who, as he was leaving the studio, saw a reproduction of *Guernica* on the wall and said, "Ah, Monsieur Picasso, so it was you who did that." "No," Picasso replied, "you did." The point of the story, of course, was that art was not an ivory tower, that art was concerned with the stuff of life. And *Guernica,* with its powerful, black-and-white condensation of world-historical experience, had had a deep, abiding impact on New York artists. Indeed the whole cyclical thrust of Picasso's art—the insistent reintegration of abstract ideas into representational images—was still affecting artists in New York in the early 1950s, beginning with de Kooning, who was once again taking an interest in the figure. In a later edition of *What Is Modern Painting?*, Barr wrote about these matters, saying of de Kooning that "without heeding anyone's whistling . . . [he] did 'go back to nature' in his series called *Woman.* In *Woman I* a paroxysm of emotion surpasses the expressionist violence of van Gogh." And that was not the end of de Kooning's transformations, either, for as Barr wrote in the late 1950s, "de Kooning has returned to a more abstract style which now seems almost classic."[44]

VII

It is significant that Barr's greatest achievement as a writer, the monograph on Matisse that was published in 1951 to accompany the big Matisse retrospective, was titled *Matisse: His Art and His Public.* In Barr's museum, the public received prominent billing. Barr's decision to give his book about Matisse, published at the moment when the Abstract Expressionists were beginning to receive serious public recognition, such an imposing subtitle underscored his belief that central to the story of modern art had been the artists' efforts to find a place for themselves and their work in the wider world. If the art was, surely for Barr, the primary thing, it was always set in a tension between, on the one hand, the context out of which it had emerged and, on the other hand, the public that would come to appreciate it over time. One might say that Barr's entire career had been devoted to these questions. Since 1929 he had worked to build an audience for modern art. Some might say that he had invented that audience. And in the 1950s, as the public appetite for art was growing and grow-

ing, the museum found itself taking an increasingly important role in shaping the artist's relationship with that audience.

Barr's acute consciousness of the audience's needs and interests had been sounded in the first proposal for the museum, published in 1929. "All over the world," he wrote, "the rising tide of interest in modern movements in art has found expression, not only in private collections but also in the formation of public galleries. . . . Nowhere has this tide of interest been more manifest than in New York. But New York alone, among the great capitals of the world, lacks a public gallery where the works of the founders and masters of the modern schools can today be seen."[45] Two years later, in his first book about Matisse, Barr began to suggest the kind of dynamic relationship that might exist between a whole range of publics—the avant-garde public, the broader public. He had this to say: "That Matisse after having survived becoming fashionable should be in danger of becoming popular while still retaining the esteem of the foremost critics is a most happy innovation, for it suggests that at least one great modern artist has escaped the isolation of his kind."[46] Two decades later, Barr was interested in playing with the multiplying aspects of the public. In *Matisse: His Art and His Public*, he spoke of the early supporters—the Steins, Hans Purrmann, Sergei Shchukin, Steichen, "these enthusiasts [who] were for years the most essential members of Matisse's *public*." Barr tracked the growth of the public, from this nucleus of critics and collec-

Henri Matisse, cover of exhibition catalog
for the Matisse retrospective, 1951.

tors, to a general public that began to know Matisse's work through the exhibitions of modern art held in Cologne, London, New York, Chicago, and Boston before World War I. He observed that "during the early 1920s Matisse's relationship to the public changed. The growing traditionalism and charm of his painting greatly increased his popularity and the commercial value of his art. In 1921, at the age of 51, Matisse, as a modern painter, received his first modest recognition in French official quarters: the Luxembourg Museum acquired an *Odalisque*." And a little later Barr spoke of another kind of esteem—a kind of reverse esteem. "In the same decade, to continue this preface to the *public* Matisse, the artist willy-nilly became a political figure." Barr described the rejection of modern art by the Nazis and the Russians, while pointing out that "the fabulous collections of his paintings confiscated by the Soviet State in 1918 remained accessible to the Moscow public until fairly recently." And, finally, Barr wrote of how Matisse, after World War II, "has recently recaptured the esteem of young artists of the *avant-garde*, esteem which he had largely lost during the three previous decades. For any good artist, the admiration and acclaim of his younger colleagues is more significant and more valuable than any amount of worldly or official success."[47] Later in the book, Barr explored this renewed critical reception with great sensitivity, especially in relation to Greenberg.

A sense of the artist as related to a time and place came through very strongly in Barr's book.[48] The insistent specificity of description and formal analysis in *Matisse: His Art and His Public* obviously marked Barr as a man who was supremely conscious of the freestanding power of the work of art, but his desire to give Matisse and Picasso a place in New York and his conception of a museum in which a department of painting and sculpture would be surrounded by other departments—of film, photography, architecture and design—pushed continuously toward a vision of the integration of the arts with life. Writing in 1951, at the moment when the audience for art was exploding, Barr suggested that the public created a supersaturated environment in which the artist, while acting as an independent figure, was also acted upon in a whole variety of ways. He was speaking at a time when America's avant-garde had finally engaged with the public. What lay ahead was a long, complex, exciting, and sometimes rancorous marriage.

12. MAKING HISTORY

I

New York City saw an extraordinary surge of public commissions for modern artists between the early 1950s and the mid-1960s. With the country booming economically, there was a sense, certainly among architects in some of the topflight Manhattan firms, that it might now be possible to support the kinds of projects that had perhaps last been seen at the 1937 International Exposition in Paris, where major works had been done by many great artists, including Robert and Sonia Delaunay, Léger, Dufy, and, of course, Picasso, who painted *Guernica* for the Spanish Pavilion.

Léger, who was in exile in the United States during the war, was already in 1944, in the *Magazine of Art*, predicting a postwar resurgence of such work in an article called "Byzantine Mosaics and Modern Art" that was inspired by an exhibition at the Metropolitan Museum of photographs and facsimiles of the mosaics of Hagia Sophia in Istanbul. Léger explained that he had been yearning to do mosaics since the 1930s, and he predicted that after the war there would be a renaissance of this great, ancient art. He saw many possibilities in the United States, where he believed that the public would respond to the boldness of mosaic décor. This was, he wrote, "the art of the future."[1] Although as it turned out mosaic was by no means the dominant material in the public art that was done in the 1950s, Léger was not wrong that there was an interest in doing such work among artists in the United States as well as in Europe. Barr's book on Matisse had ended with a long discussion of the chapel that Matisse designed in the 1940s for the Dominicans, at Vence, in the hills above Nice, and while Barr's Matisse show was up at the Modern, a gallery was added that focused on the chapel, with its stained-glass windows and tile murals. Although widely publicized, this chapel was meant for the use of a relatively small group of people, but there were also other religious decorations by School of Paris artists appearing in the postwar years. The project that

Matisse was working on at the time of his death was a stained-glass window for the Rockefeller family church in Pocantico Hills, New York. Matisse had already been among the artists who contributed work to a church in the Haute-Savoie, which also included compositions by Léger, Bonnard, and Braque. Chagall's windows for Hadassah Hospital in Jerusalem were a huge popular success when they were exhibited at the Museum of Modern Art. William Rubin, who later was chosen by Barr as his successor at the Modern, wrote his Ph.D. thesis under the direction of Meyer Schapiro on the new religious art.[2] And there were many secular works being done as well: by Miró and Calder and others for UNESCO in Paris; and Léger designed two murals for the assembly hall at the United Nations in New York.

The roll call of high-level artistic public commissions in New York City, often initiated by Gordon Bunshaft, the head architect in the firm of Skidmore, Owings & Merrill, was astonishing. It seemed as if the corporate powers were responding to Hofmann's call, in a 1950 statement, that "our working places should be made into palaces where it will be a joy to work"—and to think and to play.[3] In 1954 Harry Bertoia, a sculptor whose welded constructions have a delicate airiness, produced a seventy-foot-long metal screen wall for Manufacturers Trust Company on Fifth Avenue. The next year the painter Adolph Gottlieb designed a stained-glass façade for the office and school building of Park Avenue Synagogue. In 1956 Hofmann designed the mosaic mural that sheathed the elevator banks at 711 Third Avenue, and two years later he designed another mosaic mural, this one for the New York School of Printing and Trades. A major sculpture by Calder was installed in 1957 in the International Arrivals Building of what would become John F. Kennedy International Airport. Isamu Noguchi was involved with the design of a plaza for Lever House, which was ultimately not executed; he designed a waterfall at 666 Fifth Avenue in 1957, created a sculpture for the New School, and then, in the early 1960s, developed an elaborate sunken garden, inspired by traditional Japanese rock gardens, for the plaza of Chase Manhattan in the Wall Street area. In 1961 Reuben Nakian, the sculptor whose retrospective at the Modern was curated by O'Hara, designed a sculpture for Loeb Student Center at New York University. Josef Albers created white marble walls with incised geometric designs in gold for the Corning Glass Building on Fifth Avenue in the late 1950s, and a vast mural for the Pan Am Building on Park Avenue in 1963. Richard Lippold, who had already contributed a floating sculpture to the Seagram Building, executed commissions for Pan Am and for Avery Fisher Hall at Lincoln Center, where his *Orpheus and Apollo* went up in

Isamu Noguchi,
sunken garden at Chase
Manhattan Bank, 1960–64.

1962. Henry Moore's reclining figure was installed in the reflecting pool at Lincoln Center in 1965, and Chagall's murals were part of the Opera House that opened in 1966. Not all the focus was on major public commissions. In 1956, the Wildenstein Gallery sponsored a show called "New Forms in Door Ornamentation," showing special hardware designed for the firm of Yale and Towne by artists including Ibram Lassaw, Theodore Roszak, Léger, and the architect Philip Johnson.[4]

 The question of how artists might find a way to do more public art went back to the beginning of the 1950s, when Sam Kootz, one of the dealers most closely associated with Abstract Expressionism, mounted a show called "The Muralist and the Modern Architect" in his gallery on Madison Avenue. By presenting proposals for collaborations between five artists and as many archi-

Ezra Stoller, Josef Albers mural
in the Corning Glass Building,
717 Fifth Avenue, 1956–59.

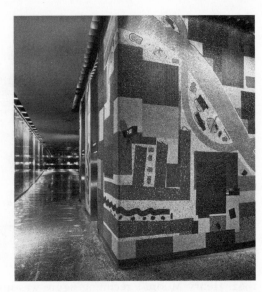

Hans Hofmann, 711 Third
Avenue mural, 1956.
Mosaic.

tects, the exhibition suggested that New York's avant-garde saw the possibil-
ity of a new relationship between the artist and the audience. "The modern
painter," Kootz wrote, "is in constant search of a wall—some large expanse
upon which he can employ his imagination and personal technique on a scale
uninhibited by the average collector's limited space."[5] This observation
echoed Greenberg's observation, two years earlier in his essay "The Crisis of
the Easel Picture," that the modern painting was moving beyond the limits
of the easel painting. Here, however, the idea was given a practical twist.
In Kootz's show, Baziotes collaborated with Philip Johnson on a house;
Gottlieb with Breuer on a plan for housing at Vassar College; Kiesler with
David Hare on a house; Hofmann with José Luis Sert on a civic center for
Chimbote, Peru; and Motherwell with the Architects Collaborative, directed
by Walter Gropius, for a school. Here, Bauhaus figures—Breuer, Gropius,
and, in a sense, Johnson, who though American had, a year earlier, in his glass
house, created the ultimate Constructivist architecture—were proposed as
collaborators with Abstract Expressionists, and Kootz kept up with the idea.
Hofmann's mosaic designs for the bank of elevators at 711 Third Avenue
probably brought these ideas closest to a full expression. Going floor-to-
ceiling, wrapping around the whole bank of elevators to create a huge
mosaicked cube, the design was a study in the opposition of the rectilinear and
the curvilinear, with blues dominating at the northeast corner, reds at the
southwest. Hofmann's painterly impulse was translated into an architectural
vision that had its origins in Ravenna and, further back, in ancient Rome.

Surely this dazzle of mosaic color was the perfect decorative medium for the Rome of postwar capitalism, which was New York City. And somewhere in the back of his mind, Hofmann may have had Léger's words about the future of the mosaic. It was also interesting that Hofmann retired from teaching not too long after completing the 711 Third Avenue commission; could the money that he made have been the nest egg that he had been looking for to cushion him after the closing of his school?

Kootz, who was joining art and architecture and no doubt hoping to make some money in the process, did not limit himself to secular projects. (Reinhardt may have been thinking of Kootz's mural projects when he said that among the offerings at Kootz were "sign painting.")[6] A year after the mural show, in October 1951, Kootz mounted "Art for a Synagogue," which was "the first completed commission." The architect, Paul Goodman's brother Percival, had come to the gallery "with no rigid requirements except of space," and Gottlieb, Motherwell, and Herbert Ferber provided a curtain, a mural, and a sculpture for Congregation B'nai Israel in Millburn, New Jersey. "Just as many of the great living French artists," Kootz wrote, "have recently made contributions to the Catholic churches of France (Matisse, Léger, Rouault, Braque and others), so these three artists have made thoughtful and original contributions to an American house of worship."[7] Of course artists were not, by and large, particularly interested in religion, but religion did have its part to play in the postwar debates about the evolving nature of social life. Matisse's religious feeling or lack thereof was a subject of articles and discussions, and there was much said about the fact that Léger, after joining the Communist Party, had not hesitated to take commissions for church decorations. In the United States, Kootz and his artists were obviously aware of a new interest in religion among writers and scholars, a development that was the subject of a symposium that *Partisan Review* published in 1950 under the title "Religion and the Intellectuals."[8]

II

An interest in institutional commissions, including religious commissions, was part of a broader concern that artists had with finding their place in a postwar world where galloping prosperity was strengthening the power of all kinds of institutions. "Who are the leaders?" everybody was asking. "And who are the followers?" Was it fair to say that the artist who was pursuing his or her own aims was necessarily leading? Or was the very idea of leadership a

particular idea of the artist's role, which in itself implied an idea about who or what an artist was? Of course the idea of the artist as a leader was knit into the story of modern art, and of the avant-garde. But there was also a process by which followers declared certain figures leaders, and if the follower was a museum with all kinds of institutionalized power, the follower could become a stealth leader—and in the midst of a boom-time city, who was there to make fine distinctions between one kind of leadership and another?

In 1960 Barr made what is perhaps his fullest statement about the museum's relationship with contemporary American art. It came in the form of a letter that he sent to *The New York Times* in response to an article in which John Canaday, then the paper's chief art critic, had characterized Barr as "without any question at all the most powerful tastemaker in American art today, and probably in the world." Canaday was writing in response to a statement that Barr had made in *Esquire,* arguing that "the vigor and quality of [Abstract Expressionism] is bound to generate a reaction—but where we are going to go I'm not willing to prophesy. What I see is a new concern with [the] figure, and a movement toward a new severe style." Barr's *Esquire* statement was, quite clearly, a response to developments among New York artists, to the kinds of things he was seeing in the galleries. And in his letter to the *Times,* he rejected the idea that he or any other museum official was a leader. He said that the museum had worked to reflect what he and his colleagues saw as developments among artists, through shows such as "New Images of Man" and the inclusion of Rauschenberg, Kelly, and Johns in "Sixteen Americans." Barr reminded Canaday that the museum was in fact an organization with some 250 employees. And Barr said that "it has never been the museum's policy to try to influence painters, sculptors, printmakers, photographers, film makers or their entrepreneurs. The artists lead: the museum follows, exhibiting, collecting and publishing their work. In so doing it tries to act with both wisdom and courage, but also with awareness of its own fallibility."[9]

The idea that the artist led and the museum followed was—and is—an admirable one. But there were problems, some of which Barr well understood. The museum was aware of its power, he wrote. "Especially in strictly contemporary art the risk of error is great and some unfairness inevitable. When a museum buys the work of one young artist, nine others and their ninety friends are disappointed. And the effects on 'taste' and the art market . . . may indeed occur. But what should museums do? Abandon their concern with recent art? Would you abandon yours?" To all these questions Barr had only a partial answer, and it brought him, interestingly, back to the permanent col-

lection, to which he was at this point devoting most of his energy. "At the Museum of Modern Art we propose a partial answer to the dilemma: we must show the many disparate, even contradictory, yet significant kinds of art our complex civilization has produced, and show them continuously in permanent galleries so that the public may have at all times a panoramic perspective of the visual arts of our period." This turning to the permanent collection was natural—it suggested an older man's reticence before the onslaught of the present. And it was well to remember that it had only been in 1953 that the museum had finally decided to establish a truly permanent collection. Before that time, the policy had been that when works reached a certain age, they would be transferred to another institution; there had been an agreement with the Metropolitan Museum of Art. By the 1960s, Barr saw the permanent collection as the anchor for the museum, as a force that might steady the museum as it confronted the immensely chaotic prospect of providing leadership in the present. Barr in any event suspected that the power of tastemakers was exaggerated. He reminded Canaday of one of Aesop's fables, in which "two flies who, perched upon the axletree of a chariot, complacently remarked to each other: 'What a dust we do raise!' "[10] He was saying that the museum was more acted upon than acting—which was probably true, at least up to a point. This was 1960; nobody could have dreamed of how much dust the art world was going to raise in the next few years, with the coming of Pop.

Barr's construction—artists lead, museums follow—however attractive it might be, also suggested a whole range of questions, which had become almost impossibly vexed by the time he made his statement in 1960. When he spoke of all the dust that was being raised, he was recognizing the fact that there were forces that were pushing artists and arts institutions in certain directions, whether they wanted to go there or not. The museum's power to thrust artists into leadership roles could not be ignored. In the 1950s the Modern focused attention on developments in the world of the Cedar Tavern and the Artists' Club. The museum's spotlight could also be a dangerous thing. The spotlight could make a career such as Rothko's look overscaled, maybe foolishly ambitious in its austerities; at least that was what some people believed, at the time of his retrospective at the museum in 1961. And the spotlight could give newer artists, whom the museum saw as comers—such as Frank Stella, with his first all-black paintings, and Jean Tinguely, with his self-destructing machines—a bold-stroke importance that they might not otherwise have acquired quite as quickly. Not that these artists weren't comers; but the museum, through its very leadership skills, could make it seem as if they

had come further, were moving faster. Barr was more than a little self-deprecating when he spoke of publicity as clouds of dust, for the take-control role of the museum could give new artists a red-hot exuberance; could even start firestorms, and start them from almost nothing.

III

While the Museum of Modern Art was getting older, it was not losing its appeal for the young. The generation of artists and writers who came to New York just after the war was now exhibiting in the museum and working there as well. One indelible image from those years is a photograph by Fred McDarrah of Frank O'Hara, in his role as a curator, coming out of the revolving door of the Modern's shiny, glass-and-metal façade—the façade that Macdonald called a surprise package. O'Hara, a slim figure in suit and tie, has the aura of a sleek jack-in-the-box. In fact, O'Hara had never exactly planned to have a curatorial career at the museum—it had just sort of happened. He had first worked at the Modern in 1951, when he had a job selling tickets and publications at the front desk; this was the kind of entry-level job that almost any young man getting into the arts takes at one time or another. But it is interesting that he wanted to be there, the story goes, so that he could spend as much time as possible with Barr's enormous Matisse exhibition—he was part of the new public. Four years later he was back at the museum, and he would more or less remain there until his death in 1966. He started out as a temporary assistant in the International Program, which was funded by the Rockefellers and separate from the museum's regular exhibition program, and by the end he was a curator, organizing major shows devoted to Reuben Nakian and Robert Motherwell and writing the catalogs.[11]

O'Hara, the quintessential downtowner, had no problem negotiating uptown—he was an elegant man defying his logical limitations. Waldo Rasmussen, who worked with O'Hara at the Modern, said that "he was very

Fred McDarrah, Frank O'Hara at the Museum of Modern Art, January 20, 1960.

adroit in adapting himself to the institution. So little an 'organization man' himself, he managed to work within it and yet keep a distinct separation from it. It was a special quality of grace he had, and no mean feat." O'Hara knew how to work with others, and he enjoyed it. "It gave him pleasure, as you can see from his collaboration as a poet working with painters, and this seemed to be true at the museum as well, even when his collaboration was essentially on a subordinate level, as it was on several exhibitions for which he assisted Dorothy Miller, James Thrall Soby, or René d'Harnoncourt. He had such an equable temperament, he communicated so much wit and warmth and good humor, that he violated the basic tenet of the Puritan work ethic on every hand: with Frank, work was fun." O'Hara was somewhat involved with "The New American Painting," which toured Europe in 1958 and 1959. Even if he had no part in the selection, the Abstract Expressionist legends included were among the artists who meant the most to him and his friends. This was the event that many believed turned the tide for American painting; when the show returned to be seen at the Modern itself, it was the museum's fullest embrace of what had happened in American art a decade earlier. O'Hara organized the U.S. contribution to Documenta II in Kassel in 1959, an expansion of "The New American Painting" that included work by Calder, Ferber, Naum Gabo, Lassaw, Lipton, Noguchi, Roszak, Smith, Rauschenberg, Hofmann, Cavallon, Marca-Relli, Pousette-Dart, Tobey, and Newman. Then, starting in 1960 with "New Spanish Painting and Sculpture," O'Hara was involved with events that were more fully his own and that culminated with the Motherwell retrospective in 1965 and the Reuben Nakian retrospective a year later. Of these later shows, Rasmussen observed that "all were very 'inside' their subjects, all passionately felt."[12] By the time that he died two days after he was hit by a jeep on Fire Island, O'Hara had good reason to believe that he'd had something to do with bringing a new kind of attention to the art with which he'd come of age fifteen years earlier. Sliding in as New York's 1940s avantgarde confronted the 1950s, he had helped ease the transition into the official art world of the 1960s.

In the catalog essays that O'Hara wrote in the 1960s, you can feel the impact of the close reading of Barr that he and so many of his friends had been doing, some of them probably practically since they were kids. True, O'Hara was rarely a first-rate writer on the visual arts; what you remember from the writing are brilliant brief forays that have a tendency to wilt without really going anywhere. He is too often guided by dazzling enthusiasms and doesn't always dig deep enough; his generalizations are airy. Yet these essays can

be read as a slightly inebriated gloss on
the brevity and clarity of Barr: The writer
moves in rapidly, setting up the situation,
presenting the facts. In the beginning of
his book about Nakian, a sculptor who
combined a fondness for mythological evo-
cations with an intuitive way of spinning
compositions in terra-cotta or welded metal,
O'Hara is really covering ground. "The
career of Reuben Nakian has had dramatic
ups and downs, advances, reversals, reval-
uations. His stylistic doubling-back and
pushing-forward is not only exemplified by
his development, but literally prefigured in
his work: the slash-cut drawing into wet clay

Reuben Nakian, Pastorale, *1948.*
Terra-cotta, 15⅝ in. high.

which ends as elegant, pastoral evocation of nymph and satyr; the harshly
formed and rigidly armatured metal sheets which turn into erotic waves of
Tarquinian lust and Lucretian submission, or autumnal leaves drifting toward
a whimsical gravitational pull."[13] His interest in Nakian was very much that of
a Silver Age New Yorker: He liked the way going forward involved going
back. Nakian's mythological images defined a new, gestural-pastoral mode.
There was a kind of delirium in Nakian's easygoing evocations of the classical
tradition; he gave metamorphoses a calligraphic amusement.[14]

In O'Hara's writing there are echoes of Barr's instinct for the telling detail
and the essential generalization, and those echoes are given a particular kind
of bold, hyper-caffeinated, late-1950s pulse. Ideas are telegraphed in a
nanosecond. After O'Hara died, Renée Neu, who had worked with him at the
museum, wrote an imaginary letter and recalled: "Sitting at my desk, with my
back to you in our cramped little office, I never tried to learn whether you
were drafting a letter, working on an introduction or writing a poem. You
would go on working and then the phone would ring: Frank, can you recom-
mend someone for such and such a job? asks personnel; Frank, from what
poem is the following line? asks a well-known and literate trustee; Frank,
Help! says one of your many friends who proceeds to dump on you his prob-
lems and/or the problems of his friends. And you always managed to come up
with the right answer. Then, when your reputation grew, there were staff
members dropping by—sometimes even on legitimate business—and friends
or out-of-towners turning up, and you'd take care of them in your usual

matter-of-fact way."[15] He was the perfect man to represent the downtown crowd in what Macdonald had called this "glass-and-chrome-and-colored-marble surprise package" of a museum.

IV

O'Hara had more or less stumbled into a job at the museum. But the growing presence of works by artists of his generation and of a generation slightly older was the product of a long, carefully managed campaign on the part of the museum—and, no doubt, on the part of the artists and their dealers. At the center of this campaign were the series of shows, organized by the Museum of Modern Art in the 1940s and 1950s, that emphasized the variety of contemporary art by presenting groups of works by some dozen or so artists. These exhibitions—with their elegantly generic titles: "Fifteen Americans" (1952), "Twelve Americans" (1956)—were an attempt to emphasize the range of American art, to suggest that the museum was willing to put many different native styles under the microscope and follow the variety of directions in which a number of artists might want to lead. These exhibitions were probably the museum's canniest response to the bursting art scene of those years, and like so many of the ideas that did the museum proud at that time, the idea went back to policies that Barr had developed around the time the museum opened. The museum's second show, which opened in December 1929, had been "Paintings by Nineteen Living Americans."[16]

In the most general way, the museum's view of America might be shaped by Barr, but from 1934, when Dorothy Miller joined the staff, she was the one who reviewed artists' work, and by the late 1940s she was responsible for the final shape of all the selected American-artists shows. Miller—who was married to Holger Cahill, who had pioneered the exhibition of American folk art at many museums—was the museum's go-America person. Alice Goldfarb Marquis, in her biography of Barr, writes that Miller "lived in bohemian casualness . . . in Greenwich Village" and was "slender, vivacious, a thick braid of dark hair circling her head and striking pieces of handwrought modern jewelry usually circling her throat and wrist."[17] Miller had been deeply involved in the American exhibitions in the early 1940s, which were among the most ill-defined and poorly selected that the museum ever had. Compared with Barr's lively orchestration of "Nineteen Living Americans" in 1929, the potboiler expressionism and realism that dominated "Americans 1942" and "American Realists and Magic Realists" in 1943 were a sorry thing. "Fourteen Ameri-

cans," in 1946—note the postwar date—was the breakthrough show for Miller and the Modern; obviously, they had been looking at what Peggy Guggenheim had been showing at Art of This Century as well as other developments in the galleries. There was still some bombast, like the big-eyed saints of David Aronson, with their coarse, waif-from-the-ghetto expressions. But also included was Loren MacIver, an artist whose elegantly fantastical ideas brought a new kind of urgency to the nostalgic strain in Surrealism. MacIver is one of America's uncategorizable major talents, a dreamer whose landscapes and still lifes have a gauzy sweetness but also a surprisingly succinct metaphoric power. In addition, "Fourteen Americans" showcased several Abstract Expressionists (Gorky, Motherwell) and a number of artists who shared some of their concerns (Noguchi, Roszak, Steinberg, Tobey). Six years later, with "Fifteen Americans," Miller was even more confident. Pollock, Rothko, Still, Baziotes, and Bradley Walker Tomlin were included—all with some of the best work of their careers; their calligraphic lines and singular images hadn't frozen yet. There were also wonderfully independent realists such as Edwin Dickinson (with his quirkily exacting renderings and off-center, near-abstract compositions) and Herman Rose (with his delicately impastoed vistas of New York, in which the whole city is aquiver). For once, Miller was justified when she wrote of again bringing "together a group of distinguished artists of marked individuality and widely differing aims. Their achievement may indicate trends in our art today, but to discover and illustrate such trends was not the primary intention behind the exhibition. The purpose was rather to give each artist an opportunity to speak

View of Noguchi gallery in "Fourteen Americans" at the Museum of Modern Art, 1946.

Herman Rose, West 56th Street. Oil on canvas, circa 1950s.

to the Museum's public, in clear and individual terms, through a strong pre-
sentation of his work."[18]

A question that was raised about "Fifteen Americans" was whether 1952
was simply too late to be giving this kind of attention to Pollock and Rothko,
considering that many of these artists had been in New York since the 1930s.
But given that many of them had not arrived at their mature styles until the
late 1940s or early 1950s, the museum's attention could be said to be right on
time. And works by some of these artists—by Pollock, by de Kooning—had
already been acquired by the museum in the 1940s. In the case of "Fifteen
Americans," the fact that it was so difficult to say whether the time was too
early or too late or exactly right suggested that for once the balance between
the museum's role as leader and the museum's role as follower was on target.
The curators were following the artists, but not too far behind, which meant
that the museum was leading its audience, but not leading in a way that would
distort what the artists were doing. The same could also be said of "Twelve
Americans," four years later. While Franz Kline and Larry Rivers represented
different generations, they had both really established themselves in the half
decade preceding the show in 1956. "Twelve Americans" was about what had
been happening on Tenth Street *recently*, another case of the museum follow-
ing the lead of the artists in the sense that Barr would later describe.

The final installment of the series during the 1950s, "Sixteen Americans"
in 1959, was felt by the museum itself to be its most aggressively up-to-the-
minute report. The museum as follower was becoming the museum as leader.
The public did not disagree. Introducing this show, which included paintings
of flags and targets by Jasper Johns, Robert Rauschenberg's combines,
Ellsworth Kelly's pared-down abstractions, and the black paintings of Frank
Stella (who was all of twenty-three at the time), Miller observed that in previ-
ous years the museum had shown "a number of distinguished artists already
well known to New York gallery visitors, although far from well known to the
Museum's larger public." For the new show, however, she said that it was
desirable to include a larger proportion of newcomers to the New York scene;
six of the sixteen had not yet had one-man shows in New York, and several
others had shown but once or had had exhibitions that were not truly pertinent
to their present work. "Perhaps," she pressed forward, "it is not too much to
claim for Sixteen Americans an unusually fresh, richly varied, vigorous and
youthful character." The show was meant to illustrate "some of the interest
and excitement experienced in exploring American art in 1959."[19] "Sixteen
Americans" still suggested a range of ages and interests. Louise Nevelson and

Richard Stankiewicz were, at least in comparison to Johns or Stella, representatives of established styles, which in their cases were versions of the junkyard Constructivism that was popular on Tenth Street. Both Nevelson and Stankiewicz were older, and had had something like ten one-person shows each. Rauschenberg, for that matter, had been a presence in New York for much of the 1950s, and in the very same year as "Sixteen Americans" he was representing the United States at both Documenta II in Kassel and the Biennale in São Paulo. The Modern had put its money behind Johns a year earlier, when Barr selected several works from his first show at Castelli for eventual inclusion in the museum's collection.

It was the appearance of Frank Stella, age twenty-three, that really turned heads. He had graduated from Princeton the year before, and had only had one or two paintings in group shows in New York. In the 1960s, Robert Rosenblum recalled "the seeming suddenness" with which Stella's paintings "assault[ed] . . . the public in 1959." The only paint on these canvases was black paint, arranged in straight lines, with the bits of canvas showing between the lines reading as lighter lines. "To most eyes," Rosenblum recalled of "Sixteen Americans," "they appeared monotonously simple and inert, a

Rudy Burckhardt, view of Frank Stella in "Sixteen Americans" at the Museum of Modern Art, 1959.

bewildering impoverishment of art in which the only unit was a regular black stripe and the only compositional principle a numbing symmetry as obvious as a child's idea of a formal garden. Critics were unusually hostile, dismissing the work on the basis of its youth ('Is it really important,' one critic [Dore Ashton] asked, 'for the public to see the work of a 23-year-old boy who has only been painting for three or four years?') or mocking what they thought to be an impudent Dada prankster who tried to bait his audience by painting nothing but pinstripes."[20] Stella's age and the fact that he had barely exhibited loomed large in many people's minds, but the truth was that neither was unprecedented in the Modern's American series.[21]

Among the few pieces of information contained in the brief biography of Stella in the catalog of "Sixteen Americans" was that he had studied with William Seitz at Princeton. Now this is quite interesting. You will remember that it was Seitz who had written a Ph.D. thesis on the Abstract Expressionists.

This had been the first thesis in the Princeton art history department on a contemporary topic, and Barr's support had been instrumental in persuading the department to allow him to do it. That thesis could be said to have established a new relationship between contemporary art and academia, a relationship by which art that had only just been created became a subject of academic discourse. And Stella's appearance at the Modern was the next step, whereby the academic discourse brought about a new development in painting, which was then embraced by the museum and the art scene. Seitz's study of the Abstract Expressionists subjected current art to art historical standards; the putative

Frank Stella, Die Fahne hoch!, *1959. Black enamel on canvas, 121½ × 73 in.*

drama of Frank Stella's black paintings, when they appeared in the museum in 1959, was that they imposed a fixed idea of radical historical change on the art scene. There was reason to believe that the art historians were now beginning to act as leaders in contemporary art. As Rosenblum explained in the first book on Stella, "in [Princeton's] extra-curricular studio classes of William Seitz and Stephen Greene, he set out rapidly to rival and then to displace the heavy authority of New York's artistic establishment."[22] Seitz and Barr—the followers—were training the new leaders, or so you might say. And Seitz was soon to become a curator at the Modern; he organized "The Art of Assemblage" in 1961.

The argument can be made that there was not much less in the way of composition or content in Stella's first black paintings than there was in some of the work that Reinhardt and Newman were doing in those years, but perhaps because this artist was an unknown quantity, his paintings could suggest a facelessness that even the most reduced Reinhardt or Newman, by virtue of the artists' previous work and well-known personalities, avoided. All through the 1950s, the increased simplicity of certain painters' work had been explained in terms of a search for transcendence, of a purification of personality, and now here was a "kid" offering reduction without the narrative-spiritual overlay that the New York School had cultivated. Carl Andre, who wrote a brief state-

ment that accompanied Stella's paintings, was challenging the heated rhetoric of the New York School, and the repetitive excess of Reinhardt's art-is-art statements, when he wrote that "Frank Stella is not interested in expression or sensitivity. He is interested in the necessities of painting." And what were those necessities? I am inclined to say that they were nothing but the necessity of taking another clever step. I am reminded of Porter's remark about Johns, that his was "an education that has been carried out in public. It shows the reaction to his education of an individual intelligent enough at first to take in all that he is being taught while giving it only part of his attention."[23]

For anybody who was inclined to see Stella as a man who had made some careful calculations as to what the work of an artistic leader would now look like, his emergence, deus ex machina, at the Museum of Modern Art, was beyond perfect. Skeptics might recall Picasso's remark that "a museum is just a lot of lies." What Picasso hated about museums was their clinical atmosphere, but that was precisely the thing about the Modern that made it so brilliant a staging ground for Stella's chilly images. Around the time that "Sixteen Americans" was up, Stella gave a lecture at Pratt Institute, in which he represented his artistic development so cleanly that he could have been a surgeon describing an operation. "There are two problems in painting," he said. "One is to find out what painting is and the other is to find out how to make a painting. . . . One learns about painting by looking at and imitating other painters," he continued, a statement no one would disagree with, except that his description of the process has the blandness of a copyist at work. "How did Kline put down that color? Brush or knife or both? Why did Guston leave the canvas bare at the edges? Why did H[elen] Frankenthaler use unsized canvas? And so on. Then, and this was the most dangerous part, I began to imitate the intellectual and emotional processes of the painters I saw. So that rainy winter days in the city would force me to paint Gandy Brodies, as bright clear days at the seashore would force me to paint de Staëls."[24]

When Stella dispensed with the delicate effects of Gandy Brodie and the bolder ones of de Staël, he was telling his audience that he'd been through all that Silver Age painterliness—that he was on to something else. "I would discover rose madder and add orange to make a Hofmann. Fortunately, one can stand only so much of this sort of thing. I got tired of other people's painting and began to make my own." This makes it all so simple. But soon, "tired of looking at my own paintings," he decided to find a better way. He ends this brief talk by speaking exclusively in terms of problems and solutions. The problem: "I had to do something about relational painting, i.e. the balancing

of the various parts with and against each other." And then he revealed the "obvious answer": "Symmetry—make it the same all over."[25] Had anybody ever spoken this way about painting before? And could anybody have even imagined that this was a way to think and speak about painting if they had not learned everything they knew within the context of the academy? The seeds of Stella's weariness with "other people's painting" might have been in de Kooning's observation, less than a decade earlier at the Modern, that he was "tired of all that," but from de Kooning's cool, sweeping intelligence to Stella's surgical moves was quite a leap.

There had been a hard-won romantic drama to de Kooning's rejections; he was howling against the inevitability of history. Stella's rejections were nothing more than a historical calculation. What Andre had called "the necessities of painting" were little more than a fancy name for historical inevitability. A dictatorship of back-to-basics aesthetics had replaced the dictatorship of the proletariat. It was the next step in that chart that Barr had put on the cover of the catalog of the "Cubism and Abstract Art" show twenty-three years earlier—in the year, as it happens, that Frank Stella had been born in Malden, Massachusetts.

V

While "Sixteen Americans" was still up at the Modern, a Swiss artist by the name of Jean Tinguely arrived in New York for the opening of his first show at the Staempfli Gallery. He made what he called "meta-matic" sculptures: motorized constructions, full of wheels and gears, that jerked and jiggled and that sometimes had drawing implements attached, so that the machine might create its own Abstract Expressionist artworks. Even before he arrived—"in tourist class on the *Queen Elizabeth*," as Calvin Tomkins related the story in a *New Yorker* profile that was to make Tinguely famous—he began to conceive *Homage to New York,* a kinetic work that would take his meta-matic sculptures into a grander, perhaps a New World scale.[26]

Tinguely had been born in Fribourg in 1925. By the 1950s he was in Paris, where he had his first show at the Galerie Arnaud and became associated with Yves Klein and the other artists who were called *nouveaux réalistes*—the name that in America would be given to the first big group Pop gallery show, "The New Realists," at Janis in November 1962. Tinguely's constructions were delicate and skeletal concatenations of found mechanical parts that had their own kind of stop-and-start Rube Goldberg movements. The origins of these

mechanical contraptions reached back to the Bauhaus—and Tinguely had studied with people who had studied there. When he arrived in New York, he already had a following in Europe. The critic Dore Ashton, who had complained of Frank Stella's youthfulness, was at the boat to meet Tinguely. She'd already seen his work in Europe, and he promptly showed her the sketches he'd done on board ship of his New York project. "It has to be in the Museum of Modern Art," Ashton recalled him saying. "It has to end up in the garbage cans of the museum." And, while Ashton was skeptical about his getting his way, she was, as Tomkins related, "somewhat awed by his talent for getting what he wanted."[27] Tinguely immediately got to know Johns and Rauschenberg—and Duchamp, whom he'd already met in Europe. And the campaign to get the Museum of Modern Art behind his project began.

New Yorkers were not optimistic about Tinguely's chances of being granted the use of the Modern's sculpture garden. They knew the museum's tendency to hold itself a bit aloof from fast-breaking developments. What they did not count on was the shifting attitude among the museum's staff as to what it meant to lead and to follow, the extent to which a staff that had come of age studying the art of the recent past was becoming increasingly interested in making predictions about the next step, the next move. George Staempfli, Tinguely's dealer, called various people, but got word back that it was impossible. Then Ashton spoke to Peter Selz, the young curator of painting and sculpture exhibitions. "Selz," according to Tomkins, "was interested. He had been fascinated by Tinguely's big meta-matic at the Paris Biennale the year before, and he was receptive to the playful and humorous aspects of Tinguely's work. ('Art hasn't been fun for a long time,' he said.) Selz spoke to the museum's director, René d'Harnoncourt, and this led to a meeting between d'Harnoncourt and Tinguely." To everybody's astonishment, by February, a few days after "Sixteen Americans" with its Stellas went down, d'Harnoncourt had given Tinguely the okay for this project, which would possibly bring fire, explosions, and mayhem to the garden of the Modern on March 17. And this was a museum, let us not forget, that had suffered a major fire two years earlier, which destroyed one of Monet's vast *Water Lilies.* Tinguely set to work in one of several Buckminster Fuller domes in the garden; they had been set up the previous September under the auspices of Arthur Drexler and the design department. Billy Klüver, a Swedish-born research scientist at Bell Labs who would assist Rauschenberg with a number of art-and-technology projects in the 1960s, got involved. Tinguely worked for three weeks in the Fuller dome on his self-destructing machine, and his presence there marked a

Ken Heyman, Jean Tinguely, Homage to New York *in the garden of the Museum of Modern Art, 1960.*

new turn in the relationship between the museum and contemporary art. Klüver observed afterward that *Homage to New York* came "out of the chaos of the dump and back again," but in between there was the full institutional support of the Museum of Modern Art.[28] Dump finds had never had it so good.

Perhaps very few people are entirely immune to the power of a take-control personality, and when the personality is a bohemian scout leader, the avant-garde is generally smitten. Although only a handful of people were actually involved in the construction of *Homage to New York*, the high-spirited reports and recollections can make it seem that half the population of the city was getting into the act. Tinguely cruised the Canal Street secondhand shops and the dumps in New Jersey for wheels, motors, bikes, baby carriages, and assorted gizmos. The Modern sold Tinguely an antiquated Addressograph machine for two dollars; Rauschenberg contributed a machine to fling silver dollars into the crowd. The performance was supposed to start early on the evening of March 17, but the audience was kept waiting for hours, and even when things did get under way, the machine's spluttering, blundering, stop-and-start operations led to a feeling that this was an event that was never really going to take off. At almost the last moment, Tinguely had painted the entire construction white, an inspired move that turned this panjandrum, with its piano body, spiky protuberances, and big suspended balloon, into a wild sketch inscribed against the museum garden's night sky. And rather than any particular thing that the machine did, it was surely the wild singularity of the evening, with all the excitement generated by an all-star audience that included Governor and Mrs. Nelson Rockefeller and reporters from TV and the international press, that gave *Homage to New York* its weight. The piano barely played, Tinguely's self-drawing machine barely drew, and other parts of the meta-matic turned or twisted in ways that the audience couldn't see. There were tons of smoke; a radio went on but was barely heard; and through it all Tinguely walked around, delighted by everything that was happening.

Posing for a photographer—smiling, his arms outstretched—he was the happy-go-lucky impresario of the avant-garde. It was not for nothing that he had gotten to know Duchamp.

It all lasted less than half an hour. The fire was kept under control. And after it was over, the audience descended into the rubble to gather souvenirs. The construction had, according to plan, self-destructed. And Tinguely had handed the Museum of Modern Art an event that captured the imagination of the audience. One might remember Dwight Macdonald's profile of Barr in 1953, with its wry mention of the postwar museum as run by people who were a little like French aristocrats during the Terror, dreaming of their glorious past—which in this case was the long-lost youth of the avant-garde. Tinguely's *Homage to New York,* with "all" New York in attendance, might recall the elaborate fireworks and pageants of Versailles; it was a celebration of the nihilism of anti-art, only given the ornamental elegance of scrap-iron construction and mounted in the city's premier modern museum. In *The Nation* a writer observed, "This is what social protest has fallen to in our day—a garden party."[29] Of course Barr had always seen anti-art as one of the things that a museum of modern art must absorb; Duchamp's *Large Glass* had for several years been on loan to the museum from Katherine Dreier. But with *Homage to New York* the destruction of art as a part of the history of art was being enacted within the museum, and enacted in a giddily dramatic way. The next year, when William Seitz, Frank Stella's teacher at Princeton, organized "The Art of Assemblage," the catalog of which included photographs and descriptions of Tinguely's *Homage to New York,* he observed that "the themes beginning to pass through the doors of art museums are (once again, as in the days of Courbet) those described by Gide as 'the squalor of reality.' "[30] But had those themes passed directly into the museum in Courbet's day? Had Courbet been inside the museum?

VI

A year later, when Mark Rothko arrived for the opening of his retrospective at the Modern, he was fifty-seven years old, and seemed like an unsettlingly gloomy figure to contemplate as he made his way through the bright, booming spectacle that was postwar art. A few years before the show opened at the Modern, jazz historian Rudi Blesh, a contemporary of Rothko's, had observed that the artist's "gentleness is only a little less terrifying than his anger." And around the same time, William Seitz, then still at Princeton

but soon to be a link between Stella and the Modern and then to become a curator there himself, wrote of Rothko's genial hostility. Rothko must have provoked these paradoxical responses. While Pollock had turned his unhappiness into drunken theatricality and made an early exit behind the wheel of an automobile, Rothko went to pieces more or less in private and over a period of two decades. Blesh wrote that Rothko had "boiled and fumed and sulked" his way through the 1950s.[31] His saturnine spirit appealed to younger bohemians who were anxious to make idols of an earlier generation's tormented souls, but even so, it cannot have been easy for Rothko always to be the pessimist among the optimists.

Mark Rothko, Untitled, 1953. Mixed media on canvas, 106 × 50⅞ in.

Rothko's Modern show was not a full retrospective, although it contained a few of the Surrealist paintings with whirligig-like visions from the mid-1940s. For all intents and purposes, the exhibition began at the end of the 1940s, with Rothko's mysteriously floating rectangles, which are all shimmering colors and fadeaway edges. These most distinctive paintings, whatever they owe to the Surrealist spirit of New York in the 1940s, are also, with their juicy, melting colors, paradigms of postwar elegance. Greenberg, in his most complete statement about Rothko's generation, the essay " 'American-Type' Painting," which was published in *Partisan Review* in 1955, referred to the Rothkos as being "among the largest gems of abstract expressionism."[32] Greenberg did away with this not exactly graceful characterization when he reprinted the essay in *Art and Culture,* which came out in the year of the Rothko show at MoMA, but I don't think he was wrong originally to describe Rothko's paintings in terms that bring to mind luxury objects. They're lavish yet severe, lyrical yet compressed, and the conjunction of opposites gives the best of them their lovely glow. The finest are from the first years—into the early 1950s—when you feel that Rothko is just discovering this gently forceful imagery. There is an element of surprise about the paintings; the arrangements of the forms, the way they array themselves in stacks, feels unexpected, like a startlingly beautiful color combination in a late-afternoon sky.

The exhibition at the Modern was a triumph for

Rothko, but like many events of the turn of the decade it also had the effect of forcing a younger generation to decide how far exactly the founding fathers had gone. The critic Max Kozloff, who was in his twenties at the time of the show, wrote that the Rothkos "have been received immediately as the most problematical works shown this year." While Kozloff's was not a negative review, he did believe that the show was overhung. "The separate paintings are not served by the abundant presence of their own kind." Kozloff had been put off by what he called "the rhetoric of an exhibition that has literally covered all walls in an attempt to impose a Rothko cosmology upon the viewer. In this respect, a single one of the mature paintings will do as much." As for the darkest, most recent work, Kozloff found that these suggested "invisible painting." "Rothko has found himself, temporarily, one hopes, in an expressive dilemma."[33]

Another review of the show, by the sculptor Sidney Geist in the little magazine *Scrap*, made some of the same points, but in much stronger terms. Geist said that an earlier picture in the show—*No. 11, 1949*—was the best, and complained of the paintings in general about "the absence of clear constructive means, the paucity of material on the canvas, and the lack of complication of imagery." There was, Geist thought, something mysterious about the paintings, but it was a weakness. The paintings were only mysterious in that they were "not open to examination and study and thoughtful attention." After complaining of the dim light at the show, he went on to say that "both the mood and the power I find oppressive—and boring—and indeed I feel myself in the presence of an ambition that is ultimately bureaucratic and thought-controlling in its nature. . . . The paintings seem to say, Don't examine, don't question, just submit. . . . Rothko has created an art which points to himself and to himself alone, and which, as far as Art is concerned, leaves no way out, admits of no alternative and has no future—not even for him; power corrupts."[34] This criticism by a sculptor who would later write a penetrating study of Brancusi could be dismissed as reflecting a lack of comprehension of Rothko's increasingly fierce simplification. Yet when Geist spoke of the "bureaucratic" and "thought-controlling" nature of this art, he may not have been wrong to feel that Rothko was giving the artist's leadership role a didacticism, a rigidity. And he may not have been wrong to see a kind of collusion between the artist and the museum.

Geist was hardly alone among the artists of the early 1960s in believing that many of the Abstract Expressionists had worked themselves into various corners, and that their art lacked a future. A Modern retrospective could be

frightening; it removed an artist's work from the fluidity of the yearly one-man show and gave it a more definitive character. "The lesson to be learned from [Rothko's] effort," Geist wrote, "—his ten years' devotion to or insistence on a restricted theme—is clear: it demonstrates the eventual futility of the search for the big statement, the 'personal image.' "[35] There were equally negative things being said about de Kooning at the beginning of the 1960s. That there were younger artists who were expressing doubts and second thoughts was a sign of health. Perhaps this was the last moment when younger artists could engage with Abstract Expressionism as a style alive with possibilities and perils and believe that their reactions to it could result in a personal style as various as painterly realism or pared-down Constructivism. A couple of years after the Rothko show, successful artists were no longer regarded as fair game for serious criticism, and in a sense younger artists could no longer learn from them. True, Geist took an extreme position about Rothko's paintings. "Power corrupts," he said. But sometimes the most extreme views suggest the more general drift of events. By 1960 the officialization of the avant-garde was an accomplished fact, and the Modern was now the arbiter of the avant-garde's monuments and amusements. If Tinguely was an amusement, Rothko was a monument. And Frank Stella, well, he was an amusement on the way to becoming a monument.

VII

In 1959, after the extraordinarily luxurious Four Seasons restaurant opened in the Seagram Building, B. H. Friedman, the novelist and chronicler of the second generation of downtown painters, published a piece called "The Most Expensive Restaurant Ever Built" in *Evergreen Review*. He obviously got a kick out of describing the insanely luxe décor. And he was anxious that his readers know that "the Four Seasons has its anonymous institutional tie, too, a very strong and close one. It is with The Museum of Modern Art. The wedding of talents is like an incestuous gang-bang."[36] For the moment the Modern was the tastemaker's tastemaker.

The restaurant was, so far as Friedman was concerned, something out of an updated version of Petronius's *Satyricon*. Joseph Seagram was Mr. Trimalchio. Friedman ogled the cherry paneling, the Fortuny fabrics, the dark brown leather, the menus "printed on handsome creamy paper [and] bound with purple faille." And the art fit right in. Friedman surveyed the Miró tapestries, the airy wire sculptures by Richard Lippold, whose work had been included in

Ezra Stoller, the Grill Room of the Four Seasons restaurant, 1958.

"Fifteen Americans" back in 1952, and mulled over the commission for murals by Mark Rothko, which had not yet been completed. Friedman couldn't bear Lippold's vast, delicate gold-dipped brass constructions, suspended above the bar. He admitted that "at a distance" they had "a surprising visual density." But "neither up close nor at a distance do they work as sculpture. There is no sense of emotional content or of spatial conquest. They work, rather, as décor, and in this context they are overwhelmed by the scale and opulence of their surroundings." From the Lippold, Friedman went on to complain about the Picasso curtain, done for *Le Tricorne* in 1919. Hanging between the Grill Room and the main dining room, it did, he admitted, make an impact from a distance, but "it has no interest as a painting *per se,* and little as a sketch drawing."[37]

Friedman listed prices. The Picasso was said to cost in excess of $100,000. The furnishings, which he thought could have been out of a good design show at the Museum of Modern Art, pushed the budget to something like $4 million. Then he described Pollock's *Blue Poles,* rented to hang in the dining room until Rothko's commission was completed. As for the Rothko commission, Friedman was voicing doubts about it even though the work wasn't yet there to see. He reflected that Rothko's "position is considerably more official here and now, in 1959, than was Picasso's in 1919 Paris, before the concept of 'museums of modern art' existed. From the point of view of such museums

and that of the architects approved by them, Rothko's more recent and regimented paintings can hardly exist, except as historical objects." This sounded very much like Geist's position. Friedman continued, "It will be a surprise if he, any more than Lippold, transcends décor. Part of a statement Rothko made for the Museum of Modern Art's 'Fifteen Americans' show in 1952 was: 'A picture lives by companionship, expanding and quickening in the eyes of the sensitive observer. It dies by the same token. It is therefore a risky act to send it out into the world.' Since then, Rothko has played his own distribution close to the vest, picking his spots carefully. This one is challenging. We'll see."[38]

Friedman was a man of the same generation as Kozloff and Geist, of the generation after Rothko, and none of them could help but see Rothko's increasingly pared-down vision as related to the institutionalization of taste at the Museum of Modern Art. History, they all seemed to agree, was overtaking the Abstract Expressionists, turning their signature styles into pawns in a historical drama that the artists, try as they might, could no longer control. To Friedman, it no longer mattered that for so many years the Modern had not paid much attention to Mark Rothko and his Abstract Expressionist buddies. Of course if one chose to look at these fast-breaking developments from Rothko's point of view, things had to have been strange indeed, for there he was, smothered in institutional attention by the Modern after a decade when all there had been to do was to stay in his studio and dream up his own version of romanticism, a romanticism that took him to unknown places through the invention of a whole range of voluptuously colored, floating-forward-and-melting-away forms. Rothko's romantic yearnings had turned into art history. And now the question was what a painter should do next. In the end, Rothko did not complete the Four Seasons commission. He returned the money he had been paid. It was said that his change of heart came after he and his wife had a meal at the restaurant and he was disgusted by the opulence of the place. "Anybody who will eat that kind of food for those kind of prices will never look at a painting of mine," he was reported to have exclaimed.[39] Rothko was aware, as Friedman was, that avant-garde experimentation was turning into a new brand of deluxe product. Rothko did not need that kind of publicity. He could see that there were many people who were ill prepared to make a distinction between his paintings, which would give a wall a rhythmic glow, and mere wall décor, and it was not to his advantage to add to their confusion.

While an artist might be glad to find his work reproduced in the large-circulation magazines, it could be disturbing to see how quickly a growing

audience accepted the hard-won triumphs of abstract art as nothing more than a new kind of pretty picture to be reproduced in a magazine. Of course the gents at the Four Seasons didn't want reproductions. They wanted the real thing. But how real would it be? As for the Museum of Modern Art, which had fought the long, hard battle for the acceptance of the art of the twentieth century, an advisory role at the Four Seasons restaurant was just one among the many spoils of victory. The museum was becoming a kind of central committee for the cause of modern art. Frank O'Hara was organizing exhibitions. Mark Rothko was being declared a new American classic. And with Frank Stella and Jean Tinguely practically making their New York premieres on West Fifty-third Street, the museum had reason to believe that it had matters firmly in hand at the beginning of what looked to be the most glamorous, publicity-crazy, and hell-raising decade in the entire history of American art. The museum that had become famous by reporting on the making of history was coming dangerously close to faking history.

13. POP THEATER

I

"The sixties so far have been my season in heaven." So observed the protagonist of a novel, *Whispers,* by B. H. Friedman, the writer who ripped into the décor of the Four Seasons and edited the important anthology *School of New York: Some Younger Artists. Whispers* took place in the gleaming New York of the early 1960s, a city where success was cool yet intoxicating, where anything could be wrapped up and taken with you. "Power used to be noisy. Not now. Now typewriters are silent." The narrator of *Whispers* was an executive and an art collector; it was a time when many high-end executives had at least a cursory interest in the visual arts. Among the men who began to collect Pop Art in 1961 and 1962 were some who had bought Abstract Expressionism a few years earlier; but journalistic accounts often focused on a new breed of collectors, such as the insurance broker Leon Kraushar. In *Pop Art,* a book by John Rublowsky published in 1965, Kraushar was quoted as saying, "It was when I discovered Pop Art that I became really involved. Here was a timely and aggressive image that spoke directly to me about things I understood." And Philip Johnson, the architect of the Four Seasons and the New York State Theater who was also a collector, explained to William K. Zinsser, the author of *Pop Goes America* (1966), "My interest is what young people do—it's my pleasure to buy works before they get pompous." "I hear the cry of artists (painters mostly) for help, for love, for recognition"—this is Friedman's hero speaking—"in short, for that abstraction of all these: money. It is so easy for me at my desk to buzz and have my secretary type a check. An electric machine does her work. A signature does mine. Or does the artist do both of ours? Or do we do the artist's? It is confusing to follow the complex flow of energy—money is that abstract." "Foundations, universities, corporations are our patrons now," the narrator explains.[1]

This flow of energy propelled Pop Art to the fore. There was a peremp-

toriness to the work of Johns, Lichtenstein, Warhol, and Oldenburg, to the appearance that Pop Art gave of just bubbling up out of images that were already familiar from the supermarket and the comic books. The paintings of American flags, Campbell's soup cans, and Hollywood stars could feel like unedited everyday experiences. And there was also, sometimes, a likable tinge of nostalgia to these pop images. The subject matter and even the stylizations were often slightly outdated, redolent of the war years, of a simpler, maybe pre–Madison Avenue sensibility. At the same time, Pop Art could be seen as some kind of ultimate fulfillment of that decades-old idea that a work of art defined an era's will-to-form. Like it or not, the *Kunstwollen* had become a cartoon. When the young critic G. R. Swenson wrote "The New American 'Sign Painters' " for *Art News* in 1962, which was one of the first big articles about what would soon be called Pop, he gave the movement a *Kunstwollen*-like sense of painters extracting artworks directly from the Zeitgeist. "Words, trade marks, commercial symbols and fragments of billboards," he explained, "are molded and fused into visual statements organized by the personality of the artist." Swenson, who had been a student at New York University's Institute of Fine Arts, a distinguished art history program, was certainly aware that the way he framed Pop Art was closer to an idea of style as reflecting the spirit of an age than it was to an idea of style as an evolutionary development handed down from artist to artist— what Swenson referred to rather dismissively as "some conventional pattern of visual grammar one or more remove from experience."[2]

Andy Warhol, One Hundred Cans, 1962. Oil on canvas, 72 × 52 in.

It was probably not coincidental that the years when Pop was coming into being were also the years when museums devoted to folk art and primitive art were opening in New York. Art that sidestepped or simply had nothing to do with the old European vision of the rise and fall of styles had been attracting a sophisticated public for quite a while. Only now the taste was spreading, as it had with the *art nègre* craze in Paris in the 1920s; an ever wider audience was looking for a way out of what it regarded as schoolbook conceptions of the history of art. And much of that public would remain blissfully unaware that there was not a single Pop artist whose achievement approached the formal

complexity and emotional authenticity of the finest work at the Museum of Primitive Art (which opened in 1957 on West Fifty-fourth Street, around the corner from the Modern) and the Museum of American Folk Art (which opened in 1963, at 49 West Fifty-third Street, just down the street from the Modern). The director of the Museum of Primitive Art was Robert Goldwater, who had, back in the 1930s, written about Riegl in his book *Primitivism in Modern Painting*. Goldwater quoted Riegl as saying that "there is a certain something in people which permits them to find pleasure in beautiful forms, and which the adherents of the technical-material theory of the development of art are as little in a position to define as are we."[3] If that executive in *Whispers* had read that line by Riegl, his reaction would have been "Hey, that's me, I know what gives me pleasure." The point was that people might define "beautiful forms" in their own way—as the geometric patterns and structures of certain African sculptures, as the flattened shapes in a landscape by an American folk artist, or as the narrative directness of a cartoon strip.[4]

The Pop artist could become a sort of independent contractor, doing whatever the occasion called for, adjusting to the collector's will-to-form. Movies or cartoons or commercial art were expressions of the *Kunstwollen* that a historian—or an artist—could dig into, learn from. For the painter, style in movies or cartoons could feel so alive that it might have the effect of pushing into the background a painter's fundamental concern with his or her materials. There was a sense in which these artists were suggesting that their subjects were more interesting than the artists themselves. The painter vanished into the work. To some this cool attitude suggested a new kind of classicism, for what had Poussin or Ingres done with their "anonymous" paint handling but vanish into a larger idea of art? The difference, and it made all the difference, was that Warhol or Lichtenstein or Johns vanished not into tradition but into commercial culture. Of course they presented this as an immensely complicated and ambiguous vanishing act, but I am not so sure. I am reminded of Duchamp's remark, at the American Federation of Arts in Houston in 1957, to the effect that "the artist acts like a mediumistic being" and that "art history has consistently decided upon the virtues of a work of art through considerations completely divorced from the rationalized explanations of the artist."[5] The artist was both invisible, in the sense of vanishing into his subject matter, and all-powerful, in the sense that the selection of the Campbell's soup can or the particular cartoon character was an all-or-nothing decision.

Robert Scull, a taxi tycoon whose brash style made him the most publicized of the Pop Art collectors, said that part of the appeal of this new art was

that you judged it on the basis of an "immediate response." You no longer had to worry "whether art is good or bad"—you no longer had to understand it in relation to a tradition. Of course nobody really believed that, or else why would they be paying good money for a Warhol or a Johns. But just as the hero of Friedman's *Whispers* could say that money was now abstract, so judgment could seem abstract—an effect of the Zeitgeist, a feeling that was everywhere. Speaking of his three sons, Scull said that "the boys understand [Pop Art] better than we do."[6]

II

The executive who narrated B. H. Friedman's *Whispers* may not have been exactly the person whom John Kenneth Galbraith had in mind in 1958 when he published *The Affluent Society*, but surely Friedman's protagonist would have had no trouble recognizing familiar terrain in Galbraith's portrait of what he dubbed the New Class. Galbraith was describing the results of an astonishing prosperity and his belief that people no longer felt tethered to unappealing careers. This feeling was part of what was drawing artists and politicians and executives together into a new kind of charmed circle. Galbraith's book—which struck a chord: it hit the bestseller lists in the summer of 1958—grew out of a belief that in the postwar period most people, at least in America, were secure in the necessities of life. Personal security, so Galbraith believed, was something that society might now begin to take for granted. His book, which was an attempt to move beyond "economic attitudes . . . rooted in the poverty, inequality, and economic peril of the past," was a plea for a society that no longer developed its priorities in relation to "the thralldom of a myth—the myth that production, by its overpowering importance and its ineluctable difficulty, is the central problem of our lives."[7]

The New Class that Galbraith described was a group of people for whom work was no longer essentially a way to make money but something that "will be enjoyable." Galbraith's New Class was what might be called a working leisure class—a leisure class that did rewarding work, work that might even benefit society at large. "The greatest prospect that we face," he wrote, "—indeed what must now be counted one of the central economic goals of our society—is to eliminate toil as a required economic institution." Galbraith's New Class was in the forefront of this move toward a culture dominated by people "whose primary identification is with their job, rather than the income it returns."[8] Among the groups that typified Galbraith's New Class

was his own group, the professors. (Galbraith himself collected miniatures from India and has written about them.) Galbraith hoped for great things from his New Class. He hoped that with the tyranny of production over-thrown, people would focus their attention on a broad consideration of the social good. Galbraith could hardly have been surprised that the New Class wasn't always so high-minded, but however much he misread these people, he did have an essential intuition. There was an ever growing class of people who were getting hold of the better things in life without the old-time struggles. There was a new ease about middle-class and upper-class life in America. Reading Galbraith, it's easy to see why his New Class might be attracted to an art that had a papery-thin lightness about it, an art with a jocular demeanor. Yet Galbraith himself didn't approve of Madison Avenue. He saw the obses-sion with advertising—it was, after all, a premier New Class career—as the downside of affluence. The New Class understood the delusionary dimension in advertising, but people seemed as inclined to use that knowledge to aes-theticize advertising as to reject it.

Does it matter that these were the Kennedy years? Yes, and the artists, who were glad that culture was now a part of the White House agenda, were attuned to the Kennedy aura. Galbraith was an economic advisor to JFK and served as his ambassador to India. And although there was no deterministic relation of cause and effect between the political and artistic worlds of the early 1960s, much flowed from the fact that Kennedy and his people were roughly the same age as the artists who were coming to prominence around 1960. They had all shared the experience of the war years and the Eisenhower years, and those experiences left them with the determination to reinvent American life as a brilliant, fast-forward cultural spectacle. A new kind of glamour was coming into play. The public had its own sky-high aspirations, and was regarding the private lives of mighty figures in the cultural and polit-ical arenas with some of the avidity that it used to reserve for the careers of ballplayers and movie stars.

This differently focused attention brought out the sexual allure in public types—the president, the artist—who had not previously been seen as related, and pretty soon eminent figures in different walks of life were regard-ing one another with particular care. Artists were invited to the White House, but that wasn't even the half of it. A few weeks after Inauguration Day, Frank O'Hara wrote a poem called "Who Is William Walton?" in which he muses about this Walton who is not the composer. O'Hara wonders "why did he take Mrs Kennedy / to the Tibor de Nagy Gallery worthy / as it is of her atten-

tion."⁹ Here was Mrs. Kennedy herself finding the time to visit a gallery that
was a stomping ground of the second generation of the New York School, and
it naturally followed that more than one artist would imagine that he or she
was going to take at least a small place at the forefront of the New Frontier.
Mrs. Kennedy was all over hip New York. Andy Warhol recalled, in *POPism*,
his book about the 1960s, that in 1963, when his own career had just taken off,
he was sitting in "Le Club one night staring at Jackie Kennedy, who was there
in a black chiffon dress down to the floor, with her hair done by Kenneth."
Warhol was "thinking how great it was that hair dressers were now going to
dinners at the White House."¹⁰ The Kennedys had a look that people admired.
O'Hara's new friend was Bill Berkson, a young man with the Ivy League
Adonis attraction and apparently dazzling way with women that led some to
regard him as the Jack Kennedy of the downtown poets. In photographs,
Berkson has the above-the-fray charisma that we know from Kennedy; he was
JFK in Kenneth Koch's play *The Election*, produced at the Living Theatre
during election week, 1960.¹¹ And when the *Mona Lisa* was sent on a tour of
America, in January 1963, *Newsweek* quoted Warhol and Kennedy practically
right next to each other. "Andy Warhol (renowned for his lifelike portraits of
Coke bottles) said he could see no sense in the visit: 'Why don't they just have
somebody copy it and send the copy? Nobody would even know the dif-
ference.' " But, the magazine went on, "most Americans . . . were highly
pleased with the visit. The President announced that the 456-year-old portrait
'will come . . . as a reminder of the friendship that exists between France and
the United States.' "¹²

Many people in America wanted a little of the Kennedy glamour, but the
artists could flatter themselves that in their case the feeling was mutual: The
people in the White House wanted a little art-world glamour, too. There was
no clearer demonstration of this than the Kennedys' decision to ask Elaine de
Kooning, the estranged wife of the Golden Boy of the Cedar Tavern, to paint
an official portrait of the Golden Boy of the White House. The portrait was
commissioned in 1962, the year before the assassination, and eventually the
whole country saw reproductions of Elaine de Kooning's portraits, which
were executed in a bravura shorthand style that was not unlike the nineteenth-
century styles of Giovanni Boldini and John Singer Sargent, only roughed up
with a bit of an Abstract Expressionist attack. After Kennedy was shot, Elaine
de Kooning wrote a brief essay about her work as court portrait painter.
Kennedy, she observed, "was not the grey, sculptural newspaper image. He
was incandescent, golden." She described how difficult it was to sketch him

Elaine de Kooning, JFK No. 10, 1963.
Oil on canvas, 60 × 46 in.

on account of his "extreme restlessness: he read papers, talked on the phone, jotted down notes, crossed and uncrossed his legs, shifted from one arm of the chair to the other, always in action at rest." The more she worked, the more she realized that she could not just treat him directly. "I . . . had to contend with this 'world image' created by the endless newspaper photographs, TV appearances, caricatures." "World image" is a turn of phrase worth lingering over. It suggests a Germanic grandeur, the thought of the *Kunsthistoriker* whom Bill de Kooning had sat talking with on the steps of a building on Tenth Street. It suggests Elaine de Kooning's fascination with the will of the times, with the forms that dominate the world. She explains that she "began to collect hundreds of photographs torn from newspapers and magazines and never missed an opportunity to draw him when he appeared on TV."[13]

Elaine de Kooning's description of her thinking while she was working on the Kennedy portraits might lead us to expect something along the lines of Warhol's repeating media-based images, but de Kooning, who believed in the painterliness of the 1950s, could not incorporate her intuitions about Kennedy's "world image" within her own relatively conventional style. This "world image" found its way into painting after the assassination, when Warhol did his silk-screened Jackies. Those canvases—with their strident, impersonal surfaces—were a Pop artist's simultaneously ghoulish and ultraclever salute to the JFK aura. And Warhol's repeating images of the elegant brunette also had their connection to Tenth Street. Just as it had occurred to some people that Bill Berkson was Frank O'Hara's JFK, it had occurred to O'Hara that Ada, Alex Katz's dark-haired, strikingly attractive wife, was a downtown version of the iconic American woman—an Elizabeth Taylor or a Jackie Kennedy. When O'Hara wrote about Katz in *Art and Literature,* he set up a line of succession that consisted of "Willem de Kooning's *Marilyn Monroe* and 'Woman' series, Katz's series of *Ada* slightly later, and then later (though Katz's *Ada* series is still continuing) Andy Warhol's series on Marilyn Monroe, Elizabeth Taylor and Jacqueline Kennedy."[14] If there was a connection

between Ada and Jackie, it went beyond the sleek brunette style or the fact that both women looked terrific in a black dress. Katz had sometimes, pre-Warhol, painted Ada, whose pale face was as open and as mysterious as Jackie's, as a series of repeated figures, as if to emphasize her downtown omnipresence. So far as Alex was concerned, Ada was the First Lady of Tenth Street. Warhol may have thought to extend the metaphor—he imagined that Ada presided over the early sixties downtown much as first Liz and then Jackie presided over the early sixties in America. There was quite a genealogy.

III

Pop Art was a darling of the news media even before the Museum of Modern Art gave its imprimatur to the movement with a symposium on December 13, 1962. All during that year, Pop—or Neo-Dada or New Realism, as the movement was variously called—was floating upward on strong currents of opinion, currents that flowed from downtown to uptown and back again, bringing dozens of young artists to near-instantaneous prominence. Gallerygoers reeled through Pop-oriented debut shows; a new look was beginning to dominate. The dealers who presented the work ranged from some who were already well established as supporters of Abstract Expressionism to some who were as new to the scene as the artists they were representing. Martha Jackson, whose "New Forms–New Media" show had shaken things up in 1960, also represented second-generation Abstract Expressionists such as Sam Francis and Paul Jenkins. Eleanor Ward, whose Stable Gallery got its name from the abandoned livery stable on Seventh Avenue where it had originally been located, represented Joan Mitchell, that Silver Age artist par excellence. Janis had shown Pollock, de Kooning, and just about all of the grand old Abstract Expressionist masters in the 1950s. Castelli emerged with Johns and Rauschenberg. And Richard Bellamy, whose Green Gallery was bankrolled by Robert Scull, had been involved (along with Ivan Karp) in the Hansa Gallery.

In 1962 the calendar was jam-packed with debuts. In January, Jim Dine—already known for his happenings—had his first gallery show at Martha Jackson's. In February, James Rosenquist had his first one-man show, at the Green Gallery. A week before Rosenquist's show went down, Roy Lichtenstein had a solo show at Castelli. Wayne Thiebaud had his first one-man show at Allan Stone in April. May saw George Segal's plaster life casts at the Green Gallery. Over the summer, Andy Warhol had his first show, of Campbell's soup cans,

at the Ferus Gallery in Los Angeles. In September, Claes Oldenburg exhibited large soft sculptures at Green. In October, Robert Indiana had his first show, at the Stable Gallery. In November, Warhol had his first New York show at the Stable, and Tom Wesselmann exhibited nudes at Green. Meanwhile, on Halloween, "The New Realists" exhibit opened at Janis—it included Dine, Lichtenstein, Oldenburg, Rosenquist, Segal, Warhol, Wesselmann, and lots of others, both Americans and Europeans—and Janis also opened a storefront annex on Fifty-seventh Street.

In short, 1962 didn't look like any other year in art that New Yorkers had ever seen. But anybody who believed that these developments were a total surprise had not been watching in the late 1950s, when Johns and Rauschenberg had stirred things up with subject matter derived from popular sources. In the autumn of 1959, Porter had gone to see Allan Kaprow's *Eighteen Happenings in Six Parts,* at the Reuben Gallery on Fourth Avenue. He reported that "actors come in, read or speak or play a musical instrument, or paint, or just move; and accompanying this are tape-recorded sounds and the activity and noise of wound-up mechanical toys. Sometimes the words spoken are drowned out by other sounds. In one room is a collage of artificial fruits, partly painted over." Of course the happenings were examples of more-or-less controlled chaos (*Eighteen Happenings* had been rehearsed for two weeks); but for those who were not especially involved, the moral could be that all chaos was equal. The happening signaled the triumph of amateurism as an artistic principle, for who could claim any particular expertise in an art based on the unpredictable? The best one could hope for was a performer with a knack for the elegant or striking gesture. An example of this might have been

John Cohen,
Claes Oldenburg
in a happening at the
Reuben Gallery, 1960.

Lucas Samaras's performance in Oldenburg's *Washes*, in which he appeared with Pat Oldenburg on a plank placed across a swimming pool at Al Roon's Health Club. Samaras was able to drop a square of white plastic into the swimming pool so that "it floated squarely and perfectly parallel to the board. Only Lucas Samaras," Al Hansen observed, "could drop a sheet of white plastic into a pool so neatly."[15] Do-it-yourselfism, essential to the successful happening, was also key to Pop Art. So far as Warhol was concerned, once inspiration had struck, even an uninspired amateur could crank out the work that constituted his multifaceted production. Warhol's portrait subjects often went to a photo booth and photographed themselves. And part of the point of Warhol's silk-screen paintings was that anybody could do them. The images were photographs (and they were generally not by Warhol); the painting was done with a squeegee passed over a silk screen; the only danger was that a worker might become overly skilled and eliminate the messiness that gave the paintings their distinctive look.

If amateurism was becoming an art form in itself, then it followed that one could not insist on an old-fashioned distinction between the audience and the artist. Everybody was jumbled together in the will of the moment. Among the program notes that visitors received on arriving at Kaprow's *Eighteen Happenings* was one that informed them that they were a part of the cast. This meant that Fairfield Porter, there as a journalist, was reporting on an event in which he was himself a participant (just as, three years later, the poet James Schuyler would become the subject of the painting he was writing about for the "Alex Katz Paints a Picture" article). All of this led straight to Warhol's most famous pronouncement—"In the future everybody will be world famous for fifteen minutes."[16] Craft, preparation, development were overthrown in favor of sensibility, opinion, happenstance, propinquity, serendipity. In the Summer 1962 issue of *Art International*, there's an ad for the Galerie Saqqarah in Gstaad, which focuses not on the art but on some people who are loafing in the gallery. An attractive long-haired woman, dressed in black pants and high boots, is lounging on a bench. Another woman gestures to her from across the room, almost as if she's asking her to dance. Three other people look on. They're all smiling, laughing. It's the Katz cutouts come to life—the gallery as a scene. John Ashbery noted of Niki de Saint-Phalle, who made collages of paint-filled balloons and then asked viewers to shoot at them, "It is the spectator who actually 'does' the painting. In doing so he fulfills at least two basic urges: the urge to 'do it yourself' and the urge to destroy a work of art."[17]

IV

Claes Oldenburg, who was turning out both happenings and Pop sculpture in 1962, had been born in Stockholm in 1929. His family had moved to the United States when he was a child, and he'd lived in Chicago from the age of seven until he went to Yale in 1946. Since arriving in New York in 1956, he had earned money shelving books at Cooper Union, the art school located in an old building in the thick of the downtown scene. In the spring of 1961, when Martha Jackson mounted "Environments, Situations, Spaces," one in a series of uptown showcases for assemblage and mixed-media work, Oldenburg put together a bunch of reliefs that were variations on the cheapo downtown stores where he liked to poke around. Six months later, in December 1961, Oldenburg recycled some of these reliefs, which had first been shown uptown, in an environment that he opened in his studio at 107 East Second Street. The

Robert McElroy, Claes Oldenburg's The Store, 107 East Second Street, December 1961.

space on East Second Street was narrow and deep, roughly ten by eighty feet, and Oldenburg filled it to the brim. "A show—!" he wrote. "Forget the commercialism and vanity of the long-prepared show. A show is the gesture of being alive, a period—before as well as during . . . a look into one's continuing daily activity." He'd "actually make a store!" It would be "a sad, past, hi(stor)ical store/a happy contemporary store too?"[18] And so *The Store* was born.

Oldenburg wanted to dump the American dream—lock, stock, and barrel—into a gallery. He was infatuated with the ordinary commerce of American culture—the stores selling inexpensive clothing, the coffee shops with the pieces of cake and pie displayed in glass-and-chrome cases—and he wanted to bring all of that into line with the extraordinary commerce that was American high culture. The installation that visitors saw in December (just in time for Christmas) was chockablock and funky, with things all jumbled together. *The Store*, which was located at the southern edge of the East Village, an area that was the northern edge of

the Lower East Side, had a symbiotic relationship with its down-at-the-heels neighborhood. *The Store* wasn't so much a freestanding work of art as it was a striking evolutionary twist, a new development in downtown commerce. The area was ethnic and inveterately working-class, a part of New York City that had been out of the mainstream for a long time, and Oldenburg was spinning his own bohemian reverie on the neighborhood's marginal status. In the East Village *Store*, Oldenburg eulogized a Lower East Side that was already in many respects a relic, an artifact, a place framed by its own history. In *Store Days*, the rather nostalgic scrapbook that Oldenburg published in 1967, he said that his intention had been "to create the environment of a store, by painting and placing (hanging, projecting, lying) objects after the spirit and in the form of popular objects of merchandise, such as may be seen in stores and store-windows of the city, especially in the area where the store is (Clinton St., f.ex., Delancey St., 14th St.)."[19] The dying old commerce was arising, phoenixlike, as an art object.

Oldenburg made most of his merchandise out of plaster. Taken as a totality, *The Store* had a crazy slob-expressionist force. The plaster pieces were painted in raucous enamel colors, and the paint dripped here and there, giving the quotidian merchandise some grungy, off-kilter charm. Everything was for sale—and not exactly cheap. A *Men's Jacket with Shirt and Tie* was $399.95, an *Ice Cream Cake* was $169.99, the *Cash Register* could be had for $349.99. Sidney Tillim, the young painter and critic who was writing the "Month in Review" column for *Arts*, called *The Store* "a combination of neighborhood free enterprise and Sears and Roebuck. Its inventory included candy bars and wedding gowns, pastries and men's suits, bread, corsets, bacon and eggs, sandwiches." Tillim was particularly tickled by the fact that Oldenburg "had even had printed up for himself a business card and, not incidentally, had the posters announcing the event printed in Spanish Harlem by a man who improvises magnificent circus-type primitive typographical layouts."[20]

The Store had a big window onto East Second Street. The lowering December weather seeped into the displays, and Oldenburg used every trick in his book to transform that winter melancholy into something artful, desperate, crazy. Oldenburg's punched-up colors turned his crumbly white plaster sculptures into gaudy winter amusements. *The Store* was a kind of romantic vision. The fascination was in the tossed-off, anything-goes quality. "The wedding gown on a cadaverous mannikin," Tillim wrote, "was more lumpish than *lumpen*, undecided as to how serious it should be as sculpture. The pastries were especially attractive, and the air-mail letter I craved as I might a bit

Robert McElroy, Claes Oldenburg's The Store,
107 East Second Street, December 1961.

of eighteenth-century porcelain which I saw here in its demotic transformation."[21] Oldenburg's relation to his kitsch sources was not fully articulated, and this thrown-together element gave *The Store* its encompassing aura. It may well have been the ripest expression of the new sense that art need not have its own will-to-form, but might simply assimilate the will of the culture, or the will of the culture of a somewhat earlier moment. There was something static—elegantly, generically marooned—about this art. An art without a will of its own was an art drifting into nostalgia—that was always the condition of Pop. And it was Oldenburg's inspiration to play with that sense by giving his store a stylized decrepitude. There are wonderful photographs of the view out the window, some of them with a figure moving quickly along the street, and the monthlong event, despite the frequently static character of the individual works, seems to have been about movement and memory and change. The crumbly plaster and dripping paint felt improvised; and so a visitor could, at least in imagination, play around with the work.

From the start, Oldenburg had intended that the various elements of his East Village environment would be purchased individually, and much of their magic seemed to vanish once they left *The Store*. By the time Tillim was writing about the show in *Arts*, a single piece by Oldenburg was already in an exhibition of recent acquisitions and gifts at the Museum of Modern Art, and Tillim could not but feel that Oldenburg's work was "psychologically violated by the setting."[22] The merchandise from *The Store* lost its quirky flavorings as it moved from the bodega to the cultural supermarket that was the Modern. After *The Store* closed in January, Oldenburg used the East Second Street space for a series of happenings, among them *Voyages I* and *Injun II*, produced by what he called his Ray Gun Theater. (For a time Oldenburg was obsessed with ray guns.) Meanwhile, *The Store* was taking on a life of its own. In April, parts of the plaster-and-enamel environment left New York for Dal-

las, Texas, where they were included in a show called "1961" at the Museum of
Contemporary Arts. Closer to home, Richard Bellamy arranged a September
show for Oldenburg at the Green Gallery. Oldenburg worked on the show
over the summer—recycling some of the pieces that had been in *The Store*,
and adding new pieces in which he recapitulated his coffee-shop and five-and-
dime motifs on much-enlarged formats. When the show opened on September
18, visitors who'd seen *The Store* on East Second Street noticed the overlaps,
but they could also be startled by the rapidity with which the wackiness of
Oldenburg's enamel-and-plaster jobs was giving way to one-size-fits-all chic.

Tillim, again writing in *Arts*, found himself reaching for a Pop exclama-
tion. "Will success spoil Rock Hunter?" he asked. And answered: "Almost
every time." There had, Tillim felt, been "a lamentable transformation." Ol-
denburg's old plaster works felt overly considered and self-conscious in the
new, cleaned-up context; and the new works, made of canvas stuffed with
foam rubber and paper cartons, had a pushy, overblown look. Tillim thought
that Oldenburg was "keep[ing] up with the times. The old *Store*, which man-
aged to mix crudity with nostalgia in a way that exposed both Oldenburg's
hostility for the 'low' subjects he was using (to bludgeon the aesthetes) and his
romanticism of the primitive-banal, has now given way to Progress." Olden-
burg's tongue-in-cheek attitude toward art-and-money could ill survive the
sobriety of Fifty-seventh Street. The work just wasn't funky anymore. There
was not just a plaster fried egg; now it was on a plate, and the plate was on a
real table. "His pies," Tillim observed, "have vacated the Greasy Spoon for
something better." And everything had gotten bigger—which wrecked the

humor. Tillim found a "forced sense of the grotesque in a hamburger as high as a man and proportionately as round, in an ice-cream cone maybe seven or eight feet long, in a slice of layer cake again as high as a man." Tillim had obviously had some reservations from the start. But gone was the "exhilarating messiness of slob-culture. . . . His things now look, in their cleaned-up state, too much like the things from which they derive. Their defenses against their own banality have broken down."[23] Yet the moment when the work was losing its funkiness, the crazy "furious brilliance" of 1961, was exactly the moment when Oldenburg and some of the other Pop artists were on the verge of making it big.

V

Andy Warhol's book *POPism: The Warhol '6os,* although written twenty years later (in collaboration with Pat Hackett), caught something of the immediate experience of those packed months when it seemed that a new art world was obliterating the old. Warhol, who was thirty-two in 1960, was already hugely successful as a commercial artist, responsible, among other projects, for a series of advertisements for I. Miller shoes that had turned a style based on folk-art casualness into sophisticated, big-city fun. In *POPism,* Warhol made getting involved in the art scene sound as easy as rolling out of bed in the morning. Warhol recalled, "I used to go around to all the galleries in the late fifties, usually with a good friend of mine named Ted Carey." Porter painted a portrait of the two of them—they weren't friends of Porter's; it was a commission—and the sight of Warhol painted in Porter's downscale intimist way is a curious thing. Warhol looks meek and recessive, like a child whose quiet demeanor gives not a hint of the devilish powerhouse that he will soon become. Warhol explained that when he and Carey commissioned the double portrait, they were thinking "it would be cheaper if he painted us in tandem and then we could cut it apart and each take half. But when he'd posed us, he sat us so close together on the couch that we couldn't slice a straight line between us and I'd had to buy Ted out."[24] Actually, the portrait shows a chair, not a couch, and one standing and one seated figure. But the story was neat, in

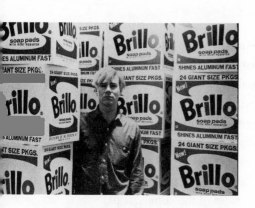

Fred McDarrah, Andy Warhol, 1964.

that Warhol was bested by Porter. But that wasn't
the kind of thing to faze Warhol, for whom being
painted by a figure from the 1950s art world (he
was painted by more than one) was just a minor
detour on his way into the new avant-garde.

By the early 1960s Warhol was already fooling
around with Pop-oriented paintings. He related
how "one afternoon Ted called up very excited to
say he'd just seen a painting at the Leo Castelli
Gallery that looked like a comic book and that I
should go right over there and have a look myself
because it was the same sort of thing I was
doing." Carey was there to buy a Jasper Johns
lightbulb drawing, Warhol explained, "so it was
easy to maneuver ourselves into the back room,
and there I saw what Ted had been telling me
about—a painting of a man in a rocket ship with
a girl in the background." It turned out to be "by
a young artist named Roy Lichtenstein."[25] Lich-
tenstein's comic-book images—a girl worried
about a guy, a guy worried about his job—give

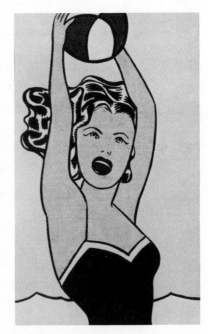

Roy Lichtenstein, Girl with Ball, *1961.*
Oil on canvas, 60½ × 36½ in.

comic-book clichés an abstract coolness. Lichtenstein's canvases were among
the first Pop paintings to gain wide acceptance, in part because they were sus-
ceptible to a kind of formalist, Bauhaus-inspired analysis that had been famil-
iar at least since the 1940s. Gene Swenson found that the space between
Lichtenstein's outlines "is as vacant as that between the wires of a mobile."
Thus Lichtenstein was given classic modern credentials—he was like Calder.
As for the stenciled rows of dots, Swenson wrote that they "seem to waver like
molecules; because of the regularity and the amount of white space between
them, however, the screen of dots (by convention a solid in the comic strips)
suggests merely a transparent plane. The picture is a stringent but amusing
exposure of visual as well as social habits."[26] Swenson could almost have been
writing about a Kandinsky.

The person showing Warhol and Carey the Lichtenstein in the back room
was Ivan Karp, who worked for Castelli, and when Warhol asked him what he
thought of the Lichtenstein, Karp said, "I think it's absolutely provocative,
don't you?" "So I told him I did paintings that were similar and asked if he'd
like to come up to my studio."[27] No long waits for studio visits here. True,

Warhol didn't get into the Castelli Gallery overnight. In the beginning he was regarded as a bit of a Johnny-come-lately, at least so far as his comic-book images were concerned. (Castelli took him on in 1964, and later referred to his not having shown Warhol earlier as a big mistake.) The work that Andy Warhol was doing in the early 1960s, as he was networking with what was turning out to be a whole new generation of dealers and critics and curators, is a small achievement, but it is something. The soup cans and the Coke bottles and the Brillo boxes, the Troy Donahues and Elvis Presleys, Warren Beattys, Natalie Woods, Marilyn Monroes—done fast, in a couple of years—reduce all the nuances of a sophisticated campy taste to a concentrate with instant impact. And Warhol found at least one Pop subject that had an immediate, visceral appeal for a sophisticated (and even for an intellectual) audience: the movies. The comic books or hardware-store products that Warhol and other Pop artists put in their work might be amusing, but how many grown-ups really responded to that stuff emotionally? The movie stars were a different matter.

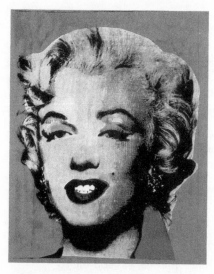

Andy Warhol, Blue Marilyn, 1964. Silk-screen ink on synthetic polymer paint on canvas, 20 × 16 in.

Back in 1951, when Warhol was in his early twenties, he had had himself photographed with his hands clutched to his head, in imitation of a famous 1928 Edward Steichen photograph of Greta Garbo. Warhol was a nerd impersonating an icon. In the early 1960s, when he was doing work that focused on Liz and Marilyn and Warren Beatty and Troy Donahue, Warhol presented gallerygoers with a Hollywood universe in which just about everybody had at one time or another found a fantasy of romantic involvement. The whole arrangement worked beautifully for the part of the audience that wasn't interested in heterosexual sex, because in the gallery context, where movie stars were detached from the Hollywood stories, anybody could be anybody else's love object. Consider, also, the particular stars that Warhol selected. They were often the ones whose personal and professional choices suggested an admiration for brainy types. The people these stars were associated with over the years included, among others, Tennessee Williams, Arthur Miller, Edward Albee, and Richard Burton. By

focusing on the beauties who liked—even loved—the brains, Warhol was presenting a thinking-person's view of Hollywood glamour. Warhol got at something special about the nerd's infatuation with the gods and goddesses of the screen. The nerd wanted to see the serious spirit inside all that beautiful flesh. Perhaps the stars' braininess was only in the eye of the beholder, but in any event Marilyn, Liz, and Warren were beauties who knew that they were especially radiant when they were basking in the attention of the intellectuals. "Let your kids go to the movies!"—so Frank O'Hara had exclaimed of his movie-besotted generation. "The soul," he wrote in "Ave Maria," "grows in darkness, embossed by silvery images."[28] The impersonality of Warhol's silk-screen method, which turned movie-star flesh into harsh patches of light and dark, created a new, mechanized erotic charge. He turned Hollywood fire into art-gallery ice. It was a one-step operation—nothing more—but it had its effect.

VI

In the paintings of the early 1960s, Warhol saluted America's ordinary pleasures: going to the movies, drinking Coca-Cola, opening a can of Campbell's soup. Pop Americana wasn't a new subject for artists, but now Warhol and others were presenting this audience-friendly imagery in a coolly clever manner that neatly matched the jokey, goodbye-to-all-that attitude that was an aspect of the Affluent Society. Ordinariness itself was becoming an abstraction—that was the point of a Campbell's soup can hanging on a gallery wall. But money, an ordinary if often maddening part of life that B. H. Friedman's executive wanted to reimagine as an abstraction, would not disappear into a painting, even if Warhol had thought to silk-screen greenbacks onto canvas.

Just a few years after Galbraith had suggested that America was coming to the end of its money worries, America's bad-news icon, the crash of 1929, appeared headed for a repeat performance in the midst of this society that was dancing into its own version of the Roaring Twenties. There had been danger signs in the stock market in 1961, but prices didn't actually start showing an across-the-board decline until March 1962. Once the decline set in, it was precipitous, until, on May 28, 1962, prices on the New York Stock Exchange went into their sharpest tailspin since the crash of 1929. The market went down 34.95 points that day, the biggest drop since 1929 (when the drop was 38.33). "*The New York Times* combined stock average," *Time* magazine reported, "dropped farther in one week than in any week since Nov. 9, 1929. Of course

this was no 1929 again—there are too many safeguards around for that but Wall Street's news was disquieting nonetheless. Today's stock market is neither the clubby preserve of the rich nor a Monte Carlo for bet-a-million adventurers: it is a national institution into which one U.S. adult in eight has placed part of his savings." That was the scene as of June 1. A week later, however, things were on the upswing. "The titanic, invisible wave of fear which had swept through the market place," *Newsweek* reported, "washing away logic and values, was suddenly contained and swallowed up amid enormous confusion." There was a "turn" that was called "vast," so that in the first week of June everything was looking up. Of Tuesday, June 5, with surging buying, one manager at Bache & Co. said, "I never had a day like this in my life." Salesmen were "sprawled in their chairs like so many winded athletes," *Newsweek* reported. "The mood," one player said, "was one of profound, thankful relief after coming so close to a major disaster. We missed a 1929-type collapse by the skin of our teeth."[29] And the disaster, having been averted, looked to some like another proof that all the disasters were behind the country.

The crash of '62 may have felt unreal to anybody who hadn't lost a lot of money; its wide-ranging or long-term economic effects appear to have been mild. By mid-June, the impression was that of a wild but harmless roller-coaster ride. Wall Street had provided scary drama, but that was all. To people in the art market, however, the Wall Street upheaval appeared in some way or other to be connected with a sea change in collectors' habits—and, maybe, with a new light-headedness in the galleries. "As dealers began sizing up their season's-end experiences last week," *Time* reported a year later, "it was obvious that the slump had one particular victim: the abstract painting that after the war made Manhattan the center of the art world. . . . The art boom has not collapsed, but it has drastically shifted."[30] Works by the most famous Abstract Expressionist painters remained huge moneymakers. *Time* illustrated a Pollock, which Sidney Janis estimated would be worth $150,000, while a Robert Indiana sign painting (on the lines of one that had recently entered the collection of the Museum of Modern Art) was thought to be worth about $2,500. Collectors wanted a change, and the inexpensiveness of Pop Art was a part of its attractiveness. If you had money, you could buy Pop on a lark.

After the worst of the crash of '62 had been averted, '29 may have looked even more remote, a dark time that would never really return. And perhaps the vehemence of the Abstract Expressionist paintings, which had grown from seeds planted in the hard soil of the 1930s, no longer felt quite right. "De

Kooning is my old master," Scull would say a little later. "I've put it in a sixteenth-century Spanish frame—I wanted to get a classical feeling."[31] Behind that classical feeling was a sense that abstract art, at least Abstract Expressionist art, was aging. What did heroic brushstrokes have to do with this new period when everything that was most alluring was like a witty aside? De Kooning's exhibition at the Sidney Janis Gallery in March 1962, which was hardly one of his strongest, only served to underline this impression. The few big paintings were perhaps too reminiscent of Franz Kline; the rest of the work was on paper and was small-sized and unimpressive. And many gallery-goers, especially perhaps some younger ones, found themselves leaving Janis with a feeling not only of disappointment but even, given how much de Kooning had meant to them, a feeling of personal hurt and betrayal.

Sidney Tillim complained in *Arts* of "continued aesthetic indigence and a deteriorating aesthetic," of "quivering fragments." Even the failures were *flawed* failures—somehow they weren't bad enough. "By shying away from real failure," Tillim wrote, de Kooning "cancels all possibilities of success." Writing in *Art International* in May, Max Kozloff spoke of the chips being down, and how critics were predating their disaffection with de Kooning, speaking of their earlier enthusiasm for his work as "a rather quaint vogue." Kozloff might have wanted to distance himself from the blanket condemnations, but he was not exactly thumbs-up, either. De Kooning, he explained, "has painted himself into a situation in which he can no longer distinguish very well between his hits and misses." The New York School seemed to be cornered, stuck in "the inadequacy of its own virtuosity."[32] So did the 1950s become a part of history—with a sheaf of bad reviews. These negative reviews might be absolutely sincere, but they also had a melodramatic aura. The writers were really psyched for their roles as actors in history, and they wanted the scenes to change fast, so that they would have a new situation in which to play. In spite of the almost universal regard in which de Kooning had been held by the downtown crowd since the 1940s, there had of course always been some reservations, and he had received some less-than-euphoric or at least shaded reviews. What was absolutely new in the criticisms of de Kooning that were cropping up in 1962 was a sense that an artist's failure in the studio could have stock-market-crash-sized reverberations.

In May 1962 Franz Kline died at fifty-one, and there were more end-of-an-era observations inspired by the passing of this man who, along with de Kooning, had been a dominant figure on the downtown scene and who had, with the violent restraint of his black-and-white paintings, helped to define 1950s ele-

James Rosenquist,
Silver Skies, 1962.
Oil on canvas,
78 × 199 in.

gance. To Tillim, writing in *Arts* the following September, it was an odd time for Kline to depart the stage—"a moment that is riddled with counter-revolutionary ideas. So the drama that attends all such deaths in art is magnified because Kline's work near the end had begun to show the diminution of force and certainty that has similarly afflicted the major living artists in the action-painting stable." There was this sense of Abstract Expressionism falling off—of failing. Tillim's farewell to Kline is pitched awfully high: "Once the illumination has been achieved, night must inevitably fall."[33] The truth was that night falling could come down to something as banal as a bunch of paintings being packed away in storage. In 1962 Robert Scull bought a sixteen-foot-long painting by James Rosenquist called *Silver Skies* for $1,400. "Even the artist thought I was crazy," Scull remarked. "He said, 'I thought I was going to have to pay warehouse charges on this for the rest of my life.'" *Silver Skies* was a huge collage of images—a tire, a car windshield, part of a soda bottle, a girl's knees—painted in Rosenquist's smoothly impersonal sign-painter style. "I *think* I've got a wall big enough for it," Scull recalled telling Rosenquist, "even though it'll mean taking down three wonderful abstract expressionist paintings." And so down they went—"down . . . came three famous action painters and up went *Silver Skies*."[34]

By the end of October 1962, when Janis, perhaps having interpreted the de Kooning debacle of six months earlier as a sign that it was time to change horses, opened his "New Realists" show, a growing contingent of gallery-goers were probably inclined to stop worrying and go along with the fun. "It is the reputation of the gallery which added a certain adrenaline quality to the manifestation," so Hess wrote in a review of the Janis event in *Art News*. "The point of the Janis show . . . was an implicit proclamation that the New had arrived and it was time for all the old fogies to pack." Janis should have

known—he'd shown the old fogies! "What *Life* (the magazine) calls the 'Red Hot Take-Over Generation' was in, and, as one artist shrieked at the first Jackson gallery exhibition, 'Next stop, Hollywood!' " The New Realists, Hess observed of the mood at the opening, "were eyeing the old abstractionists like Khrushchev used to eye Disneyland—'We will bury you' was their motto."[35]

VII

Just six weeks after "The New Realists" opened at the Janis Gallery, the Museum of Modern Art sponsored a symposium on Pop Art. Peter Selz, a curator at the Modern, moderated the panel, which was held on December 13. Henry Geldzahler was one of the speakers; the other four were Hilton Kramer, who had been the editor of *Arts* and was now the critic for *The Nation;* Leo Steinberg, who'd recently published his long piece on Jasper Johns; Dore Ashton, who had met Tinguely at the boat when he arrived in New York; and the poet Stanley Kunitz. Selz began by showing some slides that ranged from photographs of window displays and billboards taken by Russell Lee for the Farm Security Administration in the thirties to works by Rauschenberg and Johns and the other artists—among them Lichtenstein, Rosenquist, Dine, and Warhol—who had recently been profiled by Swenson in "The New American 'Sign Painters.' "

The panelists were by no means generally sympathetic to Pop. Jill Johnston, the writer on modern dance, filed a report on the panel for *The Village Voice* in which she remarked that the movement had gotten to the point where "lots of hogwash starts flying around." Aside from Geldzahler, all the panelists were keeping their distance. Johnston thought they "barked up all the dark alleys that always manage to confuse the actual situation, thereby assisting in the death of experience and the continuation of politics."[36] Ashton complained that the new artists "banish metaphor. Metaphor is necessarily a complicated device, one which insists on the play of more than one element in order to effect an image. The Pop Artist wants no such elaborate and oblique obligation." Kramer said that "Pop Art derives its small, feeble victories from the juxtaposition of two cliches: a cliche of form superimposed on a cliche of image." Kramer offered his own view of history when he remarked that behind the pretensions of the movement "looms the legendary presence of the most overrated figure in modern art: Mr. Marcel Duchamp." During the intermission, Duchamp, who was in the audience, was heard to remark that Kramer was "insufficiently light-hearted." Steinberg was an elegant mind

savoring the new scene. He spoke of "a new shudder"—Hugo's reaction to Baudelaire's *Les Fleurs du mal*—and observed that Lichtenstein's "idea seemed to be to out-bourgeois the bourgeois, to move in on him, unseat him, play his role with a vengeance, as if Lichtenstein were saying, 'You think you like the funnies. Wait till you see how I like the funnies!' " Steinberg's observation that "whether their productions are works of art I am not prepared to say at this point" annoyed Kramer, and was the occasion for a long exchange between the two of them during the discussion. Kramer wanted to insist that Steinberg was playing word games, that whether he thought that Pop paintings succeeded or not, he did in fact think that they were art—maybe " '*failed*' art."[37] And Steinberg, caught in the web of his own elaborate thought, seemed wearied by Kramer's vehemence.

An evening of talk, a lot of it negative. The most interesting words came from Kramer, who observed that "the relation of the critic to his material has been significantly reversed" by the coming of Pop. Critics, he said, "are now free to confront a class of objects . . . about which almost anything critics say will engage the mind more fully and affect the emotions more subtly than the objects whose meaning they are ostensibly elucidating."[38] One need not wonder what Kramer had in mind. There were Geldzahler and a number of other grad-student types—among them Swenson, with his pioneering "New American 'Sign Painters' " piece in *Art News*—who were performing glamorous tricks of analysis. And then there were, almost as important, all the good-natured wisecracks and slapstick routines that were inspired by the new work. Yet whatever the justice of Kramer's observations, in the context of December 1962, his presentation had to have had a tilting-at-windmills hopelessness. Negative reviews didn't really count. In *Art International* in March 1962, Max Kozloff had announced that "the art galleries are being invaded by the pinheaded and contemptible style of gum-chewers, bobby soxers, and, worse, delinquents. Not only can't I get romantic about this; I see as little reason to find it appealing as I would an hour of rock and roll into which has been inserted a few notes of modern music."[39] No matter. The public was making up its own mind.

Henry Geldzahler was the only person on the panel who was entirely happy with the way things were going in New York City. Pop Art, he explained, was "a new American regionalism," "a new two-dimensional landscape painting, the artist responding specifically to his visual environment." And if Pop Art wasn't shocking? If it was, in fact, "readily acceptable"? Well, the time had come to revise the critics' understanding of what constituted an

avant-garde. "We are still working with myths developed in the years of alien-
ation," Geldzahler said. "There is no longer any shock in art." "About a year
and a half ago," he explained, "I saw the work of Wesselmann, Warhol,
Rosenquist and Lichtenstein in their studios. They were working indepen-
dently, unaware of each other, but with a common source of imagery." And,
of course, all aware of Johns. "Within a year and a half they have had shows,
been dubbed a movement, and we are here discussing them at a symposium.
This is instant art history, art history made so aware of itself that it leaps to get
ahead of art."[40]

"Young artists of today," Kaprow explained in his 1958 essay "The Legacy
of Jackson Pollock," "need no longer say 'I am a painter' or 'a poet' or 'a
dancer.' They are simply 'artists.' All of life will be open to them."[41] But
wasn't there a difference between being an artist and being an "artist"? To
Galbraith's New Class, no longer locked into any particular job, any job was a
possibility and all jobs were things to try on—they were in quotation marks.
In 1963 Mrs. Robert Scull was taken by Andy Warhol to a photo booth, where
she hammed it up for the camera, putting her sunglasses on and taking them
off—doing a movie-star routine. She became "an actress," "a star." These
shots were transformed into *Ethel Scull Thirty-six Times*, a Pop Art version of
Ellsworth Kelly's mosaic of colored squares. A morning visitor to the Scull
apartment noted the disjunction between Warhol's Mrs. Scull—"a creature of
infinite variety"—and "the real Ethel Scull, who also happened to be in the
library that day. She was making a few morning phone calls, like any other
housewife, and it seemed unfair to me—as it probably did to her—that she
had to compete with thirty-six other versions of herself, most of them highly

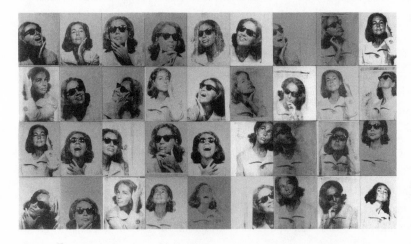

Andy Warhol,
Ethel Scull Thirty-
six Times, 1963.
79¼ × 132 in.

vivacious, on the adjacent wall. Nevertheless the portrait has given her instant renown." "Warhol took a cornball technique," Ethel Scull's husband said, "and made one of the greatest portraits of our times." Warhol "apprehended her personality"—so Scull explained to the visitor. "There's been nothing like it since Ingres."[42]

VIII

John Bernard Myers, the director of the Tibor de Nagy Gallery, where Jackie Kennedy had made the visit commemorated in Frank O'Hara's "William Walton" poem, could not but be attuned to the theatricality of the Pop explosion. Myers had been the first uptown dealer to give some support to the new ironic spirit when he singled out Larry Rivers as one of the artists to exhibit at Tibor de Nagy way back in 1951. Two years later Rivers painted *Washington Crossing the Delaware*, a brushy remake of Emanuel Leutze's 1851 American icon. The Rivers painting was a tongue-in-cheek comment on American art history, a cornball classic given a jazzed-up modern look. By 1953 there was a lot of camp theatricality to the work that Rivers was doing, but Myers had no problem with that, at least in part because he'd been involved with the theater in one way or another practically since he was a child. In the 1940s he'd been the director of an avant-garde puppet company; a decade later, he'd been one of the guiding spirits behind the legendary Artists' Theatre, which had produced plays by the likes of O'Hara and Ashbery. Myers—a lover of all things Venetian—knew something about fancy dress. He'd worked with the Neo-Romantics and the Surrealists when they were in New York in the 1940s, and he also knew a thing or two about the difference between theatricality as expression and theatricality as obfuscation.

In a piece about the early 1960s scene that he wrote for the little magazine *Art and Literature*, he described "the jazzy advertisements of *Art International* where the artist himself is sometimes seen with leather jacket and motorcycles, or happily leaping out of the surf wearing a bikini." Myers was amused, but he was not taken in. It wasn't just the artists who were dressing up; even gallery ephemera were now dressed for a party. "One's mail bulges with catalogues and announcements," Myers wrote: "a series of boxes within boxes, a balloon to be blown up, a sheet of paper large as a school map inside a cardboard tube, a booklet the size of a postage stamp." Myers reeled off an early-1960s list of art-world woes. There were the "novelty shows (mixed media, sight and sound, sound and movement, multiple vision, toys for adults, Happenings,

etc.).'" There were the people murmuring "A-r-t," and "the new collectors [who] buy with the mixed feelings of a New Jersey Dry Cleaning tycoon who gives liberally to Our Lady of Perpetual Help—just in case." And the artists were "in general delighted." "The artist feels he *needs* TV appearances."[43] The executive hero of B. H. Friedman's novel *Whispers* picked up a copy of Roger Shattuck's book *The Banquet Years* at La Guardia Airport—"a reprint, of course; I'm always a few years behind." Having read it, he mused that this book about the early twentieth century in Paris was "about the birth of the avant garde before the avant garde went into business. Hell, three big banquets in thirty years (for Rousseau, Apollinaire, and Saint-Pol-Roux)! I'm invited to three a week at grand ballrooms, one grander than the next. Was fun half as much fun before it became a business?"[44]

"Everyone," Myers wrote, "asks the same question: 'What happened?'" This Everyone did not, of course, include the Pop artists and their collectors and dealers. This was the Everyone that Denby had encountered at Katz's Tanager opening—the Everyone that had been in a good humor in February 1962. But now (Myers was writing in 1964) Everyone was feeling different. The good humor had turned frantic—become a kind of panic. "Many painters in their forties and fifties wear a look—as grey as evening—which is a combination of surprise and incomprehension. 'Where were *you* when the shit hit the fan?'—a general query." Two years later, in an essay on the sculptor Reuben Nakian, Frank O'Hara announced that "it is philistine to decry as childish the content of Pop and junk art," but the point that Myers seemed to be driving at was that the real content of the Pop movement wasn't to be found in the art but in the theatricality of the scene that had erupted around the art. Myers griped about "the crowd of job-holders from museum and press, commercial daubers with a ravenous hunger for prestige, status-seeking, profit-motivated collectors, and the art dealers with a flair for Big Business." As Myers was well aware, this could be said to be nothing but the immemorial complaint of a fading generation; but he thought otherwise. "No good," he announced, "to say it was ever thus, that there have always been changes, *this* coming in and *that* going out. The citadel has been stormed, the ram-

Advertisement for the Sonnabend Gallery, from back cover of Das Kunstwerk, *1964.*

parts have been scaled."[45] Yet the revolution had also come from within, for to the extent that Pop Art was based on the idea that the shape of art reflected the shape of life, it was based on an old idea that had been given a slick, dumbed-down presentation.

A new kind of dynamic had begun to enter into debates about art, not the old back-and-forth between avant-garde and academic or avant-garde and kitsch, but a debate about the rhetoric of art, about the way that art made its appeal to the serious gallery-going or museum-going public, about the public-ness versus the privateness of art. In December 1960 in the short-lived maga-zine *Scrap*, Anita Ventura observed that painting "has become all too public in its tone. It has left out a great deal that can only come through an address to an individual or an intimate situation." John Bernard Myers, in his "Junkdump Fair" essay, described something similar, a split between the public and private realms, "a deep cleavage between . . . public art and private art."[46] What struck Myers was less a split between high and popular culture than a split within high culture itself. In his article in *Art and Literature*, he lets the pictures speak, offering two portfolios of contemporary works that illustrate the pri-vate and public sides of art. On the private side are de Kooning, Kelly, Nakian, Esteban Vicente, Robert Goodnough, Cornell, Fritz Bultman, Richard Pousette-Dart, Red Grooms. On the public side are Victor Vasarely, Allan D'Arcangelo, Thiebaud, Tom Wesselmann, Indiana, Johns. When we look at these two lists, what may at first occur to us is that the first is more painterly, the second hard-edged and pop-based. But the distinction isn't that simple. Kelly, hard-edged, is in the first list, as is Grooms, whose caricatural vision is all about pop culture. The issue, then, has less to do with the immediate look of the work than with something about the artist's attitude toward his forms. Kelly's rather severe forms come out of some private, even idiosyncratic thought process. They flow from personal concerns or obsessions, as does Grooms's relation to pop culture. The artists in the public category lack that. Their work is impersonal; but with them impersonality is not a personal sub-ject, as it might be said to be for Kelly. Myers's public art reflects a businesslike relationship with history—cool and efficient, a matter of getting the job done; while private art involves a quirkier, perhaps tenser, more relentlessly per-sonal relationship with the past.

Myers was not alone in seeing this split. Hilton Kramer, in an essay pub-lished in *Art International* in 1960, marked the twentieth anniversary of Paul Klee's death by observing that these years "have seen the triumph of a style of art which is a form of public speech, an art which calls for—and receives—

large public quarters in which to make itself heard. Klee's art belongs to an era of privacy and conversation; it is inseparable from a certain ideal of intellectual refinement—an ideal of the European mind at its best. In some respects it represents a late stage of that ideal, when it no longer inspired monuments but had turned its gaze inward, examining the mysteries of the self and its relation to a radically new sense of reality." Klee's intricately metaphoric art had had a major impact on the Abstract Expressionists, and Kramer was interested in what in Klee's work they had sanitized and what they had transformed. The whole drift, as he saw it, had been toward a more public statement. Klee, Kramer wrote, was linked to the present through "his painstaking pursuit of an interior vision, his willingness to submit the data of his vision to a subtle and pedagogical analysis, his intricate and difficult equations of irrationalism with a graphic and expository clarity." Klee, Kramer admitted, might have "forfeited the possibility of a truly monumental art," but there was, paradoxically, a power to his work that was missing "in the midst of the public oratory which currently proliferates on every side."[47]

IX

The discussions that went on in the art magazines about the impact of the growing public attention to art may have been of limited interest to anybody much beyond the art world, but closely related issues did receive a wider hearing, especially in Dwight Macdonald's essay "Masscult and Midcult," first published in *Partisan Review* in 1960. Macdonald's theme, the survival of high culture in modern society, was hardly a new one. Among the works he mentioned were Greenberg's "Avant-Garde and Kitsch," published a generation earlier in *Partisan Review,* which had alluded to a yet earlier essay by Macdonald, about kitsch in Russian film, also published in *Partisan Review.* In part Macdonald was, as he himself admitted, reinvestigating Greenberg's split between avant-garde and kitsch, but there was a new element in his essay, which was Midcult. This existed somewhere between high culture and what he called Masscult, which was a popular culture that was fed to people by manufacturers—Hallmark greeting cards and so forth. "In these more advanced times," Macdonald explained, "the danger to High Culture is not so much from Masscult as from a peculiar hybrid bred from the latter's unnatural intercourse with the former. A whole middle culture has come into existence and threatens to absorb both its parents. This intermediate form—let us call it Midcult—has the essential qualities of Masscult—the formula, the built-in

reaction, the lack of any standard except popularity—but it decently covers them with a cultural figleaf. In Masscult the trick is plain—to please the crowd by any means. But Midcult has it both ways: it pretends to respect the standards of High Culture while in fact it waters them down and vulgarizes them."[48]

The new shock at mid-century was how modernism in art, the great twentieth-century invention, was turning into a kind of feel-good art. Macdonald compared Hemingway early and late, showing how the spare dialogue in the early story "The Undefeated" was repackaged in the "fake-Biblical" "fusion of Literature & Democracy" of *The Old Man and the Sea*. And he wrote of Thornton Wilder's *Our Town*, where "the imaginary props and sets and the interlocutory stage manager, devices Mr. Wilder got from the Chinese theater," and which Brecht had already used, were no longer a way of upsetting expectations but of cozying up to the audience. Macdonald wasn't that good on literature; his observations, though true, could sound a little obvious and prissy. Why, after all, couldn't stage mechanics be used playfully, to achieve some sort of obvious effect? He discussed the visual arts only in passing, and recent painting was not a big interest of his. But he was strong when he observed that "it is its ambiguity that makes Midcult alarming. For it presents itself as part of High Culture. Not that coterie stuff, not those snobbish inbred so-called intellectuals who are only talking to themselves. Rather the great vital mainstream, wide and clear though perhaps not so deep."[49]

I think one can carry Macdonald's idea further, and argue that by 1962 or 1963 some of the most widely talked about new work—Oldenburg's *Store*, Johns's *Flags*, Stella's black paintings, Morris Louis's veils of stained color—was a new form of Midcult, maybe Upper Midcult. I am not saying that Macdonald would have said as much. But the sense of Midcult as being a simplification of high art that will be comprehensible to an ever widening public does jibe with some of the most talked about art of the early 1960s. If the essence of high art is the powerfully personal nature of the relationship to a perhaps disinterested tradition, then the drift not only of Pop Art but also of the abstractions of Stella and Louis was toward a rejection of idiosyncrasy in favor of a more immediately available although seemingly esoteric experience—a packaged esotericism. To turn from the hard-won, inch-by-inch surfaces of de Kooning's 1950 *Excavation,* with its complex evocation of fractured figures, to a cartoon painting by Lichtenstein or one of Stella's black compositions or one of Louis's *Veils* was to see a smoothing out of experience, an eradication of the very knottedness that pulled the viewer in. The obscurity

that was inherent in the abstractness of abstract art was in danger of becoming a kind of decorative banality. Greenberg, who was a strong advocate for the work of Morris Louis in the early 1960s, would of course not have agreed, but he would have said of Duchamp and his heirs precisely that they banalized the discoveries of modern art. By now, certain artists were perhaps not so much acting in history as they were responding to popular demand, to what Macdonald, quoting Kierkegaard, called "a phantom, a monstrous abstraction, an all-embracing something which is nothing, a mirage—and that phantom is the public." Writing in *New York* magazine in 1976, Hess contrasted Warhol's populist ambitions with Robert De Niro's obsession with the high-art traditions. "Does De Niro pay the price of his ambitions, of his aristocratic disdain for fads and pride in the small compass he recognizes as art? And does the public infer his contempt and retaliate?"[50]

One of the things that made John Bernard Myers's article in *Art and Literature* especially interesting was the metaphor that he had knit into his odd title: "Junkdump Fair Surveyed." "Junkdump Fair," he explained, was the title of a puppet play by Goethe—a play that Myers may have known through his own experience in outré puppet theater twenty years before. Goethe was a god for the Romantics. He was revered by Hans Hofmann—for his stirring ideas about color, for his grand emotions. And here was another side of Goethe— Goethe examining the hoi polloi. The play is a noisy comic salute to the twice-yearly cattle markets that still take place in German towns. Just about everybody has something to sell; the skit, with its clashing dialects, is little more than a collage of cries. You can buy anything here: cakes, brooms, oil for wagon wheels, a woman, a gun. Goethe fills his pages with two-bit merchants, but there are really no characters. This is Goethe reduced to shrieks—an apt image, so far as Myers was concerned, for what was happening in art in New York City in the early 1960s. Years later, in his memoir *Tracking the Marvelous*, Myers recalled a visit by Robert Scull to the Tibor de Nagy Gallery, and how Scull tried to buy a painting for twenty-five dollars that had originally been priced at a hundred-and-twenty-five. Myers told him to leave. In "Junkdump Fair Surveyed," Myers reported that "the newspapers keep switching horses; the art magazines are too slow; the intellectuals are undependable."[51] Art life had turned into a raucous, cacophonous free-for-all. New York was not just pop theater, it was pop puppet theater. The will-to-form had been replaced by the will of the people.

14. TEACHERS

I

Harold Rosenberg spritzed ideas. His thoughts came fast, in a barrage of stunningly shaped assertions. Every sentence was ready to hit its mark, and before you'd even absorbed it, presto, there was another one to absorb. This tall, imposing man who turned fifty-four in 1960 had been part of the *Partisan Review* gang in the 1940s, had organized a little magazine, *Possibilities*, with Robert Motherwell, had published "The American Action Painters" in *Art News* in 1952, and had become the art critic for *The New Yorker* in 1967. He liked paintings that had drama and boldness and a no-holds-barred, right-out-there-in-front vehemence: de Kooning's thrashing compositions, especially, and also, later, Barnett Newman's singular jolts of color. Saul Bellow, with whom Rosenberg was a member of the Committee on Social Thought at the University of Chicago beginning in 1966, was a good friend, and remembered Rosenberg as "not only a close, ingenious reasoner, [but] also shrewd." "In argument the pitch of his voice was very high, with especially emphatic sounds that seemed to come from the region of his back teeth. He was not a dreamy conversationalist. He listened as closely as he reasoned."[1] No one would ever accuse Rosenberg of being dreamy in conversation, but many in the art world who read his criticism would have questioned the closeness of his reasoning.

Saul Steinberg, drawing of Harold Rosenberg, 1972.

Bellow wrote a short story that we have already encountered, "What Kind of Day Did You Have?," about a famous intellectual, Victor

Wulpy, modeled closely on Rosenberg. Wulpy, stuck in an airport in Buffalo, where he had been lecturing, called his lover, Katrina Goliger, to his side. As Bellow wrote about him in this story, Rosenberg was in his celebrity phase, flying around to lectures and conferences and meetings with very important people. The story was set in the last phase of Rosenberg's life, and Bellow imagined Rosenberg sitting at conference tables with captains of industry who had taken an interest in art, men like the hero of B. H. Friedman's novel *Whispers*, for whom fast-paced art-world developments mirrored the rhythms of their own business world. Although Rosenberg was a product of the 1930s, and had not lost his taste for dialectical elaborations even after he had become infatuated with the theatricalized predicaments of existentialism, the pace of his writing, with its propulsive, insistent energy, fit right in with the rhythms of the 1960s. Wulpy was in the midst of a celebrity's frantic speaking schedule; he had to get to his next gig in Chicago, but he was no longer a young man, and the strain of travel showed. Even in the midst of a chaotic, uncomfortable airport, where he and Katrina hassled with delays, ate, and hopped in the sack in a hotel room, you could feel the grandeur of this man who "had been a bohemian long before bohemianism was absorbed into everyday life." Wulpy was inordinately tall, with a bum leg, fused at the knee. He wore a "Greek or Lenin-style" sailor cap; he was still playing at being an Everyman. Beneath the cap "there was a sort of millipede tangle about the eyes. His eyes were long, extending curiously into the temples. His cheeks were as red in sickness as in health; he was almost never pale. He carried himself with admirable, nonposturing, titled grace, big but without heaviness. Not a bulky figure." The man was "a New York–style king, thoroughly American— good-natured, approachable, but making it plain that he was a sovereign; he took no crap from anybody."[2]

Out of this powerful body emerged an endless stream of words. Rosenberg began his essays with grand assertions and aimed to keep them so much to that fast-talking, big-thinking level that the reader, gulping for air and a little relief, may have felt assaulted by an almost scattershot intellectual grandeur. Saul Steinberg, like Bellow a good friend of Rosenberg's, did several drawings in which Rosenberg's rectangular head, with the strong horizontals of dark Cossack eyes and bristling mustache, was circled with words, rivers of calligraphic assertions in a balloon emerging from the author's mouth or on the table before him, which had become an oversized writing pad. Reading through a page of Rosenberg's prose, you could feel enveloped by words, or assaulted by them, as if he were engaged in a form of intellectual

rifle practice. In an essay on pop culture that came toward the end of his first collection, *The Tradition of the New,* published in 1959, the sentences were like a bombardment. "Kitsch is art that follows established rules at a time when all rules in art are put into question by each artist. As a result, the production of kitsch is manageable at a time when works of art succeed in coming into being only through tragedy, irony or a cast of the dice." You may have been wondering what tragedy had to do with putting the rules of art into question, but you were thrust straight into further assertions. "Kitsch," you were now told, "is art that has an audience at a time when art throws itself against a blank wall and reaches the public only after it has bounced off and exploded into a rubble of critical platitudes." And then, even as you were trying to absorb all those images, you were immediately told that "Kitsch is thus art produced in obedience to the basic assumptions of the Art of the Ages."[3]

Read fast, Rosenberg was damn impressive. He fired, time and again, so often that the subject that he was supposedly explicating could seem to be obliterated. Then he kept on shooting. Malice, though, did not enter into it. You did not wonder whether Rosenberg loved kitsch or hated it; what held his attention was the fun of going after it. He was a genial aggressor, maybe not an aggressor at all. "His was never a sadistic intelligence," Bellow recalled.[4] In the essays he produced during the 1960s, often for *Art News* and later for *The New Yorker,* the play of the mind was so athletic, he wanted to cram so much in so fast, that a reader was exhausted, hard-pressed to absorb it all. After reading one of the essays, you were sure of nothing except that you'd heard a lot. His intelligence kept erupting. In an essay on Pop Art, he observed that "the city dweller's 'nature' is a human fabrication—he is surrounded by fields of concrete, forests of posts and wires, etc.; while nature itself, in the form of parks, a snowfall, cats and dogs, is a detail in the stone and steel of his habitat." So far so good. But Rosenberg wouldn't stop—or even pause—there. "Given the enormous dissemination of simulated nature through window displays, motion-picture and television screens, public and private photography, magazine advertisements, art reproductions, car and bus posters, five-and-ten art, it is plain that in no other period has the visible world been to such an extent both duplicated and anticipated by artifice."[5]

Rosenberg made his name as a critic in 1952, with his view of contemporary artistic creation as existentialist drama in his essay "The American Action Painters." His criticism would forever be associated with an idea that contemporary American art was all about rough-hewn, immediate experience. The fact that he put the emphasis so squarely on the experience of the artist in the

act of painting rather than on the experience of the viewer in the act of looking gave his work a great appeal for those who were more interested in the idea of art than in the one-on-one experience that they might have when they were standing in front of a work of art. In "The American Action Painters," as we have already seen, readers were never told which artists it was for whom "the canvas began to appear" as an "arena in which to act." And the debate as to whether Rosenberg was thinking more of Pollock or of de Kooning has gone on ever since. But Rosenberg was always less interested in discussing specific works of art than he was in reflecting on the condition or situation of art writ large. He was a brilliant phrasemaker—which in some instances may have involved giving a literary currency to phrases that he heard in studios and galleries. The famous ones became part of the American language: "the anxious object," "the tradition of the new," and of course "action painting." Even many less famous phrases have a telegraphic brilliance, such as "non-art for art's sake," which he used to refer to Gorky's interest in the natural world, in flowers and plants.[6]

Rosenberg's catchphrases were not so much a response to the experience of works of art as they were a response to the challenges of conversation, to the experience of being in the seminar room or at the podium or on the bar stool. His sentences, whirling into the air, were impressive intellectual arabesques; that was the quality that Steinberg caught with the calligraphic pronouncements that were his drawings. Sometimes Rosenberg's observations were less like sentences that added up to an argument than like freestanding thoughts arranged on a proclamation. One felt here the heritage of the Leftist 1930s. Dwight Macdonald, who was no admirer of contemporary art and sparred with Rosenberg on many occasions, once complained in a letter to *Dissent* that "Rosenberg's strictures are an aside in a manifesto written in his most epigrammatic and gnomic style—if he could just once *develop* a point, he'd become a serious writer."[7] But when Rosenberg did choose to tightly relate his thoughts to one another, the effect wasn't necessarily to illuminate a subject so much as it was to create a sort of network or cage of ideas. Readers were struck at the ingenuity of it all. But the effect could also be exhausting. Even when the subject of an essay was a particular artist—de Kooning, for example—the writing could leave you feeling as if the artist was merely a stable form to be festooned with thoughts. Some of Rosenberg's discussions were so thoroughly surrounded by the sharp attack of ideas that they recalled those African fetishes in which the figure was barely perceptible beneath all the metal objects that had been nailed to its surface.[8]

II

There was something of the famously, maddeningly abstract talk at the Artists' Club about Rosenberg's writing—something of the metaphysical jolts, the crackle of ideas that were never quite tied to works of art, the sense of ideas in the air that had to be netted, caught, toyed with although never exactly defined. The Club, though, was in its twilight days by 1960, and certainly the critics who were beginning to be known in the early to mid-1960s and were

Hans Namuth, Clement Greenberg, 1950.

excited by the new work of Johns, Rauschenberg, and Stella, were tired of the ostentatiously matter-of-fact, having-a-beer-at-the-bar kind of metaphysics that had been a hallmark of the early 1950s. These younger critics were often as critical of de Kooning's recent work as they were excited by the cooler, more deliberate character of Pop Art and the canvases with large expanses of saturated hues that were dubbed Color Field paintings. And to them Rosenberg's whirling speculations could seem like the rot that was left over from the delirium of the Club. If they were inclined to look to an older critic, that person would not be Rosenberg but Greenberg. Greenberg was leading the discussions of the work of Morris Louis and Kenneth Noland, artists whose broad areas of extravagant color he believed announced a new phase in the eye-filling experience of easel painting and whose work Greenberg grouped with others under the term "Post Painterly Abstraction" when he organized an exhibition at the Los Angeles County Museum of Art in 1964.

Curious, isn't it, that Rosenberg and Greenberg, two middle-aged men, should have been so high profile in the opening years of a decade that glamorized youth above all else? But of course in the 1960s, age also came to have a kind of guru glamour, the glamour of Then, without which there could be no Now. The fascination that Rosenberg and Greenberg, both as men and as writers, exerted in the early 1960s, to be praised, blamed, reacted to in any number of ways, had everything to do with their offering an explanation of how art had arrived where it was, for better and for worse. Greenberg was skeptical about much of what came to the fore in the 1960s, especially happenings and Pop. And Rosenberg didn't care for much of the new abstract art that excited Greenberg. And their skepticism was complicated by their avidity. They were both so eager to expostulate about whatever was happening, not to

mention what they saw as each other's understandings or misunderstandings, that they could seem to be aggrandizing the things they dismissed. They brought an old-timer's wisdom to the unfolding, exploding scene. Although Greenberg's essays were few and far between in the 1960s, the perpetual-analysis machine that was Rosenberg's writing could be almost emblematic of the caffeinated atmosphere that surrounded writing and talking about art at that time. Sometimes, when Rosenberg's gibes were dead-on true, it was because he was so intimately acquainted with the desire to live absolutely in the present, even as he was criticizing that desire.

Rosenberg and Greenberg were not so much critics as they were teachers. These men who had begun as freelance writers, commenting on current events for small-circulation magazines, were now prophets of a sort, and prophets who from time to time took the roles of professors and professional advisers. Their response to specific works counted for less than their ideas about what those works meant for the present—and for the future and for the past. By the time that Rosenberg became a member of the Committee on Social Thought at the University of Chicago, Greenberg had already given the Christian Gauss Seminar in Criticism at Princeton, a series of six lectures in December 1958 and January 1959. And both men were also beginning to act as advisers to galleries and to collectors. And they were lecturing all over. And they were taking their heightened roles at the moment when, to an unprecedented degree, contemporary art was a subject in the college and university art history departments, and when the art departments in those schools were also growing rapidly. By the mid-1960s, conferences on criticism were beginning to be sponsored by foundations and universities around the country, so that it was almost as if people were talking not about art but about the history of the history of the art of their time. A decade earlier, in his essay "The Age of Criticism," Randall Jarrell had already said that criticism "has become the representative or Archetypal act of the intellectual," and there can be no question that by 1960 the art world was entering its own Age of Criticism.[9]

Max Kozloff, who was pushing thirty when Pop exploded in 1962, and would write for *The Nation*, *Art International*, and *Artforum*, gave a number of conference presentations in which he described the state of criticism psychologically, as if the point were not to interpret art but to analyze criticism itself, and to analyze it as if it were the symptom of some contemporary pathology. At a symposium titled "The Critic and the Visual Arts," sponsored by the American Federation of Arts in Boston in April 1965, Kozloff gave a talk called "Critical Schizophrenia and the Intentionalist Method." At Brandeis

University in 1967, Kozloff took part, along with Barbara Rose, Michael Fried, and Sidney Tillim, in the conference "Art Criticism in the Sixties"; his presentation was titled "Psychological Dynamics of Art Criticism in the Sixties." These conferences were out-of-town gatherings for the new New York critics; they'd been babes in the 1950s, and were absolutely at home in New York City, but here they were in the university, which was no doubt felt at least by some to be a properly clinical situation in which to discuss the state of criticism. At Brandeis, Kozloff asserted that the origins of the current crisis dated back to 1962, that year of Pop Art, when there had begun a "spate of articles by critics about criticism" that had been appearing ever since. He mentioned Greenberg's "Why Art Writing Earns Its Bad Name," with its attack on Rosenberg's "American Action Painters" essay, as well as pieces by Rosenberg, Leo Steinberg, Hilton Kramer, and Michael Fried.[10]

Most of the people who became involved in these discussions about criticism were not professors, but some were graduate students, and the professionalization of art writing involved a whole zigzagging network of connections to the academic world; all of this was not unrelated to the professionalization of art itself, which had developed right along with the rise of a vibrant market for contemporary art. You can feel the synergy in the pages of *Art International* in the early 1960s and then, a little later, in the pages of *Artforum*. Both magazines were laden with ads for new galleries that focused on Pop

Cover of Art International *designed by Robert Rauschenberg, October 20, 1961.*

Cover of special "Surrealism" issue of Artforum *designed by Ed Ruscha, September 1966.*

and Color Field and Op Art, that flash-in-the-pan movement—a matter of
eye-catching geometric games—that few self-respecting critics were quite
willing to take seriously. People like Fried and Robert Rosenblum and Kozloff
and Judd and Tillim were drawn to *Art International,* where Greenberg pub-
lished from time to time, to some extent to *Arts,* and increasingly to *Artforum,*
which began in San Francisco in 1962, was briefly in Los Angeles, and then
moved to New York. These magazines floated on the bulk of ads provided by
a booming art scene, and the articles in the magazines became an oh-so-
intellectual comment on the boom times. This was a boom time with foot-
notes. The articles sobered up the ads, gave the new art a historical placement;
the dizzy present was informed about what had come before and what might
be coming next. Kramer observed that "nowadays, when an acute conscious-
ness of art history often serves only to deprive us of a deeper sense of art in its
supra-historical meaning, there is a tendency, among artists no less than the
rest of us, to think of art—especially the art of our own time—as something
peculiarly fragile and contingent upon immediate conditions of taste, value
and opinion." Earlier that year, Hess called this the "phony crisis." "The
avant-garde audience," he wrote in *Art News,* "obeys the laws of conspicuous
consumption. There always has to be something new."[11]

For a younger generation, Greenberg and Rosenberg were discoveries,
and no matter what they happened to be saying, the vigor of their writing and
their own veteran status could give the early 1960s a historical dimension.
Rosenberg had only first collected his essays in 1959; Greenberg's *Art and Cul-
ture* did not appear until 1961. A young man like Fried has described writing to
Greenberg in 1958, while Fried was still an undergraduate at Princeton, and
his first visit to Greenberg's apartment on Bank Street, and in reading this
account you have a sense of Fried's excitement at tapping into a vein of for-
malist thinking that had been developing for decades.[12] Both Rosenberg
and Greenberg were writing for relatively small audiences in the late 1950s
and early 1960s, yet the ever enlarging world of galleries and gallerygoers and
collectors gave their pronouncements a new kind of weight. It was one of the
effects of the boom-time ebullience of the 1960s that even essays in some
small-circulation magazines such as *Partisan Review,* where Susan Sontag
published "Notes on Camp," garnered an attention far out of proportion to
their limited readership. Intellectuals were part of the scene, their stands
were cultural events that others might comment on. Bohemia, pop-versus-
highbrow, art-for-art's-sake, even the idea of obscurity could become public
subjects, exciting topics. It was as if in the midst of the art boom an old-timer's

ideas about history and tradition could crackle like a Geiger counter. Rosenberg's aesthetic was hot and Greenberg's was cool, to use one of the 1960s' favorite either/or games. Rosenberg saw history as impacting on art in ways that were messy and unruly, a perpetual attack on art's constants, while Greenberg saw change in art as detached from the hurly-burly of life, a quieter, under-the-surface kind of effect, like the "time present and time past" that are "both present in time future" in T. S. Eliot's *Four Quartets.*

Rosenberg appealed to the new decade's need for self-dramatization: The happenings, Tinguely's *Homage to New York,* Rauschenberg's dance performances could be linked, through Rosenberg's hyperbolic sensibility, to the radical 1930s and the existentialist 1950s. Greenberg also appealed to the 1960s sense of historical self-importance, to an interest in viewing recent art as a newer, flashier kind of ivory-tower enterprise. Although Greenberg was skeptical about art criticism's becoming a subgenre of art history, his large, ringingly clear ideas were a foundation on which younger writers believed they could build. Ultimately, Greenberg's and Rosenberg's visions were not as far apart as their respective supporters might have imagined them to be. Both critics were so insistent on giving the excitement of the art of the present some kind of overarching, systematic relationship with the experience of the past that they threatened to rob the work of art of its independence, as if its value was always in how it locked into, related to, reacted to tradition. Sometimes, reading Rosenberg and Greenberg one after the other, it seems to me that Rosenberg is in fact riffing on Greenberg's ideas, giving his formalist sense of tradition an existentialist zing.

III

It is no surprise that at a time when teachers were so much in the spotlight, Hans Hofmann, the greatest teacher of art that New York had ever known, should have been the subject of a retrospective at the Museum of Modern Art. By the time that the Hofmann show opened at the Modern in the fall of 1963, the entire art world could have been interpreted as a sort of comic frieze composed of good and bad students of different varieties. Eight years earlier, Johns had begun dreaming up those paintings of alphabets and maps and American flags that offered a lovingly sardonic Pop interpretation of an old-fashioned elementary school classroom décor, leading Porter to dub Johns the perfect student. And when Porter went to see Allan Kaprow's *Eighteen Happenings* in 1959, he'd observed that Kaprow "teaches art history at Rutgers

University," and that "as a teacher conscious of history he is impatient with the brush: he resembles the critics who say, 'you can't do such and such any more, it has already been done.' "[13] Porter obviously had Greenberg in mind, who, according to some reports (denied by Greenberg), had said precisely that to Porter about his representational paintings. Surely the Color Field painters whom Greenberg admired, such as Morris Louis and Kenneth Noland, were the prototypical good students, carrying on with the rule-book lessons of increased simplification that, according to Greenberg, abstract art had laid out. But even that ultimate early 1960s bad boy, Robert Rauschenberg, could be said to be Duchamp's best student, for wasn't he just doing a series of riffs on the readymade, which was nearing its fiftieth anniversary?

In the midst of all these exploding, morphing teacher-student relationships, Hofmann, who had closed his school five years earlier, could represent some ideal, at once utterly practical and nearly mystical in its impact, of the role of the teacher in American art. He was the teacher as prophet, but also the teacher as hardworking colleague and practical adviser. And he was, at this very time, struggling to be recognized not as a teacher but as a painter pure and simple, which made him all the more an emblematic figure, a symbol of every artist's desire to escape the student-teacher dynamic and at last be himself. Among the forty Hofmann paintings exhibited at the Modern, there were none from the 1930s, only a handful were from the 1940s, and more than half were from the previous four years, after the school had closed. Hofmann the teacher was being superseded by Hofmann the painter of large, vehement abstractions, with brilliant, aniline colors set in combative or lyric juxtapositions of expressionist and geometric forms. Yet that this hedonist was also a man of ideas could scarcely be denied. William Seitz, in his catalog essay, gave an extended account of Hofmann as a teacher. And in *Art News*, Fritz Bultman, a student from the 1930s, began by going straight back to the essay "Plastic Creation," which Hofmann had published in the *Art Students League Magazine* shortly after he arrived in New York, in 1933. "The mystery of plastic creation is based upon the dualism of the two-dimensional and the three-dimensional," Hofmann had written, and this primal dialectical equation was still keeping many New York artists going thirty years later.[14]

Bultman quoted Hofmann's famously outspoken wife, Miz, announcing, one imagines at some opening or another, that "in New York everyone wants to be a '*Kunstpapst*' "—an art pope—and that was what Hofmann, in his genial, follow-me-if-you-will way, had been for a long time.[15] But what Miz must have been thinking about were some of the critics who counted them-

selves among Hofmann's disciples, especially Greenberg, but probably also Rosenberg, who were saying "Yes!" and "No!" to the proliferating works of art in an explosive scene. They were the self-proclaimed *Kunstpaepste,* no question about it. And certainly neither Greenberg nor Rosenberg was ever as respectful of any of their contemporaries as they were of that senior member of the New York School, whose lectures had meant so much to so many in the late 1930s; Greenberg's slim book on Hofmann came out in 1961. It was as if Rosenberg and Greenberg, to those who read their work, were offering two divergent views of what Hofmann had said and done. For Rosenberg, he was the prophet of the continuously conflicted nature of the work of art, of art as a turbulent struggle, as a series of actions and reactions that related to life but went on at some remove from life. For Greenberg, he was the prophet of the endless search for expressive completeness through distillation, of the crystallization of the forces of art and history into the epiphany of a singular form.

The trouble was that while Hofmann had suggested all of this and much more, too, he had mostly insisted that artists concentrate on the paints and brushes and canvases in their studios. And no matter how much Greenberg or Rosenberg might agree with Hofmann that art began and ended in the studio—and they did, they did—the very professionalization of art criticism, the very transformation of art into career, was turning the life of the studio, which had once been a basic, fundamental, unexaminable fact, into an object of study—a historical phenomenon rather than the place where history happened. The studio was becoming a take-it-or-leave-it proposition, now that many teachers as well as many students had taken to heart Duchamp's suggestion that you could in fact pick up your work of art ready-made at the local hardware store.

IV

In the early 1960s, Mercedes Matter, who had studied with Hofmann in the 1930s, was teaching at Pratt Institute in Brooklyn, where she felt that traditional studio practice was being superseded by a fascination with art-world trends that were validated, hot off the presses, by courses in the theory of art and design. The discussions in the art schools reflected a more general mood; the philosopher William Barrett, who had been friends with many artists, was finding that "quite run-of-the-mill talents [were beginning] to be preoccupied with 'advancing the medium.' In terms of the market place, of course, these lofty concerns could be given a quite commercial twist."[16] And in response to

this growing tendency to think of art as a futures market, Matter published a rousing essay, "What's Wrong with U.S. Art Schools?," in *Art News* in September 1963, the very month that the Hofmann show was opening at the Modern. She worried that the art student was caught in "a particularly confusing situation. The extraordinary kaleidoscope of events of the twentieth century, of movements following so closely one upon another, of extremes absurd and great, of ideas canceling each other out and of recurrent Dada and anti-art, all this breaks at his feet in waves of cynicism, jaded feeling and no-belief." She saw students "flung into the spotlight of fashion." A student, she observed, could "go through art school and gain an acute perception of 'what is going on,' a fairly intelligent grasp of the situation, and yet have never departed a single step from his original naivete of vision." She worried that art schools were not supporting "the continuity of work in a studio. Take this away," she announced, "and the art has been taken out of the education, and the art school becomes ready-made for the Ready Made."[17]

Matter, who turned fifty in 1963, the year she published this essay, had been one of the first women to become a member of the Club. Tall and slim, she was a striking beauty, with a wide, dramatic face that stood out in photographs at the Cedar Tavern. She had the looks of a bohemian aristocrat, and she had the family to match. Her father was Arthur B. Carles, a legendary figure in the American avant-garde, who had in 1908 been a member, together with Edward Steichen, John Marin, Max Weber, and Patrick Henry Bruce, of the New Society of American Artists in Paris. Her mother, Mercedes de Cordoba Carles, was a famous beauty, the subject of lustrous photographs by Steichen. After Matter's father returned to the United States, he taught at the Pennsylvania Academy. Among his paintings, which over the years became increas-

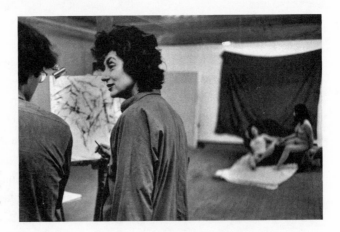

Herbert Matter, Mercedes Matter teaching at the New York Studio School in the late 1960s.

ingly abstract, the most remarkable were probably the flower pieces, in which the extravagance of the motifs provoked explosions of voluptuous color. His finest paintings had a richness that emerged from the brilliant juxtapositions of deep hues—violets and yellows, alizarins and greens. In Paris, Carles had studied the work of Matisse and had known the Steins, and in America he was friends with Hofmann, whom Mercedes met through her father. She was one of his first group of students in this country. They were lovers for a time. And Hofmann remained close to Matter and her family in later years. Matter's mother taught a series of art classes for children under the auspices of the Hofmann School. And there are a number of letters from Hofmann to Matter, in which he encouraged her painting and warned of the dangers involved in running an art school, which he said would almost inevitably drain a painter of the energy needed for one's own work in the studio.

In the early 1960s, when Pop was grabbing all the attention, Mercedes Matter must have felt that the old American avant-garde she had known when she was hardly more than a girl was fading away entirely. And yet for Matter those strong experiences remained very much alive, and the call-to-arms that was her 1963 essay on the trouble with the art schools became a rallying point for a number of artists and students and art historians as well, who did not see why the excitement of being an artist in a studio in New York ought to be so very different in 1963 than it had been in 1953, or for that matter in 1933. When Matter mentioned Hofmann's school in her essay, she linked it with the atelier where Gustave Moreau had taught Matisse and Rouault around 1900, and she observed that these institutions had been "permeated by the strength and passion of these men's beliefs." Yet Matter's argument went beyond a nostalgia for the singular, legendary teacher, for she was a modern who was willing to see some good in what she referred to as "the old academy," that bugaboo of the avant-garde that had "considered itself the custodian of traditions." The old academy, she wrote, "made specific demands not amenable to bluff or evasion; it required certain disciplines of the eye and the hand which, though often superficial in conception and violating feeling, nevertheless required effort and persistence, an attitude of rigor." Like many artists who had come of age with Hofmann, Matter was dismissive of the programmatic structure of the Bauhaus, of its systematic approach to design, of a place where "chairs and paintings became equal." She was married to Herbert Matter, an important graphic designer and photographer, and she probably believed that even his commercial work for Knoll, the furniture manufacturer, was grounded in his study of painting with Léger in Paris—an experience that, like the experience

of the Hofmann School, harked back to the nineteenth-century ateliers.[18] What appealed to Matter about the traditional ateliers and academies was that their emphasis on certain basics—especially on drawing from the model, day in and day out—suggested the freedom that could be discovered within a strict discipline.

Although there was a feeling of spontaneity about the beginnings of the New York Studio School, which Matter was instrumental in founding and then guided for many decades, a group of artists who had studied with Hofmann in fact had been talking about setting up a school ever since his closed in 1958. In the late 1950s, in letters that Hofmann wrote to Matter, he outlined in considerable and sometimes bitter detail the frustrations involved in devoting so much of one's energy to teaching. He complained that "most students are not artists: old ladys, amateurs and a few idealists that flirt with art." The serious ones "have mostly not any money to pay tuition." And when spring comes, "everybody drops out. Then come the summer problems."[19] And yet in spite of Hofmann's grave warnings, when some of Matter's students at Pratt wanted more time to draw uninterruptedly from the model and got together to find a loft in Manhattan, she could not look away from the great challenge that was staring her in the face. By the 1964–65 season, the loft at 646 Broadway was home to a wide-ranging program of drawing, painting, and sculpture, with a faculty that included Matter for drawing, Charles Cajori and Esteban Vicente for painting, and Sidney Geist and George Spaventa for sculpture. Meyer Schapiro offered some lectures, and among the visiting faculty were Leland Bell, Louis Finkelstein, Philip Guston, John Heliker, Alex Katz, and Reuben Nakian. Earl Kerkam also taught at the school. Hofmann himself was included among the list of visiting faculty on the first promotional literature and posters, although those who recall the early years are not sure he actually taught or lectured more than once or twice. But he was extravagant in praise of the school, remarking that "I feel very strongly that the Studio School is a real art school—like mine was—not a place where they teach you a few tricks."[20] In 1967

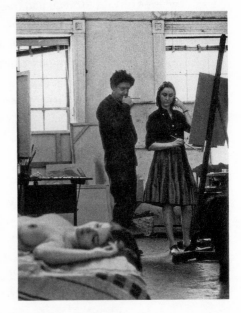

Leland Bell teaching at the New York Studio School in the late 1960s.

the school managed to buy the old Whitney Museum building, at 8 West Eighth Street; the Whitney had moved uptown in 1954. This building, an amalgam of yet older structures, cobbled together in 1930, was thus a piece of history reclaimed for a new history. The Studio School reeked of the turpentine that Duchamp had claimed drove him away from painting. It was a place dedicated to the act itself. Harold Rosenberg said, "When students in university art departments, who seem likely to become good artists, ask me where to study, I say, 'Try the New York Studio School on 8th Street, in Manhattan.' The first need in becoming an artist is to be around artists—nothing can replace that."[21]

Matter wanted the school to stand for something, but as an artist who had lived her whole life amid the experimental ambience of the avant-garde, she had to have complicated feelings about the old academies, which, as she admitted in her *Art News* essay, "may have stood still" and were "blind . . . to all new manifestations." Still, there had been a value to "this moral conservatism," which "gave a student something solid to push away from."[22] The Studio School presented art as an absolute—and also encouraged a spirit of rebellion. This was an academy without the old plaster casts, without the old idea that drawing from the figure would yield a classical solid form. Matter might want young artists to draw from the figure, but what they extracted from the figure was ultimately up to them. You might say that Matter's idea was to present a kind of abstraction of the academy. In an early brochure, the school was said to reestablish "a simple and ancient premise for the training of an artist: learning through practice. Continuity of work in the studio replaces the fragmented curricula of most modern schools."[23] What mattered was not a particular old idea of form or structure, but the idea of the art as being in the practice. "In drawing," she wrote, "it is not the shape of an idea as it exists in the mind which finally counts, but the marks on the paper, and these are not merely symbols for what is in the mind, as in mathematics, but sensible facts capable of projecting sensation."[24] An artist's feelings about nature or history had a value, but only to the extent that they were materialized on the paper or the canvas or in the lump of clay.

If the Hofmann School had been about extracting abstract principles from the experience of nature, there was a sense in which the Studio School, which echoed Hofmann's belief in a community of artists gathered together before the model or the still life, reversed the process, for Matter was anxious that abstract experiences, the experiences of the art of de Kooning and the mature Hofmann, might be reaffirmed within the experience of nature. For Matter, it

was Giacometti, whom she knew and about whom she wrote with great sensitivity, who held the key to what she wanted to see her students do, for he had moved back from Cubism to nature, he saw fragmentation as a step on the path back to coherence. An early poster for the school included reproductions of a drawing by Poussin, a sculpture by Giacometti, and a painting by Cézanne. There came to be something that was thought of as Studio School drawing, inspired by Matter, a delicate filigree of strokes, much erasure, a net of visual decisions, of placements of edge, angle, form, all juxtaposed in a web of lines that knit the surface together end to end. Her own finest paintings were crystalline structures, with the strokes of light yet rich color laid on in angled patches and small touches, to create a shimmering surface; they echoed some of Hofmann's still lifes of the 1930s and 1940s, but even more so, perhaps, some of her father's most beautiful flower canvases. In her own studio she created large still-life setups, setups that had some of the quality of the mountainous landscapes that Cézanne had first thought to

Poster for the New York Studio School designed by Herbert Matter, 1964.

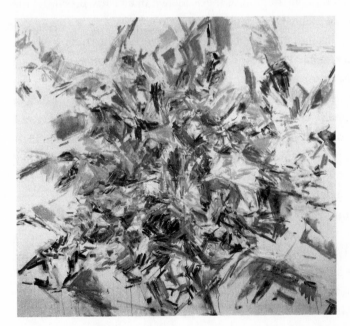

Mercedes Matter, Still Life, circa 1962–65. Oil on canvas, 44 × 45 in.

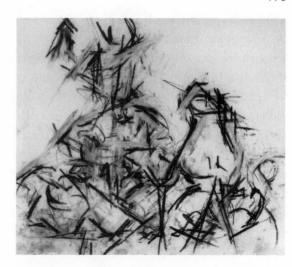

Mercedes Matter, Still Life,
circa 1950–55. Charcoal on paper,
17 ½ × 21 ½ in.

bring to still life, and she left these in place for months and years, until they became strange, dusty visions. Finkelstein, writing about her work, observed that "at first glance many of Mercedes Matter's paintings seem like Frenhofer's fabled last painting in Balzac's 'The Unknown Masterpiece,' to be an indecipherable mass of colored brushstrokes. Only after a while can we see that they are representations of real things."[25] And Matter liked the encoded mystery of art; she taught students to struggle in the morass, to battle through color and line, through nature and abstraction, until they were in touch with the materiality of the picture.

Hers was a vision of the glorious impracticality of art. And it was a younger generation of up-for-anything students, coming of age in the 1960s, a time of radical hopes and political ferment, who gave Matter's idealism its relevance, its urgency, its pulse. When things really started to take off in the late 1960s, you could have said of the New York Studio School something like what Rosenberg had said of the Hofmann School of the 1930s, namely that "in that decade of ideologies—New Deal, Marxist, Fascist—it was plain that the Hofmann teachings, too, offered a KEY."[26] At the Studio School, that radical artistic hope was that art might not be entirely overcome by the anti-art of Duchamp. Matter pushed her students to investigate the dusty romanticism of Frenhofer's studio—and to find there something lively, vital, surprising. Like any founder of a great institution, even of a chaotic, patched-together, invariably in-debt institution like the New York Studio School, Matter could be doctrinaire, dismissive of anybody else's ideas. It was not for nothing that she had opened a text on drawing by quoting Ingres, shouting at Delacroix, "Drawing

is the probity in art, the honor in art!"[27] She was the Studio School's Ingres, the teacher of drawing, even though, like any self-respecting New York School artist, she was equally attracted to Delacroix, his dialectical opposite. She invited controversy, exposing the students to artists such as Leland Bell, for example, who did not share her fondness for the fracturing of form. She had Hofmann's instinct that a strong student, when confronted with a strong teacher, would ultimately find his or her own way.

And Matter found strong support for her ideas. In 1967, when the school had been going for three years, Meyer Schapiro, who had been a friend from the beginning, gave a lecture there on the importance of drawing from the figure. And even as he affirmed the value of empirical observation in the midst of the city that had invented a new kind of abstraction, he insisted on the changed nature of empiricism. Schapiro himself had drawn seriously from life as a young man, and in his lecture he argued persuasively for the continuing importance of life drawing as a discipline. He assumed that the figure would not, in the end, be a central subject for many of the young artists to whom he was speaking. Yet the very complexity of the figure as a form, and the experience of attempting to deal with that form, would bring out "a kind of individuality which is already part of the process of art, and to a higher degree and with a greater complexity and range of possible responses." To work with the figure, to deal with the "extraordinary perception of a complex, living, self-articulated, self-adjusting body, in light and shadow, with elusive lines and complex interrelations of parts" would emphasize "the qualities of feeling, of line, of thought, and of work which you will bring to any kind of task." Drawing from life, as it was understood at the Studio School, was not anything like the classical discipline of the academy, where the figure was assumed to be the essential—the supreme—subject. As Schapiro said of drawing from the figure in the context of the Studio School, "I would propose that this method of study, which is not a clearly defined method, it is being improvised now and has some definition because it builds upon older practice—there have been art schools before, models and all that—but it is being done now within a new environment, and with a new generation, and with people who have a different sense of themselves and of art and the surroundings." For Schapiro, the New York Studio School exemplified the best way for an artist to act in history—as an individual with a limited but immensely complex and difficult and engrossing task.[28]

V

Surveying the art schools of her day, Matter complained that they upheld "the Tradition of the New—[they] dare not slip a moment behind the avant-garde." This fast-forward attitude was part of a deeper malaise, of what might be called history sickness, for there no longer seemed any possibility of considering art except in terms of historical development or evolution. Of course artists needed to know their own time and where they stood in relation to the past, but in the 1960s the obsession with being up-to-the-minute and predicting what the next minute would bring ran the risk of robbing artists of their freedom to act as individuals. This was what Matter was thinking about when she complained that the art schools had become places where "pressure and haste prevail."[29]

In one of the essays in *The Anxious Object*, published in 1964, Rosenberg announced that "consciousness of art history rules the art of our time and is key to what takes place in the galleries of New York, Los Angeles, Paris, Warsaw, Tokyo. It affects not only the objective status of new works, but the impulses that enter into their creation, their esthetic meaning, in fact, their very existence as works of art." He went on to wonder about the difference between "history-consciousness" and tradition. "Tradition is aware of the past as a single complex of forms extending through the present into the future. In contrast, the modern sense of history recognizes that the past is made up of diverse cultures which by action in our time are being resolved into a future unity, the 'one world' of democracy, of science or of the International Style. As tradition was an inescapable ingredient of the art of earlier centuries, proposing both what to paint and how to paint it, the consciousness of history is in a modern painting or sculpture as palpable as its form or motif—often, as in 'overall' abstraction, the art-historical reference is the *only* content." "Art history decides what art is."[30] Kramer, writing in *Arts* in 1963, had said much the same thing, speaking of an obsession with history, of how "certain things are said to be possible at a given moment, and everything else impossible. We nod upon receiving the pronouncements, not necessarily in agreement—far too many interesting exceptions come to mind—but out of sheer recognition of the principle that is implied in them." The sense of historical determinism had by now "spawned institutions," Kramer wrote, "and the institutions—museums, galleries, academies, publishing enterprises—are vast. They wield power."[31]

Greenberg was himself wielding considerable power by the early 1960s, for he had found a place for himself in the ever growing commercial hurly-burly of the art world, and in the fast-growing academic marketplace of ideas. Like Rosenberg, he enjoyed being a man of the world—somebody who came into contact with people who had the kind of money it took to buy works of art. Greenberg had relationships with art galleries, which were advisory and involved some kind of remuneration, and the question of the ethics of these relations, not to mention what was actually involved, has remained murky, a rat's maze of rumors and accusations. For some months between 1958 and 1961, Greenberg was an adviser to French and Co., which started a contemporary gallery with his help, and exhibited Newman and Louis. After Louis's death, in 1962, Greenberg was involved with his estate; later he was involved with Smith's. He was seen as closely involved with the Andre Emmerich Gallery, though what the arrangements were was not clear. Certainly artists gave Greenberg paintings; and he could sell them and make money. But whatever the financial gain, there can be no doubt that Greenberg was consumed by a desire to make a place in the art world for work that he admired, and that, above all else, he was provoked by his avidity for art. He became a regular visitor to Bennington College, where he organized some exhibitions and took part in the life at what was generally regarded as one of the most free-spirited institutions of higher education in the country. In his earlier years, Greenberg had been known to take a swing at people who rubbed him the wrong way, and he never stopped cultivating his reputation as the guy who would always have the last word.

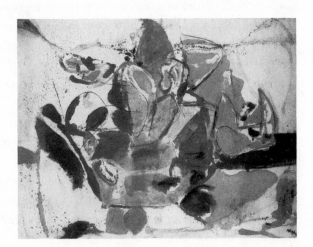

Helen Frankenthaler,
Mountains and Sea, *1952.*
Oil on unprimed canvas,
86⅝ × 117¼ in.

Morris Louis, Beta
Phi, *1960–61. Magna
on canvas, 102½ ×
166½ in.*

The contemporary work that excited Greenberg was
increasingly an art of singular, unified effects. In 1952,
Helen Frankenthaler, with whom Greenberg was romanti-
cally involved, painted a canvas called *Mountains and Sea,*
with wide, watercolor-like areas of oil paint soaked into the canvas, and later
Greenberg invited two painters in whom he took an interest, Morris Louis and
Kenneth Noland, to Frankenthaler's studio. Coming under the impact of her
casual imagery and her weightless, improvisational effects, both Louis and
Noland abandoned the dramaturgy of Abstract Expressionism and began to
create works with a swank, all-in-one look that Greenberg enthusiastically
embraced. Louis, who died in 1962 at the age of forty-nine, created veils and
unfurlings of dramatically thinned-down paint. His works from the mid-1950s
were dark, with blackish purples; later paintings had an increasingly high-
toned, almost giddy character, a sense of color gone to extremes, of the most
luscious yellows and oranges and reds, seeping one into the other, creating
elegantly graphic sunrises and sunsets. With Noland, who was born in 1924,
the effects were sparer, less diffuse; the works for which he first became
known, the *Targets,* were about a single, bold punch. There may have been
next to nothing going on in these Noland and Louis paintings, but when
Greenberg wrote about them, he filled them with historical action—the
departure from Cubism, which led to the rejection of the armature of light and
dark, which led to the suppression of space, which led to a feeling that space is

on the point of disappearing. "The suppression
of the difference between painted and unpainted
surfaces," Greenberg explained, "causes picto-
rial space to leak through—or rather, to seem
about to leak through—the framed edges of the
picture into the space beyond them."[32] There was
a mystical dimension to the power of these can-
vases, at least as Greenberg described them, for
the very emptiness of the images had forced
Greenberg, in spite of his vehement formalism,
to look for some meaning beyond the merely
visual. The sense of Morris Louis and his new
kind of stained paintings as being an event in his-
tory, as being the resolution of a dialectic, was
underscored by Michael Fried in the most ex-
traordinary manner when he preceded a long
account of Louis with a line from Marx: "The
forming of the five senses is a labor of the entire

*Kenneth Noland, Askew, 1958.
Magna on canvas, 67 × 68¾ in.*

history of the world down to the present."[33] The painting became a working
out of historical forces—of the onward marching dialectic, with its distillation
of essences, with its purification of art. Louis's veils of color became a key syn-
thesis, if not *the* ultimate synthesis. And that synthesis became the only
content.

Greenberg was extravagant in his praise of Louis and Noland, and in the
1960s he also had warm words for what Anthony Caro, Jules Olitski, and
Anne Truitt were doing, but by the end of the decade he was increasingly ret-
icent, at least in print, about contemporary art. He still, however, had a great
deal to say about the nature of art—about aesthetics, and about tradition,
which might be said to be history's out-of-time dimension. In 1961 he pub-
lished *Art and Culture*, an essay collection that remains one of the crowning
achievements of the group of New York intellectuals who had come of age in
the 1930s.[34] For Greenberg's generation, the essay was the quintessential liter-
ary form and the essay collection was the most characteristic kind of book.
The all-encompassing work of nonfiction, the volume with a large theme and
a single narrative line, was something that all of them had grown up with, but
whether or not they dreamed of producing such works, their own thinking
found its richest expressions in shorter lengths of prose. The New York intel-
lectuals, at least so I believe, could not help but recoil from the grand sweep of

pages favored by Marx and Hegel and countless other nineteenth-century and early-twentieth-century thinkers. The gathering liberalism of the *Partisan Review* crowd encouraged the quick attack, the incisive observation, the idea that could not be expanded, that had a more modest, freestanding import. And whatever one may think of Greenberg's ideas, *Art and Culture* is a beautiful book. Certainly Rosenberg never produced an essay collection with this kind of coherence. And even Meyer Schapiro, when, later in life, he began to collect his works, could not create a volume that had a sturdy, compelling unity, despite the magnificence of the parts.

The critic Sanford Schwartz has compared Greenberg's prose to Hemingway's, and his work does have the qualities of the best of Hemingway, the plainspokenness that is so full of art, but of an art that brings us to the simple beauty of speech and thought. In *Art and Culture*, Greenberg manages to maintain the immediacy of writing done over a period of some twenty years while bringing all of it together into a powerful whole. For Greenberg, the artist was never entirely free. He grappled with the medium, but the medium constrained him, pushed him in particular directions. In the midst of the essay "Picasso at Seventy-five," Greenberg observed that "like any other real style, Cubism had its own inherent laws of development. By the late twenties these all seemed to be driving toward greater if not outright abstraction. Mondrian drew the extreme and final conclusions, but Miró, especially between 1925 and 1930, was able to produce art of a revolutionary and substantial originality by sacrificing only the integrity of nature, not nature as such."[35] Greenberg's was a rigorously impersonal idea of style; according to him, style had certain inherent laws, laws to which an artist had to submit in one way or another. Like Eliot's formalist faith, to which Greenberg's thinking owed a good deal, Greenberg's vision of the inexorable evolution of style had a kind of autocratic appeal, but also a deep streak of mystical irrationality. In *Art and Culture* the relentlessness of Greenberg's vision was kept in check by the richness of his discussions of some individual

Cover of Clement Greenberg's Art and Culture, 1961.

artists—by his excitement about Monet and Renoir and Matisse and Léger and Picasso, and his curiosity about nineteenth-century Americans such as Thomas Eakins and Winslow Homer. And yet what finally holds us in Greenberg's writing, far more than his interpretations of specific works of art, is the satisfaction of a fable, the satisfaction of seeing the artist as part of a great world-historical process—which is the invention of modern art.

VI

Greenberg was a self-critical as well as a critical man, and in his writing of the 1960s you can feel that even he was beginning to question the be-all-and-end-all importance that so many critics and historians were ascribing to historical processes. Already in the essay "Modernist Painting," first published in 1960, he began to suggest that modern art offered an escape from inexorable chronology, in that it involved "a devolution, an unraveling, of tradition." For Greenberg the going back was about purification, about experiencing only what was essential to the tradition, about critiquing tradition, but this purification might also trump tradition. When he spoke of the need to purify an art form, he was also removing the visual arts from their intricate connections with other art forms—and with the cultures from which those forms emerged and by which they were nourished. In modern art, "the task of self-criticism," so Greenberg argued, "became to eliminate from the specific effects of each art any and every effect that might conceivably be borrowed from or by the medium of any other art. Thus would each art be rendered 'pure,' and in its 'purity' find the guarantee of its standards of quality as well as of its independence."[36] But an art that was this pure—that was so disconnected from the world—could also be terribly bland.

Greenberg's use of the term *modernist* has come to be so closely associated with the objectives of the art of the twentieth century that it can now take some effort to remember that in the thinking of Matisse, Picasso, Brancusi, Klee, Miró, and the other giants of modern art, "purity" was rarely if ever what was intended. They often drew their motifs and their themes from the messy richness of daily life. They wanted art to have a freestanding power, but they knew that that power was nourished by life's unruly energies. Even Mondrian believed, fervently, that his painting was about something other than mere paint and canvas. The terms *modernist* and *modernism*, so beloved by Greenberg, began the twentieth century as general characterizations of a period or of the art of a period. Revisiting the United States at the beginning

of the twentieth century, Henry James said that a "fine emphasis of modernism hung about" the campus of the University of Pennsylvania, and a 1924 pamphlet attacking modern art was called *Three Papers on "Modernist Art,"* which merely meant art after Impressionism.[37] Alfred Barr rarely if ever used either term; he spoke of modern art, modern painting, modern sculpture— a far less charged, more plainly descriptive term. Greenberg's "Modernist Painting," with its vehement rejection of representation and narrative and metaphor, argued for a particular view of modern art. He believed that modern art was an unending process of distillation. And this was turning out to be a very dangerous view—because the exclusionary spirit had such a powerful appeal among arbiters of taste, who saw in Greenberg's edicts a way of establishing who was in and who was out. Perhaps Greenberg came to recognize the danger, for in 1971, in an essay called "Necessity of Formalism," he declared that "modernism as a whole distinguishes itself by its inclusiveness, its openness, and also its indeterminateness."[38] It was almost as if he was offering a riposte to his own extremist vision—but the riposte came too late.

In his later years Greenberg was less interested in specific works than he was in arriving at a definitive description of art's stand-alone power—of the capacity that certain works of art have to hold us, even when we are not especially interested in their particular subjects or themes. And as he attempted to describe this unusual power, he became almost obsessed with Kant's view of art as being comprehended only in the experiencing, of the experience as having no significance outside of the experiencing, of the experiencing as being a union of pleasure and judgment, and of the pleasure as being inextricably tied to the inevitability of the judgment. Greenberg said that Kant was "the first to criticize the means itself of criticism. I conceive of Kant as the first real Modernist."[39] But whatever the truth of Greenberg's assertion, the centuries that separated him from Kant, in artistic matters as in so much else, gave their views an utterly different quality. For Kant, aesthetics were part of a vast architectural framework through which he explored the possibilities of the mind. He rejected the rule book of Neoclassicism in favor of a view that Isaiah Berlin characterized as that of a "restrained romantic."[40] And it was as if Greenberg, who came of age amid the violent romanticism of the 1930s and 1940s, was now yearning for this quieter kind of emotion.

To the enigma of how the most personal and singular experiences of art could be felt to have universal inevitability, Kant gave several not entirely consistent answers. At least for a time, he left open the possibility of lively debate among contradictory views as to whose judgment of taste had an

exemplary validity. But such openness was impossible for Greenberg; the violent romantic could not become the restrained romantic. If Kant's aesthetics exude an early morning beauty, Greenberg's suggest something closer to a twilight strangeness. In his memoirs, William Barrett recalled Delmore Schwartz saying, "You know Clem doesn't know what he's talking about when he mentions Kant." And Barrett observed, "The formalist [such as Greenberg] who looks at a picture merely as a flat plane with a certain pleasing arrangement of shapes and colors would be morally suspect in the eyes of Kant."[41] Yet it was precisely some moral high ground that Greenberg sought in Kant, for as Greenberg labored over a group of essays that he first presented as seminars at Bennington College in 1971, he must have been haunted by a feeling that the general level of contemporary art was sinking lower with each passing day. The idea of artistic judgment was on the verge of extinction. He complained that "what is relatively new about the badness of recent 'advanced' art . . . is that it *is* so boring and vacuous."[42] There was certainly enough phony experimentation going on in the art world of the 1970s to justify Greenberg's disgust, but the belligerence with which he embraced Kantian ideas was untrue to the eighteenth-century optimism that had probably attracted him in the first place. What was speculative in Kant became curmudgeonly in Greenberg, and that made all the difference in the world.

We have to take Greenberg seriously, I think, when he explains that "esthetic judgment—esthetic intuition—closets you with itself and with

Piet Mondrian,
Fox-Trot A: Lozenge with
Three Lines, *1929/1930.*
Oil on canvas, 30¾ × 30¾ in.

yourself." In the last of these essays that he completed—they were published as "Seminars," in acknowledgment of their Bennington College beginnings—Greenberg keeps returning to Mondrian's *Fox-Trot A,* a diamond-shaped painting in which three black lines break through the placidity of a white expanse, creating a buoyant contrapuntal mood. This gorgeously concise painting, Greenberg writes, is "as empty a picture as could be imagined short of a completely monochromatic one. Yet it works, it succeeds, and does so on the highest level."[43] Greenberg is not wrong to see in *Fox-Trot A* a thrillingly ultimate distillation of particulars into universals. By allowing his essays on aesthetics to near their conclusion on this note, however, he exposes his tendency to give the entire experience of art an unnecessarily stripped-down look—a look that Mondrian himself did not see as definitive, if we consider the increasingly elaborated and even downright metaphorical paintings of his later years. Greenberg is also refusing to acknowledge all the messy life that Mondrian brought into *Fox-Trot A* by giving it such an astonishingly frank, metaphoric title—a title that evoked the dance halls of the 1920s.[44]

Like so many of the artists and writers with whom he disagreed and argued endlessly in the 1960s and 1970s, Greenberg regarded the contemporary artistic situation as a spectacle in which nobody was much more than a puppet, guided by forces beyond his or her control. With Greenberg, quality was the force that transcended personality and history. Confronted with an art world that in the late 1960s and 1970s had to a large degree embraced a Dadaist skepticism about all matters of taste, quality, and judgment, Greenberg seized many opportunities to speak out in public; but when it came to his writing, he was inclined to say less and less. In the later essays, the masterpieces begin to blur together. It is as if all ideas of history, of dialectic, weary him. There is something creepy about the abstractness of Greenberg's judgments. And yet there is something in this teacher's voice that remains true to those times when we are dumbstruck by the grandeur of a work of art, when a painting or poem contains so much that we wonder if anything that we say can convey the experience. We hear the voice of a man who has been stung by art, and who has to explain why certain paintings and poems and novels mean so much to him. His later essays read as variations on a theme in a way that recalls the reiteration of motifs in certain groups of paintings by the artists whom Greenberg admired—say, Barnett Newman or Clyfford Still. The essays have their own kind of allover patterning, like a literary version of a Pollock arabesque. At one point, Greenberg announces, "To say it still again: Art lives in the experiencing of it. And yet again: That experiencing consists in valuing, esthetic

valuing."[45] He is determined to get it right. He will not be fooled. And his obsession with some ultimate truth becomes the grand folly that haunts Greenberg's later writings. In the end, he is talking about art in such a generalized way that the art is on the verge of vanishing entirely.

I am reminded of something that Edmund Wilson wrote in *To the Finland Station*, about how the abstractions of the German philosophers of Kant's day can seem "like foggy and amorphous myths, which hang in the gray heavens above the flat land of Königsberg and Berlin, only descending into reality in the role of intervening gods."[46] By comparison, Wilson argued, the ideas of the French Revolution could, incredibly enough, feel palpable, concrete, even when they are abstractions such as Liberty, Fraternity, and Equality. In a sense, Greenberg had moved, in his writing, from concrete ideas of abstract art—the plane, the framing rectangle, color, line—to an increasingly detached abstractness, to the amorphous myths of Kant. Only for Greenberg, these myths were wrapped not in the gray heavens above the flat plane of Königsberg but in the hedonistic veils of Morris Louis's color, a great unfurling of color that signified an excellence beyond time and circumstance, an art out-of-time, a purity of judgment that existed beyond the reach of history or the dialectic.

THE EMPIRICAL
IMAGINATION

15. BEGINNING AGAIN

I

"By reality and perfection I understand the same thing." This was the resounding assertion from Spinoza's *Ethics* that Thomas Hess used as the epigraph for a book about Barnett Newman, published in 1969. These few words, with their clashing values, were a saber-rattling way to open a monograph about a contemporary painter. They gave Newman's paintings, with their wide expanses of unmodulated color, an unsettling excitement, as if all that color, simply by being right there before our eyes, could signify perfection. How, we wonder, can reality and perfection be the same thing? A moment later, though, we realize that no artist can live without in some sense hoping that this is so. This is true for every artist in every time, in the sense that the possibility of experiencing the work of art fully must somehow always be lodged in the physicality of the work itself. But this question of the relationship between reality and perfection—or form and feeling, which in an artistic context may amount to the same thing—is especially urgent in New York, where there is often an assumption that the shape of the city, with its unsettling juxtapositions and crazily unplanned or ill-planned spaces, is not only far from perfection but is in some way incommensurate with the thought that there could be such a thing.[1]

For New York artists, who take it for granted that they live in a city that is less than perfectly beautiful, the idea of asserting that reality and perfection are one and the same may be a way of asserting the possibility that art will be able to flourish in an environment that pushes against the idea of art. A New York artist has to believe that beauty can be found in the bare, immediate facts, for only if reality, which is by its nature imperfect, has a chance at perfection, can an artist who lives in this unpredictable environment have a chance to create something with a permanent value. When Hess wrote about Newman's work, he wanted to show that its grandiose eccentricities—the radically anti-

traditional indifference to detail, to incident, to internal complication—were also commensurate with the city. Newman's vast, what-you-see-is-what-you-get planes of color are, so Hess wanted us to believe, as unexpected a reality as the tough but beautiful streets of New York. And Hess wanted to go further, and suggest that the very reality of the city itself was beautiful, although in unexpected ways. He described going in the late 1960s to see a new painting in Newman's studio on Front Street, in one of an 1820s row of condemned buildings, which was soon to "make way for a new glass and steel skyscraper."[2] Hess may have been pushing a bit hard on Newman's connections to the city, re-romanticizing the no-romantic romantic attitude, but there is something in the experience of the city that parallels, echoes, underscores the experience of art. Barnett Newman was a man who had started out in the Surrealist 1940s, and now, in the sleek Manhattan of the 1960s, he was doing enormous canvases that were scaled to the new skyscraper city, canvases that offered an enveloping view of one or two huge planes of color interrupted by one or two singular vertical stripes.

Barnett Newman, Who's Afraid of Red, Yellow, and Blue I, *1966. Oil on canvas, 75 × 48 in.*

Hess had come to Front Street to look at a painting by Newman that had a red surface with stripes in blue and yellow, one of the series of paintings known as *Who's Afraid of Red, Yellow, and Blue.* In his monograph, Hess recalled how he and Newman and some others then "drive from the studio to Brooklyn for a seafood dinner, examine some bits and pieces of local nineteenth-century municipal architecture that have been overlooked by that borough's exploiters, then head back to Manhattan over . . . Brooklyn Bridge." It was 1969, but Newman was still living in the New York of Hart Crane or Walt Whitman, a New York that was focused on the harbor, on the great waterway between Brooklyn and Manhattan. "It is a soft June night," Hess wrote; "the city lights burn through velvet layers of pollution. The car speeds up the roadway and then seems to wing above a landscape of yellow stars. 'We're at the top of the bridge,' says Barney, 'at the dip in the parabola; we are floating across like'—and he

laughs a bit—'if I may be immodest, like you move across the red in my paint-ing."[3] That analysis was offered as a quirky bit of conversation, but of course Hess wanted his readers to take in the implications of Newman's off-the-cuff metaphor. It was Newman, back in the 1940s in *The Tiger's Eye*, who had urged Americans to find the sublime on their own terms, not as a reflection of some European idea, but as a kind of American practicality. To look at what Americans had made—the Indian mounds in the Midwest, say, or the Brook-lyn Bridge—was to see a reality that had its own kind of power. To embrace what was right before your eyes in the United States was to be both an empiri-cist and a romantic; in America those might be the same thing. "We are creat-ing images," Newman wrote in "The Sublime Is Now," "whose reality is self-evident and which are devoid of the props and crutches that evoke associ-ations with outmoded images, both sublime and beautiful. We are freeing our-selves of the impediments of memory, association, nostalgia, legend, myth, or what have you." "The image we produce," Newman declared, "is the self-evident one of revelation, real and concrete."[4]

While it was all well and good for Newman to assert that he and his fellow artists were creating "out of ourselves," no artist could do that without using his eyes. What was right in front of the artist was going to be immensely important, and for Newman that was not the soaring cathedrals of England and France but the arching expanse of the Brooklyn Bridge. Newman, Hess observed, "has an antiquarian's passion for New York and for the amenity, dignity and value of a much abused and still neglected American past. He is a connoisseur of noble firehouses and Medicean post offices and remembers that Thomas Eakins did one of the bas-reliefs of horses for the Triumphal Arch in Prospect Park." Yet he was not, Hess emphasized, "a revivalist. He is in search of lost sculptors and forgotten architects. To paraphrase Joyce, he wants to forge the uncreated history of his country."[5] All this fascination with an older New York could be described as a bohemian antiquarianism, but it was also fueled by a more powerful impulse than that, by an urge to naturalize the antinaturalism of abstract art, to locate new ideas of structure and compo-sition in the facture of the places where you lived. Unexpected forms, forms that might at first seem ugly, had a beauty, and a power, about them, too. A few years earlier, Hess had observed in an essay about Paris and New York, called "A Tale of Two Cities," that "in order to exist, international art has to be embedded. Styles must have location, even if they have no names. Art must have a centripetal focus, both in time and in geography. There must be a home—even if it is seldom visited. Place is a precondition for work."[6] New-

man understood this; for decades he had been cultivating an intuitive sense of how his art fit into New York. And he was not the only artist who was interested in the city's nineteenth-century monuments; Ellsworth Kelly, as we have already seen, kept a photograph of the Brooklyn Bridge amid the clippings that he used as sources.

Newman died in 1970, the year after Hess wrote about the trip across the Brooklyn Bridge, but in the last years of his life, the map of New York that Rosenberg had described in the "Geography of Tenth Street," heart of the no-romantic romantic attitude, far from fading, had been enlarging, expanding, moving south of Houston Street and into the East Village, as a growing population of artists took up more and more of the spaces that manufacturers were vacating. Donald Judd, a great admirer of Newman's work, had, two years before Newman died, bought a cast-iron building on Spring Street, a building that he revered for its late-Victorian force and clarity; in an essay about Newman, written in 1970, Judd had quoted the older man's argument in "The Sublime Is Now" that "we are making it out of ourselves."[7] By the 1960s, de Kooning might be pretty much living on Long Island, but others were now walking the streets that he had once walked, noting the striking juxtapositions, the collage of buildings and graffiti—and making art out of all this. David Smith, who had started welding at the Terminal Iron Works in Brooklyn in the 1930s, died in upstate New York in May 1965, but others were putting industrial materials together into clean-lined forms, or experimenting, as Smith had, with the perfervid expressionism of assemblage. Hofmann, whose school, on Eighth Street, had been so much at the center of the romantic adventures of the 1940s and 1950s, died in February 1966, but already, two years earlier, the New York Studio School had opened nearby, where, as he himself had been excited to see, artists could once again learn not some tricks of the trade but how to join up with fellow students and a few inspired teachers and embark on those hard, endless hours in the studio.

II

To embrace the reality of the city is to be an empiricist. But *empiricism* is one of those words that can mean any number of different things. When the philosophers speak of an empiricist, they may be referring to somebody who believes that we can only know what is right before our eyes, or they may be referring to somebody who believes that the inferences that we draw must be rooted in what is before our eyes. For the artists of the early 1960s—who, like

artists in all times and places, were sometimes emboldened but never really constrained by philosophical arguments—empiricism might be defined as a belief that an artist had to concentrate on what was immediate, and had to avoid what was airy and speculative. When David Smith stated in the early 1960s that when he worked "there is no consciousness of ideal—but intuition and impulse," he was very much the empiricist. Allusions to empiricism of one sort or another crop up everywhere you look in the art of the early 1960s. The exhibition at the Janis Gallery in 1962 that gave Pop Art one of its first big breaks was called "The New Realists," and Janis, in an introductory note in the catalog, suggested that the artists in question were "factual artists," a term he acknowledged borrowing from his wife Harriet Janis and Rudi Blesh's book on collage. Four years later, introducing an exhibition called "Systemic Painting" at the Guggenheim, which focused on the anti-painterly direction in painting of the 1960s, Lawrence Alloway observed that "in New York there is little reliance on Platonic or Pythagorean mysteries. A system is as human as a splash of paint, more so when the splash gets routinized."[8] To be human was to be anti-philosophical, to be empirical. An empiricist could as easily be an abstractionist as a realist, just so long as the artist was focused on the materials with which he or she worked, on the moment-by-moment process of making a thing. And so artists who at first seemed to have absolutely nothing in common could in fact turn out in their own different ways to be working toward a related kind of concreteness, a concreteness that was commensurate with the nature of the city itself.[9]

Surely no two artists who were working in the New York of the early 1960s would initially appear more thoroughly contradictory than Fairfield Porter and Donald Judd, and yet they defined, rather powerfully, I believe, two poles of the empirical imagination of those years. They both wanted to start from scratch, to invent themselves as artists from the ground up, to begin again. Porter, who was born in 1907, brought a subtly, diffidently experimental spirit to his paintings of figures and landscapes and interiors; he aimed for a quirky poetic inwardness. Judd, who was born twenty-one years later, in 1928, designed stark structures in industrial materials, and wanted what he called his "specific objects" to make a bold, almost confrontational impression in the world. Both Porter and Judd, in their utterly different ways, believed that art had to grow out of the artist's absorption in the particular forms that were before his eyes, not out of a concern with the historical-formalist pressures that had brought art to the place where it was as the artist set to work. If the essential question for the ferociously individualistic artists of the late 1930s

and 1940s had been how they could take their places in a grand historical continuum, the question for the early 1960s, at least as Porter and Judd understood it in their daringly complementary ways, was how to make the most of a historical moment without being submerged by it. Both Porter and Judd wanted to accept the earth-shattering impact of Abstract Expressionism while resisting any suggestion that the future of art had to be predicated on what the Abstract Expressionists had done.

Nobody would deny that artists and gallerygoers who admired Porter and his work were rarely inclined to take Judd seriously, while Judd's admirers would generally regard Porter's work, if they happened to notice it, as being hopelessly *retardataire*. These were inherently contradictory visions, no question about it. The polemics of the early 1960s would have had it that if you liked Porter's writing and painting, you couldn't

Fairfield Porter in his studio, circa 1972.

like or even perhaps be interested in Judd's writing and sculpture—and vice versa. Porter would surely have agreed. In a lecture given at Yale in 1975, he clearly saw Judd as an enemy of the kind of work that interested him, and complained about "Judd's remark that painting on canvas is no longer credible," which Porter felt put "painting in the category of the solution of problems"—a remark that put Judd in the same category in which Porter would

Paul Katz,
Donald Judd,
at 101 Spring Street,
circa 1970.

put Greenberg, as a person who saw works of art as dominoes falling in a single direction.[10] As for Judd, he once remarked in print that "there just hasn't been any first- or even second-rate representation art for fifty years" and that "even if a live traditional art existed, I would dislike it."[11] Which didn't leave much room for Porter.

Yet once you have acknowledged that Porter and Judd were not just the oddest of couples but, really, no couple at all, you may begin to notice that there were certain strong parallels between the paths that they chose to take out of the crisis atmosphere of the early 1960s. If they were the contrarities of that decade, then they may also turn out to have had similar roots—and similar goals. I think it is highly significant that both Porter and Judd wrote a great deal around 1960. Porter, who had written short reviews and some articles for *Art News* in the 1950s, was the critic for *The Nation,* contributing a regular column between 1959 and 1961. Both Porter and Judd continued to write, composing more general, often theoretical essays in their later years, but it was in the early 1960s that they intersected most vigorously with the art world around them, trying to make sense of things in a way that worked for them. Judd, who for a few years in the early 1960s was earning his living as a reviewer, tended to praise artists who operated in an area that was neither painting nor sculpture; he admired Lee Bontecou for her canvas reliefs, Dan Flavin for his fluorescent works, Oldenburg for his oversize versions of ordinary objects. Porter, in his criticism, always insisted on what was specific and particular and curious in a work of art; he zeroed in on the emotional coloration in the contemporary representational paintings of Alex Katz and Paul Georges and Herman Rose. The words *particular* and *specific* were keynotes of Judd's writing as well. These values were, in turn, prized by Judd in opposition to what he saw as the dangers of idealism. "I leapt into the world an empiricist," he wrote; "ideality was not a quality I wanted."[12] And Porter titled an essay "Against Idealism."

If artists during the 1940s had taken empiricism for granted and hungered for a metaphysics of history, in the 1960s the process may have been reversed. Judd and Porter took New York's place in history for granted, and what they hungered for was the immediacy and specificity of art. Porter's own painting could be said to define one powerful direction in 1960s empiricism. The range of his subjects, the different formats on which he chose to work, and the variability of his paint handling all suggested an intellectual restlessness, and, maybe, an emotional makeup that was wayward but also insistent. In some of his more interesting paintings, he seemed to be following an idiosyncratic

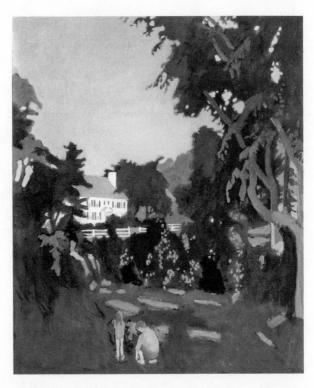

*Fairfield Porter, Six O'Clock,
1964. Oil on canvas,
71¼ × 59½ in.*

idea—looking intently, say, at a few square feet of wildflowers and weeds—to some peculiar, almost off-putting extreme. Painting autumn foliage or heavy snow in western Massachusetts, or the sloppy sidewalks of New York, or a crowded table at the end of a meal, or portraits of friends, Porter was a fiercely intelligent man who was in love with happenstance, accident, propinquity. There was a friction that developed in this work, between the informality of the subjects and the attentiveness of the artist. And Porter, a neurotic in love with the laid-back life, found himself in that friction. He explored—obsessively—life's nifty, everyday experiences. He gave gallerygoers an ever-so-slightly odd picture of an apparently easygoing world. The oddity was never surreal, though, but something closer to the surprise of one's own feelings—an unease that crept up on a person when everything was just fine, or a perfect contentment experienced for no reason at all.

 It is in the nature of empiricism that different empiricists will see things in radically different ways, and another of these directions was epitomized by Judd, whose first sculpture show was held at the Green Gallery in December 1963. This exhibition featured constructions, many painted an even cadmium red, that were poker-faced, hard-edged enigmas, dramatically constrained in

Donald Judd, Untitled, 1962.
Cadmium red light on wood with
black enamel metal pipe,
48 in. high.

their impact: a box with a length of iron pipe set into its top side; two wooden panels, set at a 90-degree angle, with a black pipe, also turning a 90-degree angle, connecting them; two pieces of wood, set apart, with six lengths of wood and an aluminum pipe, arranged in a diagonal, connecting them. Judd insisted that a work of art was something invented out of whole cloth. Yet the matter-of-factness of the presentation left a space for the artist's imagination, as a sort of faint perfume secreted by the impersonality of the forms. These works, with their wryly insistent, what-you-see-is-what-you-get impact, were harbingers of what would soon after be called Minimalism, a term Judd himself never really cared for, but they were also part of a wider-ranging disposition or inclination or habit of mind that was circulating in New York in the early 1960s. There was a need to reaffirm the basics of art making, and to make of this reaffirmation a complexly empirical drama, a drama that was not so much a rejection of the romanticism of a decade or two earlier as a deepening of the no-romantic romantic attitude. It is worth recalling some words of Wylie Sypher's, in his 1960 book, *Rococo to Cubism in Art and Literature,* that we encountered near the beginning of our story: "The romantic in his quest of personal evidence uses his own kind of realism . . . ; since his feelings cannot be fixed, he is always forced to make new appraisals as his responses change. He has nothing to trust beyond this unstable experience."[13]

III

Like much that was happening in art in New York in the extremely self-conscious atmosphere of the early 1960s, this new empiricism was immediately turned into a talking point, a marketing ploy, but it was much more than that, too. Earthworks, site-specific works, photo-realism, and experiments with video and film could in one way or another be regarded as reflecting the new empirical attitude. So could a renewed interest in geometric painting—whether in the work of older artists such as Albers and Diller or of a younger

artist, such as Kelly. The new interest in hard-edged imagery was the subject of a whole cycle of shows, beginning with "Geometric Abstraction in America," at the Whitney in 1962. Then there was "Toward a New Abstraction," at the Jewish Museum in 1963; "Black, White and Grey," at the Wadsworth Atheneum in Hartford in 1964; "The New Formalists," at the University of Michigan in 1964; Greenberg's "Post Painterly Abstraction," at the Los Angeles County Museum of Art in 1964; and "Systemic Painting," at the Guggenheim in 1966. Although Judd began to appear in these shows only with "Primary Structures," at the Jewish Museum in 1966, many artists who had interested him to one degree or another, including Stella, Kelly, Held, and George Ortman, were in these exhibitions. As the new look moved beyond New York to smaller museums, with a speed that had been set by Pop in 1962, a lot of what was being shown was understood in terms of a rejection of Tenth Street painterliness, and of course that was a part of the story.

In the early 1960s, Al Held, who had been born in 1928, was doing paintings in which the fragments of letters or geometric forms proved to be so oversized that they were cropped by the sides of the image. Painted thickly but clearly, these compositions struck Irving Sandler as suggesting "the 'grandfather principle' in art history," whereby an artist could reach back, past de Kooning and Pollock, to seek inspiration in Léger and Stuart Davis.[14] The boldness of these Helds might bring Abstract Expressionism to mind, but there was a hunger for objectivity about them that, while it recalled Léger and Davis, was also very much a part of the new empiricism. Recalling the work that he was doing in those years, Held said in an interview, "The Abstract Expressionists covered everything up with this sensibility and feeling self and I remember saying to myself: 'If this be shit it's going to be out front, if it's going to be bull shit it's going to be out front, the i's are going to be dotted, it's going to be clear bull shit. No spiritual overlay.'"[15] Held's rejection of "ambiguity," his insistence on dotting the *i*'s and crossing the *t*'s was a keynote of the early 1960s—a romance of honesty, you might say. It was as if Held was dreaming his way back into what de Kooning had described as the subjectivity of Renaissance perspective, which was now becoming a kind of objectivity. There was a hunger for objectivity in a great many areas of the arts, a hunger that reached well beyond painting and sculpture. Mary McCarthy wrote an essay called "The Fact in Fiction," in which she argued that "most of the great novels contain blocks and lumps of fact," and pointed out that "many of the great novelists were newspaper reporters or journalists"—experts in the empirical.[16]

Al Held, Last Series XII,
1964–65.
*Acrylic on paper
mounted on board,
18 × 24 in.*

This romance of honesty was one of the impulses behind Judd's constructions, but it was also one of the impulses behind a range of new kinds of representational painting, a phenomenon so widely acknowledged that the Museum of Modern Art felt the need to deal with the subject in two shows, mounted in the years around the turn of the decade. "New Images of Man," in 1959, was international in focus, including Giacometti and Dubuffet from France, Francis Bacon and Reg Butler from England, de Kooning and Pollock from New York, Richard Diebenkorn from San Francisco, but virtually ignoring the realism that was at that time emerging out of the crucible of the Hofmann School and the Club. The complaint that many artists had about this show was that by and large the artists (Giacometti excepted) refused to dot their *i*'s and cross their *t*'s. They weren't empiricists—they were sentimentalists. Porter wrote what was one of his angriest reviews in *The Nation*, complaining, "The common superficial look of the exhibition is that it collects monsters of mutilation, death and decay." Three years later, with "Recent Painting USA: The Figure," the Modern made another effort, and again many artists felt that the museum was supporting an art of moralistic self-dramatization. Philip Pearlstein, who had just published an essay called "Figure Paintings Today Are Not Made in Heaven," which emphasized the empiricism of working from life, said that

*Cover of catalog for "New Images of Man,"
1959, designed by Herbert Matter.*

the Modern show reflected a vogue for "psychological overtones" and figures that were "scorched, charred, flattened-out."[17] The same night that "Recent Painting USA" opened at the Modern, the Kornblee Gallery opened a show called "Figures" in a mansion at 8 East Seventy-ninth Street, an exhibition that focused on exactly those downtown artists who were not represented at MoMA. But already, the year before, when Janis had mounted "The New Realists," a defining moment for Pop, there had been, across the street, at the Knoedler Gallery, an exhibition called "Five Painters," which included Blaine, Matthiasdottir, De Niro, Bell, and Hyde Solomon.

Louis Matthiasdottir, who had studied with Hofmann and would soon be showing regularly at the Robert Schoelkopf Gallery, was doing work that had nothing to do with the up-front assertions of Pop. But there was no more quietly powerful exposition of the new empiricism than a series of small paintings of the head of her adolescent daughter Temma that Matthiasdottir painted in 1962 and 1963. Working in oil on paperboard and coming in close, so that the head, often cropped at top or side, seemed to burst the bounds of the frame, Matthiasdottir created a cycle of images that caught the mingled gravity and wistfulness of adolescence. The color here was very controlled: tans and grays and browns and blacks arrayed in a tight-knit, beautifully restrained orchestration. In their powerful modeling of form and their sculptural beauty that was pictorialized through the coherence of the color, these heads bore comparison with the heads of Courbet and, even more, of Corot's late, contem-

Louisa Matthiasdottir, Temma, 1962.
Oil on paperboard, 13 × 16¼ in.

Louisa Matthiasdottir, Temma, 1963.
Oil on paperboard, 16 × 13 in.

plative women, yet the mood, of a woman observing her daughter, announced a new kind of romantic spirit, a love, an empathy, that was de-eroticized, a meeting of minds or sensibilities. At the same time that Matthiasdottir was painting these small, splendid heads, she was embarking on the long series of still lifes and self-portraits that would turn out to be among the essential achievements of American art in the 1970s and 1980s.[18]

There was a classicism to Matthiasdottir's work of the early 1960s, but it was a classicism that was wrested from the naturalism of nineteenth-century art and the Constructivism of early modern art, and her work could seem too subjective, too redolent of the fractured vantage point of Abstract Expressionism, at least for a group of representational painters who hankered for the hard-edged clarity of the masters of the Renaissance. "We are all waiting for Giotto," the painter and critic Sidney Tillim had remarked, with the joke applying a Beckettish hopelessness to their hopes, and yet Tillim was in dead earnest.[19] Like the new abstract sculpture that was proposed by Donald Judd, who along with Tillim was writing for *Arts* in those years, the new representational painting was concerned with factuality, specificity, rationality, Renaissance or classical virtues to oppose to the murky, tumbled excess of the 1950s. For the artist who was thinking this way, the answer to the question of how to rationalize painting had to be framed historically, and the beginning of the rationalization of painting was in the Renaissance; among the artists who were focusing on these early Renaissance concerns was Gabriel Laderman, who was included, along with Matthiasdottir and Tillim and Pearlstein and a number of others, in a show called "Nine Realists," at the Schoelkopf Gallery in 1963. Laderman, who a quarter century later would do some of the boldest, most complex figure compositions ever to come out of an American studio, exhibited a large work titled *View of Florence,* the home not only of Giotto but also of one-point perspective, which he had painted there in 1962–63. The *View of Florence,* in which the domes of the great Renaissance churches were juxtaposed with a wall of modern apartment buildings, was a salute to the cradle of illusionism, and in that sense it could bring to mind the paintings that nineteenth-century visitors to Italy had done, but Laderman's painting, with its cool, succinct feel, reflected the same spirit as Held's canvases, with their insistence on dotting the *i*'s and crossing the *t*'s.

Of all the New Realists, none was so insistently an empiricist as Philip Pearlstein, whose first one-man show of nudes, at Allan Frumkin in March 1963, struck Tillim, writing in *Arts,* as defining the New Realism, a realism that "would be anti-expressionist, anti-rhetorical." Pearlstein's canvases were

Gabriel Laderman,
View of Florence, 1962–63.
Oil on canvas, 49 × 70½ in.

dominated by the pale tones of flesh, the bland whites of studio walls, and the steely and brownish grays of cast shadows. The models, with their bored looks, were not actors in a drama so much as they were bewilderingly complicated still-life objects to which the artist brought a laconic attentiveness. And yet there was a pull to the dullness of these paintings; the absence of editorialization became expressive. "Expression," Tillim argued, looking at Pearlstein's paintings of male and female nudes, with their insistently unemphatic paint handling, would now rest "primarily in the *restitution* of the object rather than emotional evocations *through* the object." This was a reaction to Pearlstein's direct, plainspoken readings of the nude model, which were realist in the sense that they were things seen, but not realist in the sense of showing real life, for of course the women posing in the studio were anything but. For Tillim, already, there was a paradox, since to speak of realism as inhering in the forthrightness of the work, in the restitution of the object, was to give realism a strangely abstract value, as if realism had some of the pure, almost disinterested quality of form-building that had once been associated with non-objective painting. But whatever the ambiguities of Pearlstein's work, the palpable excitement of his figure show came from its being so insistently, as Tillim said, "not witty, sophisticated, or clever," and

Philip Pearlstein, Nude on Green Cushion, 1965.
Oil on canvas, 44 × 36 in.

this declared a way beyond abstraction that was the opposite of Pop. Tillim
said that the new realism could finally be seen as well as speculated upon.
There was empirical evidence. Here was "what has become difficult to say
without wincing—a breakthrough." Pearlstein's exhibition was "historic."[20]

IV

Fairfield Porter's paintings, growing in clarity and variety and force all
through the 1960s, are a paradoxical achievement; he is rarely a realist in the
direct, unequivocal sense that Tillim would have us believe that Pearlstein is.
Although Porter had, after many years of struggle with a tendency toward a
somewhat fussy way of maneuvering paint, become the master of a wonder-
fully fluid kind of brushwork, his painting is seldom easeful or "transparent."
The mark of the brush is always a decision—an intellectualized painterliness,
you might say, though the thinking is so heartfelt, so intense that it registers
emotionally. In terms of levels of naturalistic representation and stylization,
Porter is insistently inconsistent, going from painting to painting and some-
times within a painting through different ways of dealing with detail or focus.
His mind is always working overtime, and in his best work this intensity regis-
ters as a kind of generosity.

Porter's color is odd and memorable. He can catch the full light of a Maine
summer or the grayed luminosity of a New York street. There is a shock to the
hard-edged brilliance of some of these effects, as when in a painting done in
Maine the light is so intense that the shadows on the façade of a white house
become a searing yellow. What ultimately fascinates in Porter's color may be
less the way the orchestrations create a total effect than the competitiveness of
individual hues—the daring, effulgent quality of this color. No wonder he
could do so much with autumn foliage. Porter's greens can be screeching,
astringent—or lustrously recessive. He likes crazy, wild pinks, violets, and
yellows. Some of these colors, laid on with his often thick, viscous strokes,
seem to be delighted with themselves, like words that are used in a poem less
for their descriptive power than for their independent, abstract fascination.
Porter is a realist, but his color is that of an unabashed aesthete and reminds
me of his passion for Wallace Stevens, whose *Opus Posthumous* makes an
appearance lying on a table in a 1958 interior that also includes a vase full of
flowers and Porter's young daughter Lizzie in a high chair.

Porter grew up in Chicago, in a wealthy family, and the work that he did
in his twenties and thirties, at least the little of it that still exists, had a trou-

blingly overdetermined quality, too method-
ical in some early cityscapes, too extrava-
gantly expressionist in some early woodcut
illustrations for a series of books of poems
published by a friend, the poet and radical
John Wheelwright.[21] Although the Porter
money had pretty much run out by the 1960s,
when luckily his income from painting sales
began to count for something, the family real
estate business had already made possible
the long years during which Porter struggled
to find himself as an artist. The paintings of
the 1930s had a darkness and a weightiness,
a somewhat dull allegiance to appearances,
with only flashes of casualness and precise
informality coming through, flashes (a boy
shambling down the street, a street sign) in
which in retrospect we can see the begin-
nings of something. Educated at Harvard, he
and his wife, the poet Anne Porter, knew

Fairfield Porter, Persian Rose Bush, *1975.*
Oil on board, 30 × 22 in.

Stieglitz and a whole generation of American tastemakers and artists and intel-
lectuals before, at the end of the 1940s, Porter found his way into the ferment
of Eighth Street and Tenth Street and the Artists' Club.

In his self-portraits Porter was front and center, which somehow served
only to emphasize his reserve. In 1950 he painted himself in the studio stand-
ing a bit stiffly against an arrangement of muted rectangles that were stretched
canvases with their faces to the wall. He was wearing a gray jacket and a dark
tie and casual brown shoes; his hands were held at his sides. His face was two
planes, dark and light, beneath thick dark hair. You could not see the eyes. He
was a formidable but also a somehow ghostly presence. Eighteen years later,
Porter painted another standing self-portrait, in the studio in his house in
Southampton, and this painting was brighter, with the big window behind him
revealing a neighbor's house bathed in yellow light. You saw the face clearly
now, looking straight out with small eyes. He presented himself frankly,
unabashedly. Four years later he painted a more intimate self-portrait, this
time only the head, a sort of immediate study such as he did of many of his
friends—among them the poets James Schuyler and John Ashbery and Ron
Padgett. There was still the thick hair (he was in his sixties), a softness to the

pink skin, and something strict about the thin mouth and unforgiving in the eyes. Mildness was mixed with sharpness in this man, gentle curiosity with stern judgment. After he died in 1975, Ashbery observed that he had "seemed to grow simultaneously younger and more mature, as did his painting."[22]

This was an amazingly full life. Porter devoted a huge amount of time to the early care of his first son, who was diagnosed as having childhood schizophrenia, and we can see in his letters the warmth of his relationship with his grown son Laurence, who became a scholar of French literature. Relations between Porter and his wife, Anne, whose poems were published in 1994 as *An Altogether Different Language*, were close and complex. She held things together in Southampton while he was in New York seeing shows or pursuing friendships. Their relationship was sorely tried by the poet James Schuyler, with whom Fairfield Porter was in love, probably more than platonically, and who lived in their house for a dozen years. Schuyler had come to recuperate from a nervous breakdown and never wanted to leave. Such unconventional arrangements can look strange, at least from the outside. Porter, who could be as cold as he could be warm, was not always easy to live with, Anne endured a good deal, and Schuyler, like many charismatic, unstable artistic people, knew how to take advantage of his friends. But these were wonderfully rich relationships, no matter how odd or impossible they may at times have seemed.

Fairfield Porter, Self-Portrait, *1968. Oil on canvas, 59 × 45⅜ in.*

Porter's work came out of the Silver Age of the 1950s. He was friends with de Kooning, who had first introduced Porter's work to John Bernard Myers at the Tibor de Nagy Gallery, where he began exhibiting in 1952, and like de Kooning and so many of the artists who had felt the impress of de Kooning's work, Porter was inclined to see tradition and revolution as merged in the facture of the artist's brush. The core of Porter's art, which was concerned with a desire to catch the unindividuated flow of moment-to-moment experiences, was linked to the idea of stream of consciousness in literature and symphonic nature imagery in Monet's *Water Lilies*, those vast paintings that were

coming into being when Porter was a child, and that had such a hold on New York's avant-garde at mid-century. Porter's fiercely independent spirit pushed him to rediscover Impressionist lyricism in a drier, more astringent form, and some of his most fascinating moments as a painter may have been those where he reached for a firm, almost classically architectonic structure that was not, perhaps, something to which he was naturally disposed. The sometimes almost willful awkwardness of Porter's work was a key to the particular brilliance of his Silver Age attitude. He gave its effulgence a dryness, a precision, and he did so even as he offered his own variations on de Kooning's lyrically hell-raising mid-1950s nature poetry. Porter was offering a powerful critique of the quivering, self-indulgently gestural mannerisms of Abstract Expressionism. He was dotting the Silver Age *i*'s.

V

The first show of abstract sculpture by Donald Judd opened in December 1963; by then Porter had been exhibiting regularly for a decade. Judd had grown up in New Jersey, served in the army in 1946 and 1947, and then attended the Art Students League and Columbia College, where he graduated in 1953 with a B.A. in philosophy. His work came out of a certain kind of late 1950s attitude, which saw the painterliness that had been thought radical a decade earlier as now virtually reactionary. The sculpture that Judd exhibited at the Green Gallery was immediately associated with a turn from the expressionist to the linear or volumetric that Greenberg, the next year, in his essay for the "Post Painterly Abstraction" show in Los Angeles, would explain by referring to the art historical framework of Wölfflin, who had seen a ceaseless historical shifting between the linear and the painterly. Yet there was about Judd's first exhibition, in spite of what might be called the rational manner of the presentation, a feeling for the eccentricity and idiosyncracy of Abstract Expressionism, so that the character of Judd's work could be argued to be less in opposition to that of the Abstract Expressionists than pulled out of their crazy, implacable spirit. By saying, "Why not make a sculpture that is bright red?," Judd evoked the challenging attitudes of Abstract Expressionism, of Pollock wondering, consciously or not, "Why not cover a canvas with dripped paint?" The imperturbable constructions in Judd's first show were about the surprising oddity of forms, in much the way that a single line of color in a Barnett Newman might be said to be. Any new reality could perhaps equal perfection.

Rudy Burckhardt, Donald Judd
exhibition at the Green Gallery,
New York, 1963.

The early Judd sculpture was about adjacency and abutment, about connectedness. There was a naturalism to these belligerently abstract sculptures, in the sense that they were exactly what they were. The dry particularity of Judd's combinations of a few pieces of wood and a few pieces of metal pipe suggested purist anecdotes. The box with the half-circular indentation that a pipe might fit into was a regular form that had been irregularized. There was an afterglow of Dadaism, almost, about some of this work, but the afterglow was so subdued that it was little more than a slight aesthetic coloration, an inflection, a shadow of the artist's self-awareness. Judd's work, like that of other artists who were referred to as Minimalist, was said to defy the limits of what art ought to be, but I think Judd's work did what all art does, which is to make your visual instincts feel especially alive. Judd was interested in what made people notice particular things in the world. He understood the fascination of flat shapes that were locked together into the fullness of form. He was a poet of joinings and right angles, of the sensation of completeness that came when one thing fit into another. And by isolating these details in a way that was more extreme than any artist had ever done before, Judd made it possible for gallerygoers to feel an old kind of satisfaction in a new kind of way.

Judd's prose was the first aspect of his work that the art public got to know, starting in 1959, a few years before he began to show his sculptures, which, with their sometimes precisely carpentered, sometimes machine-tooled volumes, could suggest a three-dimensional expression of what he was doing in

the writing. In those early years, Judd was writing about a considerable range
of works, from young abstract artists to contemporary realists to modern clas-
sics and subjects as diverse as Chinese pottery, medieval manuscripts, and
modern engineering. No matter what he was dealing with, Judd analyzed each
subject with the plainspoken, calculatedly flat cadences that are characteristic
of a certain kind of American prose. Of course this aestheticized foursquare-
ness is as much a matter of artistic calculation as any other prose style, and
when you actually examine Judd's enthusiasms and avidities among the art
and artists of his day, you find that his taste could be quirky and eclectic; he
liked things that looked many different ways. Judd admired John Chamber-
lain's January 1960 show at Martha Jackson, with its "grandiloquent, prolifer-
ating exhaust pipes, rods and billows of metal, exceedingly keen on remaining
junk, and proud to be confused with an ordinary wreck. The verbosity implies
the inexhaustible supply of material." Judd admired the late work of Pollock,
which Greenberg and many others had found gauche and inconsistent after
the seamlessness of the 1948–50 drip paintings. He found Lucas Samaras's sur-
real constructions, at the Green Gallery, "messy and improbable, as well as
exceptional." He admired the shaped Stellas of 1962, with their "absence of
illusionistic space [that] makes Abstract Expressionism seem now an inade-
quate style, makes it appear a compromise with representational art and its
meaning." He admired the canvas reliefs of Lee Bontecou, and the canvases of
Alfred Jensen, with their bright, thickly painted bull's-eyes and grids and rows
of numbers. And of the show "Twentieth-Century Engineering" at the
Museum of Modern Art in 1964, he observed that "dams, roads, bridges, tun-
nels, storage buildings and various other useful structures comprise the bulk
of the best visible things made in this century."[23] This could make one think of
Newman's comments, a few years later, about the Brooklyn Bridge. The sum
of these appreciations of Judd's was a surprising eclecticism, an adventure-
someness that ran back and forth through categories—of painting and sculp-
ture, painterly or anti-painterly, hip or unhip—with the exuberance of a kid
playing bumper cars. Judd was not the one-note ascetic that he is often imag-
ined to have been.

 What Judd asked of art was that it surprise him, and the more of Judd you
read, the more you feel that he was asking for himself, not on behalf of some
impersonal idea of History. And in a way most surprising and exciting of
his early writings were those in which he took an unexpected approach to the
classics—when he looked at old moderns, at Arp, say, or Léger—and saw
where he wanted to go. It was good to see him looking into tradition and

John Chamberlain, Untitled, 1963. Painted and chrome-plated steel, 31¼ in. high.

Lucas Samaras, Untitled Box No. 3, 1963. Mixed media, 27 in. high.

pulling out what he needed, and it was in the short reviews of the early 1960s that he did this most consistently. A Léger show at Janis in December 1960 provoked Judd to observe that "the chronological panoply of Léger's work is rigorous instruction for the somewhat excessive present confusion." He saw Léger as paring down, creating a telegraphic power in his art. What was surprising in this brief paragraph was that Judd appeared to be even warmer in his appreciation of the later work than of the middle period. He had special praise for *The Chinese Juggler,* a painting done in New York in 1945, in Léger's most stripped-down, to-hell-with-elegance American manner. "The paint," Judd wrote, "is applied without finesse and the color is straight. The result is awesome." Everything in this Léger is telegraphic, almost naïve. "The juggler tosses four white rings before him. Beside him is a viridian awning and an ultramarine ladder, and behind everything is a sense of white, black and yellow vertical bands." That description could almost be of the color composition of a late Judd, with panels of enameled color. What Judd was responding to was the functionality of Léger's work—Léger's determination to do no more than was absolutely necessary to convey his idea of a snakey-armed figure playing with white rings. It's not difficult to feel an affinity between the twisting, black-outlined shapes in the Léger and the donut forms and meandering lines in some paintings that Judd had been doing in the early 1960s.[24]

Fernand Léger,
The Chinese Juggler,
1945. Oil on canvas, 26 × 36 in.

VI

In 1964 and 1965, about a year apart, Judd published two long articles in *Arts*
magazine, in which he took what he felt to be the full measure of all the new
art that he had been seeing. The first article, with the carefully casual title
"Local History," was basically a description of what he saw as the situation in
New York in the wake of Abstract Expressionism. The second article, "Spe-
cific Objects," described the loose-knit aesthetic that Judd saw emerging since
the early 1960s; it was the single most important piece of writing that he ever
did. Published in the yearbooks that *Arts* produced at that time, the two pieces
were milestones in the process of saying goodbye to the 1950s, but they were
also an attempt to elude the product labels that had begun in the 1950s with
Abstract Expressionism and that were only coming faster and more furiously
as Judd was writing. The ring of his titles, with their images of specificity and
locality, was a plea for taking artists one by one. And the range of artists that
Judd covered had the disparate, unruly quality of a casual gathering of friends
or contemporaries, rather than a movement in any normal sense. Judd's work
as a critic, not unlike that of Porter, had to do with breaking through the rigid
stylistic categories and historical imperatives to suggest wider, more informal
kinds of affinity groups. What was distinctive about what Judd did in "Local
History" was that he got beyond the labeling—of Pop, Op, Primary Struc-
tures, and so forth; beyond, in other words, what he called "the bandwagon
nature of art in New York."[25] While many of what he regarded as the break-
through achievements of the late 1950s and early 1960s were by no means
unsung—he did, after all, admire Rauschenberg, Johns, Albers, Bontecou,

Chamberlain, Stella, Oldenburg, Lichtenstein, and Mark di Suvero—Judd wanted to gather these achievements together in a somewhat unusual way.

Judd observed that the trouble with Abstract Expressionism as an idea was that this "prevailing notion of style comes from the European tradition, where it is supposed to be variations within a general appearance, which a number of artists, a 'school,' supposedly even a period, may share." Judd was rejecting isms, and in this sense he was taking up where de Kooning had left off in his talk at the Modern in 1951, although of course Judd believed that de Kooning had become the avatar of the most dangerous ism of the day, that of painterliness. In place of the forward flood of styles, Judd saw artists as each going it alone, drawing on whatever, either in the past or in the present, they happened to find relevant. There was a nostalgia about Judd's thinking, about his essay "Local History," for although he was hardly nostalgic for Tenth Street taste, he was interested in the idea of artistic evolution as an almost private matter that developed among a neighborhood of artists. Judd wanted to avoid or at least to pull back from a growing sense that art was pushed forward by overwhelming forces, whether market forces or the eternal verities of art (and who any longer knew where eternal verities ended and market forces began?). Tenth Street may have been dead, but an individual could always give new life to an old idea. "It is easy to imagine de Kooning going strong again, or Joan Mitchell improving," Judd observed. "It is likely that someone will derive something new from Abstract Expressionism. If Ellsworth Kelly can do something novel with a geometric art more or less from the thirties, or Rauschenberg with Schwitters and found objects generally—which is a twenty year jump or more—then someone is going to do something surprising with Abstract Expressionism, with loose painting." What was especially interesting about Judd's thinking here was that he was making an argument for the openness of options that was not all that different from the argument that one could hear from certain realists around the same time.[26]

By the mid-1960s, Judd was no longer producing his own work. Not surprisingly, his constructions of metal, left bare or enameled in bright colors or juxtaposed with sheets of colored Plexiglas, have been seen as celebrations of impersonality, but that is only a part of the story. The workshops where his sculpture was put together were hardly alien to him. Bernstein Brothers, a firm that fabricated his metal constructions, was located near his building in SoHo, and much of the work there was done by one man, José Otero, whose initials were stamped in the metal along with Judd's. Judd wasn't fleeing the art world for the industrial world so much as he was bringing some of the craft

Donald Judd,
Untitled, 1974.
Plywood,
36 × 60 × 60 in.

values—and even aesthetic values—of the industrial world into the visual arts. There was, deep down, something messy and maybe even a little funky about Judd's taste, a taste not for the chilliness of industrial materials but for their odd warmth; the works he would later do with plywood were about the beauty of plywood, its color, its patterning, its edges with their sandwiched layers. In some instinctive, personal way, Judd's work existed at that convergence of Duchamp and Mondrian, of Dada and Constructivism, that had first, perhaps, been discussed by Sidney and Harriet Janis in their essay on Duchamp back in the 1940s. Yet for Judd this convergence was not a historical process so much as it was an empirical experience, something to be felt in the process of dreaming up works of art. Writing about the Duchamp retrospective at the Pasadena Museum of Art in *Art International* in 1964, Gerald Nordland said that an essential Dadaist question was "how to express oneself without art when all means of expression are potentially artistic. The result is a shock. It says, 'Look at the world afresh, the hardware store is filled with incredible things.'" Nordland then mentioned Duchamp's urinal, and went on to quote Motherwell as saying that "the bottle rack he chose has a more beautiful form than almost anything made, in 1914, as sculpture."[27]

When Duchamp had gone into the hardware store, it had been with the thought of undoing art. In interviews he often spoke of his desire to destroy

Marcel Duchamp, Bottle Rack,
original 1914; this replica, 1960.
Galvanized-iron bottle dryer,
23¼ in. high.

art "for myself." Yet by the 1960s this new nonart look seemed to join with the nonart look of the most radical Constructivism, and both suggested, if not always to the same people at the same time, a freedom from fixed meanings. When Judd, in the early 1960s, began to visit the hardware store and the lumberyard, where he picked up some black enamel or iron pipes, he would probably think of his act as being more in the spirit of Malevich than of Duchamp; but didn't he want viewers to accept the kind of all-in-one experience that Motherwell had responded to in the bottle rack? Certainly Judd had himself laid out the terms of the confusion in "Specific Objects" in 1965, for in following the logic of a new kind of all-in-one anti-composition, he found himself joining together unlikely things. "The parts," he observed, "are usually subordinate and not separate in Arp's sculpture and often in Brancusi's. Duchamp's readymades and other Dada objects are also seen at once and not part by part. Cornell's boxes have too many parts to seem at first to be structured. Part-by-part structure can't be too simple or too complicated. It has to seem orderly. The degree of Arp's abstraction, the moderate extent of his reference to the human body, neither imitative nor very oblique, is unlike the imagery of most of the new three-dimensional work. Duchamp's bottle-drying rack is close to some of it."[28]

Did Judd, with his cool diction, see the irony here, the irony that a specific object, the bottle rack, was now being brought into a new aesthetic category? And what was to happen to its anti-art implications? Judd's smaller-sized works—the stacks of metal boxes, for instance, that hang in so many museums—risk anti-art through a perversity, a static oddness, that echoes the affront of Dadaism. But in some of his largest works—the hundred aluminum boxes at Marfa, Texas, especially, and also some of the plywood walls—the size and the elaborateness of the variations within variations become so absorbing, so much a matter of immediate visual experience, that they push through the Dadaist idea of the object as a conundrum and reaffirm the sensuous immediacy that we associate with the most traditional forms of art.

VII

There is an irascible, prickly, epigrammatic sound to both Porter's and Judd's writing; an ornery but elegant tone that you encounter in empiricists of different stripes. There is something of Gertrude Stein's self-consciously foursquare manner in the way that Judd treats elusive questions of beauty as if they are absolutely simple, if only everybody would cut the bull. And apparently Judd liked some of Stein's work, at least he approvingly quoted a remark she made about lectures in one of her own—she said, as he recalled, that "the speaker tends to get bored and listen to the speaker."[29] I am not sure what Porter thought about Stein, but she certainly exerted a huge fascination among many of the poets with whom he was friends, and his writing, with its ultrasimple words and grammar and wildly elusive meanings, can turn straightforwardness into a kind of mystification that has a Steinian sting.

If you take a look at the writing that both men were doing around 1960, you may find an intriguing similarity in tone. There is a plainness and directness to their writing—a refusal to speculate beyond a certain degree. There is a similarity in their simple declarative sentences and sense of the language. It's as if they're trying to clear the mists of the world-historical outlook, of the grandiose aspirations of the will-to-form. Their writing has a back-to-basics appeal. Looking at art, Judd and Porter both want to see how some particular character is rooted in the most specific qualities of the form. When they write about their contemporaries, they are often so much on different sides of an issue that their writing can be tough to relate. Yet when, sometimes, they write about the same classic modern artist, you may discover a similarity in the way they think things through. Here is Porter, writing in 1960 about Arp's sculpture: "Arp never uses right angles, seldom straight lines (then only straight line segments that are part of a continuity, which in topology comes under the definition of a curve), never circles, ellipses, or plane surfaces, but always irregular or ovoid curves and surfaces, and incommensurable angles. This is the infinity with which Arp is concerned." Here, three years later, is Judd on Arp: "One of the interesting aspects of Arp's sculpture, and a relevant one currently, is that a good piece is a whole which has no parts. The protuberances can never clearly be considered other, smaller units; even partially disengaged sections are kept from being secondary units within or adding up to a larger one. This lack of distinct parts forces you to see the piece as a whole." Porter sees variety as yielding to infinity; for Judd the parts give way to the

Jean Arp, Sculpture Classique, *1960.*
Marble, 46⅞ in. high.

whole. What Porter calls Arp's effort to make infinity perceptible is in Judd a "sensation of wholeness."[30] I am not saying that they are saying the same thing, and yet there is in both of them a sense of how close looking can yield some metaphysical revelation, a revelation that inheres in the immediacy and specificity of the work.

The magic inherent in matter-of-factness held a fascination for both Porter and Judd, or so I believe. They were both rooted in an empiricist's vision of art, in the view that Wallace Stevens, a great hero of Porter's, defined when he said that "the poetry of a work of the imagination constantly illustrates the fundamental and endless struggle with fact."[31] The curious croppings and take-it-as-it-comes compositions in Porter's paintings, as much as Judd's beautifully carpentered plywood constructions, were salutes to that "fundamental and endless struggle with fact"—and to specificity and particularity. For both Porter and Judd, empiricism was linked to their efforts to give art a new kind of immediate weight. They wanted to be free of the feeling that art's revelations were inevitably and maybe even hopelessly tethered to a sweeping historical drama. Not surprisingly, both men took issue with Greenberg, with his insistence on the more or less orderly unfolding of the history of art. Greenberg so incensed Porter in the 1950s that Porter wrote a long letter to *Partisan Review* about the essay " 'American-Type' Painting." Greenberg, so Porter believed, was "very ready to tell painters what they may or may not do, without enough understanding of what they have done or are doing. Sometimes he says 'we' when 'I' would be more accurate." Porter's letter ended with an interesting observation about American "timidity." "As a war is not won by brilliant retreats, so creativeness is not advanced by imposed limitations."[32]

As for Judd, although he shared many of Greenberg's tastes, including his feeling that Pollock and Newman were the most important of the Abstract Expressionists, he also disliked the concentrated world-historical drama that supported so much of Greenberg's writing. When Judd titled his 1964 essay "Local History," he was surely registering a dissent from the elevated, inter-

nationalist grandeur of Greenberg's vantage point. "Things can only be diverse and should be diverse," Judd explained. When Judd wrote that "the history of art and art's condition at any time are pretty messy," it was difficult to feel that he wasn't registering his disagreement with Greenberg's clear-minded account. These conditions, Judd asserted, "should stay that way." "One can think about them as much as one likes, but they won't become neater; neatness isn't even a very good reason for thinking about them. A lot of things just can't be connected." In 1969, in an essay called "Complaints," published in *Studio International*, Judd really let rip on the subject of Greenberg. He complained of the "attempt to impose a universal style," and he said he found Greenberg "ignorant and hysterical." He said that Greenberg—and Michael Fried—were "wrong about mainstream history or development," and observed that "most ideas of history are simplistic, archaic and destructive." As for what was often billed as the progressivism of the avant-garde, Porter suggested his feeling about that when he wrote, in an article on Allan Kaprow and the happenings, that his "avant-garde 'event' constantly disappoints one's expectation of surprise. Like so many science fiction movies about the future, his subject matter is the undigested immediate past."[33]

VIII

Both Porter and Judd had studied philosophy in college. Judd majored in philosophy at Columbia, and to the end of his life Porter spoke of the importance of hearing Alfred North Whitehead's lectures at Harvard. There was, in the writing of both artists, a commitment to immediate experience, and then to the possibility of what one might think about that experience. Of the impact of a black-painted board in a sculpture by Ronald Bladen, Judd observed that "this is like Kline's long strokes and is a form of abbreviated naturalism." And when Porter wrote about David Smith's abstract sculptures, he commented that "he does not represent, but his variety is the variety of the direct experience of nature."[34] The close looking here yielded a kind of slippery revelation; the empiricism was like alchemy—you looked closely and were drawn into an enigma. Porter might have felt differently about this than Judd, but they both liked the way that artistic particulars could unfold in the mind's eye. Neither Judd nor Porter referred specifically to philosophers and to philosophical terms very often; they were artist-critics bringing the experience of the studio to bear on their writing. But I think it is significant that when either of them reached for philosophical references, it was not to the authors, from Nietzsche

and Kierkegaard to Sartre, who grappled with the question of man's situation in the world and had been points of reference for artists in the 1940s and early 1950s.

If there could be said to be a philosophical inclination in the thought of Porter and Judd, it was much closer to some of the sparer, more hard-nosed and skeptical thinking of eighteenth-century Britain than to the grand spiritual hopes of nineteenth-century Germany. True, Porter could seem opposed to a kind of empiricism, as when he wrote that "empiricism casts doubt on the validity of knowledge gained through the senses alone, to propose that through the senses alone you can know nothing beyond them." Yet this was a rather confusing construction, typical of Porter in its switchbacking logic, for it could be interpreted as praising, on an empirical basis, the power of seeing to achieve a truth of its own, autonomous from nature. Often with Porter, it seemed that his feeling for empiricism was far less important than his feeling "against idealism"—the title of one of his most exciting essays. Porter believed that many artists were hopelessly locked in Plato's cave. They were laboring to create works of art that were at best the shadows of an ideal. And since, for Porter, there was no use for ideals in art, the results of much artistic labor turned out to be the shadow of a phantasm. "Today," Porter wrote in 1964 in "Against Idealism," "when a painting is criticized by another painter as 'too realistic' or praised as not realistic, the painter-critic refers to the belief that reality is not known through sight alone, but conceptually. The purely visual painting is never considered as realistic as the conceptual one."[35] To paint a purely visual painting was to take a stand against the shadows in Plato's cave—and against idealism.

David Hume cropped up in both Judd's and Porter's writings, and although they used him for their own ends—which was quite naturally how any artist would use any philosopher he cared to—the fact that Hume came up now, at the turn into the 1960s, had a fascination. Judd, in 1963, reviewed the work of Walter Murch, a painter of still lifes in which ordinary objects were sunk in an elegantly misty atmosphere. Judd disliked the aura of mysterious meaning in which Murch clothed his objects. He took a rather easy shot at Murch by declaring that he was not as good as Chardin. The point was that Murch had an overly grandiose idea of "the world [as having] a spiritual order and identity, part and whole." And then, in an attempt to explain that this was not so, Judd turned to Hume, who said: "We have therefore no idea of substance, distinct from that of a collection of particular qualities, nor have we any other meaning when we either talk or reason concerning it."[36] Judd left it

at that, but perhaps the implication was that Chardin was more respectful of the nature of "particular qualities"—that he did not romanticize them. What Judd's pointing to Hume came down to was saying that artists had to stick to the specifics, and this was actually quite close to what Porter, in an interview, said interested him in Hume when he encountered his ideas at Harvard. Whitehead, Porter said, "taught us that Hume's criticism was practically unanswerable. . . . Hume's idea is that all you know is one sensation after another: you do not know the connections between them. And that was what [Whitehead] was concerned with doing, finding an answer to Hume, who he thought had not been adequately answered by Kant. . . . What I like in painting—I mean, partly what I like in painting—is to rationalize what I like in painting. Because it seems to me to relate to that [idea of Hume's that all you know is one sensation after another]. I mean I like in art when the artist doesn't know what he knows in general; he only knows what he knows specifically."[37]

Porter's and Judd's empiricism might be thought of as a sort of optimistic skepticism. And behind all their thoughts about empiricism lay the galvanic experience of Impressionism, the movement a hundred years earlier that had pushed artists to trust the evidence of their eyes and only the evidence of their eyes. Impressionism, with its assault on the structural traditions of art, had had, especially in its earliest phases, an emphasis on moment-by-moment experience that could be seen as prefiguring the experience of the Abstract Expressionist painter before the canvas in his studio. For Newman, who had few kind words for most of the art that had been produced in Western Europe in the great centuries of easel painting, Impressionism was the signal exception, the time when painters had for once operated directly, honestly. And it was significant, as I have already noted in looking at the fascination that Monet's *Water Lilies* exerted in the 1950s, that Meyer Schapiro, that friend of the Abstract Expressionists, devoted some of his most sustained writing and lecturing to the history of Impressionism. In an essay titled "The Concept of Impressionism," which was in an earlier version presented as one of the Patten Lectures at Indiana University in 1961—at the time when Porter and Judd were most active as critics, although I am certainly not suggesting any direct causal relationship—Schapiro delved deeply into the philosophical background of Impressionism. He discussed nineteenth-century scientific and philosophical theories of perception, and he suggested that Hume's ideas were part of the atmosphere in which the Impressionists came of age in the 1860s. He observed that "Hume had described the self as 'nothing but a bundle or collection of different perceptions.' " And he went on to say that "at the time

of the Impressionists, Hippolyte Taine, following Hume, spoke of the self as a fragmentary series of, or continuity among, certain sensations. The self, like substance, was a 'metaphysical illusion.' This turn of thought was paralleled by the ideas of poets and novelists who, in a doubting mood, described the self as a phantom entity, an illusion; all that one truly knows is a flux of sensations with some recurrent features. . . . 'Consciousness' was the name for a certain mode or occasion of sensation—without sensation, there would be no consciousness."[38]

Both Porter and Judd believed, absolutely, that all artistic experience—and that artistic consciousness itself—must be grounded in immediate sensation. And to the extent that they were interested in the philosophical traditions that wound back to Hume, they were attempting to reestablish a philosophical basis for the Impressionists' rabble-rousing orchestrations of keyed-up color and throw-care-to-the-wind brushwork. Judd, writing in *Art in America* in 1984, mentioned his interest in C. S. Pierce and quoted favorably from his "Concerning the Author." There Pierce celebrated his skepticism about his own thought processes, and wrote that "for years in the course of the ripening process, I used for myself to collect my ideas under the designation *fallibilism;* and indeed the first step toward *finding out* is to acknowledge you do not satisfactorily know already."[39] For Judd and Porter, the exalted ideals of beauty that Kant had reached for and that Hegel had chased through the dialectic of history may well have seemed *fallibilism* of one variety or another. Of course a skepticism about such ideas and ideals had been built into de Kooning's conversation as the 1940s were turning into the 1950s, but what was new in the thought of Judd and Porter was that they seemed uninterested in stirring the metaphysical melting pot. It was possible to see in their interest in Hume a desire to reach back to the sober empiricism that had preceded Kant's measured idealism. When Porter looked to the landscape and Judd looked to the lumberyard, they were trying to go back to the origins of art, to the basic questions of seeing and knowing that had preceded the idealization. To look more closely at Porter and then at Judd—as well as some of the artists who interested them or whose interests they shared—is to see the no-romantic romantic attitude of a decade earlier reinvented as a kind of empiricism with its own coolly romantic intensity.

The whole idea that art was a progress marked by battles and breakups was not attractive to either Porter or Judd. They were not so sure that a dialectical process could reveal a new truth. Picasso and Cubism and the whole drama of the breakup of reality, which was for Greenberg the master story, was

downgraded if not abandoned by Porter and
Judd. Picasso, that supreme master of trans-
formation, who had in a sense presided over
the New York avant-garde of the 1930s and
1940s, was in eclipse. In part this was because
there was relatively little enthusiasm for what
Picasso was doing in the 1950s and early
1960s, but the opposition went deeper than
that. Judd was frankly negative and dismis-
sive of his achievement, with its constant
fracturings and fragmentings and dialectical
shifts in style; his comments could be brashly
dismissive. As for Porter, although as an
admirer of de Kooning he could not but care
for Picasso, he was certainly not all that
caught up in the drama of his work. For
Porter and Judd, Picasso embodied the entire
enterprise of Cubism, and that was something

Kasimir Malevich, Airplane Flying, *1915.*
Oil on canvas, 22½ × 19 in.

that excited neither of them all that much. The early moderns who meant the
most to them tended to stand apart from Cubism's unfolding story. For Judd,
Malevich was in some ways a more interesting figure than Mondrian, precisely
because he jumped into abstraction so rapidly, with so little equivocation.
For Porter, there was something fascinating about Vuillard's refusal to engage

in the kind of fracturing that was so dear
to Cézanne and that, in retrospect, could be
seen as foreshadowing Cubism. It was as if
the experimental devolution of modern art,
by which Cézanne begat Picasso who begat
Mondrian, was something that Judd and
Porter wanted to scramble. Porter liked to say
that he preferred Vuillard to Cézanne, or at
least that he was more interested in Vuillard's
way of "unifying the Impressionist shimmer
into a single object" than in Cézanne's way of
"denying the essence of the shimmer by
changing it into planes to express solidity."[40]
Porter's point was not to pit Cézanne against
Vuillard but to suggest that each moment in

Edouard Vuillard, Mother and Sister of the Artist,
circa 1900. Oil on canvas, 18¼ × 22¼ in.

art presented alternative possibilities: Cézanne and Vuillard in 1900, Dufy and Mondrian in 1925, Morandi and de Kooning in 1950.

Part of what attracted Porter to Vuillard and Judd to Malevich (whose full range of work was only beginning to be well-known in New York in the 1960s and 1970s) was that these artists stood apart from the ordained patterns of art history; they could have some of the excitement of eccentric discoveries. They might inspire an artist not to exit from history (as if that could ever be possible) but to create in the moment for himself or herself—to operate empirically, with what was in front of him or her, whether that was the vase of flowers on the table or the four-by-eight pieces of plywood in the lumberyard. In 1974, when a large selection of Malevich's paintings was shown in New York for the first time, Judd wrote about them at considerable length, praising what he saw as their avoidance of an "idealistic quality" that to his mind weakened Mondrian's work. And what was this idealistic quality? Well, it was a quality that took you away from the specific toward the general. Judd quoted Malevich as writing, "That moment when the idealization of form took hold of them [the Greeks and Romans] should be considered the downfall of real art." And "art should not proceed towards reduction, or simplification, but towards complexity." For Judd, of course, complexity could resemble what others regarded as simplicity. Malevich's point, which interested Judd and might have interested Porter, too, was that the history of art, with its processes of idealization, could dull the immediacy of forms. "Art," Porter wrote, "permits you to accept illogical immediacy, and in doing so releases you from chasing after the distant and the ideal. When this occurs, the effect is exalting."[41]

IX

In 1959, Porter wrote a brief monograph on Thomas Eakins for a series published by George Braziller, called the "Great American Artist Series," that soon appeared in bookshops in cities and college towns across the country. One might imagine that Porter on Eakins was a logical match. Porter was a painter who often took his subject matter from an earlier American world of comfortably furnished homes and leisurely afternoons, so why wouldn't he want to write about an artist who'd lived in Philadelphia in the nineteenth century? Friends of Porter's have reported, however, that he was not particularly eager to write on Eakins. The assignments in the series that he would have preferred, including, no doubt, de Kooning, were already taken. Porter's text on Eakins was anything but sympathetic. Actually, it was one of the angriest

pieces that one artist has ever written about an-
other. Here we have a figure of the New York
School complaining about the American past—
about its sour provincialism, about a nineteenth-
century artist who was appalled by the philistinism
that surrounded him and yet was unable to rise
above it and embrace the hedonism of art. Written
at the end of the 1950s by an artist who must by then
have felt some confidence in his own achievement,
the book offered a backward glance at the ethos of
American art long before the coming-into-being of
the School of New York. It was also a meditation on
what might be called the wrong kind of empiri-
cism—an empiricism grounded in the factuality of
science rather than in the experience of art.

Thomas Eakins, John Biglin in a Single Scull,
1873–74. Oil on canvas, 24 5/16 × 16 in.

"Because his father's money enabled him not to
have to work for a living," Porter explained in one
of the epigrammatic thrusts that made up so much
of this odd text, Eakins "had to convince his con-
science that painting was work." Porter could barely contain his distaste for
the self-righteous Philadelphian who could not understand that "morality is
not art." Eakins's dark-toned, detailed paintings held no pleasure for Porter;
he found that Eakins's concern with the correctness of the musculature and the
accuracy of the fall of light was dryly factual in a way that held off the possi-
bility of the poetry of empiricism. Porter's text opened with Whitman's obser-
vation that "Eakins is not a painter, he is a force"—and the "not" resounded
through Porter's pages.[42] He set Eakins in the post–Civil War world when the
North was industrializing, but Porter had not a bit of the exhilarating feeling
that Alfred Kazin had around 1940, when he was writing *On Native Grounds*
and was so excited by "the years of crude expansion and technical innovation
in which *our* America had settled into shape." In *New York Jew,* a memoir that
begins with the publication of *On Native Grounds* in 1942, Kazin said that
"there was something about the end of the century—the explosive American
moneymaking that would drive so many Americans mad; the piling up of new
immigrant masses in the great American cities; the stark boldness and plain-
ness of Brooklyn Bridge; the quivering truthfulness of Dickinson; the lonely
realism of Eakins—that fascinated us."[43]

These comments will, immediately, make us think of Hess's visit with

Newman, and of the aging Abstract Expressionist's admiration for the Brooklyn Bridge and his interest in the relief sculpture by Eakins that was to be found in Prospect Park. Porter was undoubtedly enthusiastic about older American forms of architecture and engineering, and had once praised the nineteenth-century Romantic Albert Pinkham Ryder for his "imaginary nature [that] is realized by the materiality of his means."[44] But what was fascinating about the Eakins essay was a sternness that suggested to what degree the pioneer spirit of postwar New York could include a pioneer irreverence about other, earlier pioneers. Even what were seen as the success stories in earlier American art generally had to be qualified, had to be admitted to be successes only up to a point, and by the second half of the 1950s, when America was felt to be leading the world, it was possible to question the value of what earlier generations had done. To Greenberg, writing back in the 1940s, Eakins was "a great provincial artist," and his praise for Winslow Homer was shaded with the observation that "he may not have attained major quality."[45] The nineteenth-century American artists, as often as not, offered lessons in what not to do. Porter's Eakins book was a howl of disappointment. He went through Eakins's whole life—his youth in Philadelphia, his period of study in Paris, his interest in photography, the controversies over his teaching—and presented it all as a series of missed opportunities, of willful refusals to accept the freedom of the imagination that was the essence of art, the freedom of the imagination that the New York artists felt they had finally earned. It was hammered in that Eakins was a precise man—that "he liked to read mathematics . . . because it was 'so like painting.' " Porter recoiled from this statement, and fumed about the abstractness of mathematics and how that could hardly be the basis for an understanding of art. "His preoccupation with the useful," Porter observed, "did not include an appreciation for art." In France, Eakins found that he felt closer to the academics than to the realists—clearly a weakness, so far as Porter was concerned. "When tradition failed as a justification for art," Porter wrote, "conscientiousness became its shaky substitute. For it is a confession of doubt about the validity of art. The modesty of the French academicians fitted Eakins' American doubt of art, of religion, of any meaning to life that went further than its efficient maintenance."[46]

Although Porter had a lifelong interest in science, he recoiled at Eakins's idea that painting was science—at Eakins's obsession with plans, preparations, control. There were pages of the Eakins book where Porter's writing was so vehement, and vehement in so personal a way, that you could almost imagine that on some level he was experiencing Eakins as a doppelgänger—as

an artist who had taken the wrong turns that Porter, who was also from a wealthy family, had somehow ultimately avoided. Readers of the Eakins essay who were aware of Porter's own privileged background might suspect that Porter was writing from personal experience when he observed that the freedom from money worries that the Eakins family provided left Eakins needing to "convince his conscience that painting was work."[47] And there may be another connection with Eakins, for Porter, like Eakins, came from an artistic family and had to discover what art was for himself in a context where there was already an idea of art—an idea, moreover, firmly linked to the practical. Eakins's father had been a writing master. Porter's father had studied to be an architect, but ended up in the family real estate business, although he did build homes after his own designs on Great Spruce Head Island, off the coast of Maine, the family island where Porter would spend summers and do some of his most remarkable work. Porter must have recognized that he himself was not an easygoing person, and he may have feared that, like Eakins, he would become so caught up in the banality of empiricism that he would fail to take hold of all the beautiful surprises that he knew were out there in the world. Porter was after a new, no-American kind of American empiricism.

16. MAINE, MARFA, AND MANHATTAN

I

A place can make all the difference for an empiricist, whether the place is the studio where he works or the street or the landscape that he sees every day. Both Fairfield Porter and Donald Judd had a deep, abiding feeling for specific places. Porter loved Southampton, where he lived in the winter, and Great Spruce Head Island, where he lived in the summer. Judd loved the Southwest, where he spent more and more of his time, beginning in the 1970s. And they both had an intense, impassioned feeling for Manhattan and preserved their ties with the city and worked in the city even after they had moved their bases of operation elsewhere. Both men may have believed, to the ends of their lives, that the streets of Manhattan were where they had come of age as artists. Certainly, Porter saluted those city streets in a series of paintings done near the end of his life. And Judd put a great deal of effort into preserving and restoring his piece of the city, a nineteenth-century cast-iron building at 101 Spring Street that he had purchased in 1968. Both men were also determined to create environments—*places*—all their own, environments that were a pure reflection of their tastes and sensibilities, and their determination to do so almost inevitably took them away from the city, at least for periods of time. The interior of Porter's house in Southampton, with its old furniture and pleasant bohemian informality, had so strong a personality that it could be said to be one of the protagonists in his art. The interiors that Judd created in his building on Spring Street and in the various buildings that he acquired in Marfa, Texas, all carefully restored old functionalist architecture filled with furniture of his own design, were also examples of an environment stamped with a powerful aesthetic viewpoint. Though neither Judd nor Porter would have accepted the proposition that an interior was a work of art, they both wanted to feel that their art was grounded in the everyday.

The fascination and depth and complexity of Porter's painting came out of

Fairfield Porter,
Island Farmhouse,
1969. Oil on canvas,
79⅞ × 79½ in.

the extent to which he used the stuff of his life—his homes, his family, his friends—as a kind of implicit narrative, to be experienced through the partial view of his eyes. The more you know about Porter's life, the more you can see that his work exemplifies, to an amazing degree, the principle that in the arts new patterns are frequently woven from the loose ends and remnants of older ones. While it is no mystery that Porter's art was some piquant synthesis of the intimism of Vuillard and the frankness of his friend de Kooning, the mingling of sources could be far more personal than that. The huge, eccentric barnlike home and elegantly classical farmhouse and ravishing vistas of Great Spruce Head Island, Maine, which were the motifs in so many of Porter's best paintings, could be interpreted as an extended salute to his father, an amateur architect and avid naturalist who bought the island and built some of the houses when Fairfield was a boy. Writ large, that farmhouse suggested the whole yearning for a classical order, and perhaps for an especially American kind of order, because of course the idea of an indigenous classical architecture went back to Thomas Jefferson. The Neoclassicism of Porter's father's architecture makes me think of something that Lewis Mumford wrote about Neoclassicism in America, about carrying these new-old "forms into the heart of the wilderness" so that one might "be at home anywhere. . . . To be at home was to live

in that ideal world which had been conjured up out of the archeologist's research into Rome, and, in the eighteenth-century, into Greece."[1]

The Americanness of American art, which Newman and others had spoken about so often in the late 1940s, took on a different kind of poised yet passionate classical power with Judd, who experienced the vast barrenness of the American West as something fascinating, astonishing, and admirable. Judd had lived in Dallas for a couple of years as a kid, and knew "that the West, which is the Southwest there, began beyond Fort Worth. The land was pretty empty, defined only by the names in the stories about Texas by J. Frank Dobie, as the names in the Icelandic sagas substitute in that country for the monuments that don't exist." When, in 1985, Judd wrote recollections of his earlier encounters with the West, these stories had some of the rhapsodic, on-the-road excitement that powered the best Beat writing of the 1950s. He recalled 1946, when he traveled by bus with three army buddies, "from Fort McClellan, Alabama, to Los Angeles," and how they passed pretty near Marfa, and how Judd wired to his mother from Van Horn, Texas, writing: "NICE TOWN BEAUTIFUL COUNTRY MOUNTAINS." Later, in 1963, when he was already showing in New York, Judd took a Greyhound bus to Tucson, and remembered that the "first night at three o'clock somewhere in Pennsylvania a man came aboard and collected my pillow and charged me fifty cents for another."[2] Judd's recollections of those adventures had the ugly-beautiful lyricism of

Donald Judd, installation of concrete works, Marfa, TX, 1980s.

Robert Frank's photographs of the emptied-out Western landscapes in *The Americans*. His love of the Southwest had a pastoral dimension, as did Porter's feeling for Great Spruce Head Island. Judd believed that art was a realm apart, but a realm that was rooted in the wider world, in its tactility, in the experiences of measure and interval that we discover all around us. He knew that his work could feel unfocused in the ad hoc spaces of museums, and as he became an increasingly prosperous artist in the late 1960s and early 1970s, he began to seek out places, both in New York and in western Texas, where his art would seem more in sync with the architecture and its surroundings. In 1964, Judd had written enthusiastically about a show called "Twentieth-Century Engineering" at the Museum of Modern Art. "Until lately," he observed, "art has been one thing and everything else something else." Yet, in his opinion, "the forms of art and of non-art have always been connected; their occurrence shouldn't be separated as they have been. . . . It is better to consider art and non-art one thing and make the distinctions ones of degree."[3] This remark could be interpreted as a salute to Alfred Barr and his vision of the Museum of Modern Art as an omnium-gatherum of modern visual culture, yet in Judd's opinion museums rarely served art very well. He was tired of museum art, of the framed canvas hanging on the wall, and of the inadequate presentation that was generally given to the new kinds of work that he cared about the most. His weariness—an old modern weariness, of course—pushed him to find places where the plainspoken directness of his work and the work of artists whom he admired would be better served. And so he ended up developing spaces in Marfa, Texas, three hours southeast of El Paso, near the Mexican border, spaces that are as much a part of the New York story as the work that Porter did on the family island off the coast of Maine.

II

Hard, bare fact had an enormous charm for Porter. You feel this in the almost willfully klutzy manner in which he would sometimes paint the forms before his eyes, as if to say, "All that matters is that I get to some fundamental truth, even if I can't quite explain what that truth is." The challenge for Porter is that he knows that there are a number of different fundamental truths that art can reveal about nature. Is the truth of an object in its outline, as the artists of fifteenth-century Florence were convinced? Or is the truth in the frequently chaotic forms that fill out those outlines, as the Impressionists would have had us believe? Much of the fascination of Porter's paintings has to do with his

Fairfield Porter,
Ice Storm, 1969.
Oil on canvas,
26 × 28 in.

insistence on shifting between one truth and another, between the truth of clarity and the truth of chaos. The result is a dialectic of different empiricisms, a seesawing between various forms of observation and attention. It is not surprising, given Porter's interest in the unexpected, that many of the paintings that feel most lucidly complete, that have an ad hoc, almost haiku-like gracefulness, are landscapes that appear to have been done relatively quickly, as if he was taking down impressions as fast as they came, not worrying whether they were clear or chaotic, just so long as they felt authentic. In 1969 Porter taught at Amherst, in western Massachusetts, and some of the works he did there, of the campus in its autumn glory and, later, under a blanket of snow, are among his most seamlessly confident achievements. The compositions are ultracasual. In one tall, slim painting, a parking lot full of cars is surrounded by the brilliant autumn foliage, with red and orange leaves set in a dialogue with ones that are still green. The juxtaposition of parking lot and foliage suggests a contemporary version of those Japanese screens on which brilliantly stylized trees or clouds frame the action. In the snow scenes that Porter did at Amherst, you sometimes feel as if he has gone beyond composition, that he is so absorbed in catching the cold, variegated whites that he doesn't care where the painting ends or begins. Yet the work falls into place—it has the rightness of its randomness.

The mood of these paintings, exact and ebullient, specific and yet tied to some enlarging experience, jibes closely with the quotidian romanticism of the poetry of Porter's close friend James Schuyler. "A few days," Schuyler

wrote in the opening lines of one of his long, diaristic poems, "are all we have.
So count them as they pass."[4] Schuyler's poems, with their emphasis on
moments in time, meteorologic details, and quick shifts in mood, were a way
of counting the days—and the moments that made them up. And this attitude,
at once eager for immediate experience and habitually valetudinarian, sug-
gested the spirit not only of Schuyler's poetry but also of Porter's work and of
quite a number of artists and writers whom they knew or whom Porter wrote
about when he was doing criticism around 1960. The best poems by Frank
O'Hara, who was friends with both Schuyler and Porter, were pages torn
from the diary of a hyper-caffeinated city dweller. And a related flair for the
quirkily quotidian could be found in the work of other artists whom these men
wrote about or knew: in Alex Katz's sly cutout portraits of O'Hara and others;
in Nell Blaine's casually opulent paintings of bouquets of flowers. Porter's
paintings and Schuyler's poems—and works by Blaine, Katz, and O'Hara—
aestheticized the messy facts of life. The clarity of their work had nothing to
do with neatly filing experiences away. Porter and Schuyler may bring to mind
Virginia Woolf in their desire to catch what was most unexpected in life. And
the way in which Porter, this idiosyncratically modern figure, skewered the
sobriety of Eakins and a certain nineteenth-century mentality, may remind
us of the extent to which Woolf and her friends rebelled against so many
nineteenth-century conventions. Just as the unconventional forms of Virginia
Woolf's fictions mirrored the irregular sexual and social arrangements in
Bloomsbury London, so the strangely cropped compositions in Fairfield
Porter's paintings reflected the unusual shape of his life, with a poet wife, five

Fairfield Porter,
Jimmy with Lamp, 1971.
Oil on canvas, 26½ × 35¼ in.

children, and a flock of bohemian friends, many of whom were nearly a generation younger and with some of whom he was in love.

The clash in Porter's paintings between moment-to-moment experience and broader historical currents can yield a woven-together yet dissonant fascination that is reminiscent of the juxtaposition of country-house life and English history in Woolf's *Between the Acts,* although in Porter's variation history is more personal and elusively encoded. In *Island Farmhouse* (1969), the side of a straightforwardly Neoclassical building by Porter's father, its brilliance conveyed through an orchestration of yellows, becomes an emblem of Jeffersonian reason that Porter contrasts with the hedonism of high summer, with the dog relaxing in the green shadow, and the trees and water beyond. The house on Great Spruce Head Island where Porter and his family lived, with its barnlike living room that became the motif for some of the most powerful paintings, was another one of his father's creations. Here architecture becomes a reflection of social history, for the house's open spaces suggest the loosening of Victorian conventions that was an aspect of early-twentieth-century summer homes and led the way to Frank Lloyd Wright's free-form interiors. It is interesting that one of the best paintings of the Spruce Head interior contains a dress pattern, as if Porter were thinking back to his architect father, to the ideal universe of plans and patterns that set the stage for the "reality" of buildings or a piece of clothing. That same interior also includes four large model sailing ships, mounted on two opposite balconies, which his father had ordered for the children.

Painting interiors, Porter acted as a realist, yet the reality was not a given one but an invented one. This idea that the realist, who strived to be a kind of empiricist, could find an idea of artistic stylization imbedded in the look of the world was an old one. Otto Pächt, writing in the 1940s about the beginnings of naturalism in fifteenth-century Northern European illumination, observes that the scenes often also have an elegantly stylized courtly character, but he explains that there is not really a conflict here. "The artists lived in a world which, at least in the higher strata of society, ardently endeavoured to conform to certain ideal standards. The courtly life portrayed by the Flemish miniaturists was in itself a reality already cast into firm shape. Here fiction and reality had become one . . . 'formalized nature,' this was the object the artists took as their model."[5] In a sense you could say that Porter did for a bohemian lifestyle what those fifteenth-century miniaturists did for courtly experience—he accepted a certain range of conventions as the material for realist art. When James Schuyler, sitting in the Porter house in Southampton, bathed

in the light of a green lamp, began to resemble a figure in one of Vuillard's turn-of-the-century paintings of his Parisian friends, the transformation was not only in the act of painting, it was in the act of creating an environment in Southampton that echoed that Parisian world. The interior of Porter's house had a complexly expressive quality, for the old furniture and Oriental rugs and lamps giving off low light and tables piled with books and flowers and food were a self-conscious creation of Porter's and his wife's—an idea of a home. The poetic actuality was a contrivance. Porter's flair for finding the telling accident, elision, or juxtaposition was not only a function of the way he looked at the world, but more than that, of the way he lived in the world.

Virginia Woolf's diaries were among Schuyler's favorite books, he reread them often, and there was a philosophic connection between her viewpoint and that of Schuyler and Porter and some of the other artists of the 1950s as well. The emphasis on moment-to-moment flow in Woolf's fiction signaled a rejection of what she and her friends felt to be the fixed habits of the Victorian mind. That may also be true of the emphasis on the ephemeral, the atmospheric, and the impressionistic that you find in a certain strain of mid-twentieth-century New York art and literature. Porter's easygoing style signaled a rejection of a rigidly scientific approach that he saw in Eakins's depressingly "American" art. But for Porter and Schuyler, a new, telegraphic nature poetry also suggested—and for this they were indebted to de Kooning—a rejection of the absolute structures, with their distillation of sweeping historical overviews, that had characterized an earlier, messianic period in modern art. I suspect that the fascination with moments and instants that you find in Porter's painting—with fogbound mornings or the brilliance of high noon or the perfection of a just-picked flower—reflected a desire to break free of the old art historical forward march. The emphasis in Porter's paintings on ephemeral effects was, of course, an expression of the artist's avidity. But the idea of seizing the moment was also, for Porter, a protest against the one-track, representation-into-abstraction theories of artistic evolution that threatened to relegate his own paintings, and those of many artists he admired, to the footnotes in the history books and the discard racks of the museums. For Porter, who was involved in left-wing politics in the 1930s, and had helped sponsor a Marxist periodical, the rejection of Marxist ideas of progress was mixed up with a rejection of the idea that modern art was a single historical development, inevitably leading toward simplification, unification, abstraction.

The peculiarly unresolved quality of some of his bigger, stranger, more

Fairfield Porter, Lizzie, Guitar and Christmas Tree No. 2, *1973. Oil on canvas, 76 × 52 in.*

ambitious compositions was a function of Porter's no-ideology ideology. In a note written for the catalog of his last one-man show, at Hirschl and Adler in 1974, Porter observed, "It is better if [the painter] does not achieve a plan, and that the painting eludes him, with a life of its own. The painting unfolds, gradually and with difficulty, and he doesn't quite know what it is even for quite a while after he stops painting it. . . . So far as it has merit, a painting is a fact, arbitrary and individual."[6] This man who described a painting as a "fact, arbitrary and individual" could certainly come up with some humdingers. *Lizzie, Guitar and Christmas Tree* (exhibited in the 1974 show for which he prepared this statement) is a painting so oddly willful and overcomplicated that I can neither quite like it nor quite reject it. Nothing in this painting, with its deep, mahogany tones, exactly goes together: not the girl playing the guitar, the decorated Christmas tree that seems to grow out of her back, the odd, almost naïve foreshortening of the guitar case, the music stand, the pattern of the Oriental carpet, and the deep view into another room. Yet all of this doesn't exactly come apart, either. There are, in fact, two versions of this painting, close to identical, which further underscores the willfulness of the eccentricity. Porter brought to his vehemently anticlassical compositions the carefully plotted intentions of the classicist. I keep having mixed feelings about *Lizzie, Guitar and Christmas Tree,* but perhaps mixed feelings are the painting's subject. Every time I look at this painting, I'm left wondering: Is it just awful? Yet there is a story in the way Porter glories in the peculiarities. He slows things down. Looking at the painting is like engaging in a conversation in which you find yourself hyperaware of subtexts and undercurrents, of the things that people are saying even as they say anything but.

There is a related sense of enigma, of questions in the air, in *July Interior* (1964), a painting of Anne lying in bed, in which her face is crowded around

Fairfield Porter, July
Interior, *1964.*
Oil on canvas, 56⅛ × 72 in.

by the night table, the telephone, her eyeglasses, the chest of drawers, books, curtains, the view out the window, all of which adds up to an interior that, despite the strong daylight, has a strangely, elaborately disquieting aura. There is a quality in Porter's paintings of considering objects in their individuality, so that they do not quickly fall into a composition. It reminds me of something that the poet Douglas Crase has said about Emerson, that "the sentences don't even touch. . . . It is Emerson's genius that he doesn't bully his way into the space between the sentences. . . . He leaves that space open to event."[7] The relationships between the objects in Porter's paintings are spaces where we can speculate, spaces that are "open to event." That ambiguity, that air of speculative freedom—in *July Interior* and in *Lizzie, Guitar and Christmas Tree*—may bring us closer to the core of Porter's art than some of the larger, more conventionally ambitious multi-figure canvases such as *Iced Coffee, The Screen Porch, The Tennis Game,* and *July.* I like that Porter attempted these grand, deliberately plotted compositions, but the reach for some overriding order that never quite appears rather emphasizes his ambivalence about the idea of the big picture, both literally and philosophically. Everything that holds us in the work—its psychological and narrative suggestiveness, its quirkiness, its range—is grounded in his fascination with specificity and particularity, with the exact way that things happen to look. Particularity is of course essential to any work of art that is successful, yet with Porter the poetry is not just grounded in but also crystallized by the particulars, and his habit of

emphasizing the oddity or eccentricity of particulars is a way of italicizing what he feels.

III

There was something aristocratic about Porter's nonconformism. The combination both in Porter's paintings and in his criticism of largeness of purpose, unabashed idiosyncracy, and clear-eyed audacity may recall European bohemianism more than it does the American variety. To find a parallel to this powerfully original painter-critic, I think we need to look to the Englishman Walter Sickert, an artist whom Virginia Woolf praised as "a realist [who] is by no means a pessimist," words that could also apply to Porter. Sickert, who lived from 1860 to 1942, was as little understood outside England as Porter was outside the United States.[8] Both Porter and Sickert were proponents of a nineteenth-century naturalism that they imbued with a personal lyric force through their increasingly experimental, and indeed abstract, paint handling. They shared a fascination with popular imagery and popular life, which they indulged even as they cultivated their own ultra-subtle painterly tastes. There was a sardonic edge to Porter's delicately painterly representations of a cereal box or a parking lot full of cars, just as there was to the paintings that Sickert did late in life after newspaper photographs. Both Porter and Sickert wrote searchingly about their artistic passions and each had his criticism collected after his death; Porter's in *Art in Its Own Terms,* Sickert's in *A Free House!* Porter's and Sickert's lives spanned several artistic generations, and they both intrigued younger artists and writers with an independence that seemed to unite a loyalty to long-running traditions with an unabashed eagerness to experiment, to renew.[9]

The combination of progressive-mindedness and astringent aestheticism that Porter had imbibed from his parents fascinated the poets and painters whom he was meeting as a middle-aged man. And the bold, investigative spirit that Porter brought to nature was a reimagining—in a new, aestheticized realm—of the analytical habits of the radical 1930s. In 1927 Porter had taken part in a fact-finding trip to Russia and met Trotsky; in 1935 he completed a vast mural called *Turn Imperialist War into Civil War.* We have seen how Edwin Denby once wrote that what had interested him and de Kooning in the radicalism of the 1930s "was the preemptoriness and the paranoia of Marxism as a ferment or method of rhetoric."[10] The forcefulness of Porter's criticism has something to do with how that rhetoric is reshaped to articulate

sensations of surprise, intimacy, oddity. Porter's criticism has a peculiarly engrossing, moment-by-moment way of shifting focus and emphasis. This is writing that holds entire meanings in single sentences, which is a kind of close looking, a sense of the value that each word or thought holds in itself. Porter has a way of holding a microscope up to each idea or apprehension that occurs to him as he looks at a work of art, and this enables him to beautifully articulate as much as any writer ever has, the extent to which formal values are psychological values. When Porter writes of Degas that he "chose to express the disorderly present with the orderly grammar of the art of the idealists," we see immediately how a form can suggest an attitude toward content. I am fascinated by Porter's words about the paintings by the Le Nain brothers, words that we have already encountered in our discussion of John Graham and de Kooning. "As Descartes proved existence by his own existence, validated in introspection, so these bourgeois artists proved art by their own practice, validated less by comparison to Italian precedent than within the paintings themselves."[11] Here, formalism, what is "within the paintings themselves," becomes a kind of Cartesian introspection—and a kind of empiricism.

The delicate shadings that are characteristic of Porter's writing have given him the reputation of a charming if somewhat obscure critic whose best writings are about odd, slightly marginal achievements, such as Cornell's boxes or Stankiewicz's welded sculptures. No doubt about it, the writing has a lively, fine-tuned elegance, but in his own way Porter was as much a dialectician as some of his old Marxist friends, and his elegant equivocations never quite masked a sense of artistic rights and wrongs that surely alienated a lot of movers and shakers in the anything-goes art world of the 1960s. Reporting on the Pop Art, Neo-Dadaism, and happenings that were the most widely publicized developments of those years, Porter saw the divorce of feelings from ideas, and of both feelings and ideas from the material of art, from its facture, which was where he believed everything that mattered in art would both begin and end. He complained that Pop artists "are more interested in what they say than in their tools and mediums." They were, in other words, anti-empirical. And he remarked of some work by Allan Kaprow and another performance artist, Robert Whitman, that they "do to space something analogous to what Castro's four-hour speeches do to time."[12]

The central theme of Porter's writing was that you could knit form and feeling back together, for realism and abstraction were in fact two parts of one great equation. By the late 1950s, it could seem that not only was naturalism a kind of abstraction, but that abstract painting created its own reality. Porter's

criticism—and his painting, too—was a sustained reflection on these delicious paradoxes. He wrote of Joan Mitchell's abstractions that "nature is more 'really' present than in most representational paintings." And of Morandi he said that he presented a still life or landscape motif "in abstract nakedness. It expresses idea rather than sensation." If the naturalness of Abstract Expressionism could bring artists back to nature, the question of how a painter was to deal with nature was to become the subject of a great deal of discussion among artists in the 1960s. For Porter there was a reality to painting, to paint—the reality of a de Kooning—and that ought not be superseded by the reality of a representation of a chair or a tree or a face. Yet the idea that there was a kind of naturalism to paint itself also confounded the very abstractness of abstract art. So that de Kooning's example could embolden one to paint nature, as had been the case for Porter himself. Speaking of the landscape painter Seymour Remenick, Porter said that "his realism is partly a realism of reference to the objective world, but it is just as often the realism of what he has made, without reference to what it is supposed to represent."[13]

IV

If there was ever a case of the "realism of what [the artist] has made, without reference to what it is supposed to represent," that was the realism of Donald Judd. Of course Judd's work was meant to represent nothing at all, and yet in taking their place in the world, his specific objects came to have relationships with other things in the world, and in the dry, wide-open landscape of the Southwest, Judd found a natural equivalent to the emptied-out aesthetic he was after in his sculpture. "I loved the land around Tucson," he observed, "chiefly because you could see it. In regard to vegetation temperate means immoderate." In a sense he was just another artist seeking escape from the East, but his passion for a landscape without vegetation echoed the New York desire for a structure without ornament, so that in 1969 he "drove down the gulf coast of Baja California, which is excessively perfect in its lack of vegetation." By the end of the 1960s, Judd was finding a "harsh and glib situation within art in New York"; the city itself had the wrong kind of pace. The Southwest was a slowed-down, intensified experience. In Baja there was "a road . . . so wonderful that a day of driving eight hours results in eighty miles. Having come across water, beer, and food we stayed a month in El Rosario with Anita and Heraclio Espinoza, whose place was famous as a base camp for botanists and paleontologists." By 1971, after the summers driving through

Donald Judd, library in
west building of the artist's
compound, Marfa, TX.

the Southwest and staying in Baja, a move seemed absolutely necessary, for a
lot of reasons, not exactly the first being that the cacti that he had brought back
East were dying and that the Indian pottery that he collected was deteriorating
in the humidity of New York. So he began to search for a permanent spot in
the Southwest, which he eventually found in western Texas, with its "fine,
mostly high rangeland dropping to desert along the river, with mountains
over the edge in every direction. There were few people and the land was
undamaged."[14] In Marfa, Judd began by buying a few buildings, surrounding
them with an adobe wall, and setting up house. Over time, he bought much of
the downtown. The Dia Art Foundation acquired an old army base nearby.
And Judd began setting up studios for sculpture and architecture and spaces to
exhibit his own work and that of his friends—and established the Chinati
Foundation.

The American Southwest had attracted artists since the 1920s and 1930s,
when Georgia O'Keeffe and Marsden Hartley and D. H. Lawrence found
their way to Santa Fe and Taos, some four hundred miles north of Marfa along
the Rio Grande, but their interest, which involved the pageantry of Indian
religion and the power of old Southwestern symbols, both Indian and
Catholic, was not what attracted Judd to the Southwest. You might say that
what O'Keeffe and Lawrence were looking for was a reenergizing of old
European principles of the power of symbolism, the sense of life as having
some deep, abiding meaning. Judd was part of another, alternative tradition of
East Coast artists fascinated with the Southwest; they saw the abstractness

of indigenous art, of the cliff dwellings and mounds, of the patterns of rugs and textiles and pottery, as suggesting a freedom from all fixed cosmologies and belief systems. Of course there was a connection between Judd's thinking and that of O'Keeffe and Lawrence, because Judd was also looking for a place to cultivate big ideas—about man's relation to art and nature and culture—that he believed the wide world would not or could not understand. And he saw in the Southwest, where echoes of old civilizations sat so easily amid the deserts and mesas and mountains, a place to marshal his forces and set to work. Judd, out of what I imagine was a reticence about making too much of a Southwestern spirit of place, with all that that might imply about picturesque sentimentality, did not speak much about these connections. Still, he collected old pottery and blankets; he revived adobe in Marfa. In an essay about Marfa, he commented that New Mexico was too cold and too high for him, but he also may have found Santa Fe and Taos too full of the ghosts of Southwestern dreamers past. And real estate was also probably prohibitively expensive. At the Chinati Foundation in 1991, Judd presented work by another lover of the Southwest, Josef Albers, who with his wife, Anni Albers, had left Black Mountain College in the summers and traveled extensively in Mexico, collecting artifacts and photographing the ruins, and who was probably, like Judd, too astringent a figure to take an interest in Taos-style mysticism and mythology. Included in the Albers show, which was organized by the Albers Foundation in Connecticut, were a number of photographs that Albers took in Mexico in the 1940s that focused on ruins, both their general forms and their rich decorative details. Although Judd's catalog essay, a detailed attack on what he perceived as the New York critics' misunderstanding of Albers, did not really go into Albers's Southwestern connection, it was like Judd, who had a laconic side, to allow Albers's photographs to be presented without comment, at least comment by Judd. And what we see in these photographs is Albers responding to the abstractness of Southwestern art.[15]

At Marfa, Judd designed beautiful courtyards. He explored the fundamentals of carpentry—a primal sense of craft—as he developed his own ultrasimple furniture in the 1970s. And the absoluteness of his immense sculpture projects at Marfa—the hundred aluminum boxes and the series of fifteen concrete structures that lie beyond it, visible in the fields—raises questions about the power of abstract form to provoke emotion that have preoccupied architects and builders since ancient times, and certainly in the Southwest. Judd was a great admirer of Newman, and one feels in Judd's work at Marfa echoes of Newman's admiration for the fearless imagery of old American Indian

art—an art that is abstract, but in which abstraction is a primary rather than a secondary reality. Looking back to Europe, Newman saw a kind of slavery, an art crippled by pedagogy, procedures, the backward glance that informed even the most daring revolution. He complained of the "dogmatic positions of the purists, neo-plasticists and of the formalists." There was something labored, limiting about the august genealogies of the masterpieces of European art. American art was going to be about primary impulses—and that is what you feel at Marfa. Thinking of the push that Judd was making toward a spirit of architec-

Donald Judd, courtyards, Marfa, TX.

tural grandeur, I am reminded of Nietzsche, writing in *The Twilight of the Idols* that "the *architect* represents neither a Dionysian nor an Apollonian condition: here it is the great act of will, the will that moves mountains, the frenzy of the great will which aspires to art."[16]

Part of the magic of Chinati, as Judd knew full well, comes straight out of the parched Southwestern landscape. This is the only area of the United States where art, architecture, and the landscape form an ancient, abiding unity. While Judd was one of those blunt, no-nonsense American aesthetes who would probably never have admitted to having a spiritual or mystical bone in his body, he surely saw in the clarity of the Southwest's light and space and color an experience that cut through life's superficial nonsense. There is something in the taciturn surfaces of his work, in the way it quietly reveals its surprises, that is true to the Southwest—to the adobe architecture, to the baskets and ceramics with their patterns that are at once utterly simple and confoundingly complex. And in his home in Marfa, Judd gathered together Native American blankets and rugs that had the bold, geometric elegance of a Scot's beloved tartan plaids. Judd understood a good deal about the covert formal drama of Southwestern culture. The austere sculptural forms that he presented in and around a former army base in the beautifully hardscrabble landscape of western Texas were one man's idea of visual paradise. Arranged in two huge, glass-sided buildings, Judd's aluminum boxes—which repeat the same basic outer dimensions but are each absolutely distinct, with their variously open or closed sides and bisected and divided interiors and floating ele-

ments—compose a saga in which formal variations take on a narrative power. And the light of the Southwest animates Judd's mill-aluminum surfaces, turning them inkily dark in the shadows and sometimes almost transparent in the light, giving these impassive abstract forms a naturalistic dazzle.

In Marfa, working on a vast scale, Judd was able, especially in the hundred aluminum boxes, each 41 by 51 by 72 inches, to create a meditation on the aspirations of modern architecture that short-circuited all the practicalities that had so often kept that architecture from achieving an all-embracing magic. While the quality of the detail recalls the work of Mies van der Rohe, Judd releases the Platonism of architecture from the dilemma of functionality. What Judd has given us is an abstraction of the idea of utopian architecture. The apparent regularity of the hundred aluminum boxes can have the fascination of an Olympian joke, because the closer you look, the less similar they

Donald Judd, shed containing mill-aluminum works, 1982–86, Marfa, TX.

Donald Judd, installation of mill-aluminum works, 1982–86, Marfa, TX.

are. Each box has its own anatomy, its own
internal geometry, so that light and air are cap-
tured in many different ways. The boxes are
not even divided evenly between the two build-
ings. Because of the shapes of the buildings, it
turns out that one grouping is of fifty-two, one
of forty-eight. That subtle asymmetry is only
one of a whole series of asymmetries—and,
taken together, they give the work its intoxicat-
ing charm. The ultimate effect is of a quietly
exhilarating delirium, with all those secret vari-
ations and divisions, box to box, sounding in
one's memory all at once. Judd's alterations of
the buildings of the old Fort Russell at Marfa—
moving a doorway, removing a later addition,
repairing a floor—are about catching and
underscoring the essence of older American
building types. And his sculpture, with its
complicated simplicities that urge us to poke
around, to look and look some more, is tuned

*Donald Judd, installation of mill-aluminum works,
1982–86, Marfa, TX.*

to the kinds of careful exploration of pattern and interval that we bring to an
Indian bowl or rug or to watching the adobe structures of Taos Pueblo emerge
out of the surrounding hills. Newman said in "The Sublime Is Now," pub-
lished in *The Tiger's Eye* in 1948, that "here in America, some of us, free from
the weight of European culture, are finding the answer, by completely deny-
ing that art has any concern with the problem of beauty and where to find
it. . . . We are reasserting man's natural desire for the exalted, for a concern
with our relationship to the absolute emotions."[17] In the hundred aluminum
boxes at Marfa, Judd fulfills that old no-romantic romantic dream.

V

The loving eye that Judd brought to the early- and mid-twentieth-century
brick and concrete and wood buildings of the Southwest was not so different
from the eye that he brought to his cast-iron building in New York, which he
bought to live in and to work in and as a place to exhibit works by artists whom
he admired. And this eye of Judd's, so sensitive to the power of workmanlike
structures, was in turn not so different from the eye that, thirty years earlier,

de Kooning and Rudy Burckhardt and Edwin Denby and Barnett Newman had brought to the architecture of downtown New York. The importance of focusing on what was directly in front of you was what de Kooning had been emphasizing when he pointed out to Denby and Burckhardt, during their nighttime walks through the city, the patterns of old stains and reflections in the streets. That same attention was there in Burckhardt's early photographs of details of architecture, of the clash of ornamented façades, and of the startling shifts in scale, from building to building, block to block. And it was also there in Newman's loving descriptions of downtown New York, with its mix of relatively small, eighteenth- and early-nineteenth-century buildings, which were going or gone by the 1960s, and the later nineteenth-century architecture, including the cast-iron buildings, which reflected the booming manufacturing city of the post–Civil War period.

Burckhardt could have been making a light joke of all these levels of reality, when, in the 1970s, he did a movie about Charles Simonds, who had been born in 1945 and who constructed, amid the run-down streets and burned-out buildings of the Lower East Side, miniaturized structures that looked a bit like toy versions of the cliff dwellings of the American Southwest. Burckhardt was clearly fascinated by the good-looking young white guy with the long hair and the parka who made his way around the Lower East Side, provoking gatherings of Black and Hispanic locals as he constructed, with tweezers and tiny baked bricks, his fantasy architecture—a make-believe world among the real architecture, but a make-believe that was, in its own way, real. Burckhardt, an old-time urban aesthete, constructed a little movie that wasn't so much a documentary as it was a story about urban aestheticism, circa 1975. The color of the movie was shot through with sharp primaries—the colors of paint and graffiti and signs—but they were muted by the allover soft grays of the worn-down, rubble-strewn streets. The movie came out of the same moment as Scorsese's *Mean Streets* (1973), and it had that same texture of urban disarray. Burckhardt's camera was attentive to the streetscape—the details of graffiti, the scrawled messages ("LOVE CARE ME," a peace sign). And through it all, Simonds moved, poker-faced, arriving at a heap of rubble, setting down a knapsack that was his traveling studio, slathering clay on the bricks, and beginning, on this imaginary terrain, to construct his buildings, buildings that were, even as he completed them, elegantly ruinous. As Simonds worked, kids gathered to watch. At one point the Fire Department appeared, to put out a fire, and Simonds just kept on working. One has the sense that Simonds was making a political point; he wanted to bring something delicate and nuanced

Rudy Burckhardt, stills from
Dwellings, movie with
sculptor Charles Simonds,
1975.

and refined into these mean streets. But by showing the urban aesthete at work, Burckhardt highlighted Simonds's self-absorption, the extent to which he disregarded the life around him, even as he used it as a dramatic backdrop.

Simonds's play ruins made the real ruins of the Lower East Side into an aesthetic object, and while Burckhardt enjoyed the ironies, he laid them out so clearly that Simonds ended up looking less like a creative force than like one of the scenic attractions. Simonds's miniaturized dwellings were a joke on urban development. And he was only one of a large number of artists in the 1960s and 1970s who were obsessed with ideas about urban architecture—with, in other words, a place to live. In downtown New York, where everybody was looking for good, cheap space, that search could become, eventually, a subject in itself, so that Minimalist and Conceptualist art was sometimes just about defining space.[18] Mel Bochner did a work that consisted of simply marking the walls of a gallery with heights and widths—three feet ten inches, eight feet nine inches, and so forth. This was perhaps the ultimate example of real estate as an abstraction, and it seemed to be inevitable with this kind of work that

artists kept wanting to do it bigger—or, for that matter, smaller, as in the case of Simonds's brick dwellings. When literalness was all, when more and more artists were focusing on the "specific objects" that Judd had spoken of, then size became the great variable. In the 1960s everybody was an amateur (or even a professional) carpenter or contractor, with tape measure in hand, and sometimes their art ended up being a sort of dry joke on life in the lumberyard and at the construction site. The spirit of Duchamp, who died in 1968, was ubiquitous. One of Lawrence Weiner's *Statements, 1968* consisted of the words, emblazoned on a wall, "A removal of the lathing or support wall of plaster or wall board from a wall." This might bring to mind Judd's idea— some years later, when restoring one of the buildings at Marfa—of doing away with a conventional floor, exposing the substructure. The enlargement of the field of art resulted in a mandarin abstractness, in art objects that, while taking their inspiration from the most concrete of considerations, gave those concrete objects so detached a regard that they ended up more head-in- the-clouds than anything that had ever been called art before. Carl Andre's bricks or metal tiles laid on a regular pattern on the floor were an art that not only derived from the factory but also had never left there. Sometimes the taste for abstraction among the SoHo mandarins was indistinguishable from a taste for abstraction among SoHo's village idiots—empiricism could become a dead end.

Among the artists who were coming up in the 1960s, only Donald Judd really ever understood how to exaggerate or extend the beauty of the plain facts of the city. Judd's five-story cast-iron building at the corner of Spring and Mercer streets, 101 Spring, had the imperious beauty of a readymade, and the beauty of this piece of nineteenth-century archi- tecture was then italicized through Judd's at- tentiveness. Painted a grave yet rich gray, the building took on a sculptural power and disinter- estedness. In an essay he wrote about the build- ing, Judd explained that it "was built in 1870 and designed by Nicholas Whyte, whose only other

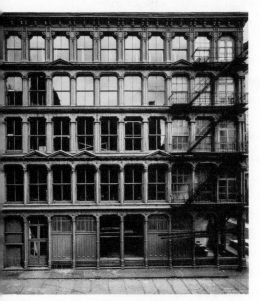

Paul Katz, Donald Judd's building at 101 Spring Street.

cast-iron building is in Brazil." Whyte's building was a product of the ex-
plosive American economy of the years after the Civil War—the years that
had fascinated Alfred Kazin. And who could doubt that the cast-iron architec-
ture of the nineteenth century was one of America's great inventions? While
the shapes and ornaments of these cast-iron façades were richly Victorian, the
underlying structures were astonishingly modern, a foreshadowing of the
metal skeletons of the International Style, a connection between the crystal
palaces of the 1840s and the Miesian skyscrapers of the 1950s. Writing about
101 Spring, Judd conveyed the same love for the city that you feel in New-
man's writings and observations. Judd didn't know the first purpose of the
building, but supposed "that something of cloth was made in the upper floors
and sold on the lower ones, since many buildings in the area were stores, since
the façade is fancy, not like that of a warehouse, and since it is mostly glass."[19]

When Judd described 101 Spring Street as "a right angle of glass," he
might have been turning the building into one of his own sculptures, although
of course he did not work in glass. "The façade is the most shallow perhaps of
any in the area and so is the furthest forerunner of the curtainwall." Judd
described how the interior had been ruined. When he bought it, "the trash was
so much that Arman could have bought the building and left it alone"—
Arman being the French artist, included in "The Art of Assemblage" and
"The New Realists," who liked to fill Plexiglas boxes with junkyard finds.
Judd described how the building, in the 1930s, on account of what he regarded
as overzealous fire laws, had been defaced with fire escapes, and how the beau-
tiful open stairway had been enclosed with concrete, "destroying most of the
mahogany railings." Judd worked to bring the building back, as much as pos-
sible, to its original state, with what he imagined were open floors. Yet he was
also transposing the building, seeing it not for manufacture and sales, but for
living and working and showing art. By emphasizing the long interior spaces,
25 by 75 feet, he created a poetry of unbroken areas. There was a dreamy aus-
terity to 101 Spring. "The given circumstances were very simple: the floors
must be open, the right angle of windows on each floor must not be inter-
rupted; and any changes must be compatible." "Other than leaving the build-
ing alone, then and now a highly positive act, my main inventions are the
floors of the 5th and 3rd floors and the parallel planes of the identical ceiling
and floor of the 4th floor. The baseboard of the 5th floor is the same oak as that
of the floor, making the floor a shallow recessed plane. There is no baseboard,
there is a gap between the walls and the floor of the 3rd floor, thus defining and
separating the floor as a plane. These ideas were precedents for some small

Paul Katz, Donald Judd at
101 Spring Street, circa 1970.

pieces and then for the 100 mill aluminum pieces in the Chinati Foundation."[20]
Thus architectural structure became a jumping-off point for abstraction—and
the reality of architecture provoked the reality of sculpture. He was speaking
the same language as Newman was when he made the analogy between the
red in his painting and the parabola of the Brooklyn Bridge.

Judd's work was a daring reimagining and extension of the idea of struc-
ture as distilled feeling that powered the thought of several generations of
Europeans, including Mondrian, El Lissitzky, Malevich, Mies van der Rohe,
Gerrit Rietveld, and Alvar Aalto. There was a modern resonance that Judd
picked up at 101 Spring, a proto-modern logic in the nineteenth-century archi-
tecture. And that was not unlike what he did at Marfa—in the house he
designed out of several old buildings, developing sleeping and eating areas
and a wonderful library; or in the suite of rooms where he worked on archi-
tecture designs and kept his collection of furniture by Rietveld and Aalto and
others. It is interesting that Judd writes about designing furniture for his chil-
dren when he settled in Marfa; this recalls the work of Rietveld, who did work
for children and whose most famous house was specially designed for the
needs of the modern family. Judd, an American pragmatist of left-liberal
views who wrote about politics and complained about "US imperialism" but
had no illusions about what fascism and communism had meant for art, did
something surprising with the visionary simplicity of early-twentieth-century
Europe, which he rediscovered in the pragmatic simplicity of the industrial

architecture of the United States. In Judd's mind there was a connection between architecture and art, and between all of this and an idea of community. These were connections that he was perhaps too scrupulous to want to make explicit in a way that might make them feel banal, but which we are meant to sense nonetheless. Judd was involved, in the years he was working on 101 Spring, in efforts to preserve the integrity of a growing artists' community below Houston Street. In January 1971, he explained in the *Lower Manhattan Township Newspaper* that "we're organizing the Lower Manhattan Township, which extends from Allen Street to the Hudson River and from West and East Houston and East Fourth Streets to Chambers and Division Streets. The township is a political organization based on geography, a pretty neutral base, dealing with anything that is a common problem within the area." In a later issue, April 1971, he complained "about the problem of rising rents. Since SoHo came above ground and had their festival, and since all the galleries moved in, except Paula Cooper which was here before, rents for the average 25 × 100 loft have risen from 150–200 dollars to 300 or more. It's getting too expensive here for young artists. If they aren't here, only dilettantes who don't mind making a good living, you don't have a live situation. Also the increased rents force out small business."[21]

Judd's downtown politics involved the idea of a bare-bones community of artists, and this was related to a bare-bones Minimalism, which had in part been inspired by the bare-bones landscape of downtown New York. The industrial architecture of Lower Manhattan, as Judd knew full well, was related to the invention of modern style, related in its emphasis on structure before ornament, in its rejection of classical forms, which inaugurated a new classicism. To embrace 101 Spring Street was in a sense to short-circuit the history-book versions of modern art, to reject the airy speculations about the development of the picture plane or of pictorial space, in favor of an indomitable empiricism. To walk down Spring Street and walk into 101 was to go back to the prehistory of the history of modern art, to trace all the metaphysical speculations back to their practical, even humdrum beginnings—and thus to insist on a disabused-but-somehow-still-optimistic continuation of an early modern dream.

VI

In Judd's work the crystalline idealism of early modern abstraction went on, but it was stripped of its idealism, brought back to a grounding in facture, in

Kitchen floor of Donald Judd's Spring Street building.

procedure. Judd was fascinated by the bones of New York buildings; he was an anatomizer of the early modern city. Judd's sense of the city was anti-dialectical; he was after something that was empirical, essential. So, for that matter, was Fairfield Porter, in the New York cityscapes that he was painting in the years when Judd was working on 101 Spring Street. Several of the finest of Porter's New York City canvases focused on Union Square and Astor Place, roughly a dozen blocks north of Judd's Spring Street building. If Judd's Manhattan was a celebration of first principles, Porter's Manhattan was a celebration of the absoluteness of impressions, of the kind of impressions that his friend James Schuyler caught in his poems, where "bizarre blocks," with "ex-/town houses, mixing Byzantine/with Gothic and Queen Anne," were at once background and foreground, with the jumble provoking a jumble of memories.[22] Judd's interest in New York was in its ground plans and actual dimensions, in the right-angled wall of glass at the right-angled city corner. Porter's view of New York was fueled by another kind of empiricism, by the empiricism of the quotidian, by the pileup of buildings and cars and people, all different, all joined in their fascinating, convivial heterogeneity.

In the early 1960s, Porter began to work on what turned out to be a cycle of paintings of the city, some ten in all, which grew grander, clearer, more specific, all the way to his death in 1975. He focused on two areas, both important to the artists. There were paintings of the neighborhood where the artists had been living and meeting and showing since the 1940s: Astor Place, where *Partisan Review* had had its offices; Cooper Square, with the great old Cooper Union art school; and Union Square, where Cornell and Burckhardt had filmed *Aviary* in the 1950s. The Club, the Hofmann School, the Cedar Tavern, the Tenth Street galleries had all been in this vicinity. So, now, was the New York Studio School. It was just a few blocks' walk to Washington Square Park, where Hofmann had run into Joan Mitchell early in the morning a quarter of a century before and asked her, "Mitcha, why aren't you home painting?" And Porter also painted the midtown area where everybody hoped to show their work, specifically West Fifty-sixth Street, which was near so many of the galleries and just three blocks from the Museum of Modern Art. In

Fairfield Porter, Near Union
Square—Looking Up Park
Avenue, 1975. *Oil on canvas,*
61¼ × 72 in.

many of these works, Porter's vantage point was that of the pedestrian. He looked from the ground up. He wanted to suggest the experience of the walker in the city, who noticed things nearby—the signs on stores, the people, the cabs, the buses—and then, lifting his head a little higher, saw the tops of the buildings and the startling, deep perspectives up the avenues and streets, into the sky. Porter did some marvelous drawings in pen and pencil when he was preparing these paintings, in which he grappled with outlines, rendering the loose-knit collage of forms, and then jotted down words here and there, the words on signs, sometimes, and at other times notations of colors—"gray" for a bus, "yellow" for a cab, "violet" for a sign. The drawings have a scintillating literalness. The color notations, dry and functional and often suggesting vibrant hues, are as basic as the colors on Judd's specific objects. This was, in a sense, Porter's way of saluting the specific objects that he bumped into on the city streets.

Porter's New York was a new version of the no-romantic romantic New York, not the New York of Art Deco skyscrapers, not the New York of huge office buildings viewed from other huge office buildings, but a New York of unplanned streetscapes and unpredictable juxtapositions. Nobody before Porter had caught the astonishing truth of the city's high, discordant, exciting color. This was a painter's color, ripe and sensuous, but also, perhaps,

grounded in the experience of color photography. Porter's brother Eliot was a celebrated photographer, mostly of landscapes, and Fairfield had written about his work on a number of occasions, and had suggested that color photography sometimes caught an experience of "the Saturnian age [when] the world appeared new: things had no names, there was no past or future, all concepts were unconscious, and all order. The radiance of such an age has been expressed by poets; but has it ever been expressed in painting or sculpture?" Porter suggested that the "Impressionist painters expressed it in a generalized way, and only by color."[23] And reading these observations and thinking about Porter's New York canvases, I can't help but believe that in painting the city that he loved, Porter was aiming to discover a new kind of all-American Impressionist pastoral. In Porter's New York paintings, the city was reclaimed as immediate, as yet unnamed experience. The words on Porter's drawings have the thrill of a first description—at once a gaining of knowledge and a loss of innocence. His paintings have a grown man's sophisticated naïveté. And some of the details are echoed in the word pictures of New York in Schuyler's diaries, including this note from 1988: "A bus panting as it waits for the light to change, the blue neon sign of the Zig Zag Bar and its blue neon cocktail glass in which the green olive hops back and forth. Across the street the words RADIO SHACK burn red: banners, canopies."[24]

Fairfield Porter, Fifty-sixth Street, *1968–71.*
Oil on canvas, 36 × 29⅞ in.

To paint the city was to see the city anew, in a range of pale and also stinging colors, in grays and yellows and greens and pinks. Porter gave the streets and the buildings, the sun and the shade, a jangling urgency. His New York was unplanned, a succession of accidents that somehow added up to a thrilling kind of structure. He knew how to shift from extreme detail to generalization as he moved from area to area. A lifetime of preparing for the unexpected was concentrated in these canvases. Porter rendered a sign with every letter in place or a bit of turn-of-the-century architectural detail in all its glorious intricacies, and then he abruptly shifted to areas of flattened-out nonspecificity. His attention was always on the move. He zeroed in on one thing and then, just as another was coming into view, he found his mind wandering off, so that the city was no longer, for that moment at least, foreground but background, a screen on which he projected his thoughts. Porter composed his New York

*Fairfield Porter, study for
Sixth Avenue lithograph,
circa 1971. Pencil on paper,
9 × 11¾ in.*

paintings without any fixed idea of structure, without any sense of Constructivist organization. The power of the paintings was in the surprising relationships and shifts of detail and no-detail. In *Near Union Square,* which was on Porter's easel at his death, certain elements—Corinthian capitals, the signs on Klein's department store, the many windows—are rendered exactingly, while dark trees in Union Square and the view up Park Avenue and the cars and trucks in the street are blurred, generalized, rushed over. New York was loose-jointed, open-ended, unfinished—a city that was still roomy enough to welcome new explorers.

The metropolis that Porter's friend de Kooning had fallen in love with in the 1930s and that he had immortalized in the black-and-white abstractions that filled his first show, at Charles Egan in 1948, had been preternaturally the night city, the dream city, the city of a time when artists were still trying to wake up to the promise of the historical imagination. Porter's 1970s New York was, triumphantly, the city of daylight, the city as an ordinary reality, and thus an affirmation of the city as a product of the empirical imagination. Porter gave a shambling specificity to the men and women who ambled or rushed along the sidewalks. He suggested, in the most abbreviated manner imaginable, their hats, their outerwear, their preoccupied airs. These men and women were there, in the New York of the 1960s and 1970s, catching the particular light of a particular hour on a particular day, which was also a moment in the great sweep of the history of this city and of cities in general, which was also the history of art, a turbulent history full of traditions and countertraditions. To insist on the full light on Lower Broadway was not to reject the

Fairfield Porter, Broadway
South of Union Square,
*1974–75. Oil on canvas,
38 × 30 in.*

night city that had come before, but to announce that you were now on the
other side of the same equation, that you had awoken from the city of meta-
physical aspirations. Countless artists, working in their studios and talking
about everything that they were doing and looking at everything that every-
body else was doing, had pushed New York to the point where this was at last
a city where painters and sculptors could take the metaphysics of art history
for granted and pour all their energies into the specifics. New York, having
found its place in the history of art, had left the artists with the glorious para-
dox of their individuality.

NOTES

THE PAINTER AND THE CITY

1. Hans Hofmann's question to Mitchell is quoted in Judith Bernstock, *Joan Mitchell* (New York: Hudson Hills Press, 1988), p. 28.
2. Rudi Blesh, *Modern Art USA: Men, Rebellion, Conquest, 1900–1956* (New York: Knopf, 1956), p. 262. The 1960 interview with de Kooning in David Sylvester, *Interviews with American Artists* (New Haven, CT: Yale University Press, 2001), p. 47. Motherwell letter to Frank O'Hara, August 18, 1965, in Frank O'Hara, *Robert Motherwell* (New York: Museum of Modern Art, 1965), p. 59.
3. Pat Passlof, "Out of the Picture," in Geoffrey Dorfman, ed., *Out of the Picture: Milton Resnick and the New York School* (New York: Midmarch Arts Press, 2002), p. 275.
4. Hans Hofmann in *Arts and Architecture*, March 1944, p. 23.
5. Nell Blaine in Hofmann Students Dossiers, Museum of Modern Art Library.
6. Tennessee Williams, "An Appreciation," in Samuel M. Kootz, ed., *Women: A Collaboration of Artists and Writers* (New York: Samuel M. Kootz Editions, 1948), unpaged.
7. Hans Hofmann, *Search for the Real and Other Essays* (Cambridge, MA: MIT Press, 1967 [1st ed., 1948]), pp. 42, 43.
8. Harold Rosenberg, *The Anxious Object* (New York: Collier Books, 1973 [1st ed., 1964]), pp. 131, 132.
9. Hofmann, *Search for the Real*, p. 42; Hofmann in James Yohe, ed., *Hans Hofmann* (New York: Rizzoli, 2002), p. 51.
10. Robert Goldwater, "Reflections on the New York School," *Quadrum* VIII (1960), p. 17. The early histories of Abstract Expressionism were written by people who knew the artists and had watched many of them develop. Thomas B. Hess's *Abstract Painting: Background and American Phase* (New York: Viking Press, 1951) is a pioneering work full of striking thought and insight. Hess's writings, now mostly out of print, are one of the large critical achievements of the postwar years; his many essays for *Art News* (of which he was executive editor from 1949 to 1965 and editor until 1972) and for *New York* (where he was art critic from 1972 until not long before his death in 1978), as well as his writings in other publications, constitute a priceless account of art and culture in the decades after World War II, and yet they have never been collected. The thought and conversation of the late 1940s and early 1950s are especially well captured in the dissertation that William C. Seitz wrote in the mid-1950s for his Ph.D. at Princeton; it was ultimately published as *Abstract Expressionist Painting in America* (Cambridge, MA: Harvard University Press, 1983). B. H. Friedman's anthology, *School of New York: Some Younger Artists* (New York: Grove Press, 1959), is a valuable work, with brief essays by a

range of critics on a range of artists. Irving Sandler—one of the contributors to Friedman's book—was the first to cover the history in a complete way in *The Triumph of American Painting: A History of Abstract Expressionism* (New York: Harper & Row, 1976) and *The New York School: The Painters and Sculptors of the Fifties* (New York: Harper & Row, 1978). Dore Ashton offers a more closely focused thematic view of the first-generation Abstract Expressionists in *The New York School: A Cultural Reckoning* (New York: Viking Press, 1973).

11. Douglas MacAgy in Robert Goldwater, ed., "A Symposium: The State of American Art," *Magazine of Art*, March 1949, p. 95.

12. Ibid.

13. Miz Hofmann quoted in Frederick S. Wight, *Hans Hofmann* (Berkeley: The Regents of the University of California, 1957), p. 20. Miz Hofmann quoted in Judith Malina, *The Diaries of Judith Malina, 1947–1957* (New York: Grove Press, 1984), p. 129.

14. Hofmann, *Search for the Real*, pp. 45, 43. Schiller quoted in Walter Kaufmann, *Hegel: A Reinterpretation* (Garden City, NY: Anchor Books, 1966), p. 26.

15. Sidney Hook, *The Hero in History* (New York: John Day, 1943), pp. 29, 31. Thomas B. Hess, *Willem de Kooning Drawings* (Greenwich, CT: A Paul Bianchini Book/New York Graphic Society, 1972), p. 57.

16. Karl Marx and Friedrich Engels, *Basic Writings on Politics and Philosophy*, ed. Lewis S. Feuer (Garden City, NY: Anchor Books, 1959), p. 320. Hans Hofmann interviewed by Irma Jaffe in 1966, published as "A Conversation with Hans Hofmann," *Artforum*, January 1971, p. 37.

17. Hofmann, *Search for the Real*, pp. 60–61. Hofmann interviewed by Katharine Kuh, *The Artist's Voice: Talks with Seventeen Artists* (New York: Harper & Row, 1962), p. 125.

18. Anton Myrer, *Evil Under the Sun* (New York: Random House, 1951), excerpts from pp. 82–86.

19. For New York's artists and critics, diagramming historical developments or the vagaries of taste was a way of taking control of the story—whether the intention was partly comic, as it was with Ad Reinhardt, or altogether serious, as it was with the painter John Graham. This fascination with charts and diagrams was fundamentally optimistic, reflecting as it did a widespread belief that it was possible to grasp large movements and patterns in history and aesthetics. The urge to contain a vast amount of knowledge in a single picture had its roots in the charts and diagrams that were so important in the social and exact sciences; they were also an aspect of the teachings of the mystical religious movements (such as Theosophy) that interested many artists. Even when the meaning of a diagram was essentially pessimistic—I am thinking of Spengler's table "Contemporary Spiritual Epochs" in the first volume of *The Decline of the West* (published in New York in 1926)—there was something exciting about the breadth of the overview. For artists, this taste could be playful—a loving, tongue-in-cheek salute to the nerdishness of the scientifically minded, or a Dadaist or Surrealist riff on nineteenth-century pedantry. But the experiments in typography and graphic design that were so essential a part of the modern enterprise also encouraged this search for new ways of telling the story of art. There were certainly European precedents, including diagrammatic presentations of information in *Die Kunstismen* (*Isms of Art*), published by Arp and El Lissitzky in Germany in 1925, and in Amedée Ozenfant's *Foundations of Modern Art*, first published in English in 1931. A study of diagrams, charts, and tables in American art yields many interesting examples. The papers of the painter John Graham, author of the immensely important 1937 book *System and Dialectics of Art*, are full of diagrams, including a three-dimensional rendering of the history of style that looks a bit

like a sculpture by Noguchi, with a vertical trunk carrying horizontal plates (signifying periods such as Iron Age, Gothic, Renaissance, etc.); the plates are incised with holes, through which are strung lines that track the evolution of particular forms—sculpture, painting, etc.—through the ages (John Graham Papers, Archives of American Art). For a 1939 show of Renaissance and post-Renaissance Italian painting at the Museum of Modern Art, Barr prepared a diagram tracing a lineage from Giotto, Masaccio, Mantegna, and Piero to Renoir, van Gogh, Seurat, and Cézanne. The first issue of the magazine *VVV*, published in June 1942, contained a chart called "Concerning the present day relative attractions of Various Creatures in Mythology and Legend"; figures such as Harold Rosenberg, Robert Motherwell, and André Masson discussed their relative levels of interest in, say, dragons (high rating from Rosenberg and Masson), Narcissus (high rating from Motherwell), and so forth. When William Seitz was working on his Ph.D. thesis on Abstract Expressionism for Princeton University in the 1950s, Motherwell provided him with a chronological diagram of American art during the 1940s; it is published in Seitz, *Abstract Expressionist Painting in America*, pp. 168–69.

20. Clement Greenberg, *The Collected Essays and Criticism*, ed. John O'Brian (Chicago: University of Chicago Press, 1986–93), vol. 1, p. 67.

21. Miz Hofmann quoted in Fritz Bultman, "Hofmann and Contradiction," in *Hans Hofmann as Teacher: Drawings by His Students/Hans Hofmann: Provincetown Scenes* (Provincetown, MA: Provincetown Art Association and Museum, 1980), p. 4.

22. Hamlin Garland, *Crumbling Idols* (Chicago: Stone and Kimball, 1894), p. 35.

23. Nell Blaine, unpublished journal entry, 1958, Houghton Library of the Harvard College Library, Cambridge, MA.

24. Lionel Abel, *The Intellectual Follies: A Memoir of Literary Venture in New York and Paris* (New York: W. W. Norton, 1984), p. 210.

25. D. H. Lawrence, *The Plumed Serpent* (New York: Vintage Books, 1955 [1st ed., 1926]), p. 79.

26. Parker Tyler, "I See the Pattern of Nijinsky Clear," in Charles Henri Ford, ed., *View: Parade of the Avant-Garde, 1940–1947* (New York: Thunder's Mouth Press, 1991), p. 175.

27. Barnett Newman, "Sublime Is Now," in Clifford Ross, ed., *Abstract Expressionism: Creators and Critics* (New York: Harry N. Abrams, 1990), p. 128. Clyfford Still, "Letter to Gordon Smith, 1959," in Ross, ed., *Abstract Expressionism*, p. 194.

28. Maya Deren, *An Anagram of Ideas on Art, Form and Film* (Yonkers, NY: The Alicat Book Shop Press, 1946), p. 52.

29. Willem de Kooning, *The Collected Writings of Willem de Kooning* (New York: Hanuman Books, 1988), p. 61. Hess in the introduction to Fred W. McDarrah, *The Artist's World in Pictures* (New York: E. P. Dutton, 1961), p. 9.

30. Johan Huizinga, *The Autumn of the Middle Ages*, trans. Rodney J. Payton and Ulrich Mammitzsch (Chicago: University of Chicago Press, 1996 [1st ed., 1921]), p. 103.

31. Ruth E. Fine, *John Marin* (New York: Abbeville Press, 1990), p. 126.

32. Nell Blaine describes the sign in Martica Sawin, *Nell Blaine: Her Art and Life* (New York: Hudson Hills Press, 1998), p. 19.

33. Greenberg, *Collected Essays*, vol. 3, p. 222.

34. Hans Hofmann in letter to Mercedes Matter, December 7, 1943, courtesy of Alex Matter.

35. Williams, "An Appreciation," unpaged.

36. Fritz Bultman, "The Achievement of Hans Hofmann," *Art News*, September 1963, p. 43.

37. Ibid., p. 44.

38. Hans Hofmann quoted in Wight, *Hofmann*, p. 49.

39. Williams, "An Appreciation," unpaged.

CLIMATE OF NEW YORK

1. MANHATTAN GEOGRAPHY

1. Alfred Kazin, *New York Jew* (New York: Knopf, 1978), p. 157. Edwin Denby, *Dancers, Buildings, and People in the Streets* (New York: Horizon Press, 1965), p. 37. Thomas B. Hess, *De Kooning: Recent Paintings* (New York: Walker & Co., 1967), p. 10.

2. R. P. Blackmur, *New Criticism in the United States* (Tokyo: Kenkyusha Ltd., 1959), pp. 151–52.

3. Georg Simmel, "The Metropolis and Mental Life," in *The Sociology of Georg Simmel,* trans. Kurt H. Wolff (New York: The Free Press, 1950), p. 423.

4. Barnett Newman, "New York," in *Selected Writings and Interviews,* ed. John P. O'Neill (New York: Knopf, 1990), p. 31. This essay was written in 1943 or 1944.

5. John Ashbery, *Reported Sightings: Art Chronicles, 1957–1987,* ed. David Bergman (New York: Knopf, 1989), p. 17.

6. Ada Louise Huxtable, *Classic New York: Georgian Gentility to Greek Elegance* (Garden City, NY: Anchor Books, 1964), p. 109.

7. Ellsworth Kelly, *Tablet: 1948–1973* (New York: The Drawing Center, 2002), p. 65.

8. Mary McCarthy, *On the Contrary* (New York: Farrar, Straus and Cudahy, 1961), p. 6.

9. Hegel quoted in Errol E. Harris, *The Spirit of Hegel* (Atlantic Highlands, NJ: Humanities Press, 1993), p. 30.

10. Cyril Connolly in "Art on the American Horizon," *Horizon,* October 1947, p. 8. Albert Camus, "The Rains of New York," in *Lyrical and Critical Essays,* trans. Ellen Conroy Kennedy (New York: Vintage Books, 1970), pp. 182–83.

11. Kenneth Sawyer, "The Importance of a Wall: Galleries," *Evergreen Review,* Spring 1959, p. 128.

12. Clement Greenberg, *The Collected Essays and Criticism,* ed. John O'Brian (Chicago: University of Chicago Press, 1986–93), vol. 2, pp. 229, 228. Greenberg in "Art on the American Horizon," *Horizon,* October 1947, pp. 29, 30.

13. Thomas B. Hess, "New York's Avant-Garde," *Art News,* Summer 1951, p. 46.

14. This history is discussed in *Tenth Street Days: The Co-ops of the '50s,* ed. Joellen Bard (New York: Education, Art & Service, 1977), and in Jennifer Samet, *The Jane Street Gallery: Celebrating New York's First Artist Cooperative* (New York: Tibor de Nagy Gallery, 2003).

15. Judith Malina, *The Diaries of Judith Malina, 1947–1957* (New York: Grove Press, 1984), p. 166.

16. Ibid., pp. 214, 224. The poet Robert Creeley has described meeting his wife in New York in 1955 to discuss their separation, and how, "at one point, locked in our argument, . . . we were walking along Eighth Street not far from the Cedar Bar, and suddenly there was Philip Guston, across the street, waving at us." From Robert Creeley, "On the Road: Notes on Artists and Poets, 1950–1965," in Neil A. Chassman, ed., *Poets of the Cities of New York and San Francisco, 1950–1965* (New York: E. P. Dutton, 1974), p. 61.

17. Paul Goodman, *The Empire City* (New York: Bobbs-Merrill, 1959), pp. 372–73. Some of the most striking records of the period—and of what Goodman called "the excitements of these arts"—are to be found in the little magazines. Those published between the late 1940s and the 1960s include: *The Tiger's Eye,* edited by Ruth and John Stephan (New York: The Tiger's Eye Publishing Co.), nos. 1–9, 1947–49; *Possibilities* 1, edited by Robert Motherwell and Harold Rosenberg (New York: Wittenborn, Schultz), no. 1,

Winter 1947–48; *trans/formation*, edited by Harry Holtzman (New York: Wittenborn, Schultz), nos. 1–3, 1950–52; *Folder*, edited by Daisy Aldan and Richard Miller (New York: Tiber Press), nos. 1–4, 1953–56; *It Is*, edited by Philip Pavia (New York: Second Half Publishing Co.), nos. 1–6, 1958–65; *Scrap*, edited by Sidney Geist and Anita Ventura (New York [no publisher name]), nos. 1–8, 1960–62; *Location*, edited by Thomas B. Hess and Harold Rosenberg (New York: Longview Foundation), nos. 1–2, 1963–64; *Art and Literature*, edited by John Ashbery, Anne Dunn, and others (Lausanne, Switzerland: Société anonyme d'éditions littéraires et artistiques), nos. 1–12, 1964–67.

18. William Gaddis, *The Recognitions* (New York: Penguin Books, 1985 [1st ed., 1955]), pp. 213, 305, 175–76.

19. Newman, *Selected Writings*, p. 158.

20. Allen Ginsberg, *Journals: Early Fifties, Early Sixties*, ed. Gordon Ball (New York: Grove Press, 1977), pp. 21, 22.

21. A. Hyatt Mayor in Stanley William Hayter et al., *Atelier 17* (New York: Wittenborn, Schultz, 1949), pp. 4, 6.

22. Carl Holty, *Reflections of Carl R. Holty, a Journal, 1961–1967*, Archives of American Art.

23. Anton Myrer, *Evil Under the Sun* (New York: Random House, 1951), p. 127.

24. Ashbery, *Reported Sightings*, pp. 240–41.

25. Goodman, *The Empire City*, p. 554.

26. E. Sinclair Hertell, ed., *New York City: Guide and Almanac, 1957–1958* (New York: New York University Press, 1957), pp. 233, 240.

27. Saul Steinberg, "Built in U.S.A.," *Art News*, February 1953, p. 16. Harold Rosenberg, *Saul Steinberg* (New York: Knopf, 1978), p. 16.

28. Ad Reinhardt, "Founding Fathers Folly Day," *Art News*, April 1954, pp. 24–25.

29. Thomas B. Hess, "U.S. Painting: Some Recent Directions," *Art News*, December 1956, p. 176.

30. May Natalie Tabak, *But Not for Love* (New York: Horizon Press, 1960), p. 29.

31. Sidney Janis, *Abstract and Surrealist Art in America* (New York: Reynal and Hitchcock, 1944), p. 49. There is a good discussion of Sidney and Harriet Janis's activities on behalf of modern art in Alfred Barr's introduction to *The Sidney and Harriet Janis Collection: A Gift to the Museum of Modern Art* (New York: The Museum of Modern Art, 1968). In 1946 Sidney and Harriet Janis collaborated on *Picasso: The Recent Years, 1939–1946*. Samuel M. Kootz's *New Frontiers in American Painting* (New York: Architectural Book Publishing Co., 1943) included work by Stuart Davis, John Graham, and Adolph Gottlieb. Greenberg wrote tributes to both men: The one to Janis is in *Collected Essays*, vol. 4; the one to Kootz has not been collected (see *Artists of the Kootz Gallery*, Sarasota, FL: The John and Mable Ringling Museum of Art, 1962). There are some very interesting memoirs by dealers, including Peggy Guggenheim's *Out of This Century: The Informal Memoirs of Peggy Guggenheim* (New York: The Dial Press, 1946 [and various later revised editions]), Julien Levy's *Memoir of an Art Gallery* (New York: G. P. Putnam's Sons, 1977), and John Bernard Myers's *Tracking the Marvelous: A Life in the New York Art World* (New York: Random House, 1983). For Levy's gallery—which closed in 1949—see also Ingrid Schaffner and Lisa Jacobs, eds., *Julien Levy: Portrait of an Art Gallery* (Cambridge, MA: MIT Press, 1998). Another useful account of a dealer is Lee Hall's *Betty Parsons: Artist, Dealer, Collector* (New York: Harry N. Abrams, 1991).

32. Aline B. Louchheim, "Betty Parsons: Her Gallery, Her Influence," *Vogue*, October 1, 1951.

33. Kootz Gallery announcements, Kootz Gallery file, Museum of Modern Art Library.

34. Harold Rosenberg in Robert Motherwell and Ad Reinhardt, eds., *Modern Artists in America, No. 1* (New York: Wittenborn, Schultz, 1951), p. 174.

35. Weldon Kees, "Contemporary French Painting; 'Talent 1950,' " *The Nation*, May 6,

1950; reprinted in Weldon Kees, *Reviews and Essays, 1936–1955*, ed. James Reidel (Ann Arbor: University of Michigan Press, 1988), pp. 161–62.

36. Thomas B. Hess in *In Memoriam: Louis Pollack, 1921–1970*, pamphlet, unpaged.

37. Louchheim, "Betty Parsons."

38. Greenberg, *Collected Essays*, vol. 3, p. 256.

39. Malina, *Diaries*, p. 144.

40. Myers, *Tracking the Marvelous*, p. 131.

41. Eleanor Ward interviewed by Paul Cummings, February 8, 1972. Archives of American Art.

42. Lois Orswell quoted in Marjorie B. Cohn, *Lois Orswell, David Smith, and Modern Art* (New Haven, CT: Yale University Press, 2002), pp. 36, 68, 70.

43. Charles R. Simpson, *SoHo: The Artist in the City* (Chicago: University of Chicago Press, 1981), pp. 247–49.

44. Norman Mailer in William Phillips and Philip Rahv, eds., "Our Country and Our Culture: A Symposium," *Partisan Review*, May–June 1952, p. 299.

45. Newman, *Selected Writings*, p. 51.

46. Meyer Schapiro, *Modern Art—19th and 20th Centuries, Selected Papers* (New York: George Braziller, 1978), p. 226. Newman, *Selected Writings*, p. 52.

47. Eric F. Goldman, *The Crucial Decade—and After: America, 1945–1960* (New York: Random House, 1956), pp. 235, 278, 260.

48. Hess, "U.S. Painting," *Art News*, December 1956, p. 174.

49. Greenberg, *Collected Essays*, vol. 2, p. 194.

50. Interview with Joan Miró in Robert Motherwell and Harold Rosenberg, eds., *Possibilities* 1 (New York: Wittenborn, Schultz, 1947), p. 66.

51. Paul Goodman, "Portrait of the Artist," *Partisan Review*, Summer 1962, pp. 450, 448.

52. Motherwell and Reinhardt, eds., *Modern Artists in America*, p. 10.

53. Katharine Kuh, *American Artists Paint the City* (Venice: 28th Biennale, 1956), p. 31.

54. Selden Rodman, *Conversations with Artists* (New York: The Devin-Adair Co., 1957), p. 84.

55. Louis Finkelstein, "Gotham News, 1945–60," in Thomas B. Hess and John Ashbery, eds., *The Avant-Garde: Art News Annual XXXIV* (New York: Macmillan, 1968), pp. 116–17. Hess, *De Kooning: Recent Paintings*, p. 23.

2. THE DIALECTICAL IMAGINATION

1. The very term *Abstract Expressionism* could have a dialectical dimension, for Alfred Barr, in a letter to Philip Pavia, the sculptor who was a key figure at the Club, explained that the term had probably first been used in a 1919 essay in *Der Sturm*, where "the writer contrasts abstract expressionism with 'material expressionism' which still refers to objects from nature" (Barr to Pavia, October 28, 1960, Philip Pavia Papers, Robert W. Woodruff Library, Emory University). An extraordinarily suggestive discussion of the dialectical forces that were at play in mid-century American art is to be found in the chapter "The Problem of Opposites" in William C. Seitz's *Abstract Expressionist Painting in America* (Cambridge, MA: Harvard University Press, 1983). An almost endless number of examples could be given of dialectical thinking, which in many respects pervaded postwar intellectual life. Writers in the *Partisan Review* orbit, including Lionel Abel and Arthur Schlesinger, used the term *counter-enlightenment* to describe the strain in nineteenth- and early-twentieth-century thought that emphasized the importance of the irrational and unstable and instinctual, particularly Nietzsche, Kierkegaard, and Schopenhauer. ("The eighteenth century produced the enlightenment

and the nineteenth the counterenlightenment," Abel wrote in *The Intellectual Follies: A Memoir of Literary Venture in New York and Paris* [New York: W. W. Norton, 1984], p. 180.) Robert Duncan, in a 1956 letter to Denise Levertov, wrote, "Your poetry as a 'room of thinking and knitting . . . cats and woman' is perhaps a counter-style just there to 'cars and people.' " (Robert J. Bertholf and Albert Gelpi, eds., *The Letters of Robert Duncan and Denise Levertov* [Stanford, CA: Stanford University Press, 2004], p. 41.) Philip Rahv's division of classic American writers into Palefaces (such as Henry James) and Redskins (such as Walt Whitman) in the opening essay of his 1949 collection *Image and Idea* (New York: New Directions) was one of many models of dialectically opposed trends that were adopted by critics and historians of art and literature.

2. Friedrich Nietzsche, *The Portable Nietzsche*, ed. and trans. Walter Kaufmann (New York: Penguin Books, 1959), p. 476.

3. Sidney Hook, *Reason, Social Myths and Democracy* (New York: Humanities Press, 1950 [1st ed., 1940]), p. 250. Kenneth Burke, *Counter-Statement* (Berkeley: University of California Press, 1968 [1st ed., 1931]), p. vii.

4. Friedrich Nietzsche, *The Will to Power*, ed. and trans. Walter Kaufmann with R. J. Hollingdale (New York: Random House, 1967), p. 419.

5. Wolfgang Paalen in Wolfgang Paalen, ed., "Inquiry on Dialectical Materialism," *Dyn*, July–August 1942, pp. 57–58. Paalen's own essays were collected as Wolfgang Paalen, *Form and Sense* (New York: Wittenborn and Co., 1945). For Paalen's painting—which includes some calligraphic abstractions of considerable beauty—see Gustav Regler, *Wolfgang Paalen* (New York: Nierendorf Editions, 1946).

6. G.W.F. Hegel, *The Philosophy of Fine Art*, trans. F.P.B. Osmaston (London: G. Bell and Sons, 1920), vol. 1, p. 400.

7. Pat Passlof, "1948," in Bill Berkson and Rackstraw Downes, eds., "Willem de Kooning on his Eighty-fifth Birthday," *Art Journal*, Fall 1989, p. 229.

8. Irving Lewis Allen, *City in Slang* (New York: Oxford University Press, 1993), p. 152.

9. From an interview in Jane Livingston, *New York School Photographs, 1936–1963* (New York: Stewart, Tabori and Chang, 1992), p. 314. Aaron Siskind's artistic development parallels a more general movement among New York artists from social to personal subject matter. In the 1930s, as a member of the Photo League, Siskind explored Harlem, producing an important body of work documenting the lives of Black people; in his early work, black-and-white is a social issue as well as an artistic issue. See Deborah Martin Kao and Charles A. Meyer, *Aaron Siskind: Toward a Personal Vision, 1935–1955* (Chestnut Hill, MA: Boston College Museum of Art, 1994).

10. Johann Wolfgang von Goethe, *The Color Theory* (1810), quoted in David S. Rubin, "Black and White Painting: An Historical Perspective," in David S. Rubin, *Black and White Are Colors: Paintings of the 1950s–1970s* (Claremont, CA: Galleries of the Claremont Colleges, 1979), p. 12. Kasimir Malevich, "Suprematism" (1927), quoted in Rubin, *Black and White*, p. 8.

11. Clement Greenberg, *The Collected Essays and Criticism*, ed. John O'Brian (Chicago: University of Chicago Press, 1986–93), vol. 2, p. 229. Hess later observed that "black and white are the disciplines the artist turns to when he is trying something new, when he wants to move decisively toward unknown areas"; black-and-white "brings an exhilarating sense of the *tabula rasa* to a traditionally overcomplicated craft." (Thomas B. Hess, *Willem de Kooning Drawings* [Greenwich, CT: A Paul Bianchini Book/New York Graphic Society, 1972], p. 33.) Matisse quoted in Jack Flam, *Matisse on Art* (Berkeley: University of California Press, 1995), pp. 165, 156. Harriet Janis and Rudi Blesh, *De Kooning* (New York: Grove Press, 1960), p. 25. Robert Creeley, "A Note on Franz Kline" (1954), in J. D. McClatchy, ed., *Poets on Painters: Essays on the Art of*

Painting by Twentieth-Century Poets (Berkeley: University of California Press, 1988), p. 220. Ben Heller, *Black and White* (New York: The Jewish Museum, 1963), unpaged.

12. Robert Motherwell, *The Collected Writings of Robert Motherwell*, ed. Stephanie Terenzio (New York: Oxford University Press, 1992), pp. 71–72.

13. Morton Feldman, *Give My Regards to Eighth Street: Collected Writings of Morton Feldman* (Cambridge, MA: Exact Change, 2000), pp. 80, 199, 116. John Cage, "A Lecture on Something," *It Is*, Autumn 1959, p. 73.

14. The title of Klee's painting echoes the title of William Hausenstein's 1922 *Barbaren und Klassiker: Ein Buch von der Bildnerei exotischer Völker;* Hausenstein had written a monograph on Klee in 1920. See Virginia Gardner Troy, *Anni Albers and Ancient American Textiles: From Bauhaus to Black Mountain* (Burlington, VT: Ashgate, 2002), p. 32.

15. Donald Kuspit has written an essay called "Dialectical Reasoning in Meyer Schapiro," published in Thomas B. Hess et al., "On the Work of Meyer Schapiro," *Social Research*, Spring 1978, pp. 93–129.

16. Alfred H. Barr, Jr., *Cubism and Abstract Art* (New York: Museum of Modern Art, 1936), pp. 13–14. Kenneth Burke in "The Western Round Table on Modern Art (1949)," in Robert Motherwell and Ad Reinhardt, eds., *Modern Artists in America, No. 1* (New York: Wittenborn, Schultz, 1951), p. 28. Fritz Bultman, "The Achievement of Hans Hofmann," *Art News*, September 1963, p. 43.

17. John D. Graham, *System and Dialectics of Art* (New York: Delphic Studios, 1937), pp. 9, 12.

18. Wolfgang Paalen in Paalen, ed., "Inquiry on Dialectic Materialism," *Dyn*, July–August 1942, p. 50.

19. Greenberg in Paalen, ed., "Inquiry on Dialectic Materialism," p. 50. Clement Greenberg, *Art and Culture* (Boston: Beacon Press, 1961), p. 230.

20. Kahnweiler associates the Cubists' joining of multiple impressions with Kant's saying that the artist can "put together the various conceptions and comprehend their variety in one perception." (Daniel-Henry Kahnweiler, *The Rise of Cubism* [New York: Wittenborn, Schultz, 1949], p. 12.) Max Eastman, *Art and the Life of Action* (New York: Knopf, 1934), pp. 14–15.

21. Hegel, *The Philosophy of Fine Art*, vol. 1, pp. 109–10, 117.

22. Greenberg, *Collected Essays*, vol. 2, p. 224.

23. Robert Motherwell might have been paraphrasing the theme of the Lucerne show when he explained, in 1944, that his painting *Spanish Prison* "consists of a dialectic between the conscious (straight lines, designed shapes, weighed color, abstract language) and the unconscious (soft lines, obscured shapes, *automatism*) resolved into a synthesis which differs as a whole from either." (Quoted in William C. Seitz, "Spirit, Time and 'Abstract Expressionism,' " *Magazine of Art*, February 1953, p. 81.)

24. Gaston Bachelard, "Surrationalism," in Julien Levy, *Surrealism* (New York: Da Capo Press, 1995 [1st ed., 1936]), p. 189. Nancy Jachec—in *The Philosophy and Politics of Abstract Expressionism* (Cambridge, England: Cambridge University Press, 2000)—has a steadier grasp of the intellectual currents at play in the 1940s and 1950s than just about any other historian who has looked at the period, although she is more inclined than I am to see political experience as shaping artistic experience.

25. Wolfgang Paalen, "The Dialectical Gospel," *Dyn*, July–August 1942, p. 56.

26. Sam Hunter, *Modern American Painting and Sculpture* (New York: Dell Publishing Co., 1959), p. 156.

27. Hans Hofmann, statement in *Contemporary American Painting and Sculpture: 1955* (Urbana: University of Illinois, 1955), pp. 207–8. Maurice Merleau-Ponty, "Hegel's

Existentialism," in *Sense and Non-Sense*, intro. and trans. Hubert L. Dreyfus and Patricia Allen Dreyfus (Evanston, IL: Northwestern University Press, 1964), p. 65.

28. Thomas B. Hess, "U.S. Painting: Some Recent Directions," *Art News*, December 1956, p. 86. Many people explained the rising postwar interest in Freud and psychoanalysis, in existentialism, in Zen, and in the philosophy of Krishnamurti as responses to a void left by the eclipse of Marxism. Hess praised the sculptor Philip Pavia for being "among the first to pick up Zen and among the first to let it drop." (Thomas B. Hess, *First One-Man Exhibition of Sculpture by Philip Pavia* [New York: Kootz Gallery, 1961], unpaged.)

29. Edwin Denby, *Dancers, Buildings, and People in the Streets* (New York: Horizon Press, 1965), pp. 263–64.

30. Engels quoted in Michael Rosen, *Hegel's Dialectic and Its Criticism* (Cambridge, England: Cambridge University Press, 1982), p. 27. Thomas B. Hess, *Willem de Kooning* (New York: Museum of Modern Art, 1968), p. 16.

31. Thomas B. Hess, *Abstract Painting: Background and American Phase* (New York: Viking Press, 1951), p. 99. Hess, "U.S. Painting," pp. 88–89.

32. Hess, *Abstract Painting*, p. 98. Hess, "U.S. Painting," pp. 176, 180.

33. Hess, "U.S. Painting," p. 180.

34. Fritz Bultman, statement in an unpublished *Notebook on Nature and Time* (c. 1960), Archives of American Art.

35. You might even say that dialectical thinking had been domesticated. In one of her short stories, Mary McCarthy describes the idle talk of a young couple by explaining, "Every social assertion Nancy and Jim made carried its own negation with it, like an Hegelian thesis. Thus it was always being said by Nancy that someone was a Communist but a terribly nice man, while Jim was remarking that someone else worked for Young and Rubicam but was astonishingly liberal." (McCarthy quoted by Elizabeth Hardwick in the foreword to Mary McCarthy, *Intellectual Memoirs: New York, 1936–1938* [New York: Harcourt Brace Jovanovich, 1992], p. xii.)

36. Anatole Broyard, "A Portrait of the Hipster," in Chandler Brossard, ed., *The Scene Before You: A New Approach to American Culture* (New York: Rinehart & Co., 1955), p. 116.

37. Fairfield Porter, *Art in Its Own Terms: Selected Criticism, 1935–1975*, ed. Rackstraw Downes (New York: Taplinger Publishing, 1979), p. 235.

38. Robert Creeley, "On the Road: Notes on Artists and Poets, 1950–1965," in Neil A. Chassman, ed., *Poets of the Cities of New York and San Francisco, 1950–1965* (New York: E. P. Dutton, 1974), p. 56.

39. William Carlos Williams, "Descent," in Chassman, *Poets of the Cities*, p. 57.

40. Wallace Stevens, *Collected Poetry and Prose* (New York: The Library of America, 1997), p. 917.

41. Ibid., p. 751. Dore Ashton cites the discussions of Stevens's talk in Sandra Kraskin and Glen MacLoud, *Painting in Poetry/Poetry in Painting: Wallace Stevens and Modern Art* (New York: Sidney Mishkin Gallery, Baruch College, 1995), p. 20.

42. Stevens, "Connoisseur of Chaos," in *Collected Poetry and Prose*, pp. 194–95.

43. Denby, *Dancers*, pp. 261–62.

44. Thomas B. Hess, *Willem de Kooning* (New York: George Braziller, 1959), p. 23.

3. THE PHILOSOPHER KING

1. Robert Creeley, "Bill the King," in Bill Berkson and Rackstraw Downes, eds., "Willem de Kooning on his Eighty-fifth Birthday," *Art Journal*, Fall 1989, p. 238. Robert

Rauschenberg statement, ibid., p. 232. Burckhardt, "Long Ago with Willem de Kooning," ibid., p. 224.

2. Kenneth Koch quoted in Marjorie Perloff, *Frank O'Hara: Poet Among Painters* (Austin: University of Texas, 1979), p. 81. Frank O'Hara, "Radio," in Frank O'Hara, *The Collected Poems of Frank O'Hara*, ed. Donald Allen (New York: Knopf, 1971), p. 234.

3. I heard the painter Charles Cajori recall de Kooning's description of the drunken man at a gathering at the New York Studio School shortly after the artist's death in 1997. The anecdote is also repeated in Irving Sandler, *A Sweeper-up After Artists: A Memoir* (New York: Thames & Hudson, 2003), p. 48.

4. Willem de Kooning, *The Collected Writings of Willem de Kooning* (New York: Hanuman Books, 1988), pp. 28–29, 10–11.

5. Ibid., p. 12.

6. Robert Motherwell, "The Modern Painter's World," *Dyn*, November 1944, p. 11. Clement Greenberg, *The Collected Essays and Criticism*, ed. John O'Brian (Chicago: University of Chicago Press, 1986–93), vol. 2, pp. 15–16.

7. Myron Stout quoted in Sanford Schwartz, *Myron Stout* (New York: Whitney Museum of American Art, 1980), p. 80. Fairfield Porter, *Art in Its Own Terms: Selected Criticism, 1935–1975*, ed. Rackstraw Downes (New York: Taplinger Publishing, 1979), p. 75.

8. Harriet Janis and Rudi Blesh, *De Kooning* (New York: Grove Press, 1960), p. 11.

9. Burckhardt, "Long Ago with Willem de Kooning," p. 224.

10. Edwin Denby, *Dancers, Buildings, and People in the Streets* (New York: Horizon Press, 1965), p. 265.

11. Ibid., p. 261. Edwin Denby, *The Complete Poems* (New York: Random House, 1986), p. 10. Denby, *Dancers*, p. 262.

12. Burckhardt, "Long Ago with Willem de Kooning," pp. 224, 222.

13. Denby, *Dancers*, p. 265.

14. Greenberg, *Collected Essays*, vol. 4, p. 19.

15. Dorothy Dehner, foreword to John Graham, *System and Dialectics of Art* (Baltimore: Johns Hopkins Press, 1971 [1st ed., 1937]), p. xv.

16. Ibid., p. xviii.

17. Graham also published a volume of poems, *Have It!*, in New York in 1923; and among his papers at the Archives of American Art are a long memoir of his childhood and drafts of a later treatise on art and philosophy that is organized alphabetically, with entries such as "Duality," "Equality," and "Newness." The best guide to his life remains Eleanor Green, *John Graham, Artist and Avatar* (Washington, DC: Phillips Collection, 1987).

18. Graham, *System and Dialectics of Art* (1937), pp. 75, 123, 45, 28.

19. Ibid., pp. 30, 123.

20. Graham and de Kooning were not the only Americans who were taking an interest in these artists. Gorky, who was close to both Graham and de Kooning, did several pencil drawings of peasant girls that are identified as "after Le Nain," although they do not appear to be based on a painting included in the Knoedler show. (See *Arshile Gorky: Portraits* [New York: Gagosian Gallery, 2002], p. 83.) Chick Austin, a student in the famous museum studies program at Harvard who had become the youthful director of the Wadsworth Atheneum in Hartford in 1927, purchased a Le Nain for the museum, *Peasants in a Landscape*, in 1931; and Alfred Barr, who knew Austin from Harvard days, had mentioned the Le Nains among the great artists to whom the nineteenth-century American painter George Caleb Bingham could be compared in the preface to the catalog of the Bingham show mounted at the Modern in 1935.

21. Janis and Blesh, *De Kooning*, p. 13. Selden Rodman, *Conversations with Artists* (New York: Devin-Adair, 1957), p. 103.

22. See Jacques Thuillier and Michel Laclotte, *Les Frères Le Nain* (Paris: Éditions de la Réunion des musées nationaux, 1978).

23. John Graham Papers, Archives of American Art.

24. See Paul Fierens, *Les Le Nain* (Paris: Librairie Floury, 1933). There has always been a connection between the fascination with the Le Nain brothers and avant-garde taste, for it was Champfleury, the great supporter of Courbet, who spearheaded the revival of interest in the Le Nains in the mid-nineteenth century. And it was in part by studying the work of the Le Nains that Courbet learned how a vehemently realistic technique could be used to shatter compositional conventions and forge a new kind of rough-hewn painterly style. The impact of their studies of figures gathered around a table, sometimes playing cards, can also be felt in Cézanne's paintings of cardplayers; see Theodore Reff, "Cézanne's 'Cardplayers' and Their Sources," *Arts*, November 1980, pp. 104–17.

25. Jean Hélion, "La Réalité dans la peinture," *Cahiers d'Art* 9–10 (1934), p. 253.

26. To move between Picasso and the Le Nains in New York was to experience a connection that Wilhelm Uhde—a pioneering dealer in and interpreter of Cubism and primitivism whom Graham cites—had emphasized a few years earlier in his book *Picasso and the French Tradition*. There the Le Nains are, along with Chardin, Géricault, Courbet, Daumier, Corot, and Manet, part of the noble tradition that leads to Picasso—the artist with whom all the New York avant-garde was obsessed. (Wilhelm Uhde, *Picasso and the French Tradition* [Paris: Éditions des Quatre Chemins, 1929], p. 13.)

27. Graham, *System and Dialectics of Art* (1937), pp. 126, 51. Uhde, *Picasso and the French Tradition*, p. 37.

28. Graham, *System and Dialectics of Art* (1937), p. 108.

29. Denby, *Dancers*, p. 261.

30. Graham, *System and Dialectics of Art* (1937), p. 108.

31. Edwin Denby, *Looking at the Dance* (New York: Pellegrini and Cudahy, 1949), p. 269.

32. There is an iron sculpture of Harlequin by Julio González—whose work would have so profound an effect on Graham's friend David Smith—that is dated 1930–31. Here a plane with a filigreed diamond pattern feels detached from the figure, seems to have a "life of its own," much like the diamond plane in de Kooning's painting. (Versions of *Harlequin*—sometimes called *Pierrot*—are in the Albright-Knox Gallery, Buffalo, NY, and the Kunsthaus, Zurich.)

33. Graham, *System and Dialectics of Art* (1937), p. 118. In 1940, in the midst of the portraits of Denby and Burckhardt, de Kooning painted a *Classic Male*, a Hercules with huge muscles; Graham bought this painting from de Kooning. Graham's Hercules sounds like the young de Kooning, struggling in his studio, laboring at his art with little to show for it.

34. Ibid.

35. Thomas B. Hess, *Abstract Painting: Background and American Phase* (New York: Viking Press, 1951), p. 104.

36. Charmion von Wiegand, *Drawings by John Graham* (New York: Pinacotheca Gallery, 1946).

37. De Kooning, *Collected Writings*, p. 67. Arthur Symons quoted in Hugh Kenner, *The Pound Era* (Berkeley: University of California Press, 1973 [1st ed., 1972]), p. 70. Kenner, *Pound Era*, p. 69.

38. Porter, *Art in Its Own Terms*, p. 163.

39. De Kooning, *Collected Writings*, p. 11. Louis Finkelstein, "Marin and de Kooning," *Magazine of Art*, October 1950, p. 206. De Kooning, *Collected Writings*, p. 34.

40. De Kooning, *Collected Writings*, p. 56. Graham, *System and Dialectics of Art* (1937), p. 96.
 De Kooning, *Collected Writings*, p. 56. Graham, *System and Dialectics of Art* (1937), p. 96.

41. De Kooning, *Collected Writings*, p. 12. De Kooning quoted in Marla Prather, *Willem de Kooning: Paintings* (New Haven, CT: Yale University Press, 1994), p. 127.

42. De Kooning, *Collected Writings*, pp. 40–41. For texts of all the talks given at the Modern's "What Abstract Art Means to Me" evening, see "What Abstract Art Means to Me: Statements by Six American Artists," *The Museum of Modern Art Bulletin*, Spring 1951.

43. De Kooning, *Collected Writings*, pp. 30–31.

44. Meyer Schapiro, "On a Painting of Van Gogh," in Charles Henri Ford, ed., *View: Parade of the Avant-Garde, 1940–1947* (New York: Thunder's Mouth Press, 1991), p. 231.

45. De Kooning, *Collected Writings*, p. 21. When "The Renaissance and Order" was published in *trans/formation* in 1951, one of the illustrations was a de Kooning *Woman* from 1950, a figure somewhat less dissolved in brushstrokes than the women he would be doing a few years later. And you can see that the woman is in a room, for in the upper left, inscribed with a few lines, is the suggestion of a window or a picture frame in perspective. This arrangement suggests the corners of rooms in Renaissance portraits, except that de Kooning's evocation is so sketchy that it can seem as if the woman is dreaming up the very room she inhabits.

46. Ibid., pp. 57, 45, 44.

47. Ibid., pp. 50–51.

48. Ibid., pp. 62–63, 64, 35–36.

49. Dehner, foreword to Graham, *System and Dialectics of Art* (1971), p. xv.

4. "I CONDEMN AND AFFIRM, SAY NO AND SAY YES"

1. Ralph Ellison, *Invisible Man* (New York: Vintage Books, 1972 [1st ed., 1952]), p. 566.

2. B. H. Friedman, *Between the Flags: Uncollected Stories, 1948–1990* (Boulder, CO: Fiction Collective Two, 1990), pp. 29, 30, 31.

3. Thomas B. Hess, *Willem de Kooning Drawings* (Greenwich, CT: A Paul Bianchini Book/New York Graphic Society, 1972), p. 17. Jack Tworkov, "Color," *It Is*, Spring 1960, p. 4. George McNeil quoted in William C. Seitz, *Abstract Expressionist Painting in America* (Cambridge, MA: Harvard University Press, 1983), p. 56. McNeil, "Sensation and Modern Painting," in *The Paintings of George McNeil* (Austin: The University Art Museum of the University of Texas, 1966), p. 6. George Sugarman, "Statement," *It Is*, Winter–Spring 1959, p. 49. Philip Pavia, "Excavations in Non-History," *It Is*, Autumn 1959, p. 4. Willem de Kooning in Irving Sandler, "The Club," in Philip Leider, ed., "The New York School," *Artforum*, September 1965, p. 31. Clement Greenberg, *Art and Culture* (Boston: Beacon Press, 1961), p. 45. Harold Rosenberg, *The Tradition of the New* (New York: Horizon Press, 1959), p. 21. McNeil, "Spontaneity," *It Is*, Winter–Spring 1959, p. 15. Seitz, *Abstract Expressionist Painting*, p. 144. Allan Kaprow, *Essays on the Blurring of Art and Life*, ed. Jeff Kelley (Berkeley: University of California Press, 1993), pp. 16, 17. Ad Reinhardt, *Art as Art: The Selected Writings of Ad Reinhardt*, ed. Barbara Rose (Berkeley: University of California Press, 1991 [1st ed., 1975]), p. 50.

4. Mercedes Matter, "What's Wrong with U.S. Art Schools?," *Art News*, September 1963, p. 40.

5. Albert Camus, "Art and Revolt," *Partisan Review*, May–June 1952, p. 272.

6. John Ashbery, *Reported Sightings: Art Chronicles, 1957–1987*, ed. David Bergman (New York: Knopf, 1989), pp. 195–97.

7. Dwight Macdonald, "The Root Is Man: Part Two," *politics*, July 1946, pp. 210, 213.

8. Frank O'Hara and Larry Rivers in Frank O'Hara, *Amorous Nightmares of Delay: Selected Plays* (Baltimore: Johns Hopkins University Press, 1997 [1st ed., 1978]), pp. 126–27, 131.

9. Harold Rosenberg, *The Anxious Object* (New York: Collier Books, 1973 [1st ed., 1964]), p. 147.

10. Lionel Abel, *The Intellectual Follies: A Memoir of Literary Venture in New York and Paris* (New York: W. W. Norton, 1984), pp. 217, 210.

11. Willem de Kooning, *The Collected Writings of Willem de Kooning* (New York: Hanuman Books, 1988), p. 50. De Kooning's dissent was foreshadowed in W. H. Auden's poem "Letter to William Coldstream, Esq.," published in *Letters from Iceland* in 1937. "We'd scrapped Significant Form, and voted for Subject," Auden wrote of a conversation with Coldstream, an English painter then at the very beginning of his career. (W. H. Auden and Louis MacNeice, *Letters from Iceland* [New York: Random House, 1937], p. 222.)

12. Clive Bell, *Art* (London: Chatto & Windus, 1914), pp. viii, 7, 8.

13. Jacqueline V. Falkenheim, in *Roger Fry and the Beginnings of Formalist Art Criticism*, writes that while "it is not possible to prove any direct influence" on Bell and Fry by Hildebrand and another late-nineteenth-century formalist, his friend Conrad Fiedler, "the general infiltration of German aesthetic ideas into British thought is easily imaginable"—and all this, of course, had had its impact in the United States. (Falkenheim, *Roger Fry and the Beginnings* [Ann Arbor, MI: UMI Research Press, 1980], p. 52.) There are far more immediate connections that can be drawn between Hildebrand's book and American art. Hans Hofmann had been urging students to read Hildebrand since his Munich days, and you can see why. "In the reciprocal way in which the whole and the parts work together for their spatial effect," Hildebrand wrote, "we recognize the artistic connection of the parts to the whole—the articulation of the appearance as an artistic organism." (Harry Francis Mallgrave and Eleftherios Ikonomou, intro. and trans., *Empathy, Form, and Space: Problems in German Aesthetics, 1873–1893* [Santa Monica, CA: The Getty Center, 1994], p. 240.) Although Hildebrand's book had first appeared in the United States in 1907, a reprint was published in 1945 by the original publisher, G. E. Stechert of New York—which increases the likelihood that artists would have seen the book in the late 1940s and 1950s. There is another interesting connection between Hildebrand and modern art in America, for Elie Nadelman, the sculptor whose rapturous classicism and striking reinterpretations of American folk art were the subject of a good deal of attention, including a Museum of Modern Art retrospective almost immediately after his death in 1946, seems to have known Hildebrand's book from his time in Germany. Nadelman had published, in Alfred Stieglitz's magazine *Camera Work* in 1910, a statement that suggests the influence of Hildebrand and that is often seen as prefiguring Clive Bell's ideas, for Nadelman says that "the subject of any work of art is for me nothing but a pretext for creating significant form, relations of forms which create a new life that has nothing to do with life in nature, a life from which art is born, and from which spring style and unity." (Lincoln Kirstein, *Elie Nadelman* [New York: Eakins Press, 1973], p. 265.)

14. Clement Greenberg, *Homemade Esthetics: Observations on Art and Taste* (New York: Oxford University Press, 1999), p. 164.

15. Holger Cahill, foreword to Jean Lipman, *American Folk Art in Wood, Metal and Stone* (New York: Pantheon, 1948), p. 23. Dorothy C. Miller, an influential curator at the Museum of Modern Art in the 1940s and 1950s, who was married to Cahill, wrote an interesting article, "Discovery and Rediscovery," in a special 1945 issue of *Art in America* called "Research in American Art." She observed that the "initial impetus" for these new directions in art history "came from an awakened interest in our native tradition

and a felt need to provoke a more substantial background for the contemporary development." (Miller, "Discovery and Rediscovery," *Art in America,* October 1945, p. 255.) That many aspects of the American past had contemporary appeal had been taken as a matter of course at the Museum of Modern Art since the museum was founded. In 1930, only a year old, the Modern had mounted "Homer, Ryder, Eakins." A selection of shows held in the next dozen or so years included "American Folk Art" and "Early Modern Architecture: Chicago, 1870–1910" in 1933; a George Caleb Bingham retrospective in 1935; "American Folk Art" again in 1938; "Indian Art of the United States" and "The Wooden House in America" in 1941; "Romantic Painting in America" in 1943; and "American Battle Painting, 1776–1918" in 1944. The Metropolitan Museum of Art sponsored a painting show, "Life in America," to coincide with the 1939 World's Fair, and did a good deal to draw attention to the formal beauties of American folk art in the 1940s. There was also a constant flow of gallery shows devoted to folk art, especially those mounted by Edith Halpert at her Downtown Gallery, beginning in the mid-1930s.

16. Barnett Newman, *Selected Writings and Interviews,* ed. John P. O'Neill (New York: Knopf, 1990), p. 174. There was also a group of artists who were known as the Indian Space Painters, including Steve Wheeler, Will Barnet, Peter Busa, and Howard Daum, who often found inspiration in the sleek, curving, labyrinthine imagery of Northwest Coast Indian art.

17. Anni Albers, who had begun weaving at the Bauhaus, and would become the most influential weaver in America, revered Peruvian textiles. In Central and South America, she found precisely the kind of pre- or anti-Renaissance idea of the unity of the arts that had inspired the return to crafts traditions at the Bauhaus. Her statement about "the magic of things not yet found useful" is from *Anni Albers: Pictorial Weavings* (Cambridge, MA: MIT Press, 1959). Her 1965 essay collection, *On Weaving,* is "dedicated to my great teachers, the weavers of ancient Peru." (Albers, *On Weaving* [Middletown, CT: Wesleyan University Press, 1965], p. 5.) Of a weaving of a bird found in Northern Peru and dating perhaps as far back as 2500 B.C., she wrote that "wherever meaning has to be conveyed by means of form alone, where, for instance, no written language exists to impart descriptively such meaning, we find a vigor in this direct, formative communication often surpassing that of cultures that have other, additional methods of transmitting information." (Ibid., pp. 67–68.) "Anni Albers Textiles" was mounted at the Museum of Modern Art in 1949, and six years later there was an exhibition called "Ancient Arts of the Andes" at the museum. See the outstanding study by Virginia Gardner Troy, *Anni Albers and Ancient American Textiles: From Bauhaus to Black Mountain* (Burlington, VT: Ashgate, 2002).

18. Dore Ashton in Joellen Bard, ed., *Tenth Street Days: The Co-ops of the '50s* (New York: Education, Art and Service, 1977), p. vi.

19. Newman, *Selected Writings,* p. 52. Newman's final statement on the entire subject of critics and historians and art, first made at a conference at Woodstock in 1952 and restated in a more succinct manner in an interview in 1970, was "aesthetics is for me like ornithology must be for the birds." (Ibid., p. 304.)

20. Meyer Schapiro, "Style," in *Theory and Philosophy of Art: Style, Artist, and Society* (New York: George Braziller, 1994), p. 55.

21. Thomas B. Hess, "Sketch for a Portrait of the Art Historian Among Artists," in Thomas B. Hess et al., "On the Work of Meyer Schapiro," *Social Research,* Spring 1978, p. 12.

22. Bernice Rose, in a recent essay on Rothko, cites Panofsky's ideas about perspective and observes that in the postwar years "his ideas were widely circulated through the New York art world," although she does not offer any specific evidence for this assertion. (Bernice Rose, *Rothko: A Painter's Progress: The Year 1949* [New York: Pace Wildenstein, 2004], p. 26.)

23. John Bernard Myers, *Tracking the Marvelous: A Life in the New York Art World* (New York: Random House, 1983), p. 44.

24. Greenberg, *Collected Essays,* vol. 2, p. 51. Pavia Collection, Archives of American Art. Joseph Frank, *The Idea of Spatial Form* (New Brunswick, NJ: Rutgers University Press, 1991), p. 54.

25. Heinrich Bluecher, "Style and the Magic of Form," *Saturday Review of Literature,* April 7, 1951, p. 46. Writing in the *Saturday Review,* Bluecher said that he was struck by the resurgence in the mid-century years of a hunger for what Nietzsche, who had spoken so often about Dionysus, called "a Grand Style . . . the wish to see the arts, which had been reduced in the absence of a style in the nineteenth century to purely individual relevance, regain their community relevance." Ad Reinhardt quoted in *It Is,* Spring 1960, p. 38.

26. Christopher S. Wood, ed., *The Vienna School Reader: Politics and Art Historical Method in the 1930s* (New York: Zone Books, 2000), p. 26.

27. In the postwar years, there was also a tendency to see Riegl's ideas as illiberal or anti-democratic. E. H. Gombrich, in *Art and Illusion,* which was first presented as a series of lectures at the National Gallery in Washington, DC, in the late 1950s, attacked Riegl for "holding a view that style is the expression of a collectivity" that could weaken what Gombrich called "resistance to totalitarian habits of mind." (Margaret Iverson, *Alois Riegl: Art History and Theory* [Cambridge, MA: MIT Press, 1993], p. 4.) But Joseph Frank pointed out that there were more connections between Gombrich and Riegl than Gombrich would acknowledge. They both believed "that styles are not a mere mechanical product of a certain level of technical skill but the result of a different way of 'seeing' the world in terms of a cultural tradition." (Frank, *The Idea of Spatial Form,* p. 189.) What precisely *Kunstwollen* meant to Riegl, not to mention to those who were influenced by him, has always remained murky. Riegl's ideas changed during his lifetime; and, as one art historian observes, "The meaning of this controversial term has never been clearly established." (Margaret Olin, *Forms of Representation in Alois Riegl's Theory of Art* [University Park: Pennsylvania State University Press, 1992], p. 148.) But if *Kunstwollen* remains hard to pin down, so much so that it has been said of the likes of Panofsky and Gombrich that in critiquing Riegl they misunderstood both him and their own relationship to him, the vagueness and vagaries of *Kunstwollen* could also be part of its pull for artists. It has been observed that "there is a theoretical void behind the *Kunstwollen,*" but that void, paradoxically, gave the idea an airy grandeur that postwar New York artists and their supporters could occupy, colonize, make their own—even, admittedly, without exactly knowing that this is what they were doing. (Wood in Wood, ed., *Vienna School Reader,* p. 27.)

28. Robert Goldwater, *Primitivism in Modern Painting* (New York: Harper and Brothers, 1938), p. 27.

29. Abel, *Intellectual Follies,* p. 211.

30. Wolfgang Paalen, "The New Image," *Dyn,* April–May 1942, p. 9.

31. Seitz, *Abstract Expressionist Painting,* p. 27.

32. Schapiro, *Theory and Philosophy of Art,* p. 51.

33. Thomas B. Hess, *Willem de Kooning* (New York: George Braziller, 1959), p. 7.

34. Meyer Schapiro, "Einstein and Cubism: Science and Art," in *The Unity of Picasso's Art* (New York: George Braziller, 2000), pp. 87–88.

35. Robert Rosenblum, "The Abstract Sublime," in *On Modern American Art: Selected Essays* (New York: Harry N. Abrams, 1999), p. 78.

36. Newman, *Selected Writings,* pp. 216–17.

37. Marla Prather writes, "According to William S. Lieberman of the Metropolitan, de Kooning liked to peruse the *Metropolitan Museum Bulletin,* where Bruegel's prints of

'The Seven Vices' were illustrated in 1943. In the summer of 1969, de Kooning made a drawing, *Untitled (Spoleto)* (National Gallery of Art, Washington), after Bruegel's *Parable of the Blind*." (Marla Prather, *Willem de Kooning: Paintings* [New Haven, CT: Yale University Press, 1994], pp. 102–3.) Some of these themes are further explored in David Anfam, "De Kooning, Bosch, and Bruegel: Some Fundamental Themes," *The Burlington Magazine*, October 2003, pp. 705–15.

38. Seymour Lipton quoted in Sam Hunter, *Modern American Painting and Sculpture* (New York: Dell Publishing, 1959), p. 177.

39. Erwin Panofsky quoted in Harriet Janis and Rudi Blesh, *De Kooning* (New York: Grove Press, 1960), p. 28.

40. Hess, *De Kooning Drawings*, p. 58. Ralph Ellison, *The Collected Essays of Ralph Ellison* (New York: Modern Library, 1995), p. 257. In 1945, when Schapiro reviewed a new book about Flemish art—*The Last Flowering of the Middle Ages*, by Baron Joseph van der Elst—in *View*, he expressed a good deal of skepticism about any connection between the art of the late Middle Ages and the art of the present, because, as he put it, "our own art is neither religious nor realistic," and yet the very fact that he felt he had to deny the connection suggests that some were making it. Greenberg also wrote about van der Elst's book in *The Nation* on August 11, 1945. It is surely not insignificant that Schapiro and Greenberg, two writers with close ties to the downtown artists, took an interest in this book. (Schapiro, "Flemish Art Reconsidered, a Review of *The Last Flowering of the Middle Ages*, by Baron Joseph van der Elst," *View*, March 1945, p. 49; Greenberg, *Collected Essays*, vol. 2, pp. 30–34.)

41. C. L. Wysuph, *Jackson Pollock: Psychoanalytic Drawings* (New York: Horizon Press, 1970), pp. 10, 15.

42. P. D. Ouspensky, *A New Model of the Universe* (New York: Knopf, 1951), p. 11. Marjorie B. Cohn, *Lois Orswell, David Smith, and Modern Art* (New Haven, CT: Yale University Press, 2002), p. 18.

43. Irving Sandler, "The Club," *Artforum*, September 1965, p. 27.

44. Robert Goldwater, "Reflections on the New York School," *Quadrum* VIII (1960), p. 24. My account of the Club is mainly derived from: Irving Sandler, "The Club," *Artforum*, September 1965; Irving Sandler, *A Sweeper-up After Artists: A Memoir* (New York: Thames & Hudson, 2003); Lewin Alcopley, "The Club," *4 Issue: A Journal for Artists*, Fall 1985; Gerald Nordland, *Philip Pavia* (Washington, DC: Washington Gallery of Modern Art, 1966); and material in the Pavia Archive of the Archives of American Art.

45. Philip Pavia, "The Unwanted Title: Abstract Expressionism," *It Is*, Spring 1960, pp. 9–10. B. H. Friedman, *Jackson Pollock: Energy Made Visible* (New York: McGraw-Hill Book Co., 1974 [1st ed., 1972]), pp. 253–54. Fairfield Porter quoted in Rackstraw Downes, introduction to Porter, *Art in Its Own Terms: Selected Criticism, 1935–1975*, ed. Rackstraw Downes (New York: Taplinger Publishing, 1979), pp. 21–22.

46. Robert Goldwater, "Everyone Knew What Everyone Else Meant," *It Is*, Autumn 1959, p. 35.

47. Jack Tworkov, "Four Excerpts from a Journal," *It Is*, Autumn 1959, p. 12.

48. Thomas B. Hess, *First One-Man Exhibition of Sculpture by Philip Pavia* (New York: Kootz Gallery, 1961), unpaged.

49. Robert Goldwater mentions the revival of bronze casting in "Art Chronicle: Masters of the New," *Partisan Review*, Summer 1962, p. 419.

50. Abel, *Intellectual Follies*, p. 207.

51. Letter to Lawrence Campbell, June 26, 1960, courtesy Anne Porter. Letter to Laurence Porter, March 10, 1956, in *Material Witness: The Selected Letters of Fairfield Porter*, ed. Ted Leigh (Ann Arbor: University of Michigan Press, 2005), p. 149.

52. James Schuyler letter to Jane Freilicher, November 3, 1954, in *Pressed Wafer: A Boston Review,* March 2000, p. 70.

53. Robert Goldwater, "Minding the Artist," *Magazine of Art,* March 1952, p. 98.

54. Schapiro, *Theory and Philosophy of Art,* pp. 139–40, 135.

55. Seitz, *Abstract Expressionist Painting,* pp. 101, 102.

56. Frank O'Hara, *Standing Still and Walking in New York,* ed. Donald Allen (San Francisco: Grey Fox Press, 1983), pp. 33–34, 35.

57. De Kooning, *Collected Writings,* p. 43.

58. George Moore quoted in Adrian Frazier, *George Moore, 1852–1933* (New Haven, CT: Yale University Press, 2000), p. 63.

59. Greenberg, *Collected Essays,* vol. 2, p. 157. Thomas B. Hess, *Abstract Painting: Background and American Phase* (New York: Viking Press, 1951), p. 28. Porter, *Art in Its Own Terms,* p. 180. Kenneth Burke, *Counter-Statement* (Berkeley: University of California Press, 1968 [1st ed., 1931]), pp. 186, 187.

60. Martica Sawin, "Robert De Niro," typescript, p. 64.

61. Sidney Tillim, "What Happened to Geometry?," *Arts,* June 1959, pp. 43–44.

62. Robert Motherwell, *The Collected Writings of Robert Motherwell,* ed. Stephanie Terenzio (New York: Oxford University Press, 1992), p. 67.

63. Alfred Russell in *University of Illinois Exhibition of Contemporary American Painting: 1952* (Urbana, IL: College of Fine and Applied Arts, 1952), p. 228.

SOME VERSIONS OF ROMANTICISM

5. HEROES

1. Eugene Jolas, "Romanticism Is Not Dead," in Eugene Jolas, ed., *Vertical: A Yearbook for Romantic-Mystic Ascensions* (New York: Gotham Book Mart Press, 1941), p. 157.

2. Barnett Newman, *Selected Writings and Interviews,* ed. John P. O'Neill (New York: Knopf, 1990), p. 173. G.W.F. Hegel, *The Philosophy of Fine Art,* trans. F.P.B. Osmaston (London: G. Bell and Sons, 1920), vol. 1, pp. 109, 108.

3. Mark Rothko, "The Romantics Were Prompted," in Robert Motherwell and Harold Rosenberg, eds., *Possibilities* 1 (New York: Wittenborn, Schultz, 1947), p. 84.

4. Clement Greenberg, *The Collected Essays and Criticism,* ed. John O'Brian (Chicago: University of Chicago Press, 1986–93), vol. 1, pp. 241, 242.

5. Ibid., vol. 1, pp. 203–4. To the literary critic Morse Peckham, who in 1951 published a much-discussed essay called "Toward a Theory of Romanticism," the key to Romanticism was what he called "dynamic organicism." (Morse Peckham, *The Triumph of Romanticism: Collected Essays* [Columbia: University of South Carolina Press, 1970], pp. 3–26.) Peckham and his ideas were quickly recognized as being relevant to the contemporary visual arts; Robert Goldwater published an essay by Peckham, "The Triumph of Romanticism," in the *Magazine of Art,* November 1952 (a month before Rosenberg's "The American Action Painters" appeared in *Art News*). "An organism," Peckham wrote in 1951 in words that might almost have been Hofmann's, "has the quality of life. It does not develop additively; it grows organically. The universe is alive. It is not something made, a perfect machine; it grows." (Peckham, *The Triumph of Romanticism,* p. 10.) This idea was what Peckham called Positive Romanticism. Romanticism's values, according to Peckham, are change, imperfection, growth, diversity, the creative imagination, and the unconscious, and for Peckham, Positive Romanticism existed in a complex counterpoint with what he called Negative

Romanticism, which might also create a powerful artistic image, but not necessarily be a conclusive or thoroughly coherent one. This seems to suggest de Kooning's thinking; his black-and-white abstractions of the late 1940s have that crushed, inward-turning, anti-organic organic power, as if every possibility for growth were presented and then botched, turned inside out.

6. Hans Hofmann quoted in Robert Motherwell and Ad Reinhardt, eds., *Modern Artists in America, No. 1* (New York: Wittenborn, Schultz, 1951), p. 21. Théophile Gautier, a participant in the nineteenth-century Romantic movement who later wrote its great history, might have been writing about Hofmann's late work when he observed that "the things passionately loved in youth should be continued in the maturity of talent, not, however, chastened and made cold, but spurred on and driven onwards with even greater fire and fury, following those men of genius who, as they grow older, become grimmer and prouder, more ardent and fiercer, exaggerating their own characteristics constantly, as did Rembrandt, Michael Angelo, and Beethoven." (Théophile Gautier, "Madame Dorval," in *A History of Romanticism*, in *The Works of Théophile Gautier*, ed. and trans. F. C. de Sumichrast [New York: George D. Sproul, 1902], vol. 16, p. 227.)

7. Martica Sawin, "Robert De Niro," typescript, pp. 29, 25. Sawin has described the figure of a woman in *Venice at Night* as being "uncannily" like a figure in Fuseli's *Nightmare*— one of the iconic Romantic images. There is a great more anecdotal information connecting the mid-century generation to the Romantics. Clyfford Still did a self-portrait based on Delacroix in 1939. Motherwell, while in graduate school at Harvard in 1937 and 1938, took a course called "The Idea of Romanticism" and was studying Delacroix's *Journal*, that supreme document of the Romantic movement. Although by 1940 he had, as he later wrote, "abandoned scholarship for painting for good, . . . the image of Delacroix's alert and cultivated mind constantly rolling, like an ever-changing tide, over the rocky questions of *l'art moderne*, an art made by self-chosen individuals rather than the tribal artists of the past, remained a sustaining moral force in my inner life, as I think it may have in the lives of many artists." (Robert Motherwell, introduction to the Viking Compass edition of *The Journal of Eugène Delacroix*, trans. Walter Pach [New York: Viking Press, 1972], p. 7.) In 1948 de Kooning was at Black Mountain College and gave a lecture called "Cézanne and the Color of Veronese," Veronese being an artist who is praised time and time again in Delacroix's *Journal*, for his "skill in refraining from *doing too much* everywhere" and for his "apparent carelessness about the details, which gives so much simplicity." (Eugène Delacroix, *The Journal of Eugène Delacroix*, ed. H. Wellington, trans. L. Norton [Ithaca, NY: Cornell University Press, 1980], p. 80.) The painter Pat Passlof, a student at Black Mountain at the time, recalls that the painterly painters whom de Kooning had chosen as the subject for his lecture alienated "an enclave of Albers aficionados, who fled his classes and left the field open to a few romantics like myself." (Passlof, "1948," in Bill Berkson and Rackstraw Downes, eds., "Willem de Kooning on his Eighty-fifth Birthday," *Art Journal*, Fall 1989, p. 229.)

8. Robert Duncan, "From a Notebook," *The Black Mountain Review* 5 (Summer 1955), pp. 209, 210. Duncan also wrote: "Back it goes to recent readings again of George MacDonald's *Lilith*, to earlier pleasures and thrills in Coleridge and Poe. But thruout I am conscious of the debt to Wallace Stevens—that there is a route back to the Romantic in Stevens" (pp. 209–10). John Ashbery is quoted by David Lehman as saying that he was more influenced by the German Romantics than by the French Symbolists. (David Lehman, *The Last Avant-Garde: The Making of the New York School of Poets* [New York: Anchor Books, 1999 (1st ed., 1998)], p. 97.)

9. B. H. Friedman, "The New Baroque," *Arts Digest*, September 15, 1954, p. 13. Jack Tworkov, "The Wandering Soutine," *Art News*, November 1950, p. 32. H. H. Arenson observed in the catalog of a Theodore Roszak show in 1956, "Unlike 'baroque,' the

word 'romantic' is now somewhat out of fashion although, viewed in the larger historical sense, it deserves as much or more respect. A tradition which can number among its adherents Giorgione, Rembrandt, Claude, Watteau, Géricault, Delacroix, and Rodin is not one to be lightly dismissed even though in recent times it has too often been corrupted into sentimentality." (H. H. Arenson, *Theodore Roszak* [Minneapolis: Walker Art Center, 1956], p. 39.)

10. Paul Goodman, "My Way of Composition," *Semi-Colon*, vol. 1, no. 1 [undated, c. 1955], unpaged. The prehistory of the no-romantic romantics remains to be written. "Romantic Painting in America," an exhibition held at the Museum of Modern Art in 1943, surveyed work from Benjamin West to the present, and included, among the stronger artists in the later part of the show, Marin, Burchfield, Loren MacIver, and Morris Graves. In the catalog, James Thrall Soby spoke of "Romantic Expressionism," and quoted the 1913 catalog statement in which John Marin discusses the "pushing, pulling" nature of the city. The next year, *American Romantic Painting*, a book about nineteenth-century art, by Edgar P. Richardson, was published by E. Weyhe, the distinguished art-book seller, whom the downtown artists patronized. Joseph Cornell, who stood at the crossroads of the old romanticism and the new, devoted a 1947 issue of *Ballet Index* to "Americana—Romantic Ballet," where he mentioned Melville, Poe, and Dickinson, and pointed out that in America the romantic ballet "had flowered and mellowed in the same Indian Summer as our literature." A few years after "Romantic Painting in America" was at the Modern, the historian Jacques Barzun commented sympathetically in the *Magazine of Art* on the Modern's decision to include contemporary works in the 1943 exhibition, and observed that realism, Impressionism, and Surrealism "derived from the parent Romanticism, with admixtures of its opposites and complementaries." (*Magazine of Art*, May 1945, p. 203.) In the catalog for the exhibition "Expressionism in American Painting," at the Albright Art Gallery in Buffalo, New York, in 1952, Expressionism was seen as arising almost dialectically, at a time when "Classicism, Romanticism and Realism had run their course and Impressionism had made its major contribution to the history of painting. . . . The Classicist had remained too aloof, the Romantic too much an escapist, the Realist too earthbound and the Impressionist too concerned with theories to touch humanity's inner consciousness." (Edgar C. Schenck, *Expressionism in American Painting* [Buffalo, NY: Albright Art Gallery, 1945], p. 9.) The connections between romanticism and expressionism were already being made several decades earlier by Barr in the catalog for "German Painting and Sculpture," at the Modern in 1931. The art historian David Anfam has recently suggested that one of the major influences on the Abstract Expressionists was "Romantic Idealism." "Romantic Idealism," he writes, "—a more pedantic concept in name than it was in everyday practice in America in the 1920s and '30s—amounted in its loosely assorted manifestations to perhaps the only common matrix from which a lot of abstract expressionism developed. We should not confuse it with the notion that proposes some hypothetical affinity in retrospect between a classic Rothko and a landscape by the German Romantic Caspar David Friedrich. Rather, romantic Idealism in this sense was a contemporary intellectual milieu, ranging from the unsystematic to the quite specific, that spawned the abstract expressionists." Anfam mentions A. N. Whitehead and Plato. (David Anfam, "Arshile Gorky's Portraits: 'Look Homeward, Angel,' " in *Arshile Gorky: Portraits* [New York: Gagosian Gallery, 2002], pp. 11–12.) Anfam's comment about Rothko and Friedrich refers to Robert Rosenblum's book *Modern Painting and the Northern Romantic Tradition: Friedrich to Rothko* (New York: Harper & Row, 1975), which was an expansion of ideas that Rosenblum originally published in the article "The Abstract Sublime," *Art News*, February 1961. While Rosenblum's book may push too hard on certain specific connections between romantic

strains in the nineteenth century and the mid-twentieth century, the 1961 article strikes me as apt in many of its suggestions, especially that "the anxieties of the atomic age suddenly seem to correspond with a Romantic tradition of the irrational and the awesome as well as with a Romantic vocabulary of boundless energies and limitless spaces." (Rosenblum, *On Modern American Art: Selected Essays* [New York: Harry N. Abrams, 1999], pp. 78–79.) Rosenblum observes that Dore Ashton, a critic closely associated with the Abstract Expressionists, had even earlier related Still to the nineteenth-century landscapist Frederic Church. In 1959 Jermayne MacAgy, a curator with close ties to the American avant-garde, organized a show called "Romantic Agony" at the Contemporary Arts Association in Houston, which included work by de Kooning, Hofmann, Pollock, Kline, and others; the title, quite obviously, was a salute to Mario Praz's famous study of certain erotic and sadistic strains in literary romanticism.

11. Edwin Denby, *Dancers, Buildings, and People in the Streets* (New York: Horizon Press, 1965), p. 266. Thomas B. Hess, *Willem de Kooning Drawings* (Greenwich, CT: A Paul Bianchini Book/New York Graphic Society, 1972), p. 26.

12. Another juxtaposition of artistic sensibilities can be found in the February 1948 issue of the *Magazine of Art*. When the magazine ran a couple of reproductions of de Kooning's black-and-white paintings at the time that he was having his first one-man show at the Charles Egan Gallery, the small feature was right next to an article by Lincoln Kirstein, a sworn enemy of the new abstract painting, called "The Interior Landscapes of Pavel Tchelitchew."

13. Saul Bellow, *Him with His Foot in His Mouth and Other Stories* (New York: Penguin Books, 1998 [1st ed., 1984]), p. 115. Lincoln Kirstein remained the most considerable of Tchelitchew's supporters, publishing a monograph toward the end of his life (Lincoln Kirstein, *Tchelitchev* [Santa Fe, NM: Twelvetrees Press, 1994]).

14. Judith Malina, *The Diaries of Judith Malina, 1947–1957* (New York: Grove Press, 1984), p. 130.

15. *Tennessee Williams Letters to Donald Windham, 1940–1965*, ed. Donald Windham (Athens: University of Georgia Press, 1996 [1st ed., 1976]), pp. 134, 140.

16. Robert Duncan, "Reviewing *View*, an Attack," first published in *The Ark* 1 (Spring 1947), reprinted in Ekbert Faas, *Young Robert Duncan: Portrait of the Poet as Homosexual in Society* (Santa Barbara, CA: Black Sparrow Press, 1983), p. 326.

17. Cyril Connolly, *The Unquiet Grave* (New York: Harper and Brothers, 1945), p. 102.

18. *The Tiger's Eye* 1 (October 1947), p. 53. *The Tiger's Eye* 9 (October 1949), p. 70. See also the catalog of an exhibition held at the Yale University Art Gallery in 2002—Pamela Franks, *The Tiger's Eye: The Art of a Magazine* (New Haven, CT: Yale University Art Gallery, 2002).

19. Jacques Barzun, "Romanticism: Definition of a Period," *Magazine of Art*, November 1949, p. 244.

20. Alfred Kazin, ed., *The Portable Blake* (New York: Viking Press, 1968 [1st ed., 1946]), pp. 6, 19. *The Tiger's Eye* featured works by Miró and Stanley William Hayter that were modeled on Blake's illuminated poems. (*The Tiger's Eye* 1 [October 1947], pp. 72–75.) In another issue of the magazine, Thomas Merton expressed the hope that *The Tiger's Eye* "will turn out to be like Blake's tiger and wake people up to the realities on which their lives depend." (*The Tiger's Eye* 6 [December 1948], p. 59.) Kazin related Blake to Beethoven—they both died in 1827—and found that "what is nearest and first in both men is so strong a sense of their own identity that they are always reaching beyond man's conception of his powers. In both there is . . . an impatience with forms and means." (Kazin, ed., *Portable Blake*, p. 7.) That thought suggests the impatience of the painters whom Greenberg and Rosenberg admired, who were fed up with the old

procedures, who wanted to work with materials in new, surprising ways. The idea of the life-giving nature of contradiction is at the core of Blake's thinking—and echoes arguments that go all the way back to Leonardo da Vinci, who in his notebooks had written that "in narrative painting one ought to mingle direct contraries so that they may afford a great contrast to one another." (Leonardo quoted in David Rosand, *Drawing Acts: Studies in Graphic Expression and Representation* [Cambridge, England: Cambridge University Press, 2002], p. 86.) As Kazin wrote, Blake believed that just "as hell can be married to heaven, the body seen by the soul, so experience lifts innocence into a higher synthesis based on vision." (Kazin, ed., *Portable Blake*, p. 42.)

21. Lloyd Goodrich, *Albert P. Ryder* (New York: Whitney Museum of American Art, 1947), p. 20. Back in 1928, Duncan Phillips, the collector who did so much to support contemporary American artists, including John Graham, wrote that Ryder was "the idol of Modernists." (*A Bulletin of the Phillips Collection* [Washington, DC: Phillips Memorial Collection, 1928], p. 33.) The literary critic Leslie Fiedler, in his 1955 book *An End to Innocence*, wrote, "One knows generally that, behind the thin neo-Classical façade of Virginia and Philadelphia and Boston, the mythical meanings of America have traditionally been sustained by the Romantic sensibility (the hero of the first American novel died a suicide, a copy of *Werther* lying on the table beside him)." (Fiedler, *An End to Innocence* [Boston: Beacon Press, 1955], p. 132.)

22. Ellen G. Landau, *Jackson Pollock* (New York: Harry N. Abrams, 1989), pp. 125, 248. Harold Rosenberg, *The Tradition of the New* (New York: Horizon Press, 1959), p. 31. In a prose poem called "The Eye of Polyphemus," published in *It Is* in 1960, Rosenberg again reached to *Moby-Dick* for a metaphor. "Each eye," he wrote of the whale, "gazes out independently on its own side: the right eye sees the right half of the landscape, the left eye the left half. In between there is darkness. The body of the whale is thus a line that divides the visible world." (*It Is*, Spring 1960, p. 28.) Melville was also mentioned by Joseph Cornell, who referred to *Typee* and *Pierre* in *Dance Index* in 1947, and by Motherwell, who referred to *Moby-Dick* in the catalog note for the "Black or White" show at Kootz in 1950.

23. Elaine de Kooning, "Kerkam Paints a Picture," *Art News*, February 1951, reprinted in Elaine de Kooning, *The Spirit of Abstract Expressionism: Selected Writings*, ed. Rose Slivka (New York: George Braziller, 1994), p. 97. Thomas Hess, foreword to Gerald Nordland, *Earl Kerkam: Memorial Exhibition* (Washington, DC: Washington Gallery of Modern Art, 1966), pp. 3–4. David Smith letter to Lois Orswell in Marjorie B. Cohn, *Lois Orswell, David Smith, and Modern Art* (New Haven, CT: Yale University Press, 2002), p. 290. Louis Finkelstein, "Earl Kerkam: 1890–1965," *Art News*, May 1965, p. 29.

24. Hess, foreword to Nordland, *Kerkam*, p. 3.

25. Kerkam quoted in Elaine de Kooning, *Spirit of Abstract Expressionism*, p. 98.

26. Martica Sawin in note to author. Finkelstein, "Earl Kerkam: 1890–1965," p. 30. Nordland, *Kerkam*, p. 17. After Kerkam's death, a group of artists—including de Kooning, Hofmann, Guston, and Rothko—wrote a letter to the Board of Directors of the Museum of Modern Art, urging the museum to mount an exhibition of Kerkam's work. (Letter to the Board of Directors of the Museum of Modern Art, July 6, 1965, courtesy of Mrs. E. Bruce Kirk.)

27. Hess, foreword to Nordland, *Kerkam*, pp. 3, 13. *In Defense of Culture, Fourth American Writers Congress and Congress of American Artists, June 6, 7, and 8, 1941* (New York: New Union Press, 1941), p. 13.

28. Denby, *Dancers*, p. 264.

29. Martica Sawin, "Earl Kerkam," *Arts*, March 1957, p. 27.

30. Thomas B. Hess, *Abstract Painting: Background and American Phase* (New York: Viking Press, 1951), p. 104.

31. Jean Cocteau, "Letter to Americans," in *Cocteau's World*, ed. Margaret Crosland (New York: Dodd, Mead, 1973), p. 398 (translation slightly altered).

32. Wylie Sypher, *Rococo to Cubism in Art and Literature* (New York: Vintage Books, 1960), p. 127.

33. Edwin Denby, *Looking at the Dance* (New York: Pellegrini & Cudahy, 1949), p. 32.

34. Anatole Broyard, *Kafka Was the Rage: A Greenwich Village Memoir* (New York: Carol Southern Books, 1993), p. 21.

35. Thomas B. Hess, *Willem de Kooning* (New York: George Braziller, 1959), p. 19.

36. Albert Parry, *Garrets and Pretenders: A History of Bohemianism in America* (New York: Covici Friede, 1933).

37. Harold Rosenberg, *Discovering the Present: Three Decades in Art, Culture, and Politics* (Chicago: University of Chicago Press, 1973), pp. 102–4.

38. The "warm June day" is mentioned in a caption in Thomas B. Hess, "De Kooning Paints a Picture," *Art News*, March 1953, p. 30.

39. Herman Cherry, "Willem de Kooning," in Bill Berkson and Rackstraw Downes, eds., "Willem de Kooning on His Eighty-fifth Birthday," *Art Journal*, Fall 1989, p. 230.

40. Sypher, *Rococo to Cubism*, p. 127. Robert Duncan, "Notes on the Psychology of Art," first published in *Occident* (Spring 1948), reprinted in Faas, *Young Robert Duncan*, p. 330.

41. Honoré de Balzac, *The Unknown Masterpiece*, trans. Richard Howard, intro. Arthur C. Danto (New York: New York Review Books, 2001), p. 40.

42. John D. Graham, *System and Dialectics of Art* (New York: Delphic Studios, 1937), p. 28. The impact of Balzac's story cannot be overestimated. In 1932, the year after Vollard published his edition, Julien Levy exhibited the prints in his gallery in New York. In 1939, when the Museum of Modern Art mounted "Picasso: Forty Years of His Art," the invitation to the show bore the famous illustration of the artist with the knitting model. Three years later that same image was on the cover of the Modern's book *Twentieth Century Portraits*. In the catalog of the Modern's 1939 Picasso retrospective, Barr included both the etching of *Painter with a Model Knitting* and an ink drawing from a series that consisted, as Barr noted, of "constellations of dots connected by lines or, better, lines with dots where the lines cross or end." This drawing, with two eyes emerging from the maze, was one of a series that Picasso had done in 1926 that was included in Vollard's edition. This virtually abstract drawing was used by Thomas Hess as the frontispiece for a special thirty-two-page section of the 1951 *Art News Annual* called "Introduction to Abstract," which traced developments from Cubism all the way up to Gorky, de Kooning, and Pollock. In 1947, at the time of an exhibition at the Modern of a new suite of Picasso lithographs, Lear Publishers in New York brought out a book called *Forty-nine Lithographs Together with Honoré Balẓac's The Hidden Masterpiece in the Form of an Allegory*. It's reasonable to believe that New York artists were aware that in 1947 Albert Skira had published in Geneva a series of paperback editions of Balzac, Petite Collection Balzac, each of which had on the cover a portrait of Balzac that had been especially designed by a contemporary artist, among them Balthus, Derain, Giacometti, and Picasso. In 1949, at the California School of Fine Arts in San Francisco, the filmmaker Sidney Peterson produced a film called *Mr. Frenhofer and the Minotaur*. Here parts of Balzac's story are read on the soundtrack, while images of a little girl with a candle and a ladder and a wounded Minotaur echo Picasso's *Minotauromachy* print. Twenty years later, when B. H. Friedman published his biography of Pollock, *Jackson Pollock: Energy Made Visible*, Balzac's story was among the sources he plumbed

for chapter headings, quoting Frenhofer's exclamation that "strictly speaking, drawing does not exist!" (Friedman, *Jackson Pollock: Energy Made Visible* [New York: McGraw-Hill Book Co., 1974 (1st ed., 1972)], p. 169.) In 1980 Dore Ashton, a critic closely associated with the Abstract Expressionists, published *A Fable of Modern Art,* a study in which Balzac's story unites a series of reflections on Picasso, Cézanne, Rilke, Schoenberg, and others. (Dore Ashton, *A Fable of Modern Art* [New York: Thames & Hudson, 1980].) An especially interesting recent treatment of the story is to be found in "The Painter's Secret: Invention and Rivalry from Vasari to Balzac," by Marc Gotlieb, in *The Art Bulletin,* September 2002. He connects the story to experimental techniques among the Romantic painters, especially Decamps, who was "credited with inventing his own technical procedures, from the introduction of new pigments and media to the use of rags, cork, scrapers, and palette knives." Jules Breton dismissed his pictures as "laboratory alchemy." Decamps himself is said to have exclaimed: "Chardin's whites, I cannot find them." (Gotlieb, "The Painter's Secret," *The Art Bulletin,* September 2002, p. 475.)

43. Balzac, *The Unknown Masterpiece,* pp. 12, 13.

44. Ibid., pp. 7, 8, 10. Fielding Dawson, *An Emotional Memoir of Franz Kline* (New York: Pantheon Books, 1967), p. 37.

45. Rosenberg, *The Anxious Object,* p. 120. Thomas B. Hess, *Willem de Kooning* (New York: Museum of Modern Art, 1968), p. 22.

46. Meyer Schapiro, *Cézanne* (New York: Harry N. Abrams, 1963), p. 28.

47. Balzac, *The Unknown Masterpiece,* pp. 40–41, 42, 43.

48. Ibid., p. 13.

49. Greenberg, *Collected Essays,* vol. 3, p. 226.

50. James Johnson Sweeney, introduction to Pollock's first one-man show, at Peggy Guggenheim's Art of This Century, quoted in Friedman, *Jackson Pollock,* pp. 59–60.

51. Friedman, *Jackson Pollock,* p. 7. Robert Motherwell, statement in "Jackson Pollock: An Artist's Symposium, Part I," *Art News,* April 1967, p. 30.

52. Edwin Denby, *The Complete Poems* (New York: Random House, 1986), p. 173.

53. Sam Hunter, "Jackson Pollock: The Maze and the Minotaur," *New World Writing,* 1956, pp. 180–81. Poe quoted in ibid., p. 186. Hunter finally cited Tocqueville's fears in his study *Democracy in America* "that the productions of democratic poets may often be surcharged with immense and incoherent imagery, with exaggerated descriptions and strange creations; and that the fantastic beings of their brains may sometimes make us regret the world of reality." (Ibid., p. 181.) All of these attitudes, so Hunter believed, were coming together in Pollock's work. Pollock had precisely the kind of American imagination that D. H. Lawrence had written about—an imagination that according to Hunter "was in fugue, in eternal revolt against the parenthood of European authority and traditional values." " 'Henceforth masterless,' " Hunter reminded his readers, was Lawrence's "half-mocking, half-admiring refrain for the new world's mystique of freedom." (Ibid.) All of which suggested a Nietzschean man.

54. Sam Hunter, *Jackson Pollock* (New York: Museum of Modern Art, 1956), p. 9.

55. James Thrall Soby, *Romantic Painting in America* (New York: Museum of Modern Art, 1943), p. 42. In 1943, Mark Tobey had produced a work in tempera called *Gothic,* a densely packed impression of stylized Gothic arches—it is a cathedral. It was reproduced in the *Magazine of Art* in February 1953, in an article by William C. Seitz titled "Spirit, Time and 'Abstract Expressionism.' "

56. Jacques Barzun, "Romanticism: Definition of a Period," *Magazine of Art,* November 1949, p. 244.

57. Hess, *Abstract Painting,* p. 154.

58. James Brooks, statement in "Jackson Pollock: An Artist's Symposium, Part I," *Art News*, April 1967, p. 31.

59. Allan Kaprow, "The Legacy of Jackson Pollock," originally published in *Art News*, October 1958, in Kaprow, *Essays on the Blurring of Art and Life*, ed. Jeff Kelley (Berkeley: University of California Press, 1993), p. 1.

60. Parker Tyler, "Jackson Pollock: The Infinite Labyrinth," *Magazine of Art*, March 1950, p. 92.

61. Frank O'Hara, *Jackson Pollock* (New York: George Braziller, 1959), pp. 20, 23.

62. Greenberg, *Collected Essays*, vol. 1, p. 165.

63. Ibid., vol. 2, p. 125. Thomas Carlyle, *On Heroes, Hero-Worship and the Heroic in History* (London: Oxford University Press, 1965 [1st ed., 1841]), p. 109.

64. O'Hara, *Jackson Pollock*, p. 11.

65. Greenberg, *Collected Essays*, vol. 1, pp. 165, 166; vol. 2, p. 125.

66. Goodrich, *Albert P. Ryder*, pp. 18, 20.

67. Duncan, "From a Notebook," p. 210.

68. Greenberg, *Collected Essays*, vol. 2, pp. 201, 202, 285–86.

69. Tennessee Williams, *Memoirs* (Garden City, NY: Doubleday, 1975), p. 56.

70. Tennessee Williams, "An Appreciation," in Samuel M. Kootz, ed., *Women: A Collaboration of Artists and Writers* (New York: Samuel M. Kootz Editions, 1948), unpaged.

71. Williams, *Memoirs*, p. 250.

72. Harold Rosenberg, *Arshile Gorky: The Man, the Time, the Idea* (New York: Sheepmeadow Press/Flying Point Books, 1962), pp. 23–24.

73. Joe LeSueur, introduction to Frank O'Hara, *Amorous Nightmares of Delay: Selected Plays* (Baltimore: Johns Hopkins University Press, 1997 [1st ed., 1978]), pp. xv–xvi.

74. Herbert Machiz, ed., *Artists' Theatre New York* (New York: Grove Press, 1960), p. 7. For more on the poets and the theater, see Philip Auslander, *The New York School Poets as Playwrights: O'Hara, Ashbery, Koch, Schuyler and the Visual Arts* (New York: Peter Lang, 1989).

75. Martica Sawin, *Nell Blaine: Her Art and Life* (New York: Hudson Hills Press, 1998), p. 45.

76. John Ashbery, "The Heroes," in Machiz, ed., *Artists' Theatre*, p. 52.

77. Anton Myrer quoted in Robert E. Knoll, ed., *Weldon Kees and the Midcentury Generation: Letters, 1935–1955* (Lincoln: University of Nebraska Press, 1986), p. 125. Weldon Kees, "Muskrat Ramble: Popular and Unpopular Music," *Partisan Review*, May 1948, pp. 618–19.

78. Elizabeth Hardwick, *Sleepless Nights* (New York: Random House, 1979), pp. 34, 35, 36. John Clellon Holmes, *The Horn* (New York: Thunder's Mouth Press, 1991 [1st ed., 1980]), p. 70.

79. Anton Myrer, *Evil Under the Sun* (New York: Random House, 1951), p. 7. Greenberg, *Collected Essays*, vol. 2, p. 202.

80. Rosenberg, *Tradition of the New*, pp. 25, 30.

81. Maurice Merleau-Ponty, "Cézanne's Doubt," in *Sense and Non-Sense*, intro. and trans. Hubert L. Dreyfus and Patricia Allen Dreyfus (Evanston, IL: Northwestern University Press, 1964), p. 19. This essay was first published in *Fontaine* in December 1945.

82. Rosenberg, *Tradition of the New*, pp. 34, 25, 27. For the response to Rosenberg's essay, see Steven Naifeh and Gregory White Smith, *Jackson Pollock: An American Saga* (New York: Clarkson N. Potter, 1989), pp. 704–14.

83. Rosenberg, *Tradition of the New*, pp. 18, 19, 33.

84. Ibid., p. 28.

6. A SPLENDID MODESTY

1. Frank O'Hara, *Art Chronicles: 1954–1966* (New York: George Braziller, 1990 [1st ed., 1975]), p. 136.
2. Philip Guston, statement in *Twelve Americans*, ed. Dorothy C. Miller (New York: Museum of Modern Art, 1956), p. 36.
3. Philip Guston quoted in *It Is*, Spring 1960, p. 38.
4. Harold Rosenberg, *Arshile Gorky: The Man, the Time, the Idea* (New York: Sheepmeadow Press/Flying Point Books, 1962), pp. 95, 53.
5. Meyer Schapiro, *Modern Art—19th and 20th Centuries, Selected Papers* (New York: George Braziller, 1978), p. 226. Thomas B. Hess, "U.S. Painting: Some Recent Directions," *Art News*, December 1956, pp. 86–87. Dore Ashton, "What Is 'Avant Garde'?" *Arts Digest*, September 1955, p. 7.
6. Lionel Trilling, "The Princess Casamassima," in *The Moral Obligation to Be Intelligent*, ed. Leon Wieseltier (New York: Farrar, Straus and Giroux, 2000), pp. 159, 169. Thomas B. Hess, *De Kooning: Recent Paintings* (New York: Walker and Co., 1967), p. 10.
7. Jacqueline Bogard Weld, *Peggy: The Wayward Guggenheim* (New York: E. P. Dutton, 1986), p. 351. William Barrett, in his memoir *The Truants*, tells the following story: "Once the painter Marca-Relli came in [the Cedar Tavern] with an Italian visitor in tow. The Italian was from Venice, and had insisted on being taken to the bar for the express purpose of meeting de Kooning. After the introduction was made I pointed out the historical significance of the occasion to de Kooning: Venice had once been the center where the pilgrims from northern Europe had come to learn about painting; now the scene had shifted, and a Venetian had come to New York to meet him. De Kooning blinked for a moment, trying to take in the full sweep of the idea, and then his face lit up with a grin: 'Gee!'" (William Barrett, *The Truants: Adventures Among the Intellectuals* [New York: Anchor Press/Doubleday, 1982], p. 143.)
8. Martica Sawin, "Robert De Niro," typescript, p. 45. Krishnamurti quoted in Aldous Huxley, foreword to Krishnamurti, *The First and Last Freedom* (New York: Harper & Row, 1975 [1st ed., 1954]), p. 12. D. T. Suzuki, *Zen and Japanese Culture* (New York: Pantheon Books, 1959), pp. 271–72.
9. Albert Camus, *The Myth of Sisyphus and Other Essays*, trans. Justin O'Brien (New York: Vintage, 1991 [1st U.S. ed., 1955]), p. 72. Jean-Paul Sartre, *Giacometti* (New York: Pierre Matisse Gallery, 1948), p. 2. William Barrett, *Irrational Man* (New York: Anchor Books, 1990 [1st ed., 1958]), p. 34. Lionel Abel, *The Intellectual Follies: A Memoir of the Literary Venture in New York and Paris* (New York: W. W. Norton, 1984), p. 116. The existentialist talk of the philosophers was echoed in studio talk and even lovers' quarrels—and rapidly descended into cliché. When Ruth Kligman, Pollock's last girlfriend, wrote about the summer of 1956, she recalled how she had reached for an existentialist explanation to make sense of her chaotic feelings as she helplessly watched Pollock drink himself to death. "My mind was constantly with Jackson. I was confused. I thought of Sartre and the theory of existentialism, the theory that an action, whether positive or negative, is an action, and I felt that I had to choose my action consciously." (Ruth Kligman, *Love Always: A Memoir of Jackson Pollock* [New York: William Morrow, 1974], p. 85.)
10. Isaiah Berlin, *The Roots of Romanticism*, ed. Henry Hardy (Princeton, NJ: Princeton University Press, 1999), p. 142. Dore Ashton, *The New York School: A Cultural Reckoning* (New York: Penguin Books, 1979 [1st ed., 1973]), p. 178. Albert Camus, "Art and Revolt," *Partisan Review*, May–June 1952, pp. 272–73. Camus, *Myth of Sisyphus*, pp.

73, 69. In the essay "The Myth of Sisyphus," Camus wrote that "in the new world of ideas, the species of centaurs collaborates with the more modest species of metropolitan man." (Camus, *Myth of Sisyphus*, p. 33.) There seems to have been an interest in centaurs in the mid-century years. Henri Focillon, in the 1936 essay "In Praise of Hands"—published in New York by Wittenborn, Schultz as part of Focillon's *The Life of Forms in Art* in 1948—spoke of the centaur as a primitive man who inhaled "the world through his hands, stretching his fingers into a web to catch the imponderable." (Henri Focillon, *The Life of Forms in Art* [New York: Wittenborn, Schultz, 1948], p. 67.) The mural *Joy of Life* that Picasso painted in Antibes in 1946 featured a large centaur playing a pipe, and Stanley William Hayter made an engraving entitled *Centauresse* in 1944. And there was John Updike's novel *The Centaur*, published in the early 1960s. While these examples are too scattered to yield any general observations, I think it would be worth looking further into the significance in those years of this disquieting mythological figure who unites the expansive intelligence of a man with the muscular vehemence of an animal. Certainly it is interesting that Greenberg, writing in 1948 of a special issue of *Verve* that featured the bucolic work Picasso had done in Antibes, said that Picasso might "be able to sum up the pathos of the second quarter of the twentieth century in a way not unworthy of that in which he stated the optimism of its first quarter." (Clement Greenberg, *The Collected Essays and Criticism*, ed. John O'Brian [Chicago: University of Chicago Press, 1986–93], vol. 2, p. 259.) There is a pathos about the figure of the centaur.

11. Sartre, *Giacometti*, pp. 2, 5. The thinking here is not that far from Trilling's thinking about Hyacinth Robinson; and, interestingly, Sartre would soon write a long essay about Tintoretto, one of the great Venetian artists, "*Le Séquestré de Venise,*" first published in *Les Temps modernes* in November 1957.

12. Jean-Paul Sartre, *Alexander Calder* (New York: Buchholz Gallery, 1947), unpaged.

13. Ibid.

14. Larry Rivers, Hofmann Student Dossiers, Museum of Modern Art Library. What promises to be the definitive work on Hofmann and his school is Tina Dickey, *Stalking the Real: Voices from the Hofmann School*, forthcoming.

15. Allan Kaprow, "The Effect of Recent Art Upon the Teaching of Art," *Art Journal*, Winter 1963–64, p. 136.

16. Hans Hofmann quoted by Harold Rosenberg in a eulogy delivered at the artist's funeral on February 20, 1966, printed in *Art News*, April 1966, p. 21.

17. In 1957, the year before the school closed, Hess could write, "In the best meaning of the term, the Hofmann School is an Academy—a temple in which mysteries and standards are preserved." (Harold Rosenberg, *The Anxious Object* [New York: Collier Books, 1973 (1st ed., 1964)], p. 146.) And Rosenberg, speaking a few years after Hofmann's death in 1966, at the time of the inauguration of a new museum at the University of California at Berkeley that had received a large Hofmann donation, declared that "Hofmann's school aimed at being an academy of the new, insofar as the new was not eccentric, factitious, or based on the tastes of spectators or even the momentary attitudes of artists." (Rosenberg, "The Teaching of Hans Hofmann," *Arts*, December 1970–January 1971, p. 17.)

18. The fluidity of American society in the postwar period, with many young people moving into the cities and into new careers, echoed the fluidity of early-nineteenth-century Europe, when, as Maurice Z. Shroder wrote in his book *Icarus: The Image of the Artist in French Romanticism*, "with the coming Revolution and the assertion of middle-class supremacy, the artist was transformed into a free social agent." (Maurice Z. Shroder, *Icarus: The Image of the Artist in French Romanticism* [Cambridge, MA: Harvard University Press, 1961], p. 41.)

19. Gustave Courbet, *The Letters of Gustave Courbet*, ed. and trans. Petra ten-Doesschate Chu (Chicago: University of Chicago Press, 1992), p. 204. Nell Blaine, Hofmann Student Dossiers, Museum of Modern Art Library. James Gahagan quoted in Cynthia Goodman, "Hans Hofmann as a Teacher," *Arts*, April 1979, p. 124.

20. Courbet, *Letters*, pp. 204–5. At the very core of the dream of a new kind of school, a school where students and teachers could come together to forge an artistic revolution, were David's battles, during the years just after 1789, to overturn the old Academy, an Academy that had refused him the Prix de Rome three times (before awarding it to him in 1774). There was a great deal of excitement inside and around David's studio, where many artists who would be directly or indirectly involved in the Romantic movement came to study. The idea of a school that dissented from an academy can be said to have originated in David's studio—as well as a new, anti-academic and inherently dialectical model for the transmission of tradition.

21. Joellen Bard, ed., *Tenth Street Days: The Co-ops of the '50s* (New York: Education, Art and Service, 1977), p. 8.

22. Joseph Stefanelli, Hofmann Student Dossiers, Museum of Modern Art Library. There is a poem by Weldon Kees called "A Salvo for Hans Hofmann," which was originally written for a Hofmann catalog. Kees, a painter and writer, had been part of Hofmann's circle in Provincetown in the 1940s and had been instrumental in organizing the series of lectures, discussions, and exhibitions called Forum '49, which Greenberg said "looks like the most exciting thing in art ever to be run outside New York in the summer—or in the winter too." (*New York–Provincetown: A 50s Connection* [Provincetown, MA: Provincetown Art Association, 1994], p. 7.) In his "Salvo" to Hofmann, Kees wrote, "Because of you, / The light burns sharper in how many rooms." It was amazing what Hofmann had pulled "Out of the summer's heat, the winter's cold, / The look of harbors and the trees, / The slashed world traced and traced again, / Enriched, enlarged, caught in a burning scrutiny / Like fog-lamps on a rotten night." Kees ended with a grand, romantic flourish, announcing that "A rainbow sleeps and wakes against the wall." This was what had happened in Hofmann's own painting. But of course Kees was also saying that this was what Hofmann had done for a whole generation of painters. He had woken American artists up to the rainbow, and then taught them how to put it on the wall. (Weldon Kees, *Poems, 1947–1954* [San Francisco: Adrian Wilson, 1954], p. 63.)

23. Mary Emma Harris, *The Arts at Black Mountain College* (Cambridge, MA: MIT Press, 1987), p. 84. The books about Black Mountain by Dawson, Duberman, and Harris cited here have now been joined by Vincent Katz, ed., *Black Mountain College: Experiment in Art* (Cambridge, MA: MIT Press, 2002), which contains a fine essay by Robert Creeley, "Olson and Black Mountain College."

24. Fielding Dawson, *The Black Mountain Book: A New Edition* (Rocky Mount: North Carolina Wesleyan College Press, 1991), p. 243.

25. Alfred Kazin, *A Lifetime Burning in Every Moment: From the Journals of Alfred Kazin* (New York: HarperCollins, 1996), p. 32.

26. Martin Duberman, *Black Mountain: An Exploration in Community* (New York: E. P. Dutton, 1972), pp. 412–13.

27. B. H. Friedman, introduction to B. H. Friedman, ed., *School of New York: Some Younger Artists* (New York: Grove Press, 1959), p. 11. The appearance of Friedman's book was accompanied by an exhibition at the Stable Gallery in December 1959.

28. John Ashbery, *Reported Sightings: Art Chronicles, 1957–1987*, ed. David Bergman (New York: Knopf, 1989), p. 241.

29. Friedman, ed., *School of New York*, pp. 10–11. Bill Berkson, "Frank O'Hara and His

Poems," in Bill Berkson and Joe LeSueur, eds., *Homage to Frank O'Hara* (Bolinas, CA: Big Sky, 1988), p. 164.

30. Milton Klonsky, *A Discourse on Hip*, ed. Ted Solotaroff (Detroit: Wayne State University Press, 1990), p. 111. Klonsky evoked a GI in a tiny bookshop that he had opened, "sitting all day and part of the night surrounded by second-hand books and piles of old literary magazines—*Partisan Review, Kenyon, Sewanee, View*, etc. . . . A dull business, once the edge had worn off." (Klonsky, *Discourse*, p. 111.) One notes that *View*, the magazine in which the Neo-Romantics and the Surrealists had faced off a half decade earlier, was already gathering dust in the Greenwich Village bookstores.

31. Fairfield Porter, *Art in Its Own Terms: Selected Criticism, 1935–1975*, ed. Rackstraw Downes (New York: Taplinger Publishing, 1979), p. 79.

32. Ashbery, *Reported Sightings*, p. 182.

33. Jean Cocteau, *Le Mystère Laïc* (Paris: Éditions des Quatre Chemins, 1928), p. 46, author's translation.

34. John Ashbery, introduction to *Jane Freilicher* (New York: Fischbach Gallery, 1995), unpaged.

35. Reproduced in *Arts and Architecture*, May 1946, p. 26.

36. André Malraux, *Museum Without Walls*, trans. Stuart Gilbert and Francis Price (Garden City, NY: Doubleday, 1967), pp. 62, 61.

37. Randall Jarrell, *Kipling, Auden & Co.: Essays and Reviews, 1935–1964* (New York: Farrar, Straus and Giroux, 1980), p. 178.

38. Thomas B. Hess, "A Tale of Two Cities," *Location*, Summer 1964, p. 40. Hess tells the reinventing-the-harpsichord story again in *Willem de Kooning Drawings* (Greenwich, CT: A Paul Bianchini Book/New York Graphic Society, 1972), p. 59, and there the implications seem less positive than in *Location;* the person who reinvents the harpsichord is said to "have sought to be free by pretending to be outside of history and apart from the present." Like so many of de Kooning's remarks, this one was firmly if somewhat elusively grounded in contemporary developments. De Kooning, who knew many people who were immersed in the music and dance worlds of the 1950s, would have been well aware of the upsurge in interest in older musical forms. Back in 1945, in *View*, the composer Lou Harrison made a plea for the revival of old instruments— clavichords, lutes—and predicted that there was an audience that would respond to something other than the instruments that had been "designed to thrill a nineteenth-century auditorium audience." (*View*, October 1945, p. 21.) Stravinsky's 1951 *Rake's Progress* had a harpsichord continuo; Noah Greenberg had founded the New York Pro Musica in 1952, in order to perform medieval and Renaissance music; five years later the Stravinsky/Balanchine *Agon*, about which de Kooning's friend Denby wrote a famous essay, was based on the forms of a suite of Baroque dances. That Stravinsky, the premier modern composer, was looking backward even as, in *Agon*, he experimented with what Denby called "his personal twelve-tone style," suggested the possibility of closing the gap between the old and the new. (Edwin Denby, *Dancers, Buildings, and People in the Streets* [New York: Horizon Press, 1965], p. 119.)

39. Willem de Kooning, interviewed in "Is Today's Artist With or Against the Past?," *Art News*, Summer 1958, p. 27. Willem de Kooning interviewed by Rosenberg, *Art News*, September 1972, p. 54. In the same interview, de Kooning explained that "Cubism went backwards from Cézanne" (p. 55). Barrett, *Truants*, p. 140.

40. T. S. Eliot, "Burnt Norton," *The Complete Poems and Plays, 1909–1950* (New York: Harcourt, Brace and World, 1952), p. 117. The idea for Eliot's essay "Tradition and the Individual Talent," with its discussion of the impersonality of art and of the necessity for the artist to give himself over to the timelessness of tradition, had come to the poet

when he was looking at prehistoric cave paintings in southwestern France in 1919—looking, in other words, at the kind of paintings that Sartre had said Giacometti felt were his "contemporaries by preference."

41. Alberto Giacometti, *A Sketchbook of Interpretive Drawings* (New York: Harry N. Abrams, 1967), p. vii.

42. See Deborah Rosenthal, "Alfred Russell's 'La Rue de Nevers,' " *Arts*, January 1978, pp. 142–44.

43. Alfred Russell, statement in *Contemporary American Painting 1952* (Urbana: University of Illinois, 1952), p. 228. Russell, statement in the catalog of a show at the Duveen-Graham Gallery in New York in 1957. Russell, quoted in Rosenthal, "Alfred Russell's 'La Rue de Nevers,' " p. 144.

44. Théophile Gautier, *A History of Romanticism*, in *The Works of Théophile Gautier*, ed. and trans. F. C. de Sumichrast (New York: George D. Sproul, 1902), vol. 16, p. 76.

45. Alfred Russell, statement in "Symposium: The Human Form," *Magazine of Art*, November 15, 1953, pp. 13, 32.

46. Russell, statement in the catalog of a show at the Duveen-Graham Gallery in New York in 1957. Harry Slochower, "The Import of Myth for Our Time," *trans/formation* 1.2 (1951), pp. 98–99.

47. Leland Bell, "The Case for Derain as an Immortal," *Art News*, May 1960, p. 26. For Bell, see Nicholas Fox Weber, *Leland Bell* (New York: Hudson Hills Press, 1986). There is a brief, evocative essay by R. B. Kitaj in *Leland Bell: Paintings* (London: Theo Waddington, 1980).

48. Bell, "The Case for Derain," p. 26.

49. Sawin, "Robert De Niro," p. 24. Robert Duncan, in a letter to Denise Levertov, who was friends with Bell, describes his own reactions to an evening spent with Bell in 1955: "We [Duncan and his partner, the painter Jess] found the evening at Lee Bell's lively enough in one way—that could lead to some appreciation of Balthus or Giacometti—and could open my eyes out of an old resistance to Hélion's work. But when one came nearer to the New York scene—there was only the necessity to put down or put in its place work which to our uncompeting eyes had had its own free wonders—of Hoffmann [*sic*], or Larry Rivers, of Kline or Dubuffet, Pollock or Still." (Robert J. Bertholf and Albert Gelpi, eds., *The Letters of Robert Duncan and Denise Levertov* [Stanford, CA: Stanford University Press, 2004], p. 21.)

50. Excerpts from an audiotape of a Leland Bell lecture, c. 1970–75. New York Studio School Library.

51. Ashbery, *Reported Sightings*, p. 195.

52. Ibid., pp. 197, 199.

53. John Ashbery, *Other Traditions* (Cambridge, MA: Harvard University Press, 2000), pp. 5, 6.

54. Hess, *De Kooning Drawings*, p. 18. John Ashbery, "The Skaters," *Art and Literature*, Autumn–Winter 1964, p. 15.

55. Ashbery, *Reported Sightings*, p. 243.

56. Ibid., pp. 66, 16, 55, 134, 150, 222, 238.

57. John Ashbery, *Self-Portrait in a Convex Mirror* (New York: Penguin Books, 1976 [1st ed., 1975]), p. 50. Ashbery, *Reported Sightings*, p. 240.

7. PASTORALS

1. Willem de Kooning, quoted in the symposium "Is Today's Artist With or Against the Past?," *Art News*, Summer 1958, p. 27.

2. Louis Finkelstein, "New Look: Abstract-Impressionism," *Art News*, March 1956, p. 36. Clement Greenberg, *The Collected Essays and Criticism*, ed. John O'Brian (Chicago: University of Chicago Press, 1986–93), vol. 4, p. 11. Joan Mitchell quoted in Judith E. Bernstock, *Joan Mitchell* (New York: Hudson Hills Press, 1988), p. 17.

3. Roger Shattuck, "Claude Monet: Approaching the Abyss," in *The Innocent Eye* (New York: Farrar, Straus and Giroux, 1984), p. 224.

4. Hans Hofmann, *The Search for the Real and Other Essays* (Cambridge, MA: MIT Press, 1967 [1st ed., 1948]), p. 67. Meyer Schapiro, *Modern Art—19th and 20th Centuries, Selected Papers* (New York: George Braziller, 1978), pp. 192–93. The Patten Lectures at Indiana University were published posthumously, in a much expanded form, as Meyer Schapiro, *Impressionism: Reflections and Perceptions* (New York: George Braziller, 1997).

5. William Empson, *Some Versions of Pastoral* (New York: New Directions, 1974 [1st ed., 1935]), p. 6. W. H. Auden, *Lectures on Shakespeare* (Princeton, NJ: Princeton University Press, 2000), p. 138. Empson, *Some Versions of Pastoral*, p. 22. Among the few actual examples that Empson gives is a movie, a 1929 documentary about a North Sea fishing fleet called *Drifters*, by John Grierson, which, Empson writes, "gave very vividly the feeling of actually living on a herring trawler and (by the beauty of shapes of water and net and fish, and subtleties of timing and so forth) what I should call a pastoral feeling about the dignity of that form of labour." (Ibid., p. 8.) Empson is looking at a kind of primitive fishing community that survives in the modern world, but what turns these fishermen into pastoral figures is the vision of a lost harmony that the filmmaker—and the moviegoer—brings to the story.

6. Auden, *Lectures on Shakespeare*, pp. 138, 140. Auden was fascinated by the pastoral. In arranging the libretto for *The Rake's Progress* in 1947, Auden had first planned to have the hero, who lived in the country, receive an inheritance from his father, but he decided that that "would destroy the pastoral tone," so he had the inheritance that brings about Tom's downfall come from a city relative. (Robert Craft, "Notes on *The Rake's Progress*," *Playbill*, Metropolitan Opera, New York, April 23, 2003, p. 7.)

7. Greenberg, *Collected Essays*, vol. 4, p. 11.

8. André Masson, "Towards Boundlessness," in *André Masson: Recent Work and Earlier Paintings* (New York: Curt Valentin Gallery, 1953), unpaged. The Asian openness of Masson's paintings had its origins in his improvisational sand paintings of the 1920s. Already in the 1930s, Georges Duthuit published a book called *Chinese Mysticism and Modern Painting* (a book cited by Suzuki) in which Masson's painting was related to Asian art; painting, Duthuit writes, "ceases to select, it aims to command the universe in its entirety." (Georges Duthuit, *Chinese Mysticism and Modern Painting* [Paris: Chroniques du Jour, 1936], p. 112.) Although the influence that Masson had on Pollock is generally said to have been strongest in the 1940s, I believe that the influence of the Asian-influenced Masson of the later 1940s can be felt in the drawings that Pollock did with ink on rice paper in 1951.

9. Peter Blanc, "The Artist and the Atom," *Magazine of Art*, April 1951, p. 146.

10. Greenberg, *Collected Essays*, vol. 4, p. 11.

11. John Rewald, *Pierre Bonnard* (New York: Museum of Modern Art, 1948), p. 48.

12. Robert De Niro, *The Art Criticism of Robert De Niro* (New York: Arts Review, [n.d.]), pp. 4, 2.

13. Finkelstein, "New Look," pp. 37, 38.

14. Arlene Croce, *Writing in the Dark, Dancing in* The New Yorker (New York: Farrar, Straus and Giroux, 2000), pp. 182–83.

15. Greenberg, *Collected Essays*, vol. 1, p. 108.

16. Nell Blaine, unpublished journal entry, 1967, Houghton Library of the Harvard College Library, Cambridge, MA.

17. Frank O'Hara, *The Collected Poems of Frank O'Hara*, ed. Donald Allen (New York: Knopf, 1971), p. 325.

18. Ben Weber and Frank O'Hara, "Song: Opus 44," in *Folder* 4 (New York: Tiber Press, 1956), musical insert, pp. 4–5. Frank O'Hara, *Standing Still and Walking in New York*, ed. Donald Allen (San Francisco: Grey Fox Press, 1983), p. 41.

19. Thomas B. Hess, *De Kooning: Recent Paintings* (New York: Walker & Co., 1967), p. 9. O'Hara, in "Larry Rivers: A Memoir," wrote, "The single most important event in [Larry's] artistic career was when de Kooning said his painting was like pressing your face into wet grass"—which might be interpreted either as a compliment or an insult, but either way has a comic-pastoral zing. (O'Hara, *Standing Still*, p. 170.)

20. Vladimir Nabokov, *Lolita* (New York: Berkeley Medallion Press, 1969 [1st ed., 1955]), pp. 133–34.

21. Gary Snyder, *Earth House Hold: Technical Notes and Queries to Fellow Dharma Revolutionaries* (New York: New Directions, 1968), pp. 35, 96. For Noguchi's work in Japan, see Louise Allison Cort and Burt Winther-Tamaki, *Isamu Noguchi and Modern Japanese Ceramics: A Close Embrace of the Earth* (Washington, DC: The Arthur M. Sackler Gallery, Smithsonian Institution, 2003).

22. Charles Olson, *Maximus Poems* (New York: Jargon/Corinth Books, 1960), p. 53. William Carlos Williams, *Paterson* (New York: New Directions, 1995), p. 17.

23. Jack Kerouac, introduction to Robert Frank, *The Americans* (New York: Scalo, 1993 [1st ed., 1958]), p. 5.

24. Walker Evans, "Robert Frank," *U.S. Camera Annual 1958* (New York: U.S. Camera Publishing, 1957), p. 90.

25. Edwin Denby, *The Complete Poems* (New York: Random House, 1986), p. 102. When James Agee wrote about Helen Levitt's photographs of kids on the streets of New York in the late 1940s, he said that her subjects were "pastoral people, persisting like wild vines upon the intricacies of a great city." In Levitt's photographs the kids playing amid the brownstone stoops and garbage cans suggested innocence "in its full original wildness, fierceness, and instinct for grace and form." (James Agee, "A Way of Seeing," in Helen Levitt and James Agee, *A Way of Seeing* [New York: Viking Press, 1965], p. 74.)

26. Over the years, Burckhardt produced films on a vast range of subjects. There are cinematic poems to the rhythms of New York, with its hurtling pedestrians and new and old buildings. There are slapstick comedies, with friends such as Denby, Ashbery, Larry Rivers, and Fairfield Porter taking part in a revival of Hollywood's Golden Age of silent film; in one early film Elaine de Kooning is a wicked witch who lures innocent children into the suburban woods, where she and her sidekicks do wackily angular modern dances. Slapstick comedy was by now itself a sort of pastoral mode. And there are lyric salutes to the beauties of Maine's woods and lakes, with close-ups of the carpeted forest floor and the clouds moving quickly across the vast sky. Burckhardt wrote that his "early films could be called documentaries when about a place I was familiar with, or travelogues when about exotic places I traveled to: Haiti, Alabama, Trinidad, Napoli, Verona, New York's Lower East side, Peru, under the Brooklyn Bridge." (Burckhardt, "How I think I made some of my photos, paintings and films," xerox typescript.) In later years, he would present, once or twice a year, in various New York locations, showings of half a dozen or so of these short films, and there was always a balancing of genres, so that city and country might be juxtaposed, or lyric and narrative, or black-and-white and color. He might show *Square Times,* from 1967, a color movie about Times Square with a soundtrack of Supremes songs, and follow it with one of his slow-moving homages to the beauties of the Maine woods. There was a nice mingling of genres, of moods, of temperaments. Alex Katz, in an article about Burckhardt, had wondered: "If Corot had lived in Dostoevsky's neighborhood, would his work look like

Burckhardt's?" (Alex Katz, "Rudolph Burckhardt: Multiple Fugitive," *Art News*, December 1963, p. 41.) One might not quite know how to answer that question, but one saw that Katz was pointing to a mingling of the gentle and the violent, a yang-and-yin kind of thing that was central to Burckhardt's achievement. And Corot, who in his later years would paint endless twilit pastorals, was of course regarded, by Schapiro and many other historians, as a precursor of Monet and Impressionism. For Rudy Burckhardt, see his series of brief memories (Rudy Burckhardt, *Mobile Homes*, ed. Kenward Elmslie [Calais, VT: Z Press, 1979]), his series of interviews (Rudy Burckhardt and Simon Pettet, *Talking Pictures: The Photography of Rudy Burckhardt* [Cambridge, MA: Zoland Books, 1994]), and a monograph (Phillip Lopate, *Rudy Burckhardt* [New York: Harry N. Abrams, 2004]).

27. V. R. Lang, *Poems and Plays with a Memoir by Alison Lurie* (New York: Random House, 1975), pp. 269, 277, 295, 279, 282.

28. Alison Lurie, in Lang, *Poems and Plays*, p. 71.

29. David Rosand, "Giorgione, Venice, and the Pastoral Vision," in Robert C. Cafritz, ed., *Places of Delight: The Pastoral Landscape* (New York: Clarkson N. Potter, 1988), pp. 48, 43. Rosand says that "the surface of a painting by Giorgione, particularly in his later work on canvas, is vibrant and open, the touches of the brush creating a loose atmospheric network that invites the eye of the viewer to bring forms into focus. Even on this essentially formal level, then, Giorgione's art insists on active engagement. Its invitation, by suggestion, implicates the viewer in its poetry." (Ibid., p. 43.) Giorgione not only originates the idea of landscape as having a freestanding integrity; he introduces the idea that the very act of painting has that kind of integrity.

30. Irving Sandler, "Joan Mitchell," in B. H. Friedman, ed., *School of New York: Some Younger Artists* (New York: Grove Press, 1959), p. 47.

31. Marion Strobel, "Tropical Pool," *Poetry*, May 1924, p. 68.

32. Georges Rodenbach, quoted in Schapiro, *Impressionism: Reflections and Perceptions*, p. 200.

33. James Schuyler quoted in Bernstock, *Joan Mitchell*, p. 134. There is a relatively small but fascinating group of books with illustrations by New York School artists. Tiber Press— which published Daisy Aldan's magazine *Folder*—produced in 1960 a quartet of large-format volumes combining the work of poets and painters (working in lithography): *Salute*, by James Schuyler and Grace Hartigan; *Permanently*, by Kenneth Koch and Alfred Leslie; *Odes*, by Frank O'Hara and Michael Goldberg; and *The Poems*, by John Ashbery and Joan Mitchell. Among the books published by John Bernard Myers at Tibor de Nagy, a standout is *Poems/Prints* (1953), combining Kenneth Koch's poems and Nell Blaine's silk-screen prints. With certain artists, one regrets that they never did full-scale book projects; Fairfield Porter, who wrote poetry and was close to poets, would have been a natural, and his jacket designs for volumes by Koch and Schuyler as well as some other scattered works suggest how much else he might have done. A study of books illustrated by New York artists, which remains to be written, would also include a remarkable work by Louisa Matthiasdottir, a series of black-and-white brush drawings for a book of poems by Matthías Johannessen, *Hólmgönqulijód*, published in Iceland in 1960.

34. Frank O'Hara and Larry Rivers, "Kenneth Koch, a Tragedy," in Frank O'Hara, *Amorous Nightmares of Delay: Selected Plays* (Baltimore: Johns Hopkins University Press, 1997 [1st ed., 1978]), p. 132. John Ashbery, *Reported Sightings: Art Chronicles, 1957–1987*, ed. David Bergman (New York: Knopf, 1989), p. 100.

35. Frank O'Hara, *What's with Modern Art?: Selected Short Reviews and Other Art Writings*, ed. Bill Berkson (Austin, TX: Mike & Dale's Press, 1999), p. 24. Mitchell quoted in Bernstock, *Joan Mitchell*, p. 31.

36. "Women Artists in Ascendance," *Life*, May 13, 1957, p. 75.

37. Gilbert Sorrentino's novel *Imaginative Qualities of Actual Things*, a rather dark account of the early 1960s, full of artistic charlatans and sexual dissatisfaction, presents Lou and Sheila, the poet and his wife, both from Brooklyn. This isn't the 1950s, but the relations between men and women within the avant-garde probably didn't really begin to change until later in the 1960s. Sheila had married Lou because she "had never met a man who was going to be a poet. Who was a poet. That Lou was a rotten poet was beside the point. She didn't know he was a rotten poet." Then Lou helps Sheila as she begins to write poetry, and the narrator observes that a man should do "Anything. Everything. But not teaching one's wife to write poems. Let her cook food. (Ah, food! Chomp, slurp, good!) Arrange a single daisy in the slender and exquisite vase some literary friend brought from Japan. So that the poet might compose a verse or two about this daisy and his love: an occasional verse, a fragile thing that may grace the first page of the new campus mimeo magazine, *Mu'fugga*, of which he is faculty advisor. 'Well, we can't really call it *Motherfucker*, boys,' he laughs, the motherfucker, 'but there *are* ways around that!' " (Gilbert Sorrentino, *Imaginative Qualities of Actual Things* [New York: Pantheon Books, 1971], pp. 13, 18.)

38. See Benedetta Craveri in "A Very Grand Girl," *The New York Review of Books*, August 14, 2003, p. 48.

39. S.F. [Sam Feinstein?], "Nell Blaine," *Art Digest*, October 1, 1953, p. 20.

40. James Schuyler, "The View from 210 Riverside Drive," in James Schuyler, *Selected Art Writings*, ed. Simon Pettet (Santa Rosa, CA: Black Sparrow Press, 1998), pp. 165, 168.

41. Friedrich von Schiller, *Works of Friedrich von Schiller*, trans. Sir Theodore Martin R. D. Boylan (New York: The Aldus Press, 1910), vol. 10, p. 37. Translations somewhat altered.

42. Ibid., pp. 37, 38.

43. Nell Blaine, unpublished journal entry, 1958, Houghton Library of the Harvard College Library, Cambridge, MA.

44. Martica Sawin, *Nell Blaine: Her Art and Life* (New York: Hudson Hills Press, 1998), p. 45.

A GRAND COLLAGE

8. JOSEPH CORNELL IN MANHATTAN

1. Harriet Janis and Rudi Blesh, *Collage: Personalities, Concepts, Techniques* (New York: Chilton Company, 1962), p. 78.

2. Frank O'Hara, *The Collected Poems of Frank O'Hara*, ed. Donald Allen (New York: Knopf, 1971), pp. 370, 356, 375–76.

3. Saul Bellow, *Seize the Day* (Greenwich, CT: Fawcett Publications, 1968 [1st ed., 1956]), p. 36. Ralph Ellison, *Invisible Man* (New York: Vintage Books, 1972 [1st ed., 1952]), pp. 527, 542, 543.

4. Edwin Denby, *Dancers, Buildings, and People in the Streets* (New York: Horizon Press, 1965), pp. 191, 199.

5. Ralph Ellison, *The Collected Essays of Ralph Ellison*, ed. John Callahan (New York: Modern Library, 1995), p. 835.

6. Peterson had made *Mr. Frenhofer and the Minotaur* at the California School of Fine Arts in 1948. In both *Manhole Covers* and *Architectural Millinery*, contemporary New York is montaged with earlier times and places. In *Manhole Covers* a clip from a Chaplin movie with the Tramp falling down a manhole is included, and in *Architectural Millinery* the

tops of nineteenth-century buildings are compared to prints of Victorian and Edwardian ladies in fancy hats, and the narrator observes that people who do not wear hats are rather like modern buildings with their flat, unadorned tops. The Modern's Point of View series also recalls some of the themes that Rudy Burckhardt first developed during the 1940s in his movies about the pace and mood of Manhattan, such as *Climate of New York*. Burckhardt would work variations on that urban theme for the rest of his life.

7. William C. Seitz, *The Art of Assemblage* (New York: Museum of Modern Art, 1961), p. 150. Hess, in his important article about "The Art of Assemblage" in *Art News* in November 1961, spoke with great warmth of a 1948 show about collage that had been organized at the Museum of Modern Art by Margaret Miller. At the time, Greenberg had called it "one of the most important as well as most beautiful shows of modern art ever held in this country," and castigated "the general run of art reviewers" for completely missing its significance. (Clement Greenberg, *The Collected Essays and Criticism*, ed. John O'Brian [Chicago: University of Chicago Press, 1988–93], vol. 2, p. 259.) In 1949 there was a show called "Illusionism and Trompe L'Oeil" at the Palace of the Legion of Honor in San Francisco, which surveyed work from the Renaissance to Picasso and Cornell. The catalog contained essays by the curator, Jermayne MacAgy, and by her husband, Douglas MacAgy, who was director of the California School of Fine Arts, where Abstract Expressionist ideas were very much in the air. Douglas MacAgy's essay, "Phantasy in Fact," included a mention of "Duchamp's famous ready-mades." (*Illusionism and Trompe L'Oeil* [San Francisco: Palace of the Legion of Honor, 1949], p. 48.)

8. Collage was also a factor in mid-century music. Virgil Thomson has written that John Cage's "own music over the last thirty years, though not entirely free of interrelated pitches, has nevertheless followed a straighter line in its evolution toward an art of collage based on non-musical sounds than that of any other artist of his time." (Virgil Thomson, "Cage and the Collage of Noises," in *American Music Since 1910* [New York: Holt, Rinehart and Winston, 1977], p. 69.) Harry Partch's compositions also reflect a collagist's vision. In *The Wayward*—which he worked on from the 1940s to the 1960s—scraps of conversation derived from Partch's encounters with hobos and other characters in the late 1930s are accompanied by percussive and reedy sounds, often produced by instruments of Partch's own design. Partch offers not only a collage of voices but also a collage of sensibilities, for if the spoken parts of *The Wayward* echo the protest literature of the 1930s, the music has an Asian pastoral inwardness that we tend to associate with the 1950s, when Partch extensively revised this work.

9. Sandra Leonard Starr, *Joseph Cornell and the Ballet* (New York: Castelli/Feigen/ Corcoran, 1983), p. 12. Among the huge literature on Cornell, this is a standout that conveys the intricacy of his thought. A very evocative anthology is Dore Ashton, ed., *A Joseph Cornell Album* (New York: Viking Press, 1974). See also Deborah Solomon, *Utopia Parkway: The Life and Work of Joseph Cornell* (New York: Farrar, Straus and Giroux, 1997).

10. Joseph Cornell, *Joseph Cornell, Theater of the Mind: Selected Diaries, Letters, and Files*, ed. Mary Ann Caws (New York: Thames & Hudson, 1993), pp. 232, 193, 258, 158.

11. Denby, *Dancers*, p. 149.

12. Comment in *Dance Index*, July–August 1944, p. 103.

13. Walter Benjamin, *The Arcades Project*, trans. Howard Eiland and Kevin McLaughlin (Cambridge, MA: Harvard University Press, 1999), p. 416.

14. Fernand Léger, *Functions of Painting* (New York: Viking Press, 1973), p. 49. An important study of Cornell's films is P. Adams Sitney, "The Cinematic Gaze of Joseph

Cornell," in Kynaston McShine, ed., *Joseph Cornell* (New York: Museum of Modern Art, 1980).

15. Watching Cornell's films, you can sometimes find yourself less engaged by the images than by the question of why they engaged Cornell. But with the opening shots of an anthology film known as *Bookstalls,* the only question is where on earth Cornell found this footage that so perfectly matches his interests and obsessions. Here Cornell begins with a boy looking through the books that are for sale in the famous stalls along the Seine. It is as if Cornell, in turning up this footage, has discovered the very archaeology of the flaneur; he has uncovered an earlier, European version of himself, an image of the eternally curious boy, looking into books to discover the world. And Cornell gives this scene a traditional movie-narrative impulse by showing the boy looking into a book that then fades to a distant scene—a fragment of a Spanish travelogue.

16. John Ashbery, *Reported Sightings: Art Chronicles, 1957–1987,* ed. David Bergman (New York: Knopf, 1989), pp. 297, 295.

17. Robert Duncan, introduction to *Translations by Jess* (New York: Odyssia Gallery, 1971), p. i. For Jess, see also Michael Auping, ed., *Jess: A Grand Collage, 1951–1993* (Buffalo, NY: Albright-Knox Art Gallery, 1987).

18. Robert Duncan, "An Art of Wondering," in J. D. McClatchy, ed., *Poets on Painters: Essays on the Art of Painting by Twentieth-Century Poets* (Berkeley: University of California Press, 1988), p. 228. First published in *Translations, Salvages, Paste-ups,* a catalog published by the Dallas Museum of Fine Arts in 1977.

19. Raymond Foye, *The Heavenly Tree Grows Downward* (New York: James Cohan Gallery, 2002), p. 26. Foye's catalog is a valuable source of information on Smith. See also Paola Igliori, ed., *American Magus: Harry Smith* (New York: Inandout Press, 1996). Among the large literature on avant-garde film in America, the essential text is P. Adams Sitney, *Visionary Film: The American Avant-Garde* (New York: Oxford University Press, 1974).

20. It was surely the homegrown quality in the thought of Mary Baker Eddy and Christian Science that appealed to Cornell and led him to become a Christian Scientist in the 1920s, when he heard about the religion from a coworker at the William Whitman Company, a textile wholesaler on Madison Avenue where he had a job at the time. Mary Baker Eddy started Christian Science in Boston in the 1860s, and had drawn on Emerson's transcendentalism, although in ways that seemed shoddy to Emerson's sophisticated admirers; her work was a popularization of Emerson, Emerson turned into a how-to idea for living. And for Cornell, who during his life belonged to a number of Christian Science congregations in Queens where most of the members were housewives, there had to have been a homemade—indeed, a homemaker's—American grandeur to Mary Baker Eddy and Christian Science; it was a kind of Christianity that might make sense to the self-invented intellectual.

21. Starr, *Cornell and the Ballet,* p. 2.

22. Sandra Leonard Starr, writing about Cornell and the ballet, observes that Ondine's legend "extends from the Greek Circe through the Roman parthenope on to Paracelsus's Udine, and she emerges during the Romantic era in the tales of E.T.A. Hoffmann, La Motte-Fouqué, and Andersen. The theme of Ondine recurs in poetry, music, drama, art, opera, and film; to paraphrase Joseph Campbell she is the heroine with a thousand faces whom the ballet Ondine celebrates in microcosm." (Starr, *Cornell and the Ballet,* p. 19.) The boxes that include night skies and constellations are thus a kind of continuation of the romantic ballet—Toumanova in that *Nebula* scenario of Cornell's. And the links are even more tangled, for the names of French hotels—Hôtel du Nord, Hôtel de l'Etoile— that dominate many of the constellation boxes also have, it turns out, a link back to

ballet. In 1949 Cornell saw *Les Rendez-vous,* a Roland Petit ballet with sets by Brassaï, which consisted, at stage right, of an enormous blowup of the words *Hôtel de la Belle Étoile.* (Starr, *Cornell and the Ballet,* p. 46.)

23. Starr, *Cornell and the Ballet,* pp. 19, 60–61.

24. The exhibition note was by Garrett P. Serviss. Quoted in Dawn Ades, *Surrealist Art: The Lindy and Edwin Bergman Collection at the Art Institute of Chicago* (Chicago: The Art Institute of Chicago, 1997), p. 75.

25. Fairfield Porter, *Art in Its Own Terms: Selected Criticism, 1935–1975,* ed. Rackstraw Downes (New York: Taplinger Publishing, 1979), p. 52.

26. Starr, *Cornell and the Ballet,* p. 25.

27. Motherwell, "On Joseph Cornell," in Cornell, *Cornell, Theater of the Mind,* pp. 13, 15. The statement was originally written in 1953.

28. Ashbery, *Reported Sightings,* pp. 15, 17.

29. Ellison, *Collected Essays,* pp. 500, 490.

9. WELDERS AND OTHERS

1. David Smith, *David Smith by David Smith,* ed. Cleve Gray (New York: Holt, Rinehart and Winston, 1968), p. 25.

2. Ibid., pp. 25, 31.

3. Frank O'Hara, *Art Chronicles, 1954–1966* (New York: George Braziller, 1990 [1st ed., 1975]), p. 55.

4. Garnett McCoy, ed., *David Smith* (New York: Praeger Publishers, 1974), pp. 76, 146–47. Smith, *Smith by Smith,* p. 146.

5. Smith, *Smith by Smith,* p. 24.

6. McCoy, ed., *David Smith,* p. 138.

7. Clement Greenberg, *The Collected Essays and Criticism,* ed. John O'Brian (Chicago: University of Chicago Press, 1986–93), vol. 4, p. 190.

8. Harriet Janis and Rudi Blesh, *Collage: Personalities, Concepts, Techniques* (New York: Chilton Company, 1962), pp. 146, 111.

9. Hans Wingler, ed., *Bauhaus* (Cambridge, MA: MIT Press, 1976), p. 143.

10. Greenberg, *Collected Essays,* vol. 4, pp. 65, 66.

11. Carola Giedion-Welcker, "Arp: An Appreciation," in *Arp* (New York: Museum of Modern Art, 1958), p. 24.

12. Janis and Blesh, *Collage,* p. 215.

13. László Moholy-Nagy quoted in Donald Drew Egbert, *Socialism and American Art: In the Light of European Utopianism, Marxism, and Anarchism* (Princeton, NJ: Princeton University Press, 1967 [1st ed., 1952]), p. 49.

14. Apollinaire quoted in *Construction and Geometry in Painting: From Malevitch to "Tomorrow"* (New York: Galerie Chalette, 1960), unpaged. Madeleine Chalette-Lejwa statement ibid. For Galerie Chalette and Mme. Chalette-Lejwa, see Ruth Apter-Gabriel, *Legacy of Commitment: The Arthur and Madeleine Chalette Lejwa Collection* (Jerusalem: Israel Museum, forthcoming).

15. Sidney Tillim, "What Happened to Geometry?," *Arts,* June 1959, p. 41.

16. Many of these small pencil sketches, in which Diller's Neoplastic forms were indicated with scribbles of colored pencil, also happened to include collage elements, rectangles of cut paper, at least they did in the years around 1960. Diller was in Janis and Blesh's *Collage,* with the artist being, as they put it, one of "those collagists who seek precision" and "employ the sheared edge for clear statement." (Janis and Blesh, *Collage,* p. 149.) For Diller, see Barbara Haskell, *Burgoyne Diller* (New York: Whitney Museum of American Art, 1990).

17. Burgoyne Diller, in *Diller* (New York: Galerie Chalette, 1961), unpaged.

18. Ilya Bolotowsky, "On Neoplasticism and My Own Work: A Memoir," in *Leonardo*, July 1969, pp. 221–22.

19. Philip Larson, "Burgoyne Diller: An American Constructivist," in *Burgoyne Diller* (Minneapolis: Walker Art Center, 1972), p. 12.

20. One should never underestimate the extent to which Kelly is a traditionalist in his attitude toward Constructivism. In 1951 he proposed to the Guggenheim Foundation "an alphabet of plastic pictorial elements, aiming to establish a new scale of painting, a closer contact between the artist and the wall, providing a way for painting to accompany modern architecture." (Ellsworth Kelly, *Line Form Color* [Cambridge, MA: Harvard University Art Museums, 1999], 2 vols. Kelly's 1951 statement is at the end of the unpaged illustration volume.) *Line Form Color*, not actually published until 1999, is an elegant progression of pared-down images, beginning with black lines (vertical, horizontal), going through pages split between black and white, through tricolor pages, and even some pages embossed with lines. Originally planned to be executed in linoleum blocks, *Line Form Color* is related in spirit to some of the design experiments of the Russian Constructivists and the Bauhaus masters—or to the album produced by the French geometric painter Auguste Herbin after the war (Auguste Herbin, *L'art non-figuratif non-objectif* [Paris: Édition Lydia Conti, 1949]). The author of *Line Form Color* is reviving the idea of the artist as a researcher into the essence of art, and if there is something almost antiquarian about Kelly's early modern avidity for the basics, he is also able to imbue his researches with the beginning-again spirit of the postwar years.

21. The best of Kelly's works that incorporate some element of chance strike us with their perfect elegance, and the chance is part of the elegance. When Kelly does an ink drawing with thick lines, cuts the drawing into squares, and then reassembles the squares in a new way, the disjunctions between the squares create the sensation of a split or a rift, of a kind of invisible line—a very considered effect. In a series of paintings from 1951— *Meschers, Cité, Talmont, Gironde*—Kelly takes these experiments with cut-and-recomposed ink drawings and renders them in oil paint. This process of trying things out with paper and then moving on to paint is not all that far from the procedure that Diller was following around the same time. In Kelly's case, the resulting paintings are grids in which each quadrant is filled with a related but distinct group of striped images. The playfulness of the cut-up drawings has a painterly energy that is disciplined and even masked by the imperturbability of the grid, as well as by Kelly's subdued paint handling. The result is a hard-edged intensity that nevertheless acknowledges the vagaries of naturalism, a naturalism that has been reduced to the touch of the artist's hand in those preparatory ink drawings. The beautifully delicate balancing act in these paintings found an admirer in none other than Braque, one of the founders of collage. Braque saw *Meschers* in a group show at the Galerie Maeght in Paris, and in the gridded fragments of Kelly's canvas, Braque found the solution to an area that he had been unable to resolve in the painting known as *Studio IX*, namely the bird in the canvas on the easel. The fragmented, segmented, gridded-off form in which we know this bird is thus an homage by the Old Master of Cubism to Ellsworth Kelly, the young American in Paris. There are very few cases of influence traveling from the young Americans to the older Europeans, and perhaps not a single other one that is so clearly documented.

22. Lawrence Alloway, "Heraldry and Sculpture," *Art International*, April 1962, p. 52.

23. *Sculpture for a Large Wall*, after being removed from the Transportation Building, was exhibited in 1998 at the Matthew Marks Gallery in New York. It is now in the collection of the Museum of Modern Art.

24. McCoy, ed., *David Smith*, p. 142. Smith emphasized González's relationship with the

romantic spirit of early-twentieth-century Barcelona. He also observed that although González "was not much given to art talk or theory," which would, in and of itself, make him a friend of the theory-shy Americans, he "sometimes used the Golden Section (1.6180). This mathematical ideal of the relationship of the diagonal with the side of the square may be homage to Cézanne and the 1912 *Section d'or* exhibition." But, Smith goes on, one does not even need a specific historical explanation for González's interest in the Golden Section, for it "has always been a constant in the eye of man." Smith, in fact, doesn't end with González but with a sort of quick glance further back, observing that "wrought metal sculpture goes back to the Bulls of Al 'Ubaid (3000 B.C.) and the life-sized figure of Pepi I from Hierakonpolis (2300 B.C.)." We are here, one might say, in the mytho-historical realm of Malraux or Focillon, with all the great formal impulses repeating and echoing through the history of art. "Iron welding and working," Smith writes, "has been in evidence in almost every period of culture in both art and function." (McCoy, ed., *David Smith*, pp. 141, 142.)

25. John Ashbery quoted in Emmie Donadio et al., *Miracle in the Scrap Heap: The Sculpture of Richard Stankiewicz* (Andover, MA: Addison Gallery of American Art, 2003), p. 6.

26. It has been pointed out that many of the landscapes in modern art, especially in late-nineteenth-century art, represented an increasingly industrialized world—not so much a rural place but a suburban place, a new hybrid nature in which the encroachment of urban life was always palpable. And just as landscape painters were moving further and further from the classical idea of a landscape dotted with little temples and stone statuary, so in the twentieth century the idea of what was interesting in nature came to be more ambiguous, more intermixed with apposite elements. Matisse painted the view through the windshield of a car. Léger painted landscapes in which the old pastoral iconography was jumbled together with the new bridges and bicycles. In America in the 1930s, Léger, with whom Stankiewicz would later study in Paris, was astonished that old machinery was left to rust in the fields, and out of this came the series of *Waste* paintings, with their twisted metal forms.

27. That there is a gravity behind the comedy of Stankiewicz's art is suggested by an interesting essay, "The Prospects for American Art," that he published in *Arts* in 1956. It is a dark, rather hard-bitten view of things. Stankiewicz speaks of a "day-to-day life which is filled with the preoccupations of my sculpture, other art activities, making a living and the rest of what makes up my days, it is not often that 'The Prospects for American Art' comes to mind as an idea to track very far." Still, he thinks it worth the effort, and he finds that the situation is paradoxical. For "art in itself—as art—I have the least fear," he observes. "Since perhaps fifty years ago, certainly since the thirties, we have had a nucleus of hard-shelled artists who have labored hard to break down the Philistine walls. . . . The young artists today inherit not only a pioneered territory but an example of tenacity and confidence in self in the face of indifference or discouragement. With this tradition of the difficult as normal, the near future has my confidence and faith." Stankiewicz sees health and nerve among artists, but as for "art's relationship to the public, the support of arts and the peculiar rigidity of our government towards the artists," this is another matter. "The state of these things is pretty dim now, and their future is not very sure." Stankiewicz goes into some detail about how "many of our best artists cannot subsist from their art. . . . The grinding tragedy of it is that today we are able for the first time to stand up to the art of any country in the world, unashamed of what we have done. Equals, at least. And the people who make this true spend their days in factories. To all the pious folk who pretend adoration of the arts, cultured awareness and sensitivity, I say think about this. *Think*." The conclusion, then, is that an artist feels "a quieter sadness and the lonely feeling that very few people care."

It is a striking view to encounter in the mid-1950s, certainly far from the optimism that we have come to expect. Perhaps the jokes in Stankiewicz's sculpture are an attempt to break through the gloom of the audience by giving the mysteries of modern art a comedic edge. (Richard Stankiewicz, "The Prospects for American Art," *Arts*, September 1956, pp. 16–17.)

28. The sculpture of the late 1940s and the 1950s is a rich and complex subject. Figurelike or totemlike images came from the hands not only of Smith and Stankiewicz but also of Louise Bourgeois, Isamu Noguchi, David Hare, Herbert Ferber, Ibram Lassaw, and Richard Lippold. These might be in wood or stone or, more often, in welded or cast metal. Ferber, Theodore Roszak, and Seymour Lipton were moving into more solid, architectonic forms, forms that often had a fantastical, sometimes biological character emphasized by their frequently roughened, irregular surfaces. Wood was the medium with which Gabriel Kohn and Mark di Suvero and Michael Lekakis were creating shapes that had a bold, almost calligraphic look, shapes that suggested a three-dimensional reimagining of the all-in-one impact of Chinese written characters. Plaster or terra-cotta were used by a number of artists, including Reuben Nakian, in his casually inscribed reliefs of mythic love affairs, and Tony Agostini, in slyly baroque abstractions. And around 1960 a feeling that was at once wittier and chillier would enter into wood carving, when George Sugarman began to paint his concatenations of unruly, wiggly shapes in kindergarten-bright colors. The sculpture of this period remains too little written about. See Lisa Phillips, *The Third Dimension: Sculpture of the New York School* (New York: Whitney Museum of American Art, 1984); and Mona Hadler and Joan Marter, eds., "Sculpture in Postwar Europe and America, 1945–59," *Art Journal*, Winter 1994.

29. McCoy, ed., *David Smith*, pp. 67–68. David Smith's welded steel *Letter*, from 1950, is a prime example of these interests. It is a rectangular frame with four horizontal bars, each one holding four or five letterlike or anthropomorphic elements. You might call this an assemblage of make-believe found objects. It's as if Smith is dreaming up an imaginary language of signs and symbols. There is a mild archaicism or esotericism behind the rather sleek look of Smith's *Letter*, and this recalls some of Cornell's boxes of the 1950s. The similarities between some of Cornell's and Smith's work from the 1950s can be rather astonishing. A Smith work such as *Letter*, with its overall regular structure creating a kind of armature to hold a family of elements, recalls a whole series of Cornells from the late 1940s and 1950s, in which boxes organized into grids are filled with an array of elements that are closely related yet distinct. The box or sculpture becomes a way of organizing—almost filing away—everything one has found or seen.

30. Ibid., p. 80.

31. Smith in an interview with Thomas Hess, in *David Smith* (New York: Marlborough-Gerson Gallery, October 1964), unpaged.

32. McCoy, ed., *David Smith*, pp. 157, 158–59.

33. Walker Evans, "On the Waterfront," *Fortune*, November 1960, p. 145.

34. McCoy, ed., *David Smith*, p. 163.

35. Karl Marx and Friedrich Engels, *Basic Writings on Politics and Philosophy*, ed. Lewis S. Feuer (Garden City, NY: Anchor Books, 1959), p. 320.

36. Smith quoted in O'Hara, *Art Chronicles*, p. 56.

37. O'Hara, *Art Chronicles*, p. 55.

38. Hilton Kramer, *The Age of the Avant-Garde: An Art Chronicle of 1956–1972* (New York: Farrar, Straus and Giroux, 1973), p. 323.

39. Ibid., p. 326.

40. Greenberg, *Collected Essays*, vol. 3, p. 278; vol. 4, pp. 191, 224, 225, 227. It is interesting

that the essay that follows this one in Greenberg's collected writings, "Post Painterly Abstraction," begins by speaking of Wölfflin and his idea of the painterly—dialectics were on Greenberg's mind.

41. David Smith, "Notes on My Work," in *Arts*, February 1960, p. 44.

42. Howard Nemerov, "*Four Soldiers:* A Sculpture in Iron by David Smith," in *David Smith: Sculpture and Drawing* (New York: Willard and Kleeman Galleries, 1952), unpaged.

10. FROM READYMADES TO CUTOUTS

1. Marcel Duchamp in *Affectionately, Marcel: The Selected Correspondence of Marcel Duchamp,* ed. Francis M. Naumann and Hector Obalk, trans. Jill Taylor (London: Thames & Hudson, 2000), pp. 43–44.

2. Ibid.

3. Francis M. Naumann, *New York Dada, 1915–1923* (New York: Harry N. Abrams, 1993), p. 36. *Oxford English Dictionary.* For the idea of the readymade in nineteenth-century American culture, see Michael Zakim, *Ready-Made Democracy: A History of Men's Dress in the American Republic, 1760–1860* (Chicago: University of Chicago Press, 2003).

4. William Gaddis, *The Recognitions* (New York: Penguin Books, 1985 [1st ed., 1955]), p. 186.

5. George Heard Hamilton, "In Advance of Whose Broken Arm?," in Joseph Masheck, ed., *Marcel Duchamp in Perspective* (Englewood Cliffs, NJ: Prentice Hall, 1975), p. 74.

6. Winthrop Sargeant, "Dada's Daddy," *Life,* April 28, 1952, pp. 100, 108, 111.

7. Marcel Duchamp quoted in Calvin Tomkins, *Duchamp: A Biography* (New York: Henry Holt, 1996), p. 159.

8. Marcel Duchamp, *The Writings of Marcel Duchamp,* ed. Michel Sanouillet and Elmer Peterson (New York: Da Capo Press, 1988 [1st ed., 1973]), p. 123.

9. Sargeant, "Dada's Daddy," pp. 111, 102.

10. Francis M. Naumann, *Marcel Duchamp: The Art of Making Art in the Age of Mechanical Reproduction* (Amsterdam: Ludion Press, 1999), p. 140.

11. Harriet and Sidney Janis, "Marcel Duchamp, Anti-Artist," originally published in *View,* March 1945, reprinted in Masheck, ed., *Duchamp,* pp. 30, 32, 36, 37.

12. The preparations for the Dada anthology are recounted in Robert Motherwell, *The Collected Writings of Robert Motherwell,* ed. Stephanie Terenzio (New York: Oxford University Press, 1992), p. 92.

13. Harold Rosenberg, *Artworks and Packages* (New York: Horizon Press, 1969), p. 199.

14. Thomas B. Hess, "J'Accuse Marcel Duchamp," *Art News,* February 1965, reprinted in Masheck, ed., *Duchamp,* p. 115.

15. Jasper Johns, "Sketchbook Notes," *Art and Literature,* Spring 1965, p. 192. Johns statement in *Sixteen Americans,* ed. Dorothy Miller (New York: Museum of Modern Art, 1959), p. 22. Max Kozloff, *Jasper Johns* (New York: Harry N. Abrams/Meridian Books, 1974), p. 12.

16. Leo Steinberg, *Other Criteria: Confrontations with Twentieth-Century Art* (New York: Oxford University Press, 1972), pp. 12, 19, 48, 54.

17. Fairfield Porter, *Art in Its Own Terms: Selected Criticism, 1935–1975,* ed. Rackstraw Downes (New York: Taplinger Publishing, 1979), pp. 44, 45, 46.

18. Roger Shattuck, commentary during "The Art of Assemblage: A Symposium (1961)," in John Elderfield, ed., *Studies in Modern Art 2: Essays on Assemblage* (New York: Museum of Modern Art, 1992), pp. 128–30.

19. Steinberg, *Other Criteria*, pp. 84, 88.

20. Ad Reinhardt quoted in Lucy R. Lippard, *Ad Reinhardt* (New York: Harry N. Abrams, 1981), p. 195.

21. Harriet and Sidney Janis, "Marcel Duchamp, Anti-Artist," p. 31. Motherwell, *Collected Writings*, p. 92. Barbara Rose, "ABC Art," in Gregory Battcock, ed., *Minimal Art: A Critical Anthology* (New York: E. P. Dutton, 1968), p. 277.

22. Ad Reinhardt, *Art as Art: The Selected Writings of Ad Reinhardt*, ed. Barbara Rose (Berkeley: University of California Press, 1991 [1st ed., 1975]), p. 14.

23. In his cartoons, Reinhardt pasted together a picture of the early 1950s with the artists smelling success: Pollock and de Kooning at the Venice Biennale; features in *Art News;* panels at the Museum of Modern Art; sales. The scene, even as it was coming into focus, was turning brash and commercial. In New York, high art was—already—turning into high commerce. Ad Reinhardt spoofed the middle-aged-men's-club aspects of the older generation, all the self-righteousness and self-importance. He observed of the New York School that it had "No woman and No emerging Talent Under Forty." In "Founding Fathers Folly Day," published in *Art News* in April 1954, the art world is a series of face-offs—of seriocomic dialectical athletic matches. You have "GottliebvsHofmann" in the "PROVINCETOWNCOWSHED," a match of "demigodvssuperman." You have "NewmanvsBeelzebub" in the "LIMBOGYMNASIUM," a match of "supermanvsdemigod." Then there's "PollockvsDekooning" at the "811BWAYBOOSTERSCLUB," a match of "wyomingpolecatvsdutchslasher." Some of the jokes may be lost on us, as when Reinhardt has "MotherwellvsMotherwell" in the "NYSCHOOLKENNELS," an "alloutknockdowngrudgefight." There's love in Reinhardt's astute satire; he exposes people, but he conveys the excitement of knowing them, too.

24. Reinhardt, *Art as Art*, pp. 4–5, 7.

25. William Rubin, *Ad Reinhardt* (New York: Museum of Modern Art, 1991), p. 8.

26. Reinhardt, *Art as Art*, pp. 77, 216, 217.

27. Ibid., p. 58.

28. Robert Rauschenberg statement in *Sixteen Americans*, p. 58.

29. Reinhardt, *Art as Art*, pp. 13, 56.

30. Harold Rosenberg, *The Anxious Object* (New York: Collier Books, 1973 [1st ed., 1964]), p. 77.

31. Marcel Duchamp, commentary during "The Art of Assemblage" in Elderfield, ed., *Studies in Modern Art 2*, p. 136.

32. Edwin Denby, "Katz: Collage, Cutout, Cut-Up," *Art News,* January 1965, pp. 42–43.

33. Frank O'Hara, *Art Chronicles: 1954–1966* (New York: George Braziller, 1990 [1st ed., 1975]), p. 146.

34. Frank O'Hara and Larry Rivers, "How to Proceed in the Arts," in O'Hara, *Art Chronicles*, p. 95.

35. Terry Southern, "Frank's Humor," in Bill Berkson and Joe LeSueur, eds., *Homage to Frank O'Hara* (Bolinas, CA: Big Sky, 1988), p. 112.

36. Frank O'Hara, *Standing Still and Walking in New York*, ed. Donald Allen (San Francisco: Grey Fox Press, 1983), p. 169. Rivers quoted in Dorothy Gees Seckler, "The Artist in America: Victim of the Culture Boom?," *Art in America*, no. 6, December 1963, p. 30.

37. John Ashbery, review in *Art News*, October 1970, reprinted in *Alex Katz* (New York: Praeger Publishers, 1971), p. 20. This volume—with contributions by more than a dozen authors—remains one of the most interesting books about Alex Katz.

38. Paul Taylor, *Private Domain* (New York: Knopf, 1987), p. 79.

39. Edwin Denby, *Dancers, Buildings, and People in the Streets* (New York: Horizon Press, 1965), p. 251.

40. Denby, "Katz: Collage, Cutout, Cut-Up," p. 42.

THE ARTIST AND THE PUBLIC

11. GOING TO THE MODERN

1. Arthur Drexler quoted in Jane Kramer, *Off Washington Square: A Reporter Looks at Greenwich Village* (New York: Duell, Sloane and Pearce, 1963), p. 82.

2. Henry-Russell Hitchcock, *Architecture: Nineteenth and Twentieth Centuries* (New York: Penguin Books, 1977), pp. 581, 582.

3. Lincoln Kirstein, *Thirty Years: Lincoln Kirstein's The New York City Ballet* (New York: Knopf, 1978), pp. 165, 164. For an excellent study of the planning and building of Lincoln Center, see Robert A. M. Stern, Thomas Mellins, and David Fishman, *New York 1960: Architecture and Urbanism Between the Second World War and the Bicentennial* (New York: Monacelli Press, 1995), pp. 677–717.

4. Ada Louise Huxtable, "Twentieth-Century Architecture," *Art in America*, no. 4 (1960), pp. 47, 52. Another architect who was for a time in the running for a Lincoln Center commission was Alvar Aalto, who brought romantic passions to his exquisitely balanced modern vision. The Lincoln Center board ultimately decided that they wanted to use only American architects; Aalto's single work in New York City, the Edgar J. Kaufmann Conference Room at 809 First Avenue, was completed in 1964.

5. Kirstein, *Thirty Years*, p. 165.

6. Lewis Mumford, *The Highway and the City* (New York: Harcourt, Brace and World, 1963), p. 132.

7. Hilla Rebay letters in *Frank Lloyd Wright: The Guggenheim Correspondence*, ed. Bruce Brooks Pfeiffer (Fresno: The Press at California State University, 1986), pp. 4, 6.

8. Hilla Rebay in *Art of Tomorrow: Fifth Catalogue of the Solomon R. Guggenheim Collection of Non-Objective Paintings* (New York: Solomon R. Guggenheim Foundation, 1939), p. 4.

9. Collective letter in *Frank Lloyd Wright: The Guggenheim Correspondence*, pp. 242, 243, 244.

10. Thomas Hess, "First View of the Guggenheim," *Art News*, November 1959, pp. 46, 68.

11. Mumford, *The Highway and the City*, pp. 129–30, 133.

12. Ibid., pp. 131, 132, 133.

13. Frederick Kiesler, *Inside the Endless House* (New York: Simon and Schuster, 1966), pp. 198–99.

14. *The New York Times*, October 21, 1959, p. 1. *The New York Times*, October 22, 1959, p. 1. *The New York Times*, October 26, 1959, p. 1.

15. Mumford, *The Highway and the City*, p. 139.

16. Hess, "First View of the Guggenheim," p. 46. Denise Levertov in Robert J. Bertholf and Albert Gelpi, eds., *The Letters of Robert Duncan and Denise Levertov* (Stanford, CA: Stanford University Press, 2004), p. 224.

17. Daniel Bell, *The End of Ideology: On the Exhaustion of Political Ideas in the Fifties* (New York: Collier Books, 1962 [1st ed., 1960]), pp. 34, 37.

18. *Newsweek*, December 17, 1962, p. 92. Sidney Tillim, "Month in Review," *Arts*, January 1962, p. 28. *Time*, June 1, 1962, p. 65.

19. Emerson quoted in Thomas B. Hess, "Culture as the Great American Dream," *Art*

News, December 1961, p. 35. Hess's essay offers a tart analysis of the Kress Foundation's populist ambitions—and the art dealers who made a fortune in the process of satisfying Mr. Kress's ambitions. "The picaresque adventures of the Kress Foundation and Collections," Hess wrote, "in four decades of buying and giving away over $50,000,000 of art is a sublime, grandiose, comic, purely American combination of the innocent with the serpentine, high idealism with low commerce, the marvelous with the funny: as beautiful as a fortuitous encounter of the Duke of Guermantes with Daddy Warbucks in the sculptured parking lot of the Miami Fontainebleau." (Hess, "Culture as the Great American Dream," p. 35.)

20. *Newsweek,* December 3, 1962, p. 103.

21. Ibid.

22. Edwin Denby, *Dancers, Buildings, and People in the Streets* (New York: Horizon Press, 1965), p. 265.

23. Edwin Denby, *The Complete Poems* (New York: Random House, 1986), p. 173. Fielding Dawson, *An Emotional Memoir of Franz Kline* (New York: Pantheon Books, 1967), pp. 135–36, 137.

24. Calvin Tomkins, *Duchamp: A Biography* (New York: Henry Holt, 1996), pp. 396–97.

25. Carl Holty, journal entry on January 21, 1962, in *Reflections of Carl R. Holty, a Journal, 1961–67,* Archives of American Art.

26. Dwight Macdonald, "Action on West Fifty-third Street—I," *The New Yorker,* December 12, 1953, p. 49. Macdonald, "Action—II," *The New Yorker,* December 19, 1953, p. 72. The enduring account of the Museum of Modern Art is Russell Lynes, *Good Old Modern: An Intimate Portrait of the Museum of Modern Art* (New York: Atheneum, 1973).

27. May Swenson, *New and Selected: Things Taking Place* (Boston: Little, Brown, 1978), p. 202.

28. Robert Goldwater, *Modern Art in Your Life* (New York: Museum of Modern Art, 1949), p. 5.

29. Thomas Hess quoted in Alfred H. Barr, Jr., *Defining Modern Art,* ed. Irving Sandler and Amy Newman (New York: Harry N. Abrams, 1986), p. 226.

30. Macdonald, "Action—I," pp. 55, 56–58.

31. Ibid., p. 58.

32. Ibid., p. 49.

33. Alfred H. Barr, Jr., *What Is Modern Painting?* (New York: Museum of Modern Art, 1943), p. 27.

34. Truman Capote and Richard Avedon, *Observations* (New York: Simon and Schuster, 1959), p. 90.

35. Macdonald, "Action—I," pp. 60, 62.

36. Macdonald, "Action—II," p. 66.

37. Thomas Hess, "A Tale of Two Cities," *Location,* Summer 1964, p. 42.

38. Thomas Hess obituary in *The New York Times,* July 14, 1978. A considerable number of artists and other people involved in the arts in New York worked at the Museum of Modern Art at one time or another. Al Held was a shipping clerk there in the mid-1950s, and acquired a great deal of old pigment that the museum was discarding, which he used to create his thickly painted canvases. (Paul Schimmel, *Action/Precision: The New Direction in New York, 1955–60* [Newport Beach, CA: Newport Harbor Art Museum, 1984], p. 35.)

39. Meyer Schapiro, *Modern Art—19th and 20th Centuries, Selected Papers* (New York: George Braziller, 1997), pp. 187–88.

40. Meyer Schapiro, statement in *Alfred H. Barr, Jr.: A Memorial Tribute, October 21, 1981* (New York: Museum of Modern Art, 1982), unpaged.

41. Barr, *What Is Modern Painting?*, p. 3.
42. Ibid., p. 27.
43. Ibid., pp. 35, 37.
44. Ibid., p. 38. Barr, *What Is Modern Painting?*, rev. ed. (New York: Museum of Modern Art, 1956), p. 44.
45. Barr, *Defining Modern Art*, pp. 69–70.
46. Alfred H. Barr, Jr., *Henri Matisse* (New York: Museum of Modern Art, 1931), p. 26.
47. Alfred H. Barr, Jr., *Matisse: His Art and His Public* (New York: Museum of Modern Art, 1951), pp. 11–12.
48. Barr, who was in contact with Matisse during the last months of the French painter's life—and in fact received a letter from him on the very day that he heard of his death—wrote movingly about the significance that his death had had for the broad public. "When Matisse died on November 3rd, 1954," Barr wrote in *The Yale Literary Magazine* special issue "Homage to Matisse," "the attention given the event by the newspapers and radio surprised even the artist's admirers. They were not used to seeing the obituary of a painter appear in front-page columns usually reserved for deceased politicians, admirals or stars of the silent film. It is said that the editor of a New York tabloid was so chagrined by the space and time given the news elsewhere that, feeling somehow betrayed by his own paper's unpreparedness, he angrily demanded the reason. 'We haven't had an art critic for years,' he was told. 'Hire one,' he commanded, 'right away.' " (*The Yale Literary Magazine*, Fall 1955, p. 38.)

12. MAKING HISTORY

1. Fernand Léger, *Magazine of Art*, April 1944, p. 144.
2. William Rubin's thesis became a book: William S. Rubin, *Modern Sacred Art and the Church of Assy* (New York: Columbia University Press, 1961).
3. Hans Hofmann quoted in Tina Dickey, "A Decisive Moment: Hofmann's Mosaic Murals," in James Yohe, ed., *Hofmann* (New York: Rizzoli, 2002), p. 271.
4. *New Forms in Door Ornamentation* (New York: The Yale and Towne Manufacturing Co./Wildenstein Gallery), 1956. In 1948, Katzenbach & Warren, a New York firm, produced screen-printed wallpaper after designs by Calder, Matisse, and Miró.
5. Samuel Kootz, foreword to *The Muralist and the Modern Architect* (New York: Kootz Gallery, 1950), unpaged.
6. Ad Reinhardt, "Founding Fathers Folly Day," *Art News*, April 1954, pp. 24–25.
7. Samuel Kootz, *Art for a Synagogue* (New York: Kootz Gallery, 1951), unpaged.
8. Editorial Statement, *Religion and the Intellectuals* (New York: Partisan Review, 1950), p. 5. No artists contributed to *Partisan Review*'s volume, but two writers who were deeply engaged with the artists—Greenberg and Schapiro—weighed in along with James Agee, Hannah Arendt, W. H. Auden, Robert Graves, Irving Howe, Alfred Kazin, Jacques Maritain, Allen Tate, Paul Tillich, and many others. Schapiro and Greenberg evinced a generally deeply skeptical view of the contemporary vogue for religious art, and this may be felt with some justice to be in tune with the feelings of many artists. Schapiro found the revival of religion a symptom of "our painful, discouraging age," a sign that a three-century-old "effort of emancipation . . . has not been successful, or at least has not completed its work." "All who are genuinely concerned with the liberty of the individual and the achievement of a human life for the entire community will sooner find the means through a socialist outlook than through religion." (*Religion*, pp. 132, 124, 132.) Yet six years later Schapiro wrote with great admiration of Chagall's illustrations for the Bible and noted with interest that the artist was "moving against the

stream of modern art." (Meyer Schapiro, *Modern Art—19th and 20th Centuries, Selected Papers* [New York: George Braziller, 1978], p. 121.) In the same symposium, Greenberg observed that "the mysteries of religion have . . . specious charms for the modern artist. They promise profundity. . . . We are through with the big words and what they advertise; their aesthetic credit, at least, is exhausted. But in the name of 'profundity' we still long to dissolve our art and ourselves in some ultimate vagueness or confusion. And what promises this better than religion?" (*Religion*, p. 69.) For the visual artist the attraction of religion could be somewhat more practical than for the poet, in that religious architecture was on the upsurge after the war; interesting architects were designing synagogues and churches, and so there were opportunities. For artists who were generally skeptical about the postwar boom, religious architecture might be a part of the boom to be skeptical about, but it might also present a link between the spirituality of art and some more generally comprehended spirituality. When Matisse was asked about his involvement with religious art, he had said that he believed in God when he worked—and might not an American artist have felt that, too? De Kooning, who drew the Crucifixion on a number of occasions during his career, was doing so again around 1960. Greenberg wrote of the attraction of the "beautiful paradoxes of the Trinity and Transubstantiation," and Newman painted, beginning in 1958, *The Stations of the Cross* and, later, *Triad* and a triangular painting called *Chartres*. (*Religion*, p. 69.) Of the series of black-and-white paintings devoted to the Passion, Newman wrote, "I had to explore its emotional complexity." (Barnett Newman, *Selected Writings and Interviews*, ed. John P. O'Neill [New York: Knopf, 1990], p. 190.) These works are not, I think, Newman's best. And yet who can doubt that for some artists religion or at least the conventions of religious observance suggested a bridge between the exhilaration of art-for-art's-sake and a form of exhilaration or even exaltation that the wider world could understand?

9. Alfred H. Barr, Jr., *Defining Modern Art*, ed. Irving Sandler and Amy Newman (New York: Harry N. Abrams, 1986), pp. 236, 237.

10. Ibid., p. 237.

11. Since the 1970s, a number of critics and historians have argued that the International Program at the Museum of Modern Art, funded by the Rockefellers, was for all intents and purposes an arm of the U.S. government. The Museum of Modern Art, so this line of thinking goes, was transforming Abstract Expressionist painting into Cold War propaganda, and thereby bringing America's new cultural achievements—which were the fruits of liberal democracy—to the attention of European audiences for whom Communist ideologies exerted a great appeal. The argument is generally believed to originate in an essay by Max Kozloff, "American Painting During the Cold War," published in *Artforum* in May 1973. Aspects of the argument have been elaborated on and modified in essays by Eva Cockcroft and others (see Francis Frascina, ed., *Pollock and After: The Critical Debate* [New York: Harper & Row, 1985]); in Serge Guilbaut, *How New York Stole the Idea of Modern Art: Abstract Expressionism, Freedom, and the Cold War*, trans. Arthur Goldhammer (Chicago: University of Chicago Press, 1983); in Nancy Jachec, *The Philosophy and Politics of Abstract Expressionism* (Cambridge, England: Cambridge University Press, 2000); and in Frances Stonor Saunders, *The Cultural Cold War* (New York: The New Press, 1999), to name a few. Michael Kimmelman offered a refutation of many of these arguments in "Revisiting the Revisionists: The Modern, Its Critics, and the Cold War," in John Elderfield, ed., *Studies in Modern Art 4: The Museum of Modern Art at Mid-Century: At Home and Abroad* (New York: Museum of Modern Art, 1994). In order to make a case that Abstract Expressionist painting was used as Cold War propaganda, the intentions of three different groups need to be dealt with. Historians must explore the views of the artists,

the objectives of the curators and administrators at the Museum of Modern Art, and the attitudes of the government officials who were involved in such cultural programs. I don't think anybody has established that there was a clear or coherent set of attitudes in any one of these groups. And certainly nobody has found a way to usefully relate the views of the artists, the museum officials, and the government officials. While there is some evidence that Abstract Expressionist painting was seen by the artists—and by curators and perhaps even by a few government officials—as reflecting a liberal ideology, the extent to which it was seen this way is highly debatable. And even if some did believe that America's avant-garde represented the triumph of liberal values—and that America's stature in the world would be improved if foreigners were exposed to the new American painting—there is not necessarily anything manipulative or sinister about this line of thinking, although it has been presented in that way in some of the literature.

12. Waldo Rasmussen, "Frank O'Hara in the Museum," in Bill Berkson and Joe LeSueur, eds., *Homage to Frank O'Hara* (Bolinas, CA: Big Sky, 1988), pp. 86, 87, 89.

13. Frank O'Hara, *Nakian* (New York: Museum of Modern Art, 1966), p. 7.

14. O'Hara liked to comment on the value of different views of tradition, which was a predictably Silver Age concern. When he wrote about the new work that he was seeing in Spain at the end of the 1950s, he compared the Spanish attitude toward tradition with that of the Americans. "If the motto of American art in recent years," he observed, "can be said to be 'Make it new,' for the Spanish it is 'Make it over.' For the authentic heir of a great past the problem is what to do with it, whereas the authentic artist's problem in America is that of bare creation with whatever help from other traditions he can avail himself of." In attempting to explain why artists in different countries worked in different ways, O'Hara presented an idea of national spirit—a Romantic idea. "The conscience of a nation, Shelley believed, lies in its artists. . . . Artists of different cultural traditions and present environments cannot simply 'take up' the impetus of the international vanguard, any more than their predecessors did in forming it, without severely altering the tempo and the application of that energy." (Frank O'Hara, *New Spanish Painting and Sculpture* [New York: Museum of Modern Art, 1960], pp. 10, 8.)

15. Renée Neu, "With Frank at MoMA," in Berkson and LeSueur, eds., *Homage to Frank O'Hara*, p. 91.

16. Introducing this exhibition, Barr had explained that "no particular school or manner is intentionally favored. Included are artists who are so 'conservative' that they are out of fashion and so 'advanced' that they are not yet generally accepted. The selection is deliberately eclectic." The show included a great many figures associated with Alfred Stieglitz, including O'Keeffe, Marin, and Demuth. But there were also artists of an earlier generation, such as John Sloan. Both the range of the selection and the idea of offering some half a dozen paintings by each artist were meant to show that the museum's agenda would delve both widely and deeply. And Barr was also very definitely rejecting the old salon-style show, in which dozens if not hundreds of artists had been represented by one or two works each; such shows had been the bane of the avant-garde. (Barr, foreword to *Paintings by Nineteen Living Americans* [New York: Museum of Modern Art, 1929], p. 9.)

17. Alice Goldfarb Marquis, *Alfred H. Barr, Jr.: Missionary for the Modern* (New York: Contemporary Books, 1989), p. 139. See Lynn Zelevansky, "Dorothy Miller's 'Americans,' 1942–1963," in Elderfield, ed., *Studies in Modern Art 4*.

18. Dorothy Miller, foreword to *Fifteen Americans* (New York: Museum of Modern Art, 1952), p. 5.

19. Dorothy Miller, foreword to *Sixteen Americans* (New York: Museum of Modern Art, 1959), p. 6.

20. Robert Rosenblum, *Frank Stella* (Baltimore: Penguin Books, 1971), p. 11.

21. Hyman Bloom, an expressionist with fantastical visionary ideas, had had not a single one-man show when he was included in "Americans 1942" (he was twenty-nine at the time). And David Aronson had been twenty-three, the same age as Stella, when his sentimental figure paintings were included in "Fourteen Americans" in 1946. But these were artists who you might say respected their elders; they were content to be "followers" in established modes, which did not mean that Bloom was not also an original, with a baroque elaborateness to his imagery that gave Soutine's churning surfaces a particularly American kind of emblematic ferocity. Stella, however, obviously rejected the role of youthful follower. He aimed to be a leader. And he aimed to be a leader of a new kind—one who emerged not from the studio so much as from the history books, from an idea of what must come next.

22. Rosenblum, *Frank Stella*, p. 13.

23. Carl Andre, statement in *Sixteen Americans*, p. 76. Fairfield Porter, *Art in Its Own Terms: Selected Criticism, 1935–1975*, ed. Rackstraw Downes (New York: Taplinger Publishing, 1979), p. 45.

24. Frank Stella in a lecture published in Rosenblum, *Frank Stella*, p. 57.

25. Ibid.

26. Calvin Tomkins, *The Bride and the Bachelors: Five Masters of the Avant-Garde. Duchamp, Tinguely, Cage, Rauschenberg, Cunningham* (New York: Viking Compass Edition, 1968 [1st ed., 1965]), p. 166.

27. Ibid., pp. 148, 167.

28. Ibid., pp. 168, 170.

29. Quoted in Tomkins, *The Bride and the Bachelors*, p. 181.

30. William C. Seitz, *The Art of Assemblage* (New York: Museum of Modern Art, 1961), p. 88.

31. Rudi Blesh, *Modern Art USA: Men, Rebellion, Conquest, 1900–1956* (New York: Knopf, 1956), p. 264. William C. Seitz, *Abstract Expressionist Painting in America* (Cambridge, MA: Harvard University Press, 1983), p. 8. Blesh, *Modern Art USA*, p. 266.

32. Clement Greenberg, *The Collected Essays and Criticism*, ed. John O'Brian (Chicago: University of Chicago Press, 1986–93), vol. 3, p. 232.

33. Max Kozloff, *Renderings: Critical Essays on a Century of Modern Art* (New York: Simon and Schuster, 1968), pp. 147, 148, 149, 151.

34. Sidney Geist, "A View of Rothko's Image," *Scrap* 5 (March 17, 1961), p. 3.

35. Ibid.

36. B. H. Friedman, "The Most Expensive Restaurant Ever Built," *Evergreen Review*, November–December 1959, p. 110.

37. Ibid., pp. 113, 114.

38. Ibid., pp. 115, 116.

39. James E. B. Breslin, *Mark Rothko: A Biography* (Chicago: University of Chicago Press, 1993), p. 406.

13. POP THEATER

1. B. H. Friedman, *Whispers* (Ithaca, NY: Ithaca House, 1972), p. 11. Friedman, "Whisper," in *Between the Flags: Uncollected Stories, 1948–1990* (Boulder, CO: Fiction Collective Two, 1990), p. 25. Leon Kraushar quoted in John Rublowsky, *Pop Art* (New York: Basic Books, 1965), p. 157. Philip Johnson quoted in William K. Zinsser, *Pop Goes America* (New York: Harper & Row, 1966), p. 20. Friedman, *Whispers*, p. 25.

2. G. R. Swenson, "The New American 'Sign Painters,' " *Art News*, September 1962, p. 45.

3. Robert Goldwater, *Primitivism in Modern Painting* (New York: Harper and Brothers, 1938), p. 24.

4. Swenson closed his article "The New American 'Sign Painters' " by recalling that "a nineteenth-century landscape painter once said that Manet's *Fifer* looked like a tailor's signboard. To this Zola responded, 'I agree with him, if by that he means that . . . the simplification effected by the artist's clear and accurate vision produces a canvas quite light, charming in its grace and naivete and acutely real.' " (Swenson, *Art News,* September 1962, p. 62.)

5. Marcel Duchamp, *The Writings of Marcel Duchamp,* ed. Michel Sanouillet and Elmer Peterson (New York: Da Capo Press, 1988 [1st ed., 1973]), pp. 138, 139.

6. Robert Scull quoted in Zinsser, *Pop Goes America,* p. 13.

7. John Kenneth Galbraith, *The Affluent Society* (Boston: Houghton Mifflin Company, 1958), pp. 3, 281.

8. Ibid., pp. 342, 340, 344.

9. Frank O'Hara, *The Collected Poems of Frank O'Hara,* ed. Donald Allen (New York: Knopf, 1971), p. 395.

10. Andy Warhol and Pat Hackett, *POPism: The Warhol Sixties* (New York: Harcourt Brace Jovanovich, 1980), pp. 36–37.

11. And perhaps O'Hara was thinking of Kennedy's break with the tradition that a man must wear a hat when he wrote of Berkson in "Biotherm": "I was thinking of you in your no hat." (O'Hara, *Collected Poems,* p. 442.)

12. *Newsweek,* December 24, 1962, p. 45.

13. Elaine de Kooning, *The Spirit of Abstract Expressionism: Selected Writings,* ed. Rose Slivka (New York: George Braziller, 1994), pp. 201, 202.

14. Frank O'Hara, *Art Chronicles: 1954–1966* (New York: George Braziller, 1990 [1st ed., 1975]), p. 143.

15. Fairfield Porter, *Art in Its Own Terms: Selected Criticism, 1935–1975,* ed. Rackstraw Downes (New York: Taplinger Publishing, 1979), p. 62. Al Hansen, *A Primer of Happenings and Time/Space Art* (New York: Something Else Press, 1965), p. 31.

16. Kynaston McShine, ed., *Andy Warhol: A Retrospective* (New York: Museum of Modern Art, 1989), p. 460.

17. *Art International,* Summer 1962, p. 24. John Ashbery, *Reported Sightings: Art Chronicles, 1957–1987,* ed. David Bergman (New York: Knopf, 1989), p. 146.

18. Claes Oldenburg, *Store Days* (New York: Something Else Press, 1967), p. 15.

19. Ibid., p. 16.

20. Sidney Tillim, "Month in Review," *Arts,* February 1962, p. 36.

21. Ibid.

22. Ibid., p. 37. One of Oldenburg's early collectors was Philip Johnson. A couple of years later—the story is told in Zinsser's *Pop Goes America*—visitors to Johnson's legendary International Style Glass House in Connecticut found one of Oldenburg's desserts, a banana split, sitting on the coffee table. "Before a meal it has a direct effect on the salivary glands," Johnson remarked, "though after dinner it's rather sickening. It does a very nostalgic thing to me. It takes me back to the town in the Middle West where I grew up." (Zinsser, *Pop Goes America,* p. 21.) The buyables from *The Store* were soon enough props decorating elegant people's homes. Oldenburg had produced a new kind of *aide-mémoire.* It was the ultimate in chic: Proustian Pop Art.

23. Sidney Tillim, "Month in Review," *Arts,* November 1962, p. 38.

24. Warhol and Hackett, *POPism,* p. 6.

25. Ibid., pp. 6–7.

26. Swenson, "The New American 'Sign Painters,' " p. 60.

27. Warhol and Hackett, *POPism*, p. 7. Warhol described Karp as a young man who "had an 'up' attitude to everything. He was sort of dancing around to the music." (Ibid.) That would have described a lot of the people whom Warhol was getting to know.

28. O'Hara, *Collected Poems*, pp. 371, 372.

29. *Time*, June 1, 1962, p. 71. *Newsweek*, June 11, 1962, pp. 19, 20.

30. *Time*, June 21, 1963, p. 62.

31. Scull quoted in Zinsser, *Pop Goes America*, p. 11.

32. Sidney Tillim, "Month in Review," *Arts*, May–June 1962, p. 82. Max Kozloff, "New York Letter," *Art International*, May 1962, pp. 75, 76.

33. Sidney Tillim, "Editorial: Franz Kline (1910–1962)," *Arts*, September 1962, p. 6.

34. Scull quoted in Zinsser, *Pop Goes America*, p. 11. "Those collectors who can't swallow Pop Art," Richard Bellamy of the Green Gallery said, "have adopted a wait-and-see attitude." But the indicators were that the new work was selling. At the Green Gallery, "its pop artists accounted for 80% of its sales"—so reported *Time*. It was selling—and the work was also exciting, unnerving. Another dealer said, "Pop art has helped to make people feel insecure. No one seems to be sure any more what a work of art is." (*Time*, June 21, 1963, p. 62.) Still, collecting Pop was a kick. Leon Kraushar took a visitor into his bedroom. "I've got Jackie Kennedy, Marilyn Monroe and Elizabeth Taylor hanging over my bed," he said. "Did you ever see anybody with three women like these hanging over their bed? And I've got a nurse in case of emergency"—he was referring to a nearby Lichtenstein painting called *The Fighting Nurse*. "I guess any nurse would be fighting if she found a man in his bedroom with these three women." (Kraushar in Zinsser, *Pop Goes America*, p. 27.)

35. Thomas B. Hess, review of "New Realists" show, *Art News*, December 1962, p. 12.

36. Jill Johnston, "The Artist in a Coca-Cola World," *The Village Voice*, January 31, 1963, p. 7.

37. "A Symposium on Pop Art," *Arts*, April 1963, pp. 38, 39, 40. Duchamp quoted by Johnston, "The Artist in a Coca-Cola World," p. 6.

38. "A Symposium on Pop Art," p. 38.

39. Max Kozloff, *Renderings: Critical Essays on a Century of Modern Art* (New York: Simon and Schuster, 1968), p. 221.

40. "A Symposium on Pop Art," p. 37. It was the great leap forward. A few months later, there was "The Popular Image Exhibition" at the Washington Gallery of Modern Art in the nation's capital. Jim Dine did a collage cover for the catalog, with the Washington Monument in the center (the phallic metaphor very much emphasized), amid a jumble of cars, coffeepot, smiling faces, teeth, telephone, STOP sign, Marlon Brando, Statue of Liberty. The show, organized by Alan Solomon, was paired with a spring Pop Festival. Oldenburg was on hand to help turn Washington into a happening. The audience sitting on camp stools, *Time* reported, included "White House Art Adviser Bill Walton, FAA Administrator Najeeb Halaby, Mrs. Arthur Schlesinger Jr. . . . A member of the gallery staff announced that she had successfully achieved blue ice cream. She had mixed blue dye and vanilla ice cream with a monkey wrench. The New Frontier moved an inch forward on its stools. This was obviously going to be some happening." Forty-eight events were performed in as many minutes by nineteen performers. There was a person wriggling in a "huge white tube of canvas," two men spraying "the place with Flit guns loaded with a foul-smelling mixture," a young woman in a black oilcloth shift standing at an ironing board ironing "medium-sized replicas of the Washington Monument," "slides of naked women," waiters spilling "bits of plaster from trays onto the audience," "a woman . . . wearing a shredded American flag on her head." At the end, *Time* reported, "official Washington [was] gurgling hip-hip for happenings." (*Time*, May 3,

1963, p. 73.) "Neo-Dadaism," Tillim had written the year before, "is being received as the aesthetic equivalent of the New Frontier." (Tillim, "Month in Review," *Arts*, November 1962, p. 36.)

41. Allan Kaprow, *Essays on the Blurring of Art and Life*, ed. Jeff Kelley (Berkeley: University of California Press, 1993), p. 9.

42. Zinsser, *Pop Goes America*, p. 14.

43. John Bernard Myers, "Junkdump Fair Surveyed," *Art and Literature*, Autumn–Winter 1964, pp. 122, 129, 130, 131.

44. Friedman, *Whispers*, p. 10.

45. Myers, "Junkdump," p. 140. O'Hara, *Nakian* (New York: Museum of Modern Art, 1966), p. 19.

46. Anita Ventura in "Scrap's First Tape," *Scrap* 2 (December 23, 1960), p. 5. Myers, "Junkdump," p. 132.

47. Hilton Kramer, "Paul Klee in 1960," *Art International*, vol. IV/2–3 (1960), pp. 28, 31.

48. Dwight Macdonald, *Against the American Grain: Essays on the Effects of Mass Culture* (New York: Random House, 1962), p. 37.

49. Ibid., pp. 41, 44, 37.

50. Ibid., p. 74. Hess quoted in Martica Sawin, "Robert De Niro," typescript, p. 92.

51. Myers, "Junkdump," p. 131.

14. TEACHERS

1. Saul Bellow, "Harold Rosenberg," in *Abstract Expressionism: A Tribute to Harold Rosenberg* (Chicago: The David and Alfred Smart Gallery, University of Chicago, 1979), p. 10.

2. Saul Bellow, "What Kind of Day Did You Have?," in *Him with His Foot in His Mouth and Other Stories* (New York: Penguin Books, 1998 [1st ed., 1984]), pp. 63, 70, 65.

3. Harold Rosenberg, *The Tradition of the New* (New York: Horizon Press, 1959), p. 266.

4. Bellow, "Harold Rosenberg," p. 10.

5. Harold Rosenberg, *The Anxious Object* (New York: Collier Books, 1973 [1st ed., 1964]), p. 61.

6. Rosenberg, *Tradition of the New*, p. 25. Harold Rosenberg, *Arshile Gorky: The Man, the Time, the Idea* (New York: Sheepmeadow Press/Flying Point Books, 1962), p. 102.

7. Dwight Macdonald, *A Moral Temper: The Letters of Dwight Macdonald*, ed. Michael Wreszin (Chicago: Ivan R. Dee, 2001), p. 276.

8. As a portraitist, Rosenberg has a way of letting his subjects bristle with ideas; they threaten to vanish, like de Kooning's *Women*. In an essay on de Kooning, we are told that "de Kooning's relation to the paintings of others has been to dislocate from within the thought that originated them." We hear that "to detach paintings from fixed social, esthetic, or metaphysical objectives is basically to redefine the profession of painting," and that "art becomes a Way by which to avoid a Way." And "in conceiving art as a way of life, de Kooning makes his engagement in his profession total, in the sense of the absorption of a priest or saint in his vocation." (Rosenberg, *Anxious Object*, pp. 110, 111, 112.) These observations sometimes hover on the edge of absurdity, and sometimes fall all the way into some pit of jokebook existentialism. Yet at the same time, it is possible to imagine that some of the ideas might be part of a terrific essay on de Kooning; the idea of art becoming "a Way by which to avoid a Way" might take you somewhere. But Rosenberg doesn't go deeper into his ideas; he just piles them up, and the effect is to keep de Kooning at a certain distance, and that distance can be sustained by Rosenberg for pages and pages. When he does mention a specific work of art, the mention often

feels dutiful—as if it's an unpleasant obligation, the obligation of the critic, to be gotten over as quickly as possible.

9. Randall Jarrell, *Poetry and the Age* (New York: Farrar, Straus and Giroux, 1953), p. 73.

10. Max Kozloff, *Renderings: Critical Essays on a Century of Modern Art* (New York: Simon and Schuster, 1968), pp. 302–3.

11. Hilton Kramer, "A Change in the Weather," *Arts*, October 1963, p. 46. Thomas B. Hess, "The Phony Crisis in American Art," *Art News*, Summer 1963, p. 25.

12. Michael Fried, "An Introduction to My Art Criticism," in *Art and Objecthood* (Chicago: University of Chicago Press, 1998), pp. 3–4.

13. Fairfield Porter, *Art in Its Own Terms: Selected Criticism, 1935–1975*, ed. Rackstraw Downes (New York: Taplinger Publishing, 1979), pp. 61–62.

14. Hans Hofmann quoted in Fritz Bultman, "The Achievement of Hans Hofmann, *Art News*, September 1963, p. 43.

15. Bultman, "The Achievement of Hans Hofmann," p. 55.

16. William Barrett, *The Truants: Adventures Among the Intellectuals* (Garden City, NY: Anchor Press/Doubleday, 1982), p. 155.

17. Mercedes Matter, "What's Wrong with U.S. Art Schools?," *Art News*, September 1963, pp. 40, 41. Matter produced, with her husband, a very interesting book about Giacometti: Herbert Matter and Mercedes Matter, *Alberto Giacometti* (New York: Harry N. Abrams, 1987).

18. Matter, "What's Wrong with U.S. Art Schools?," pp. 58, 41, 56.

19. Letter from Hofmann to Matter, probably late 1950s, courtesy of Alex Matter.

20. Hofmann in a New York Studio School brochure, c. 1970.

21. Rosenberg in a New York Studio School brochure, c. 1970.

22. Matter, "What's Wrong with U.S. Art Schools?," p. 56.

23. Statement in a New York Studio School brochure, c. 1970.

24. Matter, "Drawing," in *Notes from the New York Studio School*, November 1968, unpaged.

25. Finkelstein, "Paintings of Mercedes Matter," in *Mercedes Matter: Paintings* (New York: Salander-O'Reilly Galleries, 1996), unpaged.

26. Rosenberg, *Anxious Object*, p. 131.

27. Matter, "Drawing," in *Notes*, November 1968, unpaged.

28. Meyer Schapiro, *Meyer Schapiro: His Painting, Drawing, and Sculpture* (New York: Harry N. Abrams, 2000), pp. 47, 48, 44. The times, moreover, were especially ripe for this turn to the figure, for New York was in what Schapiro referred to as the Third Modernism. He did not explain this in any great detail, except to say that the First Modernism had extended from 1900 to about 1915 and the Second from 1915 to 1943, and that the Third extended from the 1940s to the 1960s and "revives and gives new interest and force to styles and types that arose in the first two Modernisms." (Ibid., p. 41.) Now it would seem that the First Modernism involved the reinvention of nature as abstraction, the second perhaps involved the consolidation of abstraction. Of course the second period already involved revivals, but for Schapiro it was this cycling back, the spirit of revival, that interested him in the period he was living in. This suggests that Schapiro might even have seen in Abstract Expressionism a revival of earlier expressionisms. But he also saw, as he spoke in 1967, the rapidity of change in styles, and what that did to artists, and what it did to students. And in the midst of all this, the act of drawing the human figure, even if an artist had no intention of making this his or her ultimate subject, became the subject whose inherent complexity could enable a young artist to understand the immediate, material nature of art. To understand the human figure through drawing was a way of understanding yourself as an artist. When

Schapiro lent his name and his considerable prestige to the New York Studio School, he was supporting the idea that the struggles of the artist must be particular and specific, lodged in the nitty-gritty of the studio, in the actions of the artist at a certain moment in relation to certain materials, certain objects, certain ideas. At the Studio School, Frenhofer's conflict between color and line or nature and abstraction was viewed not so much as the last stand of romanticism but as a dialectical process, pursued moment to moment, through decisions taken by a hand holding an instrument with which to draw or paint or sculpt.

29. Matter, "What's Wrong with U.S. Art Schools?," p. 56.

30. Rosenberg, *Anxious Object*, p. 25.

31. Kramer, "A Change in the Weather," p. 46.

32. Clement Greenberg, *The Collected Essays and Criticism*, ed. John O'Brian (Chicago: University of Chicago Press, 1986–93), vol. 4, p. 97.

33. Marx quoted in Fried's 1971 book on Morris Louis, reprinted in Fried, *Art and Objecthood*, p. 100.

34. Although Greenberg's *Collected Essays* were published before his death, it was not a project with which he was actively involved, and aside from *Art and Culture* (Boston: Beacon Press, 1961), he put his name to only three other books, each a monograph with a slim text—on Miró (1948), Matisse (1953), and Hofmann (1961).

35. Greenberg, *Collected Essays*, vol. 4, p. 31.

36. Ibid., vol. 4, pp. 92, 86.

37. Henry James quoted in Hugh Kenner, *The Pound Era* (Berkeley: University of California Press, 1973 [1st ed., 1971]), p. 19. *Three Papers on "Modernist Art"* (New York: American Academy of Arts and Letters, 1924).

38. Clement Greenberg, *Clement Greenberg: Late Writings*, ed. Robert C. Morgan (Minneapolis: University of Minnesota Press, 2003), p. 45. See also the 1983 essay "Beginnings of Modernism" in the same volume.

39. Greenberg, *Collected Essays*, vol. 4, p. 85. Writing at the time, the art critic Nicolas Calas was not wrong to argue that Greenberg's critical spirit remained closer to Hegel's than to Kant's. "Is Greenberg," Calas wondered, "refraining from saying that self-criticism grew out of the dialectical philosophy of Hegel to avoid the impression that his theory was modeled on a vanguard political theory of self-criticism? But Greenberg must know that Lenin had called self-criticism the criticism made from within the Bolshevik Party of its erroneous procedures." (Nicolas Calas, *Art in the Age of Risk and Other Essays* [New York: E. P. Dutton, 1968], p. 139.)

40. Isaiah Berlin, *The Roots of Romanticism*, ed. Henry Hardy (Princeton, NJ: Princeton University Press, 1999), p. 68.

41. Barrett, *The Truants*, pp. 138, 153.

42. Clement Greenberg, *Homemade Esthetics: Observations on Art and Taste* (New York: Oxford University Press, 1999), p. 49.

43. Ibid., pp. 16, 67.

44. The earliest evidence of Mondrian's use of the title *Fox-Trot* is 1920. A correspondent to the journal *Het Vaderland* described a visit to Mondrian's studio, when Mondrian explained that the title of a now unidentified work was *Fox-Trot*. The correspondent described how "the painter briefly and clearly explained to me how he had proceeded from the fox trot to arrive at its rendition or formation, and how the natural representation has, in a mysterious way, completely disappeared." And yet the "naturalistic" title was retained—for a painting nearly a decade later. (Yve-Alain Bois et al., *Piet Mondrian, 1872–1944* [n.p.: Leonardo Arte, 1994], p. 234.)

45. Greenberg, *Homemade Esthetics*, p. 70.

46. Edmund Wilson, *To the Finland Station: A Study in the Writing and Acting of History* (Garden City, NY: Doubleday/Anchor Books, 1953 [1st ed., 1940]), p. 120.

THE EMPIRICAL IMAGINATION

15. BEGINNING AGAIN

1. Spinoza quoted in Thomas B. Hess, *Barnett Newman* (New York: Walker and Co., 1969), p. 7. A connection between Spinoza and the spirit of New York is also made by the poet Jane Mayhall in "Unaccountably," which begins: "A sentence from Spinoza, clean / and devious, made me remember about / when I first came to New York." (Jane Mayhall, *Sleeping Late on Judgment Day* [New York: Knopf, 2004], p. 26.)

2. Hess, *Newman*, p. 7.

3. Ibid.

4. Barnett Newman, *Selected Writings and Interviews*, ed. John P. O'Neill (New York: Knopf, 1990), p. 173.

5. Newman, *Selected Writings*, p. 173. Hess, *Newman*, p. 9.

6. Thomas B. Hess, "A Tale of Two Cities," *Location*, Summer 1964, p. 40.

7. Donald Judd, *Complete Writings, 1959–1975* (New York: New York University Press, 1975), p. 202.

8. Sidney Janis, "On the Theme of the Exhibition," in *The New Realists* (New York: Sidney Janis Gallery, 1962), unpaged. Lawrence Alloway, introduction to *Systemic Painting* (New York: The Solomon R. Guggenheim Museum, 1966), p. 17.

9. The idea that art is essentially empirical goes back at least as far as Leonardo, who wrote, "All our knowledge has its foundation in our sensations." The art historian Alexander Nagel has observed, "The anti-Platonic and in general anti-idealist thrust of [Leonardo's] statements often has been pointed out." See Alexander Nagel, "Leonardo and *sfumato*," *Res* 24 (Autumn 1993), pp. 7–20.

10. Fairfield Porter, *Art in Its Own Terms: Selected Criticism, 1935–1975*, ed. Rackstraw Downes (New York: Taplinger Publishing, 1979), p. 277. Porter's poetry has been gathered in *The Collected Poems with Selected Drawings*, ed. John Yau and David Kermani (New York: Tibor de Nagy Editions/The Promise of Learning, 1985). An invaluable source of information on Porter is Joan Ludman, *Fairfield Porter: A Catalogue Raisonné of the Paintings, Watercolors, and Pastels* (New York: Hudson Hills, 2001).

11. Judd, *Complete Writings, 1959–1975*, p. 81. When Anne Porter, the painter's widow, read the manuscript of the present book, she recalled that Porter had taken her to one of Judd's early shows, and that he seemed to regard the work "with respect."

12. Donald Judd, *Complete Writings, 1975–1986* (Eindhoven, Netherlands: Van Abbemuseum, 1987), p. 15.

13. Wylie Sypher, *Rococo to Cubism in Art and Literature* (New York: Vintage Books, 1960), p. 127.

14. Irving Sandler, in *Toward a New Abstraction* (New York: The Jewish Museum, 1963), p. 14.

15. Al Held, from an interview in *Al Held: Italian Watercolors* (Champaign, IL: Krannert Art Museum and Kinkead Pavilion, 1993), p. 81.

16. Mary McCarthy, "The Fact in Fiction," in *On the Contrary* (New York: Farrar, Straus and Cudahy, 1961), pp. 257, 256.

17. Porter, *Art in Its Own Terms*, p. 59. Philip Pearlstein, "Figure Paintings Today Are Not Made in Heaven," *Art News*, Summer 1962, p. 39.

18. For Matthiasdottir, see Jed Perl, ed., *Louisa Matthiasdottir* (Reykjavik: Nesútgáfan, 1999). Matthiasdottir was friends with the poet Denise Levertov, who in the 1950s wrote a statement or essay about Matthiasdottir's work, the current whereabouts of which is unknown. Levertov's friend Robert Duncan, who had read Levertov on Matthiasdottir, wrote in a letter to Levertov that "your piece on Louisa [Matthiasdottir]'s painting I liked very much, because you led the eye to the color and thru it to the shared seeing of life." (Robert J. Bertholf and Albert Gelpi, eds., *The Letters of Robert Duncan and Denise Levertov* [Stanford, CA: Stanford University Press, 2004], p. 22.)

19. Sidney Tillim, "Waiting for Giotto," *Arts*, September 1962, p. 40. Gabriel Laderman wrote an interesting series of articles for *Artforum* in the late 1960s and early 1970s that reflects the concerns of a representational painter at the time; among them is a survey of current figurative work, "Unconventional Realists," *Artforum*, November 1967, pp. 42–46. A sensitive view of Laderman's own painting is Lawrence Campbell, "Gabriel Laderman: A World Inside Itself," *Art News*, October 1972, pp. 88–91.

20. Sidney Tillim, "Month in Review," *Arts*, April 1963, pp. 46, 48.

21. Wheelwright was one of the poets whom, years later, John Ashbery included in *Other Traditions*, his Norton Lectures.

22. John Ashbery, *Reported Sightings: Art Chronicles, 1957–1987*, ed. David Bergman (New York: Knopf, 1989), p. 312.

23. Judd, *Complete Writings, 1959–1975*, pp. 10, 45, 57, 137.

24. Ibid., p. 25. The work that Judd was doing in the early 1960s had an awkward directness. His last compositions with anything of a freehand look were some paintings done around 1960, in which lines snake across the surface, making broad swinging curves that are completed beyond the edge of the painting. In one of the untitled paintings of 1960, those lines with their black edge have a casual authority that brings to mind the Léger *Juggler* that he'd written about around that time. The point of that painting of Judd's— and of his admiration for the Léger—seems to have had something to do with not bearing down on a form, about the conviction being in the overall design rather than in the particularities of the working through of the design. He admired Léger's rejection of the kind of too easy elegance that was always a danger with pared-down styles.

25. Ibid., p. 151.

26. Ibid., p. 150. The 1965 essay "Specific Objects" grew out of ideas that he had discussed in his writing of the early 1960s and which he was bringing into his painting and three-dimensional works around the same time. The essay began with the cool yet resounding announcement that "half or more of the best new work in the last few years has been neither painting nor sculpture." This was, of course, not a movement in any ordinary sense, since "the common aspects are too general and too little common to define a movement." Movements, in any event, no longer worked, "linear history has unraveled somewhat." What was left was a kind of three-dimensional work that, although it "will not cleanly succeed painting and sculpture," now seems to take up where some of the very best sculpture and painting had left off. (Judd, *Complete Writings, 1959–1975*, p. 181.)

27. See Ann Temkin, "Wear and Care: Preserving Judd," *Artforum*, Summer 2004, pp. 206–7. Gerald Nordland, "Marcel Duchamp and Common Object Art," *Art International*, February 1964, p. 31.

28. Judd, *Complete Writings, 1959–1975*, p. 183.

29. Judd, *Complete Writings, 1975–1986*, p. 103.

30. Porter, *Art in Its Own Terms*, pp. 75–76. Judd, *Complete Writings, 1959–1975*, p. 92.

31. Wallace Stevens, "Poetry and War," in *Opus Posthumous: Revised, Enlarged and Corrected Edition*, ed. Milton J. Bates (New York: Knopf, 1989), p. 242.

32. Porter, *Art in Its Own Terms*, pp. 233, 236.

33. Judd, *Complete Writings, 1959–1975*, pp. 151, 197, 198. Porter, *Art in Its Own Terms*, p. 62.

34. Judd, *Complete Writings, 1959–1975*, p. 75. Porter, *Art in Its Own Terms*, p. 77.

35. Porter, *Art in Its Own Terms*, p. 104.

36. Judd, *Complete Writings, 1959–1975*, p. 72.

37. Justin Spring, *Fairfield Porter: A Life in Art* (New Haven, CT: Yale University Press, 2000), p. 38. This is a very good biography.

38. Meyer Schapiro, *Impressionism: Reflections and Perceptions* (New York: George Braziller, 1997), p. 34.

39. Judd, *Complete Writings, 1975–1986*, p. 75.

40. Porter, *Art in Its Own Terms*, p. 170.

41. Judd, *Complete Writings, 1959–1975*, p. 215. Porter, *Art in Its Own Terms*, p. 106.

42. Fairfield Porter, *Thomas Eakins* (New York: George Braziller, 1959), pp. 9, 26, 28.

43. Alfred Kazin, *New York Jew* (New York: Knopf, 1978), p. 14.

44. Porter, *Art in Its Own Terms*, p. 158.

45. Greenberg, *Art and Culture* (Boston: Beacon Press, 1961), pp. 180, 184.

46. Porter, *Thomas Eakins*, pp. 11, 12, 17.

47. Ibid., p. 28.

16. MAINE, MARFA, AND MANHATTAN

1. Lewis Mumford, *The South in Architecture* (New York: Harcourt, Brace, 1941), pp. 35–36.

2. Donald Judd, *Complete Writings, 1975–1986* (Eindhoven, Netherlands: Van Abbemuseum, 1987), pp. 96, 97.

3. Donald Judd, *Complete Writings, 1959–1975* (New York: New York University Press, 1975), p. 138.

4. James Schuyler, *Collected Poems* (New York: Noonday Press, 1995 [1st ed., 1993]), p. 354.

5. Otto Pächt, *The Master of Mary of Burgundy* (London: Faber and Faber, 1948), p. 22.

6. Fairfield Porter, *Art in Its Own Terms: Selected Criticism, 1935–1975*, ed. Rackstraw Downes (New York: Taplinger Publishing, 1979), p. 281.

7. Douglas Crase, introduction to Ralph Waldo Emerson, *Essays: First and Second Series* (New York: Vintage Books, 1990), pp. xviii–xix.

8. Virginia Woolf quoted in Wendy Baron and Richard Shone, eds., *Sickert Paintings* (London: Royal Academy of Arts, 1992), p. 176.

9. Osbert Sitwell, who edited Sickert's criticism, wrote that Sickert "adopted a rigid policy of following the truth, in whatever direction it might lead him," a judgment that could equally be made of Porter. (Osbert Sitwell, introduction to Walter Richard Sickert, *A Free House!, or The Artist as Craftsman* [London: MacMillan, 1947], p. xxv.) Their discoveries—their truths—tended to be a few beats behind or ahead of the general pace of the great cultural centers where they flourished, yet their gift for being off the beat endeared them to artists younger than themselves, and leaves their achievements always ready for rediscovery, never easy to quite figure out.

10. Edwin Denby, *Dancers, Buildings, and People in the Streets* (New York: Horizon Press, 1965), p. 264.

11. Porter, *Art in Its Own Terms*, pp. 100–1, 163.

12. Ibid., pp. 49, 139.

13. Ibid., pp. 85, 81, 125. "The opposition between 'realism' and 'abstraction' is a misleading one," Porter writes. "Both realists and abstractionists think they embody an ideal of art of which each work is the shadow: the realist making a reflection of the natural world and the abstractionist making a reflection of the world of ideas in the largest sense, which of course includes non-verbal ideas. Both think that what is real about art exists in the realm of Whitehead's 'eternal objects' and no matter how much either one pretends

to prefer either reality or unreality (like Clive Bell), this reality or unreality is an eternal object which an artist of whatever persuasion constantly refers to whenever he makes something." (Ibid., pp. 102–3.)

14. Judd, *Complete Writings, 1975–1986*, pp. 97, 98.

15. What Judd understood better than anybody else who has settled in the Southwest in the last fifty years is that you personalize influences by expanding the context in which you understand them. I do not doubt Judd's interest in Albers as a painter, but the fact that Albers took photographs of Mexican architecture reminds us of the interest that both Josef and Anni Albers took in Mexican textiles and sculpture and ceramics in the 1930s and 1940s, and how that interest was connected to Bauhaus ideas about the unity of design and art. In his essay on Albers, Judd does not really get into the whole question of the Bauhaus, but he does say that "at the least it cannot be said of the Bauhaus that it was reductionist." (Judd, "Josef Albers," in *Josef Albers* [Marfa, TX: Chinati Foundation, 1991], p. 14.) That's an important statement. I am reminded of the "grandfather principle" that Sandler had mentioned in relation to Held, for the idea of the Bauhaus, with its emphasis on the integration of all visual experience, had been anathema to the artists at the Club. What interests Judd is the empiricism of the Bauhaus—the push back to basics, to the fundamentals of visual experience. Judd, who designed a good deal of furniture, was obviously interested in the idea of reimagining all the formal possibilities that existed in the world, from the practical formalism of furniture and architecture and graphic design to the other-than-practical formalism of painting and sculpture. That was the Bauhaus's great, essential enterprise. Judd always insisted that furniture was not sculpture, and he was right. But in a sense it was only by designing both that he could convincingly make the argument—clarify the difference.

16. Friedrich Nietzsche, *The Portable Nietzsche*, ed. and trans. Walter Kaufmann (New York: Penguin Books, 1976 [1st ed., 1954]), p. 520.

17. Barnett Newman, *Selected Writings and Interviews*, ed. John P. O'Neill (New York: Knopf, 1990), p. 173.

18. In the late 1960s, Simonds lived in a building with Gordon Matta-Clark, who was known for his "splittings"—for turning abandoned buildings and industrial sites into works of art by cutting segments out of them, so that architecture gave way to anti-architecture, to architecture-sized structures in which form had no relation to function. There could also be an antiestablishment dimension to these events, as when Matta-Clark broke into an old Hudson River pier and did one of his pieces, only to have the police read about it in *The Village Voice* and come and close it down. In 1969 the collectors Holly and Horace Solomon opened a performance space at 98 Greene Street. Matta-Clark was the guiding spirit for the performances and exhibitions that went on there, and when Holly Solomon did a movie, *98.5*, about the space, among the five segments was "Clay Pit," in which Simonds built a miniature house on a woman's stomach. Below Houston Street, in the area that was just then becoming SoHo, the general preoccupation with real estate tied into the what-you-see-is-what-you-get mentality of Conceptual art.

19. Donald Judd, "101 Spring Street, New York City," in *Donald Judd Furniture Retrospective* (Rotterdam: Museum Boymans van Beuningen, 1993), p. 109.

20. Ibid., pp. 109–13.

21. Judd, *Complete Writings, 1959–1975*, pp. 202, 205.

22. James Schuyler, *Collected Poems* (New York: Noonday Press, 1995 [1st ed., 1993]), p. 245.

23. Porter, *Art in Its Own Terms*, p. 79.

24. James Schuyler, *The Diary of James Schuyler*, ed. Nathan Kernan (Santa Rosa, CA: Black Sparrow Press, 1997), p. 219.

ACKNOWLEDGMENTS

I want to express my deep gratitude to Carol Brown Janeway—acute editor, steady adviser, wonderful friend.

A great many of the ideas, attitudes, and approaches presented in this book reflect the discoveries and discriminations of Deborah Rosenthal, which she has shared with me over the years.

New Art City could not have come to fruition without Jennifer Lyons, Nathan Perl-Rosenthal, Martin Schulman, and Leon Wieseltier. Martica Sawin read the entire manuscript at a critical juncture and made invaluable suggestions.

Carol Janeway is one of the many extraordinary people at Knopf. Stephanie Koven Katz has brought her intensity, her clearheadedness, and her wit to this daunting project. Anthea Lingeman is the designer every author hopes for—she cares about words. Much thanks as well to Roméo Enriquez, who oversaw the production of the illustrations; to Ellen Feldman, who brought all the pieces of the puzzle together; and to Katherine Hourigan, Mark Birkey, Lydia Buechler, Andy Hughes, and Jon Fine.

Robert Warshaw, a trustee of the Renate, Hans and Maria Hofmann Trust, has been a great friend of this project, and the Hofmann Trust has been extraordinarily generous in assisting with the cost of reproductions and translation. I am grateful for the assistance that The Judith Rothschild Foundation has given with the illustrations. When I was just getting started on *New Art City*, I received an Ingram Merrill Foundation Award; and some of the final work was done during my stay at the American Academy in Rome as the Marion and Andrew Heiskell Visiting Critic. I am grateful for the resources of Avery Library at Columbia University, the New York Public Library, the Museum of Modern Art Library, and the Archives of American Art.

A book written over more than a decade depends on many people, and I want to mention some who have been significant: Paul Berman, Nick Bozanic, David Carbone, Arlene Croce, Alice Federico, Salvatore Federico, Ruth Franklin, Deborah Friedell, David Hanson, Timothy Hyman, Gabriel Laderman, Mari Lyons, Nick Lyons, Einar Matthiasson, J. D. McClatchy, James Miller, Anita Mozley, Jim Pappas, Martin Peretz, Ingrid Rowland, Jonah Westerman, and Karen Wright. I would also like to remember a number of friends who died while I was working on this book: Leland Bell, John Heliker, Alexander Liberman, Louisa Matthiasdottir, and Anita Moses.

For their observations on the text, their help with photographs, and countless other forms of assistance, I have many people to thank: Philippe Alexandre, Andrew Arnot, John Ashbery, Patricia Bailey, Peter Ballantine, Deborah Bell, Bill Berkson, Judith E. Bernstock, Eric Brown, Jacob Burckhardt, Woodfin Camp, Alessandra Carnielli, John Cohen, Susan Cooke, Christine Cordazzo, Betty Cuningham, Brenda Danilowitz, Tina Dickey, John Driscoll, Anita Duquette, Natalie Edgar, Shelley Farmer, Theodore Feder, Joann Harrah, Carolyn Harris, Steven Harvey, Jacqueline Hélion, Janet Hicks, Madeleine Hoffmann, Clemens Kalischer, Ellsworth Kelly, David Kermani, Diane Kirk, Nancy Kirk, Robert Lehrman, Emily Liebert, Don Lindgren, Steve Massengill, Alex Matter, Fred McDarrah, David McKee, Graham Nickson, Dianne Nilsen, Fran O'Neill, Carole M. Pesner, Anne Porter, Laurence Porter, Carl Riddle, Sheila Rohan, Alice Sebrell, Roger Shattuck, Jack Shear, Rani Singh, Elizabeth Slater, Etheleen Staley, Peter Stevens, Jan Van Der Donk, David Vaughan, Daniel Wechsler, Rob Weiner, Taki Wise, James Yohe, Virginia Zabriskie. Among the galleries and organizations that helped with the illustrations are The Josef and Anni Albers Foundation, Alexandre Gallery, Ameringer & Yohe Gallery, Babcock Galleries, Romare Bearden Foundation, The Black Mountain College Museum and Arts Center, Mark Borghi Fine Art, Center for Creative Photography, The Chinati Foundation, The Willem de Kooning Foundation, Esto Photographics Inc., The Flow Chart Foundation, The Getty Research Institute, Howard Greenberg Gallery, Hirschl and Adler Modern, Judd Foundation, Kraushaar Galleries, Pierre and Maria-Gaetana Matisse Foundation, McKee Gallery, Robert Miller Gallery, The Isamu Noguchi Foundation and Garden Museum, The North Carolina Department of Cultural Resources, The Parrish Art Museum, Salander-O'Reilly Galleries, Estate of David Smith, Staley-Wise Gallery, Tibor de Nagy Gallery, Jan Van Der Donk Rare Books, The Voyager Foundation, Whitney Museum of American Art, Richard York Gallery, Virginia Zabriskie Gallery.

ILLUSTRATIONS

THE PAINTER AND THE CITY. P. 4. *Hofmann in his Ninth Street studio.* All photographs of Hofmann are courtesy Ameringer & Yohe Gallery, NY, unless otherwise noted. *Students from the Hofmann School.* Courtesy Carolyn Harris. P. 7. Hofmann, *Pompeii.* Tate Modern, London. © 2005 Estate of Hans Hofmann/Artists Rights Society (ARS), NY. Photograph © Tate, London 2004. P. 9. Hofmann, *Drawing* and *Study.* © 2005 Estate of Hans Hofmann/Artists Rights Society (ARS), NY. All works by Hofmann are courtesy Ameringer & Yohe Gallery, NY, unless otherwise noted. P. 12. Hofmann, *711 Third Avenue mural.* © 2005 Estate of Hans Hofmann/Artists Rights Society (ARS), NY. P. 14. McDarrah, *Hofmann's house.* © by Fred W. McDarrah. P. 15. Hoffmann, *Analytical drawing.* © 2005 Estate of Hans Hofmann/Artists Rights Society (ARS), NY. P. 18. *Cover of* Cubism and Abstract Art. Courtesy Museum of Modern Art, NY. P. 19. Hofmann, *Abstract Euphony.* © 2005 Estate of Hans Hofmann/Artists Rights Society (ARS), NY. Hofmann, *The Pond.* Yale University Art Gallery, New Haven, CT. © 2005 Estate of Hans Hofmann /Artists Rights Society (ARS), NY. P. 25. Hofmann, *Landscape.* © 2005 Estate of Hans Hofmann /Artists Rights Society (ARS), NY. P. 27. Hofmann, *Vases on Yellow Cupboard* and *Circus.* © 2005 Estate of Hans Hofmann/Artists Rights Society (ARS), NY. P. 30. Hofmann, *Autumn Chill and Sun.* © 2005 Estate of Hans Hofmann/Artists Rights Society (ARS), NY.

MANHATTAN GEOGRAPHY. P. 34. Burckhardt, *Chelsea Evening.* © 2005 Estate of Rudy Burckhardt/Artists Rights Society (ARS), NY. All works by Burckhardt are courtesy Tibor de Nagy Gallery, NY. P. 35. Cohen, *The Cedar Tavern.* © John Cohen/Courtesy Deborah Bell Photographs, NY. P. 39. Kline, *Poster.* © 2005 The Franz Kline Estate/Artists Rights Society (ARS), NY. Cohen, *Tanager Gallery Opening.* © John Cohen/Courtesy Deborah Bell Photographs, NY. P. 43. Hayter, *Cinq Personnages.* © 2005 Artists Rights Society (ARS), NY/ADAGP, Paris. P. 44. Pollock, *Number 27.* Whitney Museum of American Art, NY; Purchase 53.12. © 2005 Pollock-Krasner Foundation/Artists Rights Society (ARS), NY. P. 45. Freilicher, *Early New York Evening.* Courtesy Tibor de Nagy Gallery, NY. P. 48. Steinberg, *Drawing.* © The Saul Steinberg Foundation/Artists Rights Society (ARS), NY. P. 49. Reinhardt, *Cartoon.* © 2005 Estate of Ad Reinhardt/Artists Rights Society (ARS), NY. P. 52. Motherwell, *Cover.* © Dedalus Foundation, Inc./Licensed by VAGA, NY. P. 53. *Kootz Gallery cover.* © Adolph and Esther Gottlieb Foundation/Licensed by VAGA, NY. P. 54. *Exhibition of antique lace.* Courtesy Tibor de Nagy Gallery, NY. P. 60. Porter, *Laurence Typing.* Parrish Art Museum, Southampton, NY, Gift of the Estate of Fairfield Porter, 1980. *Cover of* ART-news. © 1961, May, ARTnews LLC. Reprinted courtesy of the publisher. P. 62. Guston, *The Painter's City.* Courtesy David McKee Gallery, NY.

THE DIALECTICAL IMAGINATION. P. 65. Mondrian, *Broadway Boogie Woogie.* The Museum of Modern Art, NY. © 2005 Mondrian/Holtzman Trust c/o hcr@hcrinternational.com. P. 68. Burckhardt, *Haircut 20¢.* © 2005 Estate of Rudy Burckhardt/Artists Rights Society (ARS), NY. P. 69. Klein, *Wings of the Hawk.* © William Klein. Courtesy Howard Greenberg Gallery, NY. P. 71. De Kooning, *Painting.* The Museum of Modern Art, NY. © 2005 The Willem de Kooning Foundation/Artists Rights Society (ARS), NY. P. 72. Kline, *New York, N.Y.* Albright-Knox Art Gallery, Buffalo, NY. © 2005 The Franz Kline Estate/Artists Rights Society (ARS), NY. Motherwell, *Elegy to the Spanish Republic XXXIV.* Albright-Knox Art Gallery, Buffalo, NY. © Dedalus Foundation, Inc./Licensed by VAGA, NY.

P. 73. Pousette-Dart, *Chavade*. Museum of Modern Art, NY. Courtesy Mrs. Richard Pousette-Dart. P. 75. Picasso, *Girl Before a Mirror*. Museum of Modern Art, NY. © 2005 Estate of Pablo Picasso/Artists Rights Society (ARS), NY. P. 79. Rothko, *No. 5 (Untitled)*. Chrysler Museum of Art, Norfolk, VA. © 1998 Kate Rothko Prizel & Christopher Rothko/Artists Rights Society (ARS), NY. P. 81. Kahn, *Portrait of Thomas Hess*. Courtesy Ameringer & Yohe Gallery, NY. P. 85. De Kooning, *Dust jacket*. © 2005 The Willem de Kooning Foundation/Artists Rights Society (ARS), NY.

THE PHILOSOPHER KING. P. 87. Burckhardt, *De Kooning*. © 2005 Estate of Rudy Burckhardt/Artists Rights Society (ARS), NY. P. 89. De Kooning, *Attic*. Metropolitan Museum of Art, NY. © 2005 The Willem de Kooning Foundation/Artists Rights Society (ARS), NY. P. 92. De Kooning, *Gotham News*. Albright-Knox Art Gallery, Buffalo, NY. © 2005 The Willem de Kooning Foundation/Artists Rights Society (ARS), NY. P. 93. Mondrian, *Composition (No. IV) Blue-White*. Wadsworth Atheneum, Hartford, CT. © 2005 Mondrian/Holtzman Trust c/o hcr@hcrinternational.com. P. 95. Stout, *Untitled*. Courtesy Joan T. Washburn Gallery, NY. P. 96. De Kooning, *Study*. © 2005 The Willem de Kooning Foundation/Artists Rights Society (ARS), NY. P. 98. *De Kooning and Gorky*. Courtesy Frances Mulhall Achilles Library, Archives; Whitney Museum of American Art, NY. P. 101. Graham, *Aurea Mediocritas*. Courtesy Richard York Gallery, NY. P. 106. Le Nains, *The Peasant Meal*. Louvre, Paris. P. 107. Hélion, *Abstraction-Verte*. Fine Arts Program of the Federal Reserve Board, Washington, DC. © 2005 Artists Rights Society (ARS), NY/ADAGP, Paris. P. 110. De Kooning, *Portrait of Rudy Burckhardt*. © 2005 The Willem de Kooning Foundation/Artists Rights Society (ARS), NY. P. 111. Le Nains, *The Dice Players*. Rikjsmuseum, Amsterdam. P. 112. De Kooning, *Two Standing Men*. Metropolitan Museum of Art, NY. © 2005 The Willem de Kooning Foundation/Artists Rights Society (ARS), NY. Le Nains, *The Forge*. Louvre, Paris. P. 113. De Kooning, *Seated Man* and *Untitled*. © 2005 The Willem de Kooning Foundation/Artists Rights Society (ARS), NY. Le Nains, *Return from the Christening*. Louvre, Paris. P. 116. De Kooning, *Asheville*. Phillips Collection, Washington, DC. © 2005 The Willem de Kooning Foundation/Artists Rights Society (ARS), NY. P. 119. De Kooning, *Woman I*. Museum of Modern Art, NY. © 2005 The Willem de Kooning Foundation/Artists Rights Society (ARS), NY.

"I CONDEMN AND AFFIRM, SAY NO AND SAY YES." P. 126. McNeil, *Estuary*. Courtesy Salander-O'Reilly Galleries, NY. P. 127. Bell, *Self-Portrait at Easel*. Courtesy Salander-O'Reilly Galleries, NY. P. 130. Cohen, *The Cedar Tavern*. © John Cohen/Courtesy Deborah Bell Photographs, NY. *Rivers and Blaine*. Courtesy Carolyn Harris. P. 132. *American Sources of Modern Art*. Courtesy Museum of Modern Art, NY. P. 133. Albers, *Untitled*. Museum of Modern Art, NY. © 2005 The Josef and Anni Albers Foundation/Artists Rights Society (ARS), NY. P. 135. Schapiro, *Self-Portrait*. Courtesy Lillian M. Schapiro and Miriam Schapiro Grosof, Trustees Under the Will of Meyer Schapiro. P. 140. Newman, *Vir Heroicus Sublimis*. Museum of Modern Art, NY. © 2005 Barnett Newman Foundation/Artists Rights Society (ARS), NY. P. 141. De Kooning, *Judgment Day*. Metropolitan Museum of Art, NY. © 2005 The Willem de Kooning Foundation/Artists Rights Society (ARS), NY. P. 143. Pollock, *Untitled*. © 2005 Pollock-Krasner Foundation/Artists Rights Society (ARS), NY. P. 144. Cohen, *The Artists' Club*. © John Cohen/Courtesy Deborah Bell Photographs, NY. P. 145. Lassaw, *Procession*. Whitney Museum of American Art, NY; Purchase and exchange 56.19. Marca-Relli, *Junction*. Whitney Museum of American Art, NY; Purchase, with funds from the Friends of the Whitney Museum of American Art 59.11. P. 147. Pavia, *Sculpture at Kootz Gallery*. Courtesy Natalie Edgar. P. 149. McDarrah, *Club Panel Discussion*. © by Fred W. McDarrah. P. 151. *Club postcard*. Courtesy Philip Pavia Papers, Special Collections and Archives, Robert W. Woodruff Library, Emory University, Atlanta, GA.

HEROES. P. 159. Calder, *Frontispiece for* Vertical. © 2005 Estate of Alexander Calder/Artists Rights Society (ARS), NY. P. 161. Rothko, *The Source*. National Gallery of Art, Washington, DC. © 1998 Kate Rothko Prizel & Christopher Rothko/Artists Rights Society (ARS), NY. P. 162. De Niro, *Crucifixion After Mantegna* and *Two Figures*. Courtesy Salander-O'Reilly Galleries, NY. P. 163. Soutine, *Alley of Trees*. © 2005 Artists Rights Society (ARS), NY/ADAGP, Paris. P. 165. Tchelitchew, *Hide and Seek*. Museum of Modern Art, NY. P. 166. Abbott, *Art of This Century*. Berenice Abbott/Commerce Graphics, Ltd., NY. P. 168. MacIver, *Violet Hour*. Los Angeles County Museum of Art, Mira T. Hershey Memorial Collection. Photo © 2004 Museum Associates/LACMA. P. 170. Pollock, *Pasiphaë*. Metropolitan Museum of Art, NY. © 2005 Pollock-Krasner Foundation/Artists Rights Society (ARS), NY. P. 171. *Earl Kerkam*. Photograph and all works by Kerkam courtesy Mrs. E. Bruce Kirk. P. 178. Burckhardt, *No Encroachment, NY*. © 2005

Estate of Rudy Burckhardt/Artists Rights Society (ARS), NY. P. 180. Cohen, *Tanager Gallery, 10th Street*. © John Cohen/Courtesy Deborah Bell Photographs, NY. P. 181. Burckhardt, *De Kooning's Paint Table*. © 2005 Estate of Rudy Burckhardt/Artists Rights Society (ARS), NY. P. 183. Picasso, *The Painter with a Model Knitting*. © 2005 Estate of Pablo Picasso/Artists Rights Society (ARS), NY. P. 186. Pollock, *Gothic*. Museum of Modern Art, NY. © 2005 Pollock-Krasner Foundation/Artists Rights Society (ARS), NY. P. 187. Matter, *Jackson Pollock*. Courtesy Staley-Wise Gallery, NY, and Alex Matter. P. 189. Pollock, *The Flame*. Museum of Modern Art, NY. © 2005 Pollock-Krasner Foundation/Artists Rights Society (ARS), NY. P. 191. Pollock, *Cathedral*. Dallas Museum of Art, Dallas, TX. © 2005 Pollock-Krasner Foundation/Artists Rights Society (ARS), NY. P. 194. Pollock, *Guardians of the Secret*. San Francisco Museum of Modern Art. © 2005 Pollock-Krasner Foundation/Artists Rights Society (ARS), NY. P. 196. Pollock, *Number 1*. Museum of Contemporary Art, Los Angeles, CA. © 2005 Pollock-Krasner Foundation/Artists Rights Society (ARS), NY. P. 198. Kalischer, *Satie's Ruse of Medusa*. © Clemens Kalischer. P. 199. Kelly, *Study for* Tablet. © Ellsworth Kelly. P. 200. *Cunningham's* The Seasons. Reproduced with the permission of The Noguchi Museum, NY. P. 203. Namuth, *Jackson Pollock*. © 1991 Hans Namuth Estate. Collection Center for Creative Photography, University of Arizona.

A SPLENDID MODESTY. P. 209. Guston, *White Painting I*. San Francisco Museum of Modern Art. P. 210. Cavallon, *Untitled*. Courtesy Salander-O'Reilly Galleries, NY. P. 211. Gorky, *The Plow and the Song*. © 2005 Artists Rights Society (ARS), NY. P. 216. *Giacometti's studio*. Courtesy The Pierre and Maria-Gaetana Matisse Foundation. Calder, *Jean-Paul Sartre*. © 2005 Estate of Alexander Calder/Artists Rights Society (ARS), NY. P. 217. Matter, *Calder mobile*. © 2005 Estate of Alexander Calder/Artists Rights Society (ARS), NY. Courtesy Alex Matter. P. 218. Hamlin, *Black Mountain College*. Courtesy of The North Carolina State Archives. P. 219. Orlowsky, *Untitled*. Courtesy Ameringer & Yohe Gallery, NY. P. 220. Milius, *Hans Hofmann School*. Courtesy Ameringer & Yohe Gallery, NY. P. 222. Campbell, *Albers*. Courtesy Black Mountain College & Arts Center. P. 223. Albers, *Multiplex D*. © 2005 The Josef and Anni Albers Foundation/Artists Rights Society (ARS), NY. P. 224. Archer, *Quiet House*. Courtesy Jan Van der Donk Gallery, NY. P. 226. Archer, *Cunningham*. Courtesy Jan Van der Donk Gallery, NY. P. 228. Leslie, *Quartet No. 1*. Courtesy Allan Stone Gallery, NY. P. 229. Freilicher, *After Watteau's* Le Mezzetin. Courtesy Tibor de Nagy Gallery, NY. P. 230. Bloom, *Archeological Treasure*. Art Institute of Chicago, Chicago, IL. P. 231. Dickinson, *Ruin at Daphne*. Metropolitan Museum of Art, NY. The Edward J. Gallagher III Memorial Collection, 1955. P. 233. Hélion, *Pegeen dans l'Atelier*. © 2005 Artists Rights Society (ARS), NY/ADAGP, Paris. P. 234. Russell, *Le Rue de Nevers*. Whitney Museum of American Art, NY. P. 237. Bell, *Abstraction (III)*. Courtesy Salander-O'Reilly Galleries, NY. P. 241. Porter, *John Ashbery*. Courtesy The Flow Chart Foundation, the Estate of Fairfield Porter, and Hirschl & Adler Modern, NY.

PASTORALS. P. 249. Masson, *The Storm Winds in the Pines*. © 2005 Artists Rights Society (ARS), NY/ADAGP, Paris. P. 252. Campbell, *Remembrance of Provence*. Courtesy Tibor de Nagy Gallery, NY. P. 253. Rutledge, *Summerspace*. Courtesy the Merce Cunningham Foundation. P. 255. De Kooning, *Door to the River*. Whitney Museum of American Art, NY; Purchase, with funds from the Friends of the Whitney Museum of American Art 60.63. © 2005 The Willem de Kooning Foundation/Artists Rights Society (ARS), NY. P. 256. Dickinson, *Rock, Cape Poge*. Collection of Mr. and Mrs. Daniel W. Dietrich II. Courtesy Babcock Galleries, NY. Heliker, *Pertaining to Rome*. Courtesy The Heliker-LaHotan Foundation and Kraushaar Galleries, NY. P. 258. Noguchi, *Buson*. Reproduced with the permission of The Noguchi Museum, NY. P. 259. Diebenkorn, *41 Etchings Drypoints*. Courtesy Greenberg Van Doren Gallery, NY. P. 260. Frank, *Barber Shop Through Screen Door—McClellanville, South Carolina*. © Robert Frank from *The Americans*. Courtesy Pace/MacGill Gallery, NY. P. 261. Burckhardt, *Cover of* Mediterranean Cities. © 2005 Estate of Rudy Burckhardt/Artists Rights Society (ARS), NY. P. 262. Burckhardt, *Stills from* Verona. © 2005 Estate of Rudy Burckhardt/Artists Rights Society (ARS), NY. P. 263. Gorey, *I Too Have Lived in Arcadia*. Courtesy The Edward Gorey Charitable Trust. P. 264. Burckhardt, *Mitchell*. © 2005 Estate of Rudy Burckhardt/Artists Rights Society (ARS), NY. P. 266. Mitchell, *Pastel*. Courtesy Nathan Kernan. © The Estate of Joan Mitchell. P. 267. Mitchell, *Evenings on Seventy-third Street*. Courtesy of Cheim & Read Gallery, NY © The Estate of Joan Mitchell. P. 268. Mitchell, *Untitled*. Courtesy of Cheim & Read Gallery, NY © The Estate of Joan Mitchell. P. 270. *Blaine*. Courtesy Carolyn Harris. P. 271. *Ashbery and Blaine*. Courtesy Carolyn Harris. P. 272. Blaine, *Red and Black*. All works by Blaine courtesy Tibor de Nagy Gallery, NY, unless otherwise noted. P. 273. Blaine, *Harbor and Green Cloth II*. Whitney Museum of American Art, NY; Purchase, with funds from the Neysa McMein Purchase Award 58.48.

(ARS), NY. P. 363. Reinhardt, *Abstract Painting, Red and Blue*. © 2005 Estate of Ad Reinhardt/Artists Rights Society (ARS), NY. P. 366. Burckhardt, *Katz cutouts*. © 2005 Estate of Rudy Burckhardt/Artists Rights Society (ARS), NY. P. 367. Katz, *Frank O'Hara*. © Alex Katz/Licensed by VAGA, NY. P. 368. Katz, *Maxine*. © Alex Katz/Licensed by VAGA, NY. P. 369. Katz, *Marine and Sailor*. © Alex Katz/Licensed by VAGA, NY.

GOING TO THE MODERN. P. 376. Hanson, *New York State Theater*. Courtesy David Hanson. P. 377. Stoller, *New York State Theater*. Ezra Stoller © Esto. P. 383. Stoller, *New York State Pavilion*. Ezra Stoller © Esto. P. 389. Cohen, *Kline*. © John Cohen/Courtesy Deborah Bell Photographs, NY. P. 393. Rand, *Modern Art in Your Life*. Courtesy Mrs. Paul Rand and Museum of Modern Art, NY. P. 395. *Museum of Modern Art brochures*. Courtesy Museum of Modern Art, NY. P. 398. Burckhardt, *Mounting Tension*. © 2005 Estate of Rudy Burckhardt/Artists Rights Society (ARS), NY. P. 402. *What Is Modern Painting?* Courtesy Museum of Modern Art, NY. P. 405. Matisse, *Cover*. © 2005 Succession H. Matisse, Paris/Artists Rights Society (ARS), NY.

MAKING HISTORY. P. 409. Noguchi, *Chase Manhattan*. Reproduced with the permission of The Noguchi Museum, NY. Stoller, *Albers mural*. Ezra Stoller © Esto. P. 410. Hofmann, *711 Third Avenue mural*. © 2005 Estate of Hans Hofmann/Artists Rights Society (ARS), NY. P. 414. McDarrah, *O'Hara*. © by Fred W. McDarrah. P. 416. Nakian, *Pastorale*. Whitney Museum of American Art, NY; Gift of the artist in memory of Juliana Force 63.47a-b. P. 418. *Installation of Noguchi gallery*. Reproduced with the permission of The Noguchi Museum, NY. P. 420. Burckhardt, *Installation of Stella gallery*. © 2005 Estate of Rudy Burckhardt/Artists Rights Society (ARS), NY. P. 421. Stella, *Die Fahne hoch!* Whitney Museum of American Art, NY; Gift of Mr. and Mrs. Eugene M. Schwartz and purchase, with funds from the John I. H. Baur Purchase Fund; the Charles and Anita Blatt Fund; Peter M. Brant; B. H. Friedman; the Gilman Foundation, Inc.; Susan Morse Hilles; The Lauder Foundation; Frances and Sydney Lewis; the Albert A. List Fund; Philip Morris Incorporated; Sandra Payson; Mr. and Mrs. Albrecht Sallfield; Mrs. Percy Uris; Warner Communications Inc.; and the National Endowment for the Arts 75.22. © 2005 Frank Stella/Artists Rights Society (ARS), NY. P. 425. Heyman, *Homage to New York*. © Ken Heyman. P. 427. Rothko, *Untitled*. Whitney Museum of American Art, NY. © 1998 Kate Rothko Prizel & Christopher Rothko/Artists Rights Society (ARS), NY. P. 430. Stoller, *Grill Room*. Ezra Stoller © Esto.

POP THEATER. P. 434. Warhol, *One Hundred Cans*. Albright-Knox Art Gallery, Buffalo, NY. © 2005 Andy Warhol Foundation for the Visual Arts/Artists Rights Society (ARS), NY. P. 439. De Kooning, *JFK No. 10*. Courtesy Salander-O'Reilly Galleries, NY. P. 441. Cohen, *Oldenburg*. © John Cohen/Courtesy Deborah Bell Photographs, NY. P. 443. McElroy, *The Store*. © Robert R. McElroy/Licensed by VAGA, NY. © Claes Oldenburg and Coosje van Bruggen. P. 445. McElroy, *The Store*. © Robert R. McElroy/Licensed by VAGA, NY. © Claes Oldenburg and Coosje van Bruggen. P. 446. Burckhardt, *Oldenburg exhibition*. © 2005 Estate of Rudy Burckhardt/Artists Rights Society (ARS), NY. © Claes Oldenburg and Coosje van Bruggen. P. 447. McDarrah, *Warhol*. © by Fred W. McDarrah. P. 448. Lichtenstein, *Girl with Ball*. Museum of Modern Art, NY. P. 449. Warhol, *Blue Marilyn*. Art Museum, Princeton University, Princeton, NJ. © 2005 Andy Warhol Foundation for the Visual Arts/Artists Rights Society (ARS), NY. P. 453. Rosenquist, *Silver Skies*. Chrysler Museum of Art, Norfolk, VA; Gift of Walter P. Chrysler, Jr. 71.699. © James Rosenquist/Licensed by VAGA, NY. COLL. P. 456. Warhol, *Ethel Scull Thirty-six Times*. Jointly owned by the Whitney Museum of American Art and The Metropolitan Museum of Art; Gift of Ethel Redner Scull. © 2005 Andy Warhol Foundation for the Visual Arts/Artists Rights Society (ARS), NY.

TEACHERS. P. 463. Steinberg, *Rosenberg*. © The Saul Steinberg Foundation/Artists Rights Society (ARS), NY. P. 467. Namuth, *Greenberg*. © 1991 Hans Namuth Estate. Collection Center for Creative Photography, University of Arizona. P. 469. Rauschenberg, *Cover of Art International*. © Robert Raushenberg/Licensed by VAGA, NY. *Cover of Artforum*. © *Artforum*, September 1966 [cover]. P. 474. Matter, *Mercedes Matter*. Courtesy Staley-Wise Gallery, NY, and Alex Matter. P. 478. Matter, *Poster for Studio School*. Courtesy Mark Borghi Fine Art, NY. Matter, *Still Life*. Courtesy Mark Borghi Fine Art, NY. P. 479. Matter, *Still Life*. Courtesy Mark Borghi Fine Art, NY. P. 482. Frankenthaler, *Mountains and Sea*. © 2005 Helen Frankenthaler. P. 483. Morris Louis, *Beta Phi*. © 1961 Morris Louis. Courtesy Ameringer & Yohe Gallery, NY. P. 484. Noland, *Askew*. © Kenneth Noland/Licensed by VAGA, NY. Courtesy

Ameringer & Yohe Gallery, NY. P. 485. *Art and Culture*. Courtesy Beacon Press. P. 488. Mondrian, *Fox-Trot A: Lozenge with Three Lines*. Yale University Art Gallery, New Haven, CT. © 2005 Mondrian/Holtzman Trust c/o hcr@hcrinternational.com.

BEGINNING AGAIN. P. 494. Newman, *Who's Afraid of Red, Yellow, and Blue I*. © 2005 Barnett Newman Foundation/Artists Rights Society (ARS), NY. P. 498. Katz, *Judd*. © Paul Katz. P. 500. Porter, *Six O'Clock*. The Saint Louis Art Museum; Gift of Mr. and Mrs. R. Crosby Kemper Jr. through the Crosby Kemper Foundation. P. 501. Judd, *Untitled*. © Judd Foundation. Licensed by VAGA, NY. P. 503. Held, *Last Series XII*. © Al Held/Licensed by VAGA, NY. *New Images of Man*. Courtesy Museum of Modern Art, NY. P. 504. Matthiasdottir, *Temma*. Courtesy Salander-O'Reilly Galleries, NY. P. 506. Laderman, *View of Florence*. Courtesy Gabriel Laderman. Pearlstein, *Nude on Green Cushion*. Courtesy Philip Pearlstein and Betty Cuningham Gallery, NY. P. 508. Porter, *Persian Rose Bush*. All works by Fairfield Porter are courtesy the Estate of Fairfield Porter and Hirschl & Adler Modern, NY, unless otherwise noted. P. 509. Porter, *Self-Portrait*. Dayton Art Institute, Dayton, OH. P. 511. Burckhardt, *Judd exhibition*. © 2005 Estate of Rudy Burckhardt/Artists Rights Society (ARS), NY. P. 513. Chamberlain, *Untitled*. Whitney Museum of American Art, NY; Purchase, with funds from the Howard and Jean Lipman Foundation, Inc. and gift 66.18. © 2005 John Chamberlain/Artists Rights Society (ARS), NY. Samaras, *Untitled Box No. 3*. Whitney Museum of American Art, NY; Gift of the Howard and Jean Lipman Foundation, Inc. 66.36. © Lucas Samaras, courtesy Pace Wildenstein, NY. P. 514. Léger, *The Chinese Juggler*. © 2005 Artists Rights Society (ARS), NY/ADAGP, Paris. P. 516. Judd, *Untitled*. © Judd Foundation. Licensed by VAGA, NY. P. 517. Duchamp, *Bottle Rack*. © 2005 Artists Rights Society (ARS), NY/ADAGP, Paris/Succession Marcel Duchamp. P. 519. Arp, *Sculpture Classique*. © 2005 Artists Rights Society (ARS), NY/VG Bild-Kunst, Bonn. P. 524. Malevich, *Airplane Flying*. Museum of Modern Art, NY. Vuillard, *Mother and Sister of the Artist*. Museum of Modern Art, NY. © 2005 Artists Rights Society (ARS), NY/ADAGP, Paris.

MAINE, MARFA, AND MANHATTAN. P. 531. Judd, *Concrete works*. © Judd Foundation. Licensed by VAGA, NY. P. 537. Porter, *Lizzie, Guitar and Christmas Tree No. 2*. The Parrish Art Museum, Southampton, NY, Gift of the Estate of Fairfield Porter, 1980. P. 542. Judd, *Library*. Courtesy Judd Foundation. P. 544. Judd, *Courtyards*. Courtesy Chinati Foundation, Marfa, TX. Photograph by Florian Holzherr. P. 545. Judd, *Mill-aluminum works*. Collection Chinati Foundation, Marfa, TX. Photographs by Florian Holzherr. © Judd Foundation. Licensed by VAGA, NY. P. 546. Judd, *Mill-aluminum works*. Collection Chinati Foundation, Marfa, TX. Photograph by Florian Holzherr. © Judd Foundation. Licensed by VAGA, NY. P. 548. Burckhardt, *Dwellings*. © 2005 Estate of Rudy Burckhardt/Artists Rights Society (ARS), NY. P. 549. Katz, *101 Spring St*. © Paul Katz. P. 551. Katz, *Judd*. © Paul Katz. P. 553. *Spring Street Building*. Photograph by Rainer Judd. Courtesy Judd Foundation. P. 554. Porter, *Near Union Square—Looking Up Park Avenue*. The Metropolitan Museum of Art, NY.

INDEX

Page numbers in *italics* refer to illustrations.

Grateful acknowledgment is made to the following for permission to reprint previously published material:

ALFRED A. KNOPF: Excerpt from the poem "Unaccountably" from *Sleeping Late on Judgment Day* by Jane Mayhall. Copyright © 2004 by Jane Mayhall. Excerpts from the poems "Radio," "A Warm Day for September," and "Who Is William Walton?" from *The Collected Poems* by Frank O'Hara. Copyright © 1971 by Maureen Granville-Smith, Administratrix of the Estate of Frank O'Hara. Excerpt from the poem "Connoisseur of Chaos" from *The Collected Poems of Wallace Stevens* by Wallace Stevens. Copyright © 1954 by Wallace Stevens and renewed 1982 by Holly Stevens. Reprinted by permission of Alfred A. Knopf, a division of Random House, Inc.

CITY LIGHTS BOOKS: Excerpts from the poem "The Day Lady Died" by Frank O'Hara. Copyright © 1964 by Frank O'Hara. Reprinted by permission of City Lights Books.

GEORGES BORCHARDT, INC. AND CARCANET PRESS LIMITED: Excerpt from the poem "The Skaters" from *Rivers and Mountains* by John Ashbery. Carcanet Press Limited title is *The Mooring of Starting Out*. Copyright © 1962, 1966 by John Ashbery. Reprinted by permission of Georges Borchardt, Inc., on behalf of the author and Carcanet Press Limited.

SALLY GOODMAN: Excerpt from the poem "The Midnight Sun" from *The Collected Poems* by Paul Goodman (New York: Random House, 1973). Reprinted by permission of Sally Goodman.

HARCOURT, INC. AND FABER AND FABER LIMITED: Excerpt from the poem "Burnt Norton" from *Four Quartets* by T. S. Eliot. Copyright 1936 by Harcourt, Inc. and renewed 1964 by T. S. Eliot. Reprinted by permission of Harcourt, Inc.

THE LITERARY ESTATE OF MAY SWENSON: Excerpt from the poem "At the Museum of Modern Art" by May Swenson. Reprinted by permission of The Literary Estate of May Swenson.

MARGARET NEMEROV: Except from the poem "Four Soldiers: A Sculpture in Iron by David Smith" from *Selected Poems of Howard Nemerov* by Howard Nemerov. Reprinted by permission of Margaret Nemerov.

NEW DIRECTIONS PUBLISHING CORP. AND CARCANET PRESS LIMITED: Excerpt from the poem "The Descent" from *Collected Poems 1939–1962, Volume II* by William Carlos Williams. Copyright © 1948, 1962 by William Carlos Williams. Reprinted by permission of New Directions Publishing Corp. and Carcanet Press Limited.

POETRY: Excerpt from the poem "Tropical Pool," by Marion Stroebel from *POETRY* (May 1924), p. 38. Reprinted by permission of *POETRY*.

RANDOM HOUSE, INC. AND ROBERT CORNFIELD LITERARY AGENT: Excerpts from the poems "The Silence at Night" and "Syracuse" from *The Complete Poems of Edwin Denby* by Edwin Denby, edited by Ron Padgett. Copyright © 1986 by Full Court Press. Reprinted by permission of Random House, Inc. and Robert Cornfield Literary Agent on behalf of the Estate of Edwin Denby, Yvonne Barckhardt, Executor.

THE UNIVERSITY OF NEBRASKA PRESS: Excerpt from the poem "A Salvo for Hans Hofmann" from *The Collected Poems of Weldon Kees*. Reprinted courtesy of The University of Nebraska Press.